Manet

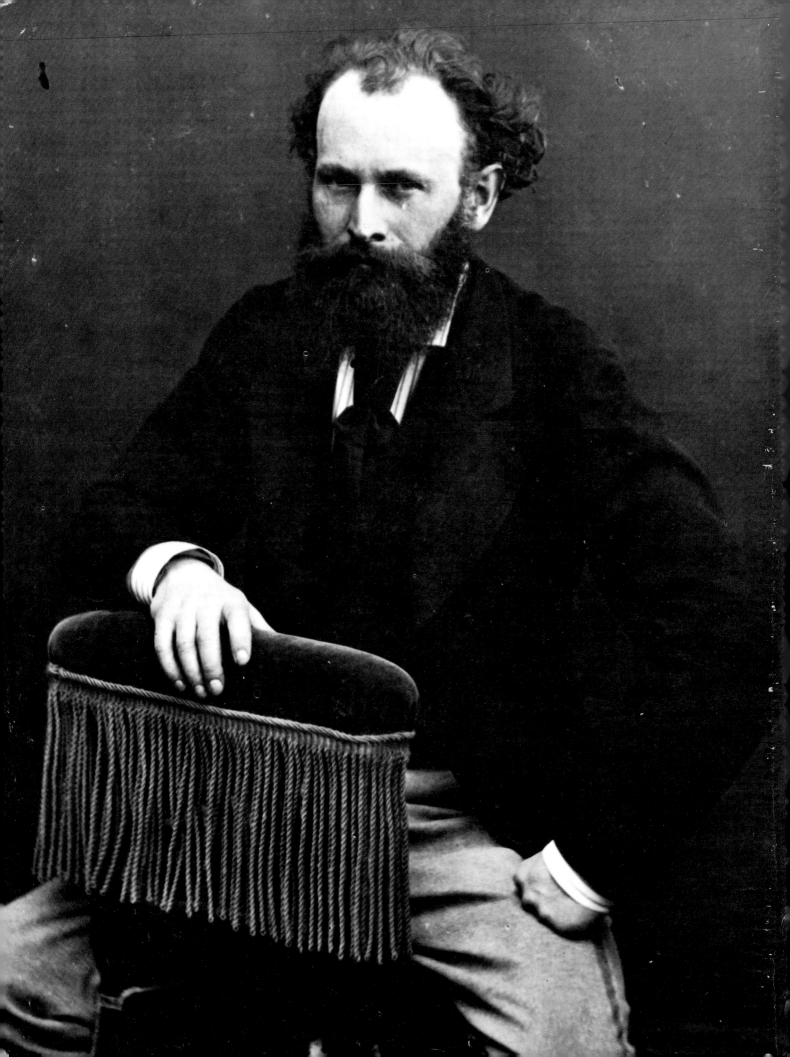

Galeries Nationales du Grand Palais, Paris
April 22–August 8, 1983

The Metropolitan Museum of Art, New York
September 10–November 27, 1983

Manet

1832-1883

Curators of the exhibition

Françoise Cachin
Conservateur, Musée d'Orsay, Paris

Charles S. Moffett
Curator, Department of European Paintings,
The Metropolitan Museum of Art, New York

in collaboration with Michel Melot
Director, Département des Estampes et de la Photographie,
Bibliothèque Nationale, Paris

The Metropolitan Museum of Art, New York
Harry N. Abrams, Inc., Publishers, New York

The exhibition in New York was made possible by Warner Communications Foundation, which also provided a subvention for the catalogue. Additional support for the exhibition has been received from the National Endowment for the Arts, Washington, D.C., a federal agency. An indemnity has been granted by the Federal Council on the Arts and Humanities.

Published by The Metropolitan Museum of Art, New York
Bradford D. Kelleher, Publisher
John P. O'Neill, Editor in Chief
Emily Walter, Editor, with the assistance of
Amy Horbar, Lauren Shakely, and Laura Hawkins
M. E. D. Laing, Consulting Editor for the project

Translations by Ernst van Haagen, Bertrand Languages, Inc.;
and by Juliet Wilson Bareau for her entries and Appendix II
Design by Bruno Pfäffli, adapted for the American
edition by Laurie Jewell

Typesetting by National Photocomposition Services, Inc.
Color separations by N.S.R.G.
Printed in France by Imprimerie Blanchard, Le Plessis-Robinson
Second printing September 1983

Cover and jacket: *The Balcony* (cat. 115), detail
Frontispiece: Nadar, *Edouard Manet*, ca. 1865
Caisse Nationale des Monuments Historiques,
Archives Photographiques
(Plate preserved at the Musée d'Orsay, Paris)

Library of Congress Cataloging in Publication Data
Main entry under title:
Manet, 1832–1883.
Includes catalogue by Françoise Cachin,
Charles S. Moffett, Juliet Wilson Bareau.
Bibliography: p. 540
Includes index.
1. Manet, Edouard, 1832–1883—Exhibitions. I. Cachin, Françoise.
II. Moffett, Charles S. III. Bareau, Juliet Wilson. IV. Galeries
nationales du Grand Palais (France) V. Metropolitan Museum of
Art (New York, N.Y.) VI. Réunion des musées nationaux (France)
N6853.M233A4 1983 760'.092'4 83-8278
ISBN 0-87099-349-6 paper (MMA) 0-87099-359-3 cloth (MMA)
ISBN 0-8109-1346-1 cloth (HNA)

Contents

Acknowledgments

The organizers of the exhibition are deeply indebted to Charles F. Stuckey and Juliet Wilson Bareau, who worked indefatigably on virtually every aspect of the catalogue, and whose knowledge and enthusiasm were invaluable. We are also grateful to Sir John Pope-Hennessy, Consultative Chairman of the Department of European Paintings, The Metropolitan Museum of Art, for his guidance and support during the course of the project. Lucy Oakley and Susan Alyson Stein, Research Assistants in the Department of European Paintings, made significant contributions to the catalogue. Colta F. Ives, Curator-in-Charge, Department of Prints and Photographs, The Metropolitan Museum of Art, coordinated the print loans for New York, and Mark Leonard, Assistant Conservator, provided technical information about Manet paintings in the Metropolitan Museum. Thanks are also due to Jean-Paul Ameline, Isabelle Cahn, and Elisabeth Salvan of the Musée d'Orsay, and to Stephanie Carroll, Marie-Noëlle Meunier, and Anne Schirrmeister for their help at various times in connection with the catalogue and the planning of the exhibition. The numerous members of the Metropolitan Museum's staff whose critically important efforts behind the scenes generally pass unnoticed include James Pilgrim, Deputy Director; Emily Rafferty, Manager, Development Office; Linda M. Sylling, Assistant Manager for Operations; Joseph R. Volpato, Security Department; Maureen Healy, Designer; and Lynton Gardner, Photographer. Special thanks are due to the editor of the American edition of the catalogue, Emily Walter, to the members of the Museum's Editorial Department who played invaluable roles in its preparation and coordination, and to the designers and production personnel who had the task of assembling it.

Jean-Claude Le Blond-Zola has very kindly allowed us to include in the catalogue a number of previously unpublished letters from Manet to Zola, edited by Colette Becker.

Our grateful acknowledgments go also to Irène Bizot and the members of her staff at the Réunion des Musées Nationaux, especially Marguerite Rebois, as well as the following individuals without whose assistance and generosity the exhibition would not have been possible:

William A. Acquavella, Acquavella Galleries, New York; Mr. and Mrs. Pierre Alechinsky; L'Association Française d'Action Artistique; Sylvie Bacot; Katharine Baetjer; Madeleine Barbin; Jeannine Baticle; Marie-Noëlle Becam; Huguette Berès; Ségolène Bergeon; the staff of the Bibliothèque d'Art et d'Archéologie (Fondation Jacques-Doucet), Paris; the staff of Département des Estampes, Bibliothèque Nationale, Paris; Stella Blum; Michel Bouille; Jean-Paul Bouillon; John M. Brealey; Richard Brettell; David Stopford Brooke; Harry A. Brooks; J. Carter Brown; Herbert Cahoon; David B. Cass; Jacques Chavy; Ute Collinet; Desmond Corcoran; Sophie Crouvezier; Andrew Czère; France Daguet; Guy-Patrice Dauberville; Yolande Davreu; Roxanne Debuisson; Anne d'Harnoncourt; Douglas Druick; Pauline Dupont-Brodin;

Mr. and Mrs. Charles Durand-Ruel; Adrian Eeles; Lola Faillant; Dennis Farr; Professor Beatrice Farwell; Claire Filhos-Petit; Hanne Finsen; Judith Fox; the staff of the Frick Art Reference Library, New York; Françoise Gardey; Teréz Gerszi; Nigel Glendinning; Caroline Godfroy; Dominique Godineau; Alain Goldrach; Gilles Gratte; Anthony Griffiths; Andrée Grivel; George Heard Hamilton; Jean-Jacques Hautefeuille; Gisela U. Helmkampf; Madeline Hours; John House; Ay-Whang Hsia; Perry Huston; Geneviève Innes; Lee Johnson; William R. Johnston; William B. Jordan; Mrs. George M. Kaufman; Yvan Kayser; Gabrielle Kopelman; Brigitte Labat; Thomas P. Lee; Patricia Lefébure; Timothy Lennon; Gérard Lévy; Georges Liebert; Walter Liedtke; Nancy Little; the staff of the Cabinet des Dessins, Musée du Louvre; Laura Lucky; Roger Mandle; Chantal Martinet; Henri Mitterand; Gilbert Mondin; Stéphanie Nicolaou; Barbara Paulsen; Robert Payne; Patricia Pellegrini; Edmund P. Pillsbury; Sylvie Poujade; Hubert Prouté; James Purcell; Theodore Reff; Jean-François Revel; John Rewald; Joseph J. Rishel; Franklin Robinson; Allen Rosenbaum; John M. Rosenfield; David E. Rust; Antoine Salomon; Barbara S. Schapiro; Henri Simonet; Martha Small; David Sommerset; Veronique Stedman; Erich Steingräber; Martin Summers; Philippe Thiébaut; the staff of the Thomas J. Watson Library, The Metropolitan Museum of Art; R. Van Spitael; Haydée Venegas; John J. Walsh, Jr.; Frances Weitzenhoffer; Ian McKibbin White; James N. Wood; and André and Georges Wormser.

Lenders to the Exhibition

Private Collections Mr. and Mrs. R. Stanley Johnson 25
Mr. and Mrs. Robert Kahn-Sriber
Mr. and Mrs. Alexander Lewyt 116
Mr. and Mrs. John L. Loeb
Mrs. John Hay Whitney 132
Anonymous lenders 5, 6, 16, 23, 67, 69, 84, 119, 129, 130, 131, 144, 147, 164, 182, 209, 210, 216, 220

Argentina
Buenos Aires Museo Nacional de Bellas Artes 19

Belgium
Tournai Musée des Beaux-Arts de Tournai 139

Brazil
São Paulo Museu de Arte 146, 208

Denmark
Copenhagen Statens Museum for Kunst 153

Federal Republic of Germany
Berlin Nationalgalerie, Staatliche Museen Preussischer Kulturbesitz 180, 218
Bremen Kunsthalle Bremen 28, 94
Hamburg Hamburger Kunsthalle 157, 206
Munich Bayerische Staatsgemäldesammlungen 109

France
Dijon Musée des Beaux-Arts 85, 200–203, 219
Le Havre Musée des Beaux-Arts 120
Lyons Musée des Beaux-Arts 1, 2
Nancy Musée des Beaux-Arts 215
Paris Bibliothèque Littéraire Jacques Doucet 124, 150
Bibliothèque Nationale 7–9, 11, 18, 22, 25, 35–37, 39–41, 43, 44, 47, 48, 52–59, 66, 69, 76, 101, 103, 105, 113, 114, 117, 123, 151, 162, 214
Collection Durand-Ruel 134
Musée Marmottan 142
Musée Nationale du Louvre (Cabinet des Dessins) 21, 51, 65, 70, 71, 75, 100, 111, 112, 136, 143, 154, 155, 161, 166, 167, 170, 171, 177, 179, 183, 191–99, 205, 217
Musée d'Orsay (Galeries du Jeu de Paume) 3, 4, 50, 62, 64, 77–80, 91, 93, 97, 106, 107, 115, 118, 135, 137, 149, 173, 178, 186, 188, 189, 221
Musée du Petit Palais 108

Great Britain
Cambridge Fitzwilliam Museum 158
London Courtauld Institute Galleries 211
National Gallery 38, 172
Oxford Ashmolean Museum of Art and Archaeology 63

Hungary
Budapest Szépművészeti Múzeum 27, 49, 124, 159

Sponsor's Statement

The Metropolitan Museum of Art and the Réunion des Musées Nationaux Français deserve praise for organizing this extraordinary retrospective exhibition of the works of Edouard Manet. Special thanks are due to Françoise Cachin and Charles S. Moffett, the exhibition's curators, for assembling these paintings, drawings, watercolors, and prints from museums and private collections throughout the world.

This magnificent catalogue and the film entitled *Manet: The First Modern Painter* are a substantial contribution to the existing body of educational and scholarly materials related to Manet, his life, and his times. Thus the Warner Communications Foundation is honored to present this large and comprehensive retrospective on the one-hundredth anniversary of Manet's death. We hope that the exhibition, catalogue, and film will be a source of pleasure and enlightenment to those who view them.

Steven J. Ross
Chairman of the Board
and Chief Executive Officer
Warner Communications Inc.

Directors' Foreword

The Metropolitan Museum of Art, New York, and the Réunion des Musées Nationaux Français, Paris, have jointly organized, with the collaboration of the Bibliothèque Nationale, Paris, this retrospective of the works of Edouard Manet (1832–1883). The exhibition, on the occasion of the centennial of the artist's death, is the most important presentation of his works in fifty years. It is through the combined efforts of all three institutions that an impressive number of paintings, drawings, and prints have been brought together from public and private collections on both sides of the Atlantic. The art of Manet, accepted today as representing a high point in the history of art, was widely rejected in his lifetime and throughout his brief twenty-year career during the Second Empire and the early Third Republic. By the end of the nineteenth century, however, Manet, who had gained considerable esteem in the United States, had become the first ambassador of modern French painting. A special tribute is rendered in this catalogue to those early collectors in the United States and Europe who, with foresight, appreciated an art then thought disturbing in its novelty, and who for the most part became major patrons of museums. This exhibition is dedicated to their memory: particularly to Etienne Moreau-Nélaton, on behalf of the Musées Nationaux Français and the Bibliothèque Nationale, and to Mrs. Henry O. Havemeyer, on behalf of the Metropolitan Museum.

The organizers of the exhibition express their deepest gratitude to their associates, to all who have contributed in one way or another to the success of the enterprise, and most especially to the private lenders and to the curators of public collections who have made possible this extraordinary event in homage to one of the greatest of French artists, who was both the last in a great tradition and a pioneer of the modern age.

Finally, we wish to extend our greatest appreciation to Warner Communications Foundation for providing a very generous grant that has been of major importance in producing this exhibition in New York and in publishing the American catalogue as well as for their subvention to the French catalogue.

Philippe de Montebello
Director
The Metropolitan Museum of Art

Hubert Landais
Director
Les Musées de France

Introduction

Françoise Cachin

Manet et manebit[1]

Edouard Manet remains one of the most enigmatic, least classifiable artists in the history of painting. In his own time, his strong personal appeal was actually something of a handicap; his seriousness was questioned, because he would not play the *cher maître* and was not pompous or dogmatic; he preferred the conversation of attractive women to discussions of aesthetics. Upon his death, Degas made the definitive statement: "He was greater than we thought."[2] In life, it would seem, the man had eclipsed the artist.

The man, as everyone agreed, was dazzling. From Baudelaire to Mallarmé, the best minds of the day came under his spell. *Grand bourgeois*, Parisian *par excellence*, with all that this implies of seeming off-handedness, love of wit, courtesy, skepticism and raillery, enlightened liberalism, and irreverence mingled with respect for traditional values—Manet was happy only in Paris: "It's not possible to live anywhere else."[3] Manet hated the country—as did Baudelaire—and carried about with him an atmosphere, as it were, of gaity and the boulevard, only slightly diminished by illness in his last years.

The image of Manet given us by Fantin-Latour (fig. 2) has been often remarked: "He whom the bourgeois imagined in the likeness of a wild dauber looks the impeccable *boulevardier*. The fierce tribune of painting is the willing slave of fashion. Marat—[Beau] Brummel."[4] Compare Théodore de Banville's well-known lines:[5]

Ce riant, ce blond Manet	Fair-haired, twinkling, this Manet,
De qui la grâce émanait	From whom grace shone every way—
Gai, subtil, charmant en somme,	Bearded, Apollonian,
Sous sa barbe d'Apollon	Subtle, gay and charming so
Eut de la nuque au talon	Had an air from top to toe
Un bel air de gentilhomme.[5]	Of the perfect gentleman.

Contemporaries were often moved to describe him. In youth, Antonin Proust, his boyhood friend: "Of medium height, well muscled. . . . Try as he might . . . when he affected the drawling speech of a Paris *gamin*, he never achieved vulgarity. He was obviously a thoroughbred. Beneath a broad forehead, the frank, straight line of the nose. The eyes small, the glance lively. . . . There were few men so attractive."[6] At thirty-five, Zola: "The hair and beard are light chestnut brown; the eyes, narrow and deep set, have a boyish liveliness and fire; the mouth very characteristic, thin, mobile, a trifle mocking at the corners."[7] In his forties, Jeanniot: "One evening in October 1878, I was walking down the rue Pigalle, when I saw coming toward me a man of youthful appearance, most distinguished, turned out with elegant simplicity. Light hair, a fine silky beard . . . gray eyes, nose straight with flaring nostrils; hands gloved, step quick and springy. It was Manet."[8] Mallarmé, with elliptic insight, moves between the *boulevardier* and the painter: "Among the ruins, goat-footed, a virile innocence in beige overcoat, beard and thin blond hair, graying with wit. In short, a scoffer at Tortoni's, elegant; in the

1. From Manet's bookplate, devised by Poulet-Malassis and etched by Bracquemond. The Latin with a play on the name "Manet" may be rendered "He abides and will abide" (fig. 1). Paris, Bibliothèque d'Art et d'Archéologie: from Poulet-Malassis to Manet, December 24, 1874. Noted by Courthion 1953, I, pp. 173–74.
2. Often quoted, notably by Blanche 1924, p. 57.
3. Morisot 1950, p. 59.
4. P. Véron, *Le Panthéon de poche*, Paris, 1975, p. 194.
5. Théodore de Banville, *Nous tous*, Paris, 1884, p. 91.
6. Proust 1897, p. 125.
7. Zola 1867, *L'Artiste*, p. 46; Zola (Dentu), p. 14.
8. Jeanniot 1907, p. 847.

studio, a fury would seize him before a blank canvas—bewildered, as though he had never before painted in his life."[9]

One of our best witnesses, his friend and model the painter Berthe Morisot, gives us a glimpse of Manet at the *vernissage* (varnishing day) at the Salon of 1869: "There I found Manet, hat on head in the sunlight, looking bewildered; he asked me to go and look at his painting, because he didn't dare go forward. I've never seen so eloquent a face; he would laugh, look worried, assure me in the same breath that his picture was very bad and that it would be a great success."[10] And if Morisot enjoyed "chatting with M. Degas . . . philosophizing with Puvis," we find her "laughing with Manet,"[11] who was gay and spirited, "direct [and] exuberant about everything."[12]

He had an impetuous temper—as in the matter of the duel with Duranty in 1870 (see cat. 90)—and was at the same time intent, apprehensive, and sure of his eminence as a painter, as Nadar's photographs show him (see Frontispiece). From the first, confidence alternated with doubts; at the time of the *Olympia* scandal, for example: "I wish I had you here, my dear Baudelaire," he wrote, "abuses rain upon me like hail . . . obviously, somebody is in the wrong. . . ."[13] In reply, the poet chided him for not being above such attacks, held up Chateaubriand and Wagner as examples, and closed with the famous, ambiguous statement, "You are but the first in the decline of your art"[14]—all this to encourage pride at the expense of vanity. And we know what Baudelaire thought of Manet at the time: "Painters always crave immediate success; but indeed, Manet's faculties are so brilliant and so fragile that it would be a pity if he became discouraged. He will never quite make good the deficiencies in his temperament. But he *has* a temperament, that's what counts."[15] Again, "Manet's talent is strong and will endure. But his character is weak. He seems to me to be prostrated and stunned by the blow."[16]

The Manet portrayed here was at the threshold of his career; the sequel was to prove that his character was not by any means "weak." But even later on, more serene, he betrayed an "underlying neurosis which he harbored, for all his outward insouciance,"[17] and this even before the illness of his last years, which obviously brought out the dark side of his personality. Then he was seen to go into hiding at times, like a sick cat, in his own words, but "curiously enough, the presence of a woman, any woman, would set him right again."[18]

This likeable man, surrounded and respected by the best young artists of his day—Bazille, Monet, and Renoir, in particular—nevertheless had no close associate to give us more of his personality than is revealed by Antonin Proust, whose *Souvenirs* turn out, after all, to be a rather superficial account. The young people who approached him late in his life, such as George Moore, Jacques-Emile Blanche, and Georges Jeanniot, occasionally give us a sense of that aura which attracted a brilliant coterie of writers, artists, and fashionable society, as well as the demimonde, to his studio each evening after five: "The soul of generosity and kindness, he was apt to be ironical in speech, often cruel. He had a formidable wit, at once trenchant and crushing. But how apt in expression, and often how true in thought!"[19]

And yet we know little of his private life. For example, who really were his friends? His relations with Degas and Fantin-Latour were often stormy. Baudelaire held him in great affection and esteem, but first Belgium, then sickness and death separated them after 1864; in any case, there was half a generation between them, and Manet never became a second Delacroix to Baudelaire. Between Manet, already famous in his circle, and the younger

Fig. 2. Henri Fantin-Latour,
drawing after his *Portrait of Edouard Manet*, 1867.
The Art Institute of Chicago

writers who were to champion him so brilliantly, Zola from 1866 and Mallarmé from 1873, the relationship was of a different kind (see cat. 106, 149). Yet Mallarmé, perhaps the closest friend of his last years, shares but few of his recollections with us.

Correspondence, by and large, adds nothing essential to our knowledge of Manet, except to confirm his loyalty as a friend, his curiosity, his humor (see, for example, the illustrated letters, cat. 191–205), and his generosity (Manet was a ready lender—to Baudelaire, Villiers, Zola, and Monet, among others). Very few revealing letters, then, no journal, and Manet died too young to be formally interviewed, as was Cézanne in his old age. As for his library, rather scanty and consisting largely of volumes sent to him by author friends,[20] it sheds not much light on his reading. Well educated and intelligent, he was a man for the give-and-take of conversation rather than a speculative thinker, and certainly not the "peintre-philosophe" that some historians would have us see in him today.[21] We are more inclined to the judgment of Jacques-Emile Blanche: "He was no theoretician. His customary remarks about his art were good-humored prattle. He spoke of it as an 'amateur Communard' might speak of the Revolution,"[22] doubtless not so much out of naiveté as to discourage idle debate; in his eyes, evidently, art did not lend itself to explanation any more than to instruction: "Art is a circle," he would say, "you're inside or outside, by accident of birth."[23]

The personal notes that Manet often jotted down between sketches can also tell us something about his thoughts and interests—music, projecting a work, the address for a gourmet delicacy, or of a model:

> fantaisie tacato
> cromathique Bach
> List walse de Schierbert[?]
> pièces romantiques Schaman[?]
> elevation—le soir
>
> Scène de boxe
>
> Patés de bécassines
>
> Mme Godet
> Montreuil sur mer
>
> rue de Rivoli 222
> Mlle Zoche Lichat
> très belle brune
> grande.[24]

But the essential story unfolded in the solitude of the studio, where Manet distilled the modernity of which he was a notorious element. The sparkling Paris of fête and spectacle, from *Music in the Tuileries* (cat. 38) to *Lola de Valence* (cat. 50) and *Masked Ball at the Opéra* (cat. 138), of *galanterie* in *Olympia* (cat. 64) and in *Nana* (cat. 157), makes a moving reappearance at the conclusion of his work and of his life, with the subtle play of the mirror in *A Bar at the Folies-Bergère* (cat. 211).

We should bear in mind that the whole of Manet's oeuvre, from *Le déjeuner sur l'herbe* (cat. 62) to *A Bar at the Folies-Bergère*, was completed in just

9. Mallarmé 1945, p. 532.
10. Morisot 1950.
11. Ibid., p. 31.
12. Ibid., p. 35.
13. Baudelaire, *Lettres à*, pp. 233–34: from Manet, May 1865.
14. Baudelaire 1973, II, p. 497: to Manet, May 11, 1865; see also Georgel 1975, p. 68.
15. Baudelaire 1973, II, p. 501: to Mme Paul Meurice, May 24, 1865.
16. Ibid., p. 502: to Champfleury, May 25, 1865.
17. Prins 1949, p. 40.
18. Ibid., p. 51.
19. Silvestre 1887, p. 161.
20. Several volumes from Manet's library are in the Pierpont Morgan Library, New York.
21. Mauner 1975.
22. Blanche 1912, p. 164.
23. Courthion 1959, II, p. 230: from Jeanniot, March 14, 1907.
24. Musée du Louvre, Cabinet des Dessins, Paris (RF 11.169).

over twenty years. The tragedy of Manet's life is not his many *succès de scandale*, which after all made him famous, or the continual scorn of official criticism, which he knew to be of little worth—"Be truthful, let say what may," he would proclaim[25]—or even the indifference of the public, who preferred Bouguereau, Meissonier, and Chaplin. It is rather that after a not very early start, he died at the age of fifty-one, at the height of his powers, just when his youthful ambitions had been surpassed by his conquest of a new freedom in painting.

Recent art criticism has concentrated on only a few years of Manet's life work—the early 1860s—and neglected his later output, hastily dubbed "Impressionist" after 1870. These studies, often cited in the present catalogue, and pioneered by N. G. Sandblad, have shown a tendency to stray into purely

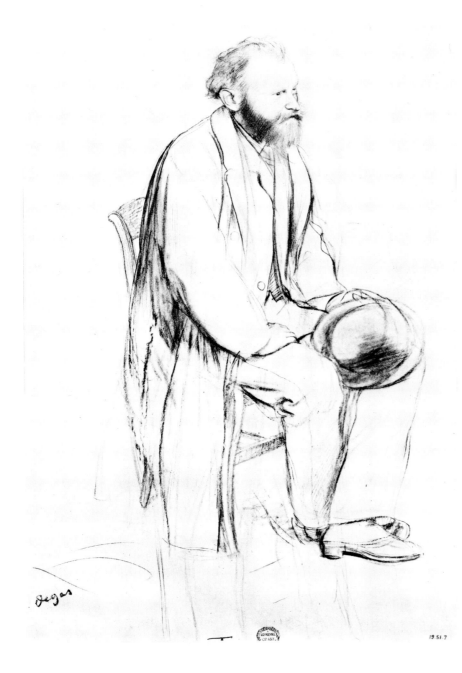

Fig. 3. Edgar Degas,
Portrait of Edouard Manet, ca. 1864, drawing.
The Metropolitan Museum of Art, New York

iconological research, to which the work of the first ten years of Manet's career is certainly more amenable. And indeed, investigation of an oeuvre so strongly linked—whether in the breach or in the observance—to the art of the past does lend itself to the game of tracking down sources and "hidden" interpretations.

But following in the distant wake of Zola, for whom subject matter weighed less than the "patches of color" that more intimately embraced truth and "temperament," we have seen in France, notably in the 1950s, a more formalist approach: a concern with pictorial values rather than with meaning, with rupture rather than with continuity.[26] Scholarship of predominantly trans-Atlantic nurture has recently gone to the opposite extreme. It is hoped that the present exhibition will allow a more balanced view.

Was Manet the last of the great classical painters, or the first of the so-called revolutionaries? Was he the *enfant terrible* of the "grand" art of the past, a somewhat prankish pupil of the masters, restorer of the true tradition beyond the teachings of the Ecole des Beaux-Arts, or was he the great forerunner, the originator of "pure" painting? He was of course all of these, in whatever proportions the vicissitudes of taste may dictate.

Ambiguous enough in itself, Manet's position in relation to the official art of his time complicates our view of his role. By a quirk of fate, the announcement of his death heralded the opening of the Salon of 1883; he had been born in 1832, across the way from that same Ecole des Beaux-Arts where his posthumous exhibition was held, in the very premises where his opponents taught.

While still a young man, he chose to study under Couture, who had been trained in the classical tradition but did not aspire to prepare his pupils as candidates for the Prix de Rome. It was that choice which presaged his attitude throughout his life.[27] Associated as he was with the Impressionists, Manet could have exhibited his work as one of them from 1874 on; but he persisted in seeking to triumph at the Salon—the home ground of established values—as an independent. Anxious though he was to receive honors, he hoped to succeed by "flouting all of the conventions of the day." When Degas belittled a mutual friend who had been awarded the Légion d'honneur, Manet answered him, "You must take everything that distinguishes you from the crowd. . . . In this dog's life of ours, where everything is a struggle, one can't be too heavily armed. . . ." "To be sure," Degas interrupted, "I was almost forgetting what a bourgeois you are" (see figs. 3, 4).[28]

The rejoinder was unfair; with the possible exception of *Le bon bock* (RW I 186), Manet did nothing to court the recognition that he would not have disdained, and his oeuvre unfolds steadfastly, without complaisance or concession to the Salon or to precedent. This moral strength is felt in his very brushwork—vigorous, expansive of gesture, resolutely personal despite all influences. The cool "bourgeois" was master also of a new mode of seeing, the standard-bearer of an avant-garde. "Manet was as important to us [Impressionists] as Cimabue and Giotto were to the Italian Renaissance," said Renoir.[29] To Manet he wrote, "You are the happy warrior, with hatred for none, like some old Gaul; and I love you for that cheerfulness in the face of injustice."[30]

In a sense, Manet magnetized—through attraction and repulsion—the artistic life of his time. Set against the eclectic and conservative taste of the Second Empire and the early Third Republic, his art defied categorization, was ever challenging. His métier, born of tradition, of undeniable virtuosity, was placed in the service of his simplifying vision, of works whose images are often abbreviations, allusions to museum art, restating its magnificence in

Fig. 4. Edgar Degas,
Manet, ca. 1864, drawing.
Private collection

25. "Faire vrai et laisser dire." Epigraph of invitation to view Manet's rejected paintings, April 1876.
26. André Malraux, *Les Voix du silence*, Paris, 1951; Bataille 1954; Gaëtan Picon, *1863: La Naissance de peinture moderne*, Geneva, 1974.
27. Boime 1980.
28. Nittis 1895, p. 188.
29. Jean Renoir, *Mon Père, Auguste Renoir*, Paris, (1962) 1981, p. 117.
30. Moreau-Nélaton 1926, II, p. 88: Renoir to Manet, December 28, 1881.
31. Spuller 1867.

modern terms, without reference to perspective, modeling, or finish, and banishing rhetoric. And Second Empire criticism, while adverse, clearly sensed its novelty: "M. Manet's system, his commitment, consists in taking large masses, patches set one beside another, in different values, all in a full, pale white light. . . . There is no question of aesthetics, beauty, moral feeling, intellectual appeal. In his eyes, painting has nothing to do with all that";[31] or, "Let us say it is a combination of colors, and regard it as we would the wild arabesques on a Persian vase, the harmony of a bouquet, the decorative effect of patterned wallpaper."[32] Not, in other words, the Beautiful, or Painting as it was then understood, even though—and herein lies the ambiguity—Manet's art for a long time openly quoted the masterpieces of the past. It was this very relationship to "the masters," often censured as one of dependency, that encouraged the liberties he took with contemporary painting. In this context, there has been mention of "pictorial compilation," and comparison has been made between Manet and Picasso.[33] That was indeed a novelty in the history of art—to paint openly from paintings, almost to the point of parody, taking painting itself as the object of its own attention; *Olympia*, daughter of Titian, Ingres, and Goya, throws down a challenge to the masters in contemporary terms.

Rejecting "sentiment" and the "ideal" in the 1860s, and then the Impressionist "effusion" in the 1870s, Manet stood alone. The painter of contemporary life, but of life as recreated in the studio, became the painter of painting itself.

He was continually reproached for "sketchy" handling, for an implausible realism, which, by concentrating attention on painting itself, in fact inaugurated modern art: "It was he," said Renoir, speaking of his own early training, "who best rendered, in his canvases, the simple formula we were all trying to learn, by attending best."[34] Matisse echoed this thought: "He was the first to *act by reflex*, thus simplifying the painter's métier. . . . Manet was direct as could be. . . . A great painter is one who finds lasting personal signs for the expression of his vision. Manet found his."[35]

These "personal signs" are often the result of a very special apprehension of reality, a synthetic vision that Manet's energetic technique and elegant handling of color rendered absolutely new, a cutting out of compositions from geometrically structured space, a generous organization of contrasts in large planes and dazzling blacks—so many constant elements, like the absence of a sentimental attitude in scenes that might otherwise be referred to as genre. Manet's work dispenses with rhetoric and commentary. The portraits are revealing in this respect; the faces—from Zola to Mallarmé (cat. 106, 149), from Suzanne Manet (cat. 97) to the waitress in *A Bar at the Folies-Bergère* (cat. 211)— are caught in their psychological individuality, despite a seeming expressionlessness, by purely plastic means. Very few of the paintings are without the note of eccentricity—of perspective, situation, or proportion—without which, according to Baudelaire, there is no Beauty. The costumed *espada*, in front of a toy bull (cat. 33), the black cat, humorous rather than diabolical, and the delightful outsize bouquet in *Olympia*, the audacity of Astruc's hand (cat. 94), and such telling details as the blue cravat and the ball in *The Balcony* (cat. 115), the oranges in *Young Woman Reclining* (cat. 29), and the improbable reflection of the woman in *A Bar at the Folies-Bergère*—all of these are so many touches of poetic humor, taken for blunders or provocation at the time, surprise effects in a universe of controlled passion, of constantly renewed invention.

Of all painters Manet is the least dull, the least liable to diminution

32. Mantz 1869.
33. André Lhote, *Nouvelle Revue française*, August 1932, p. 285.
34. Vollard 1938, p. 175.
35. Matisse 1932, quoted in Florisoone 1947, p. 122; Cogniat and Hoog 1982, pp. 35–36.
36. Save for a few canvases where extreme fragility, or terms of gift, forbid removal: *The Absinthe Drinker* (RW I 19), Ny Carlsberg Glyptotek, Copenhagen; *The Old Musician* (RW I 52), National Gallery of Art, Washington, D.C.; *The Execution of Maximilian* (RW I 127), Kunsthalle, Mannheim; *Le bon bock* (RW I 186), Philadelphia Museum of Art; and *The Laundry* (RW I 237), The Barnes Foundation Museum of Art, Merion, Pa.
37. Proust 1901, p. 76.
38. Jeanniot 1907, p. 854.

by a retrospective exhibition. His work offers the most varied images of contemporary life, with the grandeur of classical painting and the freedom of modern art; and it is in this duality that his individuality lies.

This exhibition, marking the hundredth anniversary of his death, is the first in over half a century to present an almost complete survey of his work. It is arranged chronologically, and presents beside each canvas related drawings and prints. The authors of the catalogue have tried to give some account of the creation and critical reception of Manet's works, as well as their history after leaving the studio. They have also identified the collectors to whom we owe Manet's widespread accessibility in public collections today. The main body of his output is here brought together,[36] in accordance with his wish: "I should be seen whole," he said to Antonin Proust, "don't let me go into the public collections piecemeal. I'd be misjudged."[37]

One last word of his, meant as advice to a young painter: "Conciseness in art is a necessity and a grace. . . . In a figure, look for the full light and the full shadow, the rest will come naturally. . . . And then, cultivate your memory; for nature will never give you more than information—[memory] is a lifeline that saves you from falling into banality. At all times, you must be the master, and do what pleases you. No set pieces! Please, no set pieces."[38]

Manet's Pictorial Language

Anne Coffin Hanson

"What a painter! He has everything, an intelligent mind,
an impeccable eye, and what a hand!"

Paul Signac[1]

Many writers have shared Signac's admiration for Edouard Manet's technical abilities, and yet Manet's craft has been described in only the most superficial terms, and, at times, with flagrant disregard for the obvious facts.[2] Most critics of Manet's day regarded the subject as being outside their area of competence and interest—a matter of concern only for painters. But as Castagnary once said, "Painting is not made for painters any more than brioches are made for bakers. Brioches, paintings, and all the rest are intended for the public."[3] Nevertheless, Manet developed his craft to a level that could not be ignored even by his detractors, and he ultimately changed the way oil painting was practiced throughout the world. Traditional procedures for laying in layers of color, painting slow-drying "fat" paint over thinner "lean" paint, were used and transformed by Manet. With these means, he not only described objects but also simultaneously developed a new symbolic language to express ideas and feelings.

The lure of Manet's technical virtuosity seems to have led to the view that he had little interest in his subject matter. While that attitude may have encouraged a formalist approach to his art, it did not result in careful study of his craft. Recently, Manet's oeuvre has been studied almost obsessively in terms of its sources, its political and social implications, and its psychological suggestions, often making the paintings seem peripheral to the explanations about them. What has been overlooked in both approaches is what the paintings themselves can reveal about how they were created and, therefore, about the thoughts of the painter who created them. The picture surface can also add powerfully to the effects of composition, subject matter, and context in the total meaning of the work of art.

A major retrospective exhibition offers a remarkable opportunity to correct repeated misconceptions about Manet's painting processes. The most common of these are that Manet simply copied what he saw directly from nature, that Manet painted "flat," and that Manet painted with great speed, often applying paint in a single wet layer and completing a work in a single sitting.[4] Study of his works suggests instead that he developed a remarkable system of marks or signs to express what he saw, that he held in active tension the flatness of the picture surface and the sensation of the volume of the objects depicted on it, and finally, that he achieved his goals through a slow and deliberate process of perceiving and reacting, drawing and redrawing, until he reached an effective pictorial expression.

Zola said that Manet placed himself in front of his subject and simply painted what was there. "Ask nothing more from him than a literally accurate translation," he said.[5] One must ask, however: What can be literally translated? What is out there in space and conveyed to us through a combination of our fallible senses? What is already stored in the mind as preconceived imagery? Whatever a painter does to translate perceived nature onto the two-dimensional canvas requires a system of marks to transform sensation into

graphic symbol. Clearly, Manet's processes of translation and transformation were neither literal nor immediate.

Very little is known about how we perceive and understand sensations of light on the retina. Even if one conceives of a kind of veil of colored dots within the eye, copying such minute marks on a flat canvas would fail to capture the experience of seeing a constantly changing world. There is ample evidence that Manet never intended such a transcription of human vision. His clumping of dark and light forms into distinct areas, and his persistent dependence on precisely placed lines clearly distinguish his style from that of the Impressionists. His career began with works that seem close to mid-century realism because their surfaces are more evenly covered and details more regularly applied, but the simplifications of form and the disjunctions in color which disturbed the critics in those early works were the very characteristics that Manet preserved into his later and more freely painted style.

Zola was one of the few contemporary critics to understand those qualities. He saw Manet's paintings as constructed on a precise scale of values "which from several feet away give the picture a striking sense of depth." He acknowledged the accusations that Manet's works looked flat, like "les gravures d'Epinal," but he explained that the printmakers of Epinal employed pure colors, without regard to their values, while Manet's choices were governed by the precise relationships of one tone to another.[6] Manet's close values, however, often work against other means of indicating volume. This accounts for the apparent flatness seen in photographic reproductions of his pictures. In front of an actual painting, however, surface qualities come into play and set up an interesting tension with the handling of color. In just those areas (an arm, a face, a torso) that seem to lack volume because they lack shading, painted marks describe the turning surfaces. It is as though the artist had discovered a means of simultaneously combining touch and sight. In a detail of an ordinary photograph (fig. 1) of Manet's *Portrait of Emile Zola* (cat. 106), the writer's face appears to be flatly painted and to lack structure. By

1. John Rewald, "Extraits du journal inédit de Paul Signac, 1894–1895," *Gazette des Beaux-Arts*, 6th ser., XXXVI (July–September 1949), p. 112.
2. The subject of this paper is more fully covered in Hanson 1977, Part III.
3. Castagnary 1892, I, p. 272.
4. Some of Manet's models have left descriptions of the artist at work. Although none was particularly observant or thorough, they agreed that Manet required many sittings and that he reworked his paintings extensively. See Bazire 1884, p. 82; Duret 1902, pp. 71–73; George Moore, *Modern Painting*, London, 1898, pp. 32, 41; Proust 1913, pp. 100–101; Hanson 1977, pp. 138, 160–61.
5. Zola 1867, *L'Artiste*, p. 53; Zola (Dentu), p. 26.
6. Ibid., pp. 51–52; Ibid., p. 24.

Fig. 1. *Portrait of Emile Zola* (cat. 106), detail of head

Fig. 2. *Portrait of Emile Zola*, detail of head in raking light

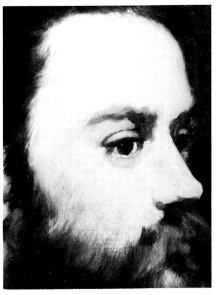

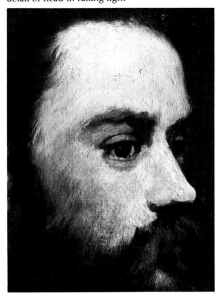

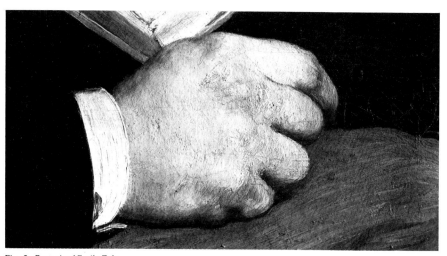

Fig. 3. *Portrait of Emile Zola,*
detail of hand in raking light

contrast, a detail of an excellent photograph taken in raking light (fig. 2)[7] shows the changing textures of the thinly painted dark eye socket, the firmly delineated bridge of the nose, and the brushstrokes that respond to the swellings of the cheeks and brow. Similarly, in painting Zola's hand (fig. 3), Manet allowed his brush to follow the contours of the knuckles and to trace the starched shirt cuff as it turns over the wrist, implying a solid form beneath.

A close look at the nude figures in *Olympia* (cat. 64) and *Le déjeuner sur l'herbe* (cat. 62) shows the same caressing strokes which follow the turning volumes of arms, legs, and torsos. Radiography can reveal similar modeling in lower preparatory layers of paint. Madeleine Hours has published a revealing study of X-rays of selected works by Manet and several of the Impressionists. She notes that both the curving brushmarks and the dark-to-light shading in the underpainting must have given Olympia's body a rounded, even voluminous effect which is lacking in the finished picture.[8]

Fig. 4. *Young Woman Reclining, in Spanish Costume* (cat. 29),
detail of left hand

Fig. 5. *Young Woman Reclining, in Spanish Costume,*
X-ray detail of left hand

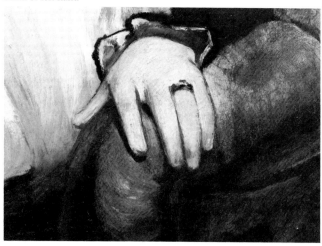

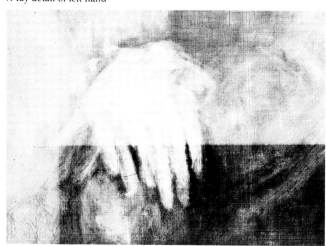

The *Young Woman Reclining, in Spanish Costume* (cat. 29) was painted about the same time as *Olympia*. Similar modeling with directional brush-strokes is present in the pink torero costume and the turning arms of the couch. X-rays demonstrate modeling in the underlayers as well (figs. 4, 5). They also provide evidence that Manet did not paint his pictures all at once. The model's hands have far too many fingers and show that Manet made several tries at their precise location before arriving at their childishly seductive gestures. Such traces of Manet's thinking are to be found in the underlayers of all his paintings. They usually represent minor readjustments, which were part of a refining process, such as the multiple contours of the necktie in *Le bon bock* (RW I 186; fig. 6) or the neck of the guitar in *The Spanish Singer* (cat. 10, fig. b). Occasionally, changes are more extensive: the drinker in *Le bon bock* once had his glass halfway to his mouth, and one can even guess

Fig. 6. *Le bon bock*, composite X-ray

7. I wish to thank Madeleine Hours, Conservateur en Chef des Musées Nationaux, for allowing me to use several fine photographs that were made for study purposes at the Laboratoire de Recherche des Musées de France (figs. 2, 3, 7, 8, 13, 17). I am also indebted to Lola Faillant for showing me the Manet files and for her many helpful comments on them.
8. Madeleine Hours, "Manière et matière des Impressionnistes," *Annales*, Laboratoire de Recherche des Musées de France, Paris, 1974, pp. 7–9.
9. Hanson 1977, pp. 165–66 and n. 153. For a complete study of *Le bon bock*, see Theodor Siegl, "The Treatment of Edouard Manet's *Le Bon Bock*," *Philadelphia Museum of Art Bulletin* LXII (1966), pp. 133–41.
10. Hanson 1970, pp. 158–66; Theodore Reff has made some significant discoveries concerning *The Dead Toreador* (cat. 73) and *The Old Musician*; see Reff 1982, nos. 67, 77.

from the surface of the painting that the sailor in *Boating* (cat. 140) once held a rope attached to the sail.[9] Major alterations seem to have occurred rarely, and then only in works that were radically reconsidered. In both *The Gypsies* (see cat. 48) and *Episode from a Bullfight* (see cat. 73), key figures were altered and eliminated when the canvases were cut apart by the artist.[10]

The modifications an artist makes in the construction of a picture can reveal much about his intentions. *The Balcony* (cat. 115) provides a good example. As a group portrait, it might be expected to give equal emphasis to the main figures. Its effect instead is that of a piercing psychological portrait of the main protagonist, Berthe Morisot. The relatively heavy paint over the entire surface of the canvas suggests that Manet made many changes as he worked on the picture; X-rays bear this out. Berthe Morisot leans forward on the balcony railing, her sharp eyes looking out into our space. Her soft white peignoir, once pyramidal in shape, now has more agitated contours as though reflecting a personal vivacity only momentarily restrained. The specificity and

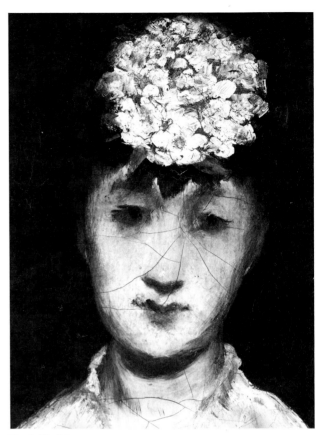

Fig. 7. *The Balcony* (cat. 115),
detail of Berthe Morisot

Fig. 8. *The Balcony,*
detail of Fanny Claus

toughness of her features give her a kind of intellectual power (fig. 7). "I look strange, rather than ugly," she said of her portrait.[11]

Fanny Claus stands behind Berthe Morisot, just outside the doors to the apartment. She is dressed in the same sharply contrasting white and green. X-rays show that in an earlier stage a dark form, possibly the doorway, cut down the right side of her figure, setting her within the interior space. Nevertheless, the original, more active forms of her head would have drawn her forward toward the viewer. Her face was originally fuller, her eyes farther apart and more defined, and her chic round hat had larger and looser contours. The final form (fig. 8)[12] is vastly changed. The figure is restrained, both physically and psychologically, by a series of almost symmetrical curves from head to arms, from arms to the slightly bowed contour of the skirt. The details of the face have been extraordinarily suppressed, the eyes barely indicated, and the paint smoothly applied. It seems that Manet intended to mask her personality, while through his brusque treatment of Berthe Morisot's features he announces her complexity and frankness.

Antoine Guillemet is represented in the interior of the apartment; the small size of his head and the slightly darker tone of his skin hold him firmly behind the two women and reaffirm the dominance of Berthe Morisot. The boy who passes through the room in the background is not visible in X-ray and may have been added on top of the background to animate the room, as do the pictures and the crockery on the rear wall.

11. Morisot 1950, p. 27: letter to her sister, Edma, May 2, 1869.
12. Lola Faillant, "L'Ecriture picturale et la photographie," *Annales,* Laboratoire de Recherche des Musées de France, Paris, 1974, pp. 43–44.
13. X-rays of their works show more even distribution of small light marks in all areas of the canvas. Hours 1974, pp. 18–21, 24–29, see note 8 above.
14. Hanson 1977, pp. 163–65.
15. The effects of scraping can be seen behind the famous black cat in *Olympia* (cat. 64) and between the legs of the firing-squad victims in the Boston version of *The Execution of the Emperor Maximilian* (cat. 104).

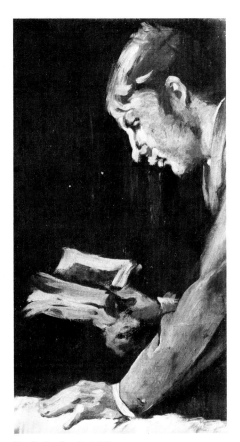

Fig. 9. *Reading* (cat. 97),
detail of Léon Leenhoff

Fig. 10. *Study of a Woman*.
The Art Institute of Chicago

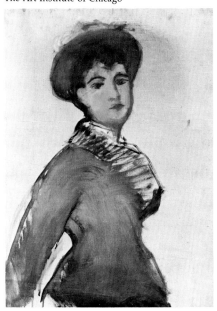

Painting over a thickly darkened ground was not Manet's usual approach. Normally he painted figures and objects on white canvas or over thin transparent washes, later adding the background around them. This practice is in part responsible for the strong disjunctions in color which the critics found so odd during Manet's lifetime—disjunctions that are evident in the three main figures of *The Balcony*. Another example of Manet's painting light over dark can be found in the figure of Léon Koëlla-Leenhoff in the upper right-hand corner of *Reading* (cat. 97; fig. 9). Except for the small area of wall behind him, the entire picture has been painted in light tones over a light ground, achieving an extraordinary blond effect. Close examination of the surface of the picture shows again and again areas of extremely thin paint which open up to the light canvas beneath. Only the animated dark leaves of the plant cut off at the left serve as contrast to the luminous transparencies. Beautiful as its pale passages are, the painting needs the punctuation of the dark area in the upper right. The addition of Léon's figure both corresponds to the plant at the left and explains Mme Manet's calm attentiveness, enclosing her quiet figure in a parenthesis of darker forms. Léon has been painted with vivid economy, the ground being used in traditional fashion to serve as the shadows along his nose and chin. He is literally set *in* the ground, and thus where he belongs in the message of the picture as a whole.

Manet's paintings in all periods of his career are punctuated by contrasting areas of light and dark. In paintings of the Impressionist period by Monet, Renoir, and Pissarro, the fresh brushmarks across the surface are inclined to be more evenly distributed, consuming details and lines, and creating consistent textures.[13] For these artists, building up an encrusted surface of paint over the entire canvas was to become a powerful means of reflecting a complete view of nature. By contrast, Manet's brushstrokes lack consistency and are more loosely disposed over the surface of the canvas. They function not so much as records of perceptions but as evocative shorthand equivalents for perceptions of the tangible world.

What can be perceived in close examination of the face of the canvas or through light studies can be even more easily demonstrated through a series of the artist's later works. Dying at the peak of his productive career, Manet left behind a great many unfinished or partially finished paintings which can be marshaled to show his normal procedures.[14] The most sparsely painted of these (although complete in its aesthetic unity) is the portrait *George Moore at the Café* (cat. 175). Here a few vivid marks of the brush establish both the entire composition and the personality of the sitter. Even in this preliminary drawing on the bare canvas, Manet used both a dark blue and a lighter brown, establishing the color harmonies before he began to cover the surface. The next step after the first drawing was to tone large areas of the surface with thin paint. Manet did this in a number of ways, inventing as he worked. The *Study of a Woman* (RW I 308; fig. 10) shows turpentine-diluted washes of paint applied over the drawing to establish a first colored layer. Here the background remains untouched. More often, Manet simultaneously established a background tone with similar washes by rubbing paint irregularly across the surface or by painting thickly and then scraping off the color to achieve a residual semitransparent tone. Often these methods were combined.[15]

The original drawing, followed by tones of color, must be drawn again in order to revitalize the contours. In *Isabelle Lemonnier with Muff* (cat. 190), Manet's thinking is evident. The repeated redrawing of the edges of Isabelle's muff pull the shape gradually away from the edge of the canvas, tightening

25

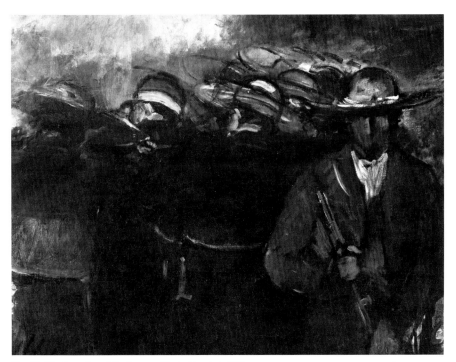

Fig. 11. *The Execution of the Emperor Maximilian* (cat. 104),
detail of firing squad

the major contours of the figure. Here and at the edges of the collar and hat,
Manet also redrew with background color itself, pulling it up to the defined
forms. It is at this stage that Manet established the stance of the figure through
the taut curving silhouette of the back. We can find Manet repeating this
method again and again. The Boston version of *The Execution of the Emperor
Maximilian* (cat. 104; fig. 11) shows similar gestured brush drawing on top of
the painted forms defining and relocating specific contours. The use of back-
ground color to contain forms and to find expressive edges can be seen in
works of different periods and styles, such as the left foot in *The Ragpicker*

Fig. 12. *The Ragpicker,* detail of foot and refuse.
Norton Simon Inc. Foundation

Fig. 13. *Portrait of Emile Zola* (cat. 106),
detail of still life in raking light

Fig. 14. Photograph of Clemenceau,
from Manet's photograph album.
Bibliothèque Nationale, Paris

Fig. 15. Benque,
photograph of Clemenceau.
Musée Clemenceau, Paris

(RW I 137; fig. 12) or the small area of color behind the woman in *Reading* (cat. 174), which defines the contours of the shoulder, collar, and hat. It is also in works such as these that Manet's swift and assured touch can be seen at its best. It is visible, too, in the still life in the *Portrait of Emile Zola* (fig. 13) or, in more refined form, in the details of *Le déjeuner sur l'herbe*. In each case, the combination of tangible form and vibrant effect could only have been achieved through the solid labors which led up to the seemingly spontaneous surface. This is no longer the traditional process of covering a broadly painted *ébauche* with more and more detailed and controlled brushstrokes. Instead, each layer remains a sketch, often visible through the one that covers it. Together they form a composite image which avoids mere facility through the richness of its conception.

Manet painted two similar portraits of Georges Clemenceau, one of which is now in the Kimbell Art Museum at Fort Worth (cat. 185), the other in the Louvre (cat. 186). As Président du Conseil Municipal de Paris, Clemenceau was busy with affairs of state and probably an unwilling model. Surely he had no sympathy for Manet's need for numerous sittings. Although we know that Clemenceau posed several times, it is easy to demonstrate that Manet also worked from at least two available photographs, one of which still remains in Manet's own photograph album. That picture (fig. 14) supplied the turn of the head; another photograph (fig. 15) gave the stance of the figure and the aggressively folded arms. In spite of these obvious sources, there is evidence in both paintings of Manet's struggle to capture more than a mere physical likeness. In both paintings, there are indications of his search for expressive contours through drawing, painting, and redrawing. In both he painted the background up to the edges of the figure, and in the case of the Louvre version, he redefined the edges by scraping out the contours with the tip of the palette knife.

These paintings are not colorful in the sense that they have many obvious hues. In a less literal sense, however, they are powerfully colored by Manet's view of Clemenceau the man. What is mere gesture in the photographs has been translated into the posture and personality of a powerful political figure through the slightest readjustment of the head, the suppression of the details of the wrinkled sleeves, and the sharpening of the contour of the back.

Since each work was apparently painted both from life and from photographs, it is probably of little importance which canvas was painted first (Manet may have alternated between the two). The Fort Worth painting has more broken contours and grittier textures in the handling of the head (fig. 16), somewhat reminiscent of the coarse surfaces of Manet's *Portrait of M. Henri Rochefort* (cat. 206). The head in the Paris version appears more simplified, although raking-light photographs show that it, too, has a vibrant surface (fig. 17). The greater directness of the Paris version suggests that it is more resolved and therefore a second try, yet this version, more than the other, shows Manet's continuing attempts at further refinements. If circumstances had been different, either work might have been carried further and a more traditional effect achieved. Since X-rays show that similar characteristic changes are present in the underlayers of more fully painted works, it is tempting to speculate as to what more might have been accomplished had Manet continued work on either portrait. Manet himself would probably not have known. He could no longer revert to preformed concepts of a desired effect, and many of his so-called unfinished pictures are fully finished in their effectiveness. In

27

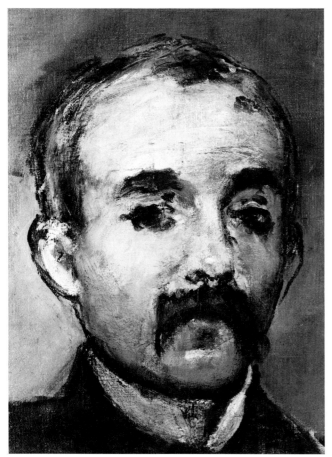

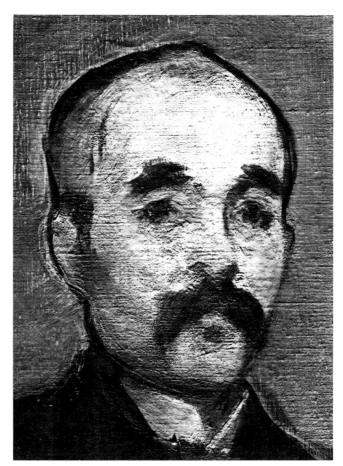

Fig. 16. *Portrait of Clemenceau at the Tribune* (cat. 185), detail of head

Fig. 17. *Portrait of Clemenceau* (cat. 186), detail of head in raking light

his miraculous touch, Manet had invented an expressive means too potent to suppress by demands for a consistent surface. He had succeeded in grasping from his multiple perceptions of the three-dimensional world those forms that convey its continuing life.

Most of Manet's paintings bear the marks of their making. It is these signs of the artist's presence that combine with the inventiveness of his compositions and the force of his subject matter to give meaning to his virtuosity and to allow generations of admirers to say, "What a painter! He has everything."

Manet and Impressionism

Charles S. Moffett

Manet is generally assumed to have been a bona fide Impressionist. For example, his work figured prominently in the exhibition organized by the Louvre and the Metropolitan Museum of Art to commemorate the one-hundredth anniversary of the first of the eight so-called Impressionist group shows held between 1874 and 1886.[1] Most authorities simply ignore the significance of Manet's refusal to participate in any of the seven that were held during his lifetime. Indeed, for more than a century critics, scholars, and specialists in the Impressionist field have referred to Manet as an Impressionist, often citing works painted during the summer of 1874, when he worked with Monet and Renoir at Argenteuil (see cat. 139–41), as evidence of his espousal of the Impressionist idiom. But the classification of Manet as an Impressionist is not without significant problems. The term itself, coined in 1874 by Louis Leroy in his review of the first Impressionist exhibition, pertains primarily to the loose, open brushwork characteristic of the *plein-air* paintings of Monet, Renoir, Pissarro, and Sisley in the early 1870s. Although certain pictures (e.g., cat. 99, 122, 132, 139–41, 174) indicate that Manet shared a variety of interests with Monet, Degas, and others who exhibited at the Impressionist exhibitions, his work is easily distinguished from theirs. Most orthodox Impressionists were landscapists who concentrated on *plein-air* subjects as purportedly realized through an objective transcription of the actual experience of color and light. In contrast, Manet was primarily a figure painter who was fascinated by subjects from modern urban life. However, the group shows that we now call the Impressionist exhibitions included paintings by a number of artists whose work is either not associated with mainstream Impressionism or is dominated by other interests. Although the exhibitions were diverse enough in character to have easily accommodated Manet's pictures, these would have run the risk of being lost in a potpourri of avant-garde styles. Moreover, the wide range in quality of the paintings exhibited would probably not have appealed to Manet, who had already begun to achieve a degree of success at the Salon. The year before the first Impressionist exhibition, *Le bon bock* (RW I 186) had been received enthusiastically by many critics reviewing the Salon; for Manet to have taken part in the independent exhibition held at Nadar's studio on the boulevard des Capucines could have tarnished his reputation.

There is, unfortunately, little information to document Manet's specific reasons for not joining his friends in their attempt to create a viable alternative to the annual, officially sanctioned exhibitions. In a letter written in February or March 1874 to James Tissot to try to persuade him to exhibit at the first group show, Degas attributed Manet's refusal to vanity: "Manet seems determined to keep aloof, he may well regret it. Yesterday I saw the arrangement of the premises, the hangings and the effect in daylight. It is as good as anywhere. . . . The realist movement no longer needs to fight with the others. It already *is*, it *exists*, it must show itself as *something distinct*, there must be a *salon of realists*. Manet does not understand that. I definitely think he is more vain than intelligent."[2]

1. New York, The Metropolitan Museum of Art, *Impressionism: A Centenary Exhibition* (exhibition catalogue), New York, 1974–75.
2. Letter dated "Friday 1874" (Paris, Bibliothèque Nationale); published in its entirety only in English translation (Edgar Germain Hilaire Degas, *Letters*, ed. Marcel Guérin, trans. Marguerite Kay, Oxford, 1948, pp. 38–40, no. 12).

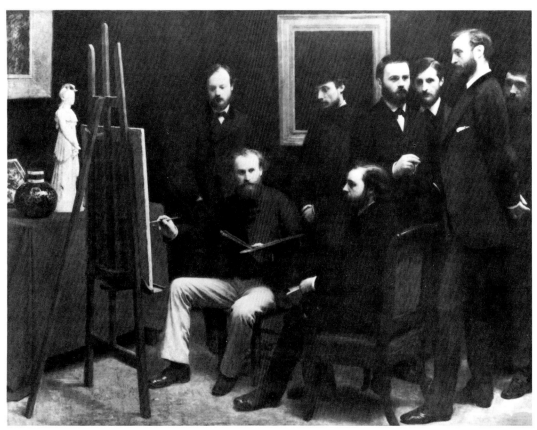

Fig. 1. Henri Fantin-Latour, *A Studio in the Batignolles Quarter*, 1870.
Musée d'Orsay (Galeries du Jeu de Paume), Paris.
From left to right: seated—Edouard Manet, Zacharie Astruc;
standing—Otto Scholderer, Auguste Renoir, Emile Zola,
Edmond Maître, Frédéric Bazille, Claude Monet

It was no secret that Manet had long coveted the kind of official ac-
claim that could be accorded only by the Salon jury, although thus far his
success had been limited to an honorable mention in 1861 (see cat. 10). He
may have been reluctant to associate in a public exhibition with artists of little
or no reputation, and he may not have been persuaded by Degas's argument
that the show constituted a realist salon, especially since the group's approach
to realism was inconsistent and the pictures were of such differing quality.
Today we remember that works by Monet, Renoir, Sisley, Pissarro, Morisot,
Cézanne, Boudin, and Degas were included in the exhibition; but there were
also examples by such lesser figures as Antoine-Ferdinand Attendu, Edouard
Béliard, Edouard Brandon, Pierre-Isador Bureau, Gustave Colin, Louis De-
bras, Louis Latouche, Alfred Meyer, Emilien Mulot-Durivage, and Léopold
Robert. The group was so diverse that its members could not even agree on a
name; Degas proposed "La Capucine" as a neutral title, and Renoir wished to
avoid any term that would signify a new school.[3] Ultimately, they chose "So-
ciété Anonyme des artistes peintres, sculpteurs, graveurs, etc."

On the occasion of the third exhibition in 1877, the members of the
Société Anonyme decided to call themselves a group of Impressionists,[4] but
for the fourth exhibition, held in 1879, they took the name Independents.[5]
Their differences of opinion and identity are underscored by Degas's sugges-

tion during the planning for the fourth show that they represent themselves as "a group of independent, realist, and impressionist artists."[6] To add to the confusion, the makeup of the group changed from exhibition to exhibition, and some artists defected to the Salon. For example, Renoir's *Mme Charpentier and Her Children* (Metropolitan Museum of Art, New York) was included in the Salon of 1879, and Monet exhibited *Lavacourt* (Dallas Museum of Fine Arts)[7] at the Salon of 1880. Although Manet's awareness of the group's internal conflicts and disarray may have played a part in his reluctance to join in the exhibitions, he nevertheless supported some of his colleagues and tried to encourage acceptance of their work. For example, in the spring of 1877 he wrote to the critic Albert Wolff to recommend the work of "my friends Messrs. Monet, Sisley, Renoir, and Mme Morisot," adding, "Perhaps you do not yet like this kind of painting, but you will. In the meantime, it would be very kind of you to mention it in *Le Figaro*."[8]

Manet's letter to Wolff is hardly surprising, because many of the artists we now call Impressionists had long been his friends. He had known Degas well since the mid-1860s (see cat. 132), and their paths sometimes crossed at the Morisot house on the rue Franklin (see cat. 122). He is also known to have been especially friendly with Monet, whom he encouraged and occasionally assisted financially. Manet first emerged as the key figure among the avant-garde painters in the Monday evening gatherings at the Café Guerbois in the late 1860s. The circle comprised older artists such as Guys and Nadar, the writers Zola, Duranty, Silvestre, and Duret, and the group of avant-garde artists that included Fantin-Latour, Desboutin, Degas, Renoir, Cézanne, Sisley, Monet, Bazille, and Pissarro.[9] By about 1870, the informal confederation of the most advanced painters and authors in Paris was more or less complete. At the Café Guerbois, ideas were exchanged, advanced, argued, and defended; one can easily imagine it as the crucible of the Impressionist movement. In a conversation with Thiébault-Sisson in 1900, Monet described the discussions at the Café Guerbois as a formative influence and a source of continuous inspiration: "In 1869 . . . Manet invited me to join him every evening at a café in the Batignolles quarter, where he and his friends would gather and talk after leaving their ateliers. There I met Fantin-Latour, Cézanne, and Degas, who joined the group shortly after his return from Italy, the art critic Duranty, Emile Zola, who was then embarking on his literary career, as well as some others. I myself brought along Sisley, Bazille, and Renoir. Nothing was more interesting than our discussions, with their perpetual clash of opinion. They sharpened one's wits, encouraged frank and impartial inquiry, and provided enthusiasm that kept us going for weeks and weeks until our ideas took final shape. One always came away feeling more involved, more determined, and thinking more clearly and distinctly."[10]

From others we learn that Manet was often at the center of these *causeries*. In 1887, Armand Silvestre, who had been a regular at the Guerbois, remembered him as a "revolutionary," a driving force in the group, whose ideas, observations, and opinions were listened to and respected: "Manet was not a *chef d'école*—no one was less suited for that by temperament, for I have never known a person less solemn by nature; but, without exaggeration, his influence was certainly considerable. Although less magisterial, less intense, and much less sure in matters of taste than Baudelaire, he nonetheless asserted in painting, as did Baudelaire in poetry, a sense of modernity which may have been widely aspired to but which had not yet seen the light of day."[11]

3. Rewald 1973, p. 313.
4. Ibid., p. 390.
5. Ibid., p. 421.
6. Ibid.
7. Wildenstein 1974, pp. 364–65, no. 578.
8. Moreau-Nélaton 1926, II, p. 41.
9. Rewald 1973, p. 197.
10. Thiébault-Sisson, "Claude Monet: Les Années d'épreuves," *Le Temps*, November 26, 1900, p. 3.
11. Silvestre 1887, pp. 160–61.

Despite Silvestre's claim that Manet was not a *chef d'école*, he had in fact described him as such eleven years earlier when referring to "the little group of intransigents of which [Manet] is considered the leader."[12] Indeed, references to Manet as the head of the artists later known as the Impressionists began to appear in the early 1870s. In June 1873, the politician and critic Ernest Duvergier de Hauranne reported that Manet had founded a new school.[13] Writing in May 1875, Castagnary described him as the head of a school and acknowledged his influence on a certain group of painters.[14] In 1876, Stéphane Mallarmé identified Manet as a key figure in an article titled "The Impressionists and Edouard Manet."[15] The same year, in *The New Painting*, Edmond Duranty referred to Manet, without actually naming him, as the "head of the movement": "Another, finally, has redoubled the boldest claims, has fought the most stubbornly, has not merely opened the windows a crack but has flung them wide—has breached the walls—to the *open air* and *real sunlight*; he has assumed leadership of the movement, and time and time again has given the public, with a candor and courage akin to genius, works that are the most innovative, the most flawed, most rife with excellence; works full of breadth and intensity, a voice distinct from all others; works in which the most powerful expression is bound to clash with the uncertainties of an almost entirely new approach that lacks, as yet, its full means of embodiment and realization."[16] While such authors as Mallarmé and Duranty may not have concurred about the goals and character of Impressionism (Duranty did not use the word in his essay of 1876), they clearly agreed that Manet was a seminal figure who functioned as the movement's undisputed, albeit unofficial, leader.

When the authors and writers who frequented the Café Guerbois moved to the Café de la Nouvelle-Athènes in the mid-1870s, Manet remained a prominent figure. Even though he continued to refuse to exhibit with his colleagues, he still participated in their gatherings and exerted an important influence on their discussions. In a letter dated August 9, 1878, Paul Alexis reported to Zola: "Sometimes in the evening at the Nouvelle Athènes, I see Manet, Duranty, etc. The other day, [there was] a great debate about the announced artists' congress. Manet was for going, taking the floor, and toppling the Ecole des Beaux-Arts. Duranty, as the wise Nestor, reminded him of practical means."[17]

No doubt Manet's importance in the group was enhanced by the controversies that seem almost always to have been generated by the paintings he submitted to the Salon. During the mid-1870s, he attracted increasing attention because, after the success of *Le bon bock* in 1873 (RW I 186), he began to encounter surprising resistance from subsequent Salon juries. In 1874, two of the four works he submitted were refused, *Masked Ball at the Opéra* (cat. 138) and *The Swallows*, 1873 (RW I 190); in 1876, the jury refused both works sent, *The Artist* (cat. 146) and *The Laundry* (RW I 237); and in 1878, problems he encountered with the jury for the Exposition Universelle caused him to decide not to submit to the same jury at the Salon.[18] Nevertheless, it was during the mid-1870s that important but previously skeptical critics such as Castagnary began to defend Manet's work: "His place is marked in the history of contemporary art. When the time comes to write about the evolutions or deviations of nineteenth-century French painting, one can forget about M. Cabanel but one must reckon with M. Manet. Such a situation should have impressed the jury."[19] Manet had begun to achieve a degree of recognition that other painters in the circle at the Nouvelle-Athènes could only imagine.

It is hardly surprising, therefore, that he did not forsake the annual Salons, to which he had first submitted work in 1859 (see cat. 10), in favor of his friends' independently organized shows. Furthermore, to have abandoned the Salon for the exhibitions held by the renegade avant-garde might have seemed to vindicate the insinuations of numerous hostile critics.

With regard to style, Hamilton observes that there are both important parallels and fundamental differences between Manet's paintings and those of the artists we would consider orthodox Impressionists: "At Boulogne in 1868 and 1869, at Arcachon and Bordeaux in the spring of 1871, and at Berck-sur-Mer in 1873, he pursued his research in the transcription of light and movement in a manner, if not entirely in a technique, analogous to the experiments of Monet and Renoir at Bougival and Argenteuil during the same period. With them he helped to make explicit the primary Impressionist concern with the moment in time and the position in space, seen instantly and revealed through light."[20] However, Hamilton's phrase "in a manner, if not entirely in a technique" and his use of the word "analogous" underscore the problem. Although Manet began about 1870 to paint *plein-air* pictures (see cat. 122), and his palette lightened considerably in succeeding years (see cat. 139–42), he did not concentrate on the subjects characteristic of the classic phase of Impressionism in the early and mid-1870s, he did not become concerned primarily with the questions of color and light that dominate the work of many of his colleagues, and he continued to create compositions that relate in certain instances only to those of Degas, the "Impressionist" who seems to have thought of himself as a "realist." In short, Manet retained an independent vision, further developed a personal, easily distinguishable technique, and pursued his own ideas about pictorial structure and space. Moreover, as Hamilton concludes, "to the end of [Manet's] life, he retained that feeling for a pictorial arrangement which is equivalent to, rather than identical with, the accidental disposition of nature so ardently admired by the Impressionists."[21]

During the late 1870s, the differences between Manet's work and that of the artists exhibiting in the group shows became sufficiently apparent for Zola and Huysmans to suggest that Manet had been overtaken by other, younger members of the avant-garde. In an article published in Saint Petersburg in 1879, Zola described Manet as the *former* leader of the Impressionist painters, and he questioned his technical abilities.[22] Huysmans adopted a similar point of view the following year: "When all is said and done, Manet is today outdistanced by most of the painters who could once, and quite rightly, have considered him their leader."[23] Ironically, Manet's position vis-à-vis contemporary art was probably best defined by Albert Wolff, who had not been sympathetic to his work. In his review of the Salon of 1882, Wolff concluded: "In the end he has an individual temperament. His painting is not for everyone; it is the work of an incomplete artist, but still of an artist. . . . There is no denying it; Manet's art is entirely his own."[24]

Manet's independence within the context of the avant-garde makes him difficult to classify. He could perhaps be most appropriately described as a painter of advanced tendencies who was a member of the informal confederation of writers, intellectuals, and painters whose common interests brought them together as a group, first at the Café Guerbois and later at the Café de la Nouvelle-Athènes. We can identify him as an Impressionist only in the sense that this has become an umbrella term for virtually all avant-garde painters working in Paris from the late 1860s through 1886, the year of the last

12. Silvestre 1876, quoted in Tabarant 1947, p. 285.
13. Duvergier de Hauranne 1873, quoted in Tabarant 1947, p. 210.
14. Castagnary 1875; see Hamilton 1969, p. 191.
15. Mallarmé 1876; see also Harris 1964.
16. Duranty 1876, p. 17.
17. *"Naturalisme pas mort": Lettres inédites du Paul Alexis à Emile Zola*, ed. B. H. Bakker, Toronto, 1971, p. 118. Bakker dates this letter August 9, 1878; Rewald 1973, p. 435: August 9, 1879.
18. Hamilton 1969, p. 208.
19. Castagnary 1892, II, p. 178.
20. Hamilton 1969, p. 177.
21. Ibid.
22. Zola 1959, p. 227; pp. 225–30 give a French translation of Zola's article, which first appeared in Russian in *Viestnik Europi (The Messenger of Europe)*.
23. Huysmans 1883, p. 158.
24. Wolff 1882, quoted in Tabarant 1947, p. 439.

"Impressionist" exhibition. As Zola observed in 1879, the word was a misnomer from its inception: "I believe I have already spoken about the small group of painters who call themselves impressionists. To me, this term seems unfortunate; but it is nonetheless undeniable that these impressionists—since they insist upon the name—are at the head of the modern movement."[25]

In the process that changed the perception of art and created the foundations of modernism—a process that began in the 1860s and continued into the 1890s—Manet is recognized as a key figure. The fact that he did not participate in the so-called Impressionist exhibitions seems to indicate that, for a variety of reasons, he chose not to become involved in a fragmented, compromised view of the movement. Even if the exhibitions had not taken place, Manet, and probably most other avant-garde artists, are unlikely to have developed very differently; the modern movement had established itself, it had momentum, and it would have emerged, in one form or another, with or without Manet exhibiting with the group. Furthermore, Manet apparently believed that more was to be gained personally and professionally by continuing to challenge the artistic establishment openly through submitting work to the Salon. The sporadic Impressionist exhibitions were important as visible evidence of the modernist movement, and they provided a rallying point for the avant-garde, but equally significant were Manet's regular skirmishes with the Salon juries and the critics. With the exception of 1878, not a single season passed during the 1870s and early 1880s without controversy generated by Manet's submissions to the Salon. The notoriety of his work made him a public figure, and as a result he became, willingly or not, the standard-bearer of the avant-garde. Ultimately, he was awarded a second-class medal at the Salon of 1881 (see cat. 206, 208), thereby legitimizing his own goals and, by implication, those of many other artists who were associated with him as fellow modernists and for whom he had long provided tacit leadership.

Since the earliest scrutiny of Manet's work in the 1860s, his name has been synonymous with modernism. For this reason, it was natural that he emerged as the central figure among the avant-garde painters who gathered at the Nouvelle-Athènes. The accounts of Duranty, Moore, Monet, and others reveal him as a charismatic figure to whom others paid close attention. Furthermore, the artists at the Nouvelle-Athènes who showed their work at the Impressionist exhibitions seem not to have resented Manet's decision not to join them. Both he and they continued to frequent the café, which apparently served as a source of unity that superseded any factionalism. The artists whose work was included in the "Impressionist" shows should perhaps be seen as a splinter group that originated in the circle in which Manet was visibly and indisputably a primary figure. The "Impressionists" joined and defected from their own organization with great frequency, but throughout the 1870s the Nouvelle-Athènes remained a consistent element in the life of virtually every important avant-garde artist in Paris. Because those who frequented the café never presented themselves as an organized entity or issued any sort of manifesto, we tend to underestimate their collective importance. However, the group that gathered there is assuredly a more accurate reflection of the revolution in art that took place in the 1870s than the membership of the Société Anonyme.

Impressionism is clearly a problematic term as used to describe the movement that evolved in Paris during the 1870s and 1880s; and Impressionist is a particularly unsuitable label for Manet, since it tends to imply that his work lies at the periphery rather than at the center of the inception of mod-

25. Zola 1959, p. 226, see note 22 above.
26. See, for example, Hugh Honour and John Fleming, *The Visual Arts: A History*, Englewood Cliffs, N. J., 1982, p. 525: "He never exhibited with the Impressionists, but from the early 1870s onwards he associated himself with them and their illusionistic innovations, experimenting with spectrum palette while retaining the firm structure of his earlier, more broadly handled, flat manner. Manet often worked at Argenteuil in 1874, painting idyllic, hedonistic scenes together with Monet and Renoir."
27. "He abides and will abide"; the motto, with its pun on Manet's name, was evidently devised by the publisher Poulet-Malassis; see Tabarant 1931, p. 278. Manet's bookplate was etched by Bracquemond (see above, Cachin, Introduction, fig. 1).

ernism. Out of convenience and habit, no doubt, we shall continue to use the word as a catch phrase, and it will continue to distort the artist's true position in the history of art. Excuses will continue to be made for his decision not to show with his friends and colleagues, and acceptable rhetorical formulas will continue to be created in order to connect him directly with the Impressionist circle.[26] And yet, in spite of more than a century's efforts, both scholarly and critical, to construe—or misconstrue—Manet as an Impressionist, the work itself endures, its significance self-evident and unimpaired. In the words of the Latin motto on the artist's bookplate: MANET ET MANEBIT.[27]

Manet and the Print

Michel Melot

Manet's graphic oeuvre, almost in its entirety, dates from the early years of the artist's career, from 1862 to 1868. Although about half these hundred-odd prints, most of them after paintings, remained unpublished during his lifetime, probably all were executed with a view to publication. They were not simply reproductions, as the term was understood in the eighteenth century, and they were not original prints, in the later manner of the Impressionists; rather, they stand between two worlds. The Ancien Régime no longer existed, and the Republic was yet to be. French capitalism was providing a new public. And Manet's painting, about 1868, began to reflect new values.

His graphic work, like all his early production, was shaped by traditional doctrine, even where he seemed to be struggling to break away. For Manet, the print was still a derivative form, the image of an image, whose function was to popularize art for a wider public by representing in a more accessible medium what had first been expressed in a painting or drawing. Manet used prints by artists other than himself—Marcantonio Raimondi's motif in *Le déjeuner sur l'herbe* (cat. 62) is a famous example—as a repository of models, and he made prints to disseminate his own contribution in turn. Thus his links with the Ancien Régime consist not so much in that he borrowed from Tiepolo and Goya—the old masters of "free" etching—a lively hand befitting the "painter of modernity" as in the constant reference of the print to an "original" of which it is a rendition or variation.

This indispensable reference he at first found in paintings, beginning with old masters—Fra Angelico (*Silentium*, H 3), for example, and Velázquez (cat. 36, 37). Later, Manet rendered his own paintings by way of a preparatory drawing, reversed or transferred by mechanical means: cutting the paper with a stylus to mark the outlines on the copperplate (e.g., cat. 51), or working from a photograph of the painting printed to the size of the plate (e.g., cat. 214). This use of photography, which appears to have been widespread, and the use of photographs of subjects that served as models (e.g., cat. 56–58, after photographs by Nadar; and cat. 60, taken from a daguerreotype) were only a modernized equivalent of means used by reproductive engravers of the eighteenth century, a technological extension that did not alter the nature of the process.

But more than the reliance of the medium on intermediate techniques that render the print a second- or third-generation work, printmaking, like painting, is concerned with iconographical or, more generally, with literary references. Manet printed subjects that were appropriate to printmaking: portraits of prominent people, stock characters, genre scenes set on the conventional stage, which had provided the essential repertory for the spate of seventeenth-century etchings — the beggar-philosophers, vagabonds, and actors, their provenance in Manet's renditions recognizable beneath their Hispanic disguise. The print, far from being a new, original medium, was still entangled in the web of grand art and its literature, even while the practitioner was attempting to break free. Hence, this particular moment in the history of

graphic art must be seen in the context of the complex interaction then developing among paintings, drawings, and prints, not to mention photography and the photomechanical processes, whose roles were as yet undeveloped.

It has been noted that Manet's graphic oeuvre, like that of the romantics, is connected to literature—Baudelaire, Poe, Mallarmé, Banville, Cros—and to "illustration," in the sense that the print is first and foremost an object of publication; it is printed matter. It is also apparent that as a printmaker, Manet was trying to escape from the prison of the medium. In graphic art, as in painting, he sought modernity—"the ephemeral, the fugitive, the contingent," as Baudelaire defined it.[1] The breakthrough he achieved is considerable. His practice could perhaps be called "autographic" reproduction: the artist copied himself, acted as his own interpreter, and within the framework of reproduction was able to take liberties that inspired a new idiom, one that was no longer an image of an image, but was itself an expressive representation. Manet also broke down the hierarchy of techniques, the division between noble and base. Dissatisfied with one of his etchings, he gave a drawing to be photoengraved (see cat. 214); he made lithographic cover designs for light music (cat. 53, 95); he used transfer paper (cat. 151, 168); he contributed to albums of reproductions made by mechanical processes (*L'Autographe au Salon*, *L'Art à Paris*), he did illustrations for journals (*La Semaine de Paris*, *La Chronique illustrée*, and *La Vie moderne*, see cat. 114, 142, 168).

And yet, the breach was still within the confines of the traditional conception of printmaking, in which the artist creates the design, and then gives it to a technician to reproduce. We know that Manet relied freely on craftsmen—Legros (see cat. 15), Bracquemond (see cat. 69), Guérard (see cat. 214)—to whom he entrusted what he considered the mechanical tasks (graining, biting, printing). This would indicate that he did not involve himself in these techniques, as other artists—such as Whistler and Degas—were to do. Manet's position was probably not too different from that of Baudelaire: The print is needed as a vehicle by which the artist can carry his work before a wider public; it is a pleasing offshoot of a work of art, and is a work of art in itself, when the aesthete condescends to think of it as such.[2]

But the future public was to decide otherwise. It would find that the print was of interest as a work of art. And it would find, moreover, in Manet's output, especially in the artist's proofs, the premises for this reappraisal, this promotion of the print as an alternative art form, not subordinate to painting. The very rendition of such paintings as *The Spanish Singer* (cat. 10) as etchings prompted a rethinking of the role of graphic resources. The painting was transformed, transposed, not carefully and literally translated. The fact that the print medium was thus perceived, as endowed with independent aesthetic value, led to investigation of the expressive, signifying power of graphic "rhetoric," formerly thought of as mere technical subtlety: attention to different states, different inkings, different papers. This meant the marshaling of new criteria of appreciation that would define the print as an art form. The criteria themselves were not new, but at the time Manet applied them, they were just becoming decisive in the recruitment and education of a print-collecting public. Thus, we see Manet shifting his ground in printmaking, as he did in painting: revising plates after publication to create new versions (*The Absinthe Drinker*, H 16; cat. 36); making serial variants on a theme (cat. 15–18), and employing different techniques (cat. 52, 53); using different papers (China and Japan papers, etc.); and better still, different inkings (see, for example, cat. 25, one proof of which has a veil of ink, contrary to the practice of printers

1. Baudelaire 1965, p. 13.
2. Charles Baudelaire, "Peintres et aquafortistes," *Revue anecdotique* XV (April 1862).

37

LA QUEUE AUX BOUCHERIES PENDANT LE SIÈGE DE PARIS.

La neige tombe ; il fait très froid ; des femmes, des hommes, des enfants font queue devant une boucherie ; ils attendent longtemps avant de recevoir une ration de viande. Des gardes nationaux surveillent cette foule pour empêcher les bousculades et les querelles.

Fig. 1. *Queue at the Butcher Shop,* illustration from Lavisse, *Manuel d'histoire de France,* schoolbook, 1912

Fig. 2. *Queue at the Butcher Shop,* 1870–71, etching. The New York Public Library

bound to the procedures for publication). Here were new qualitative distinctions, new points of aesthetic pleasure, which authenticated the print as a new art form adapted to a new type of collector, both scholarly and of modest means, of whom a collector such as the government officer Fioupou (see Provenance, cat. 9) may be taken as a prototype.

For the time being, however, that public remained limited to a few artist friends, a few critics and writers, and Manet's efforts to launch a graphic art as we know it today did not altogether succeed. Links with tradition were perhaps stronger than in the field of painting, where the issue was merely, if one may put it so, a change of style. Painting itself, its canon, its lines of communication, had not been radically altered, whereas printmaking was to undergo a basic change. It would no longer be merely multiplication, a work of collaboration whose execution might be left to a practitioner; it would no longer be simply printed matter but the unique work of a single artist alone qualified to replicate the original. One important parameter of this shift was not a concern of Manet, or of his publisher Cadart, and that was the conception of the print as a rare or unique work. In 1874, when the cover of the portfolio of Manet's prints was published by Cadart, the inscription "Tiré à 50 ex. Nés" (edition of 50 numbered copies) referred to the album, not the prints themselves, of which other editions had been made.

The change had not yet been accepted by the public under the Second Empire. While it may be said that in 1868 Manet's career as a painter was "launched," his graphic output ceased, apart from occasional projects, mainly connected with book illustration. Significantly, it was just at this date that Cadart, the publisher for the Société des Aquafortistes and leader of the art-

ists' etching revival, left publishing; his trip to the United States had been a fiasco. On the other hand, it was also just then that the future of photomechanical processes became less uncertain, with the success of the competition sponsored by the duc de Luynes. Original printmaking inherited the uncertainty. The restructuring of the art market—accurately described by Charles Blanc in the first issue of the *Gazette des Beaux-Arts* in 1859—had not appreciably affected the demand for fine prints, but the interest was already apparent: in the "autographic" etchings published by the journals (*Gazette des Beaux-Arts*, *L'Artiste*, and later, using mechanical processes, *L'Autographe au Salon*, which appeared between 1865 and 1868, and *L'Art à Paris*, in which work by Manet appeared in 1867), and perhaps above all in Manet's print *Queue at the Butcher Shop* (cat. 123), apparently not linked to any other work, drawn or painted. But if printmaking was thus to become a medium of personal experience, there had to be a break from the conception of the medium as an exclusive craft. Manet straddled the fence; he rejected the notion of printmaking as a mystery, but he rejected making the break as well.

In 1882, Manet made his last etching (cat. 214), a reproduction for publication in the *Gazette des Beaux-Arts* of his painting *Jeanne: Spring* (RW I 372), which had been a success at the Salon that year, the year he was *hors concours*. In December, he had been decorated with the Légion d'honneur by his friend Antonin Proust, minister of fine arts in the short-lived Gambetta government. Proust published an article on Manet in the *Gazette des Beaux-Arts*, and one of the illustrations, *Jeanne*, was finally reproduced with the help of a line block executed mechanically from a pen-and-ink drawing. Another of Manet's advocates, the department store magnate Hoschedé (see Provenance, cat. 32), published a booklet on the Salon of 1882; the cover bears a color reproduction of the *Jeanne* painting. It was the first color photogravure to be printed by the process developed by Charles Cros. At that date, Pissarro, Degas, and Whistler were very much involved with the techniques of original printmaking. No two were alike: in multiple states, they were inked like monotypes, signed in pencil, and scrupulously numbered; Whistler's first Venice Set scandalized his publisher. Manet, on the other hand, left the plate on which he had done the *Jeanne* etching with Guérard, and wrote to him: "Evidently etching is no longer my affair."[3]

During the years following Manet's death, printmaking came to be appreciated by collectors and artists as a medium that enjoyed the same rights and privileges as painting: it came to be regarded on equal terms, as we have tried to show it in this exhibition, and as it is once more perceived today. The renewed appreciation of graphic art in the past twenty years has reinforced the interest taken in Manet's production. The scholarship devoted to it and the very prominence given it in the present show are eloquent testimony. Indeed, there is now such a strong interest in iconographic sources that, looking at this vignette taken from a schoolbook (fig. 1), one might well wonder if it was influenced by Manet, since his own *Queue at the Butcher Shop* (fig. 2) is so similar, or whether both works derive from a common prototype. But just as neither of these images can be accounted for by the other, and Manet is not the author of their resemblance, so analysis of Manet's entire oeuvre, however painstaking, can never explain his latterday success: his innovations take on meaning in our day only as artists have appropriated them and rendered them fruitful. But that is another story; Manet was granted no part in it.

3. J. Adhémar 1965.

Catalogue

Françoise Cachin
Charles S. Moffett
Juliet Wilson Bareau

Explanatory Notes

Titles	Manet's own titles, when known, have been given preference; if there is a different title in common use, it follows Manet's in parentheses.
Dimensions	Height by width: inches (centimeters) Drawings: dimensions of the sheet Etchings: dimensions of the plate Lithographs and transfer lithographs: dimensions of the image or applied China paper
Loans	P Exhibited only in Paris NY Exhibited only in New York
Signatures	Prints: engraved or drawn by the artist on the plate or stone Atelier stamp: initials E.M. stamped on unsigned works on paper at time of posthumous inventory
Publications	Only editions of prints produced during the artist's lifetime and the posthumous issue of lithographs in 1884 are listed in the Catalogue. For full references, see Editions of the Prints.
Exhibitions	The Catalogue lists exhibitions in which Manet participated during his lifetime and posthumous exhibitions devoted exclusively to Manet or with major representations of his work. Quoted under Exhibitions in Manet's lifetime are the artist's title of the work when given, and the dimensions, in centimeters, if they differ significantly from the dimensions of the work today. The following abbreviations are used: BM, British Museum, London; BN, Bibliothèque Nationale, Paris. For full references, see List of Exhibitions.
Catalogues	D Duret 1902 M-N Moreau-Nélaton 1906, 1926, and cat. ms. T Tabarant 1931, 1947 JW Jamot and Wildenstein 1932 G Guérin 1944 PO Pool and Orienti 1967 L Leiris 1969 H Harris 1970 RO Rouart and Orienti 1970 LM Leymarie and Melot 1971 RW Rouart and Wildenstein 1975 W Wilson 1977, 1978 See Bibliography of Works Cited.
States of Prints	States are identified according to the most recent publications (Harris 1970; Wilson 1977 and 1978).
Provenances	Names associated with the history of the work are cross-referenced to the provenance or catalogue entry in which the fullest mention is given. See Index of Names Cited in the Provenances.
References	References are abbreviated, except when a source is cited only once; for full references, see Bibliography of Works Cited. For sales, see Index of Sales.

Documents Principal sources cited in the notes:

New York, Pierpont Morgan Library, Tabarant archives: various letters and documents, albums of photographs by Godet and Lochard

Paris, Archives Nationales: Dépôt Légal registry, autograph letters

Paris, Bibliothèque d'Art et d'Archéologie: autograph letters

Paris, Bibliothèque Littéraire Jacques Doucet: autograph letters

Paris, Bibliothèque Nationale, Département des Estampes, Moreau-Nélaton endowment: manuscript notebooks (see Bibliography of Works Cited under Manet et al.), albums of photographs by Godet and Lochard, and family photograph album; Département des Manuscrits: autograph letters

Paris, Musée du Louvre, Archives and Cabinet des Dessins: autograph letters, notebooks

Authors F.C. Françoise Cachin
C.S.M. Charles S. Moffett
J.W.B. Juliet Wilson Bareau

1. The Barque of Dante, after Delacroix

1854?
Oil on canvas
15 × 18″ (38 × 46 cm)
Musée des Beaux-Arts, Lyons

Catalogues
T 1931, 7; JW 1932, 2; T 1947, 6; PO 1967, 4A; RO 1970, 4A; RW 1975 I, 4

Antonin Proust relates that after a visit with Raffet and Devéria to the Louvre, then to the Musée du Luxembourg, where Devéria's *The Birth of Henri IV* was on view, Manet exclaimed: "'This is all very well, but there is a master canvas in the Luxembourg, the *Barque of Dante*. If we want to visit Delacroix, our pretext might be to ask his permission to do a copy of the *Barque*.' 'Have a care,' said Murger, to whom Manet had mentioned this plan over lunch, 'Delacroix is a cold fish.' But Delacroix received us most graciously at his studio in the rue Notre-Dame de Lorette, inquiring as to our preferences and expressing his own: you should look at Rubens, emulate Rubens, copy Rubens, Rubens was his god. . . . When the door had closed behind us, Manet said to me, 'Delacroix isn't cold at all, but his doctrine is frozen. Anyway, we'll copy the *Barque*. It's a fine piece.'"[1]

Apart from Proust's testimony, little is known of any contact between Manet and the originator of *The Barque of Dante*. This careful work is thought to be the only example of a copy by Manet from a living artist. A second, slightly smaller copy (RW I 3; fig. a), now in the Metropolitan Museum of Art, was in Manet's studio at his death. The two differ in manner, the New York version being freer, more colorful, and more suggestive of Manet's later style. They do not seem to date from the same period, and the

Fig. a. *The Barque of Dante, after Delacroix*.
The Metropolitan Museum of Art, New York

1

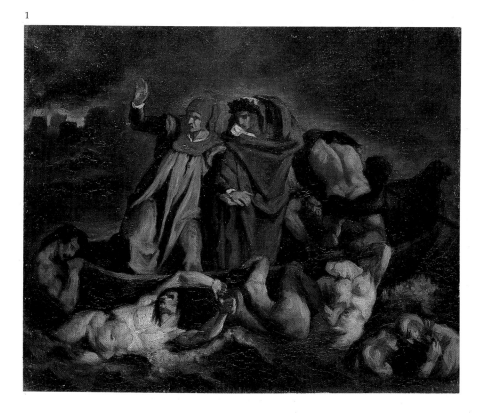

hypothetical date of 1859 for the second copy was adopted in the annotated Lochard photograph albums.[2] The Lyons painting, also photographed by Lochard, is certainly the earlier, closer, more literal version, done about 1855, when the original was on exhibit at the Exposition Universelle. It is a rare example of Manet's output in the opening years of his artistic life, of which curiously few examples remain; it must be supposed that he destroyed many pieces from the 1850s.

Biographies of Manet generally underestimate the importance of Delacroix in his development. Antonin Proust was not fond of Delacroix, and very likely he minimized his influence on Manet in his reminiscences. This copy reveals as early as 1854–55 features of line and color that Manet was to make his own. His friendship with Baudelaire in the 1860s was to reawaken his admiration for the older artist; the two friends made a point of attending Delacroix's funeral.[3] And it can hardly be mere chance that Fantin-Latour in 1864 placed Manet beside Baudelaire in his *Homage to Delacroix* (Musée d'Orsay-Galeries du Jeu de Paume, Paris).

1. Proust 1897, p. 129.
2. Photographs by Lochard. Paris, BN Estampes, Moreau-Nélaton endowment.
3. Tabarant 1963, p. 320.
4. New York, Pierpont Morgan Library, Tabarant archives.
5. Julius Meier-Graefe and Erich Klossowsky, *La Collection Chéramy*, Munich, 1908, no. 247.
6. Chéramy sale, Paris, May 5–7, 1908, no. 217.

Provenance
This study appeared at the BODINIER sale in 1903 and subsequently entered the famous collection of PAUL CHERAMY, who had been the Manet family lawyer (letter from Chéramy to Manet, 1868[4]). A collector of nineteenth-century works and a friend of the Impressionists', Chéramy was particularly attracted to copies after earlier artists.[5] When the Musée des Beaux-Arts in Lyons bought the picture at the Chéramy sale in 1908,[6] it became the first French museum to purchase a work by Manet (inv. B 830), although several had already entered the Musée du Louvre by gift (*Olympia*, cat. 64) and through the Caillebotte bequest (see Provenance, cat. 115).

F.C.

2. Spanish Cavaliers

1859
Oil on canvas
17¾ × 10¼" (45 × 26 cm)
Signed (lower left): M
Musée des Beaux-Arts, Lyons

Here, as in the *Spanish Studio Scene* (RW I 25), Manet borrows elements from his copy (RW I 21) of the *Little Cavaliers* (Musée du Louvre, Paris; attributed to Velázquez at the time, but now given to Mazo; see cat. 37, fig. a).[1] The background figure, turned toward the door and wearing a pink cloak, is the fifth from the right in the Louvre picture, but reversed, suggesting that it was copied from an engraving. The half-open door is taken from Velázquez's *Meninas*, which Manet had not yet seen in the Prado; the two figures at the left are from the *Little Cavaliers*. As for the boy carrying a tray, his resemblance to the *Boy with a Sword* (cat. 14) brings to mind a disguised Léon Leenhoff, then seven or eight years old. The figure recurs in a watercolor (RW II 454) and in an etching (H 28), both probably based on the painting. Finally, it is used again in the dark background of *The Balcony* (cat. 115) nine years later.

The usual dating of 1860–61 is open to question. There are two arguments for a slightly earlier date. Like the *Spanish Studio Scene*, this paint-

Exhibitions
Salon d'Automne 1905, no. 6; Marseilles 1961, no. 7

Catalogues
D 1902, 28; M-N cat. ms., 9; T 1931, 37; JW 1932, 10; T 1947, 31; PO 1967, 25; RO 1970, 25; RW 1975 I, 26

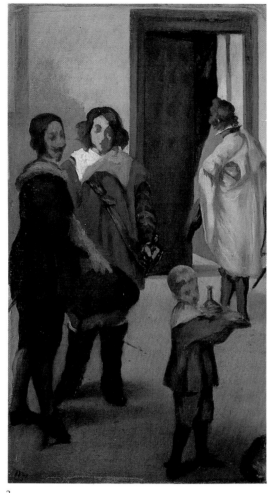

2

ing may well have been done in 1859, very soon after the copy of *Little Cavaliers*, more plausibly than in the year of *The Spanish Singer* (cat. 10).

Manet, like other artists of his time, did many copies at the Louvre and at the Musée du Luxembourg well into his career. Reff has published documents from the Louvre archives for admissions and applications for copying privileges until 1865, after which date the registers are missing,[2] and Manet's first registration at the Louvre dates from January 1850, at the very beginning of his studies under Couture. In 1852, there are hints of a lost copy of Boucher's *Diana at the Bath* (cat. 19, fig. a), interesting in light of Manet's later paintings *The Surprised Nymph* (cat. 19) and *Le déjeuner sur l'herbe* (cat. 62). For 1859, there are two copy applications on Velázquez, for the *Little Cavaliers*, mentioned above, and the *Infanta Margarita* (present location unknown; see RW II 69).[3]

The Lyons version would thus seem to be a studio endeavor. Farwell has offered the ingenious hypothesis that the present painting and the *Spanish Studio Scene* were originally parts of the same work, cut by Manet at a later date.[4]

Besides its testimony to a growing admiration for Velázquez, an admiration that began long before Manet's trip to Spain, this picture

exemplifies his working method, his simultaneous use of elements taken both from works of art in museums and from day-to-day life, molded into a "museal" imagery. Thus Léon Leenhoff carries, with his tray, a wealth of visual *souvenirs* of Murillo and Velázquez: the boy taking a glass of water in the *Water Seller of Seville*, reproduced in Charles Blanc's *Histoire des peintres*, was probably the source of the little figure.[5] Only the allusive treatment, with no modeling, already very personal to Manet, averts the impression of pastiche.

Provenance
Undoubtedly purchased directly from the artist's family (the name and address of Paul Chéramy, the Manet family lawyer, 24, rue Saint-Augustin, appear in Manet's address book[6]), this picture was in the CHERAMY collection (see Provenance, cat. 1).[7] At the Chéramy sale in May 1908,[8] the painting was purchased by DR.

RAYMOND TRIPIER, who bequeathed it to the museum in Lyons in 1917.
 Both the Jamot and Wildenstein and the Rouart and Wildenstein catalogues include Paul Guillaume among former owners of this picture, but this is unlikely since he was born in 1893.

F.C.

1. *Catalogue sommaire du Louvre* 1981, p. 124, Velázquez? inv. 943.
2. Reff 1964, p. 556.
3. *Catalogue sommaire du Louvre* 1981, p. 124, Velázquez inv. 941; see Rouart and Wildenstein 1975, II, no. 69.
4. Farwell (1973) 1981, pp. 58–59.
5. Blanc 1869, "Vélasquez," p. 3.
6. Paris, BN Estampes, Moreau-Nélaton endowment.
7. Julius Meier-Graefe and Erich Klossowsky, *La Collection Chéramy*, Munich, 1908, no. 248.
8. Chéramy sale, Paris, May 5–7, 1908, no. 219.

3. Portrait of M. and Mme Auguste Manet

1860
Oil on canvas
44 × 35¾"(111.5 × 91 cm)
Signed and dated (upper left): édouard Manet 1860
Musée d'Orsay (Galeries du Jeu de Paume), Paris

In his recollections, Antonin Proust reports a remark by Manet on Ingres's *Portrait of M. Bertin*: "Old man Bertin was typical of the 1830 bourgeoisie—what a masterpiece that portrait is! M. Ingres chose Bertin to represent a period . . . I never did the Second Empire woman, but a later one."[1] Manet was forgetting that he, too, had indeed "created a type," in the portrait of his parents, a couple exemplifying the austere *grande bourgeoisie* of the Second Empire. It is at once the image of a social type and the depiction of a severe intimacy, in which time has laid a stern dignity on the father and a serene melancholy on the mother. They are close, but separate, he seated and she standing behind him, seemingly with no link between them but the black of their garments and an undetermined object, outside the field of the picture to the lower left, on which they focus their attention.

Auguste Manet (1797–1862), a high official, chief of staff at the Ministry of Justice, then a judge at the court of Seine, and eventually court counsel, was then sixty-three. Mme Manet, née Eugénie-Désirée Fournier (1812–1885), was forty-eight. She was the daughter of a diplomatic emissary to Stockholm and godchild of Marshal Bernadotte, later Charles XIV of Sweden. They are posed here in their apartments at 69, rue de Clichy, in indoor dress.[2] Their familiar attitude is not without some tension—the father's right hand slightly clenched on the arm of his Louis-Philippe chair, the other hidden under the jacket adorned with the ribbon of the Légion d'honneur.

X-ray analysis of the painting made in July 1982 shows that the figure of the father was originally quite different (fig. a). The face appeared

Exhibitions
Salon 1861, no. 2099 (Portrait de M. et Mme M.); Alma 1867, no. 8 (Portrait de M. et Mme M . . .); Beaux-Arts 1883, no. 303; Beaux-Arts 1884, no. 6; Salon d'Automne 1905, no. 4; Paris, Bernheim-Jeune 1928, no. 29; Orangerie 1932, no. 5; Marseilles 1961, no. 8

Catalogues
D 1902, 22; M-N 1926 I, p. 31; M-N cat. ms., 26; T 1931, 33; T 1947, 37; PO 1967, 28; RO 1970, 28; RW 1975 I, 30

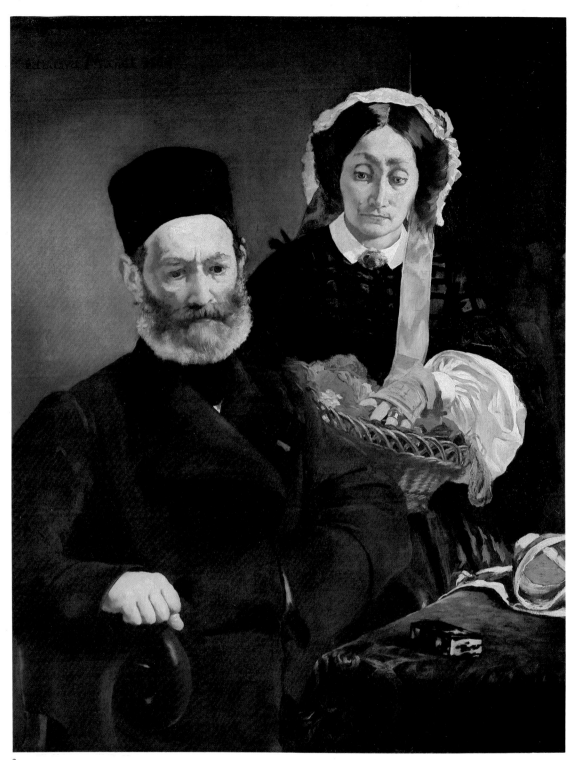

3

younger, with only a light chin beard and showing a pleasant mouth. He wore a round cap as in the preparatory drawing (cat. 4), not this lofty head-dress, and the hand was extended on the armrest.

There are no obvious clues as to when Manet altered the picture. It is not impossible that he began it earlier than is supposed, in 1859 or even earlier, and revised it for reasons of fact or of whim. We do not know whether it was exhibited at the 1861 Salon in its original or in its present state. In the absence of any detailed description at the time of exhibition, we can only state that Manet reworked it before making the print (H 6), dated 1860 (fig. b), which reproduces the present state, by which time his father was failing. The cause of his death is not known, but Philippe Burty in his 1883 obituary of the artist notes that Edouard Manet died "of the same malady as his father."[3]

Be that as it may, in the present state all the vitality seems to be concentrated in the luxuriant detail—the basket of yarn, the white linen, the blue satin of the mother's bonnet ribbon. Mme Manet's hand is in the basket, perhaps to choose wool for the work in progress on the table, which is somewhat out of line and has been seen as one of Manet's famous mistakes, intentional or otherwise, in perspective.[4] While the portrait is not contrived to flatter, the subjects were by all accounts very much pleased with it.[5] Its firmness of execution and realism of expression were at least an indication that their son was capable, that the years spent in the Couture studio had not been a total loss. Besides, they do not seem people preoccupied with appearances; love of truth and the courage to face it, even in painting, were solid bourgeois virtues they surely would have appreciated.

Yet at the time, the work was found objectionably vulgar. Léon Lagrange, in an account of the Salon of 1861, reproaches it with all the sins of realism: "But what a scourge to society is a realist painter! To him, nothing is sacred: M. Manet tramples on even more hallowed affections. M. and Mme M ____ have more than once had cause to rue the day that put a brush in the hand of this merciless portrayer."[6]

Jacques-Emile Blanche records a comment that casts light on the reaction to the painting at the Salon: "[An] old friend of Mme Manet *mère* . . . showed me a photograph of the *Charlotte Corday* [also in the Salon of 1861] by Tony Robert-Fleury, the son of another of her childhood friends: . . . 'Look at that; at least it's distinguished. Not like poor Edouard! Edouard's a nice boy, but what he does is so common; . . . there's the portrait of his parents, . . . a couple of concierges, you'd say!'"[7]

Many works have been identified as sources for this double portrait—Le Nain's *Peasants' Repast*, for example,[8] a notion soundly disputed by Reff, who suggests that the father's face shows rather the influence of a Rembrandt etching, *Bearded Man in Fur Hat*,[9] an influence even more apparent in Manet's print.

In fact, the plainness of the faces and the full, broad line are more reminiscent of Frans Hals, whom Manet especially admired. It is true that Manet did not visit the Hals Museum in Haarlem until 1872, but he had by then had ample opportunity to see the artist's works—in Amsterdam, where the registers of the Rijksmuseum document his presence in 1852,[10] on his presumed trip to Germany in 1853, and of course at the Louvre.

Manet later painted another portrait of his mother (RW I 62), in mourning for her late husband, this time full face, with a calmer expression. That work is more conventional and less striking than the double portrait.

1. Proust 1897, p. 206.
2. Léon Leenhoff's notes, cited in Tabarant 1931, p. 57.
3. Philippe Burty, *La République française*, May 3, 1883.
4. Howard 1977, pp. 15–16.
5. Tabarant 1947, p. 41.
6. Lagrange 1861, p. 52.
7. Blanche 1912, p. 153.
8. Fried 1969, pp. 45–46.
9. Reff 1969, pp. 42, 48 n. 7.
10. Ten Doesschate Chu 1975, p. 43.
11. Paul Gauguin, *Lettres de Gauguin à sa femme et à ses amis*, Paris 1946, p. 295.
12. New York, Pierpont Morgan Library.
13. J. Manet 1979, p. 21.

Twenty-two years later, the painting scorned at the Salon of 1861 seemed almost classic, but the name of Manet still had an odor of brimstone; Gauguin, writing from the South Seas, reminisced in a letter of August 1899 about the Portraits of the Century show he had seen in 1883: "At the time of the exhibition, I went with a man who didn't like Manet, Renoir, and the Impressionists; this portrait [Renoir's *Jeanne Samary*] put him in a rage. To divert his attention, I showed him a big portrait—father and mother, in the dining room—the tiny signature was barely visible. 'Now there you are,' he exclaimed. 'That's what I call painting.' 'But it's by Manet,' I told him. He was furious. . . . "[11]

As for Huysmans, in his copy of the catalogue of the exhibition, which he marked up savagely, he comments on the parents' portrait: "Old-fashioned Manet: Couture Ingresized."[12]

Provenance

This portrait remained until very recently in the possession of the artist's family. Manet must have given it to his parents during his lifetime, for it does not appear in the inventory drawn up following his death or in the catalogue of the sale of the contents of his studio. His mother, MME MANET, no doubt gave or bequeathed the painting to her son EUGENE MANET (1833–1892). When he died, it went to his wife, the artist BERTHE MORISOT (1841–1895). Manet's model, friend, and sister-in-law, Morisot formed a remarkable collection of the artist's work, acquired for the most part after his death, either at auction or from his widow, Suzanne (see Provenance, cat. 12). At Morisot's death, the picture was inherited by her daughter, JULIE MANET (1879–1967), also a painter, who as a young girl kept a diary that gives valuable information about the fortunes of Manet's work at the end of the century.[13] In 1900, she married the artist Ernest Rouart (1874–1942), the son of Henri Rouart (see Provenance, cat. 129), a collector like his father, and a close friend of Degas's. The picture remained in the ROUART family's collection until 1977, when it was acquired by the Musée du Louvre with assistance from the Rouart family, Mme J. Weil-Picard, and an anonymous foreign donor (inv. RF 1977.12).

F.C.

4. *Study for* Portrait of M. and Mme Auguste Manet

1860
Red chalk, squared for transfer
12¼ × 9¾" (31 × 25 cm)
P Musée du Louvre-Orsay, Cabinet des Dessins, Paris

Catalogues
L 1969, 150; RW 1975 II, 344

There is another study of the father's head (RW II 345) that served as a model for the second etching (H 7). The placement of the figures was retained. But whereas in the painting (cat. 3) the father seems lost—his eyes lowered—in somber reverie, he seems in this preliminary idea to be looking straight ahead. While the drawing is very sketchy, the face is more like that in the early state of the painting, revealed by X-ray (cat. 3, fig. a), in which the father looks younger, has no moustache, and wears a big beret instead of a hat. The mother is physically closer to the father in the painting, and her face there assumes more visual and psychological importance than in the drawing.

4

Provenance
This drawing remained in the ROUART family's collection for many years (see Provenance, cat. 3). Two years after the painting entered the Galeries du Jeu de Paume, the drawing was acquired by the Musées Nationaux, with funds from the Musée d'Orsay (inv. RF 37088).

F.C.

5. Portrait of Mme Brunet

1860–67?
Oil on canvas
51⅛ × 38⅝″ (130 × 98 cm)
Signed (lower left): Manet

NY Private Collection, New York

Exhibitions
Paris, Martinet 1863, no. 133; Alma 1867, no. 20
(Portrait de Mme B.); Paris, Drouot 1884, no. 15;
Orangerie 1932, no. 6; New York, Wildenstein
1948, no. 8

Catalogues
D 1902, 20; M-N 1926 I, pp. 44–47; M-N cat. ms.,
38; T 1931, 58; JW 1932, 39; T 1947, 60; PO 1967, 56;
RO 1970, 55; RW 1975 I, 31

Fig. a. Anonymous caricature, 1863 (photograph).
Bibliothèque Nationale, Moreau-Nélaton en-
dowment, Paris

PORTRAIT DE MADAME B...
Je ne dis pas que ce ne soit pas ressemblant,
mais cette pauvre dame, comme son amour-
propre doit souffrir de se voir afficher ainsi!

Fig. b. Randon, caricature in *Le Journal amusant*,
June 29, 1867

In 1867, Manet titled this painting *Portrait de Mme B . . .* in the catalogue for
the exhibition of his own work that he organized when he was not invited to
show at the Exposition Universelle. Moreau-Nélaton identifies the sitter as
Mme Brunet but refers to the picture as *La parisienne de 1862*.[1] Tabarant
states that the sitter is "Madame Brunet, née de Penne," but calls the paint-
ing *La femme au gant*[2] and acknowledges that Duret cites it as *Jeune dame en
1860*,[3] the title used in 1884 at the auction of works by Manet that was autho-
rized by his estate. In addition, Tabarant notes that Jacques-Emile Blanche,
who owned the painting, called it *Portrait de Mme de Cheverrier*. If the sitter's
maiden name was in fact de Penne, she may be related to the Mme Penne
mentioned during the 1860s in the correspondence of Baudelaire, Comman-
dant Lejosne, and others. Lee Johnson suggests that "she may have been a
member of the same family, possibly a sister-in-law" of Lieutenant Jules
Brunet, a French artillery officer with the expeditionary force in Mexico;
Brunet's drawing of the execution of a Mexican mercenary, as engraved by
C. Maurano and published in *Le Monde illustré* October 3, 1863, is evidently
one of Manet's compositional sources for *The Execution of the Emperor Maxi-
milian* (see cat. 104, 105).[4]

Mme Brunet's husband may have been either the sculptor Eugène-
Cyrille Brunet or the author and translator Pierre-Gustave Brunet. Manet
and Eugène-Cyrille Brunet worked together as students in Florence in 1857;
they jointly petitioned and were granted permission by the Academy of
Florence to copy in the cloister of the Annunziata.[5] Courthion has stated,
without documentation, that Mme Brunet, whose photograph is included in
Manet's album of photographs of family and friends,[6] was the wife of "a
sculptor of busts and medallions."[7] However, Pierre-Gustave Brunet is an
equally plausible candidate, since he and Manet shared a strong interest in
Spanish painting; in 1861, the author published *Etude sur Francisco Goya, sa
vie, et ses travaux*, and he translated the 1865 edition of William Stirling's book
on Velázquez, which included an introduction by W. Bürger (Théophile
Thoré), an early advocate of Manet's work.

In 1863, at the time of the exhibition of fourteen of Manet's paintings
at Louis Martinet's gallery, known as the Cercle Artistique, an unidentified
visitor to the show executed a satirical drawing (formerly Burty collection,
Paris) of the *Portrait of Mme Brunet* with the sarcastic caption "La . . . femme
de son ami!!!" (fig. a). If Mme Brunet's husband was one of Manet's friends,
both men must have experienced an awkward moment when she was
shown the finished painting in the artist's studio. According to Duret, "One
of his first portraits, done in 1860, was of a young lady, a friend of his family.
He had painted her standing, life-size. It seems she was not pretty. Follow-
ing his own inclinations, he must have accentuated her distinctive facial fea-
tures. In any event, when she saw herself on the canvas, and the way she

looked there, she began to cry—it is Manet himself who told me about this—and left the studio with her husband, wanting never to see the picture again."[8] Apparently Manet was unperturbed by Mme Brunet's reaction, because, as has been mentioned, he included the picture in important exhibitions in 1863 and 1867.

There is a possibility that Manet altered the portrait after showing it at the Martinet exhibition in 1863. The caricature indicates a full-length figure and a blank background. If the painting was subsequently cut at the bottom, the change in composition creates the illusion of greater proximity to the subject. The sitter's space merges with the viewer's, and there results a sense of immediacy typical of later works in which figures or compositional elements are cropped by the edge of the painting. The compositional treatment may also reflect the influence of portraits of women by Courbet, such as *Lady in a Riding Habit (L'Amazone)*, 1856 (Metropolitan Museum of Art, New York), and *Portrait of Mme Charles Maquet*, 1856 (Staatsgalerie, Stuttgart).

If the background was originally blank, the painting would have looked like many of Manet's other full-length figure compositions of the 1860s. The foliage and landscape in the background seem to derive from *Philip IV as a Hunter*, which the Louvre acquired as a Velázquez in May 1862 (the portrait is now believed to be a workshop copy, possibly by Mazo), and of which Manet made a drawing (RW II 68) and an etching (cat. 36). The drawing must have been executed after the Louvre acquired the painting, suggesting that the background of the *Portrait of Mme Brunet* was not painted before June 1862. Moreover, if the caricature made in 1863 accurately reflects the composition, the painting was cut down and the background was added between the time it was shown at Martinet's and the exhibition organized by Manet himself in 1867. A caricature by G. Randon, published in the June 29, 1867, edition of *Le Journal amusant* (fig. b), shows the composition as it is today.

Several publications cite 1860 as the date of the painting,[9] while others indicate 1862.[10] Only Meier-Graefe suggests that the picture may have been painted later—about 1864—and observes that it seems to have been cut down.[11]

Sandblad suggests general affinities with Japanese prints and with a portrait of Charles I by van Dyck.[12] Leiris, however, commenting on Sandblad's speculation about the influence of van Dyck, notes, "Such a source for Manet's portrait seems to me to be strongly overshadowed by the precedent of Velázquez's portraiture, and in particular of the Philip IV—a copy in the Louvre, painted by Mazo after Velázquez—from which Manet made a drawing and an etching."[13]

The variety of opinions about possible sources for and influences on the *Portrait of Mme Brunet* is typical of discussions about many of Manet's paintings (see, for example, cat. 10, 33). Often Manet so completely absorbed and generalized his sources that they are impossible to identify with certainty. The probable alteration of the canvas size and the later modification of the background are consonant with his working method, as can be seen in a number of other works (see, for example, cat. 73, 99, 171).

1. Moreau-Nélaton 1926, I, p. 44.
2. Tabarant 1931, p. 89.
3. Duret 1902, p. 196.
4. Johnson 1977, p. 564 n. 11.
5. Wilson 1978, no. 2.
6. Paris, BN Estampes, Moreau-Nélaton endowment.
7. Courthion 1961, p. 25.
8. Duret 1918, pp. 149–50.
9. Manet sale, Paris, February 4–5, 1884; Duret 1902; Rouart and Wildenstein 1975.
10. Moreau-Nélaton 1926; Tabarant 1931; Rouart and Orienti 1967.
11. Meier-Graefe 1912, p. 112 n. 1.
12. Sandblad 1954, p. 83.
13. Leiris 1959, p. 200 n. 11.
14. Rouart and Wildenstein, 1975, I, p. 27; see also cat. 12 and Provenance.
15. Manet sale, Paris, February 4–5, 1884, no. 15; Bodelsen 1968, p. 343.
16. Blanche 1919, p. 148.
17. Tabarant 1947, p. 58.

Provenance
Evidently refused by the sitter, this portrait was in Manet's studio when he died. In the inventory, it is listed as no. 14, "Femme au gant, mode de mil huit cent cinquante," estimated value, 300 Frs.[14] It was called "Jeune dame en 1860" at the Manet sale in 1884 and sold for only 120 Frs to THEODORE DURET (see cat. 108),[15] who in this case was apparently acting as a bidding agent for DURAND-RUEL (see Provenance, cat. 118). Shortly after the sale, in 1884, Durand-Ruel sold the picture for 500 Frs to the painter JACQUES-EMILE BLANCHE (1861–1942).[16] Blanche had been introduced to Manet about 1878 by his father, the well-known alienist Dr. Emile Blanche, who was closely connected with the Impressionists, particularly Renoir. Jacques-Emile Blanche's various published memoirs are an important source of firsthand knowledge about Manet's last years. Blanche sold the picture in the early 1930s.[17] In November 1933, M. KNOEDLER & CO. (see Provenance, cat. 172), Paris, sold it to MRS. CHARLES S. PAYSON (née Joan Whitney, 1903–1975) of New York, who added many works, including this one and Manet's *The Monet Family in the Garden* (cat. 141), to the collection of old master, Impressionist, and Post-Impressionist paintings she inherited from her parents, Mr. and Mrs. Payne Whitney.

C.S.M.

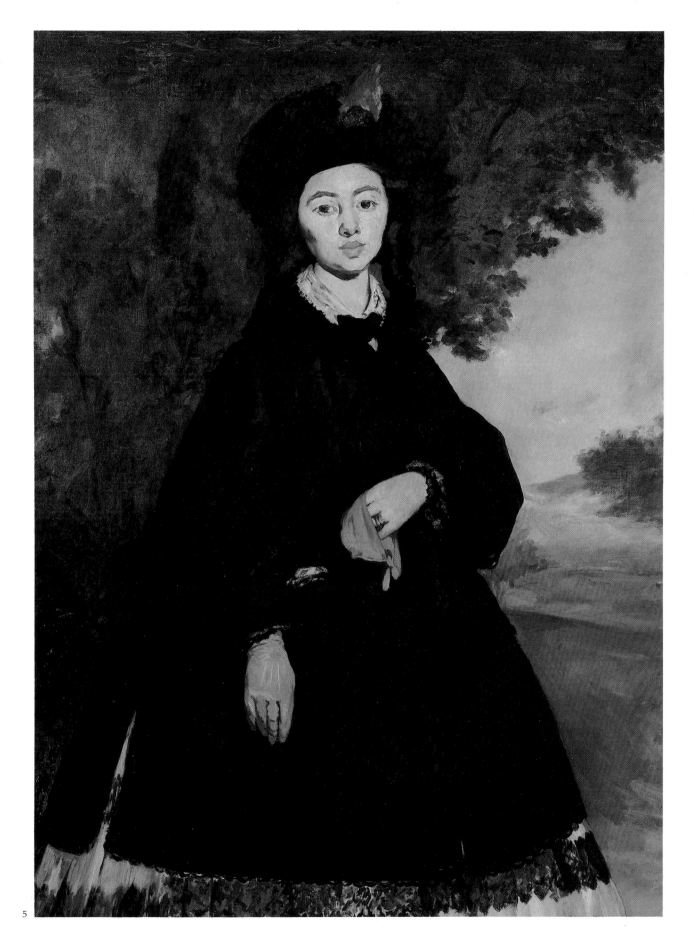

5

6. Boy with Dog

1860–61
Oil on canvas
36¼ × 28¼" (92 × 72 cm)
Signed (lower left): éd. Manet
Private Collection, Paris

In 1864, the Symbolist critic Péladan wrote, with some justice: "One part Murillo for the sky, one part Velázquez for the head, the *Boy with Dog* is the inevitable waif of the Spanish school, but when Manet copies, he disdains the subject and goes for the tone and the values. The overlap of influences is really difficult and frustrating to follow."[1]

This work represents an intermediary stage between simple copying from the masters and the realistic, "modern" subjects that Manet would later paint. Spain was to serve him as a way station for several years to come. Here, the source is unmistakable, having been positively identified in the thirties as the *Boy with Dog* in the Hermitage, a painting by Murillo,[2] for whom Manet in fact had no very high esteem—"I won't mention Murillo, I don't like him, except in some of the 'waif' studies."[3] The figure of the boy in that painting also has a basket in hand and looks at a dog with its head raised toward him from the lower left corner. Manet knew the painting through an engraving which reversed the composition; he may have seen it in Charles Blanc's *Histoire des peintres* (fig. a), from which Reff has convincingly shown he took many illustrations as subjects,[4] and a print reproducing the original painting has been published by Hanson.[5]

If the theme of the picture is similar, its spirit is nonetheless very different. Manet has completely abandoned the picaresque connotation, the expressive movement, the slight scowl; like all his figures, this is no active participant, taken on the quick, but a boy posing, almost full face, an early example of the frontal figures of which *The Fifer* (cat. 93) is the archetype. The sky is still fairly respectful to Murillo, but the pictorial treatment—especially of the basket and the dog's head—now asserts Manet's style.

Moreau-Nélaton thought the model was perhaps the same as for the *Boy with Cherries* (RW I 18). Actually, the head of this boy of twelve or so is very like the one in Velázquez's *Water Seller of Seville* (fig. b), also engraved in

Exhibitions
Paris, Martinet 1863?; Alma 1867, no. 23 (Le Gamin, 81 × 65 cm); London, Durand-Ruel 1872, no. 110; Beaux-Arts 1884, no. 7; Salon d'Automne 1905, no. 3; Berlin, Matthiesen 1928, no. 7; New York, Rosenberg 1946–47, no. 1

Catalogues
D 1902, 21; M-N 1926 I, p. 38; M-N cat. ms., 35; T 1931, 38; JW 1932, 73; T 1947, 32; PO 1967, 30; RO 1970, 29; RW 1975 I, 47

Fig. a. Engraving after Bartolomé Murillo, *Boy with a Dog*, in Charles Blanc, *Histoire des peintres*

Fig. b. Velázquez, *Water Seller of Seville* (detail). Apsley House, Wellington Museum, London

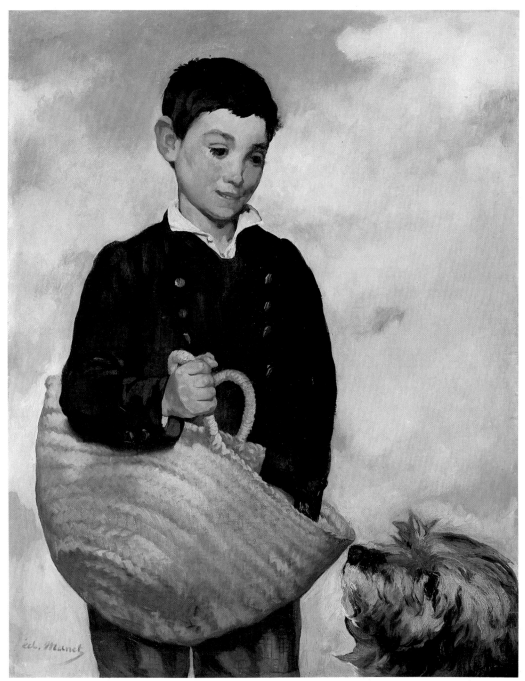

6

the volume on Spanish art in Charles Blanc's *Histoire des peintres*, which appeared in 1859—the same rather absent expression, the same hair, the same white collar.[6] As for the dog, according to a recent suggestion, it may have been the Manet family pet, the same one being walked by Léon in the foreground of *The Exposition Universelle of 1867* (RW I 123).[7]

Such juxtapositions of past and present, still fairly literal, the treatment of the sky, and the rather careful modeling of the face suggest an early date, 1860 in preference to the year 1861 noted in the Rouart and Wildenstein catalogue.

1. Péladan 1884, p. 106.
2. Bazin 1932, pp. 156–57.
3. Proust 1913, p. 37
4. Blanc 1869, "Murillo," p. 1; Reff 1970, pp. 456–58.
5. Hanson 1977, pp. 59–63.
6. Blanc 1869, "Vélasquez," p. 3.
7. Wilson 1978, no. 30.

Provenance

The dimensions given in the 1867 catalogue differ from those of the present picture, leading one to suppose that it was enlarged. Unfortunately, we were unable to examine the painting prior to the exhibition. This picture was included in the large group of works DURAND-RUEL purchased directly from the artist in 1872 (see Provenance, cat. 118).

He paid 1,500 Frs for the *Boy with Dog*, the same price as for *The Fifer* (cat. 93) and the *Woman with a Parrot* (cat. 96). The painting later entered the LAMBERT collection in Nice, then the YDAROFF DE YTURBE collection in Paris; about 1925, it was with the ALEXANDRE ROSENBERG gallery in Paris. At the end of the 1920s, it belonged to FRAU BOH-RINGER in Mannheim and to DR. G. F. REBER in

Barmen. The picture later appeared in New York in the collection of the orchestra conductor JOSEF STRANSKY, and during the 1930s, it returned to Germany, where it was owned by the BARONNE DE GOLDSCHMIDT-ROTHSCHILD (see Provenance, cat. 91) in Berlin.

F.C.

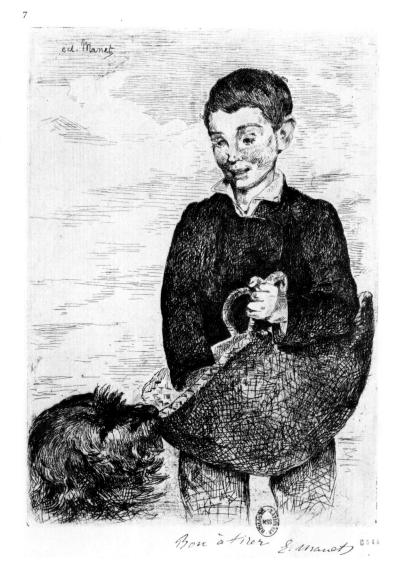

7

7. Boy with Dog

1862
Etching
8¼ × 5⅞"(20.9 × 14.8 cm)
Signed (upper left): éd. Manet (2nd state)
Bibliothèque Nationale, Paris

8. Boy with Dog

1868–74
Lithograph
Borderline: 11⅜ × 9"(28.9 × 22.8 cm)
Signed (upper left): Manet
P Bibliothèque Nationale, Paris
NY The New York Public Library

9. Boy and Dog

1862
Etching and aquatint
8⅛ × 5¾"(20.5 × 14.5 cm)
Signed (lower left): éd. M.
NY The New York Public Library (1st state)
P Bibliothèque Nationale, Paris (3rd state)

7

Publications
8 Gravures à l'eau-forte, Cadart 1862, no. 8 (le Gamin); *Eaux-fortes par Edouard Manet*, 1863?; *Edouard Manet. Eaux-fortes*, Cadart 1874

Exhibitions
Beaux-Arts 1884, no. 155; Paris, Drouot 1884, no. 164; Philadelphia-Chicago 1966–67, no. 28; Ann Arbor 1969, no. 7; Ingelheim 1977, no. 15; Paris, Berès 1978, no. 38

Catalogues
M-N 1906, 11; G 1944, 27; H 1970, 31; LM 1971, 26; W 1977, 159 W 1978, 38

2nd state (of 2). With the etched signature and with Manet's manuscript "bon à tirer" for the 1862 edition. On laid paper (watermark HALLINES). Allard du Chollet collection.

8

Publications
Manet? 1874 (Le Gamin)

Exhibitions
Beaux-Arts 1884, no. 163; Philadelphia-Chicago

In September 1862, the publisher and print dealer Alfred Cadart and his associate Félix Chevalier announced the publication of a collection of eight etchings of "various subjects" by Edouard Manet. The album appeared as one of a series that had already included sets of prints by Jongkind, Legros, and other painter-etchers—all members of the Société des Aquafortistes (Society of Etchers), founded May 31, 1862.[1] As Baudelaire wrote in the April 15 issue of the *Revue anecdotique*, etching was becoming "à la mode."

Manet's album was a response to this new fashion and part of a fresh attempt to publish "sets" of etchings, a practice revived in the nineteenth century, first by Paul Huet, with six prints published by Ritter and Goupil in 1835, and then by Daubigny, in 1851. On the inside cover of the first issue of the Société des Aquafortistes' *Eaux-fortes modernes*, Cadart listed sets of etchings by, among others, Jongkind, Legros, Bonvin, Millet, and Manet. Further sets appeared in later catalogues, under the heading "Albums and Collections."

The album *8 Gravures à l'eau-forte (8 Etchings by Edouard Manet)*, which should have appeared in an illustrated cover (see cat. 45), contained nine subjects, two of them printed on the same sheet: *Boy with Dog*, after

8

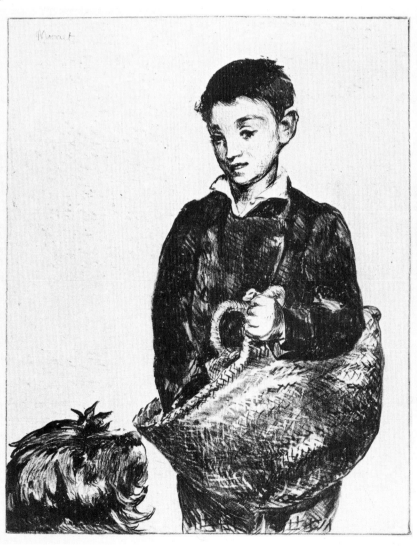

7 (detail) 8 (detail)

Manet's painting of 1860 (cat. 6), and *The Little Girl* (H 19), taken from the large painting entitled *The Old Musician* (RW I 52). They appear together as no. 8, at the end of the list on the album's title page (see cat. 45). The juxtaposition of the two images underlines the fact that they both belong to the category of "popular types," which stemmed from the realist tradition in classical art. Prints of this genre were often treated in series (see cat. 48, figs. b, c).

Compared to Manet's earliest attempts at etching (cat. 15), this print of *Boy with Dog* shows considerable assurance in the handling of the etching needle and a degree of freedom in relation to the subject. A dozen years later, Manet reinterpreted the same painting, which he sold to Durand-Ruel in 1872, in a lithograph that, apart from the elimination of the clouds in the sky, faithfully reproduces the canvas.

The lithograph (cat. 8) is almost exactly the same size as the photographic prints of the painting, which are included in the so-called Manet, or Godet, albums.[2] It therefore appears very likely that Manet made his lithograph with the help of a tracing from a photographic print of his picture. One can only hazard a guess at the reasons that might have induced him to reproduce the composition in lithography and to publish the print at the same time as the lithograph of *Civil War* (see cat. 125, fig. a). In September 1873, Manet wrote to Duret about his money problems;[3] during that winter he sold several paintings—to Henri Rouart (cat. 135) and above all to the famous baritone Jean-Baptiste Faure (cat. 50, 109). It is therefore possible that the publication in an edition of one hundred proofs, in February 1874, of the *Boy with Dog* and of *Civil War*—the first a pleasing subject and the second a

1966–67, no. 29; Ann Arbor 1969, no. 8; Ingelheim 1977, no. 45; Paris, Berès 1978, no. 75

Catalogues
M-N 1906, 86; G 1944, 71; H 1970, 30; LM 1971, 70; W 1977, 45; W 1978, 75

2nd state (of 2). Proofs from the 1874 edition with the title, the printer Lemercier's name, and indication of the edition of one hundred impressions, on applied, violet-toned paper. P: Dépôt Légal proof (registered February 20, 1874). NY: Avery collection.

9

Publications
8 Gravures à l'eau-forte, Cadart 1862, no. 7 (le Garçon et le Chien); *Eaux-fortes par Edouard Manet*, 1863? (L'enfant et le chien)

Exhibitions
Philadelphia-Chicago 1966–67, no. 20; Paris, BN 1974, no. 124; Ingelheim 1977, no. 25; Paris, Berès 1978, no. 30

Catalogues
M-N 1906, 10; G 1944, 17; H 1970, 11; LM 1971, 11; W 1977, 25; W 1978, 30

60

souvenir of a dramatic moment in France's recent history—may represent a further attempt on Manet's part to redress his financial situation.

The lithograph's faithful, even restrained, rendering of the painting contrasts with the relatively free handling and the changes in composition seen in the etching of the *Boy with Dog*, dating from 1862. These changes serve to create, in the etching, a more realistic and spontaneous, less "posed" relationship between the boy and his dog. This sense of spontaneity appears even more pronounced in another print of a similar subject, *Boy and Dog* (cat. 9), which was also published in the 1862 album. In this case, the etching is unconnected with a painting. It was based on a very free sketch (RW II 455) of Alexandre, Manet's young studio assistant and occasional model during the years from 1858 until 1859, when Alexandre hanged

9 (1st state)

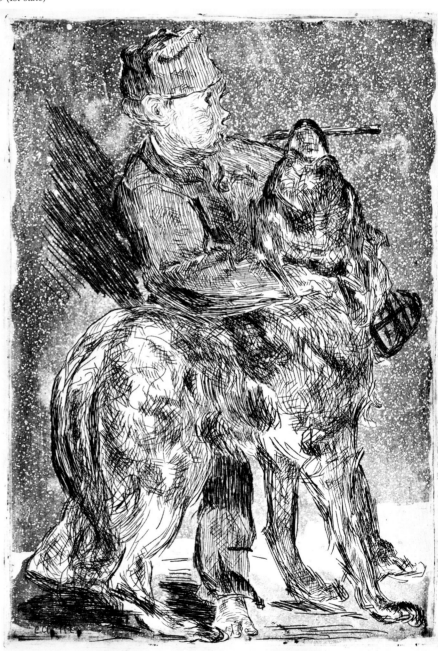

himself in the artist's studio. This tragic event affected Manet profoundly and inspired Baudelaire to write a short story, "La Corde."[4] The soft, broken lines, the mingled shapes of the little barefoot boy and the big dog, and the delicacy of the aquatint tone in the first state express the emotions evoked for Manet by this subject, which he may conceivably have sketched from life in the drawing but which he reinterpreted in etching long after the boy's death. In the final state of the print, the impression from the 1862 album appears rather hard and heavily inked, as are most of the editions printed by Auguste Delâtre. The subject, now with an etched border, gains in force but loses something of its initial charm.

This plate, reprinted on China paper for the album that the artist appears to have issued for his friends in 1863 (see cat. 47), was not published again during his lifetime, whereas the etching of the *Boy with Dog* reappeared in the album issued by Cadart in 1874. Manet expressed his satisfaction with the *Boy with Dog* in a letter, probably written in 1867 (on a "Monday 10," and therefore in the month of June), at the time of his important one-man exhibition on the avenue de l'Alma, to an unidentified correspondent who could well have been Arsène Houssaye, director of the review *L'Artiste* (see Zola's letter of June 9, 1867, to Arsène's brother Henri):[5]

Monday 10
Monsieur
I cannot let you have the print of *Little Cavaliers*. The copperplate has been damaged and will take some time to repair. However, I hasten to suggest that you choose from two other prints after paintings in my exhibition, *The Spanish Singer* [written over *Guitarist*] and *Boy with Dog*. In my view, *Boy with Dog* is a better specimen of printmaking; however, please follow your own taste and kindly let me know your choice when it is made so that I can send the plate to Delâtre, 303 rue St Jacques.

Edouard Manet
49 rue St Pétersbourg[6]

Although the plate of *Little Cavaliers, after Velázquez* (cat. 37) could not be republished on this occasion, the choice fell, in spite of Manet's advice, on that of *The Spanish Singer* (cat. 11), which appeared in *L'Artiste* shortly thereafter.

1. Bailly-Herzberg 1972, I, pp. 14–21; II, p. 144.
2. New York, Pierpont Morgan Library, Tabarant archives; Paris, BN Estampes, Moreau-Nélaton endowment (Dc 300f).
3. Tabarant 1931, p. 76.
4. Baudelaire 1975, p. 328.
5. J. Adhémar 1965, p. 231.
6. Paris, BN Manuscrits, Guérin collection, n.a.f. 24839, fols. 393–94; J. Adhémar 1965, p. 231.
7. Lugt 1956, pp. 257–59.
8. Guérin 1944, p. 21 n. 3.
9. Baudelaire, *Lettres à*, pp. 210–11 n. 6.

Provenance
7. The proof of the etching is signed and inscribed with Manet's "bon à tirer" and is printed on the same paper as that used for the album published by Cadart in 1862. The proof must have remained in the hands of Cadart or of the printer Delâtre. It reappeared among the 8,000 items in the collection of autographs formed by COMTE MAURICE ALLARD DU CHOLLET and given to the Bibliothèque Nationale in 1936 (D 04649). The same collection also included two letters by Manet (Manuscrits, n.a.f. 24022, fols. 83, 84). See Provenance, cat. 11: copperplate.

8. The proof of the lithograph in the Bibliothèque Nationale has the red stamp of the DEPOT LEGAL and the stamped date 1874 (see Provenance, cat. 105). It is one of the two Dépôt proofs transferred to the Bibliothèque Nationale in accordance with the law.

For the proof in the AVERY collection in the New York Public Library, see Provenance, cat. 17.

9. *1st state*. The unique proof in the New York Public Library is part of the AVERY collection (see Provenance, cat. 17).
3rd state. The proof from the Cadart edition of 1862 is part of the Moreau-Nélaton gift, but nothing is known of its earlier provenance. ETIENNE MOREAU-NELATON bequeathed his vast collections to the state (see Provenance, cat. 62). In 1927, the Cabinet des Estampes of the Bibliothèque Nationale received the outstanding gift (D 2905) of his nineteenth-century prints and drawings,[7] which included some twenty Manet drawings and many unique or very rare Manet prints described, often for the first time, in Moreau-Nélaton's catalogue of Manet's graphic work, published in 1906.

Marcel Guérin (see Provenance, cat. 56) records, in his own catalogue, that Moreau-Nélaton's collection included "rare items and states that came for the most part from the collections of Leenhoff and Fioupou; the latter collection, formed by a print enthusiast who was in direct contact with Manet, was enriched by the choicest proofs as they came from the press. According to Mme Manet, Fioupou shared with Baudelaire the first choice of her husband's prints during his most productive period."[8]

JOSEPH FIOUPOU (1814–?), an employee in the Ministry of Finance, an occasional critic, and a friend of Manet's and of the Impressionists', was a passionate collector of prints, drawings, and books. In 1865, Lejosne commented, "Fioupou is collecting more than ever; he now has enough to stock a print shop. . . !"[9]

Apart from the provenance of the proof of *Hat and Guitar* (cat. 47), dedicated "to my friend Fioupou," the source of Moreau-Nélaton's prints and drawings usually cannot be identified, whether from FIOUPOU or from LEON LEENHOFF (see cat. 14) or from other collections, apart from the few prints and, above all, the drawings bearing the collector's mark of ALFRED BARRION (see Provenance, cat. 40).

J.W.B.

10. The Spanish Singer *or* Guitarrero

1860
Oil on canvas
58 × 45″(147.3 × 114.3 cm)
Signed and dated (at right, on bench): ed. Manet 1860
The Metropolitan Museum of Art, New York

Exhibitions
Salon 1861, no. 2098 (Espagnol jouant de la guitare); Alma 1867, no. 3 (Le Chanteur espagnol); London, Durand-Ruel 1872, no. 38; Beaux-Arts 1884, no. 8; Exposition Universelle 1889, no. 486; Paris, Durand-Ruel 1906, no. 7; New York, Durand-Ruel 1913, no. 3; New York, Wildenstein 1937, no. 3; World's Fair 1940, no. 283; New York, Wildenstein 1948, no. 5

Catalogues
D 1902, 23; M-N 1926 I, p. 31; M-N cat. ms., 27; T 1931, 34; JW 1932, 40; T 1947, 38; PO 1967, 33; RO 1970, 32; RW 1975 I, 32

The subject and style of this painting suggest that Manet deliberately set out to achieve what he had failed to accomplish when he submitted *The Absinthe Drinker* (RW I 19) to the Salon of 1859. According to Antonin Proust, when the latter was refused, Manet commented: "I did . . . a Parisian character whom I had studied in Paris, and in executing it, I put in the simplicity of technique that I see in Velázquez's work. People don't understand. Perhaps they will understand better if I do a Spanish character."[1]

Evidently Manet's assessment of the situation was correct, because *The Spanish Singer* brought him his first popular and critical success. He submitted it with a double portrait of his parents (cat. 3) to the Salon of 1861, and both were accepted. Initially, *The Spanish Singer* was hung too high, but strong interest in the picture required the Salon officials to position it more advantageously. According to Laran and Le Bas, Delacroix and Ingres admired the painting.[2] At the end of the Salon it was awarded an honorable mention, possibly through the intervention of Delacroix,[3] and in the July 3 edition of the *Moniteur universel*, Théophile Gautier wrote: "*Caramba!* Here's a *Guitarrero* who does not come from the Opéra-Comique, and who would look out of place in a romantic lithograph; but Velázquez would have greeted him with a friendly wink, and Goya would have asked him for a light for his *papelito*. With such spirited voice he sings out his song while strumming his *jambon*. We can almost hear him. . . . There is much talent in this life-size figure, painted with a bold brush and in very true color."[4]

Nevertheless, some critics denigrated the painting. In his review of the Salon of 1861, Hector de Callias condemned both Manet's style and choice of subject: "What poetry in the idiotic mule-driver figure, in the blank wall, in the onion and the cigarette butt, whose combined odors permeate the room. The splendid brushstrokes, each one individually visible, are caked and plastered on, mortar on top of mortar!"[5]

In the July issue of the *Gazette des Beaux-Arts*, Léon Lagrange similarly declaimed: "By the choice of subject as much as by the way it is treated, the Spaniard playing the guitar recalls the methods of the school of Seville. But what a scourge to society is a realist painter!"[6]

Despite such remarks, the subject and style of *The Spanish Singer* undoubtedly appealed to the strong interest in Spanish art and culture that had been growing in France since about 1840. However, the costume is not entirely Spanish, nor do any of its parts have a common regional source. As Emile Lambert has pointed out, in 1861 Théophile Gautier recognized the costume as a mélange: "Dear Théo was enchanted by the headscarf and the espadrilles, but all the same he carefully noted the Marseilles-type jacket and the [peculiar] pants of this *guitarrero* from Montmartre."[7] In short, contrary to the illusion of Spanish and realist authenticity, the figure depicted in *The Spanish Singer* is a picturesque counterfeit created in the artist's studio.

Even Zola, who was aware of the costumes in Manet's studio that were used as props, assumed that the clothing was Spanish and believed Manet's models were easily confused with genuine Spaniards: "Observing that he paints scenes and costumes that are Spanish, the public may suppose that his models came from beyond the Pyrenees . . . it is worth mentioning that if Manet has painted *espadas* and *majos*, it is because he kept Spanish costumes in his studio and liked their colors."[8] Parts of the costumes appear in the paintings *Mlle V . . . in the Costume of an Espada* (cat. 33), *Young Man in the Costume of a Majo* (cat. 72), *Dead Toreador* (cat. 73), and *Hat and Guitar*, 1862 (RW I 60), as well as in two etchings and a watercolor (cat. 45–47); it is clear, therefore, that the costumes did not inspire the paintings, as Zola supposed, and that Manet's skillful manipulation of a relatively small costume collection was both important as a component of his creative process and exceedingly effective as a substitute for realist correctness.

It is unlikely that the model was a musician. Duret asserts that he was a singer with a troupe of Spanish musicians and dancers, but the group to which he refers had not yet in fact arrived in Paris.[9] Tabarant states that the painting was inspired by the famous Andalusian guitarist Huerta, and that to paint *The Spanish Singer* Manet secured a Sevillian model.[10] Others have suggested that Manet used a musician named Bosch, but comparison of the painting with portraits of Bosch by Manet (cat. 95) and by Bracquemond[11] indicate that this could not be correct.[12] In any case, Manet posed his model as a left-handed guitarist holding an instrument strung for a right-handed player. Left-handed players can play instruments strung in this way, but the chord indicated by the right hand suggests that the model knew nothing about music. It seems that his role as a guitarist is analogous to that of Victorine Meurent as a bullfighter in *Mlle V . . . in the Costume of an Espada* (cat. 33). Apparently Manet felt that the correct position of the guitar was inconsequential, because, according to Antonin Proust, when the error was pointed out to the artist by a visitor to his studio, he did not feel that the observation merited comment: "Yesterday, Renaud de Vilbac came by. He saw only one thing: that my Guitarrero plays left-handed on a guitar strung to be played with the right hand. What is there to say?" Instead, Manet placed importance on the speed and compositional exigencies of his execution: "Just think, I painted the head in one go. After working for two hours, I looked at it in my little black mirror, and it was all right. I never added another stroke."[13] X-rays and technical examination of the head seem to confirm Manet's comments, but in an interview published in 1884, Jean-Baptiste Faure asserted that the position of the guitar was a mistake not noticed until long after the picture was finished: "*The Guitarist* is now known as 'le gaucher,' because the man is playing left-handed—an oddity that Manet and his friends did not notice until long afterward."[14]

The question of possible sources and influences has also generated considerable discussion. According to Proust, Manet himself said, "In painting this figure, I had in mind the Madrid masters, and also Hals."[15] Wright notes "traces" of Goya, Murillo, and Velázquez, as well as "Courbet's attitude toward realism."[16] Other sources that have been suggested are the musician in Greuze's *Mandolin Player* (fig. a)[17] and several works by David Teniers the Younger, which may have provided ideas for objects in the composition.[18] Joel Isaacson, in discussing the etching of *The Spanish Singer* (cat. 11), summarizes both general and specific sources and influences; these include, in addition to those already cited, works by Armand Leleux, Courbet,

Fig. a. Jean-Baptiste Greuze, *Mandolin Player*, Muzeum Narodowe, Warsaw

Fig. b. *The Spanish Singer*, X-ray detail

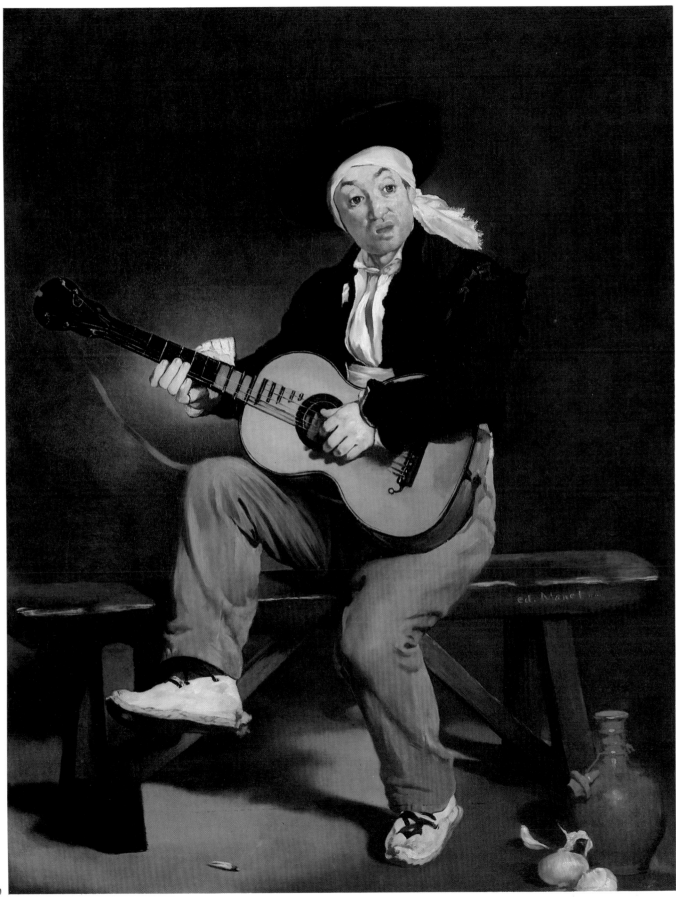

and Alphonse Legros, as well as "another possible source, more promising than [Goya's etching *The Blind Singer*[19]] . . . the engraving by Marcantonio Raimondi of *Jean-Philotée Achillini* (Joueur de Guitare)."[20]

However, one of the most important assessments was made in 1861 by a group of young artists who probably had little, if any, interest in the art-historical aspects of the painting. In 1863, the critic Fernand Desnoyers described their astonishment at the picture and their meeting with Manet to express their admiration: "MM. Legros, Fantin, Karolus Durand [*sic*], and others looked at each other in amazement, searching their memories and asking themselves, like children at a magic show: Where could Manet have come from? The Spanish musician was painted in a certain new, *strange* way that the astonished young painters had believed to be their own secret, a kind of painting lying between that called realist and that called romantic. Some landscape artists, who play nonspeaking parts in this new school, communicated their stupefaction by miming with significant gestures. M. Legros, who had himself attempted one or two ventures into the Spanish but had never crossed the Tagus, accepted the musician as a conquest of the Iberian Peninsula, at least as far as the banks of the Guadalquivir. It was resolved by acclamation that the group of young painters should go forthwith in a body to visit M. Manet. This striking manifestation of the new school duly took place."[21]

Manet welcomed the young painters and answered their questions about *The Spanish Singer* and about himself. The meeting was of great importance, because it acknowledged Manet as the de facto leader of the avant-garde and provided the group with a sense of identity that had hitherto been lacking. Indeed, it was only the first of several meetings that very likely had a profound effect on the course of art during the 1860s: "That first visit was not to be the last. The painters even brought a poet and a few art critics to M. Manet."[22]

X-rays and pentimenti indicate that the technique of *The Spanish Singer* is characteristic of much of Manet's oeuvre. There are numerous small adjustments to contours and such areas as the feet, but in other parts of the painting there is significant reworking. For example, the ceramic jug at the lower right was entirely repainted and given a different shape, perhaps to better conform with the Spanish subject. Indeed, Tabarant notes that the jug is a Spanish type known as an *alcarraza*.[23] The neck of the guitar was painted at least twice, possibly three times, and the model's right hand was shifted accordingly; both are in slightly higher positions than they were originally (fig. b).

1. Proust 1901, p. 72.
2. Laran and Le Bas 1911, p. 21.
3. Sterling and Salinger 1967, p. 27.
4. Gautier 1861, Abécédaire . . .," pp. 264–65, cited in Tabarant 1931, p. 59.
5. Callias 1861, p. 7.
6. Lagrange 1861, p. 51.
7. Lambert 1933, pp. 374–75.
8. Zola 1959, p. 93.
9. Duret 1902, p. 17.
10. Tabarant 1947, p. 41.
11. Beraldi 1885, p. 21, no. 18.
12. Sterling and Salinger 1967, p. 27; Wilson 1978, no. 74.
13. Proust 1897, p. 170.
14. Tabarant 1947, p. 42.
15. Proust 1897, p. 170.
16. Wright 1915, p. 67.
17. Richardson 1958, p. 118, no. 4; Valléry-Radot 1959, p. 215; Hanson 1966, pp. 67–69.
18. Hanson 1979, pp. 59–60.
19. T. Harris 1964, no. 35; see Richardson 1958, p. 118, no. 4.
20. Isaacson 1969, pp. 27–28.
21. Desnoyers 1863, pp. 40–41.
22. Ibid.
23. Tabarant 1947, p. 41.
24. Moreau-Nélaton 1926, I, pp. 132–33; Venturi 1939, II, pp. 189–92.
25. Callen 1974, pp. 161–62, 176 n. 25; Venturi 1939, II, p. 190 (given as 4,000 Frs).
26. Faure sale, Paris, April 29, 1878; Callen 1974.
27. Venturi 1939, p. 190; Callen 1974, pp. 173–78 n. 105; Letter from Charles Durand-Ruel, January 6, 1959 (archives, department of European paintings, The Metropolitan Museum of Art, New York).
28. Callen 1974, p. 171.
29. Howe 1946, II, p. 58; Tomkins 1970, pp. 219, 364, 367.

Provenance

DURAND-RUEL paid 3,000 Frs for this painting when he acquired it along with a large group of Manet's pictures in January 1872 (see Provenance, cat. 118).[24] That the dealer paid a higher price for only two other works (cat. 33, 74) indicates the importance the artist attached to the painting. Just one year later, Durand-Ruel sold it for 7,000 Frs[25] to the celebrated baritone JEAN-BAPTISTE FAURE (1830–1914), who had formed an impressive collection of Barbizon School paintings that he dispersed during the 1870s, when he discovered the emerging artistic talents of Manet and the Impressionists. Indeed, Faure became the most important single collector of Manet's pictures and owned no fewer than sixty-seven of them at one time or another.[26] Durand-Ruel bought the painting back from Faure on April 4, 1906, for 20,000 Frs and sold it on May 2 for 150,000 Frs.[27] Since Faure often acted as a silent partner with Durand-Ruel,[28] the recorded purchase and resale values may not indicate the full details of the transaction. The new owner was WILLIAM CHURCH OSBORN (1862–1951), the wealthy, politically active Metropolitan Museum trustee (1904–51) and president (1941–47) who was instrumental in the museum's decision to purchase Renoir's *Madame Charpentier and Her Children* in 1907.[29] Osborn's fine private collection of French Impressionist and Post-Impressionist paintings included Gauguin's *Two Tahitian Women*, Pissarro's *Jallais Hill, Pontoise*, and Monet's *The Beach at Sainte-Adresse* and *The Manneporte, Etretat, I* (all Metropolitan Museum of Art, New York). *The Spanish Singer* entered the museum's collection as Osborn's gift in 1949 (inv. 49.58.2).

C.S.M.

11. The Spanish Singer *or* Guitarrero

1861–62
Etching
1st, 2nd states: 12¼ × 9¾″ (31 × 24.7 cm); 5th state: 11⅞ × 9¾″
(30.2 × 24.7 cm)
Signed and dated (upper right): éd. Manet 1861 (2nd state);
re-etched signature: éd. Manet (5th state)

P Bibliothèque Nationale, Paris (2nd, 5th states)

NY The Metropolitan Museum of Art, New York (2nd state)

NY The Art Institute of Chicago (5th state)
 Bibliothèque Nationale, Paris (copperplate)

Manet probably worked over a period of several months on this etching after his 1860 oil painting, which was exhibited at the Salon in the spring of 1861 (cat. 10). In the second state, the copperplate is dated 1861, but Manet then effaced both signature and date, re-etching the signature only, at a later stage, along with the name of his printer, Delâtre, at the lower edge. Possibly one of the prints noted by Baudelaire in Cadart's shop window in the spring of 1862 (see cat. 37), this plate was included in the album of *8 Gravures à l'eau-forte* announced by Cadart the following September (see cat. 7–9, 45).

　　The print is a classic example of the "autograph reproduction" in fashion at the period, which occupied a position halfway between the reproductive engraving produced by an artisan and the original print made by

Publications
8 Gravures à l'eau-forte, Cadart 1862, no. 1 (Le guitarero [*sic*]); Eaux-fortes par Edouard Manet, 1863?; *L'Artiste,* July 1867; *Edouard Manet. Eaux-fortes,* Cadart 1874

Exhibitions
Beaux-Arts 1884, no. 161; Paris, Sagot 1930, no. 16; Philadelphia-Chicago 1966–67, no. 47; Ann Arbor 1969, no. 9; Paris, BN 1974–75, nos. 12–14; Ingelheim 1977, no. 13; Paris, Berès 1978 no. 29

Catalogues
M-N 1906, 4; G 1944, 16; H 1970, 12; LM 1971, 12; W 1977, 13; W 1978, 29

11 (2nd state)

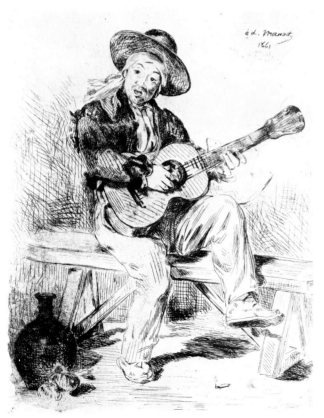

11 (5th state)

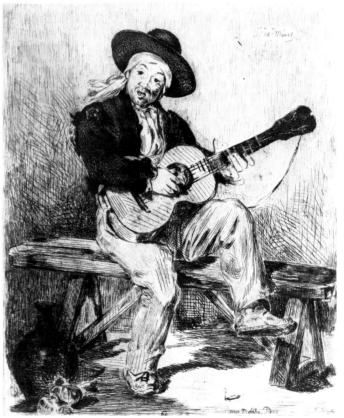

2nd state (of 6). With the signature and date. On laid paper, dedicated in pencil. P: "à mon ami Jules Vibert," Vibert, Moreau-Nélaton collections. NY: "à mon ami l'abbé Hurel," Hurel, Delteil, Le Garrec, H. Thomas collections.

5th state. With the composition completed, the signature re-etched, and the name of the printer, Delâtre, added. P: proof on laid paper (watermark HALLINES), from the 1862 edition. Moreau-Nélaton collection. NY: proof on China paper with small margins, possibly from the private printing of 1863. Loewenthal collection.

Copperplate. Pierced with a hole at top and bottom of the plate. With the stamp of the maker, Godard, on the verso. Suzanne Manet, Dumont, Strölin collections.

a painter-etcher. Manet took great pains over his print, as is shown by the existence of two drawings—a tracing no doubt used to transfer the composition onto the plate and a watercolor that may have played a role in the development of the etched design (RW II 458, 459)—and of working proofs, which show five different stages, or states, of the etched copperplate. His aim was probably the traditional one of publishing for a wider public a reproduction of a painting that had been praised by several Salon critics and had received an "honorable mention." However, Manet did not produce a faithful rendering of the painting, as a specialized artisan-engraver would have done. Charles Courtry, for example, one of the last great reproductive engravers, later gave his interpretation of the subject for the *Galerie Durand-Ruel* publication in 1874 (fig. a).[1]

Manet did not even attempt to reverse the composition on the copperplate in order to produce a printed impression with the same orientation as the painting. Rather, he attempted to find a graphic equivalent to the painting in terms of the etched line and the printed image. The ambiguity of his intention is symbolized by the signature, which appears, disappears, then reappears on the copperplate, finally accompanied by the traditional mention of the printer's name, as with *Philip IV* and *Little Cavaliers*, both after Velázquez (cat. 36, 37).

The print was published several times during the artist's life, first by Cadart as the opening print in the album of *8 Gravures*, which appeared in September 1862 (see cat. 45); then in the presumed private printing of 1863, where it appears at the head of one of the columns on the titled cover and its preparatory drawing (cat. 46, 47); and, in 1867, in the journal *L'Artiste*. Zola wrote a letter on June 9, 1867, to Henri Houssaye about Arsène Houssaye's wish to publish a print by Manet,[2] and this letter is no doubt related to a letter written by Manet dated "Monday 10," which refers to the choice between *The Spanish Singer* and the *Boy with Dog* (see cat. 7–9). Although Manet expressed his preference for the *Boy with Dog*, the choice fell on *The Spanish Singer*, authorized for publication by the Dépôt Légal on July 6, and inserted, folded, into the following issue of *L'Artiste*. (This edition of the print is therefore identifiable by the fold mark.)

After a final printing in Manet's lifetime, in the album published by Cadart in 1874, the artist's family issued a posthumous edition in 1890; the publisher Louis Dumont issued another in 1894; and his successor, Alfred Strölin, a third in 1905. Strölin canceled the plate by punching it after the edition was completed, and it came to the Bibliothèque Nationale in 1923, in a group of twenty-two of Manet's copperplates (see Provenance).

Fig. a. Charles Courtry, engraving after Manet, *The Spanish Singer*, in *La Galerie Durand-Ruel*, 1874

Provenance
2nd state. The two proofs in the second state, when the plate was dated 1861, are dedicated to two of Manet's closest friends. JULES VIBERT (1815–1879) became Manet's brother-in-law through his marriage to Martiena, Suzanne Leenhoff's sister (see cat. 12). Vibert was an artist, and so was his son Edouard (1867–1899), who later copied and imitated Manet's work (see Provenance, cat. 164).[3] The family connection suggests that LEON LEENHOFF (see cat. 14) probably acted as intermediary between the Vibert-Leenhoffs and MOREAU-NELATON (see Provenance, cat. 9), who acquired the proof for his collection.

ABBE HUREL, the dedicatee of the other proof, was a close friend of the Manet family from the early 1860s. He became vicar of the Madeleine and was one of the few people to visit Manet's bedside during his last hours. The artist made him several presents, including a version of the head of the *Jesus Mocked by the Soldiers* (cat. 87) and a portrait painted in 1875 (RW I 238). LOYS DELTEIL (1869–1927) acquired Hurel's dedicated proof of *The Spanish Singer*. Etcher, art expert, and historian, author of the thirty-one volumes of the *Peintre-graveur illustré* (*Illustrated Painter-Engraver*),[4] from 1890, Delteil began to form a superb collection of modern prints, which was sold at auction in 1928.[5] *The Spanish Singer* went for 17,100 Frs to the collector-dealer LE GARREC. It was next acquired by HENRI THOMAS, a businessman who assembled a fine collection of old master and modern prints.[6] At the Hôtel Drouot sale of his collection of modern prints in 1952,[7] the proof of *The Spanish Singer* fetched 130,000 Frs and was bought for the

Metropolitan Museum of Art (inv. 52.608.2). *5th state.* The earlier provenance of MOREAU-NELATON's impression from the 1862 edition, bequeathed by him to the Bibliothèque Nationale, is unknown (see Provenance, cat. 9).

The proof on China paper in the Art Institute of Chicago, which was probably printed for Manet's private issue in 1863 (see cat. 47), passed to the collection of JULIUS LOEWENTHAL and was acquired by the Art Institute in 1921 (inv. 21.282). *Copperplate.* The inventory of Manet's effects, made after his death (see Provenance, cat. 12), listed among various items from his studio "thirty etched copperplates."[8] A statement dated September 27, 1892, refers to these plates: "They still exist and are in Mme Manet's possession."[9] They included on the one hand those plates that had been published in Manet's lifetime and which he reclaimed from Cadart at an unknown date, probably when Cadart's business was heading for bankruptcy,[10] and on the other hand most of the unpublished plates from which Manet had printed only a few artist's proofs. After an edition had been printed from twenty-three of the plates (including thirteen "unpublished" ones) for SUZANNE MANET (see Provenance, cat. 12), who published them in Gennevilliers in 1890, the publisher and dealer LOUIS DUMONT bought all thirty plates and prepared a new edition from them in 1894 (including seven further "unpublished" subjects). ALFRED STROLIN, an important German dealer, publisher, and collector, took over Dumont's business and printed a final edition of one hundred impressions from the plates in 1905, before punching holes in them to eliminate the possibility of further printings. Two plates, however, were reprinted to illustrate the German (cat. 54) and English (H 75) editions of Théodore Duret's monograph, in 1910 and 1912.[11] These two plates, as well as six others (including cat. 37, 48, 69), were lacking from the group when, in 1923, twenty-two copperplates were transferred to the Reserve Collection of the Cabinet des Estampes in Paris, as part of Strölin's confiscated property. In 1976, the Bibliothèque Nationale printed a small edition from three of the plates (cat. 25, 53, 123). Two other copperplates, besides that of *The Spanish Singer*, are included in the exhibition (cat. 123, 214).

J.W.B.

1. *La Galerie Durand-Ruel*, Paris, 1874, p. 19; Wilson 1977, p. 16.
2. J. Adhémar 1965, p. 231.
3. Lugt 1956, p. 248.
4. Lugt 1921, p. 138; Lugt 1956, p. 111.
5. Delteil sale, Paris, June 13–15, 1928, lot 301 (repr.).
6. Lugt 1921, p. 245; Lugt 1956, pp. 194–96.
7. T[homas] sale, Paris, June 18, 1952, lot 129.
8. Rouart and Wildenstein 1975, I, p. 27.
9. Ibid., p. 28.
10. Paris, BN Manuscrits, Allard du Chollet collection, n.a.f. 24022, fol. 83; J. Adhémar 1965, p. 232.
11. Duret 1910.

12. La pêche

1861–63
Oil on canvas
30¼ × 48½" (76.8 × 123.2 cm)
Signed (lower left, on end of raft): éd. Manet
The Metropolitan Museum of Art, New York

According to Tabarant, who depends primarily on an inscription by Léon Leenhoff on a photograph of *La pêche* taken by Lochard,[1] "this picture, at first simply called *Landscape*, also known as *L'Ile Saint-Ouen*, was painted, after sketches made in front of the motif, in the studio that Manet came to occupy in 1861 at 81, rue Guyot. The man and woman, whose old-fashioned attire is curiously out of place here, are none other than Edouard Manet himself and his friend Mlle Suzanne Leenhoff, the young Dutch pianist whom he was soon to marry. The little boy is Suzanne's son, Léon Koëlla-Leenhoff, then in his tenth year, born January 29, 1852; he appears for the first time in Manet's oeuvre and will soon become a familiar model."[2]

Although the painting may have its origins in "sketches made in front of the motif," probably on the banks of the Seine at Ile Saint-Ouen, near Gennevilliers, where Manet's family owned property,[3] the composition is largely a mélange of elements from landscapes by Annibale Carracci and Rubens. As Sterling and Salinger have summarized: "Two works by Annibale Carracci, Hunting and Fishing, in the Louvre (no. 1233, La Chasse; no. 1232, La Pêche), provided the chief elements. There are also direct borrowings from Rubens, whose Landscape with a Rainbow in the Louvre (no. 2118) supplied the rainbow, the dog, and the crossed saplings. Since these motifs appear in reverse in our picture Manet may have known Bolswert's

Exhibitions
Alma 1867, no. 50? (Paysage, 90 × 117 cm); Berlin, Matthiesen 1928, no. 5; Orangerie 1932, no. 14; Venice, Biennale 1934, no. 1; Philadelphia-Chicago 1966–67, no. 11

Catalogues
D 1902, 33; M-N 1926 I, pp. 29–30; M-N cat. ms., 22; T 1931, 35; JW 1932, 30; T 1947, 29; PO 1967, 34; RO 1970, 33; RW 1975 I, 36

Fig. a. Engraving after Peter Paul Rubens, *Park of the Château of Steen*, in Charles Blanc, *Histoire des peintres*

70

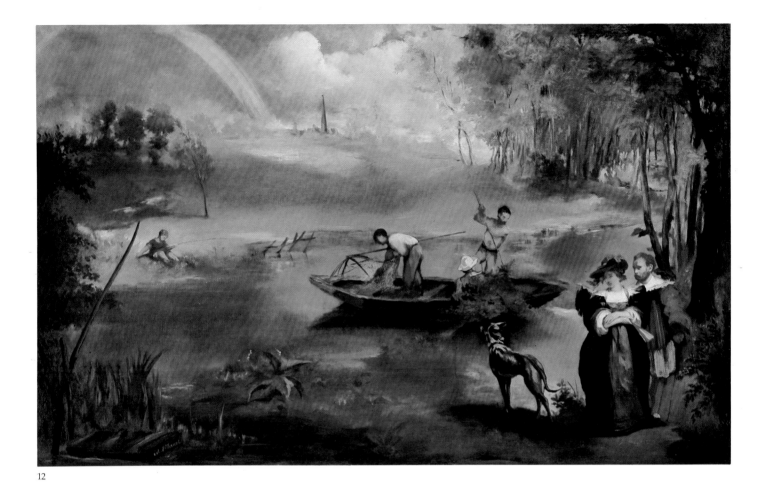

12

Fig. b. Engraving after Peter Paul Rubens, *Land-scape with Rainbow*, in Charles Blanc, *Histoire des peintres*

1. Rouart and Wildenstein 1975, I, p. 52, no. 36.
2. Tabarant 1931, p. 61.
3. New York, Pierpont Morgan Library, Tabarant archives: Mme Manet's account book cites *La pêche* as "Saint-Ouen vendu 3 mille cinq cent francs" (Saint-Ouen sold for 3,500 francs).
4. Sterling and Salinger 1967, p. 26.
5. Sandblad 1954, p. 43.
6. Reff 1970, pp. 456–57.
7. Sandblad 1954, pp. 43–44.
8. Ibid., pp. 44–45.
9. Reff 1962, p. 185.
10. Duret 1902, p. 100; Jamot 1927, *Gazette des Beaux-Arts*, pp. 37–38.
11. Hanson 1979, p. 94; Sandblad 1954, p. 171 n. 47.

engraving of the Rubens rather than the painting itself. The pair of figures at the lower right are related in costume and pose to Rubens's portraits of himself and his second wife, Hélène Fourment, in his painting of the Park of the Château of Steen in the Kunsthistorisches Museum in Vienna (no. 326). Manet, in adapting this couple, gave them the features of himself and his fiancée, Suzanne Leenhoff, whom he was to marry in 1863."[4]

The figures of Manet and Suzanne are also reversed, additional evidence that the artist may have relied on a print after Rubens's painting in Vienna.[5] Reff has noted, however, that although "these are seventeenth-century engravings by Scheltema à Bolswert . . . we may still wonder where and how Manet studied them in such specific detail. The answer is probably to be found in the chapter on Rubens in an ambitious illustrated history of European art which was being published at that time, namely Charles Blanc's *Histoire des peintres de toutes les écoles*, for in it precisely these landscapes, the Park of the Castle of Steen in the Vienna Museum [fig. a] and the Landscape with a Rainbow in the Louvre [fig. b], are reproduced in woodcuts which reverse them."[6] It seems clear that Manet used a print, whether an engraving by Bolswert or an illustration in Blanc's book, but Sandblad has also observed that, in addition, the artist was in "contact with Rubens's original in the Louvre to such a degree that, whilst preserving the distribution of light and shadow seen in the print, he has striven to reproduce the drawing of the dog with that fluency of line which is seen in Rubens, but which the engraver has not entirely succeeded in retaining."[7]

Despite all that is known about Manet's sources for *La pêche*, the meaning of the painting remains elusive. He most certainly knew that the figures in the *Park of the Castle of Steen* were Rubens and Helena Fourment. Sandblad deduces that the painting is "a chivalrous salute to Manet's betrothed, who, in fact, came from the Netherlands," and suggests that the picture is consonant with Manet's tendency to identify with masters he admired: "If we dare establish a beginning with the copy of *Les petits cavaliers* [RW I 21], the development starts from the unexpressed self-identification in this painting, passing through the open, paraphrased self-portrait in *La pêche* to the conscious but obscured parallelism of situation in *La musique aux Tuileries* [cat. 38]."[8]

In addition, the painting may be a variation on a wedding portrait. Manet and Suzanne were not married until October 1863, a little more than a year after the death of Manet's father. As Reff indicates, "Suzanne Leenhoff had been his mistress since 1850 and had borne him a son two years later. Baptized with another name and considered in society as Suzanne's younger brother, the boy's existence was evidently concealed from Manet's father, whose high position in the Ministry of Justice and at the Court of Louis Napoleon it might have damaged."[9] If the painting was executed before Manet's father died, it surreptitiously documents Manet's relationship with Suzanne and explains the presence of Léon in the background. Other elements in the picture are evidently iconographic attributes related to marriage: the rainbow, symbol of union; the dog, symbol of faithfulness; and the church in the background, which most likely refers to marriage as a sacrament.

If the painting is in fact a marriage portrait, then it also recognizes Léon's illegitimacy and simultaneously identifies him as Manet's son. As Léon's origins seem to have been kept in the background of Manet's relationship with Suzanne, so is he placed in the background of the painting, where he fishes on the banks of the Seine. Furthermore, the prominent role of fishermen in the painting may be a play on the French word for "sin." The verb "to fish," *pêcher*, is nearly identical with the verb "to sin," *pécher*. If a pun is in fact intended, it seems clearly to refer to the nature of Manet's relationship with Suzanne. The rather abstruse symbolism may have been motivated by Manet's desire to celebrate his sub-rosa "marriage" and to acknowledge his son without embarrassing either his parents or Léon.

As an allegory of the liaison between Manet and his future wife, *La pêche* could have been painted as early as 1859, as Duret and Jamot suggest;[10] as a marriage portrait, the painting seems more likely to have been executed between the death of Manet's father in September 1862 and Manet's marriage to Suzanne in October 1863, the period when he was working on *Le déjeuner sur l'herbe* (cat. 62). Indeed, a similarity between the landscapes of the two paintings has been noted,[11] and there may also be an indirect relationship with a painted study of a fisherman in a boat (RW I 65), as well as a watercolor made at about the same time (cat. 13, fig. a).

Manet's self-portraits in *La pêche* and *Music in the Tuileries* (cat. 38) are the only examples that precede those of 1878–79 (see cat. 164). In addition, *La pêche* is the only work in which Manet and Suzanne appear together.

12. Jamot and Wildenstein 1932, pp. 105–8; Rouart and Wildenstein 1975, I, pp. 25–27.
13. Manet sale, Paris, February 4–5, 1884.
14. Paris, Beaux-Arts 1884.
15. Rouart and Wildenstein 1975, I, p. 27.
16. Ibid., p. 26; Tabarant 1947, p. 34.
17. Tabarant 1931, p. 61.
18. New York, Pierpont Morgan Library, Tabarant archives: Mme Manet's account book.
19. Tabarant 1947, p. 35.

Provenance
As her husband's general legatee, SUZANNE MANET inherited all the objects listed in the posthumous inventory drawn up in June and September 1883, including furniture and works of art by Manet and others found in his apartment and in that of his mother, as well as the contents of his studio.[12] According to the terms of his will, these were sold at public auction in February 1884,[13] after the great posthumous exhibition of his work.[14] The many paintings bought in at this sale, as well as the drawings and prints remaining in Manet's portfolios, were gradually sold by Suzanne or by her son, Léon Leenhoff (see cat. 14), with advice from Antonin Proust (see cat. 187) or Henri Guérard (see Provenance, cat. 16). *La pêche* is probably the picture listed in the inventory as "Esquisse de M. Manet et sa femme," under the general category "études peintes" (painted studies), mostly unresolved works,[15] although, as Tabarant supposed, it may also correspond to the "Paysage, rivière avec barque par Manet, prisé 300 Frs" (landscape, river with small boat by Manet, value 300 Frs) included in the same inventory among works that Manet placed in the keeping of his mother.[16] According to Tabarant, who here fails to cite the source of his information, the work belonged only to Manet's younger brother, EUGENE MANET (see Provenance, cat. 3), who later gave it to the artist's widow in exchange for a portrait of his mother (RW I 346).[17] This hypothesis presumes that Eugène chose the painting from his brother's estate as a souvenir according to the terms of his will; otherwise, it would not have appeared in the inventory under any title. Tabarant's further suggestion that this picture is the one referred to in Mme Manet's account book[18] as "St. Ouen," which she sold in 1897 for 3,500 Frs, may be correct, although that price is rather high compared to those she received for larger, more important works. Nevertheless, CAMENTRON (see Provenance, cat. 50), who had purchased other works from the artist's widow in February of that year, sold it to DURAND-RUEL (see Provenance, cat. 118) on April 4. It remained in the latter's possession until 1950, when the gallery transferred it to the Société Artistique George V, directed by Durand-Ruel's brother-in-law JEAN D'ALAYER D'ARC. It later passed to the New York dealer SAM SALZ (see Provenance, cat. 188), from whom it was acquired by the Metropolitan Museum in 1957 with funds donated by Mr. and Mrs. Richard J. Bernhard (inv. 57.10).

Another version of *La pêche* was found in Suzanne Manet's bedroom at the time of her death in 1906. Her son, Léon, later tried to pass it off as a replica painted by Manet himself, but the dealers Durand-Ruel, Vollard, and Joyant considered it a poor copy made for Mme Manet, undoubtedly by her nephew, Edouard Vibert (see Provenance, cat. 164), as a souvenir of the original painting, which she apparently sold in 1897.[19]

C.S.M.

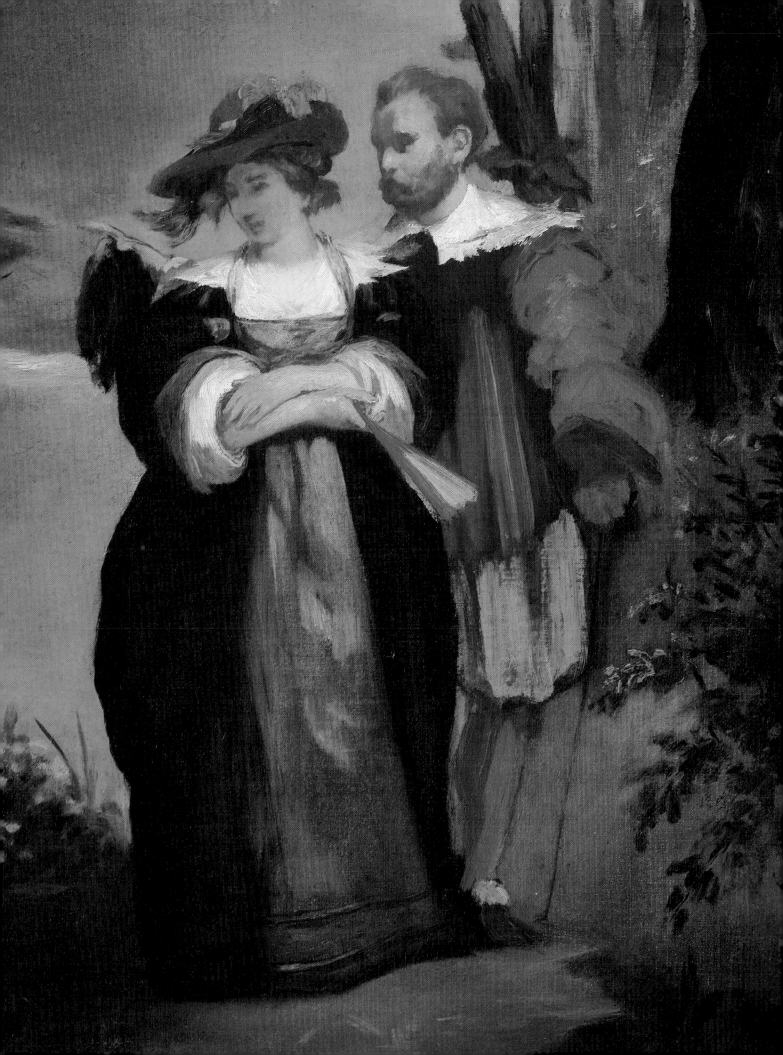

13

Fig. a. *La pêche*, ca. 1861–63. Von der Heydt-Museum, Wuppertal

13. La pêche

1860–62
Watercolor over traces of pencil
8¼ × 11⅜" (21 × 29 cm)
Boymans-van Beuningen Museum, Rotterdam

This work has been related to both *La pêche* (cat. 12) and *Le déjeuner sur l'herbe* (cat. 62), but the similarities depend solely on the bending figure in the foreground.[1] In the painting *La pêche*, a fisherman leans over in a corresponding manner but in the opposite direction, and the position of the bending figure in the background of *Le déjeuner sur l'herbe* is analogous but seems otherwise unrelated. In short, the apparent relationships may be entirely coincidental, especially since the rest of the composition of the watercolor is entirely different. There is, however, an oil sketch (fig. a) that evokes the boat both in *La pêche* and in the wooded area in *Le déjeuner sur l'herbe*.

The Rotterdam watercolor is particularly noteworthy as an early example of the characteristic wash technique that Manet used throughout his career. As Leiris points out, Manet's use of the brush serves both representational and abstract purposes.[2] It is the basis of the particularly appealing watercolor technique used in the illustrations that decorate letters to his friends (cat. 191–205), but it perhaps takes its most accomplished form in the brush-and-autographic-ink drawings that illustrate Mallarmé's translation of Edgar Allan Poe's *The Raven*, published in 1875 (cat. 151).

Exhibitions
Philadelphia-Chicago 1966–67, no. 13

Catalogues
T 1931, 46 (watercolors); T 1947, 595; L 1969, 143; RW 1975 II, 214

1. Hanson 1966, pp. 47–49; Hoetink 1968, pp. 122–23, no. 186; Rouart and Wildenstein 1975, II, no. 214; Hanson 1979, p. 94.
2. Leiris 1969, p. 55.
3. Pissarro sale, Paris, December 3, 1928, no. 68.
4. P. Cabanne, *The Great Collectors*, London, 1963, pp. 147–48; Rotterdam, Museum Boymans-van Beuningen, *Meesterwerken uit de Verzameling D. G. van Beuningen*, Rotterdam, 1949, unpaginated.

Provenance
This work was included both in the studio inventory of CAMILLE PISSARRO (see Provenance, cat. 98), drawn up when he died in 1904 (no. 34), and in the sale of his estate in 1928.[3] It was acquired by the Berlin dealer and publisher PAUL CASSIRER (1871–1926), who promoted the work of the French and German Impressionists. Between 1898 and 1901, he was associated with his cousin Bruno Cassirer (see Provenance, cat. 63). The drawing later belonged to the wealthy banker FRANZ KOENIGS of Haarlem, who assembled one of the most famous collections of drawings in Europe (see cat. 110, 126, 152). In order to pay his debts, Koenigs was forced to mortgage his pictures, and they were deposited by court order in the Museum Boymans in Rotterdam. In 1939, Koenigs's creditors put his collection on the market, and in 1941, the Dutch shipowner and financier D. G. VAN BEUNINGEN bought the greater part of it for the museum (now the Museum Boymans-van Beuningen).[4]

C.S.M.

14. Boy with a Sword

1861
Oil on canvas
51⅝ × 36¾" (131.1 × 93.3 cm)
Signed (lower left): Manet
The Metropolitan Museum of Art, New York

Exhibitions
Paris, Martinet 1863; Brussels 1863, no. 755; Alma 1867, no. 4 (L'Enfant à l'épée); New York, National Academy of Design 1883, no. 153; New York, National Academy of Design 1886, no. 303; Philadelphia 1933–34, without no.

Catalogues
D 1902, 41; M-N 1926 I, pp. 44–45, 133; M-N cat. ms., 36; T 1931, 42; JW 1932, 42; T 1947, 44; PO 1967, 37; RO 1970, 35; RW 1975 I, 37

Tabarant tells us that this work was painted in late 1861 in Manet's studio on the rue Guyot.[1] According to Bazire[2] and Tabarant,[3] the model is Léon Koëlla-Leenhoff (1852–1927), who has been variously identified as Manet's son, stepson, and brother-in-law (his wife's younger brother). Hamilton has noted, "At the time of his birth and again in 1872 Mme. Manet [née Leenhoff] legally acknowledged him as her son, but nothing is known of the putative father, Koëlla."[4] Whether he was in fact Manet's son remains a matter of conjecture, but circumstantial evidence and his role in the composition of *La pêche* (cat. 12) suggest that he was. In any case, Léon appears in more of Manet's pictures than any other member of the family; significant examples, apart from *La pêche,* include *Spanish Cavaliers* (cat. 2), *Reading* (cat. 97), *Soap Bubbles* (cat. 102), and *The Luncheon in the Studio* (cat. 109).

Boy with a Sword was first exhibited at Louis Martinet's gallery in an exhibition that opened March 1, 1863, one month before the first scheduled meeting of the jury for that year's Salon. The critic Ernest Chesneau saw the show and, despite reservations in general about Manet's ability to draw, was especially impressed by the painting: "In addition to the numerous figures wherein there is much to find fault from the point of view of draftsmanship, he has created one very fine painting, of unusual sincerity and feeling for color. I mean the *Boy with a Sword*."[5] Four years later, Zola criticized it as too tame and conventional, a picture that apparently appealed to the general public: "Then come the *Guitar Player* [cat. 10] and the *Boy with a Sword.* . . . These paintings are firm and sound, and very sensitive, moreover, with nothing to offend the weak eyesight of the many. Edouard Manet is said to have some kinship with the Spanish masters, and he has never shown it so much as in the *Boy with a Sword*. The child's head is a marvel of modeling and controlled vigor. If the artist had always painted heads like this, he would have been the darling of the public, showered with money and praises; true, he would have remained a mere echo [of the past], and we would never have known the sincere and harsh simplicity that is his great gift. For myself, I must admit that my sympathies lie elsewhere among the painter's works; I prefer the rigorous directness, the accurate and powerful color areas of *Olympia* to the close, studied niceties of *Boy with a Sword*."[6]

Paul Mantz adopted the opposite point of view, although he, too, noted the influence of seventeenth-century Spanish painting: "The broad colors and bravura brushwork of the *Spanish Guitarist* and the *Boy with a Sword* made one think of the seventeenth-century Spanish masters. Since then Manet has gotten away from these healthy practices. As a colorist he has less courage, as a craftsman he is less original. He has taken a singular liking for black tones, and his ideal consists of opposing them to chalky whites in such a way as to present on the canvas a series of more or less contrasting areas."[7]

In an article published about four years later, Armand Silvestre admired *Boy with a Sword* as "a superb piece of painting" and a work that equaled the stylistic achievement of the most beautiful portraits by Velázquez.[8] Like many other critics, his approach seems to have been influenced by the formalist approach of Zola, who wrote in his article on Manet in 1867: "Painters, especially Edouard Manet, who is an analytical painter, do not share the crowd's overriding concern with subject matter; for them, the subject is but an excuse for painting, whereas for the general public, the subject is all there is."[9]

The subject seems, at first, little more than a costume piece. According to Hanson, "*Boy with a Sword* shows young Léon Leenhoff dressed up in seventeenth-century costume like Spanish royalty. At once a portrait of a member of the family and a homage to the Spanish masters [Manet] revered, the painting admirably combines realism and fantasy."[10] Reff suggests that the painting is consistent with Manet's tendency to identify with painters he admired: "Obviously inspired by Velázquez, especially the *Little Cavaliers* which he had copied in the Louvre a year earlier, it represents a boy as a page in the aristocratic society of that time, wearing a costume based on the Velázquez and carrying a seventeenth-century sword borrowed for the occasion. The master on whom he gazes and whose sword he carries is of course his father, who had identified himself with the courtly and sophisticated Velázquez in two small paraphrases of the *Little Cavaliers*, and was to do so again the following year in *Concert in the Tuileries* [cat. 38]."[11] If the style and composition of the painting refer to Manet's aesthetic and art-historical interests, the sword that Léon carries, borrowed from the painter Charles Monginot,[12] may allude to his father's accomplishments as a swordsman. In short, the picture seems to be a disguised comment on Manet's personal and professional interests.

The work of Velázquez is often cited as an obvious influence on the style and subject of *Boy with a Sword*, but Goya's portraits of standing children may be equally important. For example, *Don Manuel Osorio Manrique de Zuñiga*, 1784, and *José Costa y Bonells, called Pepito* (fig. a), both in the Metropolitan Museum of Art, New York, are similar in size, and in each the child is surrounded by attributes that reflect the values of adults. Léon's ingenuous expression is, in fact, not unlike that of Pepito, who also stares directly at the viewer. Indeed, Albert Boime has noted a similar relationship between Manet's paintings of children and those of his teacher Thomas Couture: "Manet assimilated Couture's need for *double entendre* and hidden associations in his series of adolescents. The urchins of Couture and Manet . . . are typically placed in adult roles and are forced to behave self-consciously and handle their accessories in an awkward fashion. Couture's *Falconer* and *Drummer Boy* and Manet's *Child with a Sword* and *Fifer* [cat. 93] set the young person in a potentially risky situation by identifying the child incongruously with the military or with a barbarous sport. The child innocently plays his part and is seemingly unaware of the destructive potential of the circumstances for the grown-up."[13]

Fig. a. Francisco de Goya, *José Costa y Bonells, called Pepito*, ca. 1813. The Metropolitan Museum of Art, New York

1. Tabarant 1931, p. 69; as evidence, Tabarant cites Léon Leenhoff's assertion that he posed for the painting just before turning ten years old.
2. Bazire 1884, p. 139.
3. Tabarant 1931, p. 69.
4. Hamilton 1969, p. 130 n. 6.
5. Chesneau 1863, p. 148, quoted in Hamilton 1969, p. 39.
6. Zola 1867, *L'Artiste*, p. 55; Zola (Dentu), p. 30.
7. Paul Mantz, *L'Illustration*, June 6, 1868, quoted in Hamilton 1969, p. 120.
8. Silvestre 1872, p. 179.
9. Zola 1867, *L'Artiste*, p. 57; Zola (Dentu), p. 33.
10. Hanson 1979, p. 79.
11. Reff 1962, p. 185.
12. Meier-Graefe 1912, p. 202 n. 1.; Tabarant 1931, p. 69.
13. Boime 1980, p. 460.
14. Moreau-Nélaton 1926, I, p. 45.
15. Ibid.
16. Letter from Charles Durand-Ruel, January 6, 1959 (archives, department of European paintings, The Metropolitan Museum of Art, New York).
17. Meier-Graefe 1912, p. 313; Venturi 1939, II, p. 192.
18. Silvestre 1872, p. 179.
19. Venturi 1939, II, p. 210.
20. [Edwards] sale, Paris, February 25, 1881, no. 39, reproduction (etching of Bracquemond); Rewald 1973, p. 452.
21. Letter from Charles Durand-Ruel, January 6, 1959 (archives, department of European paintings, The Metropolitan Museum of Art, New York).
22. Weitzenhoffer 1981.
23. Duret 1902, no. 42.
24. Jamot and Wildenstein 1932, no. 43; Tabarant 1947, p. 45.
25. New York, Pierpont Morgan Library, Tabarant archives.

Provenance
When this picture was exhibited at Martinet's gallery in 1863, Manet was asking 1,000 Frs, or not less than 800 Frs, for it.[14] The exact circumstances of its first sale remain unclear. An undated entry in the same account book where Manet recorded the details of his important transactions with Durand-Ruel early in 1872 (see Provenance, cat. 118) reads: "Vendu à Fèvre [sic] l'enfant à l'épée 1.200 [Frs]" (Sold to Fèvre [sic] the boy with the sword 1,200 [Frs]).[15] The purchaser was the dealer FEBVRE, who specialized in old master works. Fèbvre must have acquired this picture before January 1872, when he sold it to DURAND-RUEL, according to the latter's stock books.[16] Yet

14

Durand-Ruel told Meier-Graefe that he bought the *Boy with a Sword* directly from Manet for 1,500 Frs as part of their second important transaction of January 1872, and the dealer himself later confirmed this version of the event.[17] In any case, Durand-Ruel advertised the picture as in his stock the following September.[18] *Boy with a Sword* was one of the pictures Durand-Ruel used as collateral against a business loan from the banker Edwards.[19] Son of an Anglo-Turkish businessman, ALFRED EDWARDS (1856–1914) was a banker, journalist, and collector. He later became the second husband, following her divorce from Thadée Natanson, of Misia Godebska, an accomplished pianist and the muse of a group of artists and writers at the end of the century. With Edwards's authorization, Durand-Ruel organized an anonymous sale of these pictures in 1881. On that occasion, Feder, a banker acting as a backer for the dealer, bought *Boy with a Sword* for 9,100 Frs.[20] On June 28, 1881, Durand-Ruel sold it for 10,000 Frs to the American painter J. Alden Weir,[21] who was acting as consultant in Paris for ERWIN DAVIS, a New York-based entrepreneur who had begun to collect French and American nineteenth-century pictures in 1880. Since he bought works by Manet, Monet, and Degas during the next few years, he deserves special recognition as one of the earliest American patrons of Impressionist art. Davis auctioned off part of his collection in New York at a sale on March 19–20, 1889, at which *Boy with a Sword* was bought for $6,700 by a phantom bidder Davis had hired to push up prices. Later that year, Davis donated the picture, along with Manet's *Woman with a Parrot* (cat. 96), to the Metropolitan Museum of Art.[22] These were the first works by the artist to enter a public collection in the United States.

Although a smaller version of the same subject, painted on panel, was included in Duret's catalogue raisonné,[23] subsequent scholars have rejected it as a copy by another hand.[24] Among Léon Leenhoff's notes, the following curious transaction is recorded about 1900: "L'Enfant à l'épée, Le Balcon, Vase de fleurs—5000 [Frs] à Gérard" (Boy with a sword, The Balcony, Vase of flowers—5,000 [Frs] to Gérard).[25]

C.S.M.

15–18. Boy with a Sword

Group of three etchings representing *Boy with a Sword* (cat. 14) turned left—that is, in reverse of the direction in the painting—and the tracing used to make the second plate (cat. 17).

15. Boy with a Sword *turned left I*

First plate
1861
Etching
10⅞ × 8½" (27.5 × 21.7 cm)
Nationalmuseum, Stockholm

16. Boy with a Sword

1861–62
Pen and brown ink
10 × 7⅛" (25.4 × 18.2 cm)
P Private Collection

17. Boy with a Sword *turned left II*

Second plate
1861–62
Etching
11⅛ × 8¾" (28.2 × 22.3 cm)
The New York Public Library

Fig. a. *Boy with a Sword, turned right*, etching and aquatint. Bibliothèque Nationale, Paris

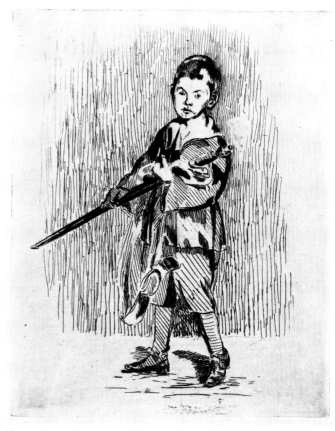

15

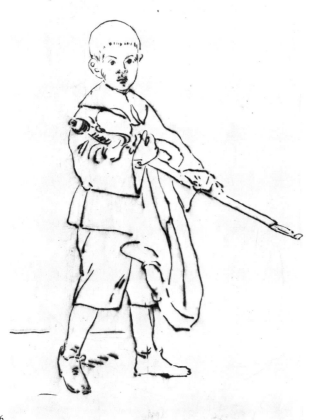

16

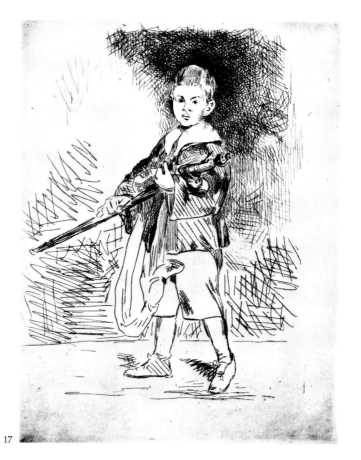

17

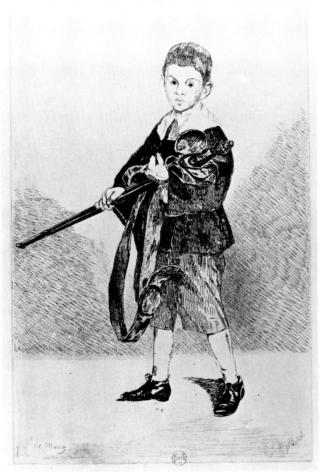

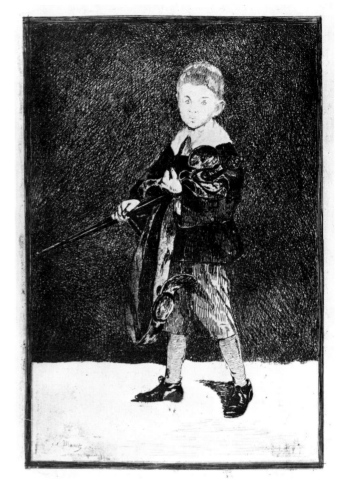

18 (3rd state)

18 (4th state)

18. Boy with a Sword *turned left III*

Third plate
1862
Etching and aquatint
Plate: 12⅝ × 9⅜″ (32 × 23.8 cm); image, 1st–3rd states: 10⅜ × 6⅞″
(26.4 × 17.4 cm); image, 4th state: 10½ × 7″ (26.8 × 17.9 cm)
Signed (lower left): éd. Manet

P Bibliothèque Nationale, Paris (3rd, 4th states)

NY The Metropolitan Museum of Art, New York (3rd state)

NY The New York Public Library (4th state)

Manet made no fewer than four different etchings after his painting of young Léon Leenhoff carrying a great sword (cat. 14). One of the versions, probably the last, is known from a unique proof in the Bibliothèque Nationale (fig. a) and shows the composition in the same direction as the painting. In the other three prints, as is often the case with Manet's reproductions of his own pictures, the image is reversed.

In order to produce an image that will appear, when printed, in the same direction as the original, the artist must draw or etch it in reverse on the copperplate or lithographic stone. If he fails to make a tracing of a draw-

15

Exhibitions
Ingelheim 1977, no. 20; Paris, Berès 1978, no. 26

Catalogues
M-N 1906, 53; G 1944, 11; H 1970, 24; LM 1971, 21;
W 1977, 20; W 1978, 26

The only known proof, on thin Japan paper.
Burty, Degas, Schotte collections.

16

Exhibitions
Paris, Berès 1978, no. 6

Catalogues
L 1969, 156; RW 1975 II, 456

Drawing in pen and brown ink on transparent
paper (laid on card). Guérard collection.

17

Exhibitions
Beaux-Arts 1884, no. 160 (counterproof); In-
gelheim 1977, no. 21

Catalogues
M-N 1906, 54; G 1944, 12; H 1970, 25; LM 1971, 22;
W 1977, 21

One of two known proofs (the other is in the
British Museum, London). Avery collection.

18

Publications
Cadart 1862–63?; *Eaux-fortes par Edouard Manet*,
1863? (l'enfant à l'épée)

Exhibitions
Beaux-Arts 1884, no. 160; Philadelphia-Chicago
1966–67, no. 27; Ann Arbor 1969, no. 6; Ingelheim
1977, no. 22; Paris, Berès 1978, no. 27

Catalogues
M-N 1906, 52; G 1944, 13; H 1970, 26; LM 1971, 23;
W 1977, 22; W 1978, 27

3rd state (of 4). With hatching in the background
and a light aquatint. Proofs on laid paper (NY:
watermark HUDELIST), from the presumed publi-
cation of 25 impressions (see text). P: Blondel col-
lection. NY: early provenance unknown.

4th state. With dark aquatint and an etched bor-
der around the subject. The only known proofs,
on thin Japan (P) and China (NY) papers. P:
Bracquemond, Degas (?), Sagot, Le Garrec
collections. NY: Avery collection.

1. Moreau-Nélaton 1906, no. 53.
2. Bailly-Herzberg 1972, II, p. 144.
3. Tabarant 1947, p. 518.
4. Paris, BN Estampes (Dc 300g, VIII).
5. Beraldi 1885–89, VIII, p. 208.
6. Lugt 1921, pp. 117–18.
7. Degas collection, second sale, Paris, November
6–7, 1918, lot 263.

ing or photograph, or to make a reversed photographic print of the original, he will find it difficult to draw a freehand image of his composition in reverse. Manet was an impatient or, more accurately, an impulsive worker and appears to have taken the necessary preparatory steps only in the case of a few prints that were clearly important to him: in particular, the fourth plate of the *Boy with a Sword* (which he still did not succeed in completing for publication), *Little Cavaliers, after Velázquez* (cat. 37), *Lola de Valence* (cat. 52), and *The Execution of Maximilian* (cat. 105).

Moreau-Nélaton recounts, in connection with what is undoubtedly the first version of the *Boy with a Sword* (cat. 15), "This print was executed under the supervision of M. Alphonse Legros, who actually participated. In response to our questions, he has written to say: 'I recall having made a few lines on the plate, just a few strokes, to show him how to do it; but the etching is actually by Manet.' Nevertheless, this work, which is certainly one of Manet's earliest attempts, is marked by the distinctive flavor of M. Legros's talent."[1]

This etching is undoubtedly one of Manet's first experiments, if not his very first, with a copperplate; executed with rigid parallel hatching and a rather heavy contour line, it is the most awkward and the least freely handled of all his known prints. It conveys few of the qualities of the painting it attempts to reproduce and exists only in a single proof, since Manet set aside the copperplate and made a second attempt.

The second version (cat. 17) appears to have been prepared with the help of a tracing made from a photograph of the oil painting (which showed the subject turned right, as in the painting), traced with a pen and brown ink and then transferred onto the copperplate. The drawing (cat. 16) presents a fuller, more confident version than the rather tight image of the first plate. The second etching follows the outlines of the tracing, and the background of sketchy crosshatched lines attempts to convey the neutral background in the portrait and the atmosphere that envelops the figure. This second version, similar in handling to the second state of *The Spanish Singer* (cat. 11), was abandoned in its turn (only two proofs are known), and Manet began work on a third copperplate (cat. 18).

This time, he started with a lightly etched design and progressively worked it up on the plate, adding a light aquatint as the final touch. Although the print must have been intended for publication in the album advertised by Cadart in September 1862 (see cat. 7–9, 45), it did not appear in the set *8 Gravures*. A proof printed on laid paper with the watermark HUDELIST and inscribed "Bon à tirer 25 épreuves sur papier pareil," with Manet's signature, does exist, however (in the New York Public Library). The suggestion that a limited edition was in fact printed is borne out by the number of proofs on the same paper with the same watermarks (HUDELIST or HALLINES) that are found on the prints published by the Société des Aquafortistes (see cat. 7–9) between 1862 and February 1863. The issue seems to have met with little success and was apparently still in print as late as 1878, when Cadart offered it for sale in his catalogue.[2] The title of this print also appears on the etched list of "quatorze eaux-fortes" (fourteen etchings) on the cover for the supposed issue of 1863 (cat. 47), and a few proofs on China paper, still in the same state, are probably examples of this printing.[3]

Manet later reworked the plate in etching and added a strong aquatint tone. Only two proofs showing this state are known, and Manet must have abandoned the plate without succeeding in republishing it. In the so-

called Lochard photograph albums, put together after Manet's death, the third state of this print is reproduced with a manuscript note, "Portrait de Léon Leenhoff. Planche non retrouvée" (Portrait of Léon Leenhoff. Plate missing).[4]

Manet made a fourth attempt to reproduce his painting, taking care this time to preserve the original direction of the painting, but, once again, the result was disappointing: on the single known proof the etching is obscured by heavy, defective biting of the plate. Even with the help of Félix Bracquemond (who kept several of the rarest proofs from this series of plates and who later produced his own print after Manet's painting to illustrate the Edwards sale catalogue of 1881; see Provenance, cat. 14), Manet did not succeed in mastering the biting of his plates, and the aquatint continued to cause him difficulties, even when the biting was in the hands of experts, such as Bracquemond and later Henri Guérard (see cat. 214).

8. Etude Ader Picard Tajan, Paris, pers. comm.
9. Wilson 1977, p. 25; Wilson 1978, passim.
10. Moreau-Nélaton 1906, intro., reprinted in Guerin 1944, pp. 15–16; Melot 1974, p. 73.
11. Wilson 1978, no. 109: letters from Suzanne Manet to Guérard.
12. Rouart and Wildenstein 1975, I, p. 27.
13. Lugt 1921, pp. 9–10; Samuel P. Avery, *The Diaries 1871–1882 of Samuel P. Avery,* ed. Madeleine Fidell Beaufort et al., New York, 1979.
14. Lugt 1956, p. 236; Lucas 1979.
15. Lucas 1979, pp. 580, 659 and passim.
16. Degas collection, second sale, Paris, November 6–7, 1918, lot 264.
17. Lugt 1956, p. 41.
18. Bouillon 1975.
19. Moreau-Nélaton 1906, intro., reprinted in Guérin 1944, p. 20.
20. Degas collection, second sale, Paris, November 6–7, 1918, lot 262 (state not described).

Provenance

15. Henri Beraldi, author of the first catalogue of Manet's graphic work, was unaware of the existence of this print of *Boy with a Sword,* of which only one impression is known.[5] It does not appear to have remained in the artist's studio, and although it may very possibly have been kept—as was the case with several proofs of other prints in this series—in the print portfolios of BRACQUE-MOND (see Provenance, cat. 18), it made its first appearance at the auction sale of Degas's collection.

EDGAR DEGAS (see Provenance, cat. 23), a passionately committed printmaker himself, assembled a remarkable collection of prints—both old master, and modern, in particular—which was dispersed after his death.[6] Of the sixty-eight impressions of prints by Manet included in his sale, at least sixty came from the collection of PHILIPPE BURTY (see Provenance, cat. 42). This first plate of *Boy with a Sword,* however, does not seem to have belonged to Burty and does not appear in the Burty sale catalogue. It appears in the second sale of the Degas collection,[7] described as a "Superbe épreuve sur japon. *Seule épreuve connue*" (Superb proof on Japan paper. *The only known proof*). Since the minutes of the sale have disappeared,[8] it is impossible to confirm that this unique item, together with a whole group of the rarest proofs, was acquired directly by a Swedish collector named SCHOTTE.

Whatever the exact circumstances, the fact remains that, of the sixty-two lots of etchings and lithographs by Manet listed in the sale catalogue, twenty-two, including most of the rarest items, found their way into this Swedish collection and passed, for still obscure reasons, on deposit into the reserves of the Nationalmuseum, Stockholm, and finally, in 1924, into the museum's collection of prints and drawings. Inventoried but never exhibited, the collection remained unknown even to specialists until its "rediscovery" and the exhibition of many rare proofs in Ingelheim in 1977 and in Paris in 1978.[9]

16. HENRI GUERARD (1846–1897), a skilled etcher and printer, became Manet's friend and technical assistant in the 1870s.[10] In 1879, he married Eva Gonzalès, Manet's favorite pupil, who died a few days after Manet's death. Guérard remained in close touch with SUZANNE MANET (see Provenance, cat. 12), and she gave him, as gifts or on consignment, many rare proofs that had been framed for the exhibition at the Ecole des Beaux-Arts in 1884 or had remained in portfolios from the artist's studio.[11] Guérard sold many of these to

the collector and agent GEORGE LUCAS (see Provenance, cat. 17), who acquired some of them for himself and others for SAMUEL P. AVERY (see Provenance, cat. 17). Guérard kept some prints for his own collection. This traced drawing for the second version of *Boy with a Sword* appeared neither in the Beaux-Arts exhibition nor in the atelier sale of 1884 and must have passed directly from the artist's portfolios described in the studio inventory,[12] either given or sold by Mme Manet, to Guérard. It remained in the Guérard family's collection until the 1960s, passing thereafter through several private collections.

17. An extraordinary collection of modern prints in the New York Public Library was the gift in 1900 of one of the most important collectors and dealers in the United States during the second half of the nineteenth century. SAMUEL PUTMAN AVERY (1822–1904)[13] began his career as a professional engraver. In 1864, he became a business associate of William T. Walters of Baltimore, a rich collector turned art dealer. Their European agent was an American who had settled in Paris: GEORGE A. LUCAS (1824–1909),[14] like Walters a gentleman from Baltimore. Between 1865 and 1885, the year in which Avery retired, Lucas spent more than 2,500,000 Frs, primarily on the purchase of paintings, on Avery's account. As for the prints Avery collected and later donated to the great public library of his hometown, Lucas's diary shows the extent to which he scoured Paris to find them—in dealers' shops, at collectors' homes, at the Hôtel Drouot—for Avery and for himself (Lucas left his own fine collection to the son of his Baltimore associate, to be given to the Maryland Institute).

The Lucas diary shows that Avery must have started collecting Manet's prints just about the time of his retirement and of the artist's death. The first reference to Manet concerns Lucas's visit, on February 2, 1884, to the exhibition preceding the Manet sale at the Hôtel Drouot. Then, from December 4 of the same year, when he recorded "At Dumonts & bought lot of eauxfortes Manet and others for SPA," there are innumerable references to visits to and acquisitions from Rouart (see Provenance, cat. 129); Guérard (see Provenance, cat. 16); the dealers Dumont (see Provenance, cat. 11), Portier (see Provenance, cat. 122), and Gosselin; and "HD"—the Hôtel Drouot.[15] Lucas appears to have counted on Guérard not just as a source of supply (see Provenance, cat. 16) but also for advice and information concerning the Manet prints he acquired for Avery. The last time Manet's name is mentioned in

Lucas's diary, on February 19, 1907, it is in connection with the purchase of three books by Moreau-Nélaton (see Provenance, cat. 9), including a "Manet"—probably the catalogue of his graphic work that had just been published.

The proof of the second plate of *Boy with a Sword* in the New York Public Library came, according to Guérin, from the collections of Burty and Degas and was included in the second Degas collection sale in 1918,[16] fourteen years after Avery's death. However, the Degas proof is undoubtedly the one acquired by Campbell Dodgson and bequeathed to the British Museum, London, in 1949 (as is proved by a comparison of the print with Moreau-Nélaton's reproduction of the Degas proof). AVERY probably acquired his proof, as usual, through LUCAS, and possibly from SUZANNE MANET (see Provenance, cat. 12) by way of GUERARD.

18. *3rd state.* The proof in the Bibliothèque Nationale was purchased on February 20, 1914 (A 8025), from PAUL BLONDEL (1855–1924),[17] a bank employee and a passionate collector of prints and drawings, mainly of iconographical and topographical interest, to which—like Fioupou (see Provenance, cat. 9)—he devoted his modest means, forming enormous collections that he bequeathed to institutions, largely to the Bibliothèque Nationale.

The proof in the Metropolitan Museum of Art, acquired in 1980, is part of the Elisha Whittlesey collection (inv. 1980.1077.1). Its early provenance is unknown.

4th state. Of the two known impressions, that in the Bibliothèque Nationale, on old Japan paper, given in 1979 (D 01.1979), belonged to the dealers SAGOT (who exhibited it in 1930) and LE GARREC and came from the collection of Bracquemond. FELIX BRACQUEMOND (1833–1914),[18] etcher, lithographer, painter, and decorative artist, and a close friend of Manet's, was renowned as the most accomplished expert in etching techniques during the years 1850–70. He helped many etchers (members of the Société des Aquafortistes as well as unaffiliated artists) with the biting of their plates, the application of aquatint grains, and the printing of their trial proofs. In this way, he acquired many proofs in rare states, amassing a fine collection, which was coveted and on occasion plundered by a collector as avid as Philippe Burty (see Provenance, cat. 42). Moreau-Nélaton reproduced in his catalogue of Manet's graphic work several rare items from the collection of Bracquemond, who recounted for him "his memories of the man whose life was for a number of years so

intimately connected with his own and who, as an etcher, gained so much from his professional experience."[19]

The other known proof, on China paper, in the New York Public Library, seems unlikely to be the one that Moreau-Nélaton mentions in Degas's collection, sold in the second Degas sale in 1918,[20] and it is probable that AVERY's proof came through his normal channels (see Provenance, cat. 17).

J.W.B.

19. The Surprised Nymph

1859–61
Oil on canvas
57½ × 45" (146 × 114 cm)
Dated (on a leaf) and signed (lower left): 1861. éd Manet
Museo Nacional de Bellas Artes, Buenos Aires

Exhibitions
Saint Petersburg 1861 (Nymphe et Satyre); Alma 1867, no. 30 (La Nymphe surprise); Beaux-Arts 1884, no. 13; Paris, Drouot 1884, no. 14

Catalogues
D 1902, 24; M-N 1926 I, p. 33; M-N cat. ms., 28; T 1931, 39; T 1947, 42; PO 1967, 35A; RO 1970, 38A; RW 1975 I, 40

Fig. a. François Boucher, *Diana at the Bath* (detail). Musée du Louvre, Paris

Fig. b. Rembrandt, *Bathsheba*. Musée du Louvre, Paris

In Manet's oeuvre *The Surprised Nymph* is truly an experimental work, one that he repeatedly modified. The painting links the copies from old masters done in the 1850s with the major canvases of 1862 and 1863. It has presented art historians with many problems, rendered more difficult by its geographical remoteness for seventy years (see Provenance) and the fact that the catalogues raisonnés reproduce a photograph of the painting in an earlier state; recent accounts, moreover, supplement but occasionally contradict each other. Farwell, however, seems to have set the record straight.[1]

This painting has always been regarded as laden with classical influences. Manet's first historian, Bazire, was struck by the Venetian inspiration, and by the influence of Lagrenée: "It's a study piece, most remarkable certainly, but declaring merely a first-rate virtuosity."[2] He might also have mentioned works to be seen in Paris that could have inspired Manet—Boucher's famous *Diana at the Bath* (fig. a) or Rembrandt's *Bathsheba*, then in the La Caze collection (fig. b). Antonin Proust, in the first and more authoritative version of his recollections, tells us that the work was begun in the rue Lavoisier studio, which Manet left late in 1859 for the rue de la Victoire, so he must have been working on it by that date: "In the rue Lavoisier, Manet had begun a large painting, *The Finding of Moses*, which he never finished; only one figure remains, which he cut from the canvas and titled *The Surprised Nymph*."[3] Photographs (by Godet and, later, by Lochard in 1883 or 1884) show the face of a satyr in the boughs at the upper right; it has since vanished. We know the work was sent to Saint Petersburg in the autumn of 1861 under the title *Nymph and Satyr*.[4] (In Manet's notebooks, in the Pierpont Morgan Library in New York, there is mention of one L. Beggrow, commissioner of the Imperial Academy of Saint Petersburg. Two artists who exhibited there with Manet were Monginot and A. Gauthier.) To complicate the iconography, it was shown in 1932 that the nude was based on a lost Rubens, *Susannah and the Elders*, known in Manet's time through an engraving by Vorstermann[5] or, as Reff has shown, simply through a reproduction of that engraving in Charles Blanc's *Histoire des peintres*.[6] Other possible sources have been suggested: by Krauss, Rembrandt's *Susannah*, in the Gemeentemuseum, The Hague;[7] by Farwell, an engraving by Raimondi (*Nymph and Satyr*) and an engraving after van Dyck.[8] We also know that the model for the nude was Manet's mistress and future wife Suzanne Leenhoff,

as related by Léon Leenhoff.[9] Another of the more likely sources is the Bathsheba in a decoration by Giulio Romano in the Palazzo del Tè in Mantua, perhaps seen by Manet, or known from an engraving (fig. c; see also cat. 21).

Fig. c. Corneille le Jeune, engraving after Giulio Romano, *Bathsheba*. Bibliothèque Nationale, Paris

These multiple sources and continuing changes give us an insight into Manet's elaboration of the idea of painting an outdoor nude to rival those of the old masters, leading a year later to *Le déjeuner sur l'herbe* (cat. 62). It would seem that too little notice has been taken of the resemblances between these two nudes, seated in much the same attitude—as though the same woman, viewed from the other side, had straightened up and, putting off her modesty and her shy glance, had emerged in a year from a primitive creative state to the dignity of myth: the transition from Suzanne to Victorine, from intimate to professional model, from *nu caché* to *nu offert*.

First, starting with an image drawn from Rubens, the biblical subject, closely following the story of the finding of Moses by Pharaoh's daughter (cat. 20), provided an opportunity for Manet to depict a nude at water's edge, following an observation noted by Antonin Proust. Proust associated this with the *Déjeuner sur l'herbe* project, but one might equally apply it to this first approach. He described a walk with Manet at Argenteuil: "Some women were bathing. Manet's eye was fixed on the flesh of the women leaving the water. 'I'm told,' he said to me, 'that I must do a nude. All right, I will! I'll do them a nude.'"[10] Manet would hardly have said that if he had already painted this nude.

But his purpose passed through one metamorphosis after another. Dissatisfied with the original composition, he cut it up and kept the nude only, expunging a handmaiden behind what was to have been Pharaoh's daughter; indeed, the handmaiden's coy pose, borrowed from Rubens and Rembrandt, made little sense in the biblical context. Susannah at the bath, having been transformed into an Egyptian princess, turned into a nymph when the picture was cropped. This nymph became a *surprised* nymph when Manet decided to send her to Saint Petersburg, hastily adding a satyr beneath the foliage so as to make the picture more "commercial," under the title *Nymph and Satyr*.[11] The operation was in fact performed so hastily and lightly—as described in Farwell's plausible explanation—that the satyr does not even show up in X-ray, while the original servant girl appears clearly enough.[12] The elimination of the satyr has been interpreted as the token of a decisive step in the evolution not only of Manet's oeuvre but of all modern painting: the arrival at a new conception of the subject matter of painting as painting itself, and at a radically new relationship between spectator and picture, since the satyr, or voyeur of the surprised woman, was henceforth to be the viewer of the canvas,[13] as it were Baudelaire's "hypocrite lecteur, mon semblable, mon frère" (hypocrite reader, my fellow, my brother).

It is a bold hypothesis, but it projects upon Manet an intellectual move that belongs rather to the art historian of the 1960s and the age of conceptual art than to the painter of 1860. Furthermore, all the evidence (Godet's and Lochard's photographs, Bazire's description for the catalogue of the posthumous exhibition at the Ecole des Beaux-Arts)[14] indicates that Manet never himself removed the satyr, which survived him among the verdure, but that it was erased and the painting retouched at a later date.

While it may be wrong to credit Manet with the revolutionary intention of moving the voyeur in front of the canvas, there is certainly a share of playfulness in the metamorphoses to which he subjects his mistress and

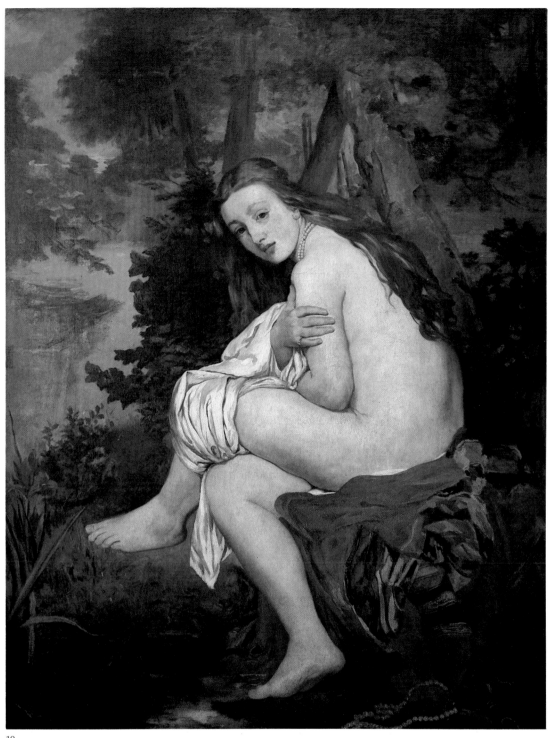

19

model: she comes from the Netherlands; she has a fine, full figure; her name is Suzanne; and it must have been amusing to fashion her into the design of Rubens's Susannah or Rembrandt's Bathsheba, only to change her, with a few wipes of the rag or a few strokes of the brush, into Pharaoh's daughter or a nymph. Manet himself undoubtedly plays on his mischievous identification with the masters. He painted his consort in the nude as did Rubens and Rembrandt theirs before him, under a thin allegorical disguise as they did, even though he passes easily from one allegory to another. But the disguise is twofold, since we have Suzanne Leenhoff as Susannah or Bathsheba transformed into Pharaoh's daughter and then into a nymph, but always, as with the great painters with whom Manet compares himself, in the role of wife and model. Let us recall that at the same period, he painted himself by her side in *La pêche* (cat. 12), a pastiche of Rubens, the two of them disguised in seventeenth-century costumes as Rubens and his wife Helena Fourment.

Technically, *The Surprised Nymph* offers another field for inquiry, which reveals the clearly laborious working out of the composition. The X-ray analysis by Giovanni Corradini[15] underlines not only Manet's iconographic hesitations but also the process of technical simplification in which he was involved: the face and the shoulder were formerly more molded by shadows and half-tones, which disappeared in the final painting, rendering it smoother, more luminous, and plainer—heralding the great nudes of 1863 in *Le déjeuner sur l'herbe* and *Olympia* (cat. 62, 64).

1. Farwell 1975.
2. Bazire 1884, p. 12.
3. Proust 1897, p. 168.
4. Godard and Lochard photographs: Paris, BN Estampes, Moreau-Nélaton endowment; New York, Pierpont Morgan Library, Tabarant archives; Barskaya 1961, p. 7.
5. Charles Sterling, "Manet et Rubens: précisions," *L'Amour de l'art* XIII (September – October 1932), p. 290.
6. Reff 1970, p. 457.
7. Krauss 1967, p. 622.
8. Farwell (1973) 1981, pp. 75–76.
9. Meier-Graefe 1912, p. 38.
10. Proust 1897, p. 171.
11. Krauss 1967, p. 624.
12. Farwell 1975, p. 229.
13. Krauss 1967, p. 624.
14. Copy of Bazire's notes, Paris, BN Estampes, Moreau-Nélaton endowment.
15. Giovanni Corradini, "La 'Nymphe surprise' de Manet et les rayons X," *Gazette des Beaux-Arts*, 6th ser., LIV (September 1959), pp. 149–54; Juan [Giovanni] Corradini, *Edouard Manet. La Ninfa Sorprendida*, Buenos Aires, 1983 (trilingual ed. Spanish, French, English).
16. Rouart and Wildenstein 1975, I, p. 17.
17. Manet sale, Paris, February 4–5, 1884, no. 14; Bodelsen 1968, p. 344.

Provenance
This picture remained in Manet's studio during his lifetime; he obviously held it in high esteem, for in his inventory of 1871–72 he set its price at 18,000 Frs, the same as for *The Old Musician* (RW I 52).[16] In the posthumous inventory of 1884, *The Surprised Nymph* (no. 11) was valued at 12,000 Frs. At the Manet sale later that year, it was estimated at only 1,500 Frs (no. 14) and sold to M. LE MEILLEUR for 1,250 Frs.[17] The picture later belonged to the Italian dealer MICHEL MANZI (1849–1915), a friend of Manet's, Degas's, and Toulouse-Lautrec's, who from 1881 was technical director of the printing studios of Boussod and Valadon (see Provenance, cat. 27) and later founded a gallery with Maurice Joyant (see Provenance, cat. 181). GEORGES BERNHEIM (see Provenance, cat. 20) exhibited it with other French paintings in Buenos Aires in 1914, when it was purchased by the Museo Nacional. Since that time, it has never left South America.

F.C.

20. *Study for* The Surprised Nymph

1860–61
Oil on board
14 × 18" (35.5 × 46 cm)
Inscribed (lower right, by Suzanne Manet?): E. M.
Nasjonalgalleriet, Oslo

This brilliantly colored sketch still shows the hand trained in Couture's studio. It enables us to understand the original composition of the Buenos Aires painting (cat. 19), partially visible, and fully revealed in X-ray: the servant woman bends solicitously over the nude, prefiguring the black servant in *Olympia* (cat. 64), and at the left, in blue, another attendant leans over the water, as though to indicate with a movement of the arm the foundling Moses.

Exhibitions
Paris, Drouot 1884, no. 18; Berlin, Matthiesen 1928, no. 2; Orangerie 1932, no. 13

Catalogues
D 1902, 25; M-N 1926, p. 33; M-N cat. ms., 29; T 1931, 40; JW 1932, 54; T 1947, 40; PO 1967, 35C; RO 1970, 38C; RW 1975 I, 39

20

Tabarant questions Proust's identification of the original subject for *The Surprised Nymph* as The Finding of Moses, accusing him of fantasy and noting that the passage in question does not appear in the final version of Proust's book, published in 1913. This argument, however, tends rather to support Proust, since the first version, published by *La Revue blanche* in 1897, was not revised by another hand and is more spontaneous and reliable than the later edition. Furthermore, this sketch, which presents the same nude, definitely corroborates Proust, and the scene painted here appears to be the discovery of Moses by the handmaiden, when Pharaoh's daughter had come down to the Nile to bathe.

To judge by the proportions of the sketch, the original painting was to have been some eight feet long (250 cm), and would have preceded *The Old Musician* (RW I 52) as Manet's first large composition. It is surely significant that he kept only the most realistic part of the picture, the nude, eliminating all deference to academic themes, traditionally taken from antiquity and the Bible.

Provenance
This study, signed after the painter's death, probably by SUZANNE MANET (see Provenance, cat. 12), was bought in by LEON LEENHOFF (see cat. 14) at the 1884 sale for 130 Frs (no. 18). Leenhoff sold it to Marcel Proust's friend Alexandre Berthier, PRINCE DE WAGRAM, who formed a remarkable collection of Impressionist pictures in only a few years' time, before being killed in World War I. He owned several other works by Manet, including the important *Old Musician* (RW I 52) and the *Head of a Negress* (RW I 68), a study of the model who posed for *Olympia* (cat. 64). The *Study for The Surprised Nymph* was purchased by GEORGES BERNHEIM, a cousin of Josse and Gaston Bernheim's (see Provenance, cat. 31) and a dealer since 1878. During the period of this transaction, the critic Félix Fénéon served as his adviser for modern art. The picture was acquired for the Nasjonalgalleriet in 1918 by the Friends of the museum (inv. 1182).

F.C.

21. Bathsheba, after Giulio Romano

1857–60
Black crayon
6⅞ × 5¼″ (17.5 × 13.3 cm)
Atelier stamp (lower right): E.M.
NY Musée du Louvre, Cabinet des Dessins, Paris

This drawing, undoubtedly a sheet from a sketchbook, must be related to *The Surprised Nymph* (cat. 19). The source, which has not previously been identified, is most certainly a detail from a fresco by Giulio Romano in the Palazzo del Tè in Mantua. Judging by the line, Manet could have made it on the spot, probably during his second trip to Italy, in 1857; but more likely, it is from a print after the painting (cat. 19, fig. c).[1] In the original octagonal composition, Bathsheba at her bath is watched by David, and at the right, taking a garment from the woman's shoulders, a servant girl stands in the same place and position as in *The Surprised Nymph* prior to the overpainting. We therefore have every reason to believe that in the evolution of the painting from the Moses episode to the surprised bather, Romano's original was as important as the northern precedents of Rubens and Rembrandt.

Provenance
This drawing was acquired from M. PAUL BENOIT of Algiers for 600 Frs by the Cabinet des Dessins in 1928 (inv. RF 11.970).

F.C.

Catalogues
L 1969, 127; RW 1975 II, 71

1. Corneille le Jeune, after Giulio Romano; or a nineteenth-century print, unidentified.

22. Bather

1860
Black and red crayon, squared for transfer
17 × 10″ (43 × 25.5 cm)
Atelier stamp (lower right): E.M.
NY Bibliothèque Nationale, Paris

Here Manet has his model turn toward left profile and assume an attitude gradually approaching that of the final composition (cat. 19). The squaring suggests that this was a preliminary idea for the painting.

For various reasons (biographical, for example, lest Suzanne be too recognizable; or stylistic, related to the slow unfolding of Manet's artistic personality), the composition was to travel by way of Rubens and Rembrandt, and perhaps also through Italy, as witness a sketch (cat. 21) from a fresco by Giulio Romano. An important drawing at the Courtauld Institute Galleries in London (cat. 25, fig. a) shows another stage, in which the young woman who draws a garment over her breast and turns to the spectator no longer resembles Suzanne Leenhoff.

Exhibitions
Orangerie 1932, no. 107

Catalogues
L 1969, 184; RW 1975 II, 361

Provenance
This drawing entered the collection of MOREAU-NELATON (see Provenance, cat. 9) at an unknown date and was included in his important bequest of drawings and prints to the Bibliothèque Nationale in 1927.

F.C.

21 22

23. Leaving the Bath

1860–61
India ink wash
10½ × 8″ (26.6 × 20.3 cm)
Atelier stamp (lower right): E.M.
Private Collection, London

Exhibitions
Paris, Drouot 1884, no. 153; Philadelphia-Chicago
1966–67, no. 15; Paris, Berès 1978, no. 3

Catalogues
T 1931, 12 (watercolors); T 1947, 554; L 1969, 188;
RW 1975 II, 362

Suzanne Manet appears to have posed also in 1860–61 for this superb wash drawing, a second stage in the evolution of *The Surprised Nymph* (cat. 19), and not in 1862–63, as Leiris suggests. The fleshy back and shoulder and the full breast of the model are easily recognized: the drawing of Manet's Dutch Suzanne shows him at his most Rembrandtesque, apart from the ill-defined foot and hand, which betray a search for the desired placement.

23

Farwell sees the source of this drawing in the attitude of a nymph at the left in Marcantonio Raimondi's engraving after Raphael's *Judgment of Paris*, the right side of which was to serve for *Le déjeuner sur l'herbe* (cat. 62).[1] If this is so, the imitation is far from literal, and does not invalidate the identification of the model, whose pose, as in *The Surprised Nymph*, would have been based on the old master original.

The surreal effect of the darkened face, in shadow though not inclined forward, and the strongly lit torso render this drawing one of Manet's strangest and most sensitive, evoking in a few lines the emotional response to a real woman, as well as to creative work in progress; an inspired drawing, it is exceptional in the painter's graphic output.

1. Farwell (1973) 1981, p. 68.
2. Manet sale, Paris, February 4–5, 1884, no. 153 (Etude); Bodelsen 1968, p. 343.
3. Ibid., nos. 158, 167; Ibid.
4. Degas collection, first sale, Paris, March 26–27, 1918, no. 220.

Provenance
This drawing was purchased for 40 Frs at the Manet sale in 1884[2] by EDGAR DEGAS (1834–1917), the painter and a longtime friend of Manet's, who bought another drawing (RW II 472) and a lithograph, *The Barricade* (cat. 125), at the same sale.[3]

Apart from gifts received from Manet, Degas owned several important canvases purchased after his friend's death: *The Execution of Maximilian* (RW I 126); *The Ham* (RW I 351), acquired at the Pertuiset sale in 1888; the *Gypsy with Cigarette* (cat. 26), bought in 1896; the *Portrait of M. Brun* (RW I 326); and the *Woman with a Cat* (RW I 337). This drawing was included in the first sale of Degas's collection in 1918.[4] In 1921, it appeared in London, in the collection of JULIEN LOUSADA.

F.C.

24

24. After the Bath

1860–61
Red chalk
11 × 8″ (28 × 20 cm)
Signed (lower right): E. Manet
The Art Institute of Chicago

Exhibitions
Beaux-Arts 1884, not in cat.; Orangerie 1932, no.
106; Philadelphia-Chicago 1966–67, no. 196

Catalogues
L 1969, 186; RW 1975 II, 363

The drawing is a preliminary idea for the bather intended for Pharaoh's daughter in the study (cat. 20) that evolved into *The Surprised Nymph* (cat. 19). It is also one of the series of preparatory drawings for a print and preceded the Courtauld Institute drawing (cat. 25, fig. a).

According to Tabarant, the model was Suzanne Leenhoff, Manet's mistress and future wife.[1] What is known of the fullness of her youthful figure is not contradicted by this drawing, and the soft and gentle face resembles the one in *Reading* (cat. 97). Manet tried out several placements for a

servant robing the figure; the face is clearly visible by X-ray in the final painting. If we imagine the sequence of preparatory studies, drawn or painted, there is every reason to believe that this drawing, the most realistic, is the earliest.

1. Tabarant 1947, p. 43.
2. Pellerin sale, Paris, May 7, 1926, no. 35.

Provenance
This red-chalk drawing appeared among the twelve sheets in a single frame that were lent to the exhibition of 1884 by ALPHONSE DUMAS (see Provenance, cat. 67). It subsequently entered the collection of AUGUSTE PELLERIN (see Provenance, cat. 100). Purchased at the Pellerin sale in 1926[2] by MARCEL GUERIN (see Provenance, cat. 56), the drawing later belonged to MME INDIG-GUERIN and was acquired by the Art Institute of Chicago with funds provided by the Joseph and Helen Regenstein Foundation (inv. 1967.30).

F.C.

25. La toilette

1861
Etching
Plate: 11¼ × 8⅞" (28.7 × 22.5 cm);
image: 11⅛ × 8⅜" (28.2 × 21.3 cm)
Initialed (lower right): M (2nd state)

NY Collection Mr. and Mrs. R. Stanley Johnson, Chicago (1st state)
P Bibliothèque Nationale, Paris (2nd state)

This composition is a variation on the principal motif of *The Surprised Nymph* (cat. 20) and the related oil and drawings (cat. 19, 21–24). In the etching of *La toilette*, the bather and her servant are indoors, beside what appears to be a great bed with draped hangings. The drawing in Chicago (cat. 24) was probably the first version of this composition. Another red-chalk drawing, used to prepare the print, demonstrates one of Manet's methods for transposing a design onto the copperplate (RW II 360; fig. a): the paper has been deeply incised with a pointed tool, which transferred the contours and principal lines of the drawing onto the surface of the copper, as a guide for etching.

The first state of the etching, which is much more detailed than the drawing, is known through two remarkably dissimilar proofs. The one from a private collection in Chicago, exhibited here, is clean-wiped and clearly printed on dead-white coated paper; the other, on the type of toned laid paper normally used by Cadart at this period, is transformed by a thick veil of ink, hand-wiped to create an extraordinary chiaroscuro effect.[1] These printing effects, still relatively unusual at the period, extend the techniques of drawing into the domain of the print, giving each impression a specific character—a foretaste of the effects that the printer Delâtre and the Impressionist printmakers were to explore systematically in the 1880s.

When he printed this plate for the 1862 publication of Manet's album of *8 Gravures*, Delâtre followed his normal technique, leaving a slight film of ink over the whole surface of the plate, so there is no contrast with the lightly toned paper that Cadart used for his publications. It is significant that, apart from a few trial inking effects or use of special papers, most of Manet's "artist's proofs," as well as the impressions from the limited issue of prints that he appears to have made in 1863 (see cat. 47), are on China paper, carefully wiped and printed in a warm brown-black ink (for example, cat. 11: 5th state; 48: 2nd state). In fact, only these proofs, rather than the Cadart impressions (or the posthumous printings, which in the case of some plates are all that have survived; see Provenance, cat. 11: copperplate), give a fair idea of Manet as a printmaker.

Publications
8 Gravures à l'eau-forte, Cadart 1862, no. 6 (la Toilette); *Eaux-fortes par Edouard Manet*, 1863?; *Edouard Manet. Eaux-fortes*, Cadart 1874

Exhibitions
Beaux-Arts 1884, no. 155; Philadelphia-Chicago 1966–67, no. 10; Ann Arbor 1969, no. 11; Ingelheim 1977, no. 8; Paris, Berès 1978, no. 37

Catalogues
M-N 1906, 9; G 1944, 26; H 1970, 20; LM 1971, 26; W 1977, 8; W 1978, 37

1st state (of 3). Before re-etching of the plate. One of two known proofs, on white coated paper. Delteil, Gerstenberg collections.

2nd state. With the composition reworked. Proof on laid paper (watermark HUDELIST), from the 1862 edition. Moreau-Nélaton collection.

Fig. a. *La toilette*, 1861, red-chalk drawing. Courtauld Institute Galleries, London

25 (1st state)

25 (2nd state)

1. Wilson 1978, no. 37.
2. Delteil sale, Paris, June 13–15, 1928, lot 302.
3. Lugt 1921, p. 519; Lugt 1956, pp. 397–98.

Provenance

1st state. This proof was unknown to Moreau-Nélaton and first appeared at the sale of the collection of DELTEIL (see Provenance, cat. 11).[2] It sold for 8,000 Frs and entered the magnificent collection of the German businessman and director of the Victoria Insurance Company, OTTO GERSTENBERG (1848–1935).[3] Gerstenberg owned several paintings by Manet, including the "other half" of *Corner in a Café-Concert* (RW I 278; cat. 172, fig. a) and *Portrait of M. Pertuiset, the Lion Hunter* (cat. 208), and his remarkable collection of nineteenth-century prints included several extremely rare Manet proofs. Part of the collection disappeared in Berlin at the end of World War II.

2nd state. The proof comes from the MOREAU-NELATON (see Provenance, cat. 9) collection.

J.W.B.

26. Gypsy with Cigarette
or Indian Woman Smoking

1862?
Oil on canvas
36¼ × 29" (92 × 73.5 cm)
The Art Museum, Princeton University, Princeton, New Jersey

Exhibitions
Paris, Drouot 1884, no. 53; New York, Wildenstein 1937, no. 22; Philadelphia-Chicago 1966–67, no. 34

Catalogues
D 1919 (supplement), 8; M-N 1926 II, p. 119; M-N cat. ms., 207; T 1931, 48; JW 1932, 304; T 1947, 50; PO 1967, 41; RO 1970, 40; RW 1975 I, 46

As Anne Coffin Hanson has shown, a catalogue entry by Duret published in 1902 erroneously identifies this work as one of three fragments cut from *The Gypsies* (RW I 41), a painting of about 1861 that Manet dismembered after his independent exhibition in 1867.[1] Duret's information about the picture now in Princeton probably depended solely on the unillustrated 1884 catalogue for the auction of Manet's work (no. 53), and he seems to have assumed that the picture looked like the woman and child at the right in Manet's etching after *The Gypsies* (cat. 48).[2] Moreover, after *Gypsy with Cigarette* appeared in

1918 as *Indian Woman Smoking a Cigarette* in the sale of works in Degas's private collection,[3] Duret included it in the 1919 supplement to his catalogue of Manet's paintings, but did not recognize it as the work he had already catalogued as the third fragment of *The Gypsies*. Hanson has been able to demonstrate that the picture Duret and others assumed to be the third fragment has never existed.

Tabarant informs us, however, but without documentation, that although *Gypsy with Cigarette* is an independent work, Manet initially considered using the image as part of the composition of *The Gypsies*.[4] If this is correct, *Gypsy with Cigarette* was probably painted about 1862, as Tabarant and most others believe. Indeed, the brushwork, the surface, and the canvas type are comparable to those of *A Basket and Onions* (RW I 44) and *The Water Drinker* (RW I 43), both fragments from *The Gypsies*. Unfortunately, effective stylistic comparison to the largest fragment, *Le bohémien* (RW I 42), is impossible because it is known only through a relatively poor photograph.

The composition, subject, and technique would have been considered astonishing in 1862, but apparently no one ever saw the picture at that time. There was no mention of it until 1883, when it appeared in the inventory of the paintings owned by Manet when he died.[5] Evidently Degas very much admired the painting, because he acquired it from Durand-Ruel in 1896. The unconventional pose and the abruptly cropped composition must have appealed to him, because similarly bold effects occur in his own work. It is also possible that he especially appreciated *Gypsy with Cigarette* because of its early date. Degas, too, was experimenting with analogous compositional devices in the early 1860s. Similarly overlapping or abruptly cut images of horses appear in his earliest racetrack pictures (e.g., *Jockeys at Epsom*, ca. 1860–62).[6] Furthermore, contemplative or pensive women are characteristic of numerous early works, and the gypsy's pose is not unlike those of many of Degas's dancers waiting in the wings or standing to one side during a rehearsal (e.g., *Dancer*, 1888).[7] However, the work by Degas that is closest to the composition of *Gypsy with Cigarette* is the pastel *Laundress and Horse*, ca. 1902.[8]

Gypsy with Cigarette is also interesting within the context of Manet's development because it anticipates by many years *The Plum* (cat. 165), another painting that depicts a woman leaning on her right arm, resting her head against her hand, and smoking a cigarette. However, in 1878, instead of focusing on a colorful figure living a nomadic existence at the periphery of European society, Manet chose a modishly attired young woman in a café. The contrast reveals much about the changes in Manet's professional and personal life during the intervening years. In 1862, he was probably drawn to the gypsy because of her costume and her innate bravado, much as he was drawn to *espadas*, *majos*, and other Spanish subjects (see cat. 33, 72).

1. Hanson 1970, pp. 162–65.
2. See Duret 1902, p. 206, nos. 53–55.
3. *Catalogue des tableaux modernes et anciens . . . composant la collection Edgar Degas*, Galerie Georges Petit, Paris, March 26–27, 1918, p. 34, no. 78.
4. Tabarant 1947, p. 51.
5. See Rouart and Wildenstein 1975, I, p. 27, "Tableaux et études," no. 47.
6. Lemoisne 1946, II, no. 75.
7. Ibid., no. 945.
8. Ibid., no. 1419.
9. Rouart and Wildenstein 1975, I, p. 27, "Tableaux et études," no. 47.
10. Manet sale, Paris, February 4–5, 1884, no. 53; Bodelsen 1968, p. 343.
11. Rouart and Wildenstein 1975, I, p. 58.
12. Degas collection, first sale, Paris, March 26–27, 1918, no. 78.
13. American Art Association sale, New York, January 4–5, 1923, no. 114.
14. Jamot and Wildenstein 1932, no. 304 (875,000 Frs).

Provenance
Listed as "Femme mexicaine" and valued at 100 Frs in the inventory of Manet's studio taken after his death,[9] this picture was sold as "Bohémienne" to "Bashkirseff" for 150 Frs in the auction of the studio's contents in February 1884.[10] Presumably, the buyer was MARIIA BASHKIRTSEVA (1860–1884), whose posthumously published diary of her life as an aspiring artist includes an account of her visit to the 1884 Manet retrospective at the Ecole des Beaux-Arts. Rouart and Wildenstein claim that the picture was with DURAND-RUEL (see Provenance, cat. 118) in 1896.[11] It was eventually acquired by Degas (see Provenance, cat. 23), whose portrait *Mlle Fiocre in the Ballet from "La Source,"* 1866–68 (Brooklyn Museum, New York), appears to be related in concept. The Paris dealers CHARLES AND ROSE VILDRAC bought *Gypsy with Cigarette* for 32,000 Frs at the sale of Degas's atelier in 1918.[12] Subsequently, DURAND-RUEL sold the picture to the STRANG collection in Christiania (now Oslo), Norway; but it soon reappeared on the Paris art market at the GALERIE BARBAZANGES and was sold to the jeweler MEYER GOODFRIEND, who amassed a large collection of nineteenth-century French pictures. At his sale in New York in 1923,[13] it was purchased by J. CHEIM for $3,500.[14] By 1932, the picture was owned by THOMAS MORLAND of New York. It was in the collection of BARON VAN DER HEYDT in Zandvoort, the Netherlands, in 1937 and later passed through the hands of the dealer JUSTIN K. THANNHAUSER (see Provenance, cat. 156). By 1959, it belonged to MR. AND MRS. ARCHIBALD S. ALEXANDER of Bernardsville, New Jersey. Mr. Alexander bequeathed it to the Art Museum, Princeton University, in 1979 (inv. 79.55).

C.S.M.

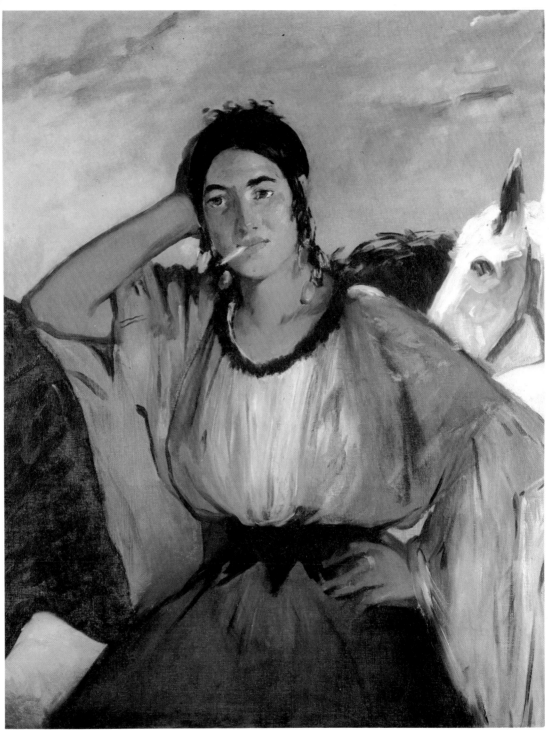

26

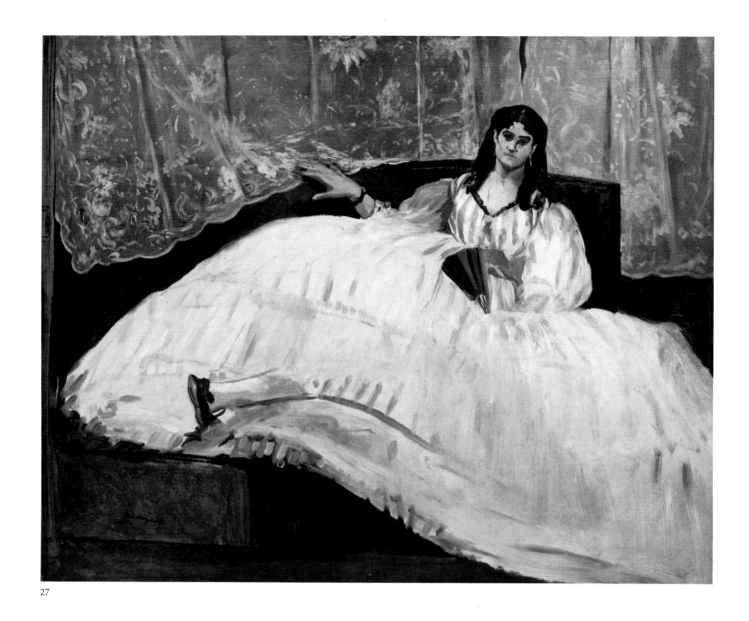

27

27. Baudelaire's Mistress, Reclining

1862
Oil on canvas
35½ × 44½″ (90 × 113 cm)
Signed (lower left): Manet
P Szépmüvészeti Múzeum, Budapest

Jeanne Duval, the mistress of Baudelaire, is seen here posed on a green couch of rather indeterminate shape, in Manet's studio on the rue Guyot;[1] the windows can be discerned behind the lace curtains. The model's identity is known from the inventory taken in the studio after Manet's death and drawn up by the notary with the help of Suzanne Manet, who was already living with the artist when he painted this work. The heading in the inven-

Exhibitions
Paris, Martinet 1865?

Catalogues
D 1902, 35; M-N 1926 I, p. 65; M-N cat. ms., 71; T 1931, 57; JW 1932, 110; T 1947, 59; PO 1967, 40; RO 1970, 37; RW 1975 I, 48

tory under which the painting is listed together with many unfinished works and sketches is "Painted Studies."[2] But Manet apparently thought it good enough to show at the Galerie Martinet in 1865, where its rough and sketchy appearance must have seemed especially shocking; he did not hang it in his studio, however, where it was discovered upon his death.[3] Possibly this fierce portrait was not very pleasing to Baudelaire, else Manet, who all his life readily gave away paintings to his friends, would have presented it to him as a gift (see Provenance).

The portrait is a strange one; here, the accusation of ugliness flung at Manet's models by contemporaries, so surprising to us today when it describes such women as Victorine Meurent or Berthe Morisot, is for once justified. The image is terribly revealing, and one can imagine Baudelaire's reaction to this devastating record of a face once passionately loved, now sickly, hardened, and embittered.

Baudelaire met Jeanne Duval in 1842, when he was twenty-one;[4] she was older than he, so that in 1862, at the time of the painting, her age would have been between forty and fifty. We know she was tall and angular, her hair slightly crimped,[5] and although she was not a black, she must have had a dark complexion; Baudelaire's playful term of endearment for her was "Black Venus." Manet, who—to judge by his work—was partial to fair-skinned, rather ample women, must have thought her quite unattractive. Jeanne Duval had been an invalid for almost fifteen years, more or less supported by Baudelaire, himself always short of funds. Theirs was a complex relationship in which a mixture of pity and dependency had replaced passion. In a letter to his mother written ten years before the date of the painting, Baudelaire complains of life with Jeanne, just prior to one of their countless estrangements: "LIVING WITH A PERSON who sets no store by your efforts, who frustrates them by persistent clumsiness or willfulness, who considers you nothing more than a servant, a piece of property . . . , someone who *won't learn anything*, someone who DOESN'T ADMIRE ME . . . , who would throw my manuscripts in the fire if that would bring in more money than letting them be published, who kicks my cat out. . . ."[6]

Here indeed is a woman who would not have charmed Manet, whom we think of as all good health and good spirits in his love life. But what would have repelled him seems to have attracted Baudelaire, since his supposed tormentor was also "my one diversion, my one pleasure, my one companion," as he confided to his mother.[7] In 1859, Jeanne Duval became partly paralyzed and was cared for thereafter in a sanatorium at the poet's expense.[8] Manet's portrait would accordingly show us a stricken woman, half paralyzed, which would account for the odd angle of the leg.

The exaggerated, cumbersome spread of the dress, which Manet has made the chief feature of the composition, is painted with a sweeping, bright, terse touch prefiguring by ten years his so-called Impressionist phase. Jacques-Emile Blanche recalls the "masterpiece dropped out of sight . . . a mask strange, exotic, and 'fateful,' a body emaciated, lost in the folds of a vast, billowing skirt of *café au lait*. . . ."[9] After seeing the work in the Galerie Indépendante at the height of the Symbolist period, Fénéon in his decadent style describes it thus: "Ennobled with strangeness and with memories, another canvas shows the fabled mistress of Baudelaire, the wayward and dolorous *créole* Jeanne Duval. Before a window curtained in floating white, she lounges like an idol, like a doll. Baudelaire's verses offer us a good likeness:

1. Tabarant 1931, p. 88.
2. Rouart and Wildenstein 1975, I, p. 27, "Maîtresse de Baudelaire couchée."
3. Tabarant 1947, p. 57.
4. Baudelaire 1975, p. xxix.
5. J. Buisson, cited in Tabarant (1942) 1963, p. 59.
6. Baudelaire 1973, I, p. 193: to Mme Aupick, March 27, 1852.
7. Ibid., p. 356: to Mme Aupick, September 11, 1857.
8. Baudelaire 1975, p. xliii.
9. Blanche 1924, p. 36.
10. Fénéon 1970, I, p. 102.
11. Baudelaire 1975, p. 164.
12. Crepet 1887, p. 95; Baudelaire 1973, II, pp. 430–31.
13. Rouart and Wildenstein 1975, I, p. 27.
14. Tabarant 1947, p. 67.
15. Rewald 1973, *Gazette des Beaux-Arts*, p. 4.

Provenance
It is possible—but unlikely—that this picture once belonged to Baudelaire, who owned a large collection of Manet's prints (see cat. 54–58 and Provenance, cat. 9, 47), because it is known that during his illness in 1866–67, "two canvases by Manet" were in his room.[12] Since MANET was among Baudelaire's creditors at the time of his death, it is plausible that the poet's heirs may have returned this portrait to the artist. The picture was listed in Manet's posthumous inventory as an "étude peinte" (painted study).[13] According to Tabarant, the inscription on the back of the stretcher, "Maîtresse de Baudelaire," is in Manet's own hand.[14]

Le jeu, l'amour, la bonne chère　　　　Good fun, and love, and all good cheer
Bouillonnent en toi, vieux chaudron:　　Bubble in thee, old cauldron: yes,
Tu n'es plus jeune, ma très chère.　　　Thou'rt no more young, my very dear.
Tu n'es plus jeune, et cependant　　　Thou'rt no more young, and nonetheless
Tes caravanes insensées　　　　　　Thy caravans by madness borne
T'ont donné ce lustre abondant　　　　Have given thee that lustrousness
Des choses qui sont trop usées　　　　Of things that have been too much worn
Et qui séduisent cependant.　　　　　And are beguiling nonetheless.

The flat, swarthy visage abjures all emotion, and to either side swirls the im-plausible immensity of a summer dress with broad violet and white stripes."[10] Fénéon reproduces Baudelaire's original poem with a few altera-tions; he might also have included the words that so admirably define what Manet may have wanted to evoke in the coiffure and the gown: "ma vieille Infante [my old Spanish princess]."[11]

SUZANNE MANET (see Provenance, cat. 12) re-tained *Baudelaire's Mistress, Reclining* for ten years, selling it in 1893 to the German art agent HER-MANN PAECHTER (according to Tabarant) or to BOUSSOD AND VALADON (according to Rouart and Wildenstein). Paechter, as Suzanne Manet's favor-ite German dealer, played an important role in the early appreciation of Manet's work in his country. Etienne Boussod was the son-in-law of the dealer Goupil, whose business he took over in 1875 in partnership with Valadon. Their principal gallery, at 2, place de l'Opéra, was devoted to official painting (Meissonier, Bouguereau, and Bonnat); a smaller branch, at 19, boulevard Montmartre, under the direction of Vincent van Gogh's brother Theo (1854–1891) from 1878, handled avant-garde art (the Impressionists, etc.).[15] The painting later appeared in Hamburg in the possession of PRO-FESSOR HEILBUT, then with the Berlin dealer BACHSTITZ, who sold it in 1916 to the Szépmü-vészeti Múzeum in Budapest (inv. 5004.368–B).

F.C.

28. *Study for* Baudelaire's Mistress, Reclining

1862
Watercolor
6⅝ × 9⅜" (16.7 × 23.8 cm)
Kunsthalle, Bremen

This preparatory study for the painting (cat. 27) shows the artist's first im-pression and the general idea of the picture; the enormous crinoline is al-ready a more important motif than the portrait. The impressive character of the face in the painting apparently prompted Manet to introduce the lace curtain, absent from the watercolor and balancing the lightness of the dress—graceful parentheses around the somber, expressionless face in the center.

Exhibitions
Berlin, Matthiesen 1928, no. 3; Paris, Berès 1978, no. 8

Catalogues
T 1931, 14 (watercolors); JW 1932, mentioned 110; T 1947, 567; L 1969, 192; RW 1975 II, 368

28

1. S. Helms and W. Werner, *Alfred Walter Heymel, 1878–1914, Geschichte einer Sammlung,* Graphisches Kabinett, Bremen (1977), with reproduction from Bremen Kunsthalle, exhibition catalogue, April–May 1909, no. 192 (repr.).
2. Lugt 1956, no. 2861b, pp. 407–8.

Provenance
As early as 1909,[1] this watercolor belonged to the poet and collector ALFRED WALTER HEYMEL (1878–1914), who with his cousin Rudolf Alfred Schröder founded Inselverlag, one of the best publishing and printing houses in Germany. Part of Heymel's important collection (which included a remarkable group of lithographs by Toulouse-Lautrec) was inherited by his cousin FRAU CLARA HEYE-SCHRODER; at her death in 1963, it went to the Kunsthalle, Bremen (inv. 63.564).[2]

F.C.

29. Young Woman Reclining, in Spanish Costume

1862
Oil on canvas
37 × 44½" (94 × 113 cm)
Inscribed and signed (lower right): à mon ami Nadar / Manet
Yale University Art Gallery, New Haven

Exhibitions
Paris, Martinet 1863, no. 130; Alma 1867, no. 35 (Jeune femme couchée en costume espagnol, 105 × 95 cm [width × height]); Beaux-Arts 1884, no. 20; Philadelphia-Chicago 1966–67, no. 52

Catalogues
D 1902, 46; M-N 1926 I, p. 47; T 1931, 55; JW 1932, 63; T 1947, 57; PO 1967, 53; RO 1970, 52; RW 1975 I, 59

This rather sturdy young woman, dressed in masculine Spanish garb, is commonly accepted as the mistress of Nadar.[1] Her identity is not in fact known (see Provenance). Farwell has suggested that the model is the same as the one for *Odalisque* (cat. 71),[2] although that watercolor seems later, and moreover the supposed mistress of Nadar has more of a baby face, a heavier chin, and a shorter nose.

It is hard to tell whether *Young Woman Reclining* was painted before or after *Mlle V . . . in the Costume of an Espada* (cat. 33), but the eroticism of the clothing is perhaps even more marked here because of the pose. The masculine disguise was a commonplace in the gallantry of the Romantic period, eloquently evoked by the silhouettes of Rosanette and "Mademoiselle Loulou" whirling through the masked ball in Flaubert's *L'Education sentimentale*—one wearing "knit breeches and soft boots with golden spurs," the other "wide trousers of scarlet silk, tight over the hips and sashed at the waist in cashmere."[3] Indeed, trousers are more revealing than skirts and, especially in the days of crinolines, suggest femininity victorious.

More than the face, the luminous accent here is the astonishing cream-velvet knee breeches and pale stockings. The provocative contrast is heightened by the passive and pliant attitude of the model, her sulking air, the spit-curl *señorita* hairdo, and the fan.

It has been thought that, as a sort of counterpart to *Olympia* (cat. 64), considering the pose and the cat, this work might complete an echo of Goya's *Majas,* one dressed (fig. a) and one nude (cat. 64, fig. b).[4] However, the dissimilar dimensions, the dates, and the different models (though it has been believed, mistakenly, that this too is Victorine Meurent[5]) do not support the hypothesis.

All the same, the allusion to Goya's *Naked Maja* is obvious and intentional. First, in the placement of the right elbow, rather artificial here, but perfectly natural in the Goya, since the *maja* rests her head on her hands laid one upon the other; second, in the contour of the couch, which is similar in the Manet and the Goya, so much so that a quotation from the Spanish painter has been suggested,[6] like Magritte's from Manet's *The Balcony* (cat.

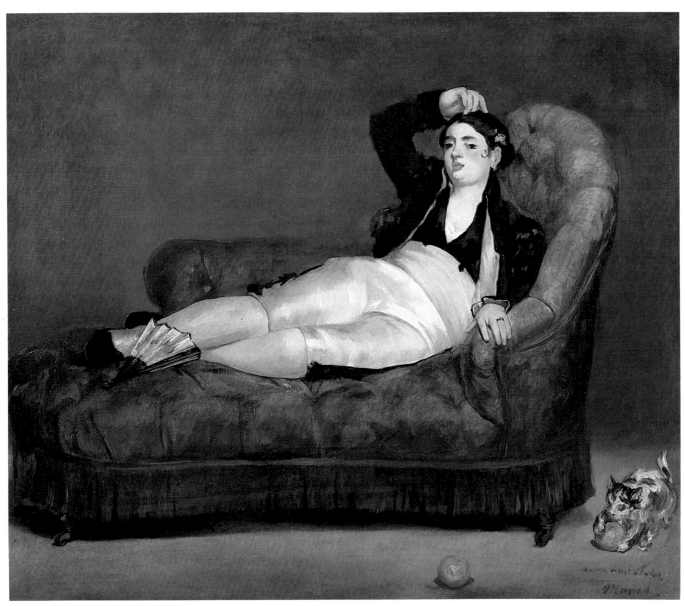

29

115) a century later. Furthermore, Nadar in particular was well acquainted with Goya's *Majas*. Baudelaire in a letter to Nadar dated May 1859 asked him to take photographs, "one for you, one for me," of two small copies of these paintings to be had on the Paris art market, or buy them if he could: "Imagine Bonington or Devéria in gallant and ferocious mood . . . the very triteness of the pose adds to the charm of these pictures."[7] Hanson sees this painting as a modernized version of the theme of the reclining Odalisque in Ingres and Delacroix.[8]

 Manet's painting also reminds one of Devéria but still more of Constantin Guys, who, like Nadar, to whom the work is dedicated, is linked to Baudelaire.[9] Guys did many ink drawings in the 1850s representing courtesans dressed in masculine garb for the *bal de l'Opéra* or for the entertainment of their escorts. Like his friends Nadar and Baudelaire, Manet himself owned many drawings by Guys.[10]

à mon ami Nadar
Manet

The presence of the cat, here toying with an orange, above the inscription can be variously interpreted. Does it perhaps allude to some coquettish behavior of this pouting lady, or is it some private joke among the three friends?—for we know that Nadar made fun of "people who have been or are infatuated with cats."[11] This does not of course rule out the possibility that Manet got the idea from an actual occurrence at the sitting in the studio, and that a real cat provided a compositional solution: an image of movement to break up the static character of the model, further emphasized by the long horizontal line of the fringe. The two orange patches, by their color as well, lend an incongruous and humorous touch of contrast. And here we encounter the first appearance in a painting of Manet's mascot, the cat, henceforth ever present.

Manet's friend Félix Bracquemond etched this picture about 1863.[12] In the print that reverses the image, we see vertical drapery at the left, which would be at the right in the painting. The etching prompted the following reaction from Manet: "I kept expecting to see you at [the Café de] Bade, to talk to you about the proof you sent me. I think it needs a background and more strength in the couch, take away the curtain, perhaps a little more busyness generally."[13] An anonymous caricature of no. 130 in the Martinet show of 1863 shows the curtain in place.[14] It may be that his thoughts about Bracquemond's engraving led him later to eliminate the curtain, between 1863 and 1867, by which time the dimensions had been reduced.

Charles Stuckey has offered the interesting hypothesis that this painting and Baudelaire's Mistress (cat. 27), which are very nearly the same size, might be a pair, the narrow element we take to be the upright of an easel at the left in the Budapest work corresponding to the curtain, later removed, on the right in the Young Woman Reclining. Yet even if they are not really pendants—and the similarly directed poses of the women argue against it—there is certainly a similarity of conception; it is not implausible that this is the second painting mentioned by Crepet in describing Baudelaire's room in 1866: "The chief ornaments on the walls were two canvases by Manet, one a copy of Goya's portrait of the duchess of Alba, which he so much admired,"[15] namely one of Goya's Majas, which unquestionably are sources for this work.

Fig. a. Francisco de Goya, *Clothed Maja*, ca. 1802. Museo del Prado, Madrid

1. Tabarant 1947, p. 55.
2. Farwell (1973) 1981, p. 167.
3. Flaubert 1952, pp. 146–47.
4. Bodkin 1927, pp. 166–67; Jamot 1927, *Burlington*.
5. Jamot 1927, *Revue de l'art*
6. Isaacson 1969, p. 34.
7. Baudelaire 1973, I, p. 574: to Nadar, May 14, 1859.
8. Hanson 1977, p. 88 n. 154.
9. Rishel 1978, p. 383.
10. Rouart and Wildenstein 1975, I, p. 27.
11. Baudelaire 1973, I, p. 573.
12. Bouillon 1972, p. 16; Bouillon 1975, p. 44, fig. 15.
13. Jean-Paul Bouillon, "Les Lettres de Manet à Bracquemond," *Gazette des Beaux-Arts*, 6th ser., CI (April 1983), pp. 145–58.
14. Moreau-Nélaton 1926, I, fig. 46.
15. Crepet 1887, p. 95.
16. Vollard 1937, p. 33.
17. Crepet 1887, p. 132.
18. N[adar] sale, Paris, November 11–12, 1895, no. 60.
19. Goncourt 1956, November 24, 1895.
20. J. Manet 1979, p. 213.
21. Julius Meier-Graefe, "Die Stellung Eduard Manet's," *Die Kunst für alle* XV (October 1899), p. 64 (ill.); Duret 1902, no. 46.
22. Hugo von Tschudi, "Die Sammlung Arnhold," *Kunst und Künstler* VII (November 1908), pp. 56 (ill.), 58, 61; M. Dormoy, "La Collection Arnhold," *L'Amour de l'art* VII (1926), pp. 241–45.
23. Tomkins 1970, pp. 299, 310, 332.

Provenance
This painting may once have belonged to Baudelaire.[16] Manet later gave it to Félix Tournachon, called NADAR (1820–1910), whom he had probably met through Baudelaire, one of Nadar's closest childhood friends. Manet must have added the dedication "to my friend Nadar" when he made the gift, several years after he had painted the picture. In fact, it was still in Manet's possession in the fall of 1865, when he offered "a woman in the costume of a majo, reclining on a red sofa" to Poulet-Malassis in exchange for Courbet's portrait of Baudelaire, which the publisher wanted to sell.[17] Nadar's important and multifaceted role in the history of painting is well known. In 1874, he lent his photographic studio for the first group exhibition by the artists dubbed Impressionists on the occasion. Manet did not participate. The work appeared at the sale of Nadar's collection in 1895,[18] which, as the Goncourts commented in their journal, "was a disaster, poor Nadar's sale; the picture by Manet that he hoped would be bid up to 10,000 Frs went for

1,200 Frs."[19] The painting apparently next belonged to AUGUSTE PELLERIN (see Provenance, cat. 109), for Julie Manet saw it in his house in 1899.[20] Meier-Graefe reproduced it in *Die Kunst* in October 1899,[21] and by 1902, it was in Berlin in the famous collection of EDUARD ARNHOLD,[22] who owned other important works by Manet, including *The Artist* (cat. 146). The picture later belonged to STEPHEN C. CLARK, brother of Robert Sterling Clark (see Provenance, cat. 127), heir to the Singer Sewing Machine Company, and trustee of both the Museum of Modern Art and the Metropolitan Museum of Art in New York. His superb collection of Impressionist and Post-Impressionist paintings included Seurat's *Invitation to the Sideshow* and three magnificent Cézannes, which went to the Metropolitan Museum when the collection was divided at his death in 1960.[23] He bequeathed the other half of his collection, including the present picture, to Yale University (inv. 1961.18.33), whose Art Gallery already owned the watercolor (cat. 30).

F.C.

30. *Study for* Young Woman Reclining, in Spanish Costume

1862
Watercolor
6½ × 9¼″ (16.4 × 23.5 cm)
Initialed (lower right): E.M
Yale University Art Gallery, New Haven

Exhibitions
Philadelphia-Chicago 1966–67, no. 53; Ann Arbor 1969, no. 21

Catalogues
D 1902, p. 31 (ill.); T 1931, 18 (watercolors); JW 1932, mentioned 63; T 1947, 561; RW 1975 II, 373

Whereas the watercolors and drawings associated with paintings are often done afterward, serving as an intermediate stage between canvas and print, this watercolor seems to be a preparatory study for the painting (cat. 29). The position of the right elbow, resting on a cushion, is a good deal more natural here; the cat is taken from life, and its whimsical silhouette is set off by the graphic signature. In proceeding to the painting, Manet accentuated the analogy with Goya's *Maja* (cat. 64, fig. b) by trimming the couch to the same outline, thus leaving the elbow somewhat artificially suspended in mid-air. Manet based his painted composition firmly on a horizontal foreground in three parallel bands—the ground, the fringes, and the couch—a device we shall encounter frequently. The foreground orange has become an essential plastic element in the painting, a sort of exclamation point to his quoted Hispanicism.

Provenance
This watercolor was recorded in the FAUCHIER-MAGNIEN collection, then with BIGNOU (see Provenance, cat. 216), who sold it to DORVILLE. After the Dorville sale in Nice (June 24, 1942, no. 341), it appeared in the collection of JOHN S. THACHER in Washington, D.C. He gave it to his alma mater, Yale University, and it entered the Art Gallery in 1959 (inv. 1959.63).

F.C.

30

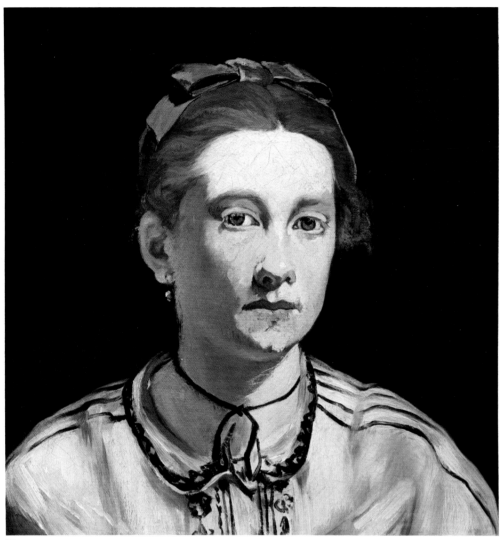

31

31. Portrait of Victorine Meurent

1862
Oil on canvas
17 × 17" (43 × 43 cm)
Signed (upper right): Manet
Museum of Fine Arts, Boston

Victorine Louise Meurent, born in 1844,[1] would have been eighteen when Manet discovered her and asked her to pose. According to Duret, he saw her in a crowd outside the Palais de Justice and was "struck by her unusual appearance and her decided air."[2]

Tabarant places the first meeting near the printer's in the rue Maître-Albert, since Manet's notebook contains the young woman's address: "Louise Meuran [sic], rue Maître-Albert, 17."[3] The two accounts are not contradictory, and Duret undoubtedly had his from Manet himself.

In any case, Victorine was a professional model, already posing at the

Exhibitions
Orangerie 1932, no. 12; Philadelphia 1933–34, without no.; New York, Wildenstein 1937, no. 5

Catalogues
D 1902, 30; M-N 1926 I, p. 48; M-N cat. ms., 77; T 1931, 56; JW 1932, 50; T 1947, 62; PO 1967, 58; RO 1970, 57; RW 1975 I, 57

studio of Couture, where her name appears early the same year, 1862. Amusing and talkative during sittings, at which she was professionally patient and motionless, with her creamy redhead's skin that caught the light so well, she was to become Manet's favorite model. From 1862 to 1875, she posed for *The Street Singer* (cat. 32), *Mlle V . . . in the Costume of an Espada* (cat. 33), *Le déjeuner sur l'herbe* (cat. 62), *Olympia* (cat. 64), and *The Railroad* (cat. 133).

She had the Paris street urchin's bluntness of speech,[4] a whimsical manner, and no small talent; she played the guitar, and, after an affair with Alfred Stevens, for whom she also posed, and an amorous escapade in the United States, she herself took up painting in the 1870s. A self-portrait admitted her to the Salon of 1876, from which Manet had been excluded. Tabarant picks up her trail much later, when she had slipped little by little from the bohemian life into alcoholism and indigence.[5]

The portrait catches her at the point where Manet had just discovered her. Her strength of character gives her the features of a woman, rather than of the young girl she actually was. Her face, here starkly lighted, quite naturally admits of a modeling with no shading or contrast. Pale lashes soften a rather absent look, and the lower face, calm and set, was to suit Manet's purpose admirably in the very special expression of indifference mingled with defiance that he would require for the bather of *Le déjeuner sur l'herbe* and for *Olympia*. Here he is manifestly enchanted with the contrast between blue ribbon and tawny hair, to be echoed in such sketches as the *Study for Le déjeuner sur l'herbe* (RW II 306) and the *Olympia* watercolor (cat. 67).

Jacques-Emile Blanche first pointed out the analogy with Corot's refined palette. A more violent, white-hot Corot: "How often does the chance meeting of a painter and a model influence decisively the character of his works! I consider a head of Victorine Meurand, wearing a blue ribbon in her hair, as the keynote of the characteristic combinations of colours on Manet's palette, as almost that of Corot in his figure pieces, and of the whole of a very pretty little school of which Alfred Stevens is a member. Let's call this class of artists the painters of colorful grays and tone on tone harmonies. This tonal mode was cradled in Spain."[6]

We might also note in passing the narrow black ribbon around Victorine's throat, setting off the whiteness of the skin—a ribbon that was to be her entire wardrobe as Olympia, and was to spill a flood of impassioned ink from 1865 to the present day.[7]

1. Goedorp 1967, p. 7.
2. Duret, quoted in Tabarant 1947, p. 47.
3. Tabarant 1947, p. 47.
4. Vollard 1938, p. 27.
5. Adolphe Tabarant, "La Fin douloureuse de celle qui fut l'Olympia," *L'Oeuvre*, July 10, 1932.
6. Blanche 1924, p. 24.
7. Leiris 1981.
8. Gimpel 1963: September 6, 1924.
9. Whitehill 1970, I, p. 431, II, pp. 446, 502, 508.

Provenance
In 1947, Tabarant described this painting as unsigned, but the earliest existing photographs, which were in the Rosenberg files in the 1920s (archives, Musée d'Orsay, Paris), show the signature clearly. The work did not appear in Manet's posthumous inventory or in the sale (see Provenance, cat. 12). Perhaps he presented it to Victorine as a gift. It first appeared at the end of the century, in the collection of SIR WILLIAM BURRELL (1861–1958), the wealthy Glasgow shipbuilder who bequeathed his vast art holdings to his native city in 1944. He owned many other works by Manet, among them *The Ham* (RW I 351) and café scenes in pastel (see cat. 166), today in the Glasgow Art Gallery and Museum, which unfortunately cannot lend under the terms of his will. The painting returned to France in 1905 through BERNHEIM-JEUNE. Josse Bernheim (1870–1941) and his twin brother, Gaston (1870–1953), were the sons of the dealer Alexandre Bernheim. Their gallery, Bernheim-Jeune, directed for twenty years by Félix Fénéon, handled Impressionist and Post-Impressionist paintings, and they published a journal and important books on art. The portrait later turned up in the famous collection of AL-PHONSE KANN, in Saint-Germain-en-Laye. A childhood friend of Marcel Proust's, Kann owned an important collection of eighteenth-century works of art and several Cézannes.[8] Acquired by the dealer PAUL ROSENBERG, the picture later belonged to ROBERT TREAT PAINE II (1861–1943), a trustee of the Museum of Fine Arts, Boston, to which he gave Van Gogh's *Postman Roulin* and Degas's portrait *M. and Mme Edmond de Morbilli*. In 1946, his son, RICHARD C. PAINE, donated the *Portrait of Victorine Meurent* to the museum in Boston in memory of his father (inv. 46.846).[9]

F.C.

32. The Street Singer

ca. 1862
Oil on canvas
69 × 42¾" (175.2 × 108.5 cm)
Signed (lower left): éd. Manet
Museum of Fine Arts, Boston

Exhibitions
Paris, Martinet 1863; Alma 1867, no. 19 (La Chanteuse des rues); Beaux-Arts 1884, no. 10

Catalogues
D 1902, 31; M-N 1926 I, pp. 44–45; M-N cat. ms., 37; T 1931, 44; JW 1932, 45; T 1947, 46; PO 1967, 45; RO 1970, 44; RW 1975 I, 50

In the early 1860s, the area surrounding the boulevard Malesherbes was being torn down and rebuilt as part of Baron Haussmann's massive replanning and modernization of Paris. Antonin Proust later recalled that as he and Manet were walking up the boulevard to the artist's studio on the rue Guyot, Manet pointed to things that interested him, such as a lone cedar standing in an otherwise destroyed garden, or the white walls of a partially demolished building enveloped in a cloud of white dust: "There it is," he exclaimed, "the symphony in white major that Théophile Gautier speaks of."

As Proust and Manet approached the rue Guyot, a woman with a guitar emerged from a café. Manet was fascinated by her and immediately recognized a possible subject for a painting: "Where the rue Guyot begins, a woman was coming out of a sleazy café, picking up her skirt, holding a guitar. [Manet] went up to her and asked her to come and pose for him. She went off laughing. 'I'll catch up with her again,' cried Manet, 'and if she still won't pose, I've got Victorine.' Victorine was his favorite model. We went up to the studio. On two easels stood the *Guitarrero* [cat. 10] and the portrait of his father and mother [cat. 3]."[1] Evidently the woman refused again, because Victorine Meurent (see cat. 31) did in fact model for *The Street Singer*.

Proust indicates that Manet's encounter with the woman in front of the cabaret happened after the artist's trip to Spain in 1865. However, Proust's recollection of the date must be incorrect, since *The Street Singer* was one of a group of fourteen pictures in the exhibition that opened at Louis Martinet's gallery on March 1, 1863. Manet, who met Victorine in 1862, must have executed the painting that year or at the beginning of 1863. Furthermore, it was certainly not the first time he had used her as a model, because the phrase "I've got Victorine" indicates that she had already posed for him. One can deduce, therefore, that Manet had probably already painted her portrait (cat. 31) as well as *Mlle V . . . in the Costume of an Espada* (cat. 33).

As Hamilton observes, the exhibition at Martinet's opened March 1, exactly one month before the jury began to review work submitted for the Salon of 1863.[2] Apparently Manet hoped that favorable reviews of the show would influence the Salon jury accordingly, but the gambit failed. For example, in the April 1 issue of the *Gazette des Beaux-Arts*, Paul Mantz lamented Manet's failure to fulfill the promise of *The Spanish Singer* (cat. 10), which had been included in the Salon of 1861. Moreover, he specifically cited *The Street Singer* as typical of Manet's misguided efforts: "M. Manet has entered, with his instinctive daring, into the realm of the impossible. We must absolutely refuse to accompany him. All form is lost in his big portraits of women, particularly in that of the *Singer*, where, because of an abnormality we find deeply disturbing, the eyebrows lose their horizontal position and slide vertically down the nose, like two commas of shadow; there is nothing there ex-

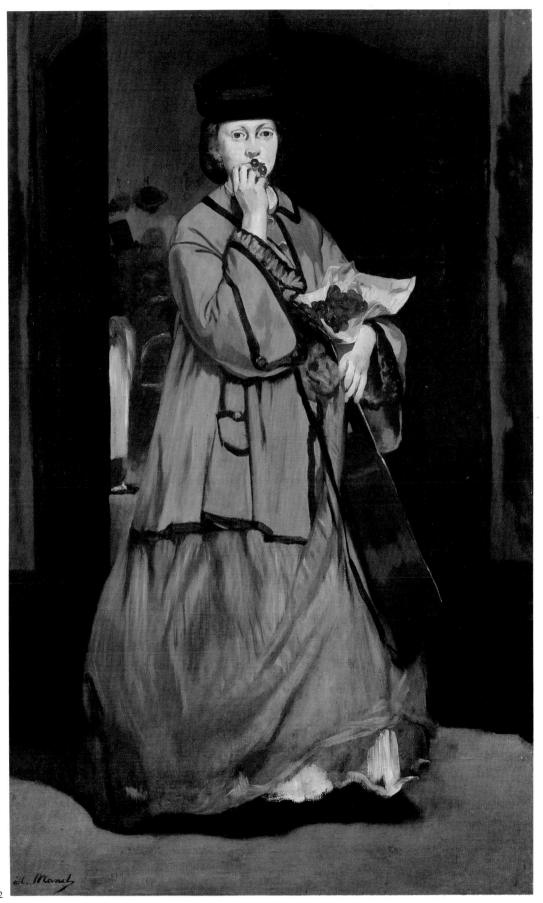

32

cept the crude conflict of the chalk whites with the black tones. The effect is pallid, hard, sinister . . . we must ask to be excused from pleading M. Manet's case before the exhibition jury."[3]

Four years passed before a critic wrote positively about the painting. In "Une Nouvelle Manière en peinture: Edouard Manet," Zola identified it as the picture he most liked of the eight he thought Manet would show at the Exposition Universelle of 1867. He praised both Manet's style and what he called "the keen search for truth": "But the canvas I like best . . . is the *Street Singer*. . . . The whole work is a soft, blond gray, and it seemed to me that it analyzes life with extreme simplicity and exactitude. A picture like this, over and above the subject matter, is enhanced by its very austerity; one feels the keen search for truth, the conscientious effort of a man who would, above all, tell frankly what he sees."[4] The contrast between Zola's attitude and that of Mantz is striking, but the difference underscores the modernity of *The Street Singer*. The older critic condemned the painting according to orthodox standards of style and execution, while the younger one admired its formalism ("the whole work is a soft, blond gray") and what he interpreted as the artist's confrontation with things as they are. In attacking *The Street Singer*, Mantz defended tradition and the principles promulgated by the Academy and the Ecole des Beaux-Arts, and apparently he did so because he found the picture threatening ("the effect is pallid, hard, sinister"). Zola, however, could see the inherent merit of the painting, despite or perhaps because of his relative youth and lack of experience as a critic.

Richardson asserts that *The Street Singer* was poorly received by most critics because it failed to accede to the contemporary taste for sentimentalism and anecdote: "Had there been a touch of pathos in the treatment of the subject, the public might have overlooked its ordinariness; after all Alfred Stevens' similar composition, *La Mendiante Tolérée*, had been well received in 1855, because for all its realism, it told a story." He also notes Mantz's objection to the "crude conflict of the chalk whites with the black tones" ("the shattering discord of chalky tones with black ones," in Richardson's translation), but he relates this stylistic trait to the influence of Japanese prints: "Look, for instance, at the way the street singer is reduced to a sort of bell-shaped cut-out, her dress being treated as an almost two-dimensional surface on which trimmings and folds form a bold, linear pattern, as in an Utamaro or a Hokusai."[5] The probable influence of Japanese prints on the style of *The Street Singer* was observed as early as 1924 by Jacques-Emile Blanche, but it was not until 1954 that Sandblad noted that the year it was painted Mme de Soye opened a shop where Japanese prints were sold. Manet is known to have been one of the earliest customers.[6]

On the other hand, Beatrice Farwell argues convincingly that the exaggerations, simplifications, and dearth of half-tones in certain early works by Manet may reflect the influence of photography. She notes that the inherent characteristics of some mid-nineteenth-century photographs provided precisely the stylistic traits and the appearance of modernity that Manet sought to incorporate into his work: "There can be no doubt that Manet, unlike Courbet and Delacroix when they worked from photographs, welcomed and accepted the clarity, the hard edges, and the sharp distinctions between light and dark that photographic images sometimes provided, and that this acceptance was put to artistic use in the reduced modeling and harsh lighting that contributed so much to the vigor of his early style. It is not a matter of his passively 'receiving' the 'influence' of the new medium, it

seems to me, but of his actively seeking out the effects that made it look 'modern' and 'real.'"[7] She suggests further that in the early 1860s Manet may actually have worked from photographs he later destroyed. Among the paintings for which she believes he may have had photographs made are *Boy with a Sword* (cat. 14), *The Surprised Nymph* (cat. 19), *The Street Singer, Mlle V . . . in the Costume of an Espada* (cat. 33), *Music in the Tuileries* (cat. 38), *Lola de Valence* (cat. 50), *Le déjeuner sur l'herbe* (cat. 62), *Olympia* (cat. 64), and *The Dead Christ and the Angels* (cat. 74), all works painted from 1861 to 1863.

In addition to the patently modern style of *The Street Singer*, contemporary viewers must have been puzzled by the subject itself. Most street entertainers active during the Second Empire were impoverished and unfortunate types,[8] and probably none was as fashionably dressed as the woman in this work. However, her hat seems to be that of a man, and makes its appearance again on the head of the gentleman at the right in *Le déjeuner sur l'herbe*. It is possible that it relates to "what seems to have been a chic flouting of the female image of the time by dressing in men's clothes,"[9] but it is no more incongruous than the presence of this fashionably dressed woman standing in the doorway of a café in a shabby section of Paris.

The cherries in a sheet of yellow paper held in the crook of the woman's arm are another inexplicable detail, but Manet may have included them for purely pictorial reasons. The yellow and red may serve no other purpose than to provide a foil for the otherwise subdued tonalities of the painting. The presence of such seemingly gratuitous elements in some of Manet's paintings is perhaps best explained by the following passage from Zola's 1867 essay: "His treatment of figure paintings is like the attitude prescribed by art schools toward still life; I mean that he groups the figures before him, somewhat at random, and then is concerned only with fixing them on the canvas as he sees them, with the sharp contrasts that they produce in juxtaposition with each other. Ask nothing more from him than a literally accurate translation. He knows neither how to sing nor how to philosophize. He knows how to paint, and that is all. . . . "[10]

Whether intended or not, details such as the hat and the cherries signal the composition as a fiction created in Manet's studio. Indeed, the cabaret doors may even have been adapted from the louvered green shutters that were apparently part of Manet's rue Guyot studio and play a prominent role in the composition of *The Balcony* (cat. 115). The subject may have been inspired by the episode on the street described by Proust, but the painting itself is an implausible combination of elements that draws attention to the formal aspects as opposed to the image of Victorine as a street singer.

The composition of *The Street Singer* relates to two other full-length images of Victorine that Manet painted in the sixties. Victorine's pose in this work is similar to that in *Woman with a Parrot* (cat. 96), and the spatial relationships between the figure and the background are not unlike those of *Mlle V . . . in the Costume of an Espada*. Although the spatial ambiguities of *The Street Singer* are not as pronounced as those of the latter work, one can see here as well that the ground plane rises, the figures in the background are too small relative to Victorine, and Manet seems to have willfully lessened the illusion of depth. Significantly, a passage of Farwell's analysis of *Mlle V . . .* could also be used in connection with this work: "The artificiality of the whole arrangement . . . can best be interpreted as the result of a carefully constructed interplay of colors and values, responding more to abstract pictorial exigencies than to the visual experience of spatial relationships."[11]

1. Proust 1913, p. 40.
2. Hamilton 1969, p. 38.
3. Mantz 1863, "Exposition . . . ," p. 383.
4. Zola 1867, *L'Artiste*, p. 56.
5. Richardson 1958, p. 18.
6. Blanche 1924, p. 26; Sandblad 1954, p. 77.
7. Farwell (1973) 1981, p. 127.
8. Reff 1982, p. 171.
9. Farwell 1969, p. 206.
10. Zola 1867, *L'Artiste*, pp. 52–53; Zola (Dentu), p. 26.
11. Farwell 1969, p. 197.
12. Callen 1974, p. 163.
13. Hoschedé sale, Paris, June 5–6, 1878, no. 42, "Femme aux cerises"; Bodelsen 1968, pp. 339–40; Wildenstein 1974, I, pp. 80–92.
14. Venturi 1939, II, p. 191; Rouart and Wildenstein 1975, I, no. 50.
15. Boston, Museum of Fine Arts. *Back Bay Boston: The City as a Work of Art* (exhibition catalogue), Boston, 1979, p. 103.

Provenance
DURAND-RUEL paid 2,000 Frs for this picture early in 1872, when he acquired a group of twenty-four works directly from the artist (see Provenance, cat. 118). He sold it on January 29, 1877, evidently for 4,000 Frs[12] to ERNEST HOSCHEDE (1837–1890), the Parisian department store magnate who squandered his fortune during the 1870s. Invited to his luxurious country house at Montgeron during the summer of 1876, Manet began a portrait of Hoschedé (RW I 246), who was then in the process of assembling a second collection of nineteenth-century French paintings (the first was sold at auction in 1874) that would include five works by Manet (cat. 72, 96; RW I 137, 147). During these years, Hoschedé was an important patron for Monet, who would eventually marry his widow. Bankruptcy forced Hoschedé to sell his second collection at auction in 1878,[13] and *The Street Singer* was purchased by FAURE (see Provenance, cat. 10) for only 450 Frs. DURAND-RUEL acquired the painting from Faure in the late 1890s (about 1895, according to Venturi, or in 1898, according to Rouart and Wildenstein[14]). The dealer then sold it for 70,000 Frs to SARAH CHOATE SEARS (1856–1935), an important Boston collector of French and American Impressionist paintings and a friend of Mary Cassatt's. Mrs. Sears bequeathed the picture to the Museum of Fine Arts, Boston, in memory of her husband, J. Montgomery Sears, retaining a life interest in her daughter, MRS. J. CAMERON BRADLEY, which terminated with the latter's death in 1966 (inv. 66.304).[15]

C.S.M.

33. Mlle V . . . in the Costume of an Espada

1862
Oil on canvas
65 × 50¼" (165.1 × 127.6 cm)
Signed and dated (lower left): éd. Manet. / 1862
The Metropolitan Museum of Art, New York

In 1862, probably during the spring, Manet painted *Mlle V . . . in the Costume of an Espada* in his studio on the rue Guyot. The model is Victorine Meurent, who had begun to pose for him that year (see cat. 31). The picture was first exhibited at the Salon des Refusés in 1863 with another painting of a Spanish subject, *Young Man in the Costume of a Majo* (cat. 72), and with *Le déjeuner sur l'herbe* (cat. 62).

Manet did not visit Spain until 1865, but he had a collection of Spanish costumes in his studio that Zola tells us inspired such pictures as *Mlle V*[1] It is possible that he acquired the colorful clothing from a Spanish tailor on the rue Saint-Marc (passage Jouffroy) whose address is recorded in a notebook that Manet is believed to have used between 1860 and 1862.[2] Farwell has observed that parts of Victorine's costume appear in other paintings: "The bolero, hat, and headscarf . . . are the same as those in The Spanish Singer of 1860 [cat. 10]. . . . the model for The Spanish Singer needed to roll back the cuffs of the bolero, while she did not. The same bolero appears, well fitted, in the painting of Manet's brother Gustave known as A Young Man in the Costume of a Majo [cat. 72]." By choosing to paint a woman in a man's clothing, and by allowing her to wear shoes unsuitable for bullfighting, Manet seems to have wanted to draw our attention to the fictive character of the composition. In Farwell's words, "Where a history painter of the time would have used these costumes in some plausible context (as Manet did in 1860), Manet in 1862 used them to present quite frankly his perfectly recognizable and named female model in a scene painted so as to leave no doubt in the viewer's mind of the total artificiality of its construction."[3]

In "Une Nouvelle Manière en peinture: Edouard Manet," Zola praised Manet's technique, and wrote that *Mlle V . . . in the Costume of an Espada* and *Young Man in the Costume of a Majo* "were thought very crude, but vigorous and quite powerful in tone. I would say that the painter was more of a colorist here than is usually the case. The palette is blond as ever, but a wild and vivid blond. The strokes are thick and energetic, and they stand out from the background with all the boldness of nature."[4] However, Zola's remarks contrast sharply with the comments about Manet's technique that were voiced by such critics as Thoré and Castagnary in their reviews of the Salon des Refusés of 1863. Thoré admired Manet as "a true painter," but criticized "the too vivid color" of all three of Manet's works; he also objected to the figures' lack of personality and the way the heads are treated in the two paintings of Spanish subjects: "The artist who, after Whistler, inspires the most debate is Manet. A true painter, too. . . . Manet's three pictures seem rather as if meant to provoke the public, which is put off by the too vivid color. In the center, a bathing scene; to the left, a Spanish *majo*; to the right, a Parisian girl in the costume of an *espada*, waving her crimson cape in a bullring. Manet loves Spain, and his favorite master seems to be Goya,

Exhibitions
Salon des Refusés 1863, no. 365 (Mademoiselle V. en costume d'Espada); Alma 1867, no. 12 (Mlle V . . . en costume d'espada); Beaux-Arts 1884, no. 15; Philadelphia-Chicago 1966–67, no. 50

Catalogues
D 1902, 37; M-N 1926 I, p. 48; M-N cat. ms., 48; T 1931, 54; JW 1932, 51; T 1947, 55; PO 1967, 51; RO 1970, 50; RW 1975 I, 58

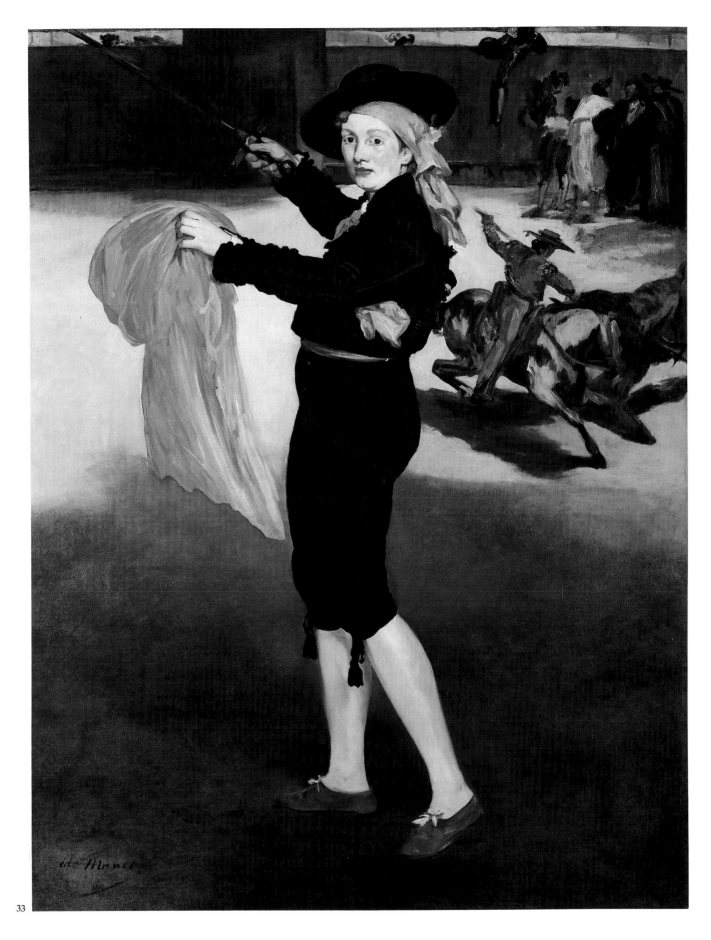

whose bright, jarring tones, whose free and spirited touch he imitates. There are some astonishing fabrics in these two Spanish figures: the *majo*'s outfit of black and the heavy scarlet mantle thrown over his arm, and the pink stockings of the young Parisienne disguised as an *espada*; but under these dashing costumes, something of the personality of the figure is missing; the heads ought to be painted differently from the fabrics, with more life and more profundity."[5] And Castagnary would only acknowledge Manet's pictures at the Salon des Refusés as sketches (*ébauches*) about which he expressed strong reservations: "A great fuss has been made about this young man. Let's be serious. The bathing scene, the *Majo*, the *Espada* are good sketches, I agree. There's a certain life in the color, a certain directness in the touch that are in no way vulgar. But then what? Is this drawing? Is this painting?"[6]

Similar accusations have been made by modern critics. John Richardson has written, "Manet's sense of design was faulty. Now instead of disguising this weakness, as a less independent artist might have done by making judicious use of the compositional formulae taught in art schools, Manet repeatedly drew attention to it by dispensing with all but the most summary indications of perspective and by trying to reproduce on his canvas the informal—or, as he called them, 'naive'—groupings of everyday life. This was courageous, but it complicated rather than simplified Manet's greatest pictorial problem. The result is that a number of his figure compositions . . . disintegrate. Worse, the spatial illusion is flawed, at times irreparably, by a further habitual weakness (due possibly to some defect in the artist's vision), a fallible sense of scale."[7] Commenting specifically about *Mlle V . . . in the Costume of an Espada*, Richardson charges that Manet's "sense of scale has let him down so badly that the bullfighting scene makes an annoying hole in the decorative schema and points up the unreality of this costume-piece instead of giving it the air of authenticity which it so sorely needs."[8]

More recently, however, several authors have suggested that the apparent technical flaws in the painting are intentional. For example, Farwell states: "The brilliantly and realistically rendered figure, obviously painted before the model, testifies to Manet's visual sensitivity and manual dexterity, but in its relation to the background scene violates the laws of linear perspective in a manner so obvious as to seem deliberate. Indeed, the artificiality of the whole arrangement, noted by critics in 1863 and frequently since, can best be interpreted as the result of a carefully constructed interplay of colors and values, responding more to abstract pictorial exigencies than to the visual experience of spatial relationships."[9] Joel Isaacson similarly observes: "Space was compressed as in the *Olympia* or denied its rational diminution as in the *Mlle Victorine in the Costume of an Espada*, where he chose to emphasize the linking of directions and the juxtaposition of forms upon the surface in relative disregard of the traditional concern with three-dimensional coherence."[10]

Hamilton believes that "Manet may have looked to the Japanese print for his composition, attempting in a similar way to arrange realistic figures in a decorative pattern freed from the limitations of conventional space."[11] And Bowness, speaking in general about Manet's work, suggests: "It is of course the surface design that Manet always emphasizes, sometimes with a Japanese-type linear pattern, sometimes building up an almost Mondrian-like grid of horizontals and verticals, and dividing the space into flat planes that he piles in parallel bands one above the other."[12] Responding

Fig. a. Francisco de Goya, *Tauromaquia*, plate 5, 1815–16, etching and aquatint

Fig. b. Marcantonio Raimondi, engraving after Mantegna or school of Raphael, *Temperance*

Fig. c. *Mlle V . . . in the Costume of an Espada*, X-ray of the canvas upside down: seated female nude

1. Zola 1867, *L'Artiste*, p. 56; Zola (Dentu), p. 32; Zola 1959, p. 93.
2. New York, Pierpont Morgan Library, Tabarant archives.
3. Farwell 1969, p. 206.
4. Zola 1867, *L'Artiste*, p. 56; Zola (Dentu), p. 32.
5. Bürger (Thoré), 1870, II, pp. 424–25.
6. Castagnary 1863, p. 76.
7. Richardson 1958, p. 13.
8. Ibid., p. 14.
9. Farwell 1969, p. 197.
10. Isaacson 1972, p. 80.

to Richardson's charge that in *Mlle V . . . in the Costume of an Espada* Manet's "sense of scale has let him down," Bowness retorts, "but [Manet] is surely trying to relate, on a single plane, the bull-fighting scene in the middle distance and Victorine's arms in the foreground."[13] It is notable that the modern point of view seems to concur with Zola's observation in 1867 that "if [Manet] assembles several objects or figures, he is guided in his choice only by his desire to create fine areas of color, fine oppositions of tone."[14]

Charles Stuckey notes that the contradictions included the subject itself: "The preposterous details that characterize many of Manet's paintings . . . draw attention to the fact that art is concocted from models and costumes. *Mademoiselle Victorine as an Espada* . . . is a case in point: considered in Realist terms, a female model posed as a toreador is laughable."[15] The ramifications of Manet's manipulation of subject and style were wide-ranging and have been summarized by Seymour Howard, who interprets the change in approach as signaling the end of a four-hundred-year tradition in European painting.[16]

Much has been written about the compositional source of *Mlle V. . . .* Farwell notes, "It has long been known that the bullfighting action in the background is from the group in Plate 5 of the Tauromaquia by Goya [fig. a], and that the barricade with its figures is freely derived from several other plates in the same series" (cat. 35, figs. a, b). She also indicates similarities between Victorine as seen in Manet's painting and three figures in prints by Marcantonio Raimondi (see fig. b).[17] Reff has proposed a connection with Titian's *Girl with a Fruit Dish*, which Manet would have known through an illustration in Blanc's *Histoire des peintres*.[18] Michael Fried points to the possible influence of Rubens's *Venus* or *Fortune*, which Manet might have known from an illustration in the *Gazette des Beaux-Arts*.[19] Leiris has convincingly connected the compositional mode with Manet's early drawings after Renaissance art, notably his drawing after Andrea del Sarto's *Punishment of the Gamblers*, from the San Filippo Benizzi fresco cycle in the Annunziata in Florence.[20] However, as Hanson cautions, following her own discussion of several possible sources, "If these sources were used (and it is possible that several were combined), they do not seem to have been chosen for the extra meaning they could add to the picture."[21]

Indeed, beyond the stylistic significance of the painting, the meaning of the image remains elusive. Farwell has suggested that *Mlle V . . . in the Costume of an Espada* and another painting of the same year of a woman in a man's clothing (cat. 29) may relate to "what seems to have been a chic flouting of the female image among some members of the flourishing demi-monde of the time by dressing in men's clothes. Possibly it could even refer back to Goya's association with the duchess of Alba, who is said to have affected bullfighters' costume on occasion."[22]

Another possibility is offered by Gautier in *Voyage en Espagne*. Isaacson points out that "Manet could have known the customs of Madrid and the details of the bullring from Mérimée or Théophile Gautier, whose *Voyage en Espagne* was published in 1843 and reprinted several times."[23] Isaacson's hypothesis may be well founded. The use of the word *espada* in the title suggests that Manet may have heeded Gautier's advice about terminology: "In Spain, one hardly ever uses the word *matador* for the person who kills the bull; one calls him the *espada*."[24] Since Manet had not yet visited Spain, Gautier's descriptions of bullfighting would have been invaluable; moreover, there exists the possibility that the painting depicts Gautier's descrip-

tion of the *espada* at the very end of the bullfight: "In a few seconds, one of the two principals will be killed. Will it be the man or the bull? There they are, the two of them, face to face, alone; the man bears no defensive arms; he is dressed as if for a ball: silk stockings and pumps, perhaps a lady's brooch in his satin jacket, a scrap of cloth, the fragile sword, and nothing more."[25]

Recent X-ray analysis of the painting reveals two very important facts. First, in addition to showing the kinds of ongoing changes and adjustments typical of Manet's technique, the X-rays indicate that originally Manet depicted Victorine holding the cape in both hands. The sword was added and the necessary modifications evidently made at a relatively advanced stage in the development of the painting. Second, *Mlle V . . .* is painted over a wholly unrelated image. Viewing the X-rays upside down (fig. c), we can see the figure of a seated female nude. Her proportions are puzzling, and thus far it has not been possible to relate her definitively to a known project.

11. Hamilton 1969, p. 72.
12. Bowness 1961, p. 277.
13. Ibid.
14. Zola 1867, *L'Artiste*, p. 51; Zola (Dentu), p. 24.
15. Stuckey 1981, p. 100.
16. Howard 1977, p. 19.
17. Farwell 1969, pp. 200, 202.
18. Reff 1969, pp. 40–41.
19. Fried 1969, p. 75 n. 147.
20. Leiris 1979, p. 113.
21. Hanson 1977, p. 80.
22. Farwell 1969, pp. 204–6.
23. Isaacson 1969, p. 11.
24. Gautier (1842) 1981, p. 105.
25. Ibid., p. 119.
26. Callen 1974, p. 163.
27. Meier-Graefe 1912, p. 313; Letter from Charles Durand-Ruel, January 6, 1959 (archives, department of European paintings, The Metropolitan Museum of Art, New York).
28. Havemeyer 1961, pp. 215–40; Weitzhoffer 1982, pp. 285–318.

Provenance

In Manet's own notes, this work and *The Dead Christ and the Angels* (cat. 76) were each valued at 4,000 Frs, making them the most expensive of the twenty-four paintings acquired from the artist by DURAND-RUEL in January 1872 (see Provenance, cat. 118). The dealer recorded paying 3,000 Frs, the final price after Manet offered to discount the lot. Durand-Ruel sold it to FAURE (see Provenance, cat. 10) on February 16, 1874, for 5,000 Frs,[26] and repurchased it on December 12, 1898, for the modest sum of 10,000 Frs. On December 31, he sold it to MR. AND MRS. HENRY O. HAVEMEYER for 150,000 Frs.[27] In her memoirs, Louisine W. Havemeyer recalls that, when she was a young girl, Mary Cassatt tried without success to introduce her to Manet, who was too ill to receive them at his home in Marly-le-Roi. Her husband purchased their first Manet, evidently *The Salmon* (RW I 140), from Durand-Ruel's exhibition of Impressionist paintings held in New York in 1886. *Mlle V . . . in the Costume of an Espada* did not enter the Havemeyer collection until Mrs. Havemeyer was able to prevail over her husband's objection to buying large pictures by the artist.[28] The Havemeyers, whose great fortune derived from sugar refining, built one of the largest and most impressive collections of works by Courbet, Manet, Degas, and the French Impressionists, the nucleus of which, bequeathed to the Metropolitan Museum in 1929 by Mrs. Havemeyer, made the greatest single addition to the museum's collection of paintings by later nineteenth-century French artists (inv. 29.100.53).

C.S.M.

34. Mlle V . . . in the Costume of an Espada

1862
Pencil, ink, and watercolor on tracing paper, laid down
12 × 11⅜" (30.5 × 29 cm)
Signed (lower right): Manet

NY Museum of Art, Rhode Island School of Design, Providence

This watercolor, which reproduces in reverse the composition of Manet's painting of the same subject (cat. 33), served as an intermediate step between the painting and the etching (cat. 35). Leiris has pointed out that "every detail of the drawing corresponds so exactly to the painting that it is tempting to assume that at this early date, 1863 [*sic*], Manet employed a photographic reproduction for the transfer."[1] Indeed, the watercolor is on a delicate tracing paper that is now laid down on heavier paper for support; Manet probably either traced the image from a photograph of the painting and then turned over the tracing paper to reverse the image, or had the photograph printed in reverse before making his tracing. Denker points out that "since the direction of the pencil hatching underlying the washes generally runs counter to Manet's customary stroke, the initial pencil tracing was

Exhibitions
New York, Wildenstein 1948, no. 47; Ann Arbor 1969, no. 15

Catalogues
L 1969, 181; RW 1975 II, 372

34

probably executed on the other side of the paper and Manet reversed the image simply by flipping over the tracing paper. In addition, since the marks incised into the surface of the paper by the tracing 'stylus' which Manet used to transfer his drawing directly onto the etching plate seem to pass over the ink and watercolor brushwork, one can be fairly certain that the watercolor was completed before the transfer process was carried out."[2]

The tracing paper has darkened, and the original colors and value relationships of the washes are no longer easily discernible. But one can still see that the watercolor reflects more closely the graphic character of the etching in its first state than it does Manet's interpretation of form and use of color in the painting.[3]

1. Leiris 1969, p. 12.
2. Denker 1975, pp. 106–7, no. 47.
3. Leiris 1969, p. 12.
4. M. A. Banks, "The Radeke Collection of Drawings," *Bulletin of the Rhode Island School of Design* XIX (1931), pp. 62–72.

Provenance
This watercolor first appeared in the collection of DR. AND MRS. GUSTAV RADEKE, who began to purchase drawings in the 1880s. Mrs. Radeke gave the collection, including this watercolor, to the Museum of Art, Rhode Island School of Design, Providence, in 1921 (inv. 21.483).[4]

C.S.M.

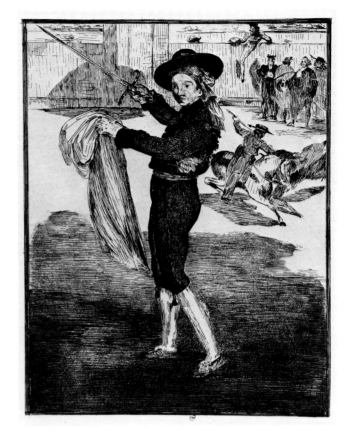

35 (1st state)

35 (3rd state)

35. The Espada

1862
Etching and aquatint
Plate: 13¼ × 11″ (33.5 × 27.8 cm); image, 1st state: 11¾ × 9⅛″
(30 × 23.2 cm); image, 2nd state: 12⅛ × 9½″ (30.7 × 24 cm)
Signed (lower left): éd. Manet
Bibliothèque Nationale, Paris (1st state)
P Bibliothèque Nationale, Paris (3rd state)
NY The Metropolitan Museum of Art, New York (3rd state)

Manet worked on the plate of *The Espada* in the same manner as he had on those of the third version of *Boy with a Sword, turned left* (cat. 18) and *Lola de Valence* (cat. 52). Starting with a light etching exactly following the outlines of the preparatory drawing (cat. 34), which had been transferred to the copperplate, he reworked the composition, adding a border around the subject and then tonal effects. These effects he created first by means of acid wash and later with an aquatint grain, which darkened the shadowed foreground to such an extent that the etched signature is obscured.

This is a classic example of the transference of a painting to an etching through the use of the watercolor tracing. The composition of the painting has been carefully reversed, and the emphasis on line and shape is clearly accentuated, creating a halfway stage between the pictorial and the

Publications
8 Gravures à l'eau-forte, Cadart 1862, no. 4 (l'Espada); *Eaux-fortes par Edouard Manet,* 1863?

Exhibitions
Beaux-Arts 1884, no. 161; Philadelphia-Chicago 1966–67, no. 51; Ann Arbor 1969, no. 16; Ingelheim 1977, no. 31; Paris, Berès 1978, no. 42

Catalogues
M-N 1906, 7; G 1944, 32; H 1970, 35; LM 1971, 29; W 1977, 31; W 1978, 42

1st state (of 3). Pure etching, before the etched border. The two known proofs, on China paper, in the Bibliothèque Nationale. Moreau-Nélaton collection.

purely graphic versions of the composition. The painting is faithfully rendered by etching in parallel hatching, which exploits the luminous effect of the white paper between the etched lines, except where they are closely crosshatched to create the dense, dark areas (particularly in the later state) of the *espada*'s black bolero.

Manet evidently regarded this as one of his most important prints, listing it in fourth place, following *The Spanish Singer* and the two etchings after paintings by Velázquez (cat. 11, 36, 37), in the album *8 Gravures à l'eau-forte*, announced by Cadart at the beginning of September 1862 (see cat. 45). It reappears on the lists of prints for the projected publication of "fourteen etchings" (see cat. 46, 47), of which the especially beautiful proof on China paper in the New York Public Library is probably an example, but then disappears altogether. It was not included in the 1874 album and, according to a note in the Lochard photograph albums, the plate was canceled.[1] It is therefore one of the rarest of Manet's published prints.

Japanese prints and, above all, the etchings of Goya have been cited as sources for this composition (see figs. a, b; cat. 33, fig. a), so that the art of the print had, in this case, a considerable impact on Manet's oil painting. And in the print after his own painting, it is interesting to note that Manet adopted the light, luminous etching style of Goya's *Tauromaquia* prints. Manet's treatment of the background, with its motifs from Goya, resembles that of the landscape in his etching after the portrait of Philip IV attributed to Velázquez (cat. 36): in both, the different planes appear to rise vertically on the surface instead of receding into the distance. Significantly, Manet chose as his principal motif, from all the prints of the *Tauromaquia*, the one showing the combat between man and beast in its most abstract form (cat. 33, fig. a).[2] In Goya's print, the group occupies a space suggested only by the cast shadows, and the figures appear like insects pinned onto the white paper. X-rays of Manet's painting *Mlle V . . . in the Costume of an Espada* reveal radical alterations, which suggest that the motifs borrowed from Goya were added at a late stage. If this is the case, then Manet's recognition and utilization of Goya's subject matter and etching style are fundamental to an understanding of his pictorial aims in the paintings of this period.

1. Paris, BN Estampes (Dc 300g, VIII, p. 206).
2. T. Harris 1964, II, no. 208, *Tauromaquia*, pl. 5.
3. Lugt 1921, p. 417, no. 2229.
4. Marx sale, Paris, April 27–May 2, 1914, lot 899 (this proof).

Provenance
1st state. The two known proofs, on China paper, were acquired by MOREAU-NELATON (see Provenance, cat. 9) and bequeathed with his collection of prints to the Bibliothèque Nationale in 1927. Their earlier provenance probably goes back to the LEENHOFF and FIOUPOU collections (see cat. 14 and Provenance, cat. 9).

3rd state. The proof from the 1862 album in the Bibliothèque Nationale was also part of the MOREAU-NELATON bequest.

The proof in the Metropolitan Museum of Art, acquired in 1969 (inv. 69.550), came from the Marx collection. ROGER MARX (1859–1913), a director of the French Beaux-Arts administration, art critic, and editor of *L'Estampe originale, L'Image,*

and the *Gazette des Beaux-Arts*,[3] was a strong supporter of avant-garde artists and particularly of innovators in printmaking. His fine collection of modern prints was sold at auction in Paris in 1914.[4]

J.W.B.

Fig. a. Francisco de Goya, *Tauromaquia*, plate 19 (detail), 1815, etching and aquatint

Fig. b. Francisco de Goya, *Tauromaquia*, plate 16 (detail), 1815, etching and aquatint

36. Philip IV, after Velázquez

1862 (1st–6th states); 1866–67? (7th, 8th states)
Etching, drypoint, and aquatint
Plate: 13⅛ × 9⅜″ (33.5 × 23.8 cm); image: 12⅝ × 7⅞″ (32 × 19.9 cm)
Signed (lower right): éd. Manet sc. (5th state); (lower left): éd. Manet
d'après Vélasquez (7th state)
Title etched on the plate by the artist: PHILIPPE IV/ROI D'Espagne
(6th state)

P Bibliothèque Nationale, Paris (6th state)
NY The New York Public Library (6th, 8th states)

A portrait of Philip IV in hunting dress, thought to be by Velázquez and now attributed to Velázquez's son-in-law and assistant, Juan Martínez del Mazo,[1] was acquired by the Musée du Louvre in May 1862. This important acquisition was no doubt soon put on view to the public, for whom everything Spanish was in demand, and it seems to have found an echo almost immediately in Manet's work. He apparently intended to publish an etched reproduction, to be sold by Cadart as a separate print, since the version that ultimately appeared in September, in the album *8 Gravures à l'eau-forte*, bears not only the traditional inscriptions indicating the painter, "Vélasquez p¹.," the engraver, "éd. Manet sc.," and the publisher's and printer's names but also an etched title below the design, "PHILIPPE IV/ROI D'Espagne." Apart from *The Spanish Singer* (cat. 11) and *Little Cavaliers, after Velázquez* (cat. 37), which Cadart may have issued separately before publishing them as the first two prints of *8 Gravures* (see cat. 7–9), none of the other plates in the album has letters.

Once the outlines of the preparatory drawing (RW II 68) had been traced for transfer to the copperplate,[2] the plate passed through several stages. Although he presumably intended to make a "marketable" reproduction of Velázquez's portrait, Manet produced a free, reversed image that contrasts markedly with the print by Haussoullier after the same work, published in the *Gazette des Beaux-Arts* a year later (fig. a).[3] Haussoullier's interpretation is a true reproductive engraving, like Courtry's copy of *The Spanish Singer* (cat. 11, fig. a). Probably begun in June or July, Manet's print, along with *The Espada* (cat. 35), was presumably one of the last to be etched before publication of the album, and its free, assured handling seems to confirm this; in the very first state, Manet captured the firm stance of the figure of the king beneath the tree and sketched in the background with impressionistic strokes. He evoked the landscape by means of fluid directional lines that have the same graphic intensity, whether they describe the ground around the king's feet or the distant trees. Manet did not retouch this area of the plate, and he must have been satisfied with his transcription of the Louvre version of the painting, where successive planes appear to rise up the picture's surface rather than recede into the distance. (Manet realized this painting was a copy when he saw the original in the Prado in 1865.)[4]

Presuming that Manet's print truly conveys his perception of the Louvre picture, it is possible to deduce the impact of the painting on his work at this period. The changes made to the *Portrait of Mme Brunet* (cat. 5) and those that can be sensed and seen in the final composition of *Mlle V . . .*

Publications
8 Gravures à l'eau-forte, Cadart 1862, no. 3 (6th state) (Philippe IV [d'après Vélasquez]); *Eaux-fortes par Edouard Manet*, 1863?

Exhibitions
Salon des Refusés 1863, no. 675 (Philippe IV, d'après Vélasquez); Beaux-Arts 1884, no. 159; Philadelphia-Chicago 1966–67, no. 6; Ann Arbor 1969, no. 3; Ingelheim 1977, no. 18; Paris, Berès 1978, no. 22

Catalogues
M-N 1906, 6; G 1944, 7; H 1970, 15; LM 1971, 8; W 1977, 18; W 1978, 22

6th state (of 8). With the etched title and the names of the publishers, Cadart and Chevalier, and of the printer, Delâtre. Proofs on laid paper (watermark HALLINES), from the 1862 edition. P: Moreau-Nélaton collection. NY: Avery collection.

8th state. With the aquatint, new etched signature replacing 1862 letters. The only known proof, on China paper. Avery collection.

Fig. a. William Haussoullier, engraving after Velázquez, *Philip IV*, in *Gazette des Beaux-Arts*, July 1, 1863

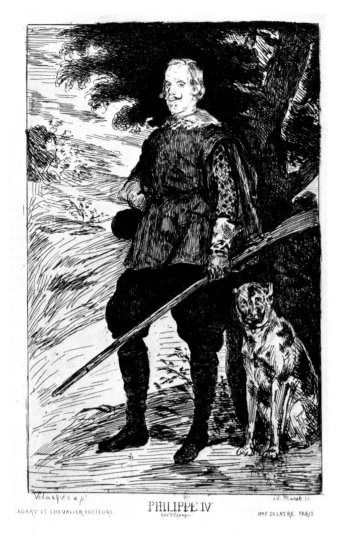

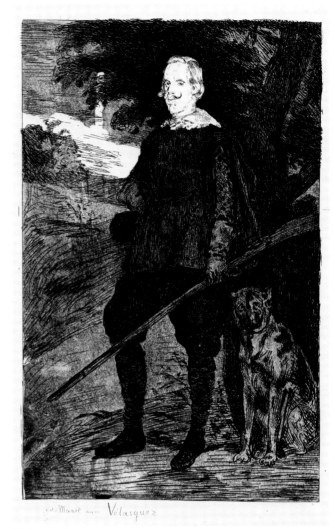

36 (6th state)

36 (8th state)

1. MI 292, on deposit from the Musée du Louvre in the Musée Goya-Jaurès, Castres.
2. Wilson 1978, no. 7.
3. Charles Blanc, "Vélasquez à Madrid," *Gazette des Beaux-Arts* XV (July 1863), p. 75.
4. Moreau-Nélaton 1926, I, p. 72.
5. T. Harris 1964, II, no. 11.
6. Paris, BN Estampes, acquired (A 1930) in 1856.

Provenance
The proof from the Cadart edition in the Bibliothèque Nationale is part of the MOREAU-NELATON bequest; its earlier provenance is unknown (see Provenance, cat. 9).

in the Costume of an Espada (cat. 33) reveal a new approach, a new emphasis on the picture plane, that Manet was to develop in *Music in the Tuileries* (cat. 38) and the lithograph of *The Balloon* (cat. 44; now known to date from September 1862).

Manet found inspiration not only in Velázquez but also in Goya, making direct use of Goya's motifs in the *Espada* (cat. 33–35) and adopting his etching technique in *Philip IV*, with broken contours and the use of lines that follow the forms to suggest volume. Whether or not Manet actually knew Goya's etched copies after Velázquez, he undoubtedly shared Goya's profound admiration for the Spanish master. The first and final states of Manet's *Philip IV*, to which he later added a veil of aquatint, are intriguingly similar to those of Goya's *Infante Don Fernando*,[5] of which the Cabinet des Estampes, in what was then the Bibliothèque Impériale, owned a superb aquatinted impression.[6]

The two proofs in the New York Public Library, one from the 1862 edition and the other, unique proof with aquatint (which may have been added for Cadart's 1874 publication), are from the AVERY collection (see Provenance, cat. 17). Here, too, information on their earlier provenance, which would be of particular interest for the unique proof, is lacking.

J.W.B.

37. Little Cavaliers, after Velázquez

1861–62 (1st–3rd states); 1867? (4th, 5th states)
Etching and drypoint
9¾ × 15⅜" (24.8 × 39 cm)
Signed (lower right): éd. Manet d'après Vélasquez
Museum of Fine Arts, Boston (1st state)

P Bibliothèque Nationale, Paris (3rd state)

NY The New York Public Library (4th state)

Manet regarded this as one of his most important prints, and it is possibly one of his earliest etchings. Its many states reveal a combination of the true painter-etcher's researches and the traditional practices of a reproductive engraver. Manet signed his plate in the traditional way, "éd. Manet d'après Vélasquez." In fact, it was probably a reproduction at second remove, which interpreted his own oil painting after the "Velázquez" in the Louvre (RW I 21; fig. a). It is interesting to speculate whether Manet regarded the water-colored first state of the print, in which the composition is still only lightly sketched, as a further, finished work in its own right or simply as an intermediate step between the painting and the later states of the print, since he went on to rework the copperplate extensively.

He strengthened the etching, defined the figures, and added boldly freehand etched inscriptions giving the names of the publishers, Cadart

Publications
8 Gravures à l'eau-forte, Cadart 1862, no. 2 (3rd state) (les Petits Cavaliers [d'après Vélasquez]); *Eaux-fortes par Edouard Manet,* 1863?; *Edouard Manet. Eaux-fortes,* Cadart 1874

Exhibitions
Salon des Refusés 1863, no. 674 (Les Petits cavaliers, d'après Vélasquez); Alma 1867, p. 16 (Les Petits Cavaliers, d'après Vélasquez); Salon 1869, no. 4066 (*Réunion de portraits,* d'après le tableau de Vélasquez du Musée du Louvre; eauforte); Beaux-Arts 1884, no. 160; Paris, Drouot 1884, no. 133; Philadelphia-Chicago 1966–67, no. 4; Ann Arbor 1969, no. 1; Ingelheim 1977, no. 10; Paris, Berès 1978, no. 23; Providence 1981, no. 35

37 (1st state)

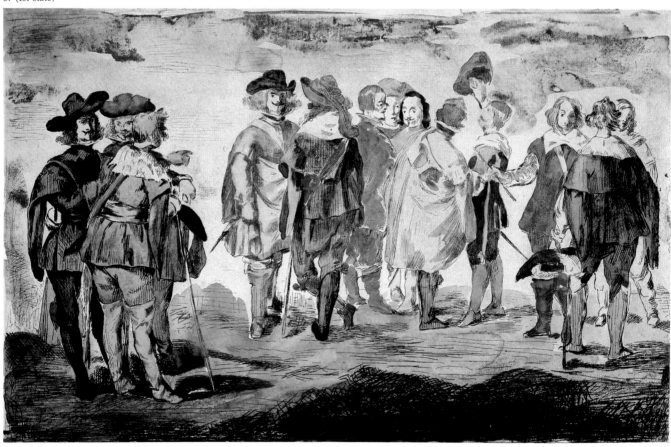

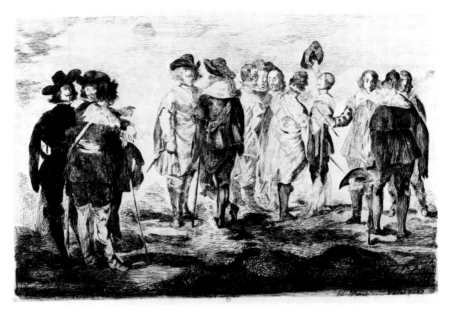

37 (3rd state)

Fig. a. Attributed to Velázquez, *Gathering of Thirteen Persons of Rank*. Musée du Louvre, Paris

Catalogues
M-N 1906, 5; JW 1932, mentioned 7; G 1944, 8; T 1947, 541; L 1969, 146; H 1970, 5; LM 1971, 4; RW 1975 II, mentioned 70; W 1977, 10; W 1978, 23 and App.

1st state (of 5). The etching lightly sketched. Proof on thin laid paper, extensively watercolored. Desfossés, Prince de Wagram collections.

3rd state. With the signature and the names of the publishers, Cadart and Chevalier, and the printer, Delâtre. Proof on laid paper (watermark HALLINES), from the 1862 edition. Moreau-Nélaton collection.

4th state. With the burnishing and drypoint rework following the "damage" to the copperplate. Only known proof. Avery collection.

1. Baudelaire 1976, p. 735.
2. Manet sale, Paris, February 4–5, 1884, lot 133; Bodelsen 1968, p. 342.
3. Desfossés sale, Paris, April 26, 1899, lot 77.

Provenance
1st state. The proof in the Museum of Fine Arts, Boston, is so extensively retouched with watercolor that it has always been counted among Manet's drawings. It was included in the "watercolor" section of the posthumous sale in 1884,[2] where it was acquired for 300 Frs by DESFOSSES (see Provenance, cat. 140). It reappeared in his

and Chevalier, and of the printer, Delâtre. Both this plate and the print of *The Spanish Singer* (cat. 11) have the kind of etched inscriptions usual for prints published separately or in a review. They may have been among the "several essays in etching" by Manet, Jeanron, and Ribot "to which M. Cadart has offered the hospitality of his shop windows on the rue de Richelieu," as noted by Baudelaire in his first article, in *La Revue anecdotique* of April 15, 1862, devoted to the etching revival.[1]

The print appeared in this state, with the etched inscriptions, in the album *8 Gravures à l'eau-forte* announced by Cadart the following September (see cat. 7–9). The painting attributed to Velázquez was undoubtedly of major importance for Manet's work (see cat. 2, 38), and his high regard for this print is proved by the number of times he exhibited and published it. It was shown in the print section of the Salon des Refusés in 1863, together with *Philip IV, after Velázquez* (cat. 36) and *Lola de Valence* (cat. 52), then in his one-man exhibition on the avenue de l'Alma in 1867, with the copy in oils, and again at the Salon of 1869, where it appears alone as no. 4066, the following number grouping four of his recent prints (see cat. 58). He republished the print as often as he could, including it in the private printing believed to have been made for his friends in 1863 (see cat. 45–47). Later, however, he was unable to comply with a request to reprint it, replying in a letter dated June 10 (presumably in 1867) that "the copperplate has been damaged and will take some time to repair" (for the full text, see cat. 7–9). The unique proof in the New York Public Library shows burnishing and drypoint work that were probably carried out as part of the restoration process. After a final reworking, the plate was published in Cadart's album *Edouard Manet. Eaux-fortes* of 1874.

sale in 1899[3] and was bought by BERNHEIM-JEUNE (see Provenance, cat. 31). It passed to the PRINCE DE WAGRAM (see Provenance, cat. 20) and reappeared in the United States in 1972, when it was acquired through the Lee M. Friedman Fund by the Museum of Fine Arts, Boston (inv. 1972.88). *3rd state.* The proof from the 1862 album came to the Bibliothèque Nationale as part of the bequest

of MOREAU-NELATON (see Provenance, cat. 9), without any indication of its earlier provenance. *4th state.* The very fine, unique proof of this state was probably acquired by LUCAS for AVERY and may well have come from the portfolios of SUZANNE MANET by way of GUERARD (see Provenance, cat. 17, 12, 16).

J.W.B.

38. Music in the Tuileries

1862
Oil on canvas
30 × 46½″ (76 × 118 cm)
Signed and dated (lower right): éd. Manet 1862
P The Trustees of the National Gallery, London

"At that time," Théodore Duret reports, "the Château des Tuileries, where the Emperor held his court, was a center of sumptuous occasions, which extended out into the Gardens. The concerts to be heard there twice a week attracted crowds of elegant society."[1]

Antonin Proust recalls many details of the period when, following the success of *The Spanish Singer* (cat. 10), "a little court gathered around [Manet]. He would go to the Tuileries almost daily from two to four o'clock, doing studies *en plein air*, under the trees, of children playing and groups of nursemaids relaxing on the chairs. Baudelaire was his usual companion. People watched with curiosity as this fashionably dressed artist set up his canvas, took up brush and palette, and painted away."[2] Proust's text, written at a point when he is emphasizing Manet's pre-Impressionist manner, should be interpreted cautiously as to his activities as a *plein-air* painter; Manet undoubtedly did this painting in his studio, in the summer of 1862, from drawings or watercolor studies (see cat. 39), of which one is a wash on a double spread of a sketchbook that blocks in the entire central portion of the composition (RW II 315; fig. a). Yet Proust's description gives us a fair notion of Manet, and the artist was himself of the company of top-hatted dandies in the picture, frequenters of his studio or of Tortoni's, the elegant boulevard café where he "would lunch before going to the Tuileries, and on his return to the same café from five to six o'clock accept compliments on his sketches as they passed from hand to hand."[3]

The very image of this elegant Second Empire society is here shown under the trees—the ladies mostly seated, the men standing. Nobody seems to be paying much attention to the musicians, probably a military band, not seen in the picture, near the painter's or the viewer's station.

The figures, all actual portraits, possibly painted from photographs,[4] are identified by Meier-Graefe,[5] with corrections by Tabarant,[6] as confirmed by Sandblad in his remarkable study of this work.[7] From left to right, we have first a masculine group composed of Manet; Albert de Balleroy (1828–1872), with whom he had shared a studio and who appears near him again two years later in Fantin-Latour's *Homage to Delacroix* (Musée d'Orsay-Galeries du Jeu de Paume, Paris); and Zacharie Astruc (1835–1907) seated, soon to be painted by Manet (cat. 94). Near the trunk of a tree, a small group of three men standing: Baudelaire (1821–1867; see cat. 54–58); Baron Taylor (1789–1879), inspector of museums and passionate exponent of Spanish art in France; and behind Baudelaire, at his left, the face of Fantin-Latour (1836–1904). The mustachioed figure standing behind Astruc has been identified as the journalist Aurélien Scholl (1833–1902), a "living incarnation of the boulevard,"[8] and the figure between the heads of Manet and Balleroy is Champfleury (see cat. 114).

In the foreground, the two ladies in bonnets are Mme Lejosne, wife

Exhibitions
Paris, Martinet 1863; Alma 1867, no. 24 (La Musique aux Tuileries); Beaux-Arts 1884, no. 9; New York, Durand-Ruel 1895, no. 14; London, Grafton 1905, no. 87; Salon d'Automne 1905, no. 2; London, Tate Gallery 1954, no. 2

Catalogues
D 1902, 16; M-N 1926 I, p. 34; M-N cat. ms., 33; T 1931, 28; JW 1932, 36; T 1947, 33; PO 1967, 32; RO 1970, 31; RW 1975 I, 51

Fig. a. Study for *Music in the Tuileries*, 1862, wash. Private collection

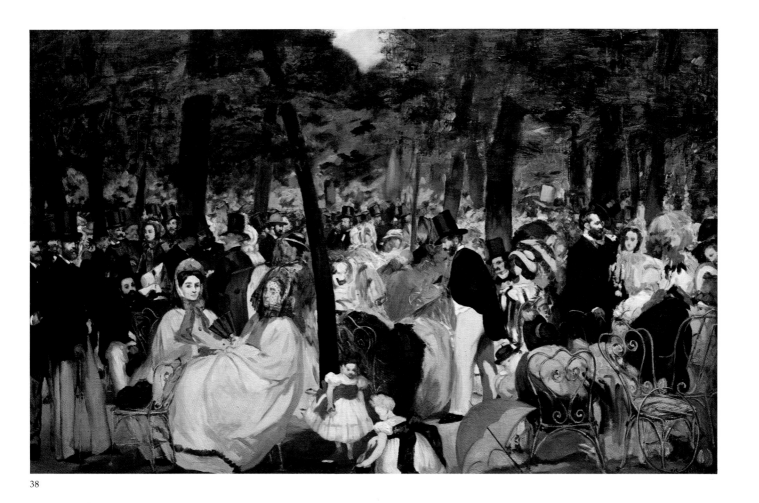

38

of Commandant Lejosne, at whose house Manet met Baudelaire and Bazille, and, according to Tabarant, Mme Loubens in a veil (Mme Offenbach, according to Meier-Graefe).

Toward the right, standing in profile, bowing, is Eugène Manet, presently to pose in *Le déjeuner sur l'herbe* (cat. 62), recognized by his daughter Julie when she saw the painting.[9] Seated to his right, his back to a tree, the recognizable face of the man Rossini called the Mozart of the Champs-Elysées, Jacques Offenbach (1819–1880), composer of *La Belle Hélène* (1864) and *La Vie parisienne* (1866).

We know through Monet that Charles Monginot (1825–1900), a painter associated with Manet and purveyor of arms for his paintings *Boy with a Sword* (cat. 14) and *The Luncheon in the Studio* (cat. 109), posed for this composition.[10] He is doubtless the standing figure at the right, politely doffing his stovepipe hat to the fine ladies, seated. In the foreground are some little girls, their frocks adorned with big bows at the back, like those Manet put in a perhaps slightly earlier painting, *Children in the Tuileries* (Museum of Art, Rhode Island School of Design, Providence), which may indeed have been painted in the gardens.[11]

The group of chairs in the foreground introduces a colorful motif of repeated curves, echoed throughout the feminine universe of the painting—including the children, bonnets, and parasols—whereas the men

and the trees are treated as dark verticals—trunks, coats, top hats. The chairs are of the new wrought-iron model, which had just recently replaced those of wood,[12] and they are painted with an insistence that must have seemed provocative, as a systematic introduction of so-called common objects into a composition.

Clearly the influence of conversations with his friend Baudelaire, who had just penned his long essay "Le Peintre de la vie moderne" (written in late 1859 and early 1860, rejected by the newspapers, and not published until 1863),[13] is reflected in the idea of this painting. The essay was about Constantin Guys, but it contained a profession of faith that Manet was perfectly ready to accept, and may also have inspired. Thus Proust tells us that from boyhood Manet thought Diderot ridiculous for asking the painters of his day not to depict certain hats because they were sure to go out of style: "'Now that is really stupid,' Manet exclaimed, 'one must be of one's time, draw what one sees, and not worry about fashion.'"[14] As early as 1846, in "L'Héroisme de la vie moderne," Baudelaire had pointed out: "The spectacle of elegant life and the thousands of ephemeral existences floating through the labyrinths of a big city . . . show that we have but to open our eyes to see our heroism." In Manet, the first part of this program is represented by *Music in the Tuileries*, and the second by *The Old Musician* (RW I 52) and *The Street Singer* (cat. 32), all painted in one year. "Paris life is rich in poetic and marvelous subjects, the marvelous envelops us and nurtures us like the atmosphere, but we don't see it."[15] "For the born *flâneur*, the passionate observer, it is an endless source of pleasure to enroll in the multitude, in the ebb and flow, the moving, the transient and boundless . . . he who loves life makes the world his family . . . the lover of universal life enters into the crowd as into a vast reservoir of electricity."[16] Manet could not fail to recognize himself in this passage, which he not only must have read or heard but may in part have inspired; Baudelaire may have been referring to Manet specifically when, wishing to show that genius "is but childhood regained," he cites a friend of his, "today a famous painter" (as Manet had been since the success of *The Spanish Singer*, cat. 10), describing a childhood memory of seeing his father dressing, and contemplating, "with amazement mingled with delight, the muscles of the arms, the gradation of colors of the skin, tinged with pink and yellow, and the network of bluish veins. . . . Already he was obsessed and possessed by form."[17]

But of course the sources of Manet's painting go beyond sentiments shared with Baudelaire. He used painting, the *genre noble*, for what had hitherto been widespread in the so-called minor iconography of news graphics and magazine illustrations. Sandblad first suggested that Manet had reinterpreted a traditional theme of popular prints, from that of Debucourt, in color, showing strollers in these same gardens, under the Consulate (1799–1804), to a wood engraving, for example, in *L'Illustration*, July 17, 1858.[18] Hanson has since shown how great may have been the influence of the engravings reproduced in *Les Français peints par eux-mêmes* (1840–42), a popular work of the time and an iconographic hunting ground for artists.[19] He also had before him the example of watercolors and drawings by such chroniclers of modern life as Gavarni and Guys.[20] We know that Manet, like his friends Nadar and Baudelaire, owned a series of Guys's watercolors of elegant society and of *la vie galante*. The receipt for a sale by Suzanne Manet to the dealer Paechter (undated, about 1900) mentions sixty drawings by Constantin Guys in the Manet collection, "horses, Bois de Boulogne sub-

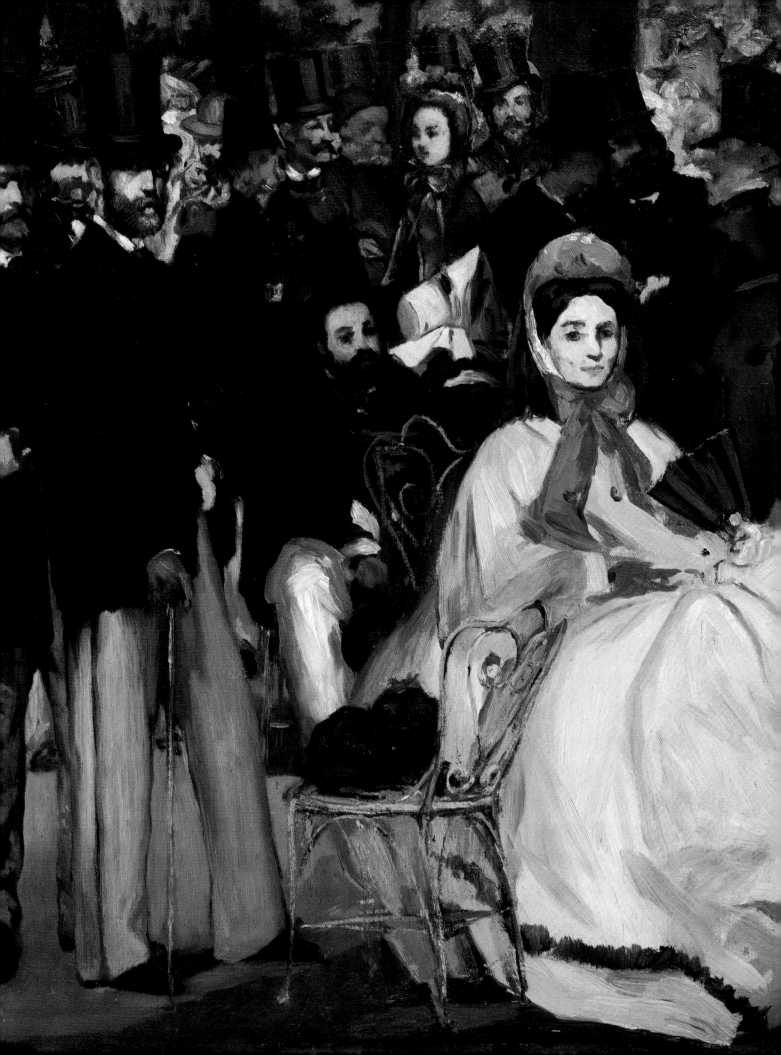

jects,"[21] and Hyslop has identified a drawing by Guys that belonged to Baudelaire, *Aux Champs-Elysées*, 1855 (Musée du Petit Palais, Paris), representing a similar subject.[22]

Furthermore, Manet was perhaps still working on the etching of his *Little Cavaliers* (cat. 37). Here he transposes that image of a meeting of artists in the open air (fig. b).[23] Having disguised himself as Rubens in *La pêche* (cat. 12), Manet now identifies himself again with Velázquez, said to have painted himself beside Murillo in the Spanish group. In fact, the 1858 Louvre catalogue entry reads: "The figures, thirteen in number, are thought to represent famous artists, contemporaries of Velázquez. He has placed himself, dressed in black, at the left, and Murillo, hardly more than his head visible, stands near him."[24] In other words, Manet, with a typical mixture of ambition, impudence, and delight in visual puns, represents himself as the "Velázquez of the Tuileries" and Albert de Balleroy as his companion Murillo.

This painting, in which there was much to interest Baudelaire, seemingly did not please him; he did not mention it in 1863, when it was shown at Martinet's and judged scandalous, both for its technique—setting off the striking, almost caricature details of the faces against the sketchiness of the apparel and the setting—and for its allegedly violent palette; according to Saint-Victor, "his *Concert in the Tuileries* hurts the eye as carnival music assaults the ear."[25] In 1867, Babou speaks of Manet's "mania for seeing things as patches," particularly in the portraits of this painting: "the Baudelaire patch, the Gautier patch, the Manet patch."[26]

Zola recorded a reminiscence by Manet himself when he wrote, in 1867, that "an exasperated visitor went so far as to threaten violence if *Music in the Tuileries* were allowed to remain in the exhibition hall." But Zola defends the painting in the name of realism: "If I had been there, I would have begged the visitor to draw back to a respectful distance, and he would then have seen that those patches live, that the crowd speaks, and that this canvas is one of the artist's characteristic works, one in which he has followed the dictates of his eye and his intuition most closely."[27]

According to Alexis, Delacroix, shortly before his death, having seen the painting, said, "I'm sorry I couldn't go to that man's defense."[28] The anecdote is to be accepted with reservations. All the same, it is tempting to imagine that before he died, the old Romantic saluted a work that might without strain be regarded (more than *Le déjeuner sur l'herbe*, which art history has generally cast in the role) as the earliest true example of modern painting, in both subject matter and technique. The progeny of this work in the ensuing decades is apparent in Bazille, Monet, and Renoir, so that it becomes the prototype of all Impressionist and Post-Impressionist art representing contemporary life out-of-doors and in popular public places.

Fig. b. Engraving after Velázquez, *Gathering of Artists*, in Charles Blanc, *Histoire des peintres*

1. Duret 1902, p. 18.
2. Proust 1897, pp. 170–71.
3. Proust 1897, p. 176.
4. Richardson 1958, p. 20.
5. Meier-Graefe 1912, pp. 107–9.
6. Tabarant 1931, pp. 52–53.
7. Sandblad 1954, pp. 17–68.
8. Meier-Graefe 1912, p. 108.
9. J. Manet 1979, p. 153.
10. Moreau-Nélaton 1926, p. 44.
11. Duret 1902, no. 17; Tabarant 1931, no. 29; Jamot and Wildenstein 1932, no. 35.
12. Sandblad 1954, p. 21.
13. Baudelaire 1976, pp. 1,413ff.
14. Proust 1897, p. 125.
15. Baudelaire 1976, pp. 495–96.
16. Ibid., pp. 691–92.
17. Ibid., pp. 690–91.
18. Sandblad 1954, p. 49.
19. Hanson 1972, p. 148.
20. Farwell (1973) 1981, pp. 80, 90, 118–20, 127–31.
21. Undated receipt (about 1900), New York, Pierpont Morgan Library, Tabarant archives; see also Rouart and Wildenstein 1975, I, p. 27.
22. Hyslop 1969, p. 116.
23. Charles Blanc, *L'Histoire des peintres*, cited in Sandblad 1954, pp. 37–38.
24. Villot 1864, no. 557.
25. Saint-Victor 1863.
26. Babou 1867, p. 289.
27. Zola 1867, *L'Artiste*, p. 56; Zola (Dentu), pp. 31–32.
28. Alexis 1880, p. 292.
29. Venturi 1939, II, p. 192.
30. Manet et al., "Copie faite pour Moreau-Nélaton . . .," p. 143; Callen 1974, pp. 168–69.
31. Venturi 1939, II, p. 192.

Provenance
Although Durand-Ruel recalled having bought this picture in 1872,[29] it seems to have remained in Manet's studio until January 1, 1883, when, according to the artist's account book, he sold it to FAURE (see Provenance, cat. 10).[30] The latter lent it in 1884 to the retrospective and in 1894 to an exhibition organized by DURAND-RUEL (see Provenance, cat. 118), who purchased the work in 1898. In 1906, the dealer sold it for 100,000 Frs to SIR HUGH LANE (1875–1915),[31] the great Irish collector of old master and Impressionist art, who received advice from his friends the painters and writers George Moore, Steer, Sickert, and Yeats. When Lane died in the sinking of the *Lusitania*, his modern French works were bequeathed to the National Gallery in London; the most important among these were the present painting, Manet's *Eva Gonzalès* (RW I 154), and Renoir's *The Umbrellas*. His other pictures were sold for the benefit of the museum in Dublin. *Music in the Tuileries* was exhibited at the Tate Gallery from 1917, then transferred in 1950 to the National Gallery (inv. 3260). The painting was cleaned in 1964.

F.C.

39. Corner of the Tuileries

1862?
India ink wash
7⅛ × 4⅜″ (18 × 11.2 cm)
Atelier stamp (lower right): E.M.
P Bibliothèque Nationale, Paris

Exhibitions
Orangerie 1932, no. 102

Catalogues
T 1947, 553; L 1969, 170; RW 1975 II, 313

This India ink brush sketch may be related to *Music in the Tuileries* (cat. 38) but is not really a preparatory study; the trees with their regular trunks reappear in the painting, but not the back view of the woman sitting on a bench—a nursemaid, perhaps. Very likely this is one of those sketches whose spontaneity and freedom enchanted the regulars at Tortoni's, according to Antonin Proust (see cat. 38).

The Louvre has two other sketchbook leaves belonging to this series, done on the spot in the Tuileries, *Two Little Girls in Profile* (RW II 311) and a page with a rather vaguely recognizable silhouette of Offenbach (RW II 314). Besides the preparatory drawing for the painting (cat. 38, fig. a), there is a charming sketch for the yellow bonnet and veiled straw hat of two figures immediately behind the seated ladies in the foreground (RW II 310).

Provenance
This drawing appeared at the sale of the BARRION collection (see Provenance, cat. 40) in 1904 under the title "Etude d'arbres avec un banc" (study of trees with a bench) among the lot of drawings acquired by MOREAU-NELATON. He bequeathed it to the Bibliothèque Nationale in 1927 (see Provenance, cat. 9).

F.C.

39

40. The Bear Trainer

1862
Brush and brown wash over pencil
6 × 10⅝" (15.4 × 27 cm)
Atelier stamp (lower left): E.M.
P Bibliothèque Nationale, Paris

41. The Bear Trainer

1862
Etching and aquatint
7⅜ × 10⅝" (18.8 × 26.9 cm)
Signed (lower left): éd. M
P Bibliothèque Nationale, Paris

The Bear Trainer represents the only case in Manet's work where a unique etching and its preparatory drawing have been reunited in the same collection. A comparison of the two throws light on one of Manet's characteristic working methods (of which other examples are cat. 16, 17, 34, 35, 124, 125). The drawing, on an irregularly cut and torn sheet of paper, is sketched out in pencil and finished with transparent brown wash—handled with greater freedom here than in the related drawing *The Acrobats* (cat. 43). The massive dark shape of the dancing bear and his shadow counterbalances the brightly lit figure of the trainer on the right, whose pose and gestures—leaning backward with arms raised, holding the bear's chain and a heavy stick—suggest the animal's dangerous nature. In the background, the crowd behind a barrier and the wheels of a wagon are drawn with a freedom that recalls some of Goya's preparatory drawings for the prints of the *Tauromaquia* and the *Disparates* or *Proverbios* series.

 Having completed his drawing, Manet placed the sheet of paper over a copperplate and pricked or incised the main lines of his composition onto the plate. He followed these indications with his etching needle, while still retaining the effect of an improvisation. A few top hats appear in the crowd; the bars of the bear's cage are clearly defined; and the stakes and rope in front of the wheels are more precisely delineated, continuing around in a circle toward the foreground, as with the shadows cast by an awning above the trainer.

 Since the composition was etched on the copperplate in the same direction as the drawing, the printed proof shows it in mirror reversal. Manet supplemented the structure of his design with an aquatint grain, setting off the man as a light shape against the surrounding shadows and the bear as a dark form against the light ground and barrier. The aquatint biting was apparently not well controlled, and some spots at upper left and a defective area at upper right may explain Manet's abandonment of the plate after he had seen a single proof in the aquatinted state.

 A date of about 1865 may have been suggested by Guérin[1] because of Moreau-Nélaton's opinion that the composition was "clearly borrowed

40
Exhibitions
Orangerie 1932, no. 104; Ingelheim 1977, no. Z/8

Catalogues
L 1969, 216; RW 1975 II, 562

41
Exhibitions
Paris, BN 1974–75, no. 140; Ingelheim 1977, no. 24

Catalogues
M-N 1906, 65; G 1944, 41; H 1970, 9; LM 1971, 35; W 1977, 24

The only known proof, on China paper.
Moreau-Nélaton collection.

40

41

from Goya"[2] and by the belief that it could have been inspired by Manet's visit to Spain in that year. Harris places the subject and its treatment in the context of Manet's prints and drawings of 1860 and 1861, however, and sees, in the idea of the standing figure dominating the composition, a relationship with *Mlle V . . . in the Costume of an Espada*, 1862 (cat. 33–35).[3] The composition undoubtedly exhibits a connection with Goya, some of whose bullfighters closely resemble the bear trainer. (Goya's *Tauromaquia* prints were readily available in France in the 1860s.) Nevertheless, the subject should be seen in the context of Manet's interest in the popular entertainments enjoyed by the Parisian public, also evident in the drawing *The Acrobats* (cat. 43) and, above all, in the lithograph *The Balloon* (cat. 44) and the painting *Music in the Tuileries* (cat. 38), the last two of which were executed during the summer of 1862.

1. Guérin 1944, no. 41.
2. Moreau-Nélaton 1906, no. 65.
3. Harris 1970, no. 9.
4. Lugt 1921, pp. 14–15, no. 76.
5. Barrion, second sale, Paris, May 25–June 1, 1904, lots 973–93 (prints), 1512 and 1513 (drawings).
6. Paris, BN Estampes (Rouart: *Marchand de vin à son comptoir*; Rouart and Wildenstein 1975, II, no. 510); one drawing remains unidentified: *Feuille de caricature*.

Provenance
40. This drawing is recorded for the first time in the sale of the Barrion collection. ALFRED BARRION (1842–1903), a pharmacist living at Bressuire (between Saumur and La Rochelle), began in 1879 to form a collection of modern prints and drawings of exceptionally high quality.[4] The collection was sold in Paris in 1904 (two years before the publication of Moreau-Nélaton's catalogue),[5] Manet's prints being dispersed in lots of two or three items and eleven drawings offered as a single lot, no. 1512. The lot was divided, and "Rouart" purchased one of the drawings for 32 Frs (see Provenance, cat. 3), according to Beurdeley's annotated copy of the catalogue.[6] Of the ten others, nine were acquired, directly or indirectly, by MOREAU-NELATON and formed part of his bequest to the Bibliothèque Nationale (see Provenance, cat. 9).

41. The unique etching proof may have come from the collection of FIOUPOU before its acquisition by MOREAU-NELATON (see Provenance, cat. 9).

J.W.B.

42. Street Musician

1862
Etching
8¼ × 11" (21 × 28 cm)
NY The New York Public Library

Manet's handling of *Boy with Sword, turned left I* (cat. 15), which marked the probable beginning of his etching career, was naïve and unsophisticated. Over the next few months his development was rapid but curiously erratic. The artist's basic problem was to find, with the etching needle and the bitten line, the same liberty and assurance of handling that characterized his drawings from the outset (see cat. 21–24). Although the plates of *Boy with Sword* (cat. 7) and *The Spanish Singer* (cat. 11) show a certain spontaneity and the hand of a true etcher rather than a reproductive printmaker, they are nevertheless limited by Manet's desire to reproduce his own paintings, which at this period were still strongly influenced by the art of the past.

At the moment when his paintings began to develop a more personal and "modern" character, in the Baudelairean sense, with *The Street Singer* (cat. 32), *Mlle V . . . in the Costume of an Espada* (cat. 33) and, above all, *Music in the Tuileries* (cat. 38), Manet's graphic work began to move in a similar direction, finding its most striking expression in the lithograph *The Balloon* (cat. 44).

In forging his new style, Manet drew on the popular culture of the period, promenading in the streets and public gardens, observing the singers, strolling players, marionettes, and the crowds gathered to watch these performers—elegant in *Music in the Tuileries*, popular in *The Balloon*

Exhibitions
Philadelphia-Chicago 1966–67, no. 35;
Washington 1982–83, no. 68

Catalogues
M-N 1906, 69; G 1944, 2; H 1970, 22; W 1977, 26

Fig. a. Alphonse Legros, *Théâtre de Polichinelle*, 1861, lithograph. Bibliothèque Nationale, Paris

42

The only known proof, on China paper.
Avery collection.

1. Harris 1970, no. 22.
2. Fried 1969, p. 39, pp. 70–71 n. 69.
3. Reff 1982, no. 68.
4. Paris, BN Estampes (Dc 300g, VIII, neg. 409).
5. Lugt 1921, pp. 381–82, no. 2071.
6. Burty sale, Paris, March 4–5, 1891, lot 247 (in 55 sublots).
7. Goncourt 1956: March 11, 1891; J. Adhémar 1965, p. 235, with an erroneous transcription "rangé" (put away) for "rayé" (canceled).

and in this print. Harris notes a naive quality that suggests the influence of Lecoq de Boisbaudron's methods: Manet may have worked directly, from memory, on the copperplate, without the help of a preparatory drawing.[1] She also points to the example of a lithographic poster of 1861 by Legros (fig. a); Fried also refers to the poster, drawing attention to the importance during that period of the popular theater and above all the marionettes of Duranty, who installed his Théâtre de Polichinelle in the Tuileries gardens in 1861.[2] Reff, for his part, has stressed the similarity with popular prints—"images d'Epinal" and caricatures—and has pointed out Manet's aim to depict "the urban milieu and its characteristic types," from the laundress with her basket to the policeman.[3]

Manet appears to have abandoned this plate after pulling a single proof. It is difficult to see how the design could have been reworked, given the spontaneous but firm handling of the left half of the print and the dominant figure of the singer. In the right half, the forms are much freer and appear bathed in light and atmosphere, creating a sense of movement, of the bustling crowd, which finds its full expression in *Music in the Tuileries* and *The Balloon*.

Provenance
A photograph taken by Lochard in 1883[4] appears to prove that this impression, if unique, was in Manet's studio at his death (see Provenance, cat. 12); then, in 1890, a proof appeared in the Burty sale. PHILIPPE BURTY (1830–1890), writer, art critic, etcher, and modern print enthusiast, amassed a collection of outstanding impressions of Manet's prints.[5] None was included in the sales held in Paris and London during his lifetime. The complete collection, in fifty-five lots, many of them made up of several prints or proofs, was sold as lot 247 in the catalogue of the sale of his collection, in March 1891.[6] Bought for 1,500 Frs by the dealer MANZI (see Provenance, cat. 19), the collection was acquired by DEGAS (see Provenance, cat. 15), with the exception, apparently, of three items, which do not reappear in the Degas sale. These items are sublot nos. 13, *Au Prado* (*At the Prado*, H 44); 18, *Mlle Morizot* [sic] (H 75); and 27, *Street Musicians*, in the Burty sale. Did LUCAS (see Provenance, cat. 17), always searching for rare items, obtain this unique proof from Manzi or even from Degas himself, after the sale, for Avery's collection? Or were there in fact two proofs of this print, one remaining in SUZANNE MANET's possession and acquired by AVERY, as usual, through GUERARD and LUCAS (see Provenance,

cat. 12, 17, 16), and another, in Burty's collection, that disappeared between 1891 and the sale of the Degas collection in 1918?

In connection with Burty's impression, the possibility of an earlier provenance is worth mentioning, since it seems likely to apply to this "unique" proof of *Street Musician*. J. Adhémar has published a passage from the Goncourt *Journal* relating to a proof stolen by Burty from Bracquemond: "In spite of the high prices made by Bracquemond's etchings at the Burty sale, Bracquemond came to see me in a rage, railing

against the soul of our friend: '. . . But what you don't know, I have never told anyone, is that he stole two prints from me, one of which was worth a 500-franc note . . . and the other perhaps 10 francs, but it was a curiosity, an extremely rare print. . . . The first is the ballad illustration by Millet . . . , the second is an etching by Manet that he made in my studio, which I printed myself and which he didn't like, and canceled the plate. . . . Yes, yes, I was certain he had stolen them. . . . So it was intriguing, wasn't it, for me to find them in his sale. . . . Well, I didn't find the expen-

sive one, the Millet. But the Manet, the one for which only one proof was pulled, which I kept, there it was, there it was!"[7]

In the Burty sale, only the proofs of *Street Musician*, *The Cats* (H 64; see cat. 113), and the frontispiece for *Les Ballades* by Théodore de Banville (H 82) come into the category of unique proofs, and the frontispiece in any case dates from a period when Manet probably no longer worked with Bracquemond.

J.W.B.

43. The Acrobats

1862?
Brush and brown wash over pencil
10⅛ × 11⅜" (25.8 × 29 cm)
Atelier stamp (lower left): E.M.
NY Bibliothèque Nationale, Paris

Lightly sketched in pencil and then reinforced and shaded with washes of brown ink, this study appears to have little in common with Manet's other drawings of 1862, which are usually characterized by a lively, often quirky outline, bold diagonal hatching applied with brush or crayon, and a subtle use of transparent washes.

Exhibitions
Orangerie 1932, no. 103

Catalogues
M-N 1926 I, fig. 29; T 1947, 544; L 1969, 217; RW 1975 II, 561

43

Fig. a. Victor Adam, *Royal Fête on the Champs-Elysées* (detail), 1829, lithograph

The drawing shows a scene at a fair or other public festival. Several pavilions appear in the background, and a crowd, lightly indicated, stands in a circle around the acrobats. On the left, a girl acrobat in a tutu adopts a provocative attitude as she faces the crowd; on the right, a wrestler observes the spectacle; and an acrobat balances on a trapeze carried by a strong man, half in shade, half in sunlight, striding into the open space on the ground. The drawing has probably faded and become less legible, but it can be related to the composition of *The Balloon*, of 1862 (cat. 44), even though it is possibly somewhat earlier. It could date from the summer of 1861, when Manet is said to have begun his studies of the different aspects of Parisian life (see cat. 38). Such scenes are depicted in numerous prints of the period (fig. a), and Farwell has shown examples extending over several decades.[1]

1. Farwell 1977, nos. 74–76.
2. Barrion, second sale, Paris, May 25–June 1, 1904, lot 1513.

Provenance
This drawing appeared as a separate lot, apart from the group of eleven, in the sale of the BARRION collection (see Provenance, cat. 40). Described under no. 1513 as "*Les Acrobates*, important dessin au lavis,"[2] it was acquired by MOREAU-NELATON and bequeathed to the Bibliothèque Nationale (see Provenance, cat. 9).

J.W.B.

44. The Balloon

1862
Lithograph
15⅞ × 20¼" (40.3 × 51.5 cm)
Signed and dated (lower right): éd. Manet 186[2]
P Bibliothèque Nationale, Paris
NY The New York Public Library

Exhibitions
Philadelphia-Chicago 1966–67, no. 40; Paris, BN 1974–75, no. 136; Santa Barbara 1977, no. 3; Ingelheim 1977, no. 28; London, BM 1978, no. 14; Providence 1981, no. 36; Washington 1982–83, no. 98

Catalogues
M-N 1906, 76; G 1944, 68; H 1970, 23; LM 1971, 68; W 1977, 28

Only state, of which five impressions are known, all on laid paper (watermark JHS). P: Moreau-Nélaton collection. NY: Avery collection.

During the spring and summer of 1862, Manet was occupied with a variety of projects. He was working on several major paintings (*The Old Musician*, RW I 52; cat. 32, 33, 38) and was also busy with a series of etchings after his own pictures or after works by Velázquez, for the album that Cadart was to announce in September (cat. 7–9, 18, 35, 37) and for the first issue of prints by the Société des Aquafortistes (cat. 48).

At this time, Cadart decided to extend his campaign for the promotion of artists' prints to the art of lithography. Burty had defended the lithographs of Géricault, Delacroix, and the romantic school, describing lithography as "the most spontaneous transcription of an artist's ideas, . . . which should always render these ideas with the force and purity of an original drawing."[1] At some time during the summer of 1862,[2] Cadart sent three lithographic stones each to five of the most active young artists in Paris (all of roughly the same age as Manet, except Ribot, who was ten years older). The stones were delivered to the artists' studios "with instructions to draw on them whatever they wanted. The results were to be made into an album and published."[3]

It appears, however, that Lemercier's printers, accustomed to impeccably finished, perfectly shaded lithographic designs (Rosenthal refers to the "clean, gray quality" of the lithographs of the period),[4] were horrified by some of the stones. Hédiard describes their reaction to Fantin-Latour's lithographs: "horrible, insane, uncivilized, nothing like it had ever been seen before."[5]

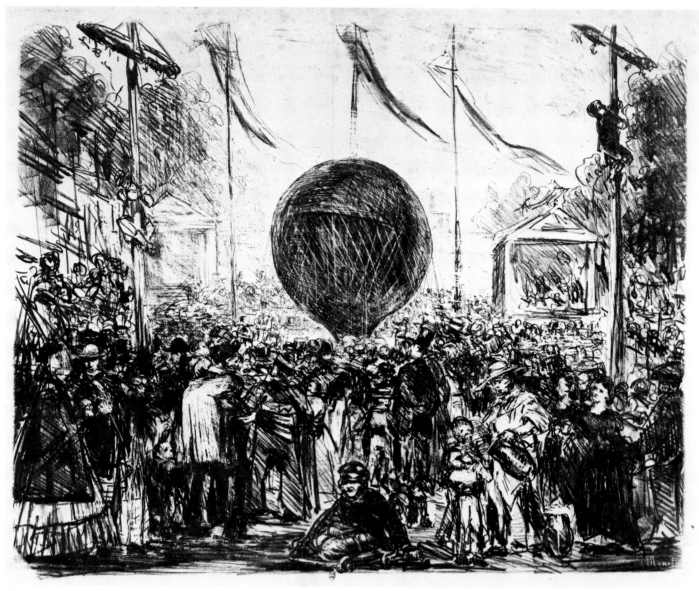

44

If Fantin-Latour's relatively "correct" images provoked such an out-cry, one can imagine the reaction to Manet's *Balloon*: a composition lacking in grace, apparently wildly "scribbled," and barely legible in places. Such freely drawn designs were no doubt regarded as an insult to the litho-grapher's profession, and, after a few trial proofs had been pulled, Cadart was persuaded to abandon his project. Druick has noted that most of the lithographs were proofed, no doubt on Cadart's instructions, on a laid paper normally used for drawing and quite unusual for lithographic printing; he concludes that Cadart intended to introduce a new type of lithograph, in the guise of an original drawing—in other words a "multiple drawing,"[6] whose possibilities had been evoked by Burty.

Manet used only one of his three stones. Unlike his colleagues in the project, who chose more traditional academic subjects, he portrayed a scene of immediate, popular interest—the ascent of a balloon, then one of the Parisian public's favorite entertainments. Reff has already suggested that the ascent might have been connected with the festivities on August 15,[7] the

Fig. a. *August 15 Festivities on the Esplanade des Invalides,* in *Le Monde illustré,* August 21, 1858

134

1. Parguez sale, Paris, April 22–24, 1861, p. xv; Bailly-Herzberg 1972, I, p. 21.
2. Druick and Hoog 1982, no. 41, provenance.
3. Hédiard 1906, p. 15; reprint 1980, p. 49.
4. Rosenthal 1925, p. 82.
5. Hédiard 1906, p. 16; reprint 1980, p. 50.
6. Druick and Hoog 1982, no. 41, provenance.

Feast of the Assumption, which Napoleon III had declared as France's *fête nationale*. Since the publication of the Moreau-Nélaton catalogue,[8] the site has generally been identified as the Tuileries. The simultaneous researches of Druick and Zegers, and of Kayser and Nicolaou of the Air and Space Museum at Paris-Le Bourget, however, have demonstrated that these August 15 celebrations are taking place on the esplanade in front of the Invalides, as shown in numerous illustrations of the period (figs. a, b).[9]

In the light of these discoveries, Druick and Zegers suggest that Manet's choice of subject has a symbolic significance close to the realities of his daily life and his concerns and convictions (see cat. 104, 105, 124).[10] This counters the esoteric interpretation suggested by Mauner, who sees in the scene a deliberate evocation of the Crucifixion, with "the great central balloon rising between the side crosses (which also recall the torture wheels found in . . . Pieter Brueghel), directly above the image of human misery in the form of the crippled beggar below."[11] In this connection, it is striking to realize to what extent the image is a scene observed from life. Kayser and Nicolaou, specialists in balloon history, are convinced that Manet was present as an enthusiastic and intelligent spectator of the ascent. Nicolaou writes: "Manet so precisely depicted the scene that he must have observed it. All the elements are there: the size of the gas balloon, capable of transporting one or two people, and the precision of the various maneuvers: behind the spectators, the balloon is being attached to the basket, while the team members hold the ropes attached to the net. A figure under the balloon secures the ropes to the load ring, and another checks the crow's feet. The fluttering banners suggest that the wind is picking up and that the balloon's departure may prove rather difficult."[12]

Druick and Zegers have found (and documents in the Hureau de Villeneuve collection at the French Air and Space Museum have confirmed) that the actual occasion is the ascent of Mme Poitevin in a balloon lent by Eugène Godard following an accident during the inflation of her own. The precision with which Manet describes the launching technique does not necessarily mean he was present at that particular ascent, however. His friend Nadar (fig. a) was an enthusiastic balloonist (the Air and Space Museum's archives provide an example, on July 10, 1862, at Montmartre, with Godard as the aeronaut and Nadar as the passenger). The numerous details—the figures holding the ropes; the bags of ballast surrounding the balloon; the two men, one seen from behind and the other crouching, in profile, working to maneuver the balloon to its place over the basket; and the balloon itself, slightly off center following the direction of the wind indicated by the banners—may well have been observed and noted in the course of one or several such ascents.

The same is true of the crowd, which is made up of many recognizable types: the lady with a veil at the left; the worker in a smock, with a child on his shoulder, holding another by the hand; the gentleman in a top hat, with a little dog; policemen; a seller of beverages pouring a drink for two children; two bareheaded working-class women; and a man wearing a cap. All these figures, not forgetting the cripple in the foreground, were no doubt sketched from life and then arranged to compose the crowd in the lithograph.

The setting itself is also absolutely true to life. The illustrated journals of the period confirm the placing, on either side of the esplanade, of the booths in which pantomimes were performed, the rows of banners, the

maypoles to left and right, and even the strolling acrobats on a raised stage which can be glimpsed above the heads of the crowd on the left of Manet's print (figs. b, c). In spite of its sketchy, imprecise appearance—the impressionistic handling that so shocked Lemercier's printers—the scene has been observed with close attention. Nevertheless, the treatment is altogether different from that of the traditional, topographical "view." Instead of giving a bird's-eye or a perspective view showing the full depth of the immense esplanade with the Invalides in the distance, Manet remains on the ground with the crowd, and his vantage point eliminates the impression of a vast space and the empty circle around the balloon, in accordance with his similar pictorial aims in *Music in the Tuileries* (cat. 38).

7. Reff 1982, no. 98.
8. Moreau-Nélaton 1926, I, pp. 40–41.
9. *Le Monde illustré*, August 21, 1858; *Le Voleur*, August 27, 1858; *L'Illustrateur des dames*, August 18, 1861 (Stéphane Nicolaou, pers. comm.).
10. D. Druick and P. Zegers, "Manet's 'Balloon': French Diversion, The Fête de l'Empereur 1862," *Print Collector's Newsletter* XIV (May–June 1983), pp. 37–46.
11. Mauner 1975, p. 175.
12. Stéphane Nicolaou, pers. comm., November 8, 1982.
13. B[iron] sale, Paris, April 13, 1910, lot 9 (repr.).
14. Burty sale, Paris, March 4–5, 1891, lot 9 (repr.); Degas collection, second sale, November 6–7, 1918, lot 269.

Provenance

The proof in the Bibliothèque Nationale, which is part of the MOREAU-NELATON bequest (see Provenance, cat. 9), was reproduced in his 1906 catalogue (identifiable by the strong fox marks in the sky, visible in the reproduction and, still, in the print). Its earlier provenance is uncertain. Since Moreau-Nélaton generally gives no collec-

tion reference in his catalogue for the prints that belonged to him, it had probably already entered his collection by 1906 and may have come from the LEENHOFF or FIOUPOU collection (see cat. 14 and Provenance, cat. 9).

The proof in the AVERY collection, in New York (see Provenance, cat. 17), was probably acquired from SUZANNE MANET through LUCAS

and GUERARD (see Provenance, cat. 12, 17, 16), since no other proof is mentioned by Guérin before Avery's death in 1904. (The marquis de Biron's proof was sold in 1910,[13] and Burty's, acquired by Degas, was auctioned in 1918;[14] see Provenance, cat. 42, 15.)

J.W.B.

45. Polichinelle Presents "Eaux-fortes par Edouard Manet"

Second cover design
1862
Etching
Plate: 12⅞ × 9½" (32.7 × 24 cm); image: 11⅝ × 8¼" (29.5 × 21.1 cm)
Signed and dated (lower right): éd. Manet 62
Title etched on the plate by the artist (center): EAUX-FORTES Par Edouard Manet
The New York Public Library

Henri Guérard added a manuscript note, probably at George Lucas's request, to the proof of this work that went to the collection of Samuel P. Avery, which he in turn gave to the New York Public Library (see Provenance). Guérard's information concerning the project that lay behind this print must have come from Manet himself or from his widow, Suzanne: "1st idea for the cover for the etchings by Manet published by Cadart and Chevalier."[1] Generally described as a "project for a frontispiece," it was in fact intended to illustrate the type of cover Cadart usually had printed, on a large sheet of colored paper that was then folded to contain a series of prints, by one or, as in the case of the publications of the Société des Aquafortistes (see cat. 7–9, 48), by several artists.

On the inside front cover of the inaugural publication of the Société's *Eaux-fortes modernes*, dated September 1, 1862 (see cat. 48), Cadart listed the prints he had available. Among them were several "collections" of etchings, including the set of six *Views of Holland* by Jongkind[2] and others by Bonvin, Chaplain, Millet, and Jacquemart. Manet's contribution was described as a collection of 8 etchings of various subjects, compositions by the

Exhibitions
Philadelphia-Chicago 1966–67, no. 129; Ann Arbor 1969, no. 16a; Ingelheim 1977, no. 34; Paris, Berès 1978, no. 39

Catalogues
M-N 1906, 48; G 1944, 29; H 1970, 38; LM 1971, 31; W 1977, 34; W 1978, 39

1st state (of 2). With a manuscript inscription in pencil, signed "H. Guérard." One of the two known proofs, printed on blue wove paper. Avery collection.

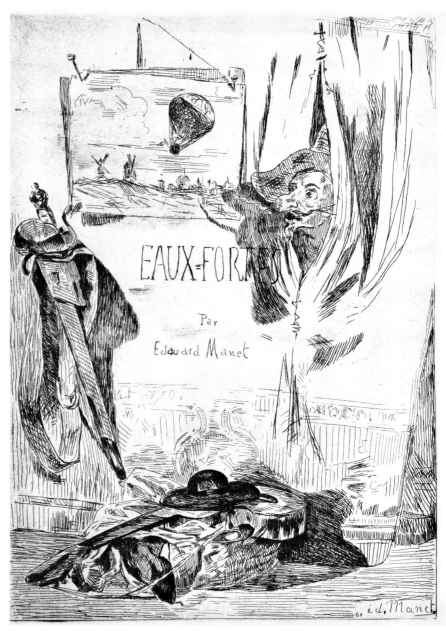

45

Fig. a. First cover design, *eaux-fortes par Edouard Manet*, 1862, etching. The New York Public Library

artist, 12 Frs for the collection, separately 2 Frs.[3] This was the album of eight sheets printed with nine etchings, six after his own paintings (see cat. 7, 11, 25, 35), two copies after Velázquez (cat. 36, 37), and one original composition (cat. 9).

The custom of illustrating the cover of this type of album was widespread, and Manet made several designs, none of them finally used for Cadart's publication. The first project (known from only two or three proofs) was probably the composition showing an open portfolio of prints on a stand, with a label lettered simply "eaux-fortes par Manet" (etchings by Manet), which is "presented" by a cat seated in the foreground (fig. a). Fried sees in this cat the traditional companion of Polichinelle (Pulcinella) and therefore a direct link with the following print, where Polichinelle himself appears through a gap in the stage curtain.[4] Mauner finds a source for this design in a print after Karel Dujardin, published in one of the issues on the

Dutch school in Charles Blanc's *Histoire des peintres* (fig. b),[5] and he points out the various elements—an image fixed to a post, a sword, and a guitar—that appear in Manet's print. Reff considers these motifs symbolic references to Manet's private life.[6]

It is undeniable that these elements appear in several of Manet's works at this period—the sword in *Boy with a Sword* (cat. 14) and the hat, bolero, and guitar in *The Spanish Singer* (cat. 10), in *Mlle V . . . in the Costume of an Espada* (cat. 33), and in the painting—the reverse of this print—of *Hat and Guitar,* an overdoor painted by Manet for his studio in the rue Guyot (RW I 60; see cat. 46,47, fig. a). Instead of reading into them a deeply symbolic significance, however, we can also see them as Manet's original interpretation of a perfectly traditional type of frontispiece, in which prints are presented in the form of an entertainment offered to the public. In this context, Fried's references to Duranty's marionettes, the Théâtre de Polichinelle, which Manet and his friends enjoyed watching in the Tuileries,[7] can be set alongside designs like Victor Adam's cover for *Nouveau recueil de croquis par divers artistes* (*New Album of Sketches by Various Artists*), published in 1831 (fig. c), or a design by Raffet for his own *Album lithographique* of 1835.[8] In Adam's cover design, Harlequin stands on stage in front of a curtain bearing the title "Variété," displaying and distributing to the enthusiastic crowd the prints, which are also parceled up in big packages marked "Croquis" (Sketches).

Apart from the objects already described, Manet's etching also includes a balloon print (a popular category of the period), which may be an allusion to his lithograph showing the ascent made on August 15 (see cat. 44). Polichinelle, as director of the show, is on the lookout for spectators, inviting them to see what is behind the curtain—in other words, the prints inside the covers of the album. In the end, the print of *Boy with a Sword*, which Manet had so much difficulty in etching and which was probably not finished in time (see cat. 18), was not included in the album, and the illustrated cover was also abandoned.

The print, known in only three impressions, is lightly etched in the first state and printed in brown ink on the blue paper used for the covers of the Société des Aquafortistes' publications. Probably because the etching was considered unlikely to withstand the printing of a large edition, the plate was apparently rebitten simply in order to reinforce and deepen the lines already etched in the copper. The unique proof in this state, also in the New York Public Library, is printed on ochre-colored Canson paper, which sets off the now more strongly etched design, printed this time in black ink. The effect is quite striking. Nevertheless, Manet decided or was forced, for technical reasons, to set aside the plate. The prints probably appeared in a cover (though none has survived) printed, like the title page in the only known complete set,[9] with an engraved title: *8 Gravures à l'eau-forte par Edouard Manet* (*8 Etchings by Edouard Manet*) followed by the list of plates: 1. *le Guitarero.* / 2. *les Petits Cavaliers (d'après Vélasquez).* / 3. *Philippe IV (d'après Vélasquez).* / 4. *l'Espada.* / 5. *le Buveur d'absinthe* / 6. *la Toilette.* / 7. *le Garçon et le Chien* / 8. *le Gamin.—la Petite Fille* (see cat. 7–9, 11, 25, 35–37). All these print titles appear, with those of earlier or more recent etchings, on the cover design, which took from this print only the motif of the "hat and guitar" (cat. 46, 47), abandoning the idea of Polichinelle's theater.

Fig. b. Engraving after Karel Dujardin, *The Charlatan* (detail), in Charles Blanc, *Histoire des peintres*

Fig. c. Victor Adam, *La Variété* (title page for a set of lithographs, detail), 1831. Bibliothèque Nationale, Paris

1. *1re idée de la couverture pour les eaux-fortes de Manet publiées par Cadart et Chevalier.*
2. Bailly-Herzberg 1972, II, pp. 121–23.
3. *Do [Collection] de 8 do [eaux-fortes] sujets divers, compositions de l'auteur coll. 12. séparé 2 [Fr]*.
4. Fried 1969, pp. 38–39.
5. Mauner 1975, pp. 169–70; Reff 1970.
6. Reff 1962.
7. Fried 1969, pp. 38–39.
8. Farwell 1977, no. 38.
9. Paris, BN Estampes (Dc 300e Rés.).
10. Wilson 1978, no. 39.
11. Paris, BN Estampes (Dc 300g, VIII, no. 421).
12. Lucas 1979, II, p. 669.

while Harris lists the two in the New York Public Library. A Lochard photograph shows a proof in the second state, taken in Manet's studio in 1883.[11] It is therefore likely that both proofs came from SUZANNE MANET and were acquired by Avery through LUCAS and GUERARD (see Provenance, cat. 12, 17, 16). Concerning the note by

Guérard on the proof in the first state, it is worth citing, by way of example, a passage from Lucas's diary for May 8, 1888: "At Guerard's for him to revise & mark the Manets bought for SPA [Samuel P. Avery]. Bought 3 of him for 20 fs."[12]

J.W.B.

46. *Cover design for "Eaux-fortes par Edouard Manet"*

1862
Pencil, watercolor, and India ink
14¾ × 10⅜" (37.5 × 26.5 cm)
The New York Public Library

47. "Eaux-fortes par Edouard Manet" Hat and Guitar

Cover design for an album of fourteen etchings
1862-63/1874
Etching, drypoint, and aquatint
Plate, 1st state: 17⅜ × 11¾" (44.1 × 29.8 cm); image, 1st state: 13⅛ × 8⅞" (33.2 × 22.4); plate, 2nd state: 9⅛ × 8⅝" (23.1 × 21.9 cm)
Title and list of fourteen plates etched on the plate by the artist (1st state); title (2nd state)
Nationalmuseum, Stockholm (1st state)
P Bibliothèque Nationale, Paris (2nd state)
NY The New York Public Library (2nd state)

Having abandoned the idea of an illustrated cover for Cadart's edition of his album *8 Gravures à l'eau-forte* (see cat. 45), Manet appears to have planned another publication with a different and more numerous selection of prints. His watercolor for the new cover design, drawn in pencil on laid paper bearing the watermark HALLINES (used by Cadart for the first issues of the Société des Aquafortistes and for Manet's album *8 Gravures*), takes up the motif of the hat and guitar on a basket of Spanish costumes. The watercolor brings out the warm tones of the wood in the guitar, its red ribbon, and the pale (probably faded) pink of the heap of cloth, which no doubt corresponds to the "cape" brandished by the model in *Mlle V . . . in the Costume of an Espada* (cat. 33, 34).

The sketched lettering and the border indicated around the composition were then vigorously redrawn with a brush and India ink. The main title was brushed to read from left to right, but below, on ruled lines, Manet took pains to write the titles of the plates in reverse so that when he copied them on the copperplate they would read correctly in the prints. As for the "hat and guitar" motif, it is copied from the painting (RW I 60) and prints in reverse in the proofs (fig. a). The watercolor drawing shows traces of the sharp instrument used to incise the main lines of the design for transfer to the plate.

46

47 (1st state)

The first state of the print is a faithful etched and aquatinted reproduction of the drawing. One proof is on the same paper as that used for the drawing and is dedicated by Manet "to M. J. Fioupou."[1] The other four known impressions are printed on a thick wove paper. Of these, only one example survives on the original folded sheet that no doubt served as the cover for the prints Manet offered to his close friends. The four proofs are dedicated: "to my friend Charles Baudelaire," "to Commandant Lejosne," "to P.M. . . ." (either Paul Montluc, the dedicatee of the complete collection of *8 Gravures* [see cat. 45], or Paul Meurice—the name has been scraped away on the proof in the New York Public Library), and to another unidentifiable friend.[2] To Baudelaire, "my friend" (the others merited an expression "of friendship" or, in the case of Lejosne, "of sincere friendship"), Manet gave the proof inscribed, at lower right, in pencil, with his initialed printing instructions: "28 pièces EM" (28 proofs EM).

None of the twenty-eight sets has survived intact. One has been reported, with a complete set of the etchings on China paper (laid on large sheets of wove paper), as belonging to Morel Vindé, an architect active around 1860 who must have been part of Manet's circle.[3] The list on the drawing includes the titles of nine prints, of which six were published in the album *8 Gravures*. On the print itself, the list has lengthened to fourteen titles, some of them earlier prints (H 8; cat. 25), others published or announced in September 1862, as well as his most recent etchings, *Lola de Valence* (cat. 52), exhibited at the Salon des Refusés in May 1863, and *Don Mariano Camprubi* (H 34; cat. 52, fig. a). The deletions and additions on both

1st state (of 6). One of five known proofs, on a single, cut sheet of thick wove paper. With a pen and ink dedication "à mon ami Charles Baudelaire / Edouard Manet," at upper right, and the edition size in pencil, at lower right, "28 pièces EM." The number inscribed in pencil in the lower right corner, "247/1," is that of the lot number in the Burty sale catalogue. Baudelaire, Burty, Degas, Schotte collections.

2nd state. With the reduction of the plate and a new engraved title. Proofs of the cover, on blue paper (single, cut sheets), signed in ink with the artist's initials and numbered "27" (P) and "30" (NY), from the 1874 edition. P: Moreau-Nélaton collection. NY: Avery collection.

Fig. a. *Hat and Guitar,* 1862. Musée Calvet, Avignon

47 (2nd state)

lists—on the drawing and the print—reveal Manet's hesitations concerning the contents of the album of "fourteen etchings."

Manet appears to have been working on the idea of this presentation printing during the summer or autumn of 1863, possibly in the context of his decision, no doubt made on the death of his father at the end of September 1862, to marry his companion, Suzanne Leenhoff.[4] The marriage took place in the Netherlands on October 28, 1863. Baudelaire commented on this event with some surprise but expressed great satisfaction on behalf of his friend (see cat. 107); the poet no doubt received his dedicated set of prints before his departure for Belgium in the spring of 1864.

For the second album of Manet's prints, published by Cadart in 1874, the plate was cut down to remove the border and the title and list, which were replaced by a professionally engraved title. In this state, the print was used both as a cover design, printed on blue paper (like the earlier project, cat. 45), and as a title page, printed on Japan paper like the other plates in the album. The complete set owned by Burty included seven prints already published in 1862 and 1863 as well as two more recent etchings, among them *The Dead Toreador* (H 55), which had been exhibited at the Salon of 1869.[5]

This project in fact marked the end of Manet's efforts to have his prints published and circulated to a wide public, both original compositions as well as the prints after his own paintings or after works by Velázquez. In 1868, he referred to Degas's opinions concerning the timeliness, or otherwise, of an art—the original print?—"within the means of the poorer classes and making paintings available for the price of 13 *sols* [10 cents]."[6] Unfortunately, Manet's own prints appear to have been sought after and appreciated by only a small circle of friends and collectors, who belonged to a limited, cultured social group.

1. Paris, BN Estampes (Dc 300g Rés.: à M. J. Fioupou).
2. Wilson 1978, no. 68.
3. Hubert Prouté, pers. comm.
4. Wilson 1978, no. 68.
5. Moreau-Nélaton 1906, intro., reprinted in Guérin 1944, p. 13; Picard sale, Paris, October 26, 1964, lot 117.
6. Moreau-Nélaton 1926, I, pp. 102–3.
7. Burty sale, Paris, March 4–5, 1891, lot 247, no. 1.
8. Degas collection, second sale, November 6–7, 1918, lot 224.

Provenance
46. On the back of the sheet is a curious bilingual note: "aquarelle / Originated Ed. Manet—provenant de sa veuve." If the "watercolor . . . came from" SUZANNE MANET, it probably passed through GUERARD to LUCAS, who would have added the inscription before dispatching it to AVERY (see Provenance, cat. 12, 16, 17).

47. The proof dedicated "to my friend Charles Baudelaire" is a moving testimony to the close relationship between the artist and the poet. Before or after the death of BAUDELAIRE (see cat. 54–58 and Provenance, cat. 27) in 1867, this choice proof was acquired by BURTY (see Provenance, cat. 42). Inscribed at lower right, beside Manet's initialed printing instructions, are the lot and sublot numbers, 247/1, in the Burty sale.[7] The proof passed from MANZI to DEGAS and reappeared in the sale of his collection in 1918,[8] when it left France for a Swedish collection (see Provenance, cat. 19, 15).

J.W.B.

48. The Gypsies

1862
Etching
Plate: 12⅝ × 9⅜″ (32 × 23.8 cm); image: 11¼ × 8⅛″ (28.5 × 20.6 cm)
Signed (lower right): éd. Manet
Title engraved below the image: LES GITANOS (3rd state)
P Bibliothèque Nationale, Paris (2nd state)
NY Bibliothèque Nationale, Paris (3rd state)

This print is a free, reversed transcription of a large composition painted by Manet in 1862. The oil and the etching were exhibited at Martinet's gallery in the following year and again in 1867 at the avenue de l'Alma one-man exhibition. After this, Manet cut the canvas; three fragments have survived (RW I 42–44).[1] The etching appears here not to record the existence of the painting in Manet's oeuvre but to mark the official start of his printmaking career. It was one of the five prints published by the Société des Aquafortistes in the first issue, dated September 1, 1862, of its series *Eaux-fortes modernes (Modern Etchings)*.

Founded in May 1862 (see cat. 7–9), the Société had its registered offices in the building on the rue de Richelieu where the print publisher and dealer Cadart carried on his activities, first at no. 66 and then, from October 1863, at no. 79, on the corner of the rue Ménars, where the large shop windows were filled with prints (fig. a). The prospectus for *Eaux-fortes modernes*, "an artistic publication of original works by the Société des Aquafortistes," announced the issue of "sixty original etched prints a year, printed on laid paper, measuring 55 × 35 centimeters, . . . at a rate of five impressions each month."[2] The cost of a year's subscription was 50 Frs in Paris and 55 Frs in the provinces, and the public was informed that "provincial and foreign subscribers will receive their subscription copies through the mail, on a wooden roller to preserve them from damage."[3] It was also possible to subscribe, at a cost of 100 Frs, to a "deluxe edition on Holland paper, in an edition of 25 proofs before letters."[4]

Manet's *Gypsies* was published in this way, together with prints by Bracquemond, Daubigny, Legros, and Ribot, in a blue cover bearing the Société's name, the title of the series, and the announcement (on the inside front cover) of the etchings by members of the Société available from the publishers, Cadart and Chevalier (see cat. 45). This was one of a few prints by Manet to receive critical attention at the time of publication. Two weeks after it first appeared, Lamquet devoted an article to the creation of the Société, noting that "M. Manet's composition includes four figures, of which at least three are quite unbearable. . . . Nevertheless, one has to recognize the powerful qualities of the effect achieved in this distinctive etching, which, when seen from a sufficient distance so that the carelessness of the drawing is no longer visible, offers a highly original effect of composition and tone."[5]

Exhibited together with the painting at Martinet's gallery in the spring of 1863, *The Gypsies* caught the attention of Paul de Saint-Victor, who criticized the painting, writing in *La Presse*: "His *Smugglers* . . . would only have to show themselves to put the most intrepid customs officers to flight,"

Publications
Eaux-fortes modernes, Société des Aquafortistes, Cadart, September 1, 1862, pl. 4; *Eaux-fortes par Edouard Manet*, 1863?; *Cent eaux-fortes par cent artistes*, Cadart 1872; *Edouard Manet. Eaux-fortes*, Cadart 1874

Exhibitions
Paris, Martinet 1863; Alma 1867, p. 16 (Les Gitanos); Beaux-Arts 1884, no. 158; Philadelphia-Chicago 1966–67, no. 32; Ann Arbor 1969, no. 13; Ingelheim 1977, no. 17; Paris, Berès 1978, no. 32

Catalogues
M-N 1906, 2; G 1944, 21; H 1970, 18; LM 1971, 16; W 1977, 17; W 1978, 32

2nd state (of 5). Before letters. Proof on China paper. Moreau-Nélaton collection.

3rd state. With the engraved title and the names of the artist and the printer, Delâtre, and with the number at upper right. On laid paper, from the 1862 Société des Aquafortistes edition. Moreau-Nélaton collection.

Fig. a. Adolphe Martial, *Cadart's Shop*, 1864, etching, published by the Société des Aquafortistes, no. 124

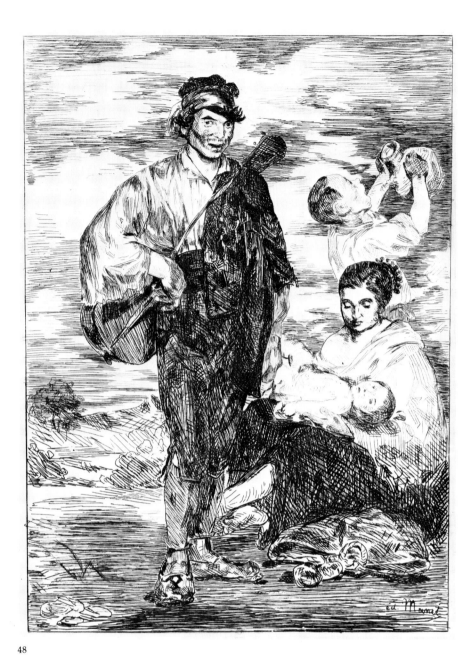

48

Fig. b. *A Woman from Limoges,* engraving in *Les Français peints par eux-mêmes*

Fig. c. *A Man from Bourges,* engraving in *Les Français peints par eux-mêmes*

adding that "the etching is more successful than the oil. His *Gypsies* have class and a fine aspect. I particularly like the one with his head thrown back who empties a jug into his open mouth; Velázquez's *Drinkers* would take him into their brotherhood."[6] Saint-Victor recognized qualities in *The Gypsies* that reminded him of the works of Velázquez, and in this composition Manet seems to have attempted to fuse the kind of images that appeared in the popular albums of *Les Français peints par eux-mêmes* (figs. b, c),[7] presenting the picturesque gypsy "type," but in the manner of Velázquez, whose presumed portrait *Philip IV as a Hunter* had been acquired by the Musée du Louvre in May 1862 (see cat. 36). The pose of the principal gypsy and the landscape background appear to owe their inspiration to both sources.

In his February 1863 review of the first five issues of the Société, Philippe Burty placed in the camp of the "excessive" etchers "M. Edouard Manet, who has the excuse of a masterful handling of color in his paintings;

his *Gypsies* appear inspired by Goya, at least in their general effect."[8] Burty had already thought it necessary, in the *Chronique des arts* of January 1, "to reassure any subscribers shocked in principle by a few rather brutal plates," by explaining that the Société's committee included "artists offering the most serious guarantees of talent and character."[9] A month later, in the review already mentioned, he thought it necessary to address a word of warning to the committee, "to avoid any ill-considered exclusions. There is already a rumor that this committee may be more severe than the official [Salon] jury! How typical of artists!" It is perhaps significant that Manet's second, and last, etching published by the Société des Aquafortistes was a much more restrained reproductive print after his painting *Lola de Valence* (cat. 52). The plate of *The Gypsies* was reissued in several of Cadart's publications and was still listed, at 6 Frs a print, in his 1878 catalogue.

Provenance
2nd state. The proof before letters, on China paper, must be an "artist's proof," printed before the lettering and number were engraved on the plate by a technician for its publication by the Société des Aquafortistes. It may have been used for the sets of prints dedicated by Manet to his friends (small margins are a characteristic of these proofs, which were mounted on large sheets contained in the illustrated cover; see cat. 47). It could conceivably have come from the collection of FIOUPOU (to whom Manet dedicated a proof of his cover design), and was acquired by MOREAU-NELATON, who bequeathed it with his print collection to the Bibliothèque Nationale (see Provenance, cat. 9).

3rd state. The proof from the Société des Aquafortistes' issue was also acquired by MOREAU-NELATON. It is interesting to note that, whereas the American print collections formed during the period 1880 to 1910 are extraordinarily rich in rare proofs, they contain relatively few examples of the editions of Manet's prints published by Cadart during his lifetime; one finds numerous impressions from the reprint editions made after his death, at the time when Lucas and Avery (see Provenance, cat. 17) were actively purchasing prints from dealers and print publishers, such as Dumont and Strölin (see Provenance, cat. 11: copperplate).

J.W.B.

1. Hanson 1970.
2. [*Publication artistique d'oeuvres originales par la Société des Aquafortistes;* . . .] *60 gravures Eaux-fortes originales par année, tirées sur papier vergé, d'un format de 0,55 cent. sur 0,35* [. . .] *à raison de 5 épreuves par mois.*
3. [. . .] *les souscripteurs de la province et de l'étranger recevront leur abonnement par la poste, sur rouleau de bois, à l'abri de toute dégradation.*
4. Bailly-Herzberg 1972, I, pp. 46, 49.
5. Lamquet, in *Les Beaux-Arts* V (September 15, 1862); Bailly-Herzberg 1972, I, p. 55 and n. 29.
6. Saint-Victor 1863; Moreau-Nélaton 1926, I, p. 46; J. Adhémar 1965, p. 231.
7. *Les Français peints par eux-mêmes, encyclopédie morale du dix-neuvième siècle–Province,* 3 vols., Paris, 1841–42: Vol. II, "Limousine," opp. p. 249, "Le Berruyer," opp. p. 525; see Hanson 1972, pp. 155–58; Hanson 1977, pp. 60–61.
8. Philippe Burty, "Livres d'art: *La Société des Aquafortistes, publication artistique d'eaux-fortes, oeuvres originales,*" *Gazette des Beaux-Arts,* XIV (February 1863), p. 191.
9. Philippe Burty, in *Chronique des arts et de la curiosité,* January 1, 1863, quoted in Bailly-Herzberg 1972, I, p. 44.

49. The Spanish Ballet

1862
India ink, pen, and wash heightened with watercolor and gouache
9 × 16⅛" (23 × 41 cm)
Signed (lower left): Manet
P Szépmüvészeti Múzeum, Budapest

On August 12, 1862, the dance troupe from the Royal Theater in Madrid opened their second triumphant season at the Hippodrome with the ballet *La Flor de Sevilla.* The principal dancers were Mariano Camprubi and Lola Melea, known as Lola de Valence. Manet, enthusiastic as all Paris was, persuaded the group to pose for him in Alfred Stevens's rue Taitbout studio, more commodious than his own.[1] He first did a painting of a group of four dancers and two guitarists (RW I 55; fig. a). This drawing appears to be the draft for the painting. The scene, though posed, simulates the tavern scene in the ballet. Manet used a table and a bench, in Stevens's studio, which reappear in another Spanish composition, *La posada,* which he painted, then drew, and etched (RW I 110; RW II 534; fig. b). It is hard to say whether the troupe posed together, or whether, as the slightly arbitrary distribution of figures suggests, Manet assembled this study for the painting from sketches of individual dancers or dancers grouped in twos. The two men wrapped in

Catalogues
T 1931, 22 (watercolors); JW 1932, mentioned 48; T 1947, 557; L 1969, 176; RW 1975 II, 533

49

their capes seem to be taken from a print by Goya (see cat. 35, fig. a). They are echoed in *La posada*, which, judging by its quite similar size and theme, may have been conceived as a pendant to *The Spanish Ballet*—a dance scene in a tavern, answering to a gathering of *toreros* in the same setting. Here Manet wished to suggest a stage performance, as indicated by the bouquet in white paper in the foreground—a first discreet appearance of one of the elements in *Olympia* (cat. 64). The two guitarists (the one at left in *Spanish Singer* pose; see cat. 10) flank two couples, one at rest (Lola de Valence seated and a tambourine player standing) and one dancing (Anita Montez and Mariano Camprubi). About this time, Camprubi inspired a charming little full-length portrait (RW I 54), a pen-and-ink drawing (RW II 461), and an etching (see cat. 52, fig. a).

1. Tabarant 1947, p. 52.
2. André sale, Paris, May 18–19, 1914, no. 76 (ill.).

Provenance
This work was purchased at the CHARLES ANDRE sale by the dealer STROLIN (see Provenance, cat. 11)[2] and given by PAL VON MAJOVSZKI to the Szépmüvészeti Múzeum in Budapest in 1925 (inv. 1925.1200).

F.C.

Fig. a. *The Spanish Ballet*, 1862. The Phillips Collection, Washington, D.C.

Fig. b. *La posada*, 1862, etching. The New York Public Library

50. Lola de Valence

1862 / after 1867
Oil on canvas
48½ × 36¼" (123 × 92 cm)
Signed (lower left): éd. Manet
P Musée d'Orsay (Galeries du Jeu de Paume), Paris

A "beauty at once darkling and lively in character," as Baudelaire was to describe the star of Mariano Camprubi's Spanish ballet (see cat. 49):[1] Lola Melea, called Lola de Valence, well known to Manet's friends, such as Baudelaire and Zacharie Astruc (see cat. 53). The latter, in his recollections of a trip he took to Spain soon after the time of this painting, wrote, "I was hoping to see Lola again, my favorite dancer, my friend Manet's amusing model, so often fêted, embraced, and cherished in Paris. What promised happiness!"[2]

In painting Lola, Manet was carrying on a well-established Paris tradition of representing Spanish dancers on the stage, from Lancret's *La Camargo* (fig. a) in the eighteenth century to Chassériau's *La Petra Camara* (Szépmüvészeti Múzeum, Budapest), which he might have had the opportunity to see at Théophile Gautier's, where it then was. In 1851, Courbet had done a likeness of *Adela Guerrero* (Musées Royaux des Beaux-Arts de Belgique, Brussels) for Leopold I, king of Belgium; probably it had no part in the evolution of Manet's painting,[3] but as Hanson has shown, it is an indication of how prevalent this kind of subject was, and how widely disseminated in popular graphic art.[4]

The Spanish theme, after the success of *The Spanish Singer* (cat. 10), and the size of the painting indicate that very likely Manet originally meant to submit it to the Salon. Probably it was in his own studio, not in that of Alfred Stevens, where the group composition was set (see cat. 49), that Manet posed Lola, at rest, her feet in the fourth position of classical dance, reminiscent also of Goya's full-length female portraits, notably his *Duchess of Alba* (fig. b). This Manet could have seen either in the Galerie Espagnole at the Louvre (1838–48),[5] or more likely in the famous Pereire collection, to which Astruc would have had access.

Manet at first placed the figure on a plain neutral background, the approach he retained in both the drawing and the etching (cat. 51, 52). It was "on the advice of his friends," Tabarant tells us, that he added, at the upper right, the stage scenery and the indication of spectators at the Hippodrome, as though Lola were about to make an entrance.[6] It was undoubtedly imaginary scenery, since although the Hippodrome could be used as a theater, it was an open-air theater, with very limited sets. Still, the allusive image must have been plausible to a spectator of the time; a Daumier print (fig. c) of a reigning *comédienne* preparing to return to the stage shows a similar arrangement—cutout drop at the left, audience in balconies at the right.[7]

This change was made later, probably even after the avenue de l'Alma show in 1867, since it is not clear in Randon's caricature, made from the exhibition (fig. d).[8] Furthermore, X-ray examination reveals two additions of about 4 inches (10 cm) top and bottom; the original canvas ended under the dancer's foot. This last alteration, as we know from the dimensions at the 1867 show (105 × 95 cm), was made later.

Exhibitions
Paris, Martinet 1863, no. 129; Alma 1867, no. 17 (Lola de Valence, 105 × 95 cm); Beaux-Arts 1884, no. 14; New York, National Academy of Design 1886, no. 227; Exposition Universelle 1889, no. 497 bis; Orangerie 1932, no. 7; Orangerie 1952, without no.; London, Tate Gallery 1954, no. 1; Philadelphia-Chicago 1966–67, no. 44

Catalogues
D 1902, 36; M-N 1926 I, p. 35; M-N cat. ms., 43; T 1931, 51; JW 1932, 46; T 1947, 52; PO 1967, 48; RO 1970, 47; RW 1975 I, 53

Fig. a. Nicolas Lancret, *La Camargo*. The Hermitage, Leningrad

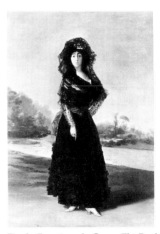

Fig. b. Francisco de Goya, *The Duchess of Alba*, 1799. The Hispanic Society of America, New York

146

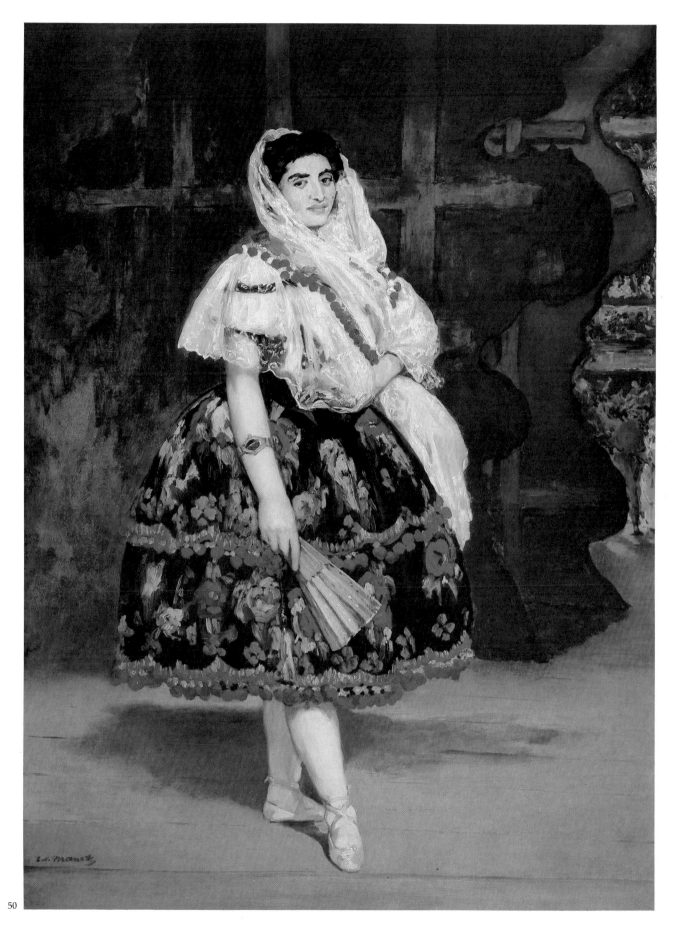

After the "synthetic" Hispanicism of *The Spanish Singer* (cat. 10), in Manet's eyes Spain herself had come to him. A Spain—an Andalusia, to be exact—thoroughly civilized and up to date, in her very much Second Empire bracelet and classical pink ballet slippers. Beneath the finery, Manet delineates the woman searchingly and without flattery. She is stocky, her legs overmuscled, and the least one can say of her face is that it lacks the ardent subtlety of Mérimée's Carmen.

Tabarant might well wonder at Baudelaire's response, and considered Lola rather "mannish."[9] For after seeing the painting in his friend's studio, Baudelaire had been delivered of this famous quatrain:

Entre tant de beautés que partout on peut voir	Among all the beauties that are to be seen
Je comprends bien, amis, que le Désir balance;	I understand, friends, Desire chooses with pain;
Mais on voit scintiller dans Lola de Valence	But one may see sparkling in Lola of Spain
Le charme inattendu d'un bijou rose et noir.	The unforeseen charm of black-rose opaline.

He sent these lines to Manet for the etching (cat. 52) with the following directions: "To be engraved in small bastard characters—Mind the spelling, the punctuation, and the capital letters. . . . It might perhaps be well to write these verses under the portrait, too, either in the pigment with a brush, or in black letter on the frame."[10] Manet seems to have adopted the latter alternative, on a cartouche attached to the frame of the painting, for the 1863 and 1867 shows (see fig. e).[11]

LOLA DE VALENCE,
ou *l'Auvergnate espagnole*.
Ni homme, ni femme; mais qu'est-ce
que ce peut être?... je me le demande.

Fig. d. Randon, caricature in *Le Journal amusant*, June 29, 1867

Looking at the color in the painting, we have some cause for surprise today, since there is no obvious combination of rose and black but rather one of white and black about the face and black and red in the magnificently painted pompon skirt. After 1867, with the new background, Manet was perhaps moved to retouch the skirt, changing the original palette. The great rose-and-black jewel in Manet's oeuvre would presently be *Olympia* (cat. 64), the painter's most truly Baudelairean work. But no doubt Baudelaire was only offering a little ditty more concerned with the model than with the portrait, with erotic allusions that are obvious—even more so at the time—when compared to a poem in *Les Fleurs du mal* that had been written for Mme Sabatier in 1857, one of the "exhibits" in the trial, which had provoked such a scandal at the time.

Fig. e. Anonymous caricature, 1863 (photograph). Bibliothèque Nationale, Moreau-Nélaton endowment, Paris

Parmi toutes les belles choses	Among the host of lovely things
Dont est fait son enchantement,	Composing her enchanting wiles,
Parmi les objets noirs ou roses	Among the parts her body sings
Qui composent son corps chantant	In sable tones or rosy smiles
Quel est le plus doux? [12]	Which is more sweet?

Zola was not mistaken when he recalled, in 1867, that Lola de Valence was "famous for the quatrain by Charles Baudelaire, as much hissed at and abused as the painting itself." Indeed, four years after the first appearance of *Lola*, Zola reinterpreted Baudelaire's text, this time in terms of the painting, not the model, and primarily to defend his own notion of Manet's modernity: "These verses . . . have in my eyes the great merit of being a rhymed judgment on the artist's whole personality. I cannot say whether my

1. Baudelaire 1975, p. 168.
2. Zacharie Astruc, *Le Généralife*, Paris, 1897, p. 269, cited in Flescher 1978, p. 100 n. 1.

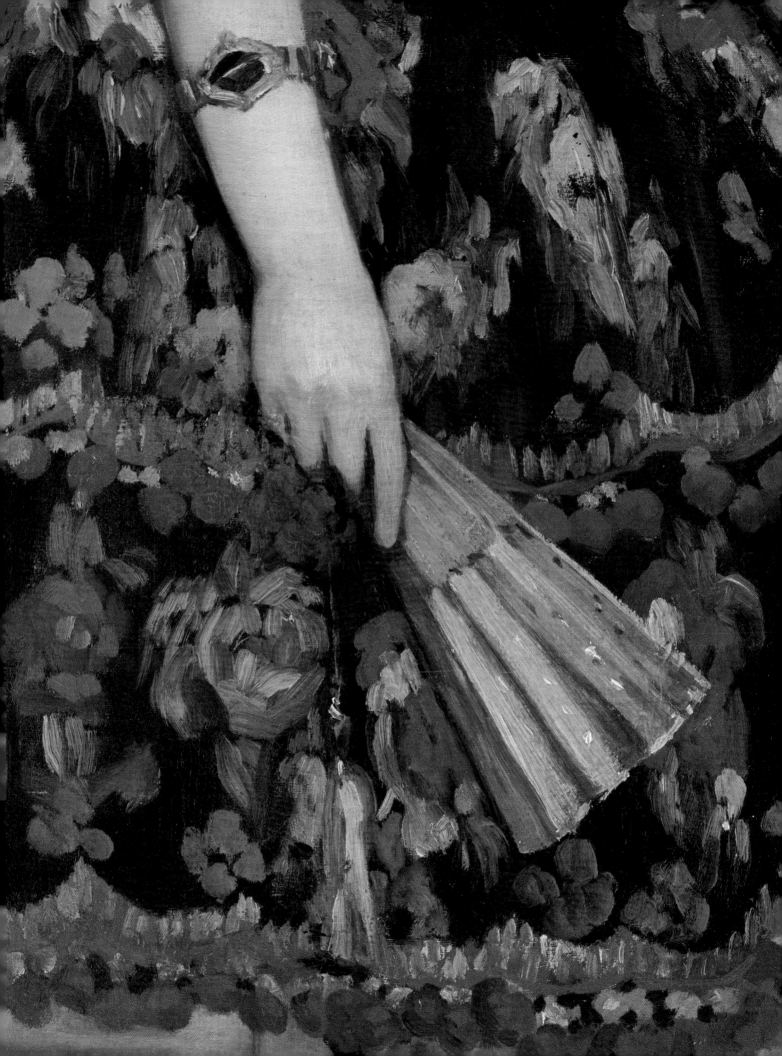

reading is strained. It is perfectly true that *Lola de Valence* is a black-and-rose jewel; the painter by this time deals in patches only, and his woman of Spain is painted broadly, in vivid contrasts; the entire canvas is covered in two hues. And the strange and true look of this work was for me an 'unforeseen charm' indeed."[13]

If Baudelaire's erotic allusions rendered the picture shocking in 1863, the thrust of the scandal was technical. The color must have seemed more violent than today, more striking against the original neutral ground than against the scenery added later. The tranquil assurance of the pose and a certain coarseness in the model only added to what the public resented as the real provocation—the textured and colorful treatment lavished with gusto upon the figure in general and the skirt in particular. "These paintings [*Lola* and *Music in the Tuileries*, cat. 38] display a tremendous vitality, but . . . in their motley red, blue, yellow, black, they are a caricature of color, not color itself."[14]

3. Toussaint 1969, no. 9.
4. Hanson 1972, pp. 152–55.
5. Baticle and Marinas 1981, pp. 88–89.
6. Tabarant 1931, p. 81.
7. Delteil 1925, XVII, no. 2897; Richardson 1958, p. 14; Hanson 1977, p. 79.
8. Randon 1867.
9. Tabarant 1947, p. 53.
10. Baudelaire 1975, pp. 168, 1149.
11. Anonymous caricature (photograph in Manet et al., "Expositions Martinet"); Zola 1867, *L'Artiste*, p. 55; Zola (Dentu), p. 31.
12. Baudelaire 1975, p. 42.
13. Zola 1867, *L'Artiste*, p. 55; Zola (Dentu), p. 31.
14. Mantz 1863, "Exposition . . . ," p. 383.
15. Moreau-Nélaton 1926, I, p. 134.
16. Tabarant 1931, p. 81.
17. Rewald 1973, *Gazette des Beaux-Arts*, p. 107.
18. Meier-Graefe 1912, p. 313; Tabarant 1931, p. 81: 1,600 Frs; Tabarant 1947, p. 53: 1,500 or 1,600 Frs.
19. Fénéon 1970, I, p. 345.

Provenance

Manet valued this canvas at 5,000 Frs in 1872, in the account book published by Moreau-Nélaton;[15] the artist sold it for half that price in 1873 to the singer FAURE,[16] his most important patron during his lifetime (see Provenance, cat. 10). The picture later passed through the hands of the dealers CAMENTRON AND MARTIN, partners on the rue Laffitte who bought many works from the Impressionists during the 1870s, as well as the contents of Daumier's studio following his death.[17] They sold the present work in July 1893 for 15,000 Frs[18] to COMTE ISAAC DE CAMONDO (1851–1911). In 1908, *Lola de Valence* entered the Musée du Louvre with the splendid Camondo bequest, which was finalized in 1911 and exhibited in 1914 (inv. RF 1991). In

1920, Félix Fénéon wrote a profile of this great donor of Impressionist art to the Louvre, which is indebted to him not only for Manet's *Lola de Valence*, but for *The Fifer* (cat. 93), too: "As he lay dying comte Abram spoke in this way to comte Isaac his son: 'So many traps await you! You will be dragged into impossible business dealings; greedy women will pursue you; you will lose at cards; borrowers will tag you as a mark. . . . ' This enumeration of dangers went on for a long time, to conclude (for mining had always been ruinous for this family of bankers from Constantinople) with the words: 'Well, none of that is really important, but watch out for engineers!' Since paternal wisdom did not warn him against the dangers of paintings, Isaac de Camondo could surrender

without qualms to his passion for them. Attracted at first by the Far East, Camondo formed in 1894 and 1895 a collection of Japanese prints; purchases at the Gillot, Hayashi, and Bing sales soon brought their number to 420. To the fine eighteenth-century furniture he already owned, he added pastels and drawings of the same period. Then, after having acquired several medieval and Renaissance sculptures and objects, he devoted his attention to Corot (figures), Manet (*The Fifer, Lola de Valence, The Port of Bordeaux*), Jongkind, Degas, Sisley, Pissarro, Renoir, Van Gogh, Lautrec, etc.—a multitude of masterpieces (including Cézanne's *House of the Hanged Man*, and three of Monet's *Cathedrals*)."[19]

F.C.

51. Lola de Valence

1862–63
Black chalk, pen and India ink, watercolor, and gouache
10⅛ × 6¾" (25.6 × 17.3 cm)
Signed (lower right): Manet
P Musée du Louvre, Cabinet des Dessins, Paris

This watercolor was made after the oil painting (cat. 50), rather than as a preparatory study for it, and served as the intermediate step between the canvas and the etching (cat. 52).[1] The pencil drawing, which looks like a tracing and was probably done from a photograph of the picture, is enlivened with ink and watercolor washes applied in touches here and there: red and green on the skirt; blue on the top of the bodice and for the signature; and pink on the lips, the bodice, and the ballet slippers. Manet incised the contours of the drawing to transfer them to the copperplate for etching. The incised lines run across the ink and watercolor washes, not always precisely along the outlines of the drawing. The modifications are exactly repeated in the etching, however, as in the reshaped edge of the skirt at lower right. The delicately drawn face is very carefully incised.

Exhibitions
Marseilles 1961, no. 42

Catalogues
M-N 1926 II, p. 118 (ill.); T 1931, 15 (watercolors); JW 1932, mentioned 46; T 1947, 558; L 1969, 178; RW 1975 II, 369

51

A second drawing, in pen and India ink with wash (RW II 370), is apparently a replica given by Manet to his friend Astruc, author of the "Serenade" to Lola, for which Manet designed a lithographic cover (cat. 53).

1. Leiris 1969, p. 57.

Provenance
The drawing, together with the painting, passed with the bequest of COMTE ISAAC DE CAMONDO (see Provenance, cat. 50) to the Musée du Louvre in 1911 (inv. RF 4102). Nothing is known of its earlier provenance.

J.W.B.

52 (1st state)

52 (5th state)

52. Lola de Valence

1863
Etching and aquatint
Plate: 10½ × 7¼″ (26.6 × 18.5 cm); image, 1st–4th states: 9⅜ × 6⅜″
(23.8 × 16.1 cm); image, 5th state: 9¼ × 6⅜″ (23.5 × 16.1 cm)
Signed (lower left): éd. Manet
Quatrain engraved on the plate (lower center, 5th state); names and
number engraved for the edition (6th state)

NY The Art Institute of Chicago (1st state)
P Bibliothèque Nationale, Paris (5th state)
NY The Metropolitan Museum of Art, New York (6th state)

52 (1st state, detail) 53 (detail)

Publications
Eaux-fortes modernes, Société des Aquafortistes, Cadart, October 1, 1863, pl. 67; *Eaux-fortes par Edouard Manet*, 1863?; *Edouard Manet. Eaux-fortes*, Cadart 1874

Exhibitions
Salon des Refusés 1863, no. 676 (Lola de Valence); Beaux-Arts 1884, no. 161; Paris, Drouot 1884, no. 163; Paris, Sagot 1930, no. 13; Philadelphia-Chicago 1966–67, no. 45; Ann Arbor 1969, no. 1; Ingelheim 1977, no. 29; Paris, Berès 1978, no. 34; Washington 1982–83, no. 34

Catalogues
M-N 1906, 3; G 1944, 23; H 1970, 33; LM 1971, 27; W 1977, 29; W 1978, 34 and App.

1st state (of 8). Lightly etched design; before aquatint and letters. The only known proof, on China paper. Burty, Degas, Hachette, Thomas collections.

5th state. With the aquatint; with the reduction of the design and the addition of Baudelaire's engraved verse below; before edition letters. The only known proof. Moreau-Nélaton collection.

6th state. With the letters (number, names of Cadart and others). On laid paper (indistinct watermark), from the edition of 1863.

1. Burty sale, Paris, March 4–5, 1891, lot 247, no. 5 ("quatre épreuves d'états différents"), with the catalogue number at lower right.
2. Degas collection, second sale, Paris, November 6–7, 1918, no. 226 (repr.).
3. Collector's mark on verso (Lugt 1921, no. 132; Lugt 1956, p. 286).
4. T[homas] sale, Paris, June 18, 1952, lot 127, (repr.). Collector's mark on verso (Lugt 1921, no. 1378).

Manet's etching after the painting *Lola de Valence* (cat. 50) was exhibited in the print section (together with his two etchings after Velázquez, cat. 36, 37) of the Salon des Refusés in May 1863. It was published by the Société des Aquafortistes the following October, with a number and the names of the publishers and printer added on the copperplate. The celebrated verse that Baudelaire sent to Manet was no doubt engraved, following the poet's very precise instructions (see cat. 50), for its exhibition in the Salon des Refusés, when the painting itself was on view at Martinet's gallery.

In the first known state of the print, etched with the help of the preparatory drawing (cat. 51), there is already an indication of background shading similar to that in the published state of *Boy with a Sword, turned left* (cat. 18, 3rd state). Manet then re-etched the plate, extensively reworking the dancer's skirt and shading the whole of the background with a fine network of lines over which he added an aquatint; the aquatint also shades the dancer's "divine legs," following Astruc's verse, which laments that they are half hidden by the shadows of her skirt (see cat. 53). Then, in order to include the four lines of Baudelaire's verse at the foot of the plate, a strip of etching was effaced. From the very beginning, the etching shows an area of ground in front of the dancer's feet that Manet was only to add at a later stage to the painting, attaching an extra strip of canvas to the lower edge (see cat. 50).

Since no original photographs of Manet's paintings taken in the 1860s appear to have survived, the drawings and prints made at the time—by Manet or by other artists and by caricaturists (see cat. 5, 29, 30, 73)—are an invaluable record of the original aspect of a painting (see cat. 5, 29, 30) or of a canvas later cut by the artist (see cat. 48, 73). In the case of *Lola de Valence*, both drawing and prints confirm the lack of background decor and show the dancer with broader outlines and a more voluminous mantilla and skirt than in the final version of the painting, suggesting that Manet may have altered her outlines when he added the theater decor and the view of the public (see cat. 50).

Manet took pains with his etching to achieve a faithful reproduction

of the oil painting. The subject faces the same direction as in the original oil, and the final state of the print is carefully etched and aquatinted, in contrast to the sketchy, impulsive portrait of Don Mariano Camprubi, the leading male dancer of the Spanish troupe (fig. a).

Provenance
1st state. This unique proof appeared at the sale of BURTY's collection,[1] passing from MANZI to DEGAS (see Provenance, cat. 42, 19, 15). Reproduced in the Degas collection sale catalogue,[2] it was acquired by ANDRE-JEAN HACHETTE (1873–1952)[3] and then by HENRI THOMAS (see Provenance, cat. 11), who lent it to Sagot's exhibition in 1930. At the sale of his collection in 1952,[4] the proof was acquired for 70,000 Frs by the Art Institute of Chicago (inv. 53.274) as part of the John H. Wrenn Memorial Collection.

5th state. Possibly the impression exhibited at the Salon des Refusés, this unique proof state may have belonged to BAUDELAIRE (see Provenance, cat. 27) or have remained in Manet's collection. In fact, nothing is known of its provenance before its acquisition by MOREAU-NELATON (see Provenance, cat. 9).
6th state. The proof from the Société des Aquafortistes' publication of 1863 was acquired by the Metropolitan Museum of Art in 1918 (inv. 18.88.28).

J.W.B.

Fig. a. *Don Mariano Camprubi*, 1862–63, etching. Bibliothèque Nationale, Paris

53. Lola de Valence

1863
Lithograph
Image: 7⅝ × 7¼" (19.5 × 18.5 cm); letters: 11⅝ × 9½" (29.5 × 24 cm)
Signed (left): éd. Manet
Titled on the lithographic stone, with letters indicating the author, POESIE ET MUSIQUE DE ZACHARIE ASTRUC, and the printer, Lemercier
P Bibliothèque Nationale, Paris (dedication proof)
NY Bibliothèque Nationale, Paris (Dépôt Légal proof)

In March 1863, a serenade entitled "Lola de Valence," with a lithographic cover design by Manet, went on sale at 3 Frs. This ephemeral song celebrating the popular Spanish dancer must have had a brief success in the drawing rooms of the Parisian bourgeoisie of the period; it is now known only from a few surviving copies, including the one dedicated by Zacharie Astruc, the author of the words and music, to Fantin-Latour. The serenade itself is dedicated to "H.M. the Queen of Spain," and the song is preceded by a Spanish couplet: "Vive dios! padre cura / Vamos otra seguidilla" (Long live the Lord! priestly father / Let's have another seguidilla). Astruc's poem[1] is of interest in its own right since it expresses the Parisian public's fascination—now difficult to understand—with this rather masculine Spanish girl (see cat. 50), who was nevertheless for Baudelaire and Astruc a muse of song as well as of dance.

The poem evokes Lola's dancing of a seguidilla to the sound of a guitar, referring to the mortal folly inspired by her smiling eyes, the caress of her voice, and the mocking smile on her lips. It likens her to a crazed butterfly, as her feet graze and scrape the ground, her "divine legs" obscured from view in the shadows of her heavy parasol of a skirt. The poem concludes with a plea for another cigarette, the sound of another castanet, urging Lola to shake from her locks the jasmine flowers for which a hundred suitors will throw themselves to the ground.

Manet drew directly on the lithographic stone, probably referring to

Publications
Astruc 1863

Exhibitions
Philadelphia-Chicago 1966–67, no. 46; Ann Arbor 1969, no. 20; Santa Barbara 1977, no. 10; Ingelheim 1977, no. 37; Paris, Berès 1978, no. 73

Catalogues
M-N 1906, 77; G 1944, 69; H 1970, 32; LM 1971, 71; W 1977, 37; W 1978, 73

With the letters around the lithographic design. Proofs of the only known state. P: Dedicated in ink "A Fantin / Bon souvenir / Zacharie Astruc." A complete copy, the double sheet of wove paper having the engraved words and music inside. Fantin-Latour and Moreau-Nélaton collections. NY: The Dépôt Légal proof has the red stamp with the date "1863" and the pencil number "1594." On a single sheet, with no music on the verso.

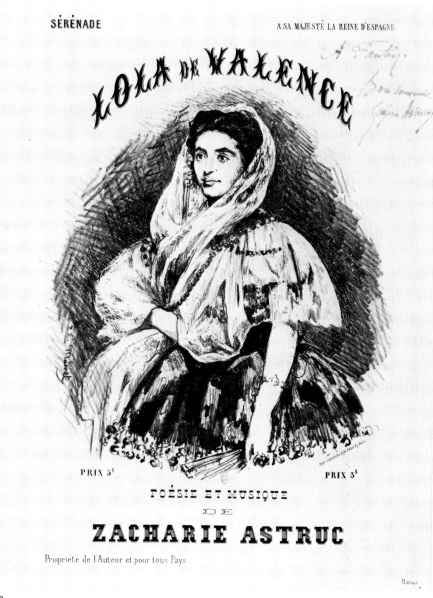

Fig. a. "Lola de Valence," sheet music for a serenade by Zacharie Astruc. Bibliothèque Nationale, Paris

his preparatory drawing for the etching (cat. 51) and adapting the composition to the size and design of the cover. The reversed image of Lola appears as a vignette, surrounded by the letters; her fan is raised to echo the curve of the lower edge of the image; and even Manet's signature follows the edge of the design on the left. The song cover moves away from the aspect of the full-length figure who appears in the painting, gazing down at the artist-spectator seated at his easel. Here she looks calmly ahead without the slightly cruel, mocking appearance in her eyes and mouth to which Astruc's poem refers. Like the etching, the lithograph emphasizes the dancer's voluptuous figure, following even more closely the contours of the watercolor drawing.

Manet's lithograph was registered by the Dépôt Légal on March 7, 1863,[2] and the copperplate engraving of Astruc's words and music was registered among the "musical works."[3] Two of the rare surviving copies of the song are dedicated by Astruc—one "au meilleur des poètes" (to the finest of poets),[4] perhaps Baudelaire; the other, catalogued here, to Fantin-Latour. In

Fantin-Latour's *Homage to Delacroix* of 1864 (Musée d'Orsay-Galeries du Jeu de Paume, Paris), he depicts himself as the painter, with his friends Manet and Baudelaire placed side by side; six years later, in Fantin-Latour's *A Studio in the Batignolles Quarter* (also in the Jeu de Paume), Manet wields the brushes to paint a portrait of Zacharie Astruc (whom he had actually painted in 1866; cat. 94). Fantin-Latour presents his friends and colleagues—painters, poets, and critics—in solemn, formal group portraits. Manet's song cover evokes in a lighter mood their distractions and the enthusiasm with which they followed the fashion in Parisian entertainments. Three years later, in 1866, Manet designed another lithographic cover for sheet music, this time for the guitar piece "Moorish Lament" (cat. 95).

1. The words of the song appear, with slight modifications, in the posthumously published poem *Lola*, see Flescher 1978, p. 101.
2. Paris, Archives Nationales (F$^{18*}$ VI) 1863, 126 estampes sans texte "1594—7 mars—Lemercier—Buste de femme (Lola de Valence) pour couverture de musique—1 lith." Registered under the same number and date: Paris, BN Estampes (Ye 79, fol.).
3. Paris, BN Musique: Registre du Dépôt des Oeuvres de Musique, 1860–63: "802 Astruc Z. Lola de Valence. Sérénade."
4. Wilson 1978, no. 73.
5. Fantin-Latour sale, Paris, March 14, 1905, lot 131 (repr.).

Provenance

The proof dedicated to Fantin-Latour was among the group of two etchings and six lithographs by Manet included in the first part of the sale of his private collection in 1905,[5] which naturally included a large number of lithographs. HENRI FANTIN-LATOUR (1836–1904), who was a master lithographer, owned proofs of all the lithographs published in Manet's lifetime, as well as a proof in the first state of *The Execution of Maximilian* (cat. 105). The dedicated proof of *Lola de Valence* was acquired by MOREAU-NELATON and entered the Bibliothèque Nationale with his bequest (see Provenance, cat. 9).

The DEPOT LEGAL proof, printed without the music, which was registered separately, has the red stamp and number corresponding to its registration and was later transferred from the Ministry of the Interior's offices to the Bibliothèque Nationale (see Provenance, cat. 105).

J.W.B.

54–58. Portraits of Baudelaire

A group of five plates, two of which show Baudelaire with a hat, in profile, and three Baudelaire bareheaded, full face. They date to 1862–69.

54. Baudelaire with a Hat

First plate
1862 or 1867–68?
Etching
5$\frac{1}{8}$ × 3" (13 × 7.5 cm)
Initialed (upper left): EM
P Bibliothèque Nationale, Paris
NY The Metropolitan Museum of Art, New York

55. Baudelaire with a Hat

Second plate
1867–68
Etching
4$\frac{1}{4}$ × 3$\frac{1}{2}$" (10.9 × 9 cm)
Initialed (upper left, 2nd state): M
Bibliothèque Nationale, Paris

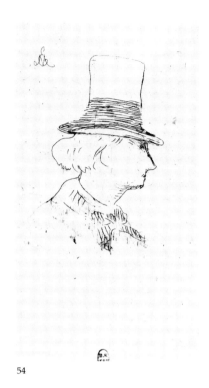

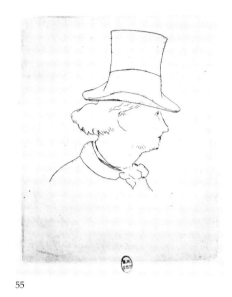

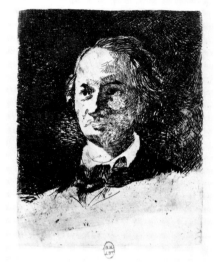

54

55

56 (1st state)

56. Baudelaire

First plate
1865–68?
Etching
4 × 3¼″ (10.2 × 8.4 cm)
Bibliothèque Nationale, Paris (1st, 2nd states)

57. Baudelaire

Second plate
1867–68
Etching and aquatint
Plate: 5¼ × 4¼″ (13.2 × 10.7 cm); image: 4⅜ × 3⅝″ (11.2 × 9.3 cm)
Bibliothèque Nationale, Paris

56 (2nd state)

58. Baudelaire

Third plate
1868
Etching
1st–3rd states: 6⅞ × 4⅛″ (17.5 × 10.6 cm); 4th state: 3⅞ × 3¼″
(9.7 × 8.3 cm)
Signed (lower right, below the shoulder; 3rd state): Manet; with the
name CHARLES BAUDELAIRE etched on the plate by the artist
(3rd state only)
Nationalmuseum, Stockholm (2nd state)
Bibliothèque Nationale, Paris (3rd, 4th states)

57 58 (2nd state)

In a letter to Charles Asselineau (fig. a), written from 49, rue de Saint-Pétersbourg (and therefore in or after 1867),[1] Manet made the following proposition: "My dear Asselineau, I believe you are working at this time on an edition of the works of Baudelaire? If you put a portrait at the beginning of 'Spleen de Paris,' I have one of Baudelaire with a hat, in other words, as a *flâneur*, which might not look bad at the start of this book. I also have another, bareheaded, more impressive, which would go well in a book of poetry. I would very much like to be given the task, and, of course, in proposing myself, *I would give* you my plates."[2]

Fig. a. Letter from Manet to Charles Asselineau, 1867–68. Bibliothèque Nationale, Département des Manuscrits, Paris

54

Exhibitions
Philadelphia-Chicago 1966–67, no. 36; Paris, BN 1974–75, no. 128; Ingelheim 1977, no. 27; Paris, Berès 1978, no. 40

Catalogues
M-N 1906, 40; G 1944, 30; H 1970, 21; LM 1971, 19; W 1977, 27; W 1978, 40

2nd state (of 2). A possibly contemporary proof (P) and an impression from the edition of 1894 (NY). P: Moreau-Nélaton collection. NY: Gobin collection.

55

Publications
Asselineau, *Charles Baudelaire, sa vie et son oeuvre*, Lemerre 1869, opp. p. 79

Exhibitions
Philadelphia-Chicago 1966–67, no. 37; Paris, BN 1974–75, nos. 129, 130; Santa Barbara 1977, no. 90; Ingelheim 1977, no. 59; Paris, Berès 1978, no. 41

Catalogues
M-N 1906, 15; G 1944, 31; H 1970, 59; LM 1971, 54; W 1977, 59; W 1978, 41

1st state (of 3). Before the initial "M" in a rectangle. On thin laid paper (watermark D–BLAUW). Moreau-Nélaton collection.

56

Exhibitions
Philadelphia-Chicago 1966–67, no. 38; Paris, BN 1974–75, nos. 131, 132; Ingelheim 1977, no. 39

Catalogues
M-N 1906, 58; G 1944, 36; H 1970, 46; LM 1971, 41; W 1977, 39

1st state (of 2). Before re-etching. The only known proof, on laid paper (watermark DEDB [De Erven D Blauw] in a flowered shield). Barrion, Cosson, Moreau-Nélaton collections.

2nd state. With the additional etching. One of two known proofs (the other is in the New York Public Library), on Japan paper. Guérin collection.

57
Exhibitions
Paris, BN 1974–75, no. 133; Ingelheim 1977, no. 60

Catalogues
M-N 1906, not mentioned; G 1944, 37; H 1970, 60; LM 1971, 55; W 1977, 133

The only known proof, on China paper. Hazard, Moreau-Nélaton collections.

58
Publications
Asselineau, *Charles Baudelaire, sa vie et son oeuvre,* Lemerre 1869, opp. p. 99

Exhibitions
Salon 1869, no. 4067 (*Quatre eaux fortes, même numéro:* Charles Beaudelaire [*sic*]); Paris, BN 1974–75, nos. 134, 135; Santa Barbara 1977, no. 91; Ingelheim 1977, no. 61; Paris, Berès 1978, nos. 46, 111

Catalogues
M-N 1906, 16; G 1944, 38; H 1970, 61; LM 1971, 56; W 1977, 61; W 1978, 46, 111

2nd state (of 4?). With extensive re-etching of the face; before the banderole with Baudelaire's name or the artist's signature. The banderole is drawn in red chalk and Baudelaire's name added in black chalk. One of three known proofs, on Japan paper. Burty, Degas, Schotte collections.

3rd state. With etched banderole and Manet's signature; still before reduction of the copperplate. One of four or five known proofs, all on thin Japan paper. Moreau-Nélaton collection.

4th state. The plate reduced for the printing in Asselineau's book; with the letters (lower left): "Peint et gravé par Manet. 1865." and the indication of the printer (lower right): "Imp. A. Salmon."

After Baudelaire's death on August 31, 1867, his friend Charles Asselineau began to prepare a work with the title *Charles Baudelaire, sa vie et son oeuvre . . . avec portraits.* J. Adhémar suggests that Manet wrote to Asselineau to propose his collaboration on the project as soon as he heard about it.[3] Unfortunately, his letter contains no clue that would permit identification or dating of the two portraits to which he refers: the *Baudelaire with a Hat* (of which there are two versions: cat. 54, 55) and the "more impressive" *Baudelaire* bareheaded (three versions: cat. 56–58). The two portraits that were in fact published in Asselineau's book also contain confusing information: the one with a hat (cat. 55) has the inscription "Peint et Gravé par Manet. 1862," and the other (cat. 58) has the same inscription with the date 1865. No portrait—painted, drawn, or etched—of Baudelaire by Manet is known from 1865. (Baudelaire was in Belgium from April 1864 to July 1866.) In 1862, however, Manet had sketched the poet's portrait—in profile, wearing a hat—among the groups of friends in the painting *Music in the Tuileries* (cat. 38). Of the two etched versions of this portrait, the first is similar to the painting in the figure of the poet but is very different from the prints of that period in style. The source of the full-face portrait is a photograph of Baudelaire taken by Nadar in 1862 (fig. b).

Baudelaire and Manet met about 1859. Manet's desire, ten years later, to contribute to Asselineau's book in homage to the poet is a testimony of their close relationship over the years, from the time of Manet's beginnings as an etcher (see cat. 11, 59, 60) until Baudelaire's final months of illness in Paris, when Suzanne Manet and Mme Paul Meurice entertained the dying poet by playing Wagner on the piano.[4] Manet may have been considered, among other artists, for the design of a frontispiece portrait of Baudelaire for Poulet-Malassis's second edition of Baudelaire's *Les Fleurs du mal;* no such project is known, however, and Bracquemond was the artist chosen for the edition published in 1861.

Although the first versions of Manet's portraits (cat. 54, 56) have their origins in the image of Baudelaire as a *flâneur* in *Music in the Tuileries* of 1862 and in a photograph taken about the same time, they were probably etched at a later date—for some unidentified occasion—and were repeated in new etchings made when Asselineau accepted Manet's proposal and

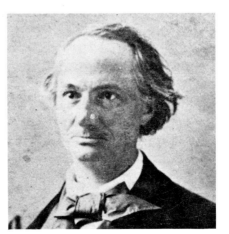

Fig. b. Nadar, *Charles Baudelaire,* 1862, photograph (detail). Bibliothèque Nationale, Paris

Fig. c. Vignette design for a portrait of Baudelaire (after a photograph by Lochard). Bibliothèque Nationale, Moreau-Nélaton endowment, Paris

asked for both portraits, which were placed chronologically in the book, following three others etched by Bracquemond.

The portrait with a hat soon found its definitive form (cat. 55), Oriental in its linear simplicity, less subtly impressionistic than the first version. Manet had considerable difficulty with the full-face portrait: a first plate is known in two quite different states (cat. 56); a second presents a remarkable variant, with an aquatint background and a dark "mourning" border (known only from a single proof, cat. 57); while the third version went through as many as four states (cat. 58). Manet began the third version with a vertical format and planned to add a vignette below the portrait, first trying out a design suggestive of Goya (fig. c),[5] and then a simple banderole with the name "Charles Baudelaire." He actually etched the banderole but then was obliged to cut down the plate to accommodate the size of the book, leaving only the bust portrait. While the dates of the two first versions are uncertain, all the others were no doubt made for Asselineau's book, published in January 1869, where they appear in their final form, accompanied by three other portraits of Baudelaire, by Roy, Courbet, and Baudelaire himself, etched especially for Asselineau by Bracquemond.

1. See Map: Manet in Paris; and Chronology.
2. Paris, BN Manuscrits, Allard du Chollet collection, n.a.f. 24022, fol. 85, quoted in J. Adhémar 1952, p. 242; Courthion 1953, I, pp. 51–52.
3. J. Adhémar 1952, p. 242.
4. Baudelaire 1973, I, p. lviii; Baudelaire, *Lettres à*, pp. 260–61.
5. Two drawings are known: one from a Lochard photograph (Leiris 1969, p. 224, described as the Guérin proof, RW II 677), the other on a 2nd state proof of the print (repr. Guérin 1944, p. 38; Harris 1970, p. 61). See Sandblad 1954, p. 64ff.
6. Wilson 1978, no. 40.
7. Barrion, second sale, Paris, May 25–June 1, 1904, lot 980 (incorrectly catalogued as Beraldi 24).
8. Mentioned in Lugt 1956, pp. 38, 270.
9. Lugt 1921, p. 268, no. 1872b.
10. Guérin 1944.
11. Guérin sale, Paris, March 19, 1952, lot 141.
12. J. Adhémar 1952.
13. Lugt 1921, p. 360, no. 1975.
14. Hazard, third sale, Paris, December 12–13, 1919, lot 259.
15. Burty sale, Paris, March 4–5, 1891, lot 20.
16. Degas collection, second sale, Paris, November 6–7, 1918, lot 248.

Provenance

54. P: The proof acquired by MOREAU-NELATON (see Provenance, cat. 9) may have been printed during the artist's lifetime (like the one on paper with a watermark including the date 1869[6]).

NY: The impression in the Metropolitan Museum of Art is part of a complete set of the thirty plates published by Dumont in 1894 (see Provenance, cat. 11: copperplate); acquired from the Parisian dealer MAURICE GOBIN thanks to the Rogers Fund, it entered the museum in 1921 (inv. 21.76.23).

55. The early provenance of this proof, acquired by MOREAU-NELATON (see Provenance, cat. 9), is unknown.

56. *1st state.* This unique proof appeared at the BARRION sale (see Provenance, cat. 40) in 1904;[7] acquired by PAUL COSSON,[8] it passed to MOREAU-NELATON (see Provenance, cat. 9).

2nd state. This proof belonged to MARCEL GUERIN (1873–1948),[9] the author, after Moreau-Nélaton, of a catalogue raisonné of Manet's graphic work,[10] as well as of catalogues of Forain's and Gauguin's prints. Guérin was an industrialist who formed a very fine collection of nineteenth-century prints. His collection was partially dispersed in two sales in 1921 and 1922, but the proof of the Baudelaire portrait must have remained in the family, since it appeared in the Guérin sale of 1952,[11] when it was bought for 70,000 Frs by the Bibliothèque Nationale (inv. A 10.919).[12]

57. This unique proof belonged to N. A. HAZARD (1834–1913), a gentleman of private means who lived in the Oise département and was a neighbor and friend of the celebrated collector comte Doria. He built a major collection of paintings, drawings, and prints of the French school from the 1830s to the Impressionists[13] and worked with Delteil on the catalogue raisonné of Daumier's lithographs.

The Baudelaire proof appeared in the sale of Hazard's fine print collection in 1919[14] and was acquired for 55 Frs by MOREAU-NELATON (see Provenance, cat. 9), who had been unaware of its existence at the time he wrote his catalogue.

58. *2nd state.* The proof with the drawing of the banderole belonged to BURTY (see Provenance, cat. 42)[15] and passed to MANZI (see Provenance, cat. 19), then DEGAS (see Provenance, cat. 15), and, following the sale of his collection in 1918,[16] to Sweden (see Provenance, cat. 15).

3rd state. The early provenance of this proof, before its acquisition by MOREAU-NELATON (see Provenance, cat. 9), is unknown.

4th state. Print in a copy of the book belonging to the Département des Imprimés in the Bibliothèque Nationale and acquired through the DEPOT LEGAL (see Provenance, cat. 105).

J.W.B.

59. Portrait of Edgar Allan Poe

1860–62
Brush and India ink
Paper: 12 × 8⅞″ (30.5 × 22.7 cm); image: 4½ × 4⅛″ (11.5 × 10.5 cm)
Atelier stamp (lower left): E.M.
NY Bibliothèque Nationale, Paris

This drawing, based on a daguerreotype of Poe made in 1848,[1] shows him as a rather youthful, romantic figure, with ruffled hair framing his high, broad brow. The vignette presentation suggests that it must have been intended as a book illustration, probably a frontispiece. Charles Baudelaire's correspon-

Exhibitions
Ingelheim 1977, no. Z/5; Paris, Berès 1978, no. 2

Catalogues
L 1969, 215; H 1970, fig. 4; RW 1975 II, 489

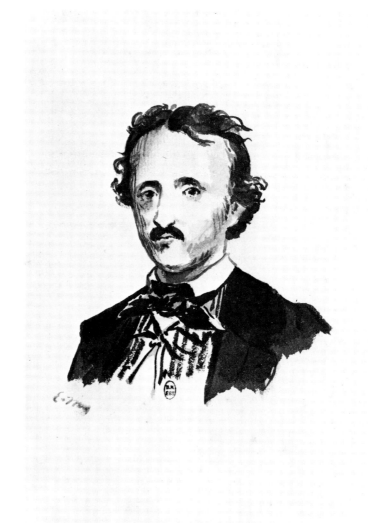

59

dence of 1858–62 is full of references to an edition of his collected articles on Poe, and then to a more complete publication—a French homage to the great American poet—which was to be illustrated by a portrait, perhaps two portraits, of Poe.

In May 1859, Baudelaire wrote to Nadar about the portrait he had in mind, "a portrait in a garland of emblems." Baudelaire himself would supply the necessary elements for "a portrait . . . framed by allegorical figures representing his principal conceptions—rather like the head of Christ surrounded by the instruments of the Passion—and the whole thing frenziedly romantic, if possible."[2] Six months earlier he had referred to "the drawing project for the portrait of Poe,"[3] which he had sent to his publisher, Poulet-Malassis; in May 1860 he wrote to him again to say that he wanted the publication to be as sumptuous as possible, adding reassuringly, "We have plenty of time to think about it."[4] He referred to it again in March 1861 and still later, in August or September 1862.[5] Meanwhile, he was working on his project with Bracquemond—a frontispiece portrait of himself for *Les Fleurs du mal*.[6] Writing to Poulet-Malassis in January 1861, he described how

"Bracquemond spent the day with me on Friday and drew a portrait straight off, on the etching plate, without bothering about the photograph."[7]

Manet could have been introduced to Baudelaire by any one of several mutual friends—Nadar or Lejosne, for example—but it may have been Bracquemond who suggested to Baudelaire, when Manet took up etching, that the poet and artist collaborate. Baudelaire preferred not to work with well-known artists, since the modest task of making frontispieces, "for which I shall be very difficult to please," was rather poorly paid.[8] In July 1860, Baudelaire wrote to the publisher Alfred Guichon to inform him that his "fine edition" of Poe's works would be illustrated with two engraved portraits of Poe after "two classic portraits" in the American and English editions.[9] Manet's drawing and etched portrait (cat. 60) may well have been made at this time, but Baudelaire was still referring to "the matter of the *illustrated* Poe" a year later. Manet's two portraits have been variously dated to 1860, 1865, and 1880.[10] Although it is difficult to assess the style of works made from reproductions, in this case photographs, an early date appears more likely—after the beginner's etchings, such as the first plate of the *Boy with a Sword, turned left* (cat. 15), but probably before Manet's etching style became less rigid in 1862.

The brush-and-India-ink drawing is handled with considerable assurance. Starting with a pale gray sketch, Manet progressively darkened the ink, applying it finally to the vest, the stripes on the shirt, the large bow, and the hair, in rich touches of velvet black that contrast with the soft pallor of Poe's face (a face Baudelaire called "very feminine") with its piercing gaze.

Provenance
The drawing, with atelier stamp, passed from SUZANNE MANET (see Provenance, cat. 12), no doubt through an intermediary, to BARRION (see Provenance, cat. 40). It was acquired at or after his sale[11] by MOREAU-NELATON (see Provenance, cat. 9) and bequeathed to the Bibliothèque Nationale in 1927.

J.W.B.

1. Harris 1970, p. 25, fig. 3.
2. Baudelaire 1973, I, p. 575: to Nadar, May 14 and 16, 1859, cited in Harris 1970, p. 25.
3. Ibid., p. 519: to Poulet-Malassis, about November 1, 1858.
4. Ibid., II, p. 49: to Poulet-Malassis, May 20, 1860.
5. Ibid., pp. 136, 257: to Poulet-Malassis.
6. Ibid., pp. 83, 85: to Poulet-Malassis, August 1860.
7. Ibid., p. 127: to Poulet-Malassis, January 10, 1861.
8. Ibid., I, p. 577: to Nadar, May 15, 1859.
9. Ibid., II, p. 65: to Guichon, July 13, 1860, quoted in Harris 1970, p. 25.
10. Harris 1970, no. 2: 1860; Leiris 1969, p. 68: 1865; Rouart and Wildenstein 1975, II, no. 489: 1880.
11. Barrion, second sale, Paris, May 25–June 1, 1904, lot 1512 ("Portrait d'Edgar Poe. Signé E. M.").

60. Edgar Allan Poe

1860–62
Etching
7⅝ × 6″ (19.3 × 15.3 cm)
NY The Metropolitan Museum of Art, New York

This etching, based on a very handsome daguerreotype portrait of Poe (fig. a),[1] is an interpretation far removed from Baudelaire's "frenziedly romantic" idea of the poet (see cat. 59). Instead of the garland of emblems or the allegorical figures suggested in Baudelaire's letters—ornaments quite opposed to Manet's tastes—Poe appears here enclosed within a little frame decorated by a large bow. The face is modeled in the same way as in the drawing (cat. 59), with short, dry strokes and hatching to which the etching technique gives a rather hard, unfinished appearance. Behind the figure, a network of closely crosshatched lines creates a dense, airless background that emphasizes the cramped presentation of the portrait.

Exhibitions
Philadelphia-Chicago 1966–67, no. 137; Ingelheim 1977, no. 2; Paris, Berès 1978, no. 61

Catalogues
M-N 1906, 46; G 1944, 55; H 1970, 2; LM 1971, 1; W 1977, 2; W 1978, 61

Proof from the first edition of this plate, published by Dumont in 1894 (see Provenance, cat. 11: copperplate), on bluish laid paper. Gobin collection.

60

Fig. a. Edgar Allan Poe, 1848, daguerreotype.
Bibliothèque Nationale, Paris

1. Harris 1970, p. 25, fig. 3.
2. Wilson 1978, no. 61.
3. Baudelaire 1976, pp. 735–36: *Revue anecdotique,*
 April 15, 1862.
4. Baudelaire 1973, II, p. 296: to Manet's mother,
 March 28, 1863; p. 322: to the photographer
 Carjat, October 6, 1863.

The etching was never used, and only one or two contemporary proofs are known, including one (in the New York Public Library) on paper with the same watermark as a proof of *The Little Girl* (H 19; see cat. 7–9),[2] an etching after Manet's *The Old Musician* (RW I 52), which was probably completed in the spring of 1862. It is worth noting that Baudelaire first began to mention Manet in his critical writings in the spring of 1862[3] and to refer to him in his correspondence in a manner that proves their friendship in 1863.[4] There are also notes acknowledging debts, dating from 1860 or 1861, and the friendship and mutual esteem of the two men, which was apparently undisturbed by the Poe project, was established early on in relation to Manet's artistic career, from at least as early as 1859.

Provenance
This impression, printed after Manet's death, was part of the edition published by Dumont in 1894 (see Provenance, cat. 11: copperplate), of which a complete set was acquired from the dealer GOBIN (see Provenance, cat. 54) by the Metropolitan Museum of Art in 1921 (inv. 21.76.29).

J.W.B.

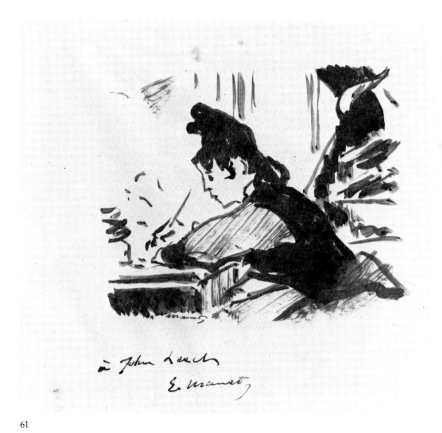

61

Fig. a. *Woman Writing*, pencil. Musée du Louvre, Cabinet des Dessins, Paris

61. Woman Writing

1862–64
Brush and black ink, 5½ × 6¼″ (14.1 × 15.9 cm)
Signed (under writing table): Manet
Inscribed (lower left): à John Leech / E. Manet
Sterling and Francine Clark Art Institute,
Williamstown, Massachusetts

This drawing, so spontaneous, so free, would certainly have been assigned a date in the late 1870s were it not for the dedication. John Leech, the English caricaturist, whom Manet met in Paris in 1862, died in 1864; hence this drawing was either done in 1862 and presented in Paris at the same time, or done later and sent to London between the two dates.

A pencil sketch of the same subject, on a double notebook page (RW II 382; fig. a), is dated 1878 by Leiris, under the title *Femme écrivant dans un café*. Although this dating must be incorrect, the suggested locale is quite plausible. The desk at which the woman writes and the fact that she is hatless and wears a light blouse under her vest warrant a guess that she is the cashier of a café; behind the young woman is a hint of steps ascending, a top hat and a cane, and a coat hanging up.

The liveliness of the drawing echoes that of the life sketch, and assures us that Manet's interest in café, concert, or café-concert scenes did not begin in the 1870s, the decade to which such minor works are often automat-

Catalogues
RW 1975 II, 383

164

ically assigned along with the oil paintings on related themes. Very likely Manet inscribed the drawing to his English friend as a souvenir of time spent in his company at the café.

Provenance
After having belonged to JOHN LEECH (1817–1864), this drawing appeared on the English art market

with SCOTT & FOWLES, then in New York in the collection of ROBERT STERLING CLARK (see Provenance, cat. 127).

F.C.

62. Le déjeuner sur l'herbe

1863
Oil on canvas
82 × 104" (208 × 264 cm) (214 × 270 cm untrimmed)
Signed and dated (lower right): éd. Manet 1863
P Musée d'Orsay (Galeries du Jeu de Paume), Paris

Exhibitions
Salon des Refusés 1863, no. 363 (Le Bain); Alma 1867, no. 1 (Le Déjeuner sur l'herbe); Beaux-Arts 1884, no. 19; Exposition Universelle 1900, no. 440; Orangerie 1932, no. 16; Orangerie 1952, without no.

Catalogues
D 1902, 43; M-N 1926 I, pp. 44–49; M-N cat. ms., 50; T 1931, 62; JW 1932, 79; T 1947, 66; PO 1967, 59A; RO 1970, 58A; RW 1975 I, 67

In 1863, the jury for the Salon had rejected many more works—2,783 out of 5,000 submitted—than in previous years. The storm of protest reached the Tuileries, and Napoleon III decided to have a look for himself. He came on April 20, before the opening, to view the rejects; astonished by the severity of the jury, he commanded that an exhibition be held outside the official Salon, to show the rejected works and let the public reach its own conclusions. The result was the famous Salon des Refusés, attended by more than 7,000 visitors on the first day.[1]

"There was no more than a turnstile to separate the show from the other one. As at Madame Tussaud's in London, one passed into the Chamber of Horrors. People expected to have a good laugh, and laugh they did, as soon as they got through the door. Manet, in the farthest hall, went right through the wall with his *Déjeuner sur l'herbe*," reported Cazin, himself one of the *refusés*.[2] Such an outcry had never before been known, not even against Courbet.

To either side of his big canvas, then titled *Le bain*, Manet showed *Young Man in the Costume of a Majo* (cat. 72) and *Mlle V . . . in the Costume of an Espada* (cat. 33).[3] With Whistler, whose *White Girl* (National Gallery of Art, Washington, D.C.) fared hardly better, Manet shared a formidable *succès de scandale*, assigned more prominence by history than the work itself, which remains enigmatic and ambiguous, for all the clear iconographic precedents identified.

The work offended by the manner of its painting as well as by its subject matter; most of the notices compared it unfavorably with the "exquisite taste" and technique of two nudes acclaimed at the Salon show—Baudry's *The Pearl and the Wave* (Museo del Prado, Madrid) and Cabanel's *Birth of Venus* (fig. a), which was forthwith purchased by the emperor.

A few sample comments: "Manet will show talent once he learns drawing and perspective, and taste once he stops choosing his subjects for the sake of scandal. . . . We cannot find it altogether a chaste enterprise, to set down under the trees, beside students in cap and gown, a female clad only in leafy shade. Certainly a secondary consideration, but more than the composition itself I lament the intention that inspires it. . . . M. Manet plans

Fig. a. Alexandre Cabanel, *Birth of Venus*, 1863. Musée d'Orsay-Louvre, Paris

to achieve celebrity by outraging the bourgeois. . . . His taste is corrupted by infatuation with the bizarre."[4]

"The bathing scene, the *Majo*, the *Espada* are good sketches, I agree. There's a certain life in the color, a certain directness in the touch that are in no way vulgar. But then what? Is this drawing? Is this painting? M. Manet means to be firm and strong, he is merely hard; strange to say, he is no less soft than hard."[5]

"A common *bréda* [low prostitute, as found in the Bréda quarter near Les Batignolles], stark naked at that, lounges brazenly between two warders properly draped and cravatted . . . these two seem like students on holiday, misbehaving to prove themselves men; and I seek in vain for the meaning of this uncouth riddle."[6]

But probably the criticism most disappointing to Manet was one of the more restrained, by Baudelaire's friend Théophile Thoré: "*Le bain* is in questionable taste. The nude woman lacks beauty of form, unhappily . . . and the gentleman sprawled beside her is as unprepossessing as could well be imagined. . . . I fail to see what can have induced a distinguished and intelligent artist to adopt so absurd a composition. Yet there are qualities of color and light in the landscape, and indeed very true bits of modeling in the torso of the woman."[7]

Only Astruc (see cat. 94) supported his friend, in a daily newsletter issued during the Salon, concluding on the last day, "[Manet] is the *éclat* of it all, the pungent flavor, the astonishment."[8]

Antonin Proust in his *Souvenirs*, otherwise so indispensable to our sense of Manet's experience, especially at the period of this work, occasionally confuses the dating of conversations reported; and he was writing toward the close of the century, when he wished to emphasize Manet's pre-Impressionism, seeing him as a precursor of *la peinture claire et de plein air*. We should therefore accept his testimony with some caution: "Not long before he did the *Déjeuner sur l'herbe* and *Olympia*, we were at Argenteuil one Sunday, lying on the bank, watching the white barques ply the Seine. . . . Some women were bathing. Manet's eye was fixed on the flesh of the women leaving the water. 'I'm told,' he said to me, 'that I must do a nude. All right, I will! I'll do them a nude. Back in our studio days, I copied Giorgione's women, the women with musicians. That's a dark picture. The background has retreated. I'm going to do it over, and do it in the transparency of the atmosphere, with figures like those you see over there. I'll take a beating; they'll say I'm finding inspiration in Italians now, instead of Spaniards.'" Then Proust goes on to have Manet eulogize Courbet: "'There's something very French about that master painter—no use talking, we in France have a basic honesty that always brings us back to the truth, in spite of all the acrobatic *tours de force*. Look at Le Nain, Watteau, Chardin, David himself—they have a feeling for truth.'"[9]

Apart from the question of date—"I'll do them a nude" may well have been said in reference to *The Surprised Nymph* (cat. 19)—the idea of doing a modern "Giorgione" and the wish to enlist in the—incidentally French—grand tradition of realism is certainly in character for Manet, and for all that his 1860s paintings suggest. But when this passage was read to Degas, himself a privileged witness of the sixties, upon its publication in 1897, he burst out in exasperation, "[Proust] has got it all mixed up. Manet never thought of *plein air* when he did the *Déjeuner sur l'herbe*. He never thought of it until after seeing those first Monet canvases."[10]

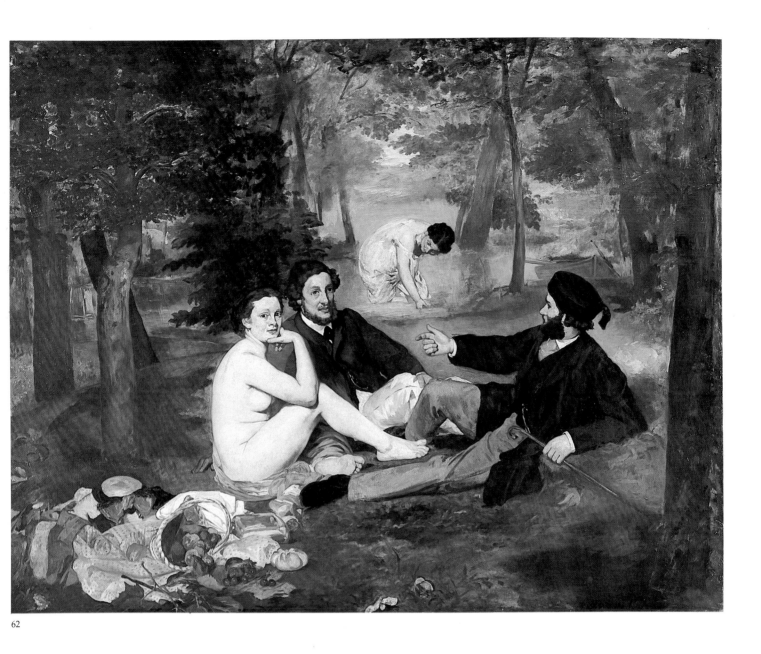

62

The landscape, furthermore, is treated in a very casual way, sketched with the brush like a stage set behind the models, who quite obviously are posing in the studio. For his background, Manet used earlier sketches of the Ile Saint-Ouen, near the family property at Gennevilliers. We also recognize the boat from *La pêche* (cat. 12), and the posture of the bather emerging recalls that of the fisherman in the same painting.[11] The boat appears in a preparatory sketch (cat. 13, fig. a).

Is the somewhat disturbing contrast between the figures and the background a mark of ineptitude, or a deliberate effect? It has been interpreted as reflecting a Japanese influence—figures cut out and mounted on a background, itself treated as flat, like wallpaper[12]—but there is no certainty of this, and it is entirely possible that Manet did not achieve the unity between figures and landscape that he would have wished; the same shortcoming had earlier prompted him to destroy *The Finding of Moses* (see cat. 19, 20), originally of the same size and format—in short, more or less a draft of the *Déjeuner*.[13]

What were Manet's objectives? The will to shock, attributed by contemporary critics, can hardly have been the sole motive. According to Antonin Proust, he had expressed his intentions quite clearly: to do a modern Giorgione, taking inspiration from the *Concert champêtre* (fig. b). And there was, in fact, a very good copy of it by Fantin-Latour in Manet's studio. Yet for the actual composition he made a literal adaptation of the group of two river gods and a nymph in an engraving by Marcantonio Raimondi from a composition by Raphael, the *Judgment of Paris* (fig. c)—itself partly inspired by classical reliefs. The engraving, widely circulated in the studios, was regarded by the author of a then recent catalogue of engravings as "Marcantonio's finest."[14] This seemingly forgotten source, rediscovered in 1908 by Pauli,[15] was surely no secret to the artistic public of the time, at least not to the painters. The critic Chesneau, in his review of the Salon, had in fact noted the borrowing, and censured it.[16] The mythological story recommended itself to Manet, in these allegories of rivers and water plants, by affording him a classical model of "bathing in nature," a theme about which his thoughts had been revolving for a year with his *Finding of Moses* and *The Surprised Nymph*. Again, he may have been captivated by the very gaze of the nymph, turned toward the viewer; of the seventeen divinities in the picture, of which the chosen group is but a detail, she alone frankly eyes the viewer. Manet is content to follow the original faithfully, while dressing the two men in the fashion of the day, substituting a cane for the reed in the left hand of the river god at the right and eliminating the one in the right hand, leaving it half open, almost in the center of the composition, a living question mark: Is it pointing a finger at Victorine's nakedness? Explaining something to unlistening companions? It has even been suggested that the forefinger had been a perch for the little bird fluttering at the top of the canvas, a surrogate for the winged Victory at the center of the engraving. Manet would thus have left a key to the enigma of his composition for clairvoyant historians: an iconological program harking back to the Renaissance, but with an added note of irony. Victory crowning Venus in the *Judgment of Paris* becomes a *oisillon*, a young bird, in a rude personification of this Paris—taking the name to refer to the city—where the new Venus becomes a prostitute.[17] We do not in any way subscribe to this interpretation, but it reveals what flights of fancy have recently been inspired by Manet's work.

If Manet has any reference in mind, it is not to Renaissance idealism but—far more directly—to Courbet, his senior and rival in realism and modernity, whose maverick ways he was to imitate two years later by setting up his own private show, not far away, at the doorstep of the Exposition Universelle of 1867. For although Manet's use of the Raimondi engraving is well known, it is not so well known that Courbet most probably used another group from the same plate, the Three Graces, for his *Young Ladies of the Village* of 1852 (City Art Gallery, Leeds) and his scandalous *Bather* of 1853 (Musée Fabre, Montpellier).[18] Undoubtedly, the transcription of Raimondi was understood in the studios, and particularly by Courbet. In using sources like Courbet's and a theme similar to his, was not Manet rather clearly addressing himself to him, and seeking to surpass him by showing a nude, at the Salon, in a scene from "modern life," as though Victorine were one of the *Demoiselles de la bords de la Seine*, 1857 (Musée du Petit Palais, Paris), but wide awake, nude and impudent in the company of persons of the opposite sex, actualizing a "realistic" scene where Courbet could but suggest one?

The two works have many points in common: the brilliance and de-

Fig. b. Titian, *Concert champêtre* (formerly attributed to Giorgione). Musée du Louvre, Paris

Fig. c. Marcantonio Raimondi, engraving after Raphael, *The Judgment of Paris*

Fig. d. Achille Devéria, *Le déjeuner sur l'herbe*, 1834, lithograph

Fig. e. A. Morlon, *Boating Party on the Banks of the Seine*, 1860, lithograph

tail of the still lifes; Courbet's shawl, apparel, and flowers, which answer to the clothes and picnic lunch of Manet; the boat drawn up on the bank (Manet's greenery is simply more schematic); finally, for the younger artist all trace of reverie has disappeared, leaving a scene less bathed in sensuality, drier and plainer.

All the same, this picnic outing enrolled Manet in the train of Courbet's realism. For the public of the time, evidently, here were a *grisette* and her partner, bathing in the environs of Paris, with two elegant young knights of Bohemia—Eugène Manet's tasseled cap is the *faluche* worn by students. Hanson and Farwell have discovered some charming romantic vignettes, from Devéria to Morlon (figs. d, e), which, while not actually sources of the painting, prove the currency and prevalence of such scenes, although the girls at these collations are either not nude or are represented allegorically.[19]

Here there is nothing of the idyllic, though an influence of Watteau's *fêtes champêtres* has been seen by some;[20] but Watteau himself bore the imprint of Giorgione's *Concert champêtre*, which thus provided a common source for both artists, more than a century apart.[21] The only tangible manifestation of idyllic well-being is perhaps the imposing still life in the foreground; such virtuosity was an affront in itself, expressing as it did Manet's remarkable skill while he insolently proceeded to paint the rest of the composition in this strong, colorful, simplified way. What is more, the still life accentuates the nudity of the woman, who becomes, in the presence of this heap of fashionable raiment, undressed rather than nude. The picnic lunch is utterly unrealistic in its assemblage of fruits—the cherries of June, the figs of September— and shows in the self-styled realist painter a certain irreverence for the seasons. The silver flask, lastly, betrays a liberal accompaniment to the viands.

But the still life has another, plastic peculiarity: it creates a perspective, a sense of depth, in the foreground, and is modeled with a light hand, whereas the figures and the background are all but devoid of relief, their flat shapes conforming to the picture plane, quite as though the still life were real, and the company of four reduced to a mythical image. Only the dour gaze of Victorine seems to pass through a glass separating the foursome from us the spectators and from the still life.

Giorgione, then, supplied the theme, and Raimondi the formula; but Titian is present too, in the still life: it occupies the same place in the picture, and is furnished with the same basket, as in *The Virgin with the White Rabbit* in the Louvre, where Manet had copied it about the year 1854 (RW I 5). And in the whole canvas, this fine bit of foreground is all that evokes the Italian Renaissance and lends the scene that abundance, ease, and cheer which are inherent in the theme but contradicted by the three frozen figures.

Who were the models for this *bréda* and the two young blades, all three like characters out of Henri Murger's *Scènes de la vie de Bohème*? Manet had posed Victorine Meurent, his favorite model for a year past (see cat. 31), opposite one of his brothers, Eugène by some accounts,[22] Gustave by others.[23] Antonin Proust, who was close to Manet at the time, gives us a clue to this little mystery: "For this painting, both his brothers posed,"[24] alternately or successively. That seems likely enough, for the bearded profile is less individualized than the third party's full face; he is the young Dutch sculptor Ferdinand Leenhoff, brother to Suzanne Leenhoff, soon to become Manet's wife. The scantily clad young lady emerging from the water in the background has not been identified—Proust speaks of "some little

169

transient"—but it could easily be Victorine again, or some composite figure.

It may be wondered why the public and the critics were offended by this nude, far less "naughty" and hypocritical to our eyes today than are those of Baudry or Cabanel. Hanson has quite rightly pointed out that the nude is there not *qua* nude, but as a model taking a rest between poses, and that one of the causes of scandal was just this apparition of an artist's model, by profession reputedly of easy virtue, so singularly present here on the canvas.[25] Odilon Redon's reaction is instructive: "The painter is not being intelligent if, after he has painted a nude woman, she leaves us with the feeling that she is about to get dressed again. . . . There is one in Manet's *Le déjeuner sur l'herbe* who will hasten to do so, after the discomfort of sitting on the cold grass beside the down-to-earth gentlemen she is with."[26] Indeed, traditional painting, where the model becomes "a nude," out of time, an object, a reference to a different culture, is here reversed. Manet passes from the object of reference—Raphael's nymph—to a particular model, whom he directs to imitate, as it were, the classical pose. He reverses the operation to be performed in the studio according to school doctrine, and transforms the ideal into the real.

And there is in fact something contrived, dry, "deadpan" about this *grande machine* wherein Manet had his friends play out a kind of *tableau vivant*, as in the parlor game dear to Second Empire society. This play of the live pose on things classical, on museum pieces, gave rise to a certain uneasiness, an embarrassment, like listening to a joke that goes on too long. Manet, let us not forget, himself called the painting *La partie carrée*[27] (*The Party of Four*), and may have conceived it as a joke, too, in the famous Second Empire spirit of parody, exemplified for us by Offenbach's *La Belle Hélène*, which came out just months after *Le déjeuner sur l'herbe*. This water nymph come down to pose for Manet in the shape of Victorine is as unfettered in her ways as those light-opera goddesses patterned after the *biches* of the period, who "ont de bien drôles de façons" (will do the very strangest things)—a hit tune picked up by the same public that took offense at the painting. The taste for the "corrupting" joke was just then being wrathfully denounced by the Goncourt brothers in a novel about artists' life: "This new form of French wit, . . . rising from the studio into literature, the theater, society . . . a light and playful formula for blasphemy . . . nineteenth-century *blague* [joke], the great destroyer . . . the assassin of all respect . . . the *vis comica* of our decadence," and so forth.[28] The element of farce in this painting, which has been noted by Sandblad and especially by Nochlin,[29] perhaps accounts for the faint uneasiness we feel today, when we are not in the least scandalized and the allusive parody of the "masters" has lost all power to provoke.

The ambiguity of the work, however, lies in that, parody though it may be, born of a wager or a practical joke, it bears witness also to a lofty ambition: to prove, by adapting old masters—Raphael by way of Raimondi, and Giorgione—that it was possible, using simplified and resolutely novel means, to produce a "contemporary masterpiece." Manet was still determined to meet the challenge of the great painters, but this time in a new and highly original thematic mode, made up in equal parts of deference and provocation.

He had perhaps been assisted in this enterprise, curiously enough, by a professor at the Ecole, Fantin-Latour's master, Lecoq de Boisbaudran. Wechsler has aptly brought to light a text that may not actually have been

read by Manet but must at any rate have been discussed in the studios and at the cafés, *L'Education de la mémoire pittoresque*, just republished in 1862. It recommended that one take one's pupils with their models "to some picturesque spot, a great natural park or the like . . . [where] a wide glade received ample light from the sky, and, near the wood, a pond reflected the tall trees . . . some models had been engaged for the expedition; they were asked to walk, sit, run . . . now nude . . . now draped. . . . There was Mythology, come to life before our eyes."[30]

This blend of tradition and modernism places the canvas, in the gradual dissociation of Manet's work from his masters, between *The Surprised Nymph* (cat. 19), where the past is contested virtually on its own ground, and *The Luncheon in the Studio* (cat. 109) or *The Balcony* (cat. 115), where the past is assimilated, absorbed into a quite personal vision. Irony, which is here something of a confession of weakness, will then be no longer required. Yet *Le déjeuner sur l'herbe*, as a sort of initiation into modernity, still permeated with the *esprit de blague*, was necessary to Manet's attainment, a few months later, of the assurance and harmony of *Olympia* (cat. 64).

In the *Déjeuner*, Hofmann sees a dialectical work, a painting in unreconciled contrasts, opposing the natural, feminine world to the artificial and civilized world of men,[31] a realist allegory of that Paradise Lost which, in his view, underlies all nineteenth-century iconography. Farwell sees the image as corresponding truly to a Paradise Regained, to the expression of a realized masculine fantasy,[32] whose progeny can be found, early in the following century, in Matisse's *Joy of Life* and in Picasso's *Demoiselles d'Avignon*.[33] It remained for Picasso to conjure up the ruling spirit of *Le déjeuner sur l'herbe*, and subject Manet's painting to an iconoclastic and creative process in a series of *Déjeuners* based on Manet's "museum masterpiece," doing unto Manet as Manet had done unto the Italian Renaissance painters.

Quite certainly, audacity of technique and unorthodoxy of theme have rendered this painting one of the clichés in the history of art, the "first modern painting." Yet now that the scandal has long since blown over, the work, impressive as it is for its decisive technique, its colors, and its simplicity, falls short of the serenity of a great masterpiece. Not because it "offends against modesty," as the emperor said, but perhaps because it accommodates too many contradictions. Cézanne, standing before Giorgione's *Concert champêtre* at the Louvre, noted its profound harmony, and then made reference to Manet: "You know, in *Le déjeuner sur l'herbe* Manet should have added, what can I say, a touch of nobility, or whatever it is, that here enraptures all the senses."[34]

1. Tabarant 1947, pp. 299–346.
2. Cazin, quoted in Tabarant 1931, p. 95.
3. Paris, Palais des Champs-Elysées, *Catalogue des ouvrages de peinture, sculpture, gravure . . . refusés par le Jury de 1863 et exposés par décision de S. M. L'Empereur au Salon annexe*, May 15, 1863, Paris, 1863, nos. 363–65.
4. Chesneau 1864, pp. 188–89.
5. Castagnary 1863.
6. Etienne 1863, p. 30.
7. Bürger (Thoré) 1863.
8. Astruc 1863.
9. Proust 1897, pp. 171–72.
10. D. Halévy 1960, pp. 110–11.
11. Hanson 1966, p. 49.
12. Sandblad 1954, p. 94.
13. Ibid., p. 89.
14. Delessert, cited in Albert Boime, "Les Hommes d'affaires et les arts en France au 19ème siècle," *Actes de la recherche en sciences sociales*, no. 28 (June 1979) pp. 62–63.
15. Pauli 1908, p. 53.
16. Chesneau 1864, p. 189.
17. Andersen 1973.
18. Reff 1980, p. 15.
19. Hanson 1977, pp. 94–95; Farwell 1977, pp. 39, 72, 73.
20. Fried 1969.
21. Haskell 1973, pp. 372–74.
22. Moreau-Nélaton 1926, I, p. 49.
23. Tabarant 1931, p. 93.
24. Proust 1897, p. 172.
25. Hanson 1977, p. 95.
26. Odilon Redon, *A Soi-même*, Paris, 1961, pp. 94–95: May 14, 1888.
27. Manet et al., "Copie faite pour Moreau-Nélaton"
28. Jules and Edmond de Goncourt, *Manette Salomon*, new ed., Paris, 1881, pp. 28–29.
29. Sandblad 1954, p. 29; Nochlin 1968, p. 16.
30. Wechsler 1978, p. 35.
31. Hofmann 1961, p. 172.
32. Farwell (1973) 1981, pp. 240–54.
33. Ibid., p. 255.
34. Quoted in Cézanne 1978, p. 137.
35. Rouart and Wildenstein 1975, I, p. 17.
36. Blanche 1912, pp. 153–54.
37. Rouart and Wildenstein 1975, I, p. 20.
38. R. Kœchlin et al., "La Donation Etienne Moreau-Nélaton," *Bulletin de la Société de l'histoire de l'art français*, 1927, pp. 118–52.

Provenance
In his manuscript inventory of 1872,[35] Manet valued this picture at 25,000 Frs., calling it "La partie carrée" (the party of four). Dr. Emile Blanche (see Provenance, cat. 5) almost bought it during the 1870s, according to his son Jacques-Emile: "My father, aware that I liked Manet's work, once told me: 'Yes, it's odd; there's something to it. I once negotiated with Edouard to buy his "Déjeuner sur l'herbe"; there was space for it on the wall of the dining room. Your mother was anxious about the bather's nudity. Perhaps she was right after all, but we could have put the picture aside, and you would have had it later.'"[36] Manet kept *Le déjeuner sur l'herbe* in his studio until 1878, when he sold it to the singer FAURE (see Provenance, cat. 10) for 2,600 Frs.[37] The picture remained in

Faure's collection for twenty years, until DURAND-RUEL (see Provenance, cat. 118) bought it in 1898 for 20,000 Frs. The dealer soon sold it to MOREAU-NELATON, who lent it to the Exposition Universelle in 1900. The painter and writer ETIENNE MOREAU-NELATON (1859–1927; see also Provenance, cat. 9)[38] will go down in art history on three counts: as a remarkable collector, as an excellent art historian, and as a great donor. His studies of Manet, Corot, Delacroix (who was a close friend of his grandfather's), and Daubigny, although more than half a century old, remain basic references and represent a great moment in French art historical research. He was also one of the most prodigious donors to the national collections, and French museums would not be what they are without him; his gift of 1906 included

thirty-four works, to which later bequests were added. He gave a series of masterpieces of drawing (3,000 sheets) and painting by Corot (*The Bridge at Mantes*), Delacroix (*The Entry of the Crusaders into Jerusalem* and the *Still Life with Lobster*), Fantin-Latour (the *Homage to Delacroix*, in which Manet is depicted), and the Impressionists, among these ten Monets including the *Field of Poppies*, seven Sisleys, two of the most beautiful Pissarros in the Musées Nationaux, and a charming Berthe Morisot, *Chasing Butterflies*. He gave

two Manet still lifes (cat. 77, 80) as well as the portrait *Berthe Morisot with a Fan* (RW I 181), *The Blonde with Bare Breasts* (cat. 178), and *Le déjeuner sur l'herbe*. The painting was exhibited with Moreau-Nélaton's collection at the Musée des Arts Décoratifs in 1907, entered the Musée du Louvre in 1934 (inv. RF 1668), and was installed with the Impressionist collection in the Galeries du Jeu de Paume in 1947.

F.C.

63. Le déjeuner sur l'herbe

1862–63
Pencil, watercolor, pen and India ink
14⅝ × 18⅜" (37 × 46.8 cm); sheet, 16⅛ × 18⅞" (40.8 × 47.8 cm)
Inscribed (in margin, probably by Suzanne Manet): Ed. Manet
The Visitors of The Ashmolean Museum, Oxford

Exhibitions
Exposition Universelle 1900, no. 1150; Paris, Berès 1978, no. 9

Catalogues
D 1902, p. 134; T 1931, 25 (watercolors); JW 1932, mentioned 79; T 1947, 568; L 1969, 197; RW 1975 II, 306

It is not certain whether this charming watercolor is a study for the painting (cat. 62), as is generally claimed (Tabarant, Rouart and Wildenstein). Wilson believes it to be an intermediate stage between the painting and the reduced replica in the Courtauld Institute in London (RW I 66).[1] None of the changes in the Courtauld version—except the color of the woman's hair—are seen here. The theory presupposes that the Courtauld version is later than the

63

173

Salon painting, which does seem likely,[2] but the contrary has also been maintained.[3] Wilson's hypothesis that the watercolor followed the painting, and may even have been traced from a photograph, is quite convincing, to judge by the generally discontinuous pencil outline of the figures, landscape, and still-life objects, in which Manet redid with greater freedom of execution details that interested him. It is not out of the question that this drawing, like so many done from paintings (see cat. 34, 51, 75), was intended for an etching. It gives Victorine—red-haired, as we see her in the portrait (cat. 31)—a fresher and prettier face than in the painting, and turns her gaze, like Ferdinand Leenhoff's, upon Eugène Manet, whose attitude suddenly assumes a different meaning from that in the painting, the gesture of the hand suggesting a lively dialogue. There is no supporting evidence for the speculation that the young woman posing, red-haired as in the Courtauld painting, is not Victorine Meurent;[4] the figure is the same, and only the color of the hair is different.

1. Wilson 1978, no. 9.
2. Cooper 1954, no. 32.
3. Bowness 1961, p. 276.
4. Tabarant 1931; Cooper 1954, no. 32.
5. Blot 1934.

Provenance
The dealer PORTIER (see Provenance, cat. 122) was the first known owner of this watercolor. It subsequently belonged to the dealer and collector EUGENE BLOT, who published his memoirs in 1934,[5] and was no. 105 in his sale on May 10, 1906. The work next passed in turn to BERNHARDT and to the Berlin dealer BRUNO CASSIRER (1872–1941), publisher of the journal *Kunst und Künstler* and cousin of Paul Cassirer (see Provenance, cat. 13),

with whom he founded a gallery in Berlin. When Bruno Cassirer took refuge in England at the end of the 1930s, he took the watercolor to Oxford along with his collection and devoted his time to publishing. In the 1950s, the work passed by inheritance to his daughter SOPHIE WALZER, and it was recently given to the museum in Oxford (inv. 1980.83).

F.C.

64. Olympia

1863
Oil on canvas
51⅜ × 74¾" (130.5 × 190 cm)
Signed and dated (lower left): éd. Manet 1863
P Musée d'Orsay (Galeries du Jeu de Paume), Paris

"Like a man falling into a snowdrift, Manet has made a hole in public opinion," Champfleury wrote to Baudelaire at the time of the Salon of 1865, where *Olympia* appeared.[1] Nearly half a century later, in 1907, we find Oriane de Guermantes reporting further on the state of opinion, still lukewarm even in the avant-garde: "The other day . . . , at the Louvre, we came across Manet's *Olympia*. Nobody is astonished by it any more. It looks like something by Ingres! And yet heaven knows I've broken many a lance for this painting which I don't entirely like, though assuredly it's by *someone*," and she adds, "It doesn't perhaps quite belong in the Louvre."[2]

Nearer our own time, in 1932, at the last retrospective exhibition, the scandal was alive and well: "*Olympia* is shocking" still, "arouses a sacred horror . . . monster of profane love . . . she is a scandal, an idol; public presence and power of the skeleton in Society's closet. . . . The purity of a perfect line embraces the Impure *par excellence*, whose office demands candid, quiet ignorance of shame. Bestial Vestal consecrated to the nude absolute, she bears dreams of all the primitive barbarism and animal ritual hidden and

Exhibitions
Salon 1865, no. 1428 (Olympia); Alma 1867, no. 2 (Olympia); Beaux-Arts 1884, no. 23; Paris, Drouot 1884, no. 1; Exposition Universelle 1889, no. 487; Orangerie 1932, no. 15; Orangerie 1952, without no.

Catalogues
D 1902, 44; M-N 1926 I, pp. 67–70; M-N cat. ms., 75; T 1931, 66; JW 1932, 82; T 1947, 68; PO 1967, 62; RO 1970, 61; RW 1975 I, 69

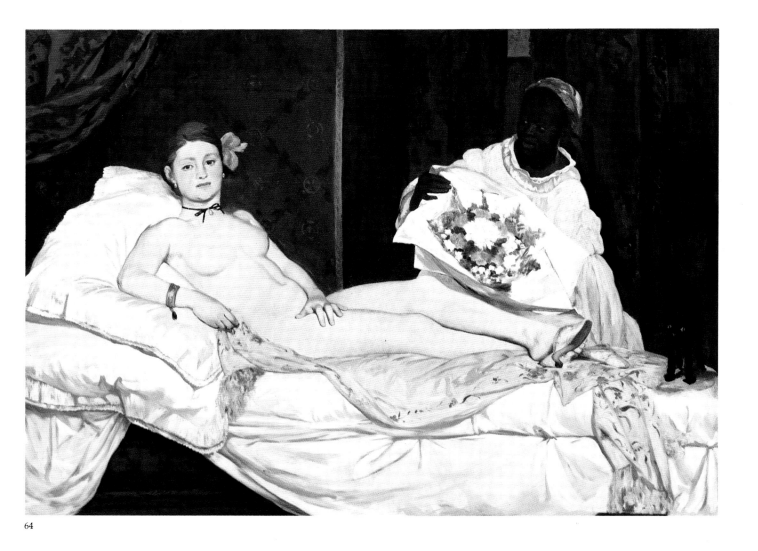

64

preserved in the customs and practices of urban prostitution."[3] As for the artist himself at the same period, his standing as a painter and his creative power were still being denied: "*Olympia* is a small, mean character, living on the cheap, and on the canvas she holds the quite modest place assigned her by the painter's brush. . . . If his creative power had been less meager, he would have given his *Olympia* something of the grandeur of the *Naked Maja* . . . , not this silly, phlegmatic creature. . . . "[4]

What is the judgment of today, more than a century after its conception? A classic masterpiece, peer of the finest nudes in the history of art, and perhaps the last of a series beginning with the great Venetians and continuing with Velázquez (*Rokeby Venus*), Goya (*Naked Maja*), and of course the great Odalisques of Ingres. And at the same time a painting undeniably modern, in its handling and its spirit of polemic and irony: the black cat at the right is a final exclamation point, closing that long series with a Manetesque wink and flourish. Beyond this, the importance accorded to the bouquet and its bearer, as essential to the subject as the nude figure, clarifies the enigma of Manet's thought: *Olympia* is first and foremost grand painting, and it was meant as such. It was, moreover, precisely this inverted hierarchy of values that was resented by the best critics of the time: "His current vice is a kind of pantheism, esteeming a head no more highly than a shoe, and

175

sometimes assigning more importance to a bunch of flowers than to the face of a woman, as in his famous painting with the black cat."[5]

It is very difficult today to approach the work with any objectivity. Never has woman's nakedness been so covered with commentary; except for the *Mona Lisa*, never has paint been varnished with so many layers of literature, never has a painting so tempted the gluttony of the art historian. And *Olympia*, contemporary heroine that she is, has enjoyed perennial publicity since her creation: the first scandal of her appearance at the Salon of 1865, revived by her presence in the 1867 show organized by Manet on the fringe of the Exposition Universelle, controversy in 1890 when she was bestowed on the Louvre (Musée du Luxembourg; see Provenance), and again in her 1907 advent to the Louvre beside Ingres's *Grande odalisque* in the Salle des Etats.

The prevailing reactions to this painting have always been of two kinds. The formal reaction responds to technical, painterly values, the novelties they offer, the pleasures they afford. It comes directly from Zola, who also expressed the opinion of artists and writers in the Café Guerbois circle, his friend Cézanne in particular, when he summed up the case in an apostrophe to Manet: "For you, a picture is but an opportunity for analysis. You wanted a nude, and you took Olympia, the first to come along; you wanted bright, luminous patches, and the bouquet served; you wanted black patches, and you added a black woman and a black cat. What does all this mean? You hardly know, nor do I. But I do know that you succeeded admirably in creating a work of painting, of great painting, and in vigorously translating into a special language the verities of light and shade, the realities of persons and things."[6] This frame of mind, emphasizing the "work of painting" aspect, has persisted in the commentaries of Duret, Jamot, Venturi, Malraux, and Bataille.[7]

The other reaction, widely represented by the critics of the day, in revulsion or derision, emphasizes subject matter. In the past twenty years, it has drifted into a preoccupation with image alone, among many art historians primarily concerned with sources, iconographic significance, and public response as clues to psychological history. Generally speaking, this is the approach of Reff, Farwell, Scharf (history and photography), Van Emde Boas (psychoanalysis), and Clark (Marxist sociology).[8] Reff gives a remarkable synthesis, reviewing almost all the documentation available on the subject to date.[9] These responses are characteristically fascinating, even those most remote from the work itself or most strongly marked by the ideological fashions and climate of the times. In any case, they testify to the manifold riches of a masterpiece that has lived on, stimulating investigation, imagination, and confrontation.

With all the voluminous literature on the sources and critical fortunes of the painting, remarkably little is known about its production.[10] The date 1863 indicates that Manet intended it for the Salon of 1864, and there is evidence that he preferred to temporize in the face of violent public reaction to the *Déjeuner*.[11]

At all events, the project had the benefit of mature consideration and of many exchanges with his literary friends, including Baudelaire and Astruc. *Olympia* draws upon museum art, and also on life experience, literature, and a humor that has evanesced in the majestic glow that masterpieces inevitably take on. It is entirely possible that Manet, as in *Le déjeuner sur l'herbe*, meant at one and the same time to align himself with the old masters

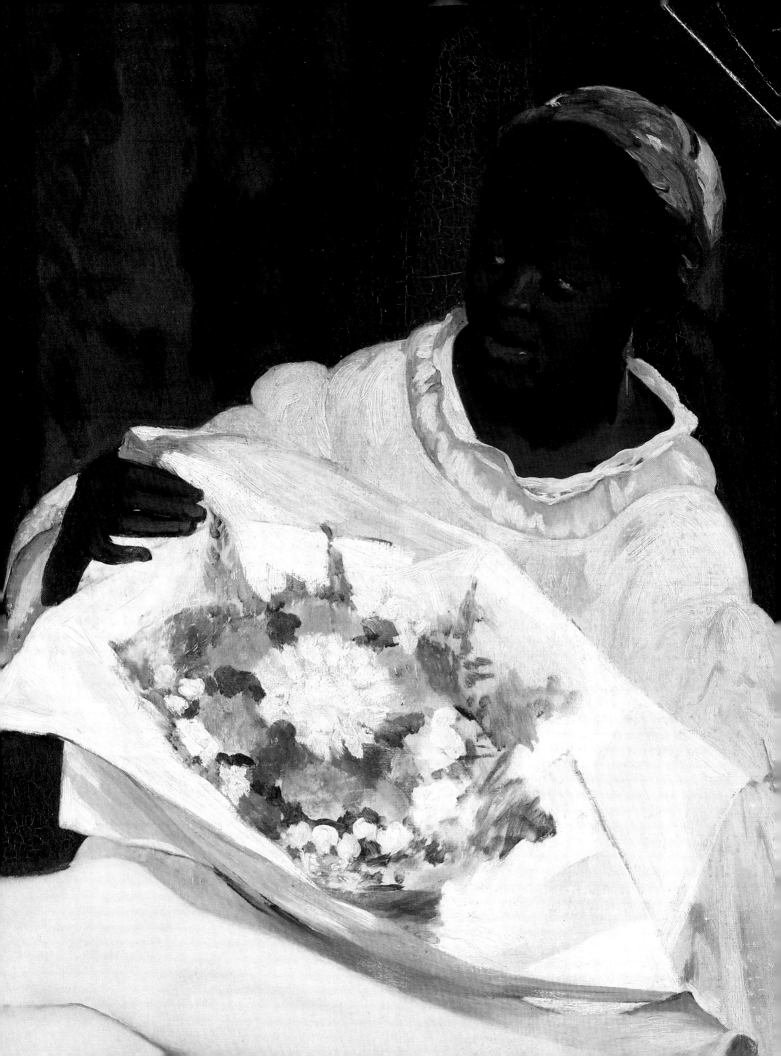

and to deliver a parody, a torch of modernism in the hand of his model, Victorine of the brazen youthful gaze, already heavy with experience, who would symbolize the artist's cool effrontery in causing her to mimic a model of the past while retaining her own individuality: "Free daughter of Bohemia, artist's model, butterfly of the brasseries . . . with her cruel, childlike face and eyes of mystery."[12]

Two pictorial sources are obvious: Titian's *Venus of Urbino* (fig. a), copied by Manet in Florence as a young man (RW I 7), for composition; and Goya's *Naked Maja* (fig. b) for arrogance and shock of novelty.

From Titian, Manet borrowed the general attitude of the nude, right elbow resting on two cushions and left hand in the classic *Venus pudica* position, hiding her sex. But he adapts the famous nude in a subtly irreverent manner. Although in Manet's time the *Venus of Urbino* was thought to have represented a celebrated courtesan, the nudity of Titian's young woman is innocent, soft, gentle—the little dog sleeping at her feet symbolizes domestic fidelity, and the women seen in the background are a young bride's chambermaids, busying themselves about the wedding chest.[13] In contrast to this girl of Venice, Olympia under the same green hanging somewhat reduced in area lifts her head to stare at us; the modestly placed hand is here firmly applied, insistently modeled in perspective against the flatness of the rest of the picture, so that it becomes the center of the composition, focusing attention on what it conceals. The little sleeping dog has become a black cat, arching its back, flashing its tail and yellow eyes—embodiment of the familiar of witches, beast of ill omen, and manifest erotic allusion.[14] The two serving women, engaged in the duties of a reputable household, are replaced by the superb black woman presenting a bouquet from a client. And in place of the fair sunny atmosphere of a chamber open to the sky, we have a closed space leading only to a reception room. Lastly, the soft contours of the Italian nude have given way to a firm delineation of the body, seen as a cutout against the background.

From Goya, Manet takes the candor of subject, the individuality of model, but where the Maja is an inviting lover, Olympia is cold and practical; like the Spanish woman, she looks and waits, but with no curiosity, no joy, no mystery; mercenary love supersedes passion, a naturalist's answer to a romantic image.

The very interesting iconographic studies devoted to *Olympia* in the context of Manet's time have shown that he was not a pioneer;[15] the theme of the reclining nude was a commonplace of the Salon in the nineteenth century, and Manet synthesized scattered features, none of which, taken in isolation, was so "explosive." More provocative nudes had flirted with scandal at the Salon. First there was Clésinger's sculpture *Woman Bitten by a Serpent*, 1847 (Musée du Louvre, Paris), in which everybody had recognized the model, Mme Sabatier; but the scandal was contained within high society, and the artist emerged magnified. Chassériau painted his mistress, the courtesan Alice Ozy, in the nude (Musée d'Avignon), and suffered nothing worse than admiration and a few bawdy but flattering verses. The nudes of Ingres and of Delacroix are far more voluptuous than *Olympia*. Those of Courbet, frankly erotic, such as the *Nude in White Stockings* (Barnes Foundation, Merion, Pa.), were well known, but not shown at the Salon, and intended for a special audience. One of the precursors of *Olympia* may have been the central figure of the *Romans of the Decadence*, which had gained a triumph for Manet's master Thomas Couture at the Salon of 1847 and was by

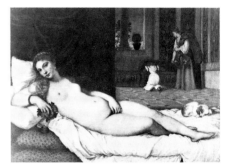

Fig. a. Titian, *Venus of Urbino*, Galleria degli Uffizi, Florence

Fig. b. Francisco de Goya, *Naked Maja*, ca. 1802. Museo del Prado, Madrid

this time enshrined in the Musée du Luxembourg.[16] That courtesan is similarly posed, but draped, with the dejected look proper to a Magdalen before repentance, as opposed to Olympia's cool regard. But those women, whether "nudes" or courtesans, were sheltered by some convention that kept up appearances—serpent, bacchante, sleeping Aphrodite, Oriental Odalisque, courtesan of antiquity; remoteness of time or place allowed every license to nudity.

Then why this uproar? Because this was a realistic nude and a contemporary scene. *Olympia* was a highly personalized nude,[17] an assemblage of qualities, both good and bad, and not, as was taught at the Ecole des Beaux-Arts in the tradition of Ingres, an idealized image of perfection gleaned from various models. Victorine was a bit short in the leg, small and narrow in the chest; her foot was anything but aristocratic; and her square face with pointed chin, her cold and challenging regard, did not express tenderness, timidity, shyness, or wantonness—the traditionally obligatory feminine expressions.[18] She presents herself without shame, without mythological or allegorical excuse. One is reminded of the bold Parisiennes noted at the time in the loges of the Théâtre des Italiens by Taine's Thomas Graindorge: "They are sphynxes . . . you look them in the eye; at two paces they don't flinch. With three lorgnettes trained upon her, the youngest of them does not stir. She declines to notice that you are there. No blush rises to her cheek. . . . She is in repose, or at least she seems so. But how disturbing is that repose . . . all of her speaks, and it all cries out, 'I want, I will have, more; I want, and I will have, without cease or limit. . . . I scorn you, and all else.'"[19]

To Manet's contemporaries, furthermore, the setting was perfectly explicit, as it is not for us today. In vain did the entry in the Salon catalogue display as epigraph a stanza of Astruc's insipid poem *Olympia*:

Quand, lasse de songer, Olympia s'éveille,	When tired of dreams, Olympia will arise,
Le printemps entre au bras du doux messager noir	Spring enters on the kind black envoy's arm;
C'est l'esclave à la nuit amoureuse pareille,	For in the dark of the amorous night, the slave
Qui veut fêter le jour délicieux à voir,	Would celebrate the day so fair to see—
L'auguste jeune fille en qui la flamme veille.	The august maiden, keeper of the flame.

The last line must have inspired hilarity, since Manet had quite simply, without equivocation, painted a prostitute on her couch, ready for action, expecting a client.

The plausible hypothesis has been offered that one reason for the scandal surrounding *Olympia* may have been an analogy with the pornographic photographs showing nude prostitutes brazenly displaying their charms—calling cards, as it were, and widely distributed.[20] Even though there may be no specific photograph in question, the painting accurately captures the spirit of these representations (fig. c).

Here is a woman for sale, spiced with the exotic fragrance of the harem and the Second Empire brothel. A bouquet of flowers—made up and wrapped by a florist, and obviously sent by a client—more sensitive and more expressive than the model herself, is brought in by a black servant, a sort of nursemaid-procuress. She represents a tradition well established

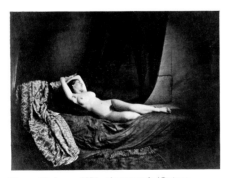

Fig. c. *Nude*, ca. 1854, photograph (Quinet Studio). Bibliothèque Nationale, Paris

since the eighteenth century of showing, in a perfumed Oriental atmosphere, women in the bath or at their toilet, tended or waited upon by black maidservants. They have been traced from the famous Nattier in the Louvre, *Mlle de Clermont at the Bath*, 1773, which must have been well known to Manet, to Jalabert's *Odalisque* (fig. d), in which Mathey sees a possible source for *Olympia*.[21] Along the way, there were Sigalon's *The Courtesan*, 1822 (Musée du Louvre, Paris), and of course the *Odalisque with Slave* of Ingres, 1839 (Fogg Art Museum, Cambridge, Mass.), and the *Odalisque* of Benouville (fig. e). (In this last, the roles are reversed, the white Odalisque being draped and the black slave half nude.)[22] The presence of the black woman serves to evoke the supposed delights of the harem, and to set off the white flesh of the Odalisque. Manet recalls this contrast for a humorous decorative motif in the two cats, black and white, of the print *Cats' Rendezvous* (cat. 114).

Fig. d. Jean Jalabert, *Odalisque*, 1842. Musée des Beaux-Arts, Carcassonne

But Olympia's servant is the warden of purchased favors, not a harem slave, and Manet subtly associates her with her mistress by dressing her in a pink related to the tints of the nude and by contrasting the elegant black hand on the white paper with Olympia's short, taloned paw, which in its strength and assurance reminds us of the hands of Ingres's *M. Bertin* (Musée du Louvre, Paris), symbols of power and authority. Like the cat and the mysterious background, the Negro woman belongs to the dark world, whereas the only black note in Olympia is the notorious ribbon at her neck, serving not so much to tie up the pearl as to accent her nudity: "Her head is empty, a black velvet string isolates it from the essence of her being," Valéry tells us.[23] Today, Michel Leiris writes: "The last impediment to utter nakedness . . . the neck band—hardly more than a thread—as neat as the tie on a gift package, above the rich offering of the two breasts, forms a bow to be undone with ease by pulling an end."[24]

Fig. e. Jean-Achille Benouville, *Odalisque*, 1844. Musée des Beaux-Arts, Pau

Manet must have thought of Baudelaire; the composition of the black woman with bouquet is a pictorial rendering of certain passages of *Les Fleurs du mal*, as in "La Malabraise." That Olympia herself seems literally to illustrate certain poems in the collection is now generally accepted.[25] The bracelet brings to mind "La très chère était nue et, connaissant mon coeur elle n'avait gardé que ses bijoux sonores" (My very dear lay nude, for knowing well my heart, she had kept nothing on but her resounding jewels); her mules

Sous tes souliers de satin,	Beneath thy slippers satiny,
Sous tes charmants pieds de soie,	Neath thy pretty silken feet
Moi, je mets ma grande joie,	Do I lay my joy complete,
Mon génie et mon destin	My genius and my destiny;

and her companion the cat "J'eusse aimé vivre auprès d'une jeune géante comme aux pieds d'une reine un chat voluptueux" (I should have wished to live with some young giantess, as at a queen's fair feet a cat, voluptuous).

What Baudelaire thought of the painting we do not know; very likely he did not see it in 1864 before his departure for Brussels, whence he returned to go into hospital. The one mention of the painting in a letter from Baudelaire to Manet, written in Brussels in 1865, expresses the curiosity of one who has not seen the work, at least not in its final state, and requests a description from a visitor from Paris: "He added that the painting of the nude woman, with the Negress and the cat (is it definitely a cat?), was much better than the religious painting."[26]

And in fact we do tend to forget, looking at this canvas in isolation

180

today, how provocatively it was paired at the Salon with *Jesus M[c]* *Soldiers* (cat. 87), a realistic treatment seeming to illustrate the ico[n] Renan's *Vie de Jésus*, published the same year. It has been sug[gested] Manet was referring to an anecdote—apocryphal, to be sure—about Titian, told by Charles Blanc after Aretino. Titian supposedly presented Charles V with a *Venus* and a *Mocking of Christ* at the same time, to flatter both his sensuality and his piety.[27] Quite near the two canvases at the Salon, Fantin-Latour's *Homage to Truth* (destroyed), in which Manet was prominently portrayed, rendered the artist's realist propensities explicit.

The name "Olympia" has been variously interpreted.[28] First, it is the title of the poem written by Astruc in 1864—after the painting—and used in the catalogue for the Salon of 1865.[29] It is believed that Manet thereupon titled the canvas.[30] "Olympia," or "Olympe," was a sobriquet of popular *cocottes*, and the name given the rival of La Dame aux Camélias; Reff and Farwell take it as a social label quite intelligible to the public. The fatal doll in *Les Contes d'Hoffmann* is called Olympia; familiar, as the heroine of an obscure Parnassian, to the haunts of Manet and Baudelaire.[31] One may also see simply an intention to deride mythology—a painter of contemporary reality loosing a bolt from Mount Olympus at the academicians.

Reactions at the Salon of 1865 surpassed all apprehensions, and momentarily devastated Manet, who complained to Baudelaire, "Abuses rain upon me like hail. I have never before been in such a fix. . . . I should have wished to have your sound opinion of my work, for all this outcry is disturbing, and clearly somebody is wrong."[32] The man whom Duret was to meet a few months later (see cat. 108) was on the verge of a nervous breakdown. The criticisms are well known and repetitive; let a few examples suffice: "Terrible canvases, challenges to the mob, pranks or parodies, what can I say? . . . What's this yellow-bellied Odalisque, this vile model picked up who knows where. . . . "[33] "The crowd, as at the morgue, presses together in front of the gamy *Olympia*."[34] "A wretched model. . . . The flesh tones are dirty. . . . The shadows are indicated by more or less broad streaks of monochrome. . . . "[35] "An almost childish ignorance of the first elements of drawing, . . . a bent for unbelievable vulgarity."[36] "This russet brunette is of a consummate ugliness. . . . White, black, red, green set up a frightful din on the canvas."[37]

Critical response and caricatures (fig. f) bear witness that Manet shocked, surprised, and taunted the wider public into laughter, betokening incomprehension but also embarrassment. Manet had doubtless breached a taboo by candidly presenting the image of a prostitute, whether she was in high style[38] or of low degree;[39] but there has recently been so much insistence on the iconographic aspects that we tend to forget how shocking was the manner of painting. This is difficult to imagine today, when a hundred years of modern art have emphasized the "museum art" aspects of the work. Furthermore, it is clear that the painting, despite its recent cleaning, has darkened; its colors and contrasts must have been far stronger—as witness the watercolor (cat. 67). Hardly ten years later, it was already remarked, "The tones of the painting are dimmed, the *moiré* of the skin has vanished . . . the Negress and the cat have become opaque black masses. . . . Evidently this painting must have aged a great deal."[40] Besides, the parodic references to Titian, the absolute master, and to the Italian Renaissance were resented by contemporaries as a sort of sacrilege, so obvious that the reviews do not even mention it.

Maxet.
La Naissance du petit Ébéniste
- M. Manet a pris la chose trop à la lettre ;
Que c'était comme un bouquet de fleurs !
Les lettres de faire-part sont au nom de la mère Michel et de son chat.

Fig. f. Cham, caricature in *Le Charivari*, 1865

1. Baudelaire, *Lettres à*, p. 84, from Champfleury, 1865.
2. Marcel Proust, *A La Recherche du temps perdu*, Paris, 1956, II, p. 522.
3. Valéry 1932, p. x.
4. Zervos 1932, pp. 295–96.
5. Bürger (Thoré) 1868, p. 532.
6. Zola 1867, *L'Artiste*, pp. 58–59; Zola (Dentu), p. 36.
7. Jamot 1927, *Burlington*, p. 31; Venturi 1953; André Malraux, *Les Voix du silence*, Paris, 1951, p. 101; Bataille 1955, p. 74.
8. Reff 1964; Farwell (1973) 1981; Scharf 1968; Van Emde Boas 1966; Clark 1980.
9. Reff 1976.
10. Pickvance 1977, p. 761.
11. Bazire 1884, p. 26.
12. Geffroy 1892, pp. 119–20.
13. Reff 1976, p. 118.
14. Curtiss 1966.
15. F. Mathey 1948; Sandblad 1954; Reff 1964; Reff 1976, pp. 53–54; Farwell (1973) 1981, p. 215.
16. Reff 1976, p. 19.
17. Farwell (1973) 1981, pp. 223–24.
18. Ibid., pp. 215–16.
19. H. Taine, *Vie et opinions de M. Frédéric-Thomas Graindorge*, Paris, 1867, pp. 171–73.
20. Needham 1972, pp. 81–89.
21. F. Mathey 1948, p. 3.
22. Compte 1978.
23. Valéry 1932, p. x.
24. Leiris 1981, p. 193.

Itself a contemporary version of a classic theme, *Olympia* promptly became the subject of copies and parodies. It was fairly copied by Gauguin in 1891 (present location unknown); reinterpreted by Cézanne in his famous *A Modern Olympia* (fig. g), with the spectator—or bearded client—brought upon the scene; parodied by Picasso in a sketch (fig. h), with the black woman nude on the bed and himself sitting nude beside her; more recently transformed into *art brut* by Dubuffet (*Olympia*, 1950, private collection, New York); and slicked up by the Pop artist Larry Rivers, who superimposes two Olympias, one white and one black, 1970 (Musée d'Art Moderne, Paris). It is notable that few painters have taken an interest in *Olympia* in a spirit of sheer appreciation and enjoyment, except for the dazzling still life, the bouquet of flowers. This is found repeated by Renoir in the *Still Life with Bouquet*, 1871 (Museum of Fine Arts, Houston). But the painting as a whole has directly inspired only iconographic playfulness, so promptly was it perceived as an archetype.

Surprisingly, when it appeared in 1865 nobody seems to have been sensitive to the remarkable refinement of whites and ivories of the figure, of the spread cloth, and the diaphanous cashmere shawl (by way of homage to Ingres), or to the virtuosity of the bouquet. Nor did they respond to the quite classical composition based on horizontals and diagonals—an inverted triangle formed by the heads of the two women and Olympia's hand. After the half-triumph of *Le déjeuner sur l'herbe*, the total mastery of sources and subject matter emerges forcefully in the firm, simplified touch: "It's all flat, no modeling . . . the queen of spades, one would say, fresh from her bath."[41] The sinuous outline of Olympia and the broad pale areas, with little or no contrast or modeling, have even been attributed to an early influence of Japanese prints.[42]

We have only two remarks of Manet's about the painting—apart from his surprise and disappointment at the scandal it provoked—made fifteen years later and reported by Antonin Proust. Reproached for the vibrant lines of *Skating*, 1877 (RW I 260), Manet replied to a visitor, Sir Frederick Leighton, president of the Royal Academy, "I've been told also, sir, that the contours of *Olympia* are too sharp. Things do even out."[43] And a little later, probably in response to the volume that had just been published by J. Claretie, in whose opinion the creator of *Olympia*, "so strange and greenish, . . . was clearly resolved to startle, and to fire off a revolver right next the sightseer's ear,"[44] Manet reportedly said: "How foolish must one be to say I'm trying to fire pistol shots. . . . I render, as simply as can be, the things I see. Take *Olympia*, could anything be plainer? There are hard parts, I'm told. They were there. I saw them. I put down what I saw."[45]

Fig. g. Paul Cézanne, *A Modern Olympia*, 1870. Private collection

25. Blanche 1924, p. 33; Jamot 1927, *Burlington*, p. 31; Sandblad 1954, p. 98.
26. Baudelaire 1973, II, p. 497: to Manet, May 11, 1865.
27. Blanc 1868, quoted in Reff 1976, pp. 46–47.
28. Reff 1976, pp. 111–12.
29. Flescher (1977) 1978, p. 95ff.
30. Rosenthal 1925, p. 124.
31. Alston 1978.
32. Baudelaire, *Lettres à*, pp. 233–34: from Manet, May 4, 1865.
33. Claretie 1865, *L'Artiste*, p. 226.
34. Saint-Victor 1865.
35. Gautier 1865.
36. Chesneau 1865.
37. Deriège 1865.
38. Reff 1976, pp. 117–18.
39. Clark 1980, p. 39.
40. Bertall 1876, p. 2.
41. Courbet, quoted in Wolff 1882.
42. Sandblad 1954, pp. 78–79.
43. Proust 1897, p. 207.
44. Clarétie 1872, *L'Art français . . .* , p. 204.
45. Proust 1897, p. 201.
46. Manet et al., "Copie faite pour Moreau-Nélaton . . . ," p. 131.
47. Manet sale, Paris, February 4-5, 1884, no. 1; Bodelsen 1968, p. 344.
48. Rewald 1973, *Gazette des Beaux-Arts*, p. 42.
49. *Le Temps*, February 9, 1890.
50. F. Mathey 1948.
51. Ibid.; Robida 1958, p. 152.
52. *Le Journal des curieux*, March 10, 1907.

Fig. h. Pablo Picasso, *Parody of Olympia*, 1901, drawing. Private collection

Provenance

Manet kept *Olympia* in his successive studios all his life; in 1872, he valued it at 20,000 Frs.[46] The picture was included in his posthumous sale[47] but failed to meet its reserve (10,000 Frs) and was bought in by the family. Late in 1888, Monet learned from his friend the American painter John Singer Sargent that SUZANNE MANET, in need of money, was on the verge of selling the painting to an American, whose identity has never been determined. Monet quickly initiated a public subscription to purchase the work from Manet's widow and offer it to the Musée du Louvre. He did not quite attain the 20,000 Frs she was asking (remember that Chauchard had just purchased Millet's *Angelus* for 750,000 Frs, as well as a Meissonier for 850,000 Frs[48]) but offered the total sum collected (19,415 Frs) to Suzanne Manet on March 18, 1890, after having written to the minister of public instruction and fine arts, Fallières, on February 7: "In the name of a group of subscribers, I have the honor of offering to the State Edouard Manet's *Olympia* . . . ; the great majority of those who are interested in French painting agree that Edouard Manet's role was useful and decisive. Not only did he play an important individual part, he was also the representative of a great and fruitful evolution. It thus appears impossible to us that such a work does not belong in our national collections, that the master is denied entrance where his pupils have already been admitted. In addition, we have noted with concern the incessant movement of the art market, the competition from America, and the easily foreseen departure for another continent of so many works of art that are the joy and the glory of France. . . . Our desire is to see it take its place in the Louvre, when the time comes, among the productions of the French school. . . . We hope that you will lend your support to the work with which we are associated, with the satisfaction of simply having accomplished an act of justice." The list of contributors followed the letter: "Bracquemond, Philippe Burty, Albert Besnard, Maurice Bouchor, Félix Bouchor, de Bellio, Jean Béraud, Bérend, Marcel Bernstein, Bing, Léon Béclard, Edmond Bazire, Jacques Blanche, Boldini, Blot, Bourdin, Cazin, Eugène Carrière, Jules Chéret, Emmanuel Chabrier, Clapisson, Gustave Caillebotte, Carriès, Degas, Desboutin, Dalou, Carolus Duran, Duez, Durand-Ruel, Dauphin, Armand Dayot, Jean Dolent, Théodore Duret, Fantin-Latour, Auguste Flameng, [Henri] Guérard, Mme Guérard-Gonzalès, Paul Gallimard, Gervex, Guillemet, Gustave Geffroy, J. K. Huysmans, Maurice Hamel, [Alexandre] Harrison, Helleu, Jeanniot, Frantz-Jourdain, Lhermitte, Lerolle, M. et Mme Leclanché, Stéphane Mallarmé, Octave Mirbeau, Roger Marx, Moreau-Nélaton, Alexandre Millerand, Claude Monet, Oppenheim, Puvis de Chavannes, Antonin Proust, Camille Pelletan, Camille Pissarro, Portier, Georges Petit, Rolin, Th. Ribot, Renoir, J.-F. Raffaelli, Ary Renan, Roll, Robin, H. Rouart, Félicien Rops, J. Sargent, Mme de Scey-Montbéliard, Thornley, De Vuillefroy, Van Cutsem, Anonymous, Double Incognito, A.H., H.H., L.N., R.G."[49] This is a remarkable list, for it includes a large spectrum of artists outside the circle of Manet's friends and collectors: for example, Roll gave 500 Frs. Several absences are worth noting; Rodin gave this excuse: "Impossible to come up with the money, I am sorry."[50] And Zola—who had written in 1867: "This canvas is the painter's veritable flesh and blood; destiny has marked its place in the Louvre"—abstained with this bizarre explanation: "My dear Monet, I am very sorry, but I have absolutely made up my mind not to buy paintings, not even for the Louvre. So many collectors form syndicates to raise the prices of a painter whose works they own; I understand this, but I have promised myself, as a writer, never to become involved in such affairs. . . . I have championed Manet with my pen enough not to fear criticism now for grudging him his glory. Manet will go to the Louvre, but he must do it by himself, with full national recognition of his talent and not in the roundabout manner of this gift, which smells of the coterie and of publicity seeking."[51] In 1890, seven years after Manet's death, the picture was accepted for the Musée du Luxembourg, the normal procedure when less than the required ten years had passed since the death of a painter. So the question was postponed until 1893, when it was decided in the negative. The official argument was: Manet in the Louvre, perhaps, but not this canvas. *Olympia* was destined to remain in the Luxembourg for seventeen more years, entering the Louvre only on January 6, 1907 (inv. RF 644), following the intervention of Monet and Geffroy with Clemenceau, then Président du Conseil, who gave the order to Dujardin-Beaumetz, undersecretary of state for fine arts. The picture was then hung in the Salle des Etats, next to Ingres's *Grande Odalisque*, and a new storm of controversy was precipitated.[52] Manet entered the Louvre in force, for the same year Moreau-Nélaton's gift, which included *Le déjeuner sur l'herbe*, was installed in the Pavillon de Marsan, in the Musée des Arts Décoratifs (see Provenance, cat. 62).

F.C.

65. *Study for* Olympia

Red chalk
9⅝ × 18" (24.5 × 45.7 cm)
Atelier stamp (under the knees): E.M.
P Musée du Louvre, Cabinet des Dessins, Paris

Catalogues
T 1931, p. 522; JW 1932, 82; T 1947, 570; L 1969, 195; RW 1975 II, 376

This fine drawing of Victorine Meurent by Manet recalls in its firmness and rigor his master Couture, and drawings of the Ingres tradition before him. Only the left foot, oddly foreshortened, shows a careless line. As can be seen in *Le déjeuner sur l'herbe* (cat. 62), Victorine did not have a classical foot—far from it—and Manet had reason enough to let Olympia wear those dainty mules.

The strange feature of this drawing is the blank face, with not a mark on it. The position of the body is slightly different in the completed work—the placement of the arms, the crossing of the legs, and the orientation of the head—but the line of the breast and belly is already as in the painting, where the same sinuous outline shapes the body and serves in lieu of modeling. Farwell puts forward the idea that this drawing and the other very similar one (cat. 66) were done at the same session, and that the position of the

65

right leg, conventionally concealing the pubic region, shifts at the time of the painting to a less modest attitude.[1]

Tabarant believes, on grounds of style, that the drawing is earlier,[2] which would suggest that Manet resurrected it for his *Olympia* project, but Reff's analysis is convincing when he places the drawing at a point in the development of the work when Manet is turning to a more classical model for his nude.[3] At all events, the fact that the body is obviously Victorine's places the drawings in 1862 at the earliest.

1. Farwell (1973) 1981, p. 202.
2. Tabarant 1947, p. 76.
3. Reff 1976, p. 74.
4. Rouart sale, Paris, December 9, 1912, no. 207.
5. Doucet sale, Paris, December 28, 1917, no. 238.
6. Anonymous sale, Paris, March 30, 1935, no. 42.

Provenance
This drawing was in the collection of HENRI ROUART (see Provenance, cat. 129), who probably obtained it directly from Manet's widow. At the Rouart sale in 1912,[4] it was purchased by the couturier and collector JACQUES DOUCET (see Provenance, cat. 135). The drawing was included in Doucet's sale in 1917[5] and reappeared at a public auction in 1935,[6] when it was acquired by the Musée du Louvre (inv. RF 24.335).

F.C.

66

66. *Study for* Olympia

1862–63
Red chalk, squared for transfer
8¾ × 11¾" (22.5 × 30 cm)
NY Bibliothèque Nationale, Paris

Exhibitions
Orangerie 1932, no. 108; Ingelheim 1977, no. Z/9

Catalogues
T 1947, 57; L 1969, 194; RW 1975 II, 377

1. Leiris 1969, p. 109.
2. Barrion, second sale, Paris, May 25–June 1, 1904, no. 115, "Femme nue couchée, à la sanguine."

This study is probably based on the previous drawing of Victorine (cat. 65). Leiris prefers to interpret this one as the first view, because it is less developed.[1] The legs are in nearly the same position, but the left arm lies beside the body, whereas in the first one the hand is lightly sketched in and rests on the right thigh.

Provenance
This drawing, squared for transfer, is one of the first ideas for *Olympia*. It belonged to ALFRED BARRION (see Provenance, cat. 40) and appeared at the sale of his drawings held in 1904,[2] when it was no doubt purchased by MOREAU-NELATON (see Provenance, cat. 9), who bequeathed it to the Bibliothèque Nationale in 1927.

F.C.

67. Olympia

1863
Watercolor
7⅞ × 12¼" (20 × 31 cm)
Signed (lower right): E. Manet
Private Collection

Exhibitions
Beaux-Arts 1884, no. 179; Exposition Universelle 1900, no. 1152; Berlin, Matthiesen 1928, no. 9; Paris, Bernheim-Jeune 1928, no. 2; [Philadelphia]-Chicago 1966–67, no. 55

More than a preparatory study for the painting, as is commonly assumed,[1] this is probably a watercolor drawing after the painting, an intermediate step between the canvas and the etchings (cat. 68, 69); note the simplification of values and the omission of color details, for example in the shawl.[2] It

67

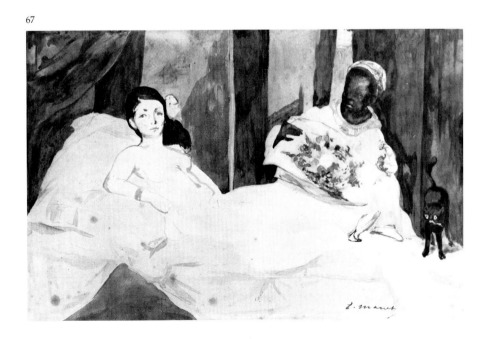

may be that the watercolor reproduces a prefinal state of the painting, before the opening in the curtain behind the black woman had been narrowed; as X-ray examination shows, it was at one time wider. Behind the servant, the light area is either an open door or, more likely, a mirror. Olympia's hair is more flamboyant in color and more conspicuously spread upon the shoulder.

The freshness and liveliness of the watercolor probably tell us something about the original color of the painting, which must since have darkened a good deal in the background. All the variants, in relation to the painting as we know it, indicate that Manet reworked it between 1863 and 1865, when he submitted it to the jury of the Salon, so that this watercolor would be our best indication of the first state of the work.

It is interesting to note that the etchings were based on the final state of the painting but show a slight departure from it as well as from the watercolor: the addition of the *frisons* on Olympia's forehead. Their presence is not easily accounted for.

Catalogues
D 1902, p. 134; T 1931, 27 (watercolors); JW 1932, mentioned 82; G 1944, mentioned 39 (ill.); T 1947, 575; L 1969, 196; RW 1975 II, 381

1. Rouart and Wildenstein 1975, II, no. 381; Reff 1976, p. 77.
2. J. Mathey 1967, p. 21.
3. Manet et al., Lochard photographs.
4. Vollard 1937, pp. 44, 49–51.

Provenance
In the installation photographs of the 1884 exhibition,[3] this watercolor can be identified among eleven other drawings in one large frame, designated at the end of the catalogue by the brief note "179. Cadre. Appartient à M. Alph. Dumas" (179. Frame. Owned by M. Alph. Dumas). ALPHONSE DUMAS, an amateur painter of independent means, directed the Galerie de l'Union Artistique, where Vollard made his debut as a dealer. In his *Souvenirs*, Vollard recalled that about 1892 Dumas showed him a box containing some drawings and prints by Manet, including this watercolor, the gouache version of the *Cats' Rendezvous* (cat. 114, fig. e), several admirable drawings in red chalk, and a dozen sketches of cats. Toward the end of the 1870s, when Dumas was taken to visit Manet, who had been told that the dealer admired his work, he had felt obliged to take the "lot" Manet offered him for the price of 10 louis. Dumas, who detested Impressionist art and had little more appreciation for Manet, asked VOLLARD (see Provenance, cat. 98) to sell the works.[4] The watercolor later belonged to AUGUSTE PELLERIN (see Provenance, cat. 100), who lent it to the exhibition in 1900, and then to JULES STRAUSS (1861–1939), the financier of German origin, who collected mostly works by Sisley. Between the two world wars, the watercolor was in the hands of BERNHEIM-JEUNE (see Provenance, cat. 31) and of ALBERT MAYER, and in 1947, through the dealer ALFRED DABER, it was purchased by DERRICK MORLEY of London.

F.C.

68. Olympia, *large plate*

1867
Etching
Plate: 6⅜ × 9½" (16.1 × 24.2 cm); image: 5¼ × 7¼" (13.3 × 18.5 cm)
Signed (lower center; 2nd state): Manet; (lower left below the subject; 3rd state): Manet del.
The New York Public Library

69. Olympia, *small plate*

1867
Etching and aquatint
Plate: 3½ × 8¼" (8.8 × 20.6 cm); image, 1st–3rd states: 3½ × 7¼" (8.8 × 18.3 cm); image, 4th state: 3½ × 7" (8.8 × 17.8 cm)
Bibliothèque Nationale, Paris (1st state)
P Private Collection (6th state)

One of the features of Manet's portrait of Emile Zola, painted for the Salon of 1868 (cat. 106), is a superb still life composed of books, pamphlets, the

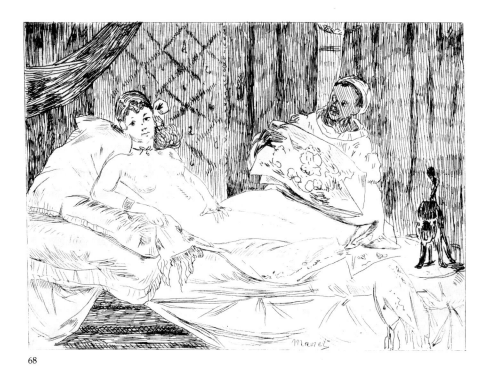

68

68

Exhibitions
Philadelphia-Chicago 1966–67, no. 57; Ann Arbor
1969, no. 22; Paris, BN 1974–75, no. 141; Ingelheim
1977, no. 52; Paris, Berès 1978, no. 48

Catalogues
M-N 1906, 37; G 1944, 40; H 1970, 52; LM 1971, 44;
W 1977, 52; W 1978, 48

2nd state (of 4). One of two proofs before extensive
re-etching of the plate, on laid paper. Signed near
the lower edge on the bed sheet. Avery collection.

69

Publications
Emile Zola, *Ed. Manet*, Dentu 1867, opp. p. 36

Exhibitions
Philadelphia-Chicago 1966–67, no. 57; Ann Arbor
1969, no. 22; Paris, BN 1974–75, nos. 142–44; In-
gelheim 1977, no. 53; Paris, Berès 1978,
nos. 47, 110

Catalogues
M-N 1906, 17; G 1944, 39; H 1970, 53; LM 1971, 45;
W 1977, 53; W 1978, 47, 110

1st state (of 6). One of two known proofs, re-
touched with brush and India ink (with pink wash
on the maid's face), on thin laid paper. With a
pencil inscription (see Provenance). Bracque-
mond, Moreau-Nélaton collections.

6th state. Impression in the final state, inserted in
the Zola pamphlet. In original blue paper cover.

writer's quill pen and inkpot, and his pipe, scattered over his work table.
Among the profusion of objects is a blue paper-covered pamphlet that bears
the artist's name and serves as the painting's signature. This is the pamphlet
published for Zola and Manet by Dentu on the occasion of Manet's major
one-man exhibition in May 1867. It consists of a re-edition of Zola's January 1
article in the *Revue du XIX^e siècle*, a frontispiece portrait of Manet etched by
Bracquemond (fig. a), and Manet's little etching after his painting *Olympia*
(cat. 64) opposite Zola's famous analysis of the painting (fig. b).[1]

Zola had suggested the idea of putting the brochure on sale at Ma-
net's exhibition, held in a pavilion built at the artist's expense off the avenue
de l'Alma. Hippolyte Babou—a critic, one of the founders of the Société des
Aquafortistes (see cat. 7–9), a frequenter of the Café Guerbois, and a
member of Manet's circle of friends—has left an evocative description of the
exhibition: "a small, square salon, arranged with tasteful elegance. . . . M.
Manet's salon is part boudoir, part chapel. A young Spanish girl might con-
fide her thoughts on love there, while leafing through a prayer book; the
place has a refreshing, luminous, and peaceful atmosphere."[2] Babou men-
tioned the "pretty little catalogue" that was slipped into his hand, quoting
long extracts from the preface in terms that were quite flattering to Manet.
He refers to Zola's pamphlet, however, only in order to attack the "furious
young art critic" who "has not released his prey, as I had supposed. He has
just had a pamphlet published by Dentu. . . ."[3]

The idea of the pamphlet developed during the months preceding
the opening of the exhibition in May, and a very friendly letter from Manet
to Zola provides the best information concerning the project. Manet re-
sponded positively to Zola's proposal, suggesting the inclusion of "an
etched portrait of me at the front" and asking for details of "the format of the
pamphlet so that I can have the etching printed" (that is, Bracquemond's
etching [fig. a] after a photograph of Manet by Camentron[4]). After sealing

69

the letter, Manet reopened it, having remembered that "I recently made a woodblock after *Olympia*, which was intended for Lacroix's *Paris-Guide*," adding that "if it didn't cost us too much, we could insert it. . . . I am going to write to an engraver skilled enough to make a good job of it."[5]

The works after *Olympia* include a wood engraving (G 88; fig. c), an etching unpublished during Manet's lifetime (cat. 68), and the one included in the pamphlet (cat. 69). The woodblock, engraved, according to Guérin, by Moller, is virtually unknown in contemporary proofs and was not published until 1902.[6] If it really was intended for the celebrated *Paris-Guide* published by Lacroix on the occasion of the Exposition Universelle of 1867,[7] Manet misjudged the format, since the size of his image on the block exceeds that of the guide itself.

The woodblock reproduces the composition in reverse but closely follows the picture, and the slightly wider gap between the curtains behind the maid may reflect the original state of the painting (see cat. 64). Although the woodblock may have been engraved at this stage, Manet went on to repeat the design, probably through the use of a tracing (maybe the lost drawing [RW II 378] he gave to Degas), on a "large" etched copperplate (cat. 68). This print is known only from two proofs in the early luminous and delicate state of the etching (one before and one with the signature: see Provenance). Because its format was unsuitable for the brochure or because he had already spoiled the plate by re-etching it too heavily, Manet abandoned this version and began a small copperplate (cat. 69).

The slightly modified composition of the first plate is repeated here: the "auguste jeune fille" celebrated in Astruc's poem again has a curl on her forehead, as it appears in the *Olympia* on the wall in Zola's portrait (see cat. 106), but the cat is reduced to its original size. Surprisingly, Manet simply repeated his first version; if tracings of all three *Olympia* prints are superimposed, they reveal only minor modifications. Even the "small plate" (cat. 69) appears to have been made from a tracing of the large one (the exhibited proof of the latter shows indentations in the paper following the contours and main lines of the design), and in order to fit the format of the pamphlet, Manet simply eliminated the 2 cm margin at the top and the 2.5 cm margin at the bottom of the large plate, which overlapped the new copperplate chosen to suit the page size of the pamphlet.

The first states of the etching Manet finally used are very delicately worked, retouched in ink on the exhibited proof, and reworked with aquatint wash on the plate before it was reduced at the sides.[8] It is difficult to es-

Fig. a. *Ed. Manet*, pamphlet by Emile Zola, 1867, frontispiece (portrait of Manet by Bracquemond, etching) and title page

Fig. b. Zola's pamphlet *Ed. Manet*, page 36 facing the etching after *Olympia* (cat. 69)

188

Fig. c. Woodblock after *Olympia*, drawn by Manet and engraved by Moller. Bibliothèque Nationale, Paris

timate the undoubtedly important role played by Bracquemond in the development and completion of the etching. A proof in the first state, which belonged to him, bears an inscription "bitten and printed by Bracquemond,"[9] and Harris has noted the alteration, probably made by Manet himself, on the cover and title page of a copy of the pamphlet dedicated by the artist to Signorini (Brera, Milan), where the printed indication "eau-forte d'Ed. Manet d'après *Olympia*" has been amended by the deletion of the artist's name and the addition of a "B" in the same ink.[10] Harris also points out that the plate is unsigned (unlike the woodblock and the large etching), but this may not be significant since the print was destined to appear in a publication entirely devoted to Manet, who is named as the author of the etching on the cover and the title page.

Although some may agree with Zola that, in its published state, "the etching of the *Olympia* . . . is a failure,"[11] the lack of success alone does not refute Manet's authorship of the work. Moreau-Nélaton's statement must also be taken into account: "It has also been said that the *Olympia*, etched for Zola's defense of his artist, was not by Manet but by M. Bracquemond, in spite of the indication on the title page of the little volume itself. I only mention these views in order to refute them. As far as *Olympia* is concerned, one need only cite the testimony of M. Bracquemond himself, who showed me the various states in his possession of a print that came from his press, like so many others, but on which he collaborated only as the printer."[12] There is no denying, however, that the *Olympia* of the pamphlet has a finicky appearance—which must certainly have displeased Manet—that is only partly the result of the cramped format, which destroys the rhythm and harmony of the original composition.

Printed in an edition of 600 impressions for the pamphlet,[13] this reproduction of the painting Zola considered the artist's "chef d'oeuvre" is a proof of their friendship and their joint efforts for the success of Manet's exhibition. The price and the number sold are unknown, but it is likely that the illustrated pamphlet was appreciated only by the "devotees and people of refined taste" referred to in Babou's review.[14]

1. Zola 1867 (Dentu), p. 36.
2. Babou 1867, p. 286.
3. Ibid., p. 287 and n. 1.
4. Bouillon 1975, p. 40, figs. 7, 8.
5. Appendix I, letter 5.
6. Duret 1902, opp. p. 28.
7. *Paris-Guide* 1867.
8. Wilson 1978, no. 47, 6th state.
9. Ibid., 1st state.
10. Harris 1970, p. 150, no. 53.
11. J. Adhémar 1965, p. 231.
12. Moreau-Nélaton 1906, intro., reprinted in Guérin 1944, p. 15.
13. Wilson 1978, no. 47, 6th state.
14. Babou 1867, p. 286.
15. Cf. Guérin 1944, p. 40, 1st state, repr. (H. Thomas collection), without signature; Harris 1970, p. 52, 1st state, repr. fig. 103 (New York Public Library), with signature at bottom of sheet (not described by Harris).
16. Moreau-Nélaton 1906, p. 17.

Provenance
68. This apparently unique proof, in the first state of the etched design but with the signature,[15] was acquired by AVERY, probably through LUCAS and perhaps from GUERARD and SUZANNE MANET (see Provenance, cat. 17, 16, 12).

69. *1st state.* This retouched proof has a pencil inscription: "1er état retouché par Manet. Cette épreuve m'a été offerte par Mr. [*sic*] Bracquemond (février 1906)." BRACQUEMOND (see Provenance,

cat. 18) no doubt gave this proof to MOREAU-NELATON (see Provenance, cat. 9) when the latter was completing work on his catalogue raisonné of Manet's prints. The book was dedicated to Bracquemond, and a facsimile of this proof appeared on the cover.[16]
6th state. The definitive state of the etching is in a copy of Zola's pamphlet, in its original paper cover. The pamphlet lacks any indication of provenance.

J.W.B.

70. The Woman with the Cat

1862–63?
India ink wash
7⅞ × 10⅝" (20 × 27 cm)

P Musée du Louvre, Cabinet des Dessins, Paris

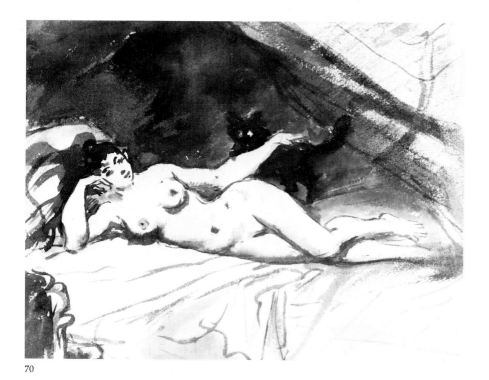

70

It is of course tempting to see this drawing as an early idea for *Olympia*, but it is very different from the preliminary drawings of Victorine Meurent (cat. 65, 66). Everything about it suggests an invention, preceding the painting by a year or more but recording the idea of a nude and a black cat, or else a fantasy, a diversion, done by Manet as a counterpart to his more academic preparatory drawings while he sought a fresh approach to his painting. The pose may have been freely inspired by a Delacroix Odalisque,[1] or by Goya's *Naked Maja* (cat. 64, fig. b) in the contour of the hip, but it all evokes Baudelaire in spirit and Constantin Guys in form.

At all events, the sharp contrast of values in *Olympia* between the nude on the bed and the dark background is anticipated here, as are the shining eyes of the cat. The cat will be shifted to the right, and replaced by the black servant in its role as a foil for Olympia's body.

Whether done at the time of the painting's conception or earlier as an idea to be developed further, the drawing prefigures one aspect of the painting that its standing as a masterpiece shields from us today: its humor, frozen in the painting, but bright and free in the drawing.

This wash drawing was engraved on wood by Prunaire (G 87).[2] A single proof is known; the engraving was reproduced in 1906 by Duret.[3] There is another drawing on the same theme (L 190) that apparently belonged to Duret.[4]

Exhibitions
Saint Petersburg 1912, no. 410

Catalogues
D 1902, p. 52; T 1931, 28 (watercolors); JW 1932, mentioned 82; T 1947, 574; W 1969, 191; RW 1975 II, 379

1. Reff 1976, p. 72.
2. Guérin 1944, no. 87.
3. Duret 1906, p. 62.
4. Tabarant 1931, p. 522; Reff 1976, p. 71, fig. 40 (authenticity in doubt).
5. H. Adhémar 1976.
6. Beurdeley, ninth sale, Paris, November 30, 1920, no. 310.

Provenance
Leiris, Reff, and Rouart and Wildenstein considered this a lost work; it was published by H. Adhémar in 1976.[5] Its first known owner was ALFRED BEURDELEY (1847–1919), whose family manufactured furniture and objets d'art. His very important collection of nineteenth-century paintings, drawings, and prints included two other drawings by Manet (RW II 250, 476). In 1920, the wash drawing appeared at the Beurdeley sale;[6] it later belonged to M. AND MME KAHN-SRIBER, who in 1975 generously gave it to the Musée du Louvre, retaining a life interest (inv. RF 36.056).
F.C.

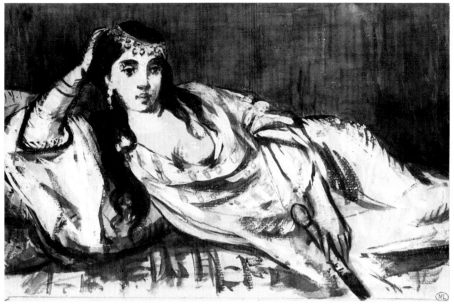

71

71. Odalisque

1862–68?
Watercolor and India ink heightened with gouache
5⅛ × 7⅞" (13 × 20 cm)
Atelier stamp (lower right): E.M.

NY Musée du Louvre, Cabinet des Dessins, Paris

Exhibitions
Paris, Drouot 1884, no. 155; Orangerie 1932, no. 105; Marseilles 1961, no. 44

Catalogues
T 1931, 17; T 1947, 562; L 1969, 193; RW 1975 II, 366

Distinctive as this drawing is in Manet's oeuvre, its precise dating, like that of the etching (H 56), is problematical. The year 1862 has been suggested,[1] by analogy with *Young Woman Reclining, in Spanish Costume* (cat. 29) and the preparatory drawings for *Olympia* (cat. 65, 66). However, the style is very different. The etching made from this drawing is usually dated 1868.[2] We must therefore suppose either that Manet kept the drawing and later used it for the print, or that the generally accepted dating is too early and the drawing and the print were done at the same time, about 1868.

The romantic, Oriental theme, inspired by Ingres and above all by Delacroix, is exceptional in Manet's work, and it was in quite a different spirit that he later painted *The Sultana* (RW I 175).

It has been suggested that the model here is the same as the one in *Young Woman Reclining*, supposedly the mistress of Nadar;[3] but one could just as well see this as a figure of fantasy. On the other hand, the effect of transparency of the striped mousseline, repeated and developed in *The Sultana*, was surely observed from life. Indeed, the costume, the pose, and the cut-off fan, perhaps of peacock feathers, held negligently as in the *Odalisque* of Ingres, foreshadow the portrait of Nina de Callias (cat. 137), the Odalisque of the Decadents.

1. Tabarant 1947, p. 55; Rouart and Wildenstein 1975, II, no. 366; Reff 1976, p. 69.
2. Harris 1970, no. 56; Wilson 1978, no. 70.
3. Farwell, cited in Hanson 1977, p. 88.
4. Manet sale, Paris, February 4–5, 1884, no. 155; Bodelsen 1968, p. 342.
5. Pellerin sale, Paris, May 7, 1926, no. 33.

Provenance
This watercolor was purchased at the Manet sale in 1884 (no. 155) by MARCEL BERNSTEIN (see Provenance, cat. 209) for 84 Frs.[4] It was later in the collection of AUGUSTE PELLERIN (see Provenance, cat. 100) and was acquired at the Pellerin sale in 1926[5] by the Friends of the Louvre for the museum (inv. RF 6929).

F.C.

72. Young Man in the Costume of a Majo

1863
Oil on canvas
74 × 49⅛″ (188 × 124.8 cm)
Signed and dated (lower right): éd. Manet 1863
The Metropolitan Museum of Art, New York

Manet's younger brother posed for this picture in 1863 in the artist's studio on the rue Guyot. In a letter dated May 9, 1961, Manet's grandnephew Denis Rouart informed the Metropolitan Museum, "It is Gustave Manet who posed for *Young Man in the Costume of a Majo*, and that is absolutely certain, because my mother, Eugène Manet's daughter [Julie], always knew it. Besides, the resemblance to his photographs is striking, and there can be no doubt about it. Berthe Morisot always said that it was her brother-in-law."

Gustave's costume is typical of those worn by *majos* and *majas*, the young working-class Spaniards whose stylish, somewhat flamboyant manner of dress was often affected by members of all classes, including the nobility. The nineteenth-century vogue in France for Spanish art and culture had apparently enabled Manet to buy or borrow the costume as a studio prop. Zola informs us that he kept a collection of such items in the studio.[1]

Evidently Zola wished his readers to understand how Manet worked, because, in addition to being accused of plagiarism, the artist had been criticized for having imitated too closely the work of Spanish masters and for having merely painted models "from beyond the Pyrenees." The critic hoped that viewers would see that Manet's pictures offered more than a nineteenth-century reprise of seventeenth-century Spanish painting devoted to picturesque genre subjects.

The critical and popular attitudes described by Zola in 1867 were voiced as soon as the picture was first exhibited at the Salon des Refusés of 1863, where it was shown with *Mlle V . . . in the Costume of an Espada* (cat. 33) and *Le déjeuner sur l'herbe* (cat. 62). The three paintings were not well received by the critics, but Théophile Thoré was more positive than most: "The artist who, after Whistler, inspires the most debate is Manet. A true painter, too. . . . Manet's three pictures seem rather as if meant to provoke the public, which is put off by the too vivid color. In the center, a bathing scene; to the left, a Spanish *majo*; to the right, a Parisian girl in the costume of an *espada*, waving her crimson cape in a bullring. Manet loves Spain, and his favorite master seems to be Goya, whose bright, jarring tones, whose free and spirited touch he imitates. There are some astonishing fabrics in these two Spanish figures: the *majo*'s outfit of black and the heavy scarlet mantle thrown over his arm, and the pink stockings of the young Parisienne disguised as an *espada*; but under these dashing costumes, something of the personality of the figure is missing; the heads ought to be painted differently from the fabrics, with more life and more profundity."[2]

Despite his reservations, Thoré was at least able to see that Manet's art was emerging in the context of widespread changes in the character of painting. "French art," he wrote earlier in the same article, "as it is seen in the [Salon des Refusés] seems to begin, or to begin all over again. It is odd and crude yet sometimes exactly right, even profound."[3]

Exhibitions
Salon des Refusés 1863, no. 364 (Jeune homme en costume de Majo); Alma 1867, no. 13 (Jeune homme en costume de majo); London, Durand-Ruel 1874, no. 4?; Beaux-Arts 1884, no. 11; New York, Durand-Ruel 1913, no. 4; Orangerie 1932, no. 9; New York, Wildenstein 1948, no. 11

Catalogues
D 1902, 32; M-N 1926 I, p. 48; M-N cat. ms., 49; T 1931, 53; JW 1932, 52; T 1947, 54; PO 1967, 50; RO 1970, 49; RW 1975 I, 70

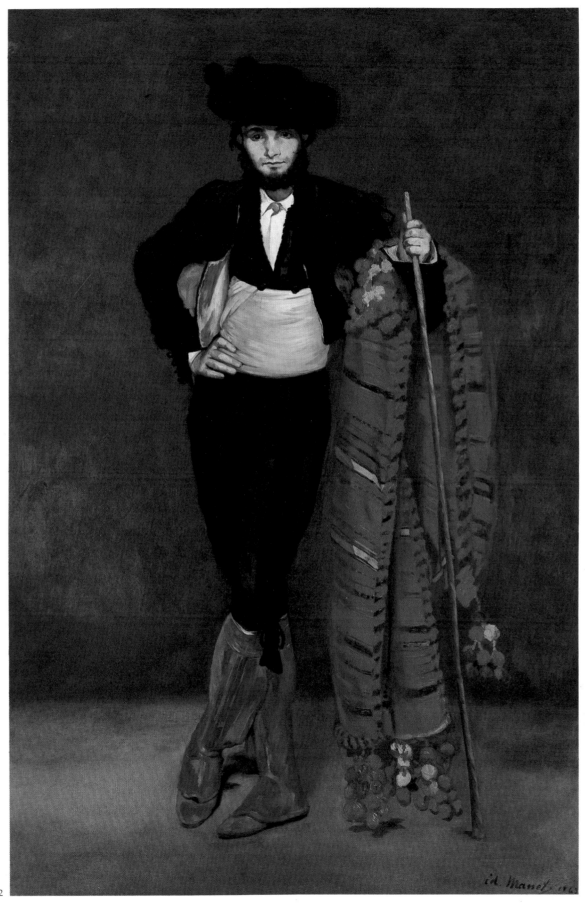

72

Thoré's admiration for the treatment of the *majo*'s costume is indeed understandable. The subject seems to serve largely as a pretext for the manipulation of rich blacks and grays in the pants, jacket, vest, beard, and hat; for the combination of browns in the boots; and for the orchestration of reds, oranges, and yellows in the blanket. Nevertheless, the costume, like that of *Mlle V . . . in the Costume of an Espada*, is a kind of pictorial equivalent of examples described by Théophile Gautier in *Voyage en Espagne*, the first edition of which had appeared twenty years earlier. Gautier describes such accoutrements as a *majo*'s boots ("leather leggings with openings at the sides showing the leg"), his *vara* ("it's all the rage to carry a *vara* or a white stick split at the top, four feet in length, and to lean on it nonchalantly when one stops to chat"), and his two foulards ("hanging out of the jacket pockets").[4] But even if Manet depended in part on Gautier's description of Andalusian *majos*, he may also have conceived of a *majo* as an ideal subject from modern life, at least as defined by Baudelaire in "Le Peintre de la vie moderne" (1863). In his essay, Baudelaire celebrates "the beauty of circumstance and the sketch of manners," and devotes a section to a discussion of the dandy as an appropriate subject. The eccentric dress, the attitude, and the behavior of the *majo* unquestionably identify him as a variation of the dandy as described by Baudelaire: "They are all representatives of what is finest in human pride, of that compelling need, alas only too rare today, to combat and destroy triviality."[5]

Majoism must also have appealed to Manet as a subject analogous to his art. Both depend upon assemblages of colorful and stylish details intended principally for effect. For example, Manet seems to have delighted as much in the colored scarves protruding from the *majo*'s pockets as in the act of painting them. As components of the *majo*'s costume and Manet's composition, the scarves are useful as accents of color; their value is primarily aesthetic, and thus they draw attention to the artificial aspects of both the subject and the painting. Moreover, Manet seems to have wanted his viewer to be conscious of the fact that he painted the subject in his studio. The *vara* on which Gustave leans is unmistakably similar to the stick that a studio model uses to hold a pose, and the title of the work identifies it as a painting of a model in a costume. Manet thereby strikes a balance between art as imitation of life and life as imitation of art. In doing so, he largely neutralizes the significance of the subject per se. The result is an emphasis on the formal character of the picture, precisely that aspect which in 1863 Thoré had found so exciting.

1. Zola 1867, *L'Artiste*, p. 53; Zola (Dentu), p. 27.
2. Bürger (Thoré) 1863, quoted in Hamilton 1969, p. 50.
3. Ibid.
4. Gautier (1842) 1981, p. 261.
5. Baudelaire 1965, p. 28.
6. Callen 1974, pp. 163, 176 n. 40.
7. Meier-Graefe 1912, p. 312.
8. Venturi 1939, II, p. 190.
9. Hoschedé sale, Paris, June 5–6, 1878; Bodelsen 1968, p. 340.
10. Letter from Charles Durand-Ruel, January 6, 1959 (archives, department of European paintings, The Metropolitan Museum of Art, New York).
11. Havemeyer 1961, p. 224.

Provenance
Manet sold this picture for 1,500 Frs to DURAND-RUEL in January 1872, when the dealer acquired twenty-four works by the artist (see Provenance, cat. 118). Durand-Ruel sold it on January 29, 1877, to HOSCHEDE (see Provenance, cat. 32), probably for 4,000 Frs,[6] although Meier-Graefe gives the price as 2,000 Frs,[7] and Venturi as 1,500 Frs.[8] FAURE (see Provenance, cat. 10) bought the painting for the relatively modest sum of 650 Frs at Hoschedé's bankruptcy auction in Paris in 1878.[9] On December 31, 1898, Faure sold it back to DURAND-RUEL, who sold it in New York on February 24, 1899, to MR. AND MRS. H. O. HAVEMEYER (see Provenance, cat. 33) for 100,000 Frs.[10] Mrs. Havemeyer recounts in her memoirs that her husband bought the picture as a "worthy pendant" to Manet's *A Matador* (cat. 92), which they had acquired the preceding year.[11] *Young Man in the Costume of a Majo* entered the Metropolitan Museum with the Havemeyer bequest in 1929 (inv. 29.100.54).

C.S.M.

73. The Dead Man (The Dead Toreador)

1864–65?
Oil on canvas
29⅞ × 60⅜" (76 × 153.3 cm)
Signed (lower right): Manet
National Gallery of Art, Washington, D.C.

Exhibitions
Salon 1864, no. 1282 (Episode d'une course de taureaux); Paris, Martinet 1865 (L'espada mort)?; Alma 1867, no. 5 (L'homme mort); Le Havre 1868 (L'homme mort); Beaux-Arts 1884, no. 24; Exposition Universelle 1889, no. 488; Chicago 1893, no. 2737; Orangerie 1932, no. 19; Philadelphia-Chicago 1966–67, no. 59; Washington 1982–83, no. 77

Catalogues
D 1902, 51; M-N 1926 I, pp. 57–59; M-N cat. ms., 52; T 1931, 73; JW 1932, 83; T 1947, 73; PO 1967, 65; RO 1970, 64; RW 1975 I, 72

Fig. a. Bertall, "Spanish Toys," in *Le Journal amusant*, May 21, 1864

Fig. b. Cham, caricature in *Le Charivari*, May 22, 1864

In 1864, the Salon jury accepted both paintings submitted by Manet, *Episode from a Bullfight* and *The Dead Christ and the Angels* (cat. 74). Both are about death, and both are compositions fabricated in the studio that depict subjects Manet had never seen. Obviously he had never seen an angel, and his knowledge of bullfighting in Spain was limited to such sources as Goya's *Tauromaquia* etchings (e.g., cat. 33, fig. a) and Alfred Dehodencq's painting *Bullfight* (cat. 91, fig. a), which was shown at the Salon of 1851 and subsequently acquired by the Musée du Luxembourg. Manet's only trip to Spain took place in 1865.

Critics who reviewed the Salon of 1864 attacked the inappropriateness of the too realistic, cadaver-like body of Christ. They also faulted *Episode from a Bullfight,* mainly because of the allegedly incorrect spatial relationship both between the dead toreador in the foreground and the bull and between the toreador and the other figures in the background. The composition proved so controversial that it inspired caricatures by Bertall (fig. a), Cham (fig. b), and Oullevay,[1] all of whom ridiculed the flatness and the proportions of the figures, as well as the irrational space. Hector de Callias's review in the June 1 issue of *L'Artiste* is typical of the point of view adopted by virtually everyone who wrote about the painting: "He goes to Spain—in body or mind, no matter; will not the spirit serve as well as the flesh?—and brings back a *Bullfight* divided into three planes, a discourse in three movements. In the foreground, a toreador, perhaps an *espada,* who has failed to thrust his slender sword into the neck of the bull at the correct angle, and whom the bull must have gored with paired swords, his horns.

"Next, a minuscule bull. Perspective, you will say. But no; for in the background, against the barriers, the *toreros* are of a reasonable size, and seem to be laughing at the bull, which they could trample under the heels of their pumps."[2] Moreover, Callias adopted a more restrained attitude than most of his colleagues. Edmond About, for example, simply dismissed the painting as "a wooden bullfighter, killed by a horned rat."[3]

Between the Salon of 1864 and his independent exhibition in 1867, Manet cut up the *Episode from a Bullfight.* Several authors suggest that he did so because of the adverse critical response.[4] However, the fragmenting and subsequent reworking of paintings were already established aspects of his technique, and continued to be an important factor in his work from time to time throughout his career (see cat. 5, 99, 104, 172). In most instances, aesthetic considerations alone could account for this procedure. In the case of the *Episode from a Bullfight,* he seems to have extracted two principal fragments and discarded the rest of the painting. The sections he kept and reworked as independent paintings are *The Dead Toreador* and *The Bullfight* (RW I 73; fig. c), in the Frick Collection, New York. Proust recalled, "One day he boldly took a knife and cut out the figure of the dead toreador,"[5] but we do not know exactly when it happened. It is possible that Manet cut up the

Episode from a Bullfight shortly after the Salon, because in late 1864 or early 1865 he wrote to the dealer Louis Martinet, indicating his intention to send eight pictures to an exhibition at his gallery. Item no. 2 in Manet's list is "L'Espada mort." The title suggests that Manet had already cut it out of the large picture, since the title he used in the Salon of 1864 was "Episode d'un combat de taureaux." Whether or not *The Dead Toreador* was exhibited in 1865 is not known; ultimately Manet sent six works, of which only two were shown, but we have neither a list of those actually sent nor any indication of the titles of those exhibited.[6] The earliest date that we can be certain Manet exhibited *The Dead Toreador* is 1867, when he included it as *The Dead Man* in his independent exhibition on the avenue de l'Alma. In short, there is a possibility that Manet did not cut the two fragments from the large picture until after his trip to Spain. The likelihood increases in view of Theodore Reff's recent observation that the surface and paint handling of *The Bullfight* in the Frick Collection were worked on after Manet's return from Spain in late 1865;[7] the brushwork and palette are close to those of *The Bullfight* of 1865–66 in the Art Institute of Chicago (RW I 107), and the loose treatment of the figures in the stands seems to confirm Proust's report that Manet was dissatisfied with the background: "Manet was bothered by the ring. He had painted the figures with the precision of the primitives, bringing it all too close to the viewer."[8]

Fig. c. *The Bullfight*, 1864–65. The Frick Collection, New York

Fig. d. Italian school, *Dead Soldier* (formerly attributed to Velázquez). National Gallery, London

Reff has recently demonstrated through laboratory analysis and X-rays that *The Bullfight* in New York and *The Dead Toreador* share a common border.[9] Their paint surfaces were originally continuous along a line that runs in the Frick picture from the bottom left corner to the legs of the matador standing at the right, and in the Washington picture from the upper right corner to a point at the left about two thirds the length of the top edge. Pentimenti and X-ray photographs show that a bull was painted out of the fragment that is now *The Dead Toreador*, and that Manet made numerous changes in the course of reworking the section that became *The Bullfight*. In addition, he seems to have originally included a picador and two matadors, which were painted out before he finished the *Episode from a Bullfight*, and at an undetermined stage in the evolution of the picture he also adjusted the position of the dead toreador's legs. In other words, from its inception the painting was subject to ongoing revisions until Manet had distilled the two images now in the National Gallery of Art and the Frick Collection.

Considering its problematical beginnings, *The Dead Toreador* soon enjoyed great success. In 1868, it was awarded a silver medal at an exhibition in Le Havre. Four years later, Armand Silvestre praised it as "a masterpiece of drawing, and the most complete symphony in black major ever attempted."[10] Fifty years later, Matisse praised it as "one of the most beautiful Manets. I saw it in Philadelphia, in the Widener collection, a magnificent collection of works of all periods, among Rembrandts and Rubenses, and I marveled at the masterful fashion in which it stood up to its neighbors."[11]

There are two principal sources often discussed in connection with *The Dead Toreador*: the *Dead Soldier* (fig. d), catalogued by the National Gallery, London, as "conceivably . . . a Neapolitan work . . . possibly later in date than the 17th century," but believed during Manet's lifetime to be a Velázquez,[12] and Gérôme's *Dead Caesar*, exhibited at the Salon of 1859 (present location unknown). When Manet painted *The Dead Toreador*, the *Dead Soldier* was in the Pourtalès collection in Paris. Reff points out that although Manet probably would not have been able to see the "Velázquez," "he would

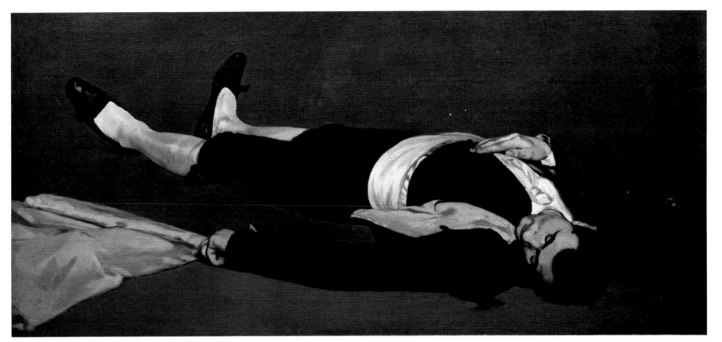

73

surely have seen the large photograph of it published by Goupil in 1863," and
adds, "it has been argued that before painting his [*Episode from a Bullfight*]
. . . he must also have seen the original, since [as Peladan observed in 1884]
his dead toreador 'is an actual copy of its coloring, tonal values, lighting,
and brushwork.'"[13] Indeed, in a review of the Salon of 1864, Théophile
Thoré was the first to identify the dead toreador as "unabashedly copied
from a masterpiece in the Galerie Pourtalès—by Velázquez, no less."[14]
Baudelaire immediately protested Thoré's insinuations of plagiarism and ex-
cessive seventeenth-century Spanish influence on Manet's work, but in
his reply Thoré politely suggested, "unquestionably, M. Manet must have
had some sort of second sight, through whatever medium, if he never vis-
ited the Pourtalès collection. . . ."[15]

The likelihood that Manet also relied on the composition of
Gérôme's *Dead Caesar* was first noted by Bates Lowry[16] and later extensively
investigated by Gerald M. Ackerman. Ackerman argues, "It seems logical to
suppose that Gérôme's adaptation of the Pourtalès *Dead Soldier* preceded
Manet's, and that Manet based his figure on Gérôme's, even if Manet's
invention—the formal presentation in an ideal manner—is closer to that of
the *Dead Soldier*."[17] Reff also discusses the possible influence of Gérôme's
Dead Caesar,[18] but on purely visual grounds the affinities between *The Dead
Toreador* and the painting formerly attributed to Velázquez are far more
compelling.

Farwell suggests, however, that Manet relied on an entirely different
image for the disposition of the dead toreador. She notes a strong similarity
to the figure of a fallen soldier in an illustration by Gigoux on page 51 of the
1835 edition of *Gil Blas*.[19] She concludes, "Manet's *Toreador* is closer in fact to
the Gigoux version than to either of the others. This would tend to resolve
also the argument in letters exchanged in the pages of *L'Indépendance belge*
between Baudelaire and Thoré-Bürger over the figure's derivation (see

Tabarant 1947, 84–85)."[20] Nevertheless, even if Manet was influenced by an image such as that of Gérôme's *Dead Caesar* or the soldier in Gigoux's drawing, the composition, mood, and darkness of the work from the Pourtalès collection must have played an important role in Manet's decision to extract and rework the dead toreador as an independent image.

When Manet cut *Episode from a Bullfight* into fragments, he created two simpler but more powerful images. *Episode from a Bullfight* had an anecdotal character, in contrast to the virtually iconic strength of *The Dead Toreador*. Manet self-edited a somewhat complex composition, repainted parts of it, and fashioned an image that has become one of the most famous in the history of art. From a painting with the character of a prolix narrative he synthesized a few well-chosen words, reducing a canvas of 49⅝ × 66⅛" (126 × 168 cm) to one of 29⅞ × 60⅜" (76 × 153.3 cm). The painting gained in clarity, monumentality, and universality. Indeed, Manet himself found the result broad enough in its appeal and implications to title it *The Dead Man* in his 1867 exhibition.

Linda Nochlin has criticized *The Dead Toreador* as too detached and devoid of meaningful human feeling. Comparing it to Edmond de Goncourt's virtually clinical description of his dying brother, she concludes, "This same isolation of the fact of death from a context of transcendental significance or value characterizes Manet's *Dead Toreador*. . . ."[21] Indeed, it is an image of death as we have come to know it in modern life—matter of fact, objectively reported, and emotionally cool. But evidently it has never been recognized as an image of the bullfighter as an artist felled in the midst of a performance—through his own miscalculation or his adversary's skill. Manet may well have identified personally with the toreador, especially having been savaged by the critics in 1864.

Several authors have noted that the dead toreador relates to the figure in Manet's lithograph *Civil War* (cat. 125, fig. a).[22] Whether there is a direct connection with this work, or with works by other artists discussed above, seems less important than that *The Dead Toreador* is archetypal in character. Harris points out that the dead soldier lying in front of a wall in *Civil War* "is very similar to a widely circulated photograph of a dead Confederate soldier taken on a battlefield of the American Civil War in 1863 by Alexander Gardner."[23] It is likely that at least on one level these images relate to one another because they share a common theme that artists will focus on as long as people die in wars. Indeed, *The Dead Toreador*, the *Dead Soldier*, and Gérôme's *Dead Caesar* could all be said to anticipate Robert Capa's photograph of the last soldier killed in Leipzig before the armistice on May 7, 1945.[24] To a certain extent, the image of a fallen warrior is common coin, but Manet's *Toreador*, as a work of art and as a metaphor, seems unquestionably the most poignant and gripping of all.

1. Oullevay, in *Le Monde illustré*, May 1864.
2. Callias 1864, p. 242.
3. About 1864, p. 157.
4. Bazire 1884, p. 42; Gonse 1884, p. 140; Moreau-Nélaton 1926, I, p. 57; Tabarant 1931, p. 119; Hamilton 1969, p. 54.
5. Proust 1913, p. 47.
6. Baudelaire, *Lettres à*, p. 215: from Hippolyte Lejosne, February 21, 1865.
7. Theodore Reff, lecture delivered at the Frick Collection, New York, November 20, 1982.
8. Proust 1913, p. 47.
9. Reff 1982, p. 77.
10. Silvestre 1872, p. 179.
11. Matisse 1932.
12. London, National Gallery, *Illustrated General Catalogue*, London, 1973, p. 339, no. 741.
13. Reff 1982, no. 78.
14. Bürger (Thoré) 1870, II, p. 98.
15. Bürger (Thoré), quoted in Tabarant 1947, p. 85; Baudelaire 1973, II, p. 386.
16. Lowry 1963, p. 33.
17. Ackerman 1967, p. 165.
18. Reff 1982, no. 78.
19. Alain René Le Sage, *Histoire de Gil Blas de Santillane*, Paris, 1835, p. 51.
20. Farwell (1973) 1981, pp. 61, 294 n. 22.
21. Nochlin 1972, p. 64.
22. Harris 1970, p. 192; Reff 1982, nos. 73, 76.
23. Harris 1970, p. 192.
24. New York, I[nternational] C[enter of] P[hotography], *Robert Capa 1913–1954*, series ed., Cornell Capa, New York, 1974, pp. 90–91.
25. Morisot 1950, p. 119.
26. Rewald 1973, *Gazette des Beaux-Arts*, p. 107.
27. Meier-Graefe 1912, p. 310; Venturi 1939, II, p. 190.
28. Walker 1964, pp. 116–19; D. E. Finley, *A Standard of Excellence: Andrew Mellon Founds the National Gallery of Art in Washington*, Washington, D.C., 1973, pp. 93–102, 105–7.
29. Edith Standen, former curator of the Widener Collection, The Metropolitan Museum of Art, New York, pers. comm., 1982.
30. D. E. Finley 1973, p. 99, see note 28 above.
31. Tabarant 1947, p. 87.

Provenance
DURAND-RUEL paid 2,000 Frs for this picture early in 1872, when he acquired a group of twenty-four works directly from the artist (see Provenance, cat. 118). He sold it to FAURE (see Provenance, cat. 10) for 3,000 Frs on February 9, 1874. According to Berthe Morisot, Faure refused an offer of 20,000 Frs for the painting some ten years later,[25] although he evidently received only 16,000 Frs when he sold it back to DURAND-RUEL in 1892. Prices recorded by Durand-Ruel for the works by Manet that Faure sold to him during the 1890s are generally rather low, however, which suggests that their business arrangements may have been more complicated. The following year, the picture was included in an exhibition in Chicago; the catalogue cites the owner as JAMES S. INGLIS (1853–1907), a partner in the New York–London firm of Cottier and Co.,[26] to whom Durand-Ruel had sold it for 20,000 or perhaps 30,000 Frs.[27] In 1894, it was acquired by the trolley-car magnate P. A. B. WIDENER (1834–1915), whose art collection, one of the most important formed in the United States during his generation, consisted primarily of old master paintings and decorative arts, with a few nineteenth-century French pictures, including works by Corot, Degas, Manet, and Renoir.[28] Widener displayed *The Dead Man* prominently on a staircase wall so that visitors to Lynnewood Hall, his home in Elkins Park, near Philadelphia, would see it without distractions.[29] At Widener's death in 1915, his son Joseph inherited the collection with the proviso that it be given to a museum in New York, Philadelphia, or Washington, D.C.[30] In 1942, JOSEPH WIDENER (1872–1943) donated one hundred pictures, among them Manet's *The Dead Man* (inv. 636) and *At the Races* (RW I 97), to the National Gallery of Art, Washington, D.C. Tabarant mistakenly reports that Joseph Widener left *The Dead Man* to Harvard University, another beneficiary, but this would have violated the terms of his father's will.[31]

C.S.M.

74. The Dead Christ and the Angels
(The Dead Christ with Angels)

1864
Oil on canvas
70⅝ × 59″ (179 × 150 cm)
Signed (lower left): Manet
Inscribed (lower right, on rock): évang[ile]. sel[on]. S⸱ Jean /
chap[itre]. XX v. XII
The Metropolitan Museum of Art, New York

Exhibitions
Salon 1864, no. 1281 (Les anges au tombeau du
Christ); Alma 1867, no. 7 (Le Christ mort et les
anges); London, Durand-Ruel 1872, no. 91; Boston
1883, no. 1; New York, Durand-Ruel 1895, no. 8;
Orangerie 1932, no. 20; World's Fair 1940, no. 197

Catalogues
D 1902, 56; M-N 1926 I, pp. 56–58; M-N cat. ms.,
51; T 1931, 72; JW 1932, 85; T 1947, 71; PO 1967, 64;
RO 1970, 63; RW 1975 I, 74

In November 1863, Manet declared to his friend the abbé Hurel: "I am going to do a dead Christ, with angels, a variation on the scene of the Magdalen at the sepulchre according to Saint John."[1] The picture was exhibited by Manet at the Salon of 1864 as *The Angels at the Tomb of Christ,* at his independent exhibition in 1867 as *The Dead Christ and the Angels,* and at an exhibition in 1872 at the London branch of Durand-Ruel as *Christ in the Sepulchre*.

In March 1864, Baudelaire wrote to the marquis Philippe de Chennevières, curator at the Louvre in charge of the Salon, to request that the paintings by his friends Manet and Fantin-Latour be installed as advantageously as possible: "May I strongly recommend two friends of mine, one of whom has already benefited from your kindness: M. Manet and M. Fantin. M. Manet is sending an *Episode from a Bullfight* and a *Resurrecting Christ Attended by Angels.* M. Fantin is sending an *Homage to the Late Eugène Delacroix* and *Tannhaüser in the Venusberg.* You will see what marvelous talent is revealed in these paintings, and in whatever category they may be placed, do your best to position them well."[2]

Baudelaire's opinion of Manet's paintings was shared by few critics. Many savaged *The Dead Christ and the Angels* and were equally hostile toward the *Episode from a Bullfight,* from which Manet later cut two fragments that were reworked as *The Bullfight* (cat. 73, fig. c) and *The Dead Toreador* (cat. 73). For example, Edmond About, in a review of the Salon of 1864, dismissed the two paintings in three short acerbic sentences: "Let us not talk about the two damp squibs by Manet that failed to go off. This young man, who paints in ink and is constantly dropping his inkwell, will soon not even exasperate the bourgeoisie. He will spell out his lovely caricatures of angels in vain; the public will go its own way, saying, 'There is Manet amusing himself again; let's go look at some paintings.'"[3]

An anonymous critic, writing in the May 1 edition of *La Vie parisienne,* sarcastically advised his readers, "Do not miss Manet's *Christ,* or *The Poor Miner Raised from the Coal Mine,* painted for Renan."[4] Ernest Renan was the author of the recently published *Vie de Jésus,* an extremely popular and controversial biography that interprets the person of Christ as a mortal whose deification was dependent upon events that can be explained in terms of rational, not spiritual, phenomena. The reference to a coal miner was an attack on Manet's technique; many critics observed that Christ's body looked like an unwashed cadaver, insinuating that he had ignored Christ's spirituality and was incapable of creating the illusion of shadows.

Théophile Gautier also objected to Manet's treatment of the angels: "The angels, one of whom has brilliant azure wings, have nothing celestial

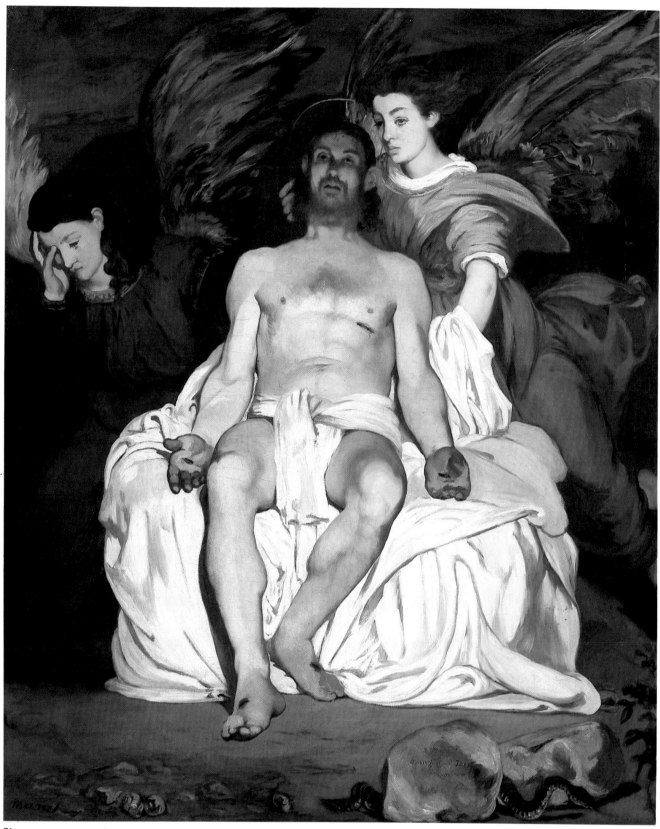

74

about them, and the artist hasn't tried to raise them above a vulgar level." Nevertheless, he took the trouble to underscore Manet's considerable technical ability: "But one shouldn't, for all that, assume that Manet is devoid of talent; he has it, and a great deal of it. Like Courbet, but in another way, he has true pictorial qualities, the qualities of a true painter. He attacks each part boldly and knows how to preserve the larger unity of the local colors. From one end of the painting to another his figures are related to the range of color selected, and are like the preliminary sketches of a master. Unhappily, Manet intentionally abandons them at this state and doesn't carry his work very far."[5] Hector de Callias, in a review of the Salon of 1864, adopted a similar point of view: "In the middle of the shadows of the sepulchre, a strange azure wing shines forth; an inexplicably pink drapery falls across Christ's knees. Shall we say that Manet, for all his shortcomings, is nevertheless a painter whose temperament is revealed in every brushstroke? What intelligence he would have if he didn't want to have too much intelligence."[6]

Thoré, too, discussed the angels in his review of the Salon of 1864, but he more or less dismissed other critics' and the public's objections as irrelevant: "Oh, those bizarre wings from another world, tinted with azure more intense than the farthest reaches of the sky. No earthly bird can boast such plumage. But perhaps angels, those celestial birds, wear such colors, and therefore the public has no right to laugh, since no one has ever seen an angel, or for that matter a sphinx . . . in the fourteenth century, and even later, almost all the painters of Europe . . . painted angels' wings that were blue, green, and even red. . . . One shouldn't argue about angels or colors."[7]

The question of angels is particularly interesting, because, as Manet's *Woman with a Parrot* (cat. 96) may have been a reply to Courbet's *Woman with a Parrot*, 1866 (Metropolitan Museum of Art, New York), itself a reply to Manet's *Olympia* (cat. 64), *The Dead Christ and the Angels* may be Manet's comment on Courbet's remarks in a well-known open letter, dated December 25, 1861, to a group of students at the Ecole des Beaux-Arts: "I maintain . . . that painting is an essentially *concrete* art and can only consist of the representation of *real* and *existing* things. It is a completely physical language, the words of which consist of all visible objects; an object which is *abstract*, not visible, nonexistent, is not within the realm of painting."[8]

In 1884, Victor Fournel quoted Courbet as having specifically addressed the question of painting angels: "He would be convulsed with laughter, speaking of the *Transfiguration*, of the *Virgin of Saint Sixtus*, and of the *Cuisine des Anges*: "'Angels! Madonnas! Who ever saw one? Auguste, come here. Have you ever seen an angel?' 'No, Monsieur Courbet.' 'Well, neither have I. The first time you do see one, be sure to let me know.'"[9] According to Vollard, Renoir said that Courbet taunted Manet himself about painting angels: "You've seen angels, to know if they have a behind?"[10] Vollard also discussed the matter with Degas, whom he quotes as having said: "Yes, I know Courbet said he'd never seen any angels and so could not know if they have backsides, and furthermore, given their size, it is unlikely that the wings Manet put on them could support them. But I don't give a damn about all that, because there is real drawing in this *Christ with Angels*! And the transparent quality of the paint! Oh, the devil!"[11]

Like Gautier and Callias, Degas admired the painting for its formal prowess. Coincidentally, Degas's remarks echo Zola's much earlier com-

Fig. a. Engraving after Francisco de Ribalta, *The Dead Christ Supported by Two Angels*, in Charles Blanc, *Histoire des peintres*

Fig. b. Engraving after Paolo Veronese, *The Descent from the Cross*, as *Christ in the Tomb* in Charles Blanc, *Histoire des peintres*

ments about the picture in 1867: "There I find all of Manet revealed, with the bias of his eye and the boldness of his hand. It has been said that this Christ is not a Christ, and I acknowledge that this could be so; for me, it is a cadaver freely and vigorously painted in a strong light, and I even like the angels in the background, children with great blue wings who are so strangely elegant and gentle."[12]

With the exception of Thoré,[13] contemporary critics seem not to have been interested in possible sources for the painting. Modern critics, however, have suggested a variety of possibilities. As Sterling and Salinger

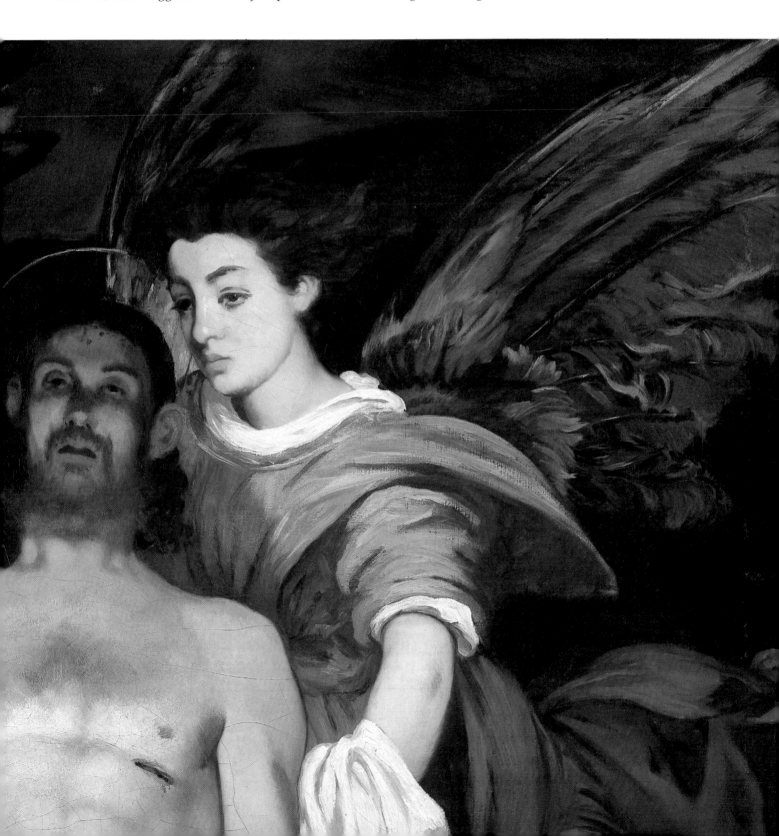

have summarized, *The Dead Christ and the Angels* "recalls compositions by several artists of the Italian Renaissance, especially Veronese's paintings of the Dead Christ in the Hermitage and in the Museums at Lille and Ottawa. There is also similarity to a picture in the Louvre formerly attributed to Tintoretto and an even more direct connection with the Dead Christ and Angels by Mantegna in Copenhagen, which was well known through two engravings."[14] Leiris has pointed out that the work most convincing as a possible source is Ribalta's *Dead Christ Supported by Two Angels* in the Prado. He notes that Manet could have known the picture through wood-engraving and lithographic reproductions, and that it was in fact illustrated in the section on Spanish art in Charles Blanc's *Histoire des peintres* (fig. a).[15] Reff has pointed out that the version of Veronese's *Descent from the Cross* in the Hermitage, a painting first cited by Florisoone as a possible source, was also illustrated by Blanc with the title *Christ in the Tomb* (fig. b).[16] In 1864, Baudelaire, in reply to Thoré's observations about the influence of Italian and Spanish Baroque painting, dismissed any similarities as "mysterious coincidences"[17] (see cat. 73).

The inscription on the rock at the lower right of *The Dead Christ and the Angels* seems to identify the passage from the Bible that the painting illustrates: évang. sel. S! Jean / chap. XX v. XII (Gospel according to Saint John, chapter 20, verse 12).[18] However, the painting is at variance with the text. In the Bible, Christ is no longer in the tomb, and the angels are dressed in white and are in different positions: "And [Mary Magdelen] seeth two angels in white sitting, the one at the head, and the other at the feet, where the body of Jesus had lain." In addition, the position of the wound is apparently incorrect. Baudelaire sent a note to Manet warning him that it was on the wrong side, but the picture had apparently already been sent to the Salon: "By the way, it seems certain that the lance wound was made on the right side. Therefore it will be necessary for you to make a change in the position, before the opening [of the Salon]. Verify it in the four Gospels. And take care not to give malicious people cause to laugh."[19]

Although the position of the wound in Christ's side is a matter of debate,[20] Baudelaire's letter suggests that Manet's contemporaries would have perceived it as misplaced. The apparently incorrect position of the wound and the discrepancy between the text and the painting are analogous to equally blatant but similarly purposeful incongruities in other pictures of the 1860s. For example, Manet chose to depict a woman as a matador (cat. 33), deliberately posed a model holding a guitar upside down (cat. 10), and depicted a nude woman seated with two fully clothed men at a picnic (cat. 62). Such anomalies seem intended to remind us that the paintings are cogently composed works of art, not merely illustrations of a given subject painted according to conventions and formulas taught by professors at the Ecole des Beaux-Arts.

1. Tabarant 1931, pp. 188–89; Tabarant 1947, p. 80.
2. Chennevières 1883, p. 40; Baudelaire 1973, II, p. 350: to Chennevières, March 1864.
3. About, quoted in Hamilton 1969, p. 53.
4. Tabarant 1931, p. 118.
5. Gautier 1864, quoted in Hamilton 1969, p. 57.
6. Callias 1864, p. 242.
7. Bürger (Thoré) 1870, II, p. 99.
8. Courbet, quoted in Nochlin 1966, p. 35.
9. Fournel 1884, p. 356.
10. Vollard 1920, p. 44.
11. Vollard 1924, pp. 65–66.
12. Zola 1867, *L'Artiste*, p. 57; Zola (Dentu), p. 54; Bouillon 1974, p. 88.
13. Bürger (Thoré) 1870, II, p. 99.
14. Sterling and Salinger 1967, p. 37.
15. Leiris 1959, p. 199 n. 7.
16. Reff 1970, pp. 456–58; Florisoone 1937, p. 27.
17. Baudelaire 1973, II, p. 386: letter to Bürger (Thoré), June 20, 1864.
18. See Jennifer M. Sheppard, "The Inscription in Manet's 'The Dead Christ with Angels,'" *Metropolitan Museum Journal* 16 (1981), pp. 199–200; the painting and significance of the inscription are also the subject of a forthcoming article by Jane Mayo Roos.
19. Baudelaire 1973, II, p. 352: to Manet, early April 1864.
20. Guerin 1944, no. 34; Gurewich 1957.
21. Manet et al., "Copie faite pour Moreau-Nélaton. . .," p. 130; Rouart and Wildenstein 1975, I, pp. 17–18.
22. Letter from Charles Durand-Ruel, January 6, 1959 (archives, department of European paintings, The Metropolitan Museum of Art, New York).
23. Venturi 1939, II, p. 91; Letter from Charles Durand-Ruel, see note 22 above.
24. Havemeyer 1961, pp. 236–37.

Provenance
According to Manet's account book,[21] this work and *Mlle V. . . in the Costume of an Espada* (cat. 33), each priced at 4,000 Frs, were the most expensive of the twenty-four paintings acquired from the artist by DURAND-RUEL in January 1872 (see Provenance, cat. 118); the dealer reported the price as 3,000 Frs. Durand-Ruel's stock books record that *The Dead Christ and the Angels* was again purchased by the firm from an unidentified seller on July 4, 1881; perhaps the dealer had used it as collateral on a business loan in the late 1870s (see Provenance, cat. 14).[22] Given its scale and subject, the painting must have been unsuitable for many collectors. During the 1890s, friends of Manet's tried to arrange for its presentation to the Musée du Louvre, but Durand-Ruel sold it on February 7, 1903, to MR. AND MRS. H. O. HAVEMEYER (see Provenance, cat. 33).[23] In her memoirs, Louisine W. Havemeyer recounts her unsuccessful attempts to hang it in her house, until finally, concluding "that it would be impossible to live with that mighty picture," she put it in storage.[24] Following her husband's death in 1907, Mrs. Havemeyer lent the work to the Metropolitan Museum; it became part of the permanent collection through her bequest in 1929 (inv. 29.100.51).

C.S.M.

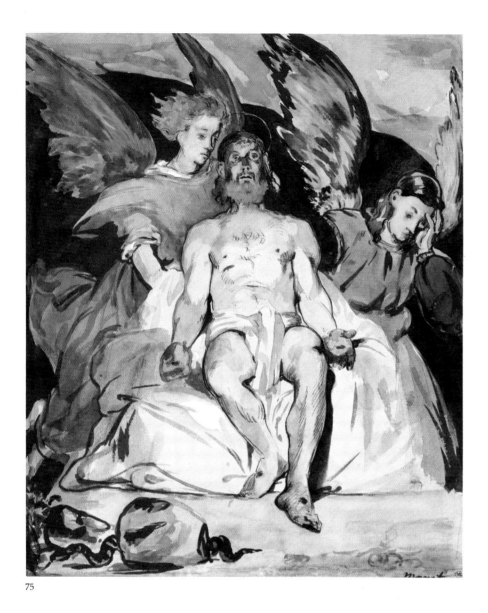

75

75. The Dead Christ and the Angels
(The Dead Christ with Angels)

1865–67
Pencil, watercolor, gouache, pen and India ink
12¾ × 10⅝″ (32.4 × 27 cm)
Signed (lower right): Manet
NY Musée du Louvre, Cabinet des Dessins, Paris

This superb watercolor reproduces, in reverse, the painting shown at the Salon of 1864 (cat. 74). The reversal of the image suggests that it was made as a preparatory drawing for the print (cat. 76), and this is confirmed by their virtually identical dimensions. On stylistic grounds, Harris dates the etching to about 1866–67,[1] and this dating no doubt applies to the watercolor as well.

Assuming that the watercolor and the print were executed two or

Exhibitions
Paris, Cercle de l'Union Artistique 1870; Berlin, Matthiesen 1928, no. 91; Paris, Bernheim-Jeune 1928, no. 7; Marseilles 1961, no. 49

Catalogues
M-N 1926 II, 336; T 1931, 31 (watercolors); JW 1932, mentioned 85; T 1947, 577; L 1969, 198; RO 1970, mentioned 63; RW 1975 II, 130

three years after the painting, it is interesting to note that Manet did not correct the "error," pointed out by Baudelaire[2] and others, concerning the position of the wound in Christ's side (see cat. 74). But he could hardly have altered such an important detail, given that he evidently intended the etching to reproduce the painting faithfully. This is proved by the preparatory drawing, which is a careful copy of the original oil, reduced to the size of his copperplate and reversed so that the print would be in the same direction as the painting.

Unlike most of Manet's preparatory drawings for prints (for example, cat. 16, 34, 51), this one shows no incisions or indentations made in order to transfer the image onto the copperplate. It is possible that Manet treated this important drawing with greater respect than usual and that a tracing was made from it as an intermediate step. A small detail proves conclusively that the drawing was in fact used for the print: the watercolored background failed to fill an area over the sleeve next to the wrist of the weeping angel, and this light patch appears again in the print. Manet shaded the area with etched lines but did not cover it with the very dark "lavis" aquatint which he added over the background. Furthermore, the "stopped-out" white areas in the first state of the print, on the neck and on the rolled-up sleeve of the angel supporting the figure of Christ, correspond to the areas heightened with white gouache on the drawing.

The drawing is technically very complex. Over a light pencil sketch (possibly based on a tracing from a photograph of the painting), the colors of the oil painting are faithfully reproduced in watercolor, which varies in density from transparent washes on the body of Christ to an opaque medium in the background; the brush was also used to "draw" the forms in dark brown watercolor. Manet then applied white and pink gouache, which creates a strange effect over the watercolor on the angels' faces and one visible hand. Finally, he reworked some of the contours and the modeling of Christ's body with pen and ink. This complex mixed-media work has a remarkable spontaneity and is one of the most impressive of all Manet's drawings. It has been slightly trimmed, as is shown by the partly cut signature and a comparison of the design with that of the etching.

1. Harris 1970, p. 145.
2. Baudelaire 1973, II, p. 352.
3. Tabarant 1930, p. 66.

Provenance
Tabarant states that Manet gave this watercolor replica of his painting to ZOLA (see Provenance, cat. 106) around 1865.[3] It is more likely that the gift was made after their collaboration on the Alma exhibition in 1867 (see cat. 68, 69), although it is not known who lent the watercolor to an exhibition in 1870—Zola or Manet. In 1918, Zola's widow donated it to the Musée du Louvre, retaining a life interest; it entered the Cabinet des Dessins in 1925 (inv. RF 4520).

J.W.B.

Exhibitions
Beaux-Arts 1884, no. 159; Paris, Drouot 1884, no. 162; Philadelphia-Chicago 1966–67, no. 70; Ann Arbor 1969, no. 26; Ingelheim 1977, no. 51; Paris, Berès 1978, no. 44

76. The Dead Christ and the Angels (The Dead Christ with Angels)

1866–67
Etching and aquatint
Plate: 15⅞ × 13⅛″ (40.3 × 33.2 cm); image: 13¼ × 11⅛″ (33.5 × 28.4 cm)
P Bibliothèque Nationale, Paris (1st state)
NY The New York Public Library (3rd state)

The Dead Christ and the Angels (cat. 74) was the largest copperplate ever etched by Manet, and it represents an exceptional effort on his part to produce a multiple image of one of his most important paintings. Although the

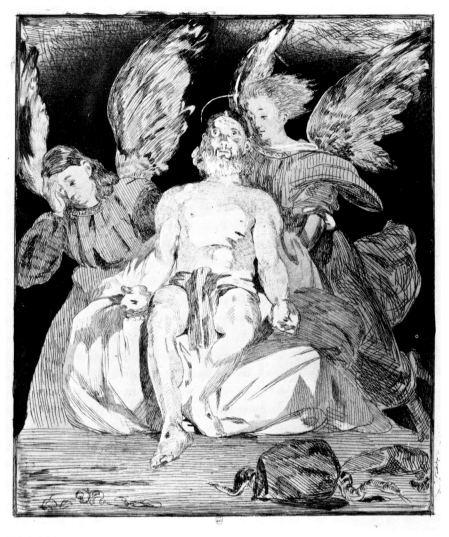

76 (1st state)

painting was shown at the Salon of 1864, the watercolor (cat. 75) and the etching were not necessarily made at that time. Manet may simply have wished to produce a handsome reproductive print to add to the small group of etchings in his one-man show in May 1867,[1] particularly since Zola, who was closely involved with the exhibition (see cat. 68, 69), had singled out the painting for special praise.[2] (Manet presented him with the watercolor used for the print as a gift.)

In fact, the first state of the print somewhat contradicts the terms of Zola's naturalistic analysis of the painting as "a cadaver freely and vigorously painted in a strong light" with "angels . . . who are so strangely elegant and gentle."[3] In the print, the purity of the etched line and the contrast of the two tones of the aquatint "lavis," similar to an ink wash, against the brilliant whiteness of the fine China paper, create an extraordinarily mystical effect. In black and white, illuminated from below, the etched face and body of Christ stand out dramatically against the lavis half-tones of the angels and the perfectly controlled tones of the background, which graduate from a deep, mysterious black toward the supernaturally light areas at the top.

When Manet subsequently reworked his plate in an attempt to

Catalogues
M-N 1906, 59; G 1944, 34; H 1970, 51; LM 1971, 36; W 1977, 51; W 1978, 44

1st state (of 3). With aquatint but before re-etching. One of two known proofs, on China paper. Moreau-Nélaton collection.

3rd state. With extensive re-etching of the plate. One of the few proofs described, on China paper. Avery collection.

206

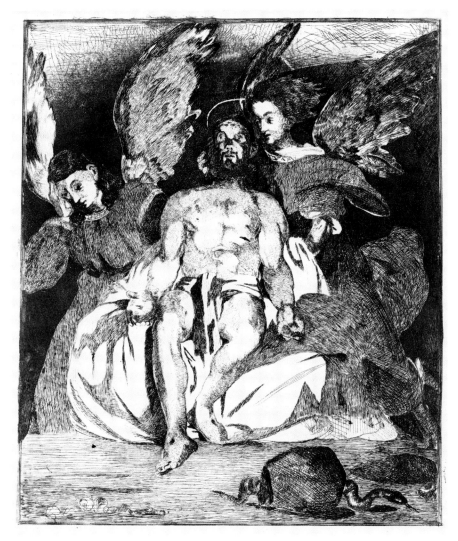

76 (3rd state)

1. Paris, Alma 1867, p. 16: *Les Gitanos* (cat. 48), *Portrait de Philippe IV* (cat. 36), *Les Petits Cavaliers* (cat. 37).
2. Zola 1867, *L'Artiste*, p. 57; Zola (Dentu), p. 34.
3. Hamilton 1969, p. 98.
4. Wilson 1978, nos. 44, 93.

Provenance

1st state. The proof belonging to MOREAU-NELA-TON (see Provenance, cat. 9), which he reproduced in his catalogue, was neither mentioned nor reproduced by Guérin, who referred only to the proof in the Ernest Rouart collection (Detroit Institute of Arts). Moreau-Nélaton also owned two proofs in the third state, but there is no indication of the previous provenance of any of these proofs. It is tempting to imagine that Manet gave one or more to Baudelaire (see Provenance, cat. 27), who was back in Paris by July 1866, and that Moreau-Nélaton obtained them from this source. *3rd state*. The proof acquired by AVERY may have come, through LUCAS, from GUERARD, who owned an impression and the copperplate himself[4] (see Provenance, cat. 17, 16). However, there is nothing on the proof to confirm this hypothesis.

J.W.B.

match the realism of the painting and the watercolor, enhancing the muscular forms of the body, the volume of the draperies, and the modeling of the heads, he destroyed the ethereal effect of the first state, although the later proof catalogued here is also printed on China paper and retains, more than the others, the mystical luminosity of the first state. Nevertheless, the whole is now overladen with detail, the grand design of the composition is lost, and the print has become rather anecdotal, whereas in the watercolor Manet maintained a perfect balance between spirituality and realism.

This large plate was never published or exhibited during Manet's lifetime, and he never again attempted such an ambitious etching. For his later large-format graphic works, he turned to lithography, restricting his use of etching primarily to works of small dimensions, usually book illustrations (see cat. 117). A proof of *The Dead Christ and the Angels* in its final state was shown in the posthumous 1884 exhibition, between impressions of *Philip IV, after Velázquez* (cat. 36) and *The Candle Seller* (H 8), a curious juxtaposition that suggests the ambiguous position of this work, halfway between the great religious images of seventeenth-century Spanish art and the realistic contemporary religious scenes of Legros and Ribot.

77. Peonies in a Vase on a Stand

1864
Oil on canvas
36¾ × 27⅝" (93.2 × 70.2 cm)
Signed (lower right): Manet
P Musée d'Orsay (Galeries du Jeu de Paume), Paris

Manet painted pictures of flowers at two specific periods of his life: a peony series in 1864–65, of which this is the centerpiece, and a series of smaller bouquets eighteen years later, in the last two years of his life, when he was already stricken by illness. These last are fresh impromptu visions, made as life slipped away. Those painted at the peak of his artistic vitality are allegories of vanity: flowers, some of which are already fading—an image of the transience of beauty. The poet André Fraigneau sees a moral in the composition itself: "Manet's vase of peonies is the story of the death of a flower, or to use the cruel and more precise medical term, the *agony* of a flower. The story reads from right to left, ending in the middle";[1] that is, from the bud on the right, to the flowers in full bloom at the top and left, to the end of the spiral in the middle, where the peonies are about to wilt, the last having dropped some of its petals. Poetic license, perhaps, but the idea is sound, and Fraigneau has rightly felt, if not formulated, the link with the Flemish or Spanish *vanitas* bouquets of the seventeenth century.

Even if one rejects a metaphysical interpretation, one must admit that this magnificent bouquet holds something of the dramatic and the sensual not to be found in flowers painted about the same time by Manet's friend Fantin-Latour, by Courbet, or even by such younger artists as Monet (*Spring Flowers*, Cleveland Museum of Art) or Renoir (*Arum and Plants*, Sammlung Oskar Reinhart, Winterthur), or in Degas's *Woman with Chrysanthemums* (Metropolitan Museum of Art, New York). All these contemporary flower paintings show a more solid, more organized exuberance, a splendor not, as here, on the verge of decay.

Van Gogh was much struck by this painting, and mentions it at a time when he was himself working on a flower series: "Do you remember that one day we saw a very extraordinary Manet at the Hôtel Drouot, some huge pink peonies with their green leaves against a light background? As free in the open air and as much a flower as anything could be, and yet painted in a perfectly solid impasto. . . . That's what I'd call simplicity of technique."[2]

Peonies were at that time in high esteem, recently introduced into Europe and still regarded as an item of luxury. This is a generous bouquet, in a vase very much in the style of the Second Empire, apparently being prepared for display, as witness the cut flower on the table. An elegant clientele such as Manet would have had in mind when painting his flowers and still lifes could recognize the image as a familiar one.

Critics—even hostile critics—have always granted Manet's virtuosity in still-life and flower painting, much of it in works otherwise decried, such as *Le déjeuner sur l'herbe* (cat. 62) and *Olympia* (cat. 64). Thoré, for example, to whom Manet gave a still life with peonies (cat. 79),[3] speaks of "undeniable painterly qualities" in the peony studies.[4]

Exhibitions
Paris, Martinet 1865?; Cadart 1865?; Alma 1867, no. 33 (Un vase de fleurs); London, Durand-Ruel 1872; Exposition Universelle 1900, no. 452; Orangerie 1932, no. 21; Orangerie 1952, without no.

Catalogues
D 1902, 84; M-N 1926 I, pp. 62–64; M-N cat. ms., 65; T 1931, 75; JW 1932, 101; T 1947, 79; PO 1967, 71; RO 1970, 70; RW 1975 I, 86

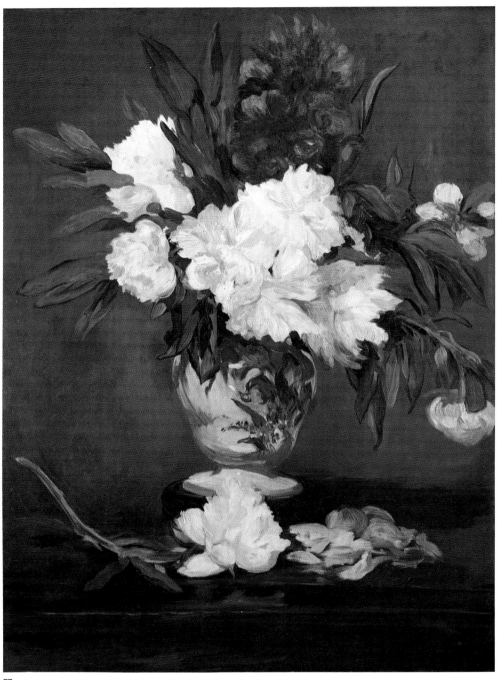

77

1. André Fraigneau, "Lumière sur un bouquet de Manet," *Plaisirs de France,* April 1964, p. 12.
2. Vincent van Gogh, *The Complete Letters of Vincent van Gogh,* 3 vols., Greenwich, Conn., n.d., III, p. 20, letter 527.
3. Bürger (Thoré) 1865, cited in Tabarant 1931, p. 123.
4. Ibid.
5. Tabarant 1947, p. 93.
6. Manet et al., "Copie faite pour Moreau-Nélaton . . . ," p. 131; Rouart and Wildenstein 1965, I, p. 17.
7. Venturi 1939, II, p. 192.
8. Saulnier sale, Paris, June 5, 1886, no. 62.

The fact is, Manet simply liked peonies. He grew them in his garden at Gennevilliers,[5] and their exuberance—with color more important than their somewhat indeterminate shape—was in perfect harmony with his generous and sensuous brushwork.

Provenance

DURAND-RUEL acquired this picture for 400 Frs (600 Frs, according to Manet's account book[6]) in 1872, as part of his first large purchase of canvases from the artist (see Provenance, cat. 118).[7] It later entered the collection of JOHN SAULNIER of Bordeaux, and DURAND-RUEL bought it again at the Saulnier sale in 1886.[8] The painting subsequently belonged to MOREAU-NELATON (see Provenance, cat. 62) and was included in his gift of 1906 (inv. RF 1669), which was displayed in the Musée des Arts Décoratifs and entered the Musée du Louvre in 1937.

F.C.

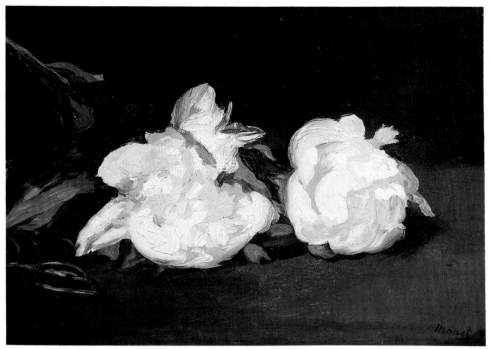

78

78. Branch of White Peonies, with Pruning Shears

1864?
Oil on canvas
12¼ × 18¼" (31 × 46.5 cm)
Inscribed (lower right, by Suzanne Manet): Manet
Musée d'Orsay (Galeries du Jeu de Paume), Paris

Exhibitions
Beaux-Arts 1884, no. 38; Orangerie 1952, without no.

Catalogues
D 1902, 86; M-N cat. ms., 67 (and 70); T 1931, 78, 81; JW 1932, 105; T 1947, 81; PO 1967, 73, 76; RO 1970, 72, 75; RW 1975 I, 88

Manet's virtuosity in still-life and flower painting was always recognized, and even in the much maligned *Olympia* (cat. 64), the central bouquet found favor with the severest critics.[1] Here, Manet deals with the subject brilliantly, but as if in passing, with a kind of exquisite carelessness manifest in the composition itself—the abandoned flowers and shears suggesting a brief pause in the fashioning of a bouquet. The effect lies entirely in the rich, confident brushwork, which expresses the unassuming splendor of cut peonies.

Sometimes dated 1864, sometimes 1867–68,[2] this little canvas by its style and technique suggest the earlier date, associating it with another painting (cat. 77), of which it might pass for an enlarged detail.

1. Chesneau 1865.
2. Wildenstein: 1864; Tabarant: 1867–68.
3. Tabarant 1947, p. 95.
4. Geneviève and Jean Lacambre, eds., *Champfleury: Le Réalisme*, Paris, 1973.
5. Tabarant 1931, pp. 124–26, nos. 78, 81.
6. Champfleury sale, Paris, April 28–29, 1890, no. 18.
7. Chocquet sale, Paris, July 1–4, 1899, no. 72.

Provenance
Manet is supposed to have given this small painting to his friend[3]—who was also close to Baudelaire, Nadar, and especially Courbet—Jules Husson, called CHAMPFLEURY (1821–1889), the realist novelist, critic, and songwriter.[4] In his catalogue, Tabarant assigned separate numbers to two canvases differing in their dimensions by only one centimeter,[5] but evidently there is only a single picture, this one, which can be identified with that shown at the 1884 retrospective as no. 38, "Flowers, owned by M. Champfleury." Tabarant published a letter from Champfleury to Léon Leenhoff in which he agrees to lend a picture to the Ecole des Beaux-Arts and proposes to send it by boat from Sèvres, where he was curator of the Musée National de Céramique. (For the ties between Champfleury and Manet, see cat. 114, 117.) At Champfleury's sale in 1890,[6] the picture was purchased by VICTOR CHOCQUET (see Provenance, cat. 158). It appeared at the sale of his widow, MME CHOCQUET, in 1899,[7] when it was acquired by COMTE ISAAC DE CAMONDO (see Provenance, cat. 50) for 1,627.50 Frs. Camondo bought Cézanne's *House of the Hanged Man* at the same sale. *Branch of White Peonies, with Pruning Shears* was included in Camondo's bequest to the Musée du Louvre in 1908, which entered the museum in 1911 and was exhibited in 1914 (inv. RF 1995).

F.C.

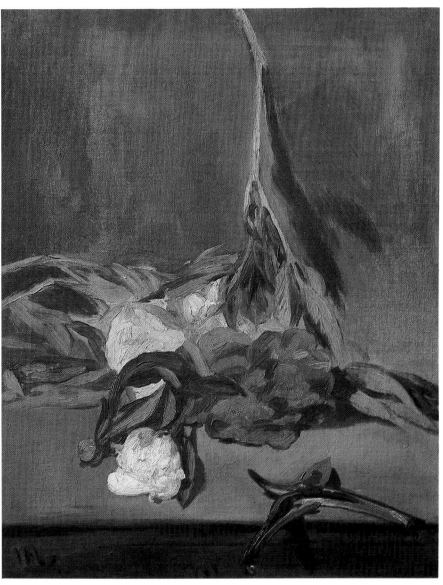

79

79. Peony Stems and Pruning Shears

1864
Oil on canvas
22⅜ × 18¼″ (56.8 × 46.2 cm)
Initialed (lower left): M.
Musée d'Orsay (Galeries du Jeu de Paume), Paris

Exhibitions
Beaux-Arts 1884, no. 37; Orangerie 1952, without no.

Catalogues
D 1902, 87; M-N 1926 I, pp. 63–64; M-N cat. ms., 68; T 1931, 79; JW 1932, 143; T 1947, 80; PO 1967, 72; RO 1970, 71; RW 1975 I, 91

The composition of this painting is altogether unusual for a still life of flowers, and Manet seems to have treated it like a still life of game in the manner of Chardin or Oudry, with game of fur and feather hanging head down from a wall. Soon after, incidentally, he adopted that traditional treatment in *Rabbit* (RW I 118), directly inspired by Chardin. The open shears threatening the flowers like a weapon emphasize the perhaps deliberate substitution of a cut flower for a slain animal.

Manet presented the canvas to Théophile Thoré (see Provenance) in acknowledgment of a word of praise for his shows at Martinet's and Cadart's in 1865, both of which had included peonies. Thoré had specifically admired "still lifes . . . as well as studies of peonies that revealed undeniable painterly qualities."[1]

1. Bürger (Thoré) 1865, quoted in Tabarant 1931, p. 123.

Provenance
Manet gave this painting to Baudelaire's friend, the realist critic THEOPHILE THORE (called Willy Bürger, 1807–1869). A friend of Courbet's, Rousseau's, and Prud'hon's, Thoré-Bürger promoted Manet's first exhibited pictures, though not without criticizing them (see cat. 62, 73, 80, 81, 89). At the critic's death, MME PAUL LACROIX inherited the work, and it was later acquired by

MARY CASSATT (1844–1926). This great artist, who was friendly with the Impressionists—Degas in particular—played an important role in the dispersal of Manet's work, especially to the United States, by recommending purchases to her friend Mrs. Havemeyer, as well as to Macomber, Potter Palmer, Sears, and Whittemore (see Provenance, cat. 33, 104, 99, 32, 132). She still owned the picture when Duret's first catalogue was published in

1902. In 1903, the work was in the hands of BERNHEIM-JEUNE (see Provenance, cat. 31). It was subsequently acquired by COMTE ISAAC DE CAMONDO (see Provenance, cat. 50) and was included in his bequest of 1908 to the Musée du Louvre, entering the collection in 1911 (inv. RF 1996).

F.C.

80. Fruit on a Table

1864
Oil on canvas
17¾ × 28⅞" (45 × 73.5 cm)
Signed (lower right): Manet
P Musée d'Orsay (Galeries du Jeu de Paume), Paris

This work is the pendant to *Salmon, Pike, and Shrimp* (RW I 82; fig. a). Evidently both were painted in 1864, because they appear as item no. 5, "Poissons—fruits (Pendants)," in a list of eight works that Manet intended to send to the dealer Louis Martinet for an exhibition that opened in February 1865. He included the list in an undated letter apparently sent to Martinet in late 1864 or early 1865.[1] However, Hippolyte Lejosne wrote to Baudelaire that Manet sent six paintings to Martinet, of which only two were shown. He further disclosed, "Apparently . . . this show is beneath mediocrity, and to have a canvas or canvases seen there would be compromising."[2] Unfortunately, we have neither a list of the works delivered to Martinet nor any documentation indicating the exact titles of the pictures exhibited (see cat. 73). Nevertheless, it would appear that Martinet did in fact exhibit still lifes, because following an exhibition later that year at the gallery of the print dealer Cadart, Théophile Thoré reported, "There are certain works by Manet that were seen at an exhibition on the boulevard des Italiens [Martinet's gallery] that have since been seen again and examined more closely at Cadart's . . . still lifes in which the artist arranged fruit and fish on a dazzling white tablecloth, as well as studies of peonies that revealed undeniable painterly qualities."[3] Since there was only one still life of fruit on the list of pictures to be sent to Martinet, it is very likely that *Fruit on a Table* was in both exhibitions.

The subject matter of the painting appears often in eighteenth-century French paintings, especially works by such artists as Jean-Baptiste-Siméon Chardin and Anne Vallayer-Coster. During the Second Empire, Chardin's relatively simple and realistically rendered still lifes were especially popular, and several artists emulated his style. Although *Fruit on a Table* is by no means as derivative of Chardin as, for example, the work of the fashionable Second Empire still-life painter Philippe Rousseau (fig. b), it

Exhibitions
Paris, Martinet 1865?; Cadart 1865?; Alma 1867, no. 47 (Fruits); Beaux-Arts 1884, no. 32; Orangerie 1932, no. 18; Orangerie 1952, without no.

Catalogues
D 1902, 71; M-N 1926 I, pp. 62–63; M-N cat. ms., 62; T 1931, 88; JW 1932, 100; T 1947, 91; PO 1967, 81; RO 1970, 80; RW 1975 I, 83

Fig. a. *Salmon, Pike, and Shrimp*, 1864. Norton Simon Inc. Foundation, Pasadena, Calif.

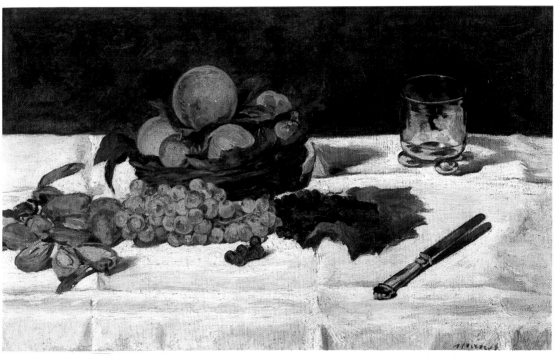

80

Fig. b. Philippe Rousseau, *Still Life with Ham*, ca. 1870. The Metropolitan Museum of Art, New York

1. Moreau-Nélaton 1926, I, p. 62; Rouart and Wildenstein 1975, I, p. 13.
2. Baudelaire, *Lettres à*, p. 215: from Hippolyte Lejosne, February 1865.
3. Bürger (Thoré) 1865, quoted in Tabarant 1931, p. 123.
4. Wildenstein 1974, I, nos. 102–4.
5. Tabarant 1947, p. 19.
6. Ibid., p. 23.
7. Duret 1902, p. 71.

Provenance
This picture was lent to the 1884 exhibition by DR. SIREDEY, the Manet family physician, who attended the artist in his last illness.[5] Manet presented him with his copy after Rembrandt's *Anatomy Lesson* (RW I 8), and in 1883, Suzanne Manet gave him the artist's *Head of a Man* (RW I

seems directed at the same taste. Indeed, Manet's admiration for Chardin is more pronounced in such a work as *The Brioche*, 1870 (RW I 157), which seems to have been inspired by Chardin's 1763 painting of the same title, a work acquired by the Louvre and placed on exhibition in 1869.

Fruit on a Table differs considerably, however, from the work of many Second Empire painters, whose pictures often include such intrinsically elegant, decorative objects as pieces of porcelain and silver. The elegance of Manet's still life with fruit derives, in contrast, from its simplicity, directness, and manner of execution. The composition is remarkably spare, consisting of two rectangular fields—the white tablecloth and the dark background—that serve as a foil for the shapes, forms, and colors of the objects laid out on the table. Indeed, the artist seems less interested in the nature of the subject matter than in compositional rhythms, interrelationships of color, and subtleties of picture surface and brushstroke.

In 1867, Monet painted three still lifes that are reminiscent of Manet's *Fruit on a Table*.[4] *Still Life: Pears and Fruit* (formerly David-Weill collection, Paris) is especially similar; again, we see a composition consisting of two rectangles—the familiar white tablecloth and a dark background—against which Monet has organized grapes, a basket of pears, and some loose fruit. Although Monet was more obviously motivated by a fascination with color and light, it seems clear that his 1867 still lifes are at least indirectly related to *Fruit on a Table*, which he may have seen at Martinet's, Cadart's, Manet's studio, or Manet's 1867 exhibition on the avenue de l'Alma.

11),[6] no doubt in thanks for attending her husband during the last months of his life. From his widow, MME SIREDEY, the picture passed into the hands of BERNHEIM-JEUNE (see Provenance, cat. 31) in 1901 and then, through DURET (see cat. 108), into the collection of MOREAU-NELATON (see Provenance, cat. 62), who is listed as the owner in Duret's

catalogue of 1902.[7] Moreau-Nélaton presented *Fruit on a Table* to the Musée du Louvre in 1906 (inv. RF 1670), and it was exhibited at the Musée des Arts Décoratifs from 1907 until 1934, when it was transferred to the Louvre.

C.S.M.

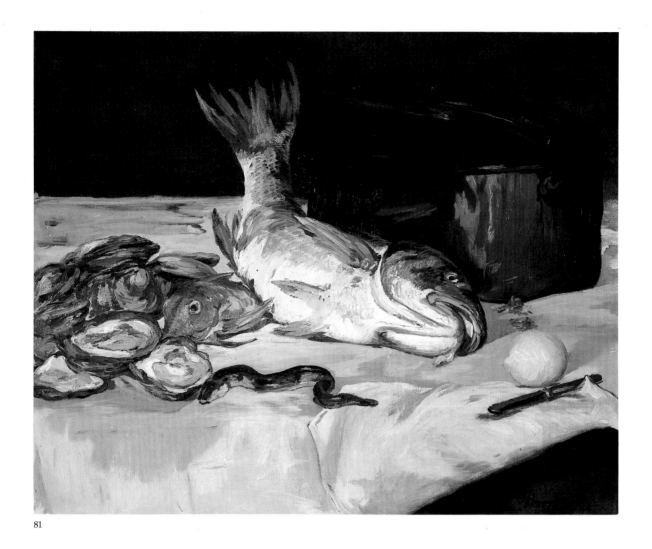

81

81. Still Life with Fish

1864
Oil on canvas
28⅞ × 36¼" (73.4 × 92.1 cm)
Signed (lower right): Manet
The Art Institute of Chicago

Manet painted *Still Life with Fish* at Boulogne-sur-Mer during the summer of 1864.[1] He included it, as he did *The Dead Toreador* (cat. 73) and *Fruit on a Table* (cat. 80), in a list sent to the dealer Louis Martinet in December 1864 or January 1865 in connection with an exhibition that opened in February.[2] We do not know if this picture, listed as item no. 4, "Poissons, etc. Nature Morte," was actually exhibited at Martinet's gallery. However, that same year it was apparently shown during the spring at the gallery of the print dealer Cadart, because in referring to the latter exhibition in the May 16 edition of *Le Constitutionnel*, Théophile Thoré mentions "still lifes in which the artist arranged fruit and fish on a dazzling white tablecloth" (see cat. 80).[3]

As in *Fruit on a Table*, the composition consists of elements organized

Exhibitions
Paris, Martinet 1865?; Cadart 1865?; Alma 1867, no. 38 (Poissons [nature morté]); Beaux-Arts 1884, no. 31; Exposition Universelle 1900, no. 449; New York, Durand-Ruel 1913, no. 6; New York, Wildenstein 1937, no. 7; World's Fair 1940, no. 282; Philadelphia-Chicago 1966–67, no. 95

Catalogues
D 1902, 70; M-N 1926 I, p. 63; M-N cat. ms., 59; T 1931, 90; JW 1932, 96; T 1947, 90; PO 1967, 80; RO 1970, 79; RW 1975 I, 80

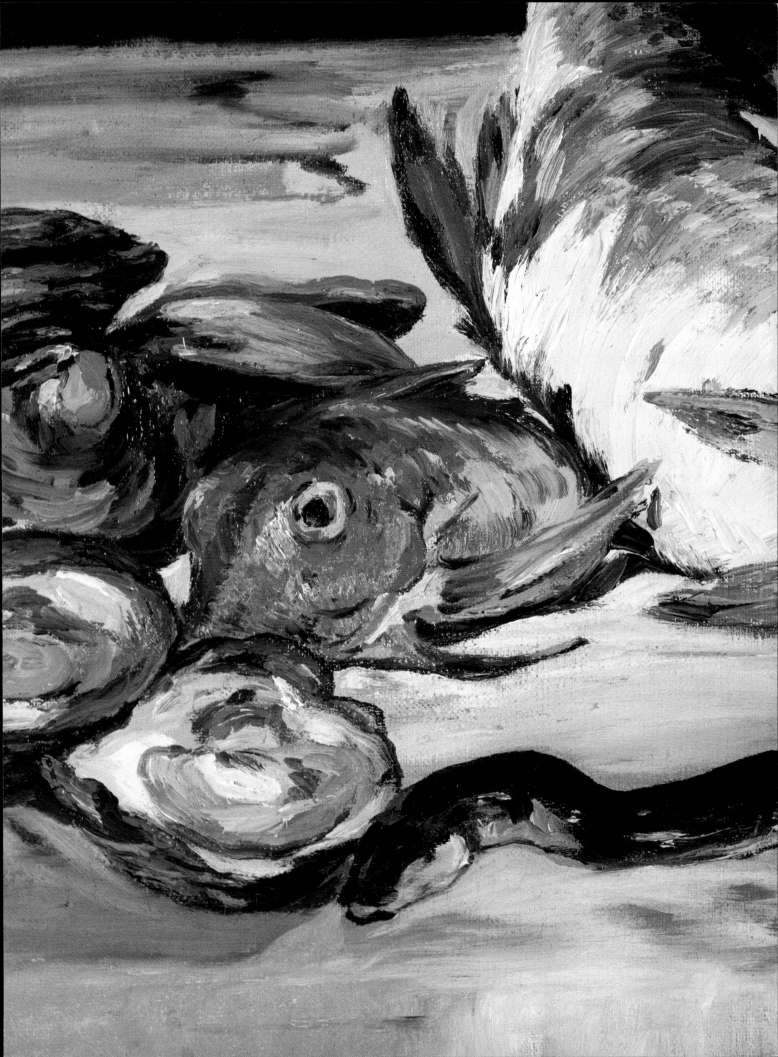

primarily along a diagonal that runs from the lower left to the upper right of the painting. Indeed, the knife at the right in each painting seems deliberately positioned in order to emphasize the diagonal axis of the composition. Moreover, Manet appears to have placed the large fish (a carp or a mullet[4]) on the opposite axis in order to both enliven and balance the compositional structure.

Evidently, the composition of *Still Life with Fish* derives from that of Chardin's *The Silver Tureen*, 1727–28 (fig. a). In the Manet, the placement of the copper pot, the carp or mullet, the red gurnard, and the lemon corresponds closely to that of the tureen, the hare, the quail, and the fruit in the foreground of the Chardin. Manet could have seen Chardin's still life in an exhibition at Martinet's gallery in 1860; moreover, Thoré reviewed the exhibition and specifically praised *The Silver Tureen*.[5] Manet's emulation of Chardin, also reflected in *Fruit on a Table* and *The Brioche* (RW I 157), is an indication of the strong interest of Second Empire artists and collectors in that master's work, especially his still lifes.

Fig. a. Jean-Baptiste Chardin, *The Silver Tureen*, 1727–28. The Metropolitan Museum of Art, New York

Provenance
The dealer FELIX GERARD lent this picture to the 1884 Manet retrospective at the Ecole des Beaux-Arts. According to Duret, Gérard once asked him to help find a buyer for this picture and for Manet's *Races at Longchamp* (cat. 99).[6] By 1900, *Still Life with Fish* was with the GALERIE MANZI-JOYANT in Paris (see Provenance, cat. 19, 181). DURAND-RUEL (see Provenance, cat. 118) sold it to ALFRED CHATAIN of Chicago, presumably about 1913, when the dealer exhibited it in his New York gallery. By 1920, it was in the collection of MRS. JOHN W. SIMPSON (died 1943), who with her lawyer husband formed a large collection, primarily of eighteenth- and nineteenth-century European paintings.[7] Mrs. Simpson was the daughter of the

great collector of American and European art George I. Seney, and had her bust sculpted by Rodin in 1903 (National Gallery of Art, Washington, D.C.). She left *Still Life with Fish* on consignment with M. Knoedler & Co. in 1942; in July of that year, it was purchased by the Art Institute of Chicago with funds given by Annie Swan Coburn for the Mr. and Mrs. Lewis Larned Coburn Memorial Collection (inv. 42.331).

The early provenance for this picture has often been confused because of the existence of a slightly larger replica, first published in 1912 and acquired no later than 1922 by the Nationalmuseum of Stockholm (this second version is generally condemned as a forgery[8]).

C.S.M.

1. Tabarant 1931, p. 131.
2. Moreau-Nélaton 1926, I, p. 62; Rouart and Wildenstein 1975, I, p. 13.
3. Bürger (Thoré), quoted in Tabarant 1931, p. 123.
4. Courthion 1961, p. 84, identifies the fish as a mullet; Chicago, Art Institute, *Paintings in The Art Institute of Chicago*, Chicago, 1961, refers to it as a carp.
5. Rosenberg 1979, p. 136.
6. Gérard sale, Paris, March 28–29, 1905, preface.
7. Gimpel 1963.
8. Tabarant 1947, pp. 97–98.

82. Still Life with Melon and Peaches

1866?
Oil on canvas
27⅛ × 36¼" (69 × 92.2 cm)
Signed (lower right): Manet
National Gallery of Art, Washington, D.C.

Rouart and Wildenstein and others identify this picture as catalogue no. 36, *Un déjeuner (nature morte)*, in Manet's 1867 exhibition on the avenue de l'Alma,[1] but that painting could also have been *The Salmon* in the Shelburne Museum (RW I 140; fig. a), a work generally dated 1869. The dimensions of *Un déjeuner (nature morte)* were cited in the 1867 catalogue as 73 × 94 cm, approximately the same as those of both *Still Life with Melon and Peaches* and *The Salmon* (72 × 92 cm). Moreover, the subject matter of the Shelburne picture corresponds more closely to the title of no. 36 in the 1867 catalogue than does *Still Life with Melon and Peaches*, which could easily be the work referred to by catalogue no. 37, *Fruits*. Unfortunately, no dimensions were recorded for the latter picture. However, since both have nearly identical dimensions,

Exhibitions
Alma 1867, no. 37 (Fruits)?; New York, Durand-Ruel 1913, no. 17; Philadelphia-Chicago 1966–67, no. 99

Catalogues
D 1902, not mentioned; M-N 1926 I, p. 89; M-N cat. ms., 94; T 1931, 124; JW 1932, 131; T 1947, 127; PO 1967, 111; RO 1970, 110; RW 1975 I, 121

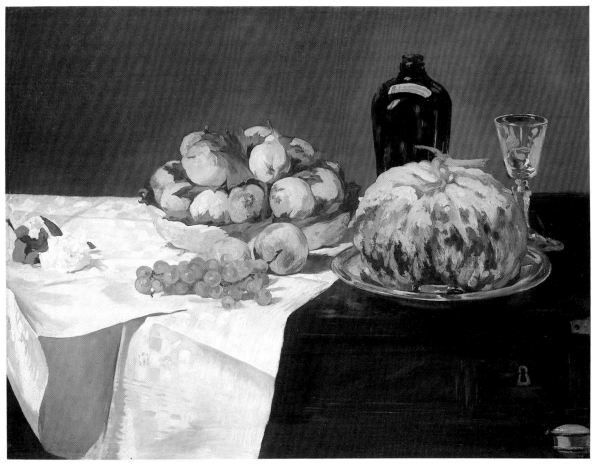

82

Fig. a. *The Salmon*, 1866–69? Shelburne Museum, Shelburne, Vt.

Fig. b. Randon, caricature in *Le Journal amusant*, June 29, 1867

depict a still life on a white tablecloth on the same buffet, and are listed consecutively in the 1867 catalogue, it is possible that they are pendants. But we can know with certainty only that *Still Life with Melon and Peaches* was shown in 1867; G. Randon's suite of caricatures after a selection of paintings in Manet's show (fig. b) included the Washington picture (without catalogue number) but no other still lifes.

Most authors date *Still Life with Melon and Peaches* 1866 or 1867, apparently on the basis of its inclusion in Manet's independent exhibition. Still lifes play a rather limited role in Manet's oeuvre, and there are no other examples to which it can be compared in terms of composition and style. As Rishel points out, *Still Life with Melon and Peaches* is often mentioned in connection with *The Luncheon in the Studio* of 1868 (cat. 109), but the similarity is limited to the fact that the same tablecloth seems to appear in both works.[2]

The subject and composition of *Still Life with Melon and Peaches* are typical of those of the still lifes popular in France from the mid-1850s through the 1870s. Such pictures are in the tradition of seventeenth- and eighteenth-century French still-life painting, especially the latter, but *Still Life with Melon and Peaches* seems specifically directed to the taste of wealthy Second Empire collectors. Indeed, the picture suggests the kind of affluence that often characterizes the work of Philippe Rousseau (see cat. 80, fig. b), the fashionable Second Empire still-life painter whose career was fostered by the support of Count Nieuwerkerke, superintendent of fine arts under Napoleon III.

Hanson asserts that such paintings as *Still Life with Melon and Peaches* "speak of 'la vie moderne' as persuasively as some of the portraits or street scenes which record other forms of affluence and pleasure"; moreover, she suggests that these pictures provide a glimpse of Second Empire life, a "sense of the people who have left the table in such casual disarray."[3] Even if this is true, these pictures enjoyed little popular or commercial success at the time they were painted. Difficult as it is to believe today, the execution of *Still Life with Melon and Peaches* was probably considered too modern, too radical in its paint handling and its emphasis on paint surface, touch, and color. Very likely, the reasons for which the painting is so admired today are those that disturbed Manet's contemporaries; indeed, John Walker's assessment of the picture in 1975 would have been shared by few viewers in 1867: "It is in still-life painting that Manet's three most admirable qualities are especially apparent: his dexterous brushwork, his superb control of value relations, and his mastery of texture . . . his feeling for the manipulation of pigment was intense."[4]

1. Rouart and Wildenstein 1975, I, no. 121.
2. Rishel 1978, p. 330.
3. Hanson 1977, p. 70.
4. Walker 1975, p. 454.
5. Letter from Charles Durand-Ruel, December 13, 1982 (archives, department of European paintings, The Metropolitan Museum of Art, New York).
6. Walker 1975, pp. 47–48.

Provenance

This picture was sold at auction in Brussels on March 22, 1875 (no. 44), as part of the collection of nineteenth-century paintings belonging to the late LEOPOLD BAUGNEE, about whom nothing is known. On September 26, 1910, a M. Depret, acting on behalf of his father-in-law, M. PEROUSE, who lived at the Château de Forges and 40, quai Debilly, Paris, deposited the picture for sale with Durand-Ruel (see Provenance, cat. 118). The dealer found a buyer, but Pérouse declined to sell and took the picture back.[5] By 1913, it was in the collection of EUGENE MEYER, who lent it to Durand-Ruel's Manet exhibition in New York that year. With his wife, Agnes, Eugene Meyer (1875–1959), a banker, a broker, and later the owner of the *Washington Post*, began acquiring major works by French Impressionist and Post-Impressionist painters, especially Cézanne, in the early years of the twentieth century.[6] *Still Life with Melon and Peaches* entered the collection of the National Gallery of Art, Washington, D.C., as their gift in 1960 (inv. 1549).

C.S.M.

83. Battle of the Kearsarge and the Alabama

1864
Oil on canvas
52¾ × 50" (134 × 127 cm)
Signed (lower right): Manet
The John G. Johnson Collection, Philadelphia

On June 19, 1864, a corvette of the United States Navy, the *Kearsarge*, attacked and sank the Confederate vessel *Alabama* off Cherbourg. This incident of the American Civil War, so near the coast of France, received much public attention. The event had been long in preparation; the Southern ship was not a privateer as has been said but a raider built and outfitted for the Richmond government, and her captain, Commander Semmes, boasted of having sent to the bottom sixty-five Northern merchantmen. He was a popular figure in England, as well as in Cherbourg,[1] and, while the ship was in port for repairs and provisions, had been much fêted. In the week after the battle, all the French newspapers were full of details and commentary. Manet, it seems, notwithstanding the much later testimony of Antonin Proust, had not been present.[2] Manet's letter to Philippe Burty thanking him for his article praising the painting[3] strengthens the supposition that it was done from descriptions and perhaps photographs, for, having painted the victorious ship soon after (cat. 84), he wrote, "The *Kearsage* [*sic*] was anchored at Boulogne last Sunday. I went to have a look. I had got it about

Exhibitions
Cadart 1864; Alma 1867, no. 22 (Le Combat des navires américains, *Kerseage* et *Alabama*); Salon 1872, no. 1059 (Combat du *Kearsarge* et de l'*Alabama*); Beaux-Arts 1884, no. 35; New York, National Academy of Design 1886, no. 178; Philadelphia 1933–34, without no.; New York, Wildenstein 1937, no. 9; New York, Rosenberg 1946–47, no. 14; Philadelphia-Chicago 1966–67, no. 62

Catalogues
D 1902, 81; M-N 1926 I, pp. 60–61, 137–138; M-N cat. ms., 54; T 1931, 69; JW 1932, 87; T 1947, 74; PO 1967, 67; RO 1970, 66; RW 1975 I, 76

right. So then I painted her as she looked on the water. Judge for yourself."[4]

This work was Manet's first painting of a current event, merging reportage with the historical. The theme of the sea fight was of course highly traditional, particularly in Dutch painting, and Manet certainly had it in mind, undertaking to carry on a familiar genre. The subject was likely to interest a wide public; one has only to leaf through issues of *L'Illustration* from the early 1860s to see that nearly every one reports and illustrates a naval engagement, a storm at sea, the departure of a fleet—in short, some maritime event. It has been suggested that the engraving published in *L'Illustration* on June 25 provided the basis for the painting,[5] but the differences between the compositions make this improbable.

Manet's objective in this painting was accuracy. The French sailboat, bounding to the rescue of the men in the water, flies the regulation blue-bordered white flag of pilot boats; as in the descriptions of the action, the three-master is about to sink,[6] going down by the stern, all her jibs still set in the attempt to regain the shore; the little steamer at the right is the English rescue ship that will take the Southerners to England. Manet, having spent almost a year at sea in his youth, intending to become an officer in the merchant marine, must have been fascinated by this event. Furthermore, seascapes were to be the only scenery to interest him, except toward the end of his life, when illness kept him within the walls of his garden.

In this, as in all his seascapes, the water takes up three quarters of the canvas, in a disturbingly unusual composition; the caption of the caricature by Cham that appeared in *Le Charivari* at the time of the 1872 Salon, where the painting was again exhibited, shows clearly why the fanciers of marine painting were annoyed: "The *Kearsage* [sic] and the *Alabama*, finding M. Manet's salt water unworthy of belief, decide to fight in the shelter of the picture frame."[7] And Stop wrote: "Untroubled by the vulgar bourgeois laws of perspective, M. Manet conceives the clever idea of giving us a vertical section of the Ocean, so that we may read the physiognomy of the fishes for their impressions of the conflict taking place above their heads."[8] The same idea is found in a caricature published in *Le Grelot au Salon* (fig. a), where Olympia's cat appears at the bottom of the sea. The device of moving the scene to the top of the canvas has been attributed to a Japanese influence,[9] more convincing in Manet's later marine subjects.

But what we should see in the composition is the vision of a man accustomed to experiencing the sea from on board ship, not from the shore. His sea is not littoral; it is open water. There is something of lyric power in this painting—the drama of the subject, the expression of vitality, the interplay of light and color in which the blacks and a few spots of red set off the strong green of the water. Barbey d'Aurevilly, from Normandy and himself a lover of the sea, put it well: "There is a feeling of nature and of scene . . . very simple and powerful. . . . M. Manet has set back his two ships to the horizon. He has been pleased to diminish them by distance, but his sea, heaving all about, extending to the very frame of the picture, . . . is more dangerous than the battle. . . . A grand idea, grandly executed. Today, with his *Alabama* canvas, he has wedded nature. . . . M. Manet has behaved like the Doge of Venice, casting a ring—I can assure you it is a ring of gold—into the sea."[10]

The greatness and intensity of the painting are perhaps accounted for by its chronological placement within Manet's oeuvre. The year after the scandal of *Le déjeuner sur l'herbe* (cat. 62) was a gloomy one for the artist;

Fig. a. Anonymous caricature, "From the bottom of the sea, its last resting place, M. Manet's faithful cat follows the details of the battle," in *Le Grelot au Salon*

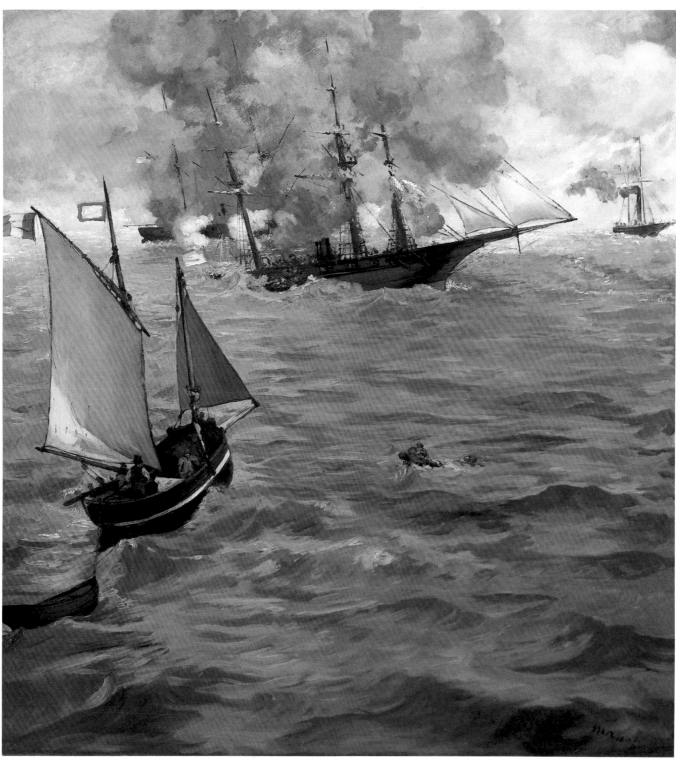

possessed by a determination to show himself worthy of the Salon's approval, he addressed himself to "grand" subjects. The paintings of 1864 are concerned with death following confrontation: *Episode from a Bullfight*, from which he cut and kept *The Dead Toreador* (cat. 73); *The Dead Christ and the Angels* (cat. 74); and the demise of a ship. Manet had never seen a dead bullfighter, and the plastic image is gripping rather than moving; no religiosity is evident in *The Dead Christ*, and its appeal is sensual rather than mystical; but the going down of a ship, something Manet must have contemplated often enough as a young man serving on the Atlantic, touched personal experience.

In 1880, the painting prompted one M. Baudart of Brussels to ask Manet to do a large canvas for a panorama, showing "a sea fight in which the English are victorious."[11] Manet's response to this intriguing suggestion is not known.

1. L. Peillard "La Mer rougie de sang," *Les Nouvelles littéraires*, May 27, 1965, p. 6; Rishel 1979, no. 248.
2. Proust 1897, p. 174; Duret 1902, pp. 80–81.
3. Moreau-Nélaton 1926, I, p. 60: Manet to Burty, July 18, 1864.
4. Ibid., p. 61.
5. Sandblad 1954, p. 131.
6. Sloane 1951, p. 94.
7. Cham, "Le Salon pour rire," *Le Charivari*, June 2, 1872.
8. Stop, in *Le Journal amusant*, May 23, 1872.
9. Hanson 1962.
10. Barbey d'Aurevilly 1872.
11. New York, Pierpont Morgan Library, Tabarant archives: to Manet, May 2, 1880.
12. Venturi 1939, p. 191.
13. Tabarant 1947, pp. 89, 196.
14. Silvestre 1872.
15. Anonymous (L *** et al.) sale, Paris, March 23, 1878, no. 32.
16. France Daguet, pers. comm. to Durand-Ruel, January 1983.
17. Tabarant 1947, p. 89.
18. See note 16 above.
19. Saarinen 1958, pp. 92–117.

Provenance
This picture, priced at 3,000 Frs, was among the group purchased directly from Manet by DU-RAND-RUEL in January 1872 (see Provenance, cat. 118).[12] At Manet's request, the dealer lent it to the Salon in May 1872,[13] and he apparently still owned it in September.[14] The painting subsequently appeared at auction[15] and was knocked down for 700 Frs to the publisher GEORGES CHARPENTIER (see cat. 190). He left it on consignment with Durand-Ruel on October 24, 1884, and took it back on October 27, 1887.[16] Later, the work belonged to THEODORE DURET (see cat. 108), who tried in vain to promote its acquisition by the French state, as shown in his letter of May 2, 1889, to Suzanne Manet: "During Castagnary's lifetime, I tried to no avail to arrange for the purchase of the *Alabama* by the State. Being unsuccessful at this, and unable to keep the painting for lack of space, I have arranged with Durand-Ruel to send it to New York, where it will fetch a good price."[17] Castagnary had become director of fine arts in 1887 and had died in the following year. Accord-

ing to the stock books of DURAND-RUEL, the picture was accepted on consignment from Duret on March 21, 1888, purchased for 3,000 Frs on October 16, and sold to the New York branch on the same day for 4,000 Frs. On the following day, the latter sold "a painting by Manet"—not further identified in the stock books—to Johnson for $1,500;[18] this can only be the *Battle of the Kearsarge and the Alabama*, the only Manet ever owned by the lawyer JOHN G. JOHNSON (1841–1917) of Philadelphia. His enormous collection, especially rich in works by Delacroix, Corot, and Millet, was catalogued by Berenson and Valentiner early in the twentieth century. Particularly attracted to landscape, Johnson was drawn to Courbet for his work in that genre; his one Manet is more at home among the other works in the collection than representative of Manet in general. The *Battle of the Kearsarge and the Alabama* entered the Philadelphia Museum of Art in 1933 (inv. 1027) along with Johnson's collection, the most important group of works ever entrusted to the museum.[19]

F.C.

84. Fishing Boat Coming in Before the Wind (The Kearsarge at Boulogne)

1864
Oil on canvas
32 × 39¼" (81 × 99.4 cm)
Signed (lower left): Manet
Private Collection

Exhibitions
Paris, Martinet 1865 (La mer, le navire fédéral Kerseage en rade de Boulogne sur mer)?; Alma 1867, no. 45 (Bateau de pêche arrivant vent arrière); New York, Wildenstein 1948, no. 5; Philadelphia-Chicago 1966–67, no. 63

Going to Boulogne in July, as he had done almost every summer since childhood, Manet was to see the Northern vessel he had just painted, glimpsed through the smoke of cannonades, as he said in the letter to Philippe Burty (see cat. 83). The composition here is similar, much as though the *Alabama*, in sinking, had left her conqueror in plain sight but a few moments later; the same kind of sequence can be recognized in the bullfight series (see cat. 91).

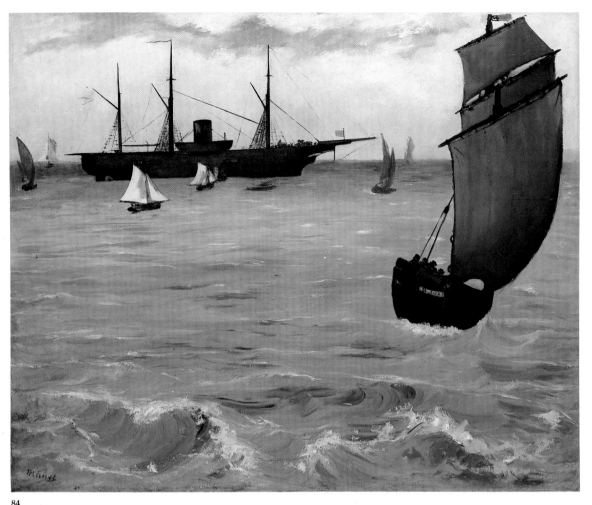

84

The *Kearsarge* is quietly at anchor, and here again the sea fills the space except for the fishing boat in the foreground, added in the studio (it is absent from the watercolor, cat. 85), with spars and rigging somewhat Japanesque in treatment. The same motif is echoed in an etching probably made the following winter (H 40) and in *Steamboat*, also exhibited at the Alma exhibition in 1867 (see cat. 86). The addition of the sailboat is a characteristic example of Manet's *modus operandi*. Then, to give more presence to the American ship, he left out the fort at the upper left in the watercolor (cat. 85). Feeling perhaps the importance of the *Kearsarge* weakened by the spread sail in the foreground, he added the two little white-sailed boats to accentuate the black of the corvette, like butterflies accosting some giant beetle. Manet thus moved from the real-life scene of the watercolor to the more highly organized composition of the final seascape, much as he generally did for his figure paintings.

Maintaining the same point of view, and the essential importance of the sea itself, Manet enlivened the scene, a bit artificially perhaps, with a fringe of waves in the foreground, in a frothy fashion to which he would return sixteen years later (cat. 207).

BATEAU DE PÊCHE ARRIVANT VENT ARRIÈRE.

Quel diable peut donc pousser l'artiste à faire et surtout à nous montrer des machines comme ça, quand rien ne l'y oblige?

Fig. a. Randon, caricature in *Le Journal amusant*, June 29, 1867

Catalogues
D 1902, 83; M-N 1926 I, p. 62; M-N cat. ms., 55; T 1931, 70; JW 1932, 88; T 1947, 75; PO 1967, 68; RO 1970, 67; RW 1975 I, 75

1. Manet et al., "Expositions Martinet"; Rouart and Wildenstein 1975, I, p. 13.
2. Randon 1867.
3. Rewald 1973, *Gazette des Beaux-Arts*, p. 106.
4. Goupy sale, Paris, March 30, 1898, no. 20.

In Manet's 1865 letter to Martinet, this painting is listed as no. 7, under the title "La mer, le navire fédéral Kerseage [sic] en rade de Boulogne sur mer,"[1] but it is not known to have been actually exhibited at that time. In his 1867 show, Manet presented several seascapes, and Randon's caricature (fig. a)[2] serves to identify this one as no. 45 in the catalogue, with Manet's new title as here adopted, which gives more prominence to the fishing boat in the foreground than to the American vessel. The Rouart and Wildenstein catalogue assigns this title to another painting entirely (RW I 77), unrelated to the series of seascapes exhibited by Manet.

Provenance
This picture was in the hands of BOUSSOD AND VALADON (see Provenance, cat. 27) during the period when Theo van Gogh directed their branch for contemporary art. It was probably he who sold the work to the collector GUSTAVE GOUPY in 1890.[3] At the Goupy sale in 1898,[4] DURAND-RUEL (see Provenance, cat. 118) bought the painting, and he subsequently sent it to New York. It later entered the collection of Mary Cassatt's friend MRS. H. O. HAVEMEYER (see Provenance, cat. 33). One can easily understand why the great American collectors at the end of the century, such as Mrs. Havemeyer and Mr. Johnson, who owned the picture in the preceding entry, were particularly drawn to seascapes by Manet that depicted a relatively recent event in American history.

F.C.

85. The Kearsarge at Boulogne

1864
Watercolor
10 × 13¼" (25.5 × 33.5 cm)
Atelier stamp (lower right): E.M.
P Musée des Beaux-Arts, Dijon

Exhibitions
Beaux-Arts 1884, no. 123; Paris, Drouot 1884, no. 128; Philadelphia-Chicago 1966–67, no. 63

Probably this is the watercolor, taken from life, on which the more elaborate oil painting (cat. 84), with its greater emphasis on the boat and the surface of

85

the sea, was based. The watercolor is drawn with a brush, very economically, in a Japanese manner; note the shape of the sail at the upper right, the small craft in the foreground, the silhouette of the fort of Boulogne at the upper left, and the three dabs of color in the American flag at the stern of the ship. While the composition here is the same as for the canvas, notably in the dominance of the great sheet of water, the studio work was to represent a far-reaching transformation.

Provenance
DR. ALBERT ROBIN (see Provenance, cat. 156), who was friendly with Manet and Méry Laurent, purchased this watercolor along with other works at the Manet sale in 1884.[1] It remained in his collection, and in 1929, he bequeathed it to the museum in Dijon, his native city (inv. 29.59 E).

F.C.

Catalogues
T 1931, 32 (watercolors); JW 1932, mentioned 88; T 1947, 578; L 1969, 201; RW 1975 II, 223

1. Manet sale, Paris, February 4–5, 1884, no. 128; Bodelsen 1968, p. 342.

86. Steamboat, Seascape
or Sea View, Calm Weather

1864–65
Oil on canvas
29¼ × 36½" (74 × 93 cm)
Signed (lower right): Manet
The Art Institute of Chicago

It is difficult to identify this painting among the seascapes shown by Manet in 1867. In Randon's caricature (fig. a), it is titled *Le Steam-Boat* and numbered 34.[1] The catalogue lists three seascapes besides the *Battle* (cat. 83), as follows: no. 34, *Le Steam-Boat* (21 × 100 cm); no. 40, *Vue de mer, temps calme* (72 × 92 cm); and no. 45, *Bateau de pêche arrivant vent arrière* (dimensions not given). The dimensions and the subject of the present painting suggest that there was confusion about the caricature, and that this was *Vue de mer, temps calme* (*Sea View, Calm Weather*), for which the dimensions correspond. The title *La mer* in the list of works sent by Manet to Martinet in 1865[2] tends to support that hypothesis. Besides, the measurements attributed to *Le Steam-Boat* in the 1867 catalogue suggest a printing error; if we read "81" instead of "21," we have the dimensions of another marine painting, *The Porpoises* (RW I 79), also showing a steamboat.

And indeed, while the composition is similar to that of the two preceding canvases (cat. 83, 84), the treatment of the sea is very different. Like the paint itself, the sea is smooth, extending unbroken to the horizon, with a still more convincing suggestion of conscious Japanese influence. As Hanson has in fact noted,[3] perspective is denied; there is no distinction in tone between the water nearby and at the horizon, whereas in the two *Kearsarge* works Manet observed the traditional gradation of brilliance and hue to indicate distance. The dark sails are arranged in a rather decorative manner on the bright blue ground, superimposed on the picture plane as in Ukiyoe prints. Manet here puts aside all classical illusionism; it is likely that he

Exhibitions
Paris, Martinet 1865 (La mer)?; Alma 1967, no. 34 (Le Steam-Boat [marine]) or 40 (Vue de mer, temps calme); Exposition Universelle 1900, no. 442; [Philadelphia]-Chicago 1966–67, no. 65

Catalogues
D 1902, 79; M-N 1926 I, p. 62; M-N cat. ms., 56; T 1931, 107; JW 1932, 92; T 1947, 76; PO 1967, 88; RO 1970, 87; RW 1975 I, 78

LE STEAM-BOAT (MARINE),

ou la vapeur appliquée à la navigation dans un plat d'oseille.

Fig. a. Randon, caricature in *Le Journal amusant*, June 29, 1867

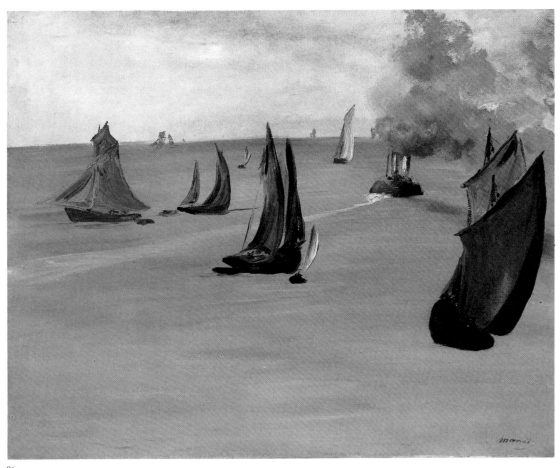

86

painted this canvas after the other two upon returning to Paris in the autumn, or even from sketches during the winter of 1864–65, as a studio recreation, an ideogram as it were, of once balmy weather. Of the three seascapes, this is the most remote from natural observation.

We might mention the possible influence of Manet's seascapes on those by Monet dating from 1866 to 1868, especially *Boats Leaving the Harbor*, 1868 (Hillstead Museum, Farmington, Conn.), where there are the same dark sails against the light, on a similarly intense sea. But Monet's glints of breaking waves herald an Impressionist technique, which in turn informs Manet's seascape treatment in the following decade in *The Escape of Rochefort* (cat. 207).

1. Randon 1867.
2. Manet et al., "Expositions Martinet"; Rouart and Wildenstein 1975, I, p. 13.
3. Hanson 1962, p. 336.
4. Tabarant 1947, p. 195.
5. American Art Association sale, New York, February 14, 1902, no. 17.

Provenance
Tabarant confuses this picture with another view of Boulogne when he states that it was among the group purchased by Durand-Ruel in 1872.[4] The work may possibly correspond with no. 81 in the Manet sale, "Temps calme—marine" (fair weather—seascape); the dimensions given in the catalogue are different, but they often include the frame. At the end of the century, it belonged to LEON CLAPISSON (see Provenance, cat. 210) and subsequently to MME A. DUREAU, who lent it to the Centennale de l'Art Français at the Exposition Universelle of 1900. Soon afterward, it was in the hands of E. F. MILLIKEN in New York, who sold it in 1902.[5] The following note, "Signed at the right. Initials 'E.M.' on the sail," which appears in the catalogue of his sale, may indicate that the present signature is false. The picture's next owner was MRS. POTTER PALMER (see Provenance, cat. 99) of Chicago, whose sons H. AND P. PALMER gave it to the Art Institute of Chicago in 1922 (inv. 22.425).

F.C.

87. Jesus Mocked by the Soldiers

1864–65
Oil on canvas
75⅛ × 58⅜″ (190.8 × 148.3 cm)
Signed and dated (lower right): Manet/1865

NY The Art Institute of Chicago

A letter from Commandant Lejosne to Baudelaire, dated January 4, 1865, informs us that Manet began *Jesus Mocked by the Soldiers* the previous year: "I haven't seen Manet since New Year's; the Thursday before, we dined at his mother's. . . . Manet is still working away at his Christ Mocked, but I haven't seen the painting for some time."[1]

Despite the hostile reception accorded his only other similarly ambitious religious painting, *The Dead Christ and the Angels* (cat. 74), exhibited at the Salon of 1864, Manet submitted *Jesus Mocked by the Soldiers* to the jury for the Salon of 1865. According to Antonin Proust, Manet first submitted only *Olympia* (cat. 64), which was refused, but when he later resubmitted it together with *Jesus Mocked by the Soldiers*, both were accepted.[2] Duret claims the paintings were accepted because the jury was afraid to risk a repetition of the situation that necessitated the Salon des Refusés in 1863.[3]

The critical and popular response to *Jesus Mocked by the Soldiers* recalls the reception accorded *The Dead Christ and the Angels*. Paul de Saint-Victor wrote in *La Presse*: "The crowd, as at the morgue, presses together in front of the gamy *Olympia* and the horrible *Ecce Homo* of M. Manet. Art, having sunk so low, does not even deserve reprimand."[4] Other critics agreed: A. J. du Pays ("offensive eccentricities"), Charles Clément ("beyond words"), Félix Jahyer ("this manner so contrary to art"), Ernest Chesneau ("an almost childish ignorance of the fundamentals of drawing . . . a prejudice in favor of inconceivable vulgarity"), Théophile Gautier *fils* ("The *Christ Mocked* beggars description"), Théophile Gautier *père* ("the artist seems to have taken pleasure in bringing together ignoble, low, and horrible types. . . . The technique recalls, without the verve, the most foolish sketches of Goya when he amused himself as a painter by throwing buckets of paint at his canvases").[5]

Manet admitted to Baudelaire that the flood of unfavorable comments disturbed him.[6] Twenty years later, Edmond Bazire summed up the situation as follows: "This Jesus, who truly suffers at the hands of the brutal soldiers, is a man instead of a god but was accepted as neither. . . . People were fanatical about prettiness, and would have liked to see appealing faces on all the figures, victim and executioners alike. There is and always will be a group of people who need to have nature embellished, and who will have nothing to do with art unless it is a lie. Such a point of view flourished at that time; the Empire had idealized tastes, and hated to see things as they are."[7]

Nevertheless, the spate of critical attention made Manet famous. According to Duret, "The outcry raised over the *Olympia* and the *Christ Mocked*, added to the noise generated earlier by *Le déjeuner sur l'herbe*, brought Manet a notoriety such as no painter before him had ever known. . . . Degas could say, without exaggerating, that Manet was as well known as Garibaldi. When he walked down the street, the passersby would turn to look at him."[8]

Thoré, too, attacked *Jesus Mocked by the Soldiers* in his review of the

Exhibitions
Salon 1865, no. 1427 (Jésus insulté par les soldats); Alma 1867, no. 6 (Jésus insulté par les soldats); Paris, Drouot 1884, no. 17 (withdrawn); New York, Durand-Ruel 1895, no. 9; Philadelphia-Chicago 1966–67, no. 71

Catalogues
D 1902, 57; M-N 1926 I, pp. 67–68; M-N cat. ms., 74; T 1931, 101; JW 1932, 113; T 1947, 105; PO 1967, 89A; RO 1970, 88A; RW 1975 I, 102

Fig. a. Engraving after Anthony van Dyck, *Ecce Homo*, as *The Crowning with Thorns* in Charles Blanc, *Histoire des peintres*

Fig. b. Engraving after Titian, *Christ Crowned with Thorns*, as *Le Christ au roseau* in Charles Blanc, *Histoire des peintres*

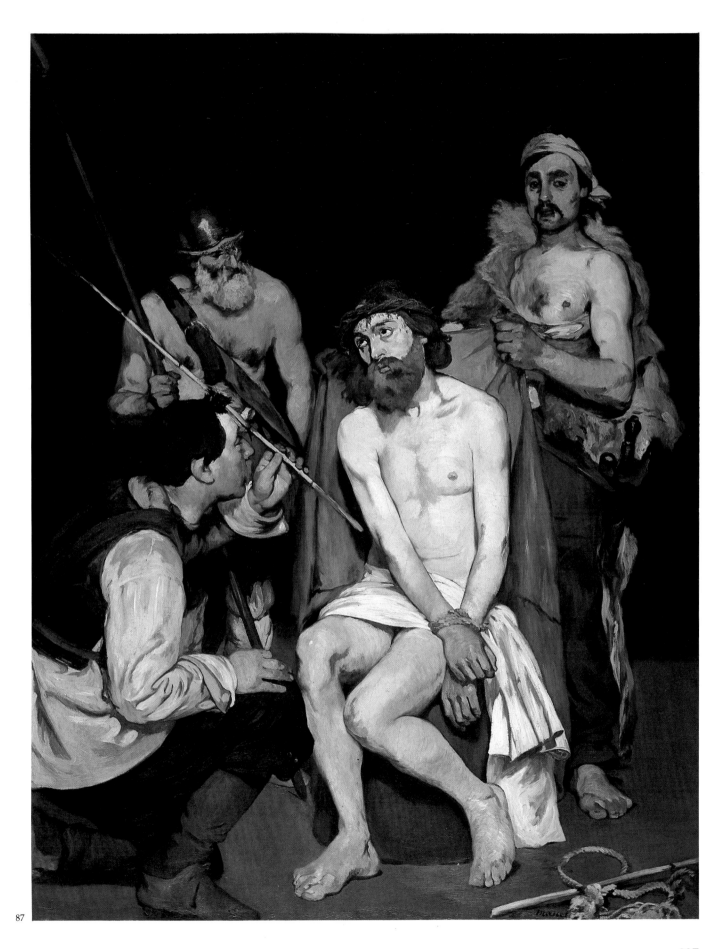

Salon of 1865, but he recognized the compositional source as van Dyck's *Christ Crowned with Thorns* (formerly Kaiser Friedrich Museum, Berlin; destroyed 1945).[9] Since then many authors have noted a possible connection between Manet's painting and Titian's *Christ Crowned with Thorns* (Musée du Louvre, Paris), but only in 1959 did Leiris examine the likelihood of another "equally prominent element in the genesis of Manet's painting," an engraving by Scheltema à Bolswert after van Dyck's *Christ Crowned with Thorns*.[10] While the source seems correct, Reff has suggested that Manet was probably not familiar with the Bolswert print but rather with a reproduction of van Dyck's similarly composed *Ecce Homo* (Museo del Prado, Madrid) in Charles Blanc's *Histoire des peintres* (fig. a).[11] Reff has noted that Blanc's *Histoire* may have provided Manet with information that influenced his decision to submit *Jesus Mocked by the Soldiers* in combination with *Olympia*; noting first that the composition of *Jesus Mocked by the Soldiers* is indebted to Titian's *Christ Crowned with Thorns* (fig. b), "which provided the composition and the central figure, even if . . . the other figures were reminiscent of a well-known composition by van Dyck," he points out, "Titian himself was supposed to have paired pictures of the same subjects [as Manet's Salon entries in 1865] in order to impress an important patron. In the chapter on him in Blanc's popular *Histoire des peintres*, it was reported that on being summoned by the Emperor Charles V, Titian brought 'a *Christ Crowned with Thorns* and a *Venus*, as if to flatter him in feelings of devotion and sensuality at the same time.' "[12] Although, as Reff indicates, the story has since been recognized as apocryphal, it was accepted during the nineteenth century and may have appealed to Manet.

Other sources and influences have also been suggested. For example, Tschudi cites a Venetian inspiration; Meier-Graefe stresses Spanish sources; Bazin detects an unspecified Spanish source; Jedlicka mentions Velázquez; Leiris believes that in addition to van Dyck's *Christ Crowned with Thorns*, Manet was influenced by Titian's *Christ Crowned with Thorns* in the Louvre and by Velázquez's *Adoration of the Magi* in the Prado; and Maxon draws attention to the "learned assimilation of the grandeurs of the middle period of Velázquez."[13] Hanson, after acknowledging Leiris's article, suggests that "Manet's composition is closer to a *Christ Mocked* in the Museum at Lille attributed to Terbrugghen, while the kneeling figures [*sic*] with the arrow appear to derive from Velázquez' *Adoration of the Magi* in the Prado, and the man holding the cloak from his *Forge of Vulcan* in the same museum."[14]

Unlike *The Dead Christ and the Angels*, *Jesus Mocked by the Soldiers* is a fairly accurate illustration of an episode described in the Bible: "Then the soldiers of the governor took Jesus into the common hall, and gathered unto him the whole band of soldiers. And they stripped him, and put on him a scarlet robe. And when they had platted a crown of thorns, they put it upon his head, and a reed in his right hand: and they bowed the knee before him, and mocked him, saying, 'Hail, King of the Jews.' And they spit upon him, and took the reed, and smote him on the head. And after that they had mocked him, they took the robe off from him."[15]

Nevertheless, as Hamilton has indicated, the work is disconcerting as an unresolved mélange of disparate props and stylistic elements: "The Italianate composition, the somber Spanish coloring, the theatrical properties, and the contemporary personages are parts which fail to coalesce into a whole convincing either as design or expression. A popular model, Janvier, posed for the central figure; the three attendant soldiers were commonplace contemporary types, dressed in a curious mixture of modern clothing and theatrical

1. Baudelaire, *Lettres à*, p. 210: from Hippolyte Lejosne, January 4, 1865.
2. Proust 1897, p. 172; Proust 1913, p. 47.
3. Duret 1902, p. 27.
4. Saint-Victor 1865, quoted in Moreau-Nélaton 1926, I, p. 69.
5. A. J. du Pays, in *L'Illustration*, May 13, 1865; Charles Clément, in *Journal des débats*, May 21, 1865; Félix Jahyer, in *Etudes sur les Beaux-Arts: Salon de 1865*, Paris, 1865, p. 23; Ernest Chesneau, in *Le Constitutionnel*, May 16, 1865; Théophile Gautier *fils*, in *Le Monde illustré*, May 16, 1865; Théophile Gautier in *Moniteur*, June 24, 1865: all quoted in Hamilton 1969, pp. 67, 70–74; Clément, Chesneau, Gautier, and Gautier *fils* are quoted in Tabarant 1947, pp. 106–7, 109.
6. Hamilton 1969, p. 34.
7. Bazire 1884, pp. 44–45.
8. Duret 1902, p. 34.
9. Bürger (Thoré) 1865; see Hamilton 1969, p. 78.
10. Leiris 1959, p. 199.
11. Reff 1970, p. 457.
12. Reff 1976, pp. 46–47.
13. Tschudi 1902, p. 19; Meier-Graefe 1912, p. 71; Bazin 1932, p. 155; Jedlicka 1941, pp. 86–87, 379; Leiris 1959, pp. 199–200; Maxon 1970, p. 75.
14. Hanson 1979, p. 109.
15. Matt. 27: 27–31.
16. Hamilton 1969, p. 66.
17. Hanson 1977, p. 110.
18. Manet et al.
19. Rouart and Wildenstein 1975, I, pp. 17–18.
20. Ibid., p. 27, no. 17, "Tableaux et études" (Le Christ insulté par les soldats).
21. Manet et al., "Copie faite pour Moreau-Nélaton . . . ," p. 102.
22. Manet sale, Paris, February 4–5, 1884, no. 17; Bodelsen 1968, p. 341.
23. Rouart and Wildenstein 1975, I, p. 102.
24. Tabarant 1947, p. 113.
25. Callen 1974, p. 171.
26. Hanson 1966, no. 71.
27. James Jackson Jarvis, *Art Thoughts*, Boston, 1879, p. 269.
28. Account books, Durand-Ruel, Paris; France Daguet, pers. comm., January 1983.

Provenance
In an inventory Manet compiled in 1872 of works for sale, he valued this picture at 15,000 Frs (only his estimates for *Olympia* [cat. 64], *Le déjeuner sur l'herbe* [cat. 62], and *The Execution of the Emperor Maximilian* [RW I 127] were higher).[19] The picture remained unsold during his lifetime, however, and in the studio inventory prepared after his death, its value was estimated at only 1,500 Frs.[20] In June 1883, Léon Leenhoff sent the picture to Bertaux, rue de Clichy, to be relined, presumably

to make it more salable.[21] But the picture was nevertheless withdrawn from the 1884 auction of the contents of Manet's studio.[22] According to Rouart and Wildenstein, the dealers BOUSSOD AND VALADON (see Provenance, cat. 27) acquired the work from Léon Leenhoff in 1893;[23] according to Tabarant, DURAND-RUEL (see Provenance, cat. 118) bought it directly from Manet's widow.[24] Stock books for Durand-Ruel, however, indicate that he bought a half-share in the picture from FAURE (see Provenance, cat. 10) on April 17, 1894,[25] and exhibited it in New York the following year. Hanson lists as its owner in 1899 the American connoisseur, art critic, and collector James Jackson Jarves,[26] but this is obviously erroneous since he died in 1888. A harsh critic of Manet's work, Jarves called the artist "the painter-in-chief of Ugliness," described *Olympia*'s flesh as "of the hue of green meat," and characterized *Jesus Mocked by the Soldiers* as "an exhibition of ribald ferocity, united to brutal coarseness of brush."[27] On October 23, 1911, Durand-Ruel sold the picture for $22,000 to JAMES DEERING (1859–1925) of Chicago,[28] heir to the Deering Harvester (later International Harvester) Company, whose lavish Miami estate, Vizcaya, was later adapted for use as a museum. *Jesus Mocked by the Soldiers* entered the collection of the Art Institute of Chicago as part of Deering's bequest in 1925 (inv. 25.703).

C.S.M.

costume. The soldier to the right of Christ wears trousers, an antique sword, and a fur jacket."[16] Janvier, who was also a locksmith (*serrurier*), was so immediately recognizable that the picture became known as "Christ au serrurier." As with other paintings of the 1860s, Manet seems to have wanted to underscore the painting as a work fabricated in the studio.

Hanson proposes that "Manet has attempted to make a universal image for all time, any time, all people and all places that has to do with human feelings on a level shared by saints and heroes with the most ordinary of men."[17] But the visual evidence does not support such a contention, nor do the goals of most of Manet's paintings of the 1860s suggest that Hanson's interpretation is a valid avenue of approach. *Jesus Mocked by the Soldiers* may be an attempt to bridge the ever-widening gap between religious subjects and subjects appropriate to modern life, but the painting seems to succeed as neither. Apparently, Manet recognized the problem, because he never again executed a religious subject. Even the sympathetic organizers of the 1884 memorial exhibition at the Ecole des Beaux-Arts found the painting discouraging; although both of Manet's large religious paintings were readily available for the show, they were among the five Salon pictures that were not included. A note by Bazire about *The Monk* (RW I 104) suggests that it was Antonin Proust who eliminated the religious works from the exhibition.[18]

88. *Study for* Jesus Mocked by the Soldiers

1864
Pen and brown ink, and brush and brown wash
over traces of pencil
10⅝ × 8¼" (26.9 × 21 cm)
Atelier stamp (lower center): E.M.
NY Museum of Fine Arts, Boston

Exhibitions
Berlin, Matthiesen 1928, no. 13; New York, Wildenstein 1948, no. 48

Catalogues
T 1931, 33 (watercolors); JW 1932, mentioned 113; T 1947, 581; L 1969, 199; RW 1975 II, 131

This work is a study for *Jesus Mocked by the Soldiers* (cat. 87), but it represents a relatively early stage in the development of the composition of the painting. Rouart and Wildenstein suggest that it is Manet's "first idea" for the picture,[1] which concurs with Leiris's analysis: "The only form in it with precise graphic consistency is the central figure of Christ. All other elements are merely suggested. The second compositional stage was the painting itself, in which Manet established the final group of figures by juxtaposing other independently studied models to the figure of Christ."[2]

As a drawing that illustrates a single step in the conception of a composition, it is typical of the progressive character of Manet's technique. There are, however, few such sketches for Manet's paintings, because he often developed the compositions of his pictures as part of the actual process of the painting. Pentimenti, X-ray photographs, and technical examination of many works show that the paintings underwent numerous changes and

88

adjustments. In short, Manet's painting technique integrates much of the trial-and-error experimentation that other artists often incorporate in their drawings. The *Study for Jesus Mocked by the Soldiers* is, therefore, exceedingly rare as a drawing that reveals the incipient phase of a major composition.

Provenance
In 1922, Glaser published this drawing[3] as in the collection of DR. GEORG SWARZENSKI (1876–1957), director of the Städelsches Kunstinstitut in Frankfurt-am-Main. In the late 1930s, Swarzenski fled Nazi Germany and went to live with his son, Dr. Hanns Swarzenski, of the Institute for Advanced Study in Princeton, New Jersey. From 1939, the elder Dr. Swarzenski was fellow for research in medieval art and in sculpture at the Museum of Fine Arts, Boston.[4] His son later joined him at the museum, first as research fellow in the department of paintings, and then as curator of the department of decorative arts and sculpture.[5] Following his father's death, HANNS SWARZENSKI inherited this drawing, which was acquired in 1968 by the Museum of Fine Arts (inv. 68.755) through the generosity of Mrs. Thomas B. Card, Charles C. Cunningham, Jr., and the Arthur Tracy Cabot Fund.

C.S.M.

1. Rouart and Wildenstein 1975, II, no. 131.
2. Leiris 1969, p. 31.
3. Glaser 1922, no. 5.
4. G. H. Edgell, "Preamble," in *Essays in Honor of Georg Swarzenski*, Chicago, 1951, p. 7.
5. P. T. Rathbone, "Hanns Swarzenski: The Curator-Connoisseur," in *Intuition und Kunstwissenschaft: Festschrift für Hanns Swarzenski . . .*, Berlin, 1973, pp. 11–12.

89. The Tragic Actor

1865–66
Oil on canvas
73¾ × 42½" (187.2 × 108.1 cm)
Signed (lower right): Manet
NY National Gallery of Art, Washington, D.C.

Exhibitions
Alma 1867, no. 18 (L'Acteur tragique); New York, Durand-Ruel 1895, no. 13; Washington 1982–83, no. 27

Catalogues
D 1902, 77; M-N 1926 I, pp. 76–77; M-N cat. ms., 87; T 1931, 103; JW 1932, 125; T 1947, 103; PO 1967, 90; RO 1970, 90; RW 1975 I, 106

In a letter of March 1866, Manet announced to Baudelaire: "I have sent two paintings to the exhibition; I plan to have photographs taken and to send you some. A portrait of Rouvière in the role of Hamlet, which I am calling the Tragic Actor to avoid the criticism of those who might not find it a good likeness—and a fifer of the Light Infantry Guard. . . . "[1] Both *The Tragic Actor* and *The Fifer* (cat. 93) were refused by the jury. Although neither was controversial, the jury's decision perhaps reflected the lingering hostility generated by the pictures that Manet had exhibited at the Salon the previous year, *Jesus Mocked by the Soldiers* (cat. 87) and the notorious *Olympia* (cat. 64). In addition, the members of the jury included Gérôme, Cabanel, Meissonier, Gleyre, and Baudry, none of whom were especially sympathetic to Manet's work.[2]

That spring, there were so many refusals that a demand was made for a Salon des Refusés, but the rejected artists were only permitted to show work in their own studios (see cat. 92). According to Tabarant, Manet exhibited *The Tragic Actor* and *The Fifer* at his studio on the rue Guyot, "but only for his friends."[3] One of the visitors to Manet's studio was Théophile Thoré, who subsequently mentioned *The Tragic Actor* in his review of the Salon of 1866: "I prefer Manet's wild sketches to those Herculean academic works [at the Salon]. And so I've been back to his studio, where I found a large portrait of a man in black, in the spirit of Velázquez's portraits, that the jury has turned down."[4]

Thoré's reference to Velázquez is particularly interesting because, as David Solkin notes, the *Portrait of Pablillos de Valladolid* (fig. a) is often cited as the source for *The Tragic Actor*.[5] Indeed, a passage in a letter from Manet to Fantin-Latour, written during Manet's trip to Spain in 1865, strongly suggests that possibility: "The most astonishing example in [Velázquez's] splendid oeuvre, and perhaps the most astonishing piece of painting ever done, is the painting listed in the catalogue as *Portrait of a Famous Actor in the Time of Philip IV.* The background vanishes, and atmosphere envelops the good man, a vital presence dressed in black."[6] However, Tabarant notes that Manet began the painting two months before he left for Spain.[7] Richardson, on the other hand, believes it was painted after Manet's return to Paris, asserting that "on stylistic grounds, this could not have been painted before Manet went to Spain."[8] Solkin acknowledges the influence of Velázquez in a general way, but not the portrait of Pablillos as the specific source; in addition, he notes: "The emphasis on Velázquez has apparently caused scholars to overlook another class of pictorial art that seems historically and iconographically much closer to Manet's composition than does any work by the Old Masters. The portrayal of actors in their roles has a long history in French art stretching back at least as far as the seventeenth century. Though such representations were by no means uncommon in the fine arts, it was in the realm of the popular print that they

enjoyed their greatest vogue. . . . Numerous engravings from pre-Revolutionary France show full-length actor figures, isolated in space, whose legs cast distinct shadows onto an otherwise undefined background."[9]

In any case, the rich orchestration of blacks, which seems to reflect Manet's admiration for Velázquez's portraits generally and perhaps also the lithographs illustrating *Hamlet* by Rouvière's friend Delacroix,[10] is particularly appropriate to the subject. Philibert Rouvière (1809–1865), a student of Baron Gros's who exhibited in the Salons between 1831 and 1837 and who established his reputation as an actor in the role of Hamlet in 1846–47, died a few months after Manet began his portrait. Solkin tells us that his style of acting was characterized by a masterly use of makeup and costume, which, in the case of Hamlet, was strongly influenced by Delacroix's interpretations. He was also noted for extremely emotional renditions of his roles, which some critics characterized as histrionic. It is clear, however, that he was a brilliant tragedian, one whose success depended largely on visual effects and gesture, perhaps influenced by his early training as a painter.

Rouvière's life ended sadly. After a string of successes in 1854–55, followed by a three-year contract with the Comédie Française and the award of a pension by the government, he had great difficulty finding work. As Baudelaire wrote in 1859 in an article about Rouvière, "There is a life that is troubled and twisted, like certain gnarled trees—the pomegranate, for example—tortured in their growth, yielding complex and savory fruit, whose proud and ruddy blossoms seem to tell a tale of sap that has not flowed for a long time."[11] In the early 1860s, he seems to have returned seriously to painting, because in addition to his alleged participation in the Salon des Refusés in 1863, he exhibited a *Self-Portrait as Hamlet* (present location unknown) in the Salon of 1864. He appeared on the stage for the last time in January 1865; poor health may have caused him to terminate his performances, because, according to Solkin, by the time Manet asked him to pose for the portrait, he "was already seriously ill, probably too ill in fact to endure the tedium of posing either frequently or for long periods in Manet's studio."[12]

Rouvière died October 19, 1865, before the picture had been completed. To finish it, Manet had Antonin Proust pose for the hands and Paul Roudier for the legs.[13] Very likely the pose, including the positions of the hands and feet, had already been established, but Rouvière's death probably affected the final appearance of the painting. With the sword at his feet and bathed in floodlight from above, which causes the bizarre wishbone-shaped shadow, Rouvière seems to be depicted in mid-performance; the precise moment of the play does not seem to be important. The painting is effective both as a portrait of Rouvière as a consummate professional in his greatest role and as a portrait of a tragic figure whose career and life were rapidly drawing to an end.[14]

Manet's assertion to Baudelaire that he used the title *The Tragic Actor* to avoid the issue of the painting as a likeness of Rouvière suggests that he hoped the image would succeed as a painting with a broader significance than a portrait of a specific individual. Indeed, the choice of title seems to have been influenced by motives similar to those that led him the following year to exhibit his painting of a dead bullfighter as *The Dead Man* (see cat. 73).

Fig. a. Velázquez, *Portrait of Pablillos de Valladolid*. Museo del Prado, Madrid

1. Baudelaire, *Lettres à*, pp. 238–39: from Manet, March 27, 1866.
2. Hamilton 1969, p. 82 n. 3.
3. Tabarant 1947, pp. 123–24.
4. Bürger (Thoré) 1870, p. 318.
5. Solkin 1975, p. 702.
6. Moreau-Nélaton 1926, I, p. 72.
7. Tabarant 1947, p. 127.
8. Richardson 1958, p. 27.
9. Solkin 1975, p. 705.
10. Ibid., p. 709.
11. Baudelaire 1976, p. 60.
12. Solkin 1965, pp. 707–8.
13. Proust 1913, p. 49.
14. Solkin 1975, p. 709.
15. Venturi 1939, II, p. 190.
16. Rouart and Wildenstein 1975, I, p. 17.
17. Meier-Graefe 1912, p. 310.
18. Boston, Foreign Exhibition, 1883.

Provenance
This picture was one of the group of twenty-four works acquired from the artist by DURAND-RUEL early in 1872 (see Provenance, cat. 118). The price was 1,000 Frs, according to the dealer;[15] 2,000 Frs, according to Manet.[16] According to Meier-Graefe, Durand-Ruel sold it shortly thereafter to Faure (see Provenance, cat. 10) for 1,500 Frs,[17] but there is no record of such a sale or of its repurchase by the dealer, who exhibited it in Boston in 1883.[18] Durand-Ruel's archives indicate that he sold it in 1898 to GEORGE VANDERBILT (1862–1914), the wealthy investor who built a huge estate near Asheville, North Carolina. Vanderbilt also bought *Repose: Portrait of Berthe Morisot* (cat. 121) in the same year. At his death, both pictures passed to his widow (née Edith Stuyvesant Dresser, later Mrs. Peter G. Gerry). EDITH STUYVESANT VANDERBILT GERRY bequeathed *The Tragic Actor* to the National Gallery of Art, Washington, D.C., in 1959 (inv. 1530).

C.S.M.

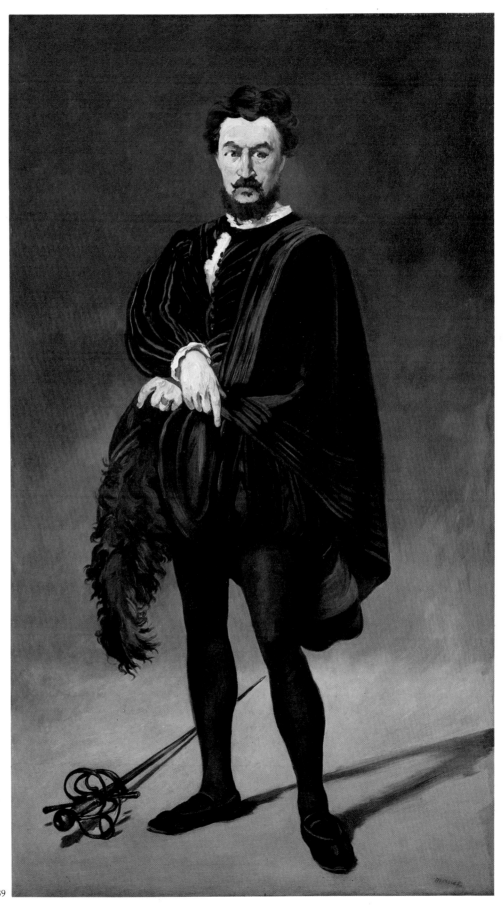

89

90. Philosopher

1865–67
Oil on canvas
73¾ × 42½" (187.3 × 108 cm)
Signed (lower left): Manet
The Art Institute of Chicago

When Manet wrote from Madrid in the summer of 1865 to his friend Fantin-Latour expressing enthusiasm for Velázquez, who "for himself alone is worth the journey," he mentioned among the works that impressed him most "the philosophers, astounding pieces!"[1] And on his return in the autumn, he started a series of works directly inspired by two Velázquez paintings he had seen at the Prado, *Aesop* and *Menippus*.[2]

Two in the series are very much alike—nearly the same dimensions, similar facial expressions and garments—and apparently were intended as pendants: the *Philosopher* shown here and the one known as *Philosopher with Cap* (RW I 100), hand extended as if for alms. A third painting, *The Ragpicker* (RW I 137; fig. a), dated 1869 by Rouart and Wildenstein, seems to belong to the same series,[3] though painted in a seemingly later style, more lightly and more in the manner of a sketch.

The visit to Madrid had confirmed Manet's already keen interest in subjects at once realistic and symbolic, exemplified in such works as *The Old Musician* (RW I 52), painted in 1862 and representing an artist in poverty, or the *Absinthe Drinker* (RW I 19). Our *Philosopher* clearly comes straight from the *Menippus* of Velázquez (fig. b); the figure has the same attitude, same mantle, same hat, same smile. But the Velázquez figure, with the attributes of learning and privation (book and pitcher), turns away slightly and bestows on us a glance of pre-Socratic irony. Manet gives us his philosopher full-face, more "cynical" in the modern sense of the word than his prototype, more jovial, his smile expressing as much self-satisfaction as humor. His countenance, as if under a spotlight, the only bright touch in the dark panel, shines in a context of aggressive poverty: his cape little more than an old blanket; his trousers hand-me-downs, too long and rolled up; the oyster shells in the litter suggesting garbage rather than relics of a feast.

In painting these impressive effigies of mendicant sages, Manet was in fact adapting the Spanish tradition to a contemporary theme dear to Baudelaire, who in "Le Vin des chiffonniers" displays a somber vision of such a character

au coeur du vieux faubourg	in the heart of the old *faubourg*
labyrinthe fangeux	the stinking labyrinth
où l'humanité grouille	where mankind swarms
en ferments orageux.[4]	in stormy ferment.

The beggar-philosopher was in fact a "type parisien" so familiar at mid-century that in the *Paris-Guide* published for the Exposition Universelle of 1867, Charles Yriarte—Goya specialist and friend of Manet's—discussed him at length, deploring his rapid disappearance because of Haussmann's transformation of Paris and elimination of the "cours des miracles": "The straight

Exhibitions
Alma 1867, no. 31 (Philosophe); Paris, Cercle de l'Union Artistique 1870; London, Durand-Ruel 1872, no. 15; Beaux-Arts 1884, no. 30; New York, National Academy of Design 1886, no. 244; New York, Durand-Ruel 1913, no. 5; [Philadelphia]-Chicago 1966–67, no. 73

Catalogues
D 1902, 65; M-N 1926 I, p. 76; M-N cat. ms., 83; T 1931, 104; JW 1932, 111; T 1947, 111; PO 1967, 95; RO 1970, 94; RW 1975 I, 99

Fig. a. *The Ragpicker*, 1869. Norton Simon Inc. Foundation, Pasadena, Calif.

Fig. b. Velázquez, *Menippus*. Museo del Prado, Madrid

234

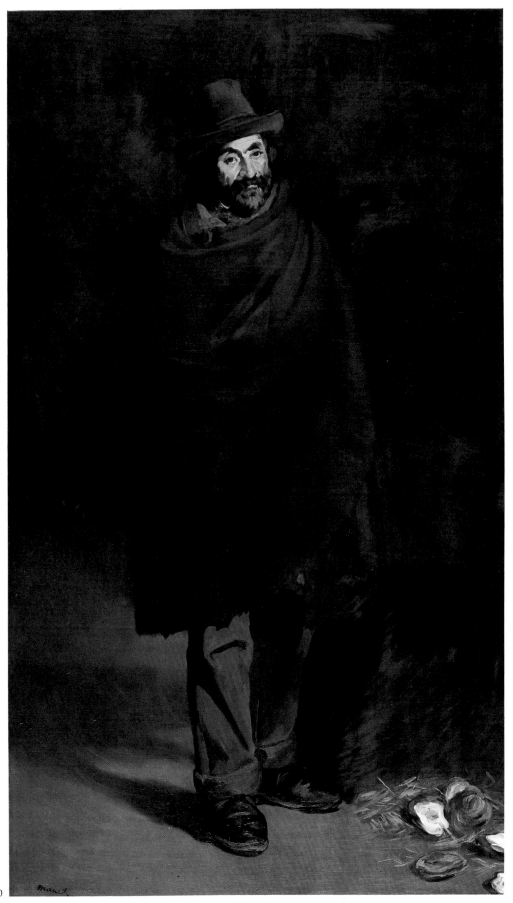

line is killing the picturesque, the unforeseen. . . . No more colorful rags, no more extravagant songs or extraordinary speeches . . . the strolling musicians, the philosopher-ragpickers . . . have departed . . . in the early morning hours, awaiting the arrival of the cabbages and watercress in the sheds of the markets, such a one would entertain the tradesmen with the finest verses of Virgil and Horace . . . where today shall we find an easygoing, benign constable to smile at these classic divagations we so admired in our youth?"[5] Manet here shows us an everyday sight, a reminiscence of an encounter, using a studio model and an evocation of Spain.

Tabarant believes that Manet's brother Eugène posed for the *Philosopher* but gives no source, relying no doubt on his conversations with Léon Leenhoff.[6] But the face rather resembles that of the professional model who had recently posed for *Jesus Mocked by the Soldiers* (see cat. 87).

Manet first showed this painting at his exhibition of 1867; and since Zola does not mention it in his article that appeared January 1, 1867, we may assume that the painting was then not yet finished. Randon's amusing caricature, showing the *Philosopher* drawing a dagger from his cloak (fig. c), suggests that the character must have seemed a bit sinister. Apparently this was not one of the most well received paintings at the show, except perhaps by Baudelaire's friend Hippolyte Babou, who seems to have considered it one of the best, while commenting that it was too clearly inspired by Velázquez.[7]

Three years later, when the painting was again shown at the Cercle de l'Union Artistique, the critic Duranty, one of the Café Guerbois regulars, dismissed it with a few icy words: "M. Manet showed a philosopher treading on oyster shells."[8] The same evening, Tabarant reports, "Manet entered the Guerbois, went straight up to Duranty and slapped his face."[9] A duel ensued. Manet, whose seconds were Zola and Vigneau, slightly wounded Duranty. The duel was followed by reconciliation and a growing friendship: "Manet behaved very well indeed, and I have the highest esteem for him."[10] It was perhaps the beggar's philosophical smile that presided at this tragicomic incident.

1. Moreau-Nélaton 1926, I, pp. 71–72.
2. López-Rey 1963, nos. 73, 38.
3. Hanson 1966, p. 95.
4. Baudelaire 1975, p. 106.
5. *Paris-Guide* 1867, II, pp. 929–32.
6. Tabarant 1931, p. 145; Tabarant 1947, p. 115.
7. Babou 1867, pp. 288–89.
8. Duranty, in *Paris Journal*, February 19, 1870, quoted in Tabarant 1947, p. 173.
9. Tabarant 1947, p. 115.
10. Duranty, quoted in Crouzet 1964, p. 292.
11. Venturi 1939, II, pp. 189–92.
12. Rouart and Wildenstein 1975, I, p. 17.
13. Callen 1974, pp. 169, 171.
14. Venturi 1939, II, p. 190.
15. Daniel C. Rich, *Exhibition of the Arthur Jerome Eddy Collection of Modern Paintings and Sculpture* (exhibition catalogue), The Art Institute of Chicago, Chicago, 1931.

Provenance
This was among the twenty-four paintings purchased from the artist by DURAND-RUEL in January 1872 (see Provenance, cat. 118). According to the latter, the price for *Philospher* was 1,000 Frs,[11] whereas according to Manet, it was one of four related paintings (RW I 19, 100, 137) that he called "philosophers" and sold for a total price of 6,000 Frs.[12] Durand-Ruel sold one of these separately (RW I 137) and the other three as a group to the singer FAURE (see Provenance, cat. 10) on November 10, 1882, for a total of 5,750 Frs. Since Faure frequently acted as a silent backer for Durand-Ruel, the modest price suggests that the dealer may have held a part interest in the works. In any event, during the following decade, the dealer reacquired all three, starting with the present picture, for which he paid 10,000 Frs in 1894.[13] Shortly thereafter, he sold it for 20,000

Frs[14] to ARTHUR JEROME EDDY (1859–1920), the Chicago lawyer who went on to assemble a landmark collection of late nineteenth- and early twentieth-century art and who was portrayed by Whistler (1894) and Rodin (1898). After viewing the Armory Show in New York in 1913, Eddy arranged for its exhibition at the Art Institute of Chicago. His numerous lectures, articles, and books contributed significantly to the introduction of modern art to the American public. Following the death of her husband, his collection went to MRS. EDDY and their son, JEROME O. EDDY, who gave it to the Art Institute of Chicago in 1931 (inv. 31.504).[15] The picture then joined another of Manet's "philosophers" (RW I 100), one that Durand-Ruel had sold directly to the Art Institute in 1912.

F.C.

PHILOSOPHE.
Malédiction ! tête et sang !! on se permet de manger des huîtres sans m'inviter !!!

Fig. c. Randon, caricature in *Le Journal amusant*, June 29, 1867

91. Bullfight

1865–66
Oil on canvas
35½ × 43¼″ (90 × 110 cm)
Signed (lower right): Manet
Musée d'Orsay (Galeries du Jeu de Paume), Paris

Exhibitions
Beaux-Arts 1884, no. 36; Exposition Universelle 1900, no. 441; London, Grafton 1905, no. 86; Berlin, Matthiesen 1928, no. 16; New York, Rosenberg 1946–47, no. 3

Catalogues
D 1902, 73; M-N 1926 I, p. 75; M-N cat. ms., 79; T 1931, 114; JW 1932, 120; T 1947, 120; PO 1967, 101; RO 1970, 100; RW 1975 I, 107

The bullfight is "one of the finest, strangest, and most fearful spectacles to be seen," wrote Manet to Baudelaire on September 14, 1865. "I hope when I return to put on canvas the brilliant, shimmering, and at once dramatic aspects of the *corrida* I attended."[1] A letter to Astruc dated September 17 states his intention to "put on canvas the whole animated scene—the colorful multitude, and then the drama—the *picador* and his horse thrown down, mauled by the great horns, and the crowd of *chulos* trying to turn the enraged animal."[2]

Manet's fascination with the bullfight had its inception much earlier; Antonin Proust tells us that one of the modern paintings on view at the Musée du Luxembourg most interesting to him was a bullfight scene by Dehodencq (fig. a). As we know, Manet had already done two paintings on the

91

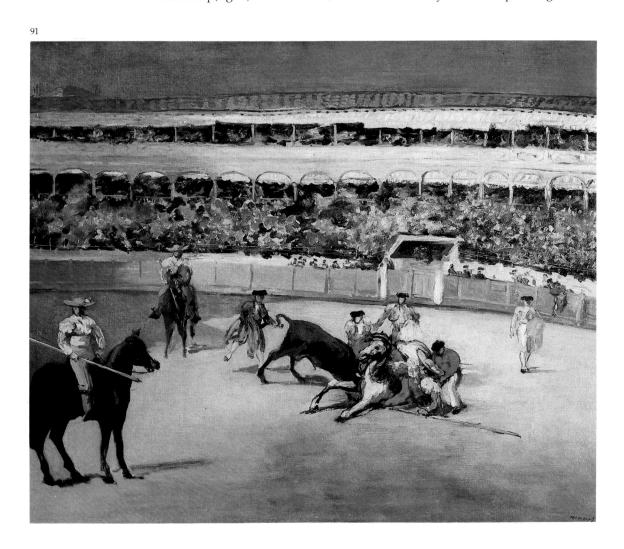

237

theme (cat. 33, 73). Very likely he painted this canvas in his Paris studio from sketches made on the spot and since lost (with the exception of a single watercolor, RW II 530). As often with Manet, personal experience merges with cultural heritage: the perspective places Manet within the arena, and the visual experience is overlaid with memories of Goya's bullfight prints. If there is a certain awkwardness and improvisational feeling in the staging of the dramatic action, the fact is that Manet went to Goya for the compositional components and proceeded to organize them in his own way. For example, X-ray examination shows that the small standing figure at the right was added later, painted over the barrier, filling what Manet perhaps felt was a gap. By contrast, the shimmering handling of the spectators creates a strong, bold effect of the crowd in sunlight.

This painting is the most important—at least in size—of a series of three. At the Art Institute of Chicago there is a canvas rather close to this one, but more rectilinear in composition and representing a later stage of the contest, since the horse that is here being attacked there lies dead, and the bull has been stuck with the *banderillas* (RW I 108). A small sketch (RW I 109) was probably done for the present painting; it shows a more restricted view of the scene, the bull pausing, about to charge.

Manet never once painted the dramatic climax of the *corrida*, the kill. He was concerned primarily with the spectacle and, in this canvas, besides the central melee of horse, bull, and *chulos*, with the figures of two mounted *picadores* at the left and a small bullfighter added at the right, facing us and frankly detached from the action. They were probably sketched from life at various points in time, and then put in somewhat randomly to furnish the composition. Despite the intention expressed in his letters not to neglect "the drama," there is nothing here "of blood, of sensuality, and of death," but only a cheerful travelogue. Clearly Manet was sensitive not so much to the drama of confrontation, loneliness, and peril as to a spectacle fascinating chiefly for the colorful, teeming crowd in the sun-drenched stands, appealing to the pictorial sentiments proper, rather than to the violent emotions, heroic and otherwise, ordinarily associated with a bullfight.

1. Baudelaire, *Lettres à*, p. 236: from Manet, September 14, 1865.
2. "Lettres d'Edouard Manet sur son voyage en Espagne," *Arts*, March 16, 1945.
3. Pertuiset sale, Paris, June 8, 1888, no. 2.

Provenance
Manet sold this picture directly to his patron and friend EUGENE PERTUISET, the subject of the celebrated *Lion Hunter* (cat. 208). At the Pertuiset sale in 1888,[3] the present work was knocked down for 1,200 Frs to DURAND-RUEL (see Provenance, cat. 118), who sold it, probably through PAUL CASSIRER (see Provenance, cat. 13), to the BARONNE DE GOLDSCHMIDT-ROTHSCHILD of Berlin, who still owned it in 1931, according to Tabarant. Late in the 1930s, the baronne fled Nazi Germany for France. The picture entered the Musées Nationaux in 1976, in lieu of payment of estate taxes, and with the aid of the Friends of the Louvre (inv. RF 1976–8).

F.C.

Fig. a. Alfred Dehodencq, *Bullfight in Madrid*, 1850. Musée des Beaux-Arts, Pau

239

92. A Matador *or* Matador Saluting

1866 or 1867
Oil on canvas
67⅜ × 44½″ (171.1 × 113 cm)
Signed (lower left): Manet

NY The Metropolitan Museum of Art, New York

In response to the furor that resulted from the selection of paintings included in the Salon of 1865 (cat. 64, 87), the jury adopted a more conservative approach the following year. According to Tabarant, "In particular, it was felt that the best way to avoid a repetition of the bewilderment of critics and public over an *Olympia* was to shut the door in the face of M. Manet, the fomenter of scandal, and it refused his *Fifer* [cat. 93] and *Tragic Actor* [cat. 89] without so much as looking at them."[1] One of the many other artists whose work was refused was an obscure painter, Jules Holtzappel, who subsequently committed suicide; the members of the Salon jury were labeled assassins, and there was a demand for a Salon des Refusés. The prefect of police declared that no such exhibition could take place, but that artists would be allowed to have small shows in their own studios, "under the express condition that they not open the doors too wide."[2] Tabarant claims, without documentation, that *A Matador* was one of the paintings Manet exhibited in his studio in the spring of 1866. However, Zola did not mention the painting in the article that appeared in the January 1867 issue of the *Revue du XIX^e siècle*, nor did Thoré in the discussion of his visit to Manet's studio that was included in his July 1866 review of the Salon. Zola's omission, particularly, leads one to speculate that the picture may have been executed early in 1867.

The first documented appearance of *A Matador* was at Manet's exhibition of his own work that he organized when he was excluded from the Exposition Universelle of 1867. The title he used in the catalogue, *Un matador de taureaux*, apparently disregards the advice of Théophile Gautier in *Voyage en Espagne*: "In Spain the word *matador* is hardly ever used to designate the one who kills the bull; he is called the *espada* . . . and they don't say *toreador* either, but rather *torero*."[3] Tabarant identifies the model as Manet's brother Eugène, and says the picture was painted in 1866 in the artist's studio on the rue Guyot.[4] Moreau-Nélaton, too, claims that Eugène posed, and he also asserts that the painting represents the bullfighter accepting the applause of the crowd following the death of the bull.[5] However, the auction catalogue for the Duret sale identifies the model as a member of a troupe of Spanish dancers who performed in Paris during the Exposition Universelle of 1867;[6] this information may be correct, because Duret bought *A Matador* directly from Manet in 1871 or 1872. Duret said later that the picture represents the moment the bullfighter asks permission to kill the bull.[7] Nevertheless, it may be significant that the gesture of the matador is similar to that of the figure at the left in *La posada* (RW I 110); the etching of the same subject (H 36; cat. 49, fig. b) indicates more clearly that the figure stands before a devotional altar or niche decorated with candles and religious objects, but it is impossible to know if there is a direct connection between *A Matador* and the figure in *La posada*.

Unlike earlier bullfight subjects, such as *Mlle V. . . in the Costume of an Espada* (cat. 33) and *The Dead Toreador* (cat. 73), *A Matador* was executed after Manet's trip to Spain in 1865, his only visit. Obviously it reflects his continu-

Exhibitions
Alma 1867, no. 16 (Un matador de taureaux); Beaux-Arts 1884, no. 34; New York, Durand-Ruel 1895, no. 24; Philadelphia 1933–34, without no.

Catalogues
D 1902, 78; M-N 1926 I, p. 76; M-N cat. ms., 78; T 1931, 113; JW 1932, 124; T 1947, 121; PO 1967, 102; RO 1970, 101; RW 1975 I, 111

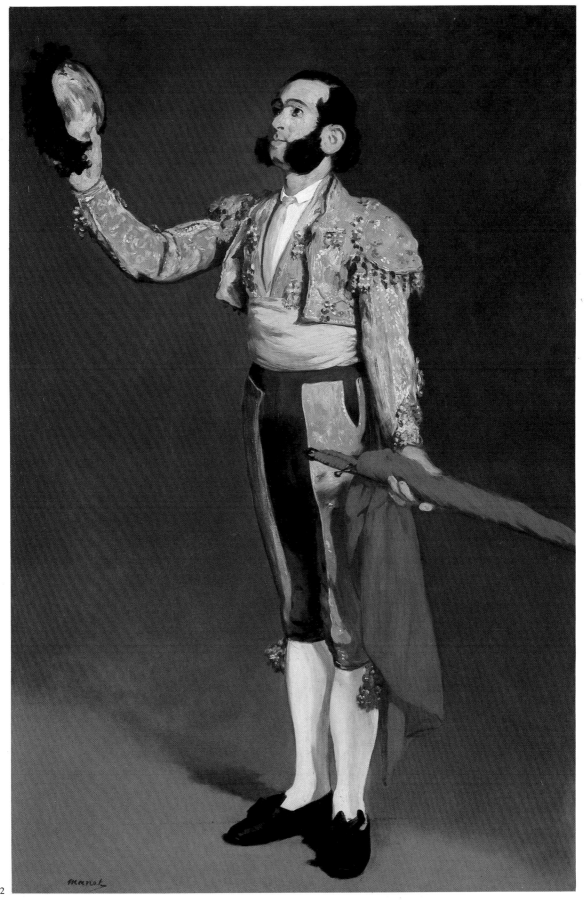

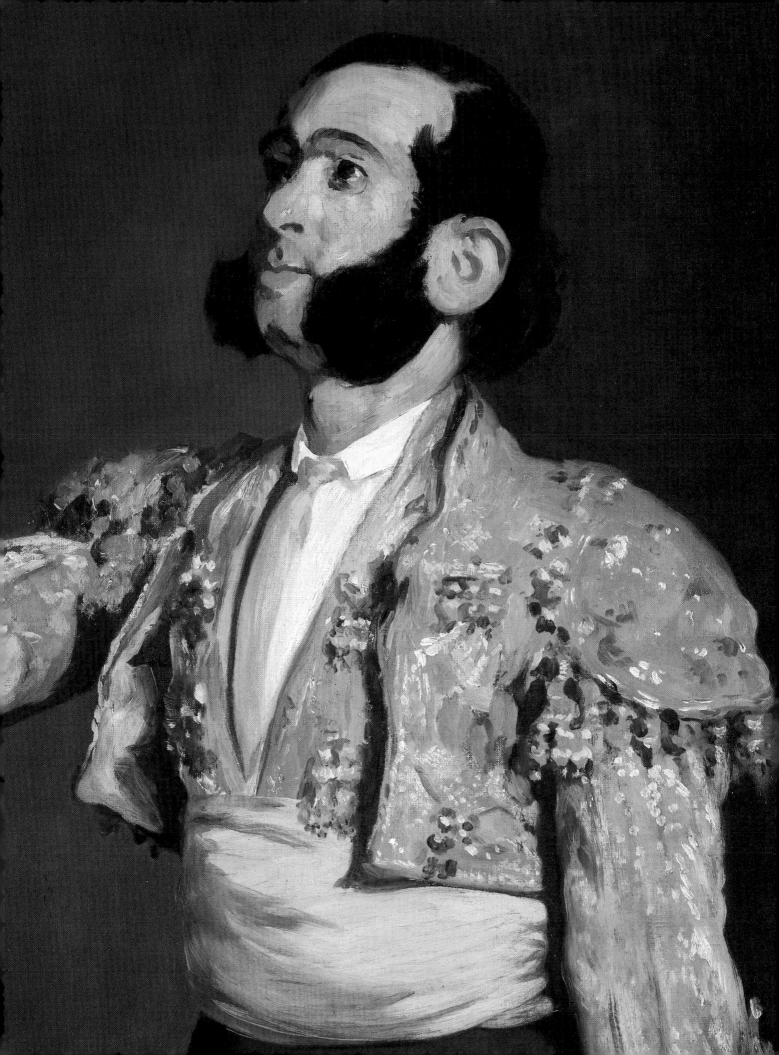

1. Tabarant 1947, p. 373.
2. Ibid., p. 366.
3. Gautier (1842) 1981, p. 105.
4. Tabarant 1930, p. 69; Tabarant 1932, pp. 152–54.
5. Moreau-Nélaton 1926, I, p. 76.
6. Duret sale, Paris, March 19, 1894, no. 20.
7. Duret 1902, p. 212.
8. Isaacson 1969, p. 9.
9. Zola 1867, L'Artiste, p. 52; Zola (Dentu), p. 25.
10. Tabarant 1947, p. 121.
11. Rey 1938, p. 21.
12. Duret sale, Paris, March 19, 1894.
13. Meier-Graefe 1912, p. 316.
14. Letter from Charles Durand-Ruel, January 6, 1959 (archives, department of European paintings, The Metropolitan Museum of Art, New York).
15. Havemeyer 1961, pp. 222–24.

ing admiration for seventeenth-century Spanish painting. As Isaacson has pointed out, fourteen of twenty-eight paintings made during 1865–66 reveal a renewed enthusiasm for Spain and its art, and twenty-eight of the fifty-three paintings and all of the etchings included in the independent exhibition in 1867 reflect a preoccupation with Spanish style and subjects that is typical of the early work.[8] The composition and the fluidity of the paint handling of *A Matador* are clearly indebted to Velázquez and Zurbarán, but the immediacy of the figure and the emphasis on the two-dimensionality of the paint on the picture plane are very different. Such works undoubtedly inspired Zola's description of "the first impression produced by a canvas by Manet": "At first the eye sees only broadly applied colors. Soon the objects define themselves and fall into place; after several seconds, it comes together, vigorous and solid, and one is delighted to contemplate this clear, sober painting, which renders nature with a gentle roughness, if I may so express myself."[9]

Provenance
Manet sold this work in 1870 to THEODORE DURET (see cat. 108) for 1,200 Frs, paid in installments the following year.[10] As Manet explained in a letter to Duret,[11] he would not normally have sold such an important work for less than 2,500 Frs, and he wished that Duret not let it be known he had paid less than 2,000 Frs. When Duret dispersed part of his large collection at auction in 1894,[12] the picture was acquired by DURAND-RUEL (see Provenance, cat. 118) for 10,500 Frs.[13] He sold it on December 31, 1898, to MR. AND MRS. H. O. HAVEMEYER (see Provenance, cat. 33).[14] In Mrs. Havemeyer's memoirs, she describes how she coveted the pic-

ture but hesitated in buying it, anxious that her husband would find it too large, until Mary Cassatt overcame these objections, saying, "Don't be foolish. . . . It is just the size Manet wanted it, and that ought to suffice for Mr. Havemeyer. . . ."[15] In fact, he was so pleased with the effect made by the painting, their first large Manet, in their private gallery that the next year he bought the artist's *Young Man in the Costume of a Majo* (cat. 72) as a companion for it. Both pictures came to the Metropolitan Museum as part of Mrs. Havemeyer's bequest in 1929 (inv. 29.100.52).

C.S.M.

93. The Fifer

1866
Oil on canvas
63 × 38½" (160 × 98 cm)
Signed (lower right): Manet
Musée d'Orsay (Galeries du Jeu de Paume), Paris

Exhibitions
Alma 1867, no. 11 (Le fifre); London, Durand-Ruel 1872, no. 106; Beaux-Arts 1884, no. 33; New York, National Academy of Design 1886, no. 22; Exposition Universelle 1889, no. 485; Orangerie 1932, no. 23; Orangerie 1952, without no.

Catalogues
D 1902, 76; M-N 1926 I, pp. 79–80; M-N cat. ms., 88; T 1931, 117; JW 1932, 126; T 1947, 117; PO 1967, 105; RO 1970, 104; RW 1975 I, 113

"I have sent two paintings to the exhibition; I plan to have photographs taken and to send you some. A portrait of Rouvière in the role of Hamlet [cat. 89] . . . and a fifer in the Light Infantry Guard—but they must be seen to be appreciated," wrote Manet to Baudelaire on March 27, 1866.[1]

The young model for *The Fifer* was a boy trooper in the Imperial Guard at the Pépinière barracks who had been introduced to Manet by his friend Commandant Lejosne. This was confirmed in a letter dated June 11, 1962, from Julie Rouart-Manet to Mrs. L. Harris.[2] Paul Jamot suggested that Victorine Meurent posed for the picture,[3] and indeed there is some resemblance in the expression, but none in the shape of the face or the size of the ear. On the other hand, it has also been thought that Léon Koëlla-Leenhoff was the model, again in garb borrowed through Commandant Lejosne.[4]

The identification matters little; the true model for *The Fifer* is to be found in the work of Velázquez. Manet had returned from his trip to Spain some months before beginning this canvas; a letter to Fantin-Latour from Madrid recorded his admiration for the Spanish master, whom he described as "alone worth the journey. . . . He is the painter *par excellence*. I was not merely surprised, I was overwhelmed. . . . The most astonishing example in this splendid oeuvre, and perhaps the most astonishing piece of painting ever done, is the painting listed in the catalogue as *Portrait of a Famous Actor in the Time of Philip IV*. The background vanishes, and atmosphere envelops the good man, a vital presence dressed in black."[5] Here we have a clear statement, coming for once from Manet himself rather than from a commentator, of what he was trying to do—specifically in *The Fifer* and *The Tragic Actor* (cat. 89), as well as later in most of his portraits of men, from *Duret* (cat. 108) to *Clemenceau* (cat. 186).

Like most of the Louvre canvases that have been studied by X-ray, this work was executed decisively, with little hesitation or revision, except for a slight enlargement of the ear, serving to emphasize the youthfulness of the figure. The painting has not been cleaned; the patina of age has deepened the fine modulation of the background gray, but it must have been drier and more contrasted originally, and the "playing card" look—flat like the imagery of Epinal—so harshly criticized at the time, must have been more obvious.

The painting was rejected by the jury of the 1866 Salon, which accepted works by such newcomers as Monet (*Camille*, Kunsthalle, Bremen) and Pissarro (*Banks of the Marne in Winter*, Art Institute of Chicago), and by Courbet (*Woman with a Parrot*, Metropolitan Museum of Art, New York), who was still controversial.

Of course this figure, with dark masses and lines emphasizing the cutout effect and the flatness of the picture plane, seemed more radical and overtly "modern" than the entries just mentioned. In common with the work of Monet and Pissarro, it shows a broad, simplifying hand, but the boldness of the flat image, of what had by then become a genre theme, treated without sentiment and purged of all superfluous detail, was a provocation to the jury—whose most influential members, it should be recalled, were Baudry, Cabanel, Gérôme, and Meissonier.

Critics who saw the work at the Alma exhibition in the spring of 1867 or at the artist's studio the previous year were hardly more indulgent—except for Zola, then twenty-six, who was brought to the studio by Guillemet and had already become associated with the Batignolles group through Cézanne and probably Duranty.[6] Zola's article in *L'Evénement* of May 7, 1866, took up the cudgels on behalf of Manet and his art: "The work I like best is certainly *The Fifer*, one of this year's Salon rejects. On a luminous gray background, the young musician stands forth, in undress uniform, red trousers with fatigue cap. He plays his instrument, full face and eyes front. I said before that M. Manet's talent lies in rightness and simplicity, and I was thinking especially of the impression this canvas left with me. I feel that no stronger effect could be achieved by any less complicated means. M. Manet is of a dry temperament, subsuming detail. He delineates his figures sharply, not shrinking from the abruptness of nature; he goes from black to white without hesitation, presenting objects in all their vigor, detached from each other. His whole being bids him see in patches, in simple elements charged with energy. One might say that all he wants is to find related values and

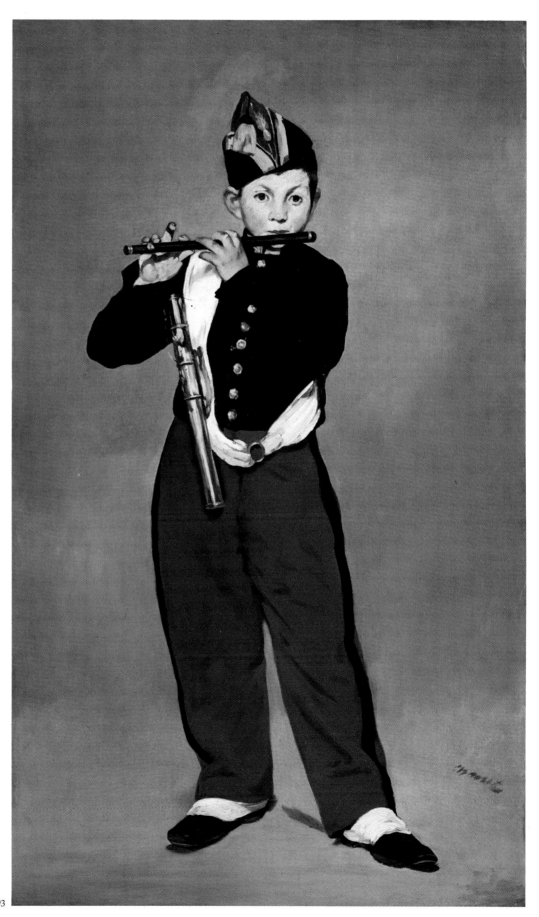

then juxtapose them on a canvas. As a result, the canvas is covered with strong, solid painting. In this picture I recognize a man who searches out the true, and from it draws a world alive with personal and potent life."[7]

It should be remembered that despite his *succès de scandale* of previous years, Manet had yet to sell anything; furthermore, the Salon's latest rebuff confirmed his exclusion from the circle of the elect, those who ranked as professionals able to live, materially and morally, by their painting. But if Zola's unorthodox opinion won him no clientele or academic support—quite the contrary—it was nevertheless a great encouragement to Manet. Baudelaire was already quite ill; but here was fresh aid and comfort. The same day, Manet wrote a few lines of acknowledgment: "Dear Monsieur Zola, . . . [I am] proud and happy to be championed by a man of your talent; what a fine article. A thousand thanks."[8] Months later, Zola again mentioned *The Fifer* in the course of his long essay on Manet: "One of our foremost modern landscape painters has called this work 'an outfitter's signboard,' and I agree—if he meant that the young musician's outfit was handled with a sign painter's simplicity: yellow braid, blue-black tunic, red trousers, all have become broad patches of color."[9]

What such public support may have meant at the time is better understood if we note that in 1884, after Manet's death, a softened official criticism on the occasion of the retrospective at the Ecole des Beaux-Arts concluded thus: "In 1866, a gray tone provided the background for several figures, in particular *The Fifer*, which for some years has been considered a definitive and classic type. It portrays a young musician, the drawing undistinguished but illuminated in lively colors, among which the red of the trousers speaks out boldly. He is applied on a ground of monochrome gray—nothing underfoot, no air, no perspective; the poor unfortunate is plastered to an invisible wall. The notion that there really is an atmosphere behind bodies and surrounding them never occurs to Manet; he remains true to the system of the cutout, to the forthright art of playing cards. *The Fifer*, an amusing instance of barbarian imagery, is like the Knave of Diamonds placarded to a door."[10]

The figure is in fact a latter-day icon, erect, unassuming, impressive, meeting the viewer's eye like a stained-glass saint, a Poulbot urchin painted like a Spanish grandee, and carrying the artist's colors and principles like a banner. Manet had never before been so radical in simplifying his technique, in abridgment. Depth is suggested only by the perfunctory little shadow behind the left foot and, perhaps, by the "extraordinary signature set in the depth of space."[11] Later figures, as in *Soap Bubbles* (cat. 102), will seem slightly *passé* after *The Fifer*.

Certainly the red-and-black pictorial image rather than the actual boy engaged Manet's attention; still, and here the painter's richness and subtlety are revealed, the subject is very important: not for itself—there is no sentimentality over the dressed-up child, as would be the case with a child by Bastien-Lepage—but as a familiar and commonplace figure assigned a new significance.

Contemporary critics as well as art historians today have seen here the influence of popular imagery, in particular that from Epinal.[12] Comparison with reproductions in books, which reduce a painting to the scale of a playing card or print, may be convincing as regards the color relationships and the "naive" presentation of the figure. But here, the format and the ennoblement of a popular theme speak louder than the analogy with color

prints. The idea of painting a boy in uniform may well have come to Manet through popular imagery. Zola's mention of the outfitter's signboard has a real counterpart in the life-size Epinal posters representing members of the military services in full array. (Their purpose is not known; were they carnival artifacts, barracks insignia?)[13] Their crude line and color may have prompted Manet to strike out against the recent condemnation of *Olympia* (cat. 64), which Courbet called a playing card.

The stylistic role of Japanese prints has also been invoked, beginning with Zola's lines, between which we can read Manet's own thoughts, and which may in fact have been suggested by him: "It has been said in mockery that Edouard Manet's canvases are reminiscent of Epinal prints, and there is much truth in the jest, as well as high praise: the methods are alike, with colors applied in plaques, except that the Epinal craftsmen use pure tones, paying no attention to values, whereas Manet multiplies his color tones and sets them in their proper relationships. It would be more to the point to compare this simplified painting with Japanese prints, which are similar in their strange elegance and splendid color areas."[14]

Indeed, the use of a large, flat area of black comes straight from Japanese prints, as do the black stripes at the trouser seams; they are authentic enough, but used methodically to emphasize the black outline, from top to toe, thus creating a work in which, more than in any other, Japan and Manet's Spain are merged. Manet's contribution is to combine a humble theme and a celebration of line and color with a head-on presence, an image having nothing to do with those from the past, like Watteau's *Gilles* (Musée du Louvre, Paris), but presaging the turn of the century.

After Gauguin and the Cloisonnists, who saw *The Fifer* at the Centennale of 1889, it especially impressed the Nabis and the Fauves-to-be when they saw it at Durand-Ruel's in 1894. Evenepoël, a pupil of Gustave Moreau's, as were Matisse and Marquet, and associated also with Bonnard and the *Revue blanche* painters, bears witness to this enthusiasm: "Among the forty canvases gathered there, some were altogether remarkable in idea, distinction of tone, and beauty of paint. Among the rest, there is a little military flutist, or rather fifer, that is a marvel, the work of a master, and would hold its own with the finest canvases in the Louvre. It is laid on with a truculence, a finesse of tone, a simplicity of treatment, a vigor that are difficult to conceive."[15]

1. Baudelaire, *Lettres à*, pp. 238–39: from Manet, March 27, 1866.
2. Letter from Julie Manet-Rouart to Mrs. L. Harris, June 11, 1962 (archives, department of European paintings, The Metropolitan Museum of Art, New York).
3. Jamot 1927, *La Revue de l'art* . . . , p. 34.
4. Tabarant 1947, p. 119.
5. Moreau-Nélaton 1926, I, p. 72.
6. Tabarant 1931, p. 179.
7. Zola 1959, p. 68.
8. See Appendix I, letter 1.
9. Zola 1867, *L'Artiste*, p. 59; Zola (Dentu), p. 37.
10. Mantz 1884.
11. Georgel 1975, p. 74.
12. Hanson 1977, p. 183; Welsh-Ovcharov 1981, p. 23.
13. Collections of the Musée Nationale des Arts et Traditions Populaires, Paris.
14. Zola 1867, *L'Artiste*, p. 52; Zola (Dentu), p. 24.
15. Henri Evenepoël, *Correspondance*, n.d., p. 21: to his father, May 1894.
16. Venturi 1939, II, p. 191; Callen 1974, p. 163.
17. Tabarant 1931, pp. 156–57.

Provenance
DURAND-RUEL paid 1,500 Frs for *The Fifer*, which was among the group of paintings he bought from Manet in 1872 (see Provenance, cat. 118). The picture subsequently belonged for twenty years to the singer FAURE (see Provenance, cat. 10), who purchased it for 2,000 Frs on November 11, 1873.[16] DURAND-RUEL bought it back from him in 1893 and sold it in January 1894 for 30,000 Frs to COMTE ISAAC DE CAMONDO (see Provenance, cat. 50).[17] The painting was included in Camondo's bequest to the Musée du Louvre in 1908, which entered the museum in 1911 and was exhibited in 1914 (inv. RF 1992). It is strongly significant that this collector of Japanese prints was attracted to a picture then considered one of Manet's most Japanizing works.

F.C.

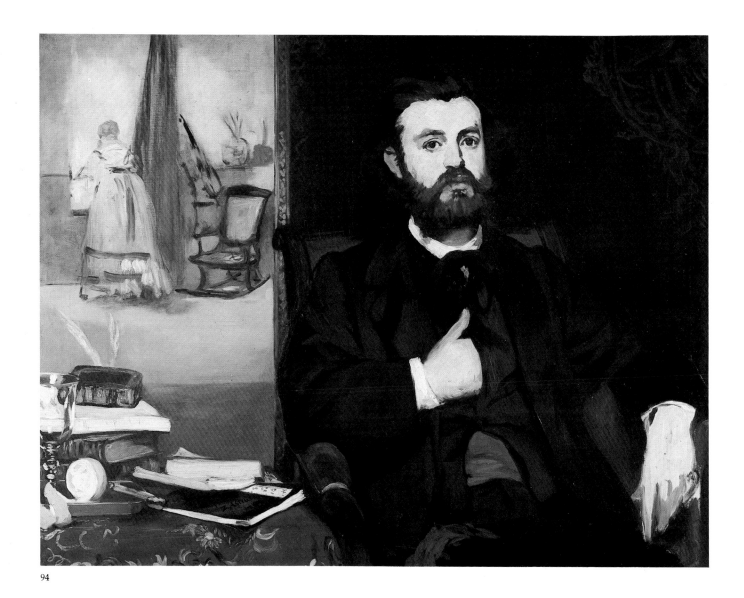

94

94. Portrait of Zacharie Astruc

1866
Oil on canvas
35½ × 45¾″ (90 × 116 cm)
Inscribed and signed on Japanese book (lower left): au poète
Z. Astruc/son ami/Manet 1866
Kunsthalle, Bremen

Zacharie Astruc (1835–1907) was an important figure in Manet's early life, witnessing and probably to some extent sharing in the realization of his artistic independence in the late 1850s and early 1860s. This portrait depicts an engaging person, and also records a stage in Manet's artistic development between the portrait of his parents (cat. 3), of which it is reminiscent in some respects, and the portrait of Emile Zola (cat. 106), compared to which it is like a rough draft, less finished perhaps, but warmer.

Exhibitions
Alma 1867, no. 43 (Portrait de Z. A.); New York, Durand-Ruel 1895, no. 6; London, Grafton 1905, no. 102; Berlin, Matthiesen 1928, no. 11

Catalogues
D 1902, 48; M-N 1926 I, fig. 71; M-N cat. ms., 72; T 1931, 71; JW 1932, 103; T 1947, 77; PO 1967, 70; RO 1970, 69; RW 1975 I, 92

Before his official recognition as a sculptor in the 1880s and 1890s (we owe to him, for example, the charming *Mask Peddler*, 1883, in the Luxembourg Gardens), and at the time of this portrait, Astruc was primarily a writer and critic, and only incidentally a painter. To him belongs the honor of having first championed Manet against the general hue and cry, as early as 1863, when Baudelaire remained silent. He had known Manet practically from the time he first settled in Paris, in 1854 or 1855, or by 1857 at the latest, when Manet made the acquaintance of Astruc's friend Fantin-Latour.[1]

By 1860, Astruc was one of Manet's intimates. He had been portrayed with Balleroy and Baudelaire in *Music in the Tuileries* (cat. 38); and in *A Studio in the Batignolles Quarter* of 1870 (Musée du Louvre, Paris), Fantin-Latour shows Astruc seated, turning toward Manet at the easel.[2] In the same year, Manet did another portrait of Astruc in *The Music Lesson* (RW I 152), in which he plays the guitar. They were to remain friends until Manet's death, although their association was less close after 1870, when their artistic interests and affiliations diverged; for Manet, Astruc would always be his defender of the 1860s, most involved in the conception of *Olympia* (see cat. 64), and perhaps his immediate intercessor with both Japan and Spain.

In the history of culture, there are not a few such supporting roles—minor artists or writers, of great charm and rare insight, of brilliant conversation, with many promising talents; history is disappointed in them, their best contribution being merged in the genius of others. Such, at any rate, was Astruc's part in Manet's career, and this portrait is a tribute to what he was and an acknowledgment of Manet's debt to him; perhaps the portrait is psychologically sound as well, in that the rather soft handsomeness of the face and the vague character of the hand might be thought to anticipate the verdict of posterity.

For a long time after the 1866 date was suggested by Moreau-Nélaton, this portrait was dated 1863–64, but Flescher has conclusively reinstated the 1866 dating, visible on the canvas itself, more plausible stylistically, and confirmed, if confirmation were required, by the published correspondence between Manet and Astruc.[3] The painting, then, was done in the rue Guyot studio following Manet's trip to Spain, which Astruc had so painstakingly planned.

Yet there are few allusions to Spain in this work. The principle of the composition is one of intense contrasts, heightened today in the right-hand section by the deepening of the bitumen color; the young critic's rather long locks are now hardly distinguishable. There is contrast between flesh and background, and most of all between the two halves of the painting—light on the left, dark on the right. This is a new move in Manet's work; it echoes the composition of *Olympia*,[4] but the source in both works would be the background of Titian's *Venus of Urbino* (see cat. 64, fig. a), which is similarly divided into two large areas.

Manet adopted both the draped curtain, here at the upper right, and the subject's attributes arranged on a table, stock properties of classical portraiture; for his first portrait of an author, Manet chose a stack of books with goose quills, in the tradition of the genre from the sixteenth century to Courbet's portrait of Baudelaire (Musée Fabre, Montpellier), which was well known to Manet, the poet having recently attempted to sell it to him.[5] An author was customarily shown doing something—reading, for example, or pen in hand. Here Astruc merely poses, hand in vest like Manet's father in the portrait of his parents, in fine bohemian attire, black velvet set off by a

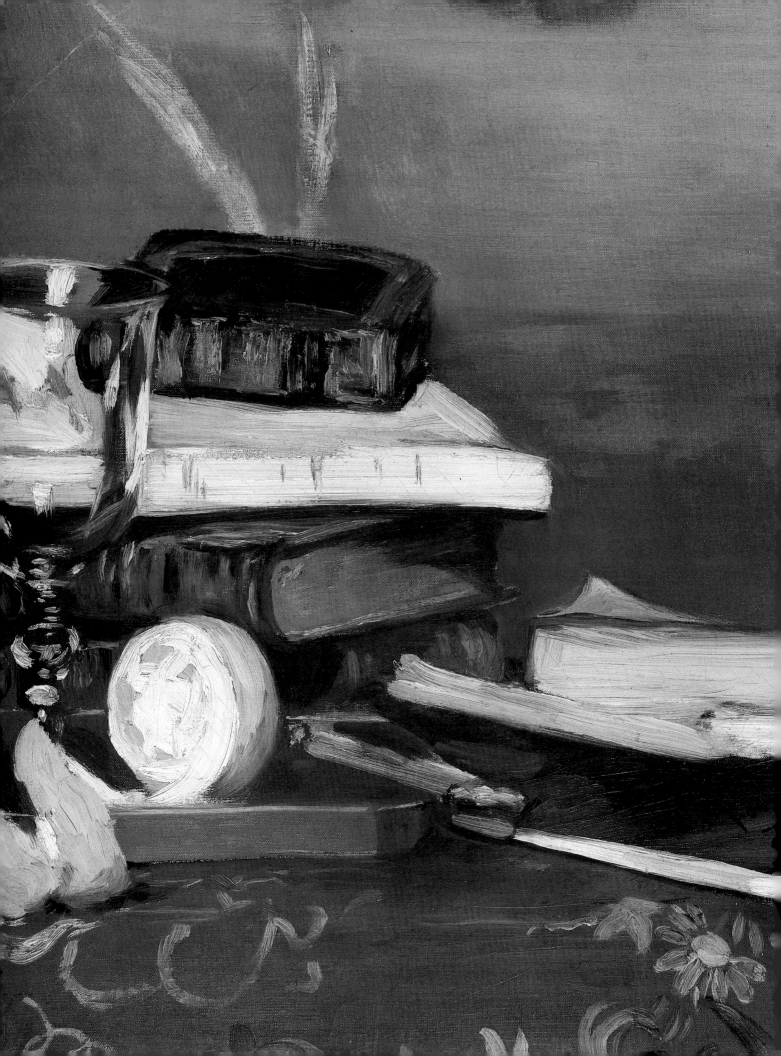

red sash. On the cloth of the table are arrayed sundry objects suggesting Astruc's interests and activities: old bound books, and contemporary works identifiable by the acid-green and yellow covers affected by publishers of the time; in the foreground, a Japanese volume records his predilection for that culture. The year before, Astruc had written a Japanesque play, *L'Ile de la demoiselle*, and he collected Japanese prints and illustrated books; hence the placement of the dedication "au poète Z. Astruc" on the Japanese album. Not one allusion, however, to Astruc's passionate enthusiasm for all things Spanish. As for the half-peeled lemon and the glass of water, these are an early instance of a Manet leitmotiv and a direct reference to Dutch still life, seemingly without special reference to Astruc.

The left-hand section of the picture holds more novelty, and more mystery too. Its composition is clear enough, and finds a source in Venetian painting. Art historians have seen it as a view into another room[6] or as a mirror,[7] but the most likely interpretation would construe it as a painting hanging behind or resting on the table. And in fact, Bazire, an intimate of Manet's, so interprets it in his description of the canvas at the time of the 1884 retrospective: "At left, a picture in full light."[8] The idea of an entranceway may be ruled out as unreasonable in relation to the table and the armchair, and the gilded frame might be that of a mirror but is surely not of a door. A mirror would be plausible enough, but it is inconceivable, at least as of that date, that Manet would have omitted the mirror images we ought to see— books, inkstand with quills behind the books, or himself painting Astruc.

Granted, then, that what we see at the left is a painting; what painting is it? Nothing of Manet's fits. Flescher surmises it to be a painting by Astruc himself, for he did paint numerous interiors with a woman at the window; however, they were watercolors, and apparently of later date. Furthermore, Manet expressly inscribed his canvas "to the poet" Z. Astruc, and it was painted when the subject's literary activity was in the ascendant. So why not simply posit a fictitious work, invented by Manet, very likely representing a back view of Astruc's blond wife (who was not to find the work to her liking; see Provenance), as well as the guitar Astruc was to be shown playing some years later when portrayed in *The Music Lesson*. Otherwise, the composition echoes the background of the *Venus of Urbino* in the woman's dress, in the pot on the windowsill, in the idea of an opening within an opening.

The originality of the work lies chiefly in its contrasts—of values, of composition, of technique. For as in *Le déjeuner sur l'herbe* (cat. 62), there is a great difference between the treatment of the center of interest—there, the threesome with still life; here, Astruc's face—and that of the rest of the composition. The contrast is further emphasized by proximity: the face is elaborated, "finished," while the hand, barely sketched in, appears to project forward, as if drawing attention to a provocative carelessness on the part of the artist. Paintings like this may explain the often expressed idea that Manet did not know how to paint hands. But in this, Manet of course meant to do what he did, and may have been encouraged in his sketchy treatment of secondary features by the manner of Hals and of Velázquez, so recently and so enthusiastically discovered in the Prado. Moreover, the hand protruding from the picture, if painted minutely, would have diverted attention from the open and amiable visage of "le bel Astruc": "My feeling for you, " Manet wrote him in a letter of 1868, "is a gauge of what yours must be for me."[9] One could not better define the meaning of a good portrait.

1. Flescher (1977) 1978, p. 95ff.
2. Druick and Hoog 1982, no. 73.
3. Flescher (1977) 1978, pp. 174–93.
4. Hopp 1968, pp. 33–39.
5. Baudelaire 1973, p. 236.
6. Hopp 1968, p. 35.
7. Tabarant 1931, p. 115; Mauner 1975, p. 153.
8. Manet et al., "Copie faite pour Moreau-Nélaton . . . ," p. 93, Bazire's notes.
9. "Lettres d'Edouard Manet sur son voyage en Espagne," *Arts*, March 16, 1945.
10. Zola 1867 (Dentu), p. 39, no. 1.
11. Tabarant 1931, p. 115; Flescher (1977) 1978, p. 174.
12. Rouart and Wildenstein 1975, I, p. 27, no. 12, "Tableaux et études."
13. Tabarant 1931, p. 115.
14. Meier-Graefe 1912, p. 314.

95. Moorish Lament

1866
Lithograph
Image: 7½ × 7¼" (19.5 × 18.5 cm); letters: 11⅝ × 9½" (29.5 × 24 cm)
Signed (lower left, below the guitar): Manet; lithographed title and letters
NY Nationalmuseum, Stockholm

Jaime Bosch was a Catalan composer and guitar player who settled in Paris in 1852.[1] He gave numerous concerts and performed in the private homes of a music-loving circle for which Manet seems to have organized his engagements.[2] He played, indeed, at Manet's home, perhaps accompanied at the piano by the artist's wife. In February 1865, Mme Paul Meurice wrote to Baudelaire, who was then in Belgium, giving a lively account of a musical evening at the Manets, where "Mme Manet played like an angel, M. Bosch scratched his guitar like a treasure, Cherubini-Astruc sang, [and] the Com-

Publications
J. Bosch 1866

Exhibitions
Philadelphia-Chicago 1966–67, no. 48; Ann Arbor 1969, no. 20a; Santa Barbara 1977, no. 9; Ingelheim 1977, no. 38; Paris, Berès 1978, no. 74

Catalogues
M-N 1906, 78; G 1944, 70; H 1970, 29; LM 1971, 69; W 1977, 38; W 1978, 74

11 (2nd state, detail)

95 (detail)

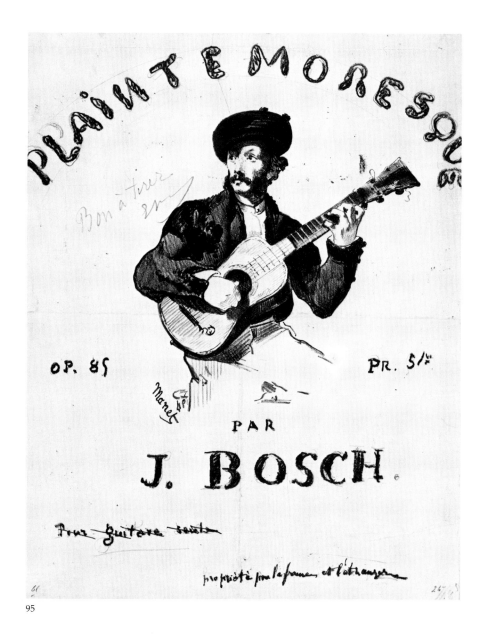

95

Fig. a. "Plainte moresque" ("Moorish Lament")
by J. Bosch, sheet music for a guitar piece "Dédiée
á son ami E. Manet" (detail)

mandante Thérèse [Lejosne] also sang."[3] Commandant Lejosne also referred to "a little musical evening" at the Manet home during this period,[4] and Mme Meurice, in relating to Baudelaire how much his friends in Paris missed him and how "Manet, discouraged, is destroying his best studies," informed him that "we make music every fortnight, at my home," adding that "it has to be *Haydn* for Manet."[5]

Sensitive, a prey to doubt and anguish, as shown in letters to and from Baudelaire,[6] Manet no doubt found consolation in music, whether that performed by his wife and Mme Meurice, the light music of Astruc (see cat. 53), or the more serious pieces of Bosch, whose version of this *Moorish Lament*, "composée pour Guitar seule," is "dédiée à son ami E. Manet," as indicated on the page with the printed music (fig. a).

The preparatory drawing (RW II 457) shows an initial layout for the lettering, with the dedication as part of the cover design.[7] The dedication, and the indication "Pour guitare seule," which is crossed out on this litho-

253

graphic proof, were finally both placed inside the folded sheet; the lettering, lithographed by Lemercier according to Manet's design, is more harmoniously disposed around the figure than on the cover of *Lola de Valence* (cat. 53). The figure of the guitarist Bosch, lightly indicated with brush and wash in the drawing (and no doubt based on a quick sketch made during one of the musical evenings), was firmly drawn with lithographic crayon on the stone and has a marvelously energetic quality, particularly in the proof of the first state. Manet has captured his friend in a characteristic attitude, "scratching his guitar" in expert fashion, with an alert but slightly romantic expression appropriate to the music.

This ephemeral piece of music, registered at the Dépôt Légal on September 15, 1866, is known from only four impressions besides this "state," hitherto presumed unique.[8] One of the four, the Dépôt Légal proof without the music, recently came to light in the Département de la Musique at the Bibliothèque Nationale,[9] enabling the print, previously catalogued together with *Lola de Valence*, in 1863, to be correctly dated.

1st state (of 2). Before the lithographed letters, added here by the artist in lithographic crayon over pencil; inscribed in pencil at upper left over the guitarist's shoulder "Bon à tirer, EM." One of two known proofs, on wove paper. Burty, Degas, Schotte collections.

Provenance
This proof, which belonged to BURTY (see Provenance, cat. 42), was acquired at his sale by MANZI (see Provenance, cat. 19),[10] and passed to DEGAS (see Provenance, cat. 15). Sold for 110 Frs at his auction in 1918,[11] it went to the Swedish collector SCHOTTE (see Provenance, cat. 15) and finally to the Nationalmuseum (inv. 324.1924).

J.W.B.

1. D. Prat, *Diccionario Biográfico, Bibliográfico, Histórico, Crítico de Guitarras . . .* , Buenos Aires, 1934.
2. Paris, Bibliothèque d'Art et d'Archéologie: letters from Manet to various people.
3. Baudelaire, *Lettres à,* p. 266: from Mme Paul Meurice, [February] 1865.
4. Ibid., p. 212: from Lejosne, January 22, 1865.
5. Ibid., p. 263: from Mme Meurice, [January?] 1865.
6. Ibid., pp. 232–34: from Manet, 1865; Baudelaire 1973, II, pp. 496–97: to Manet, May 11, 1865, pp. 500–501: to Mme Meurice, May 24, 1865.
7. Lochard photograph no. 185, Paris, BN Estampes (Dc 300g, VII); Bazire 1884, p. 73 (repr.).
8. Paris, BN Estampes (A72950); Paul Prouté S. A., *Signac* (exhibition catalogue), Paris, 1983, no. 170 (repr.).
9. Wilson 1978, no. 74, 2nd state.
10. Burty sale, Paris, March 4–5, 1891, lot 247, no. 51.
11. Degas collection, second sale, Paris, November 6–7, 1918, lot 270.

96. Young Lady in 1866 (Woman with a Parrot)

1866
Oil on canvas
72⅞ × 50⅝" (185.1 × 128.6 cm)
Signed (lower left): Manet
The Metropolitan Museum of Art, New York

Zola's first article about Manet appeared in *L'Evénement* on May 7, 1866. A revised and expanded version was published in the January 1, 1867, edition of the *Revue du XIX^e siècle*. Referring to *Young Lady in 1866* as *The Woman in Pink*, Zola described it as one of four recently finished works: "The paint is hardly dry on four other canvases: *The Smoker* [RW I 112], *The Guitar Player* [RW I 122], *Portrait of a Lady* [RW I 62], and *The Woman in Pink*. The portrait is one of the best things the artist has done, and I must repeat what I said before: great simplicity and correctness, and a delicate, clear look. In conclusion, I find that *The Woman in Pink* succinctly characterizes the innate stylishness of Edouard Manet. A young woman, wearing a long pink peignoir, stands with her head gracefully tilted to one side as she breathes in the scent of a bunch of violets that she holds in her right hand. To her left, a parrot leans forward from his perch. The peignoir is exceedingly elegant, pleasant to look at, very ample and sumptuous; the young woman's gesture is unutterably charming. It might be too pretty, if the artist had not tempered it with his characteristic spareness."[1]

Zola's article had been written in defense of Manet's work after *The*

Exhibitions
Alma 1867, no. 15 (Jeune dame en 1866); Salon 1868, no. 1659 (Une jeune femme); London, Durand-Ruel 1872, no. 49; New York, National Academy of Design 1883, no. 182; Beaux-Arts 1884, no. 39 (not exhibited?)

Catalogues
D 1902, 88; M-N 1926 I, p. 88; M-N cat. ms., 89; T 1931, 111; JW 1932, 132; T 1947, 115; PO 1967, 103; RO 1970, 102; RW 1975 I, 115

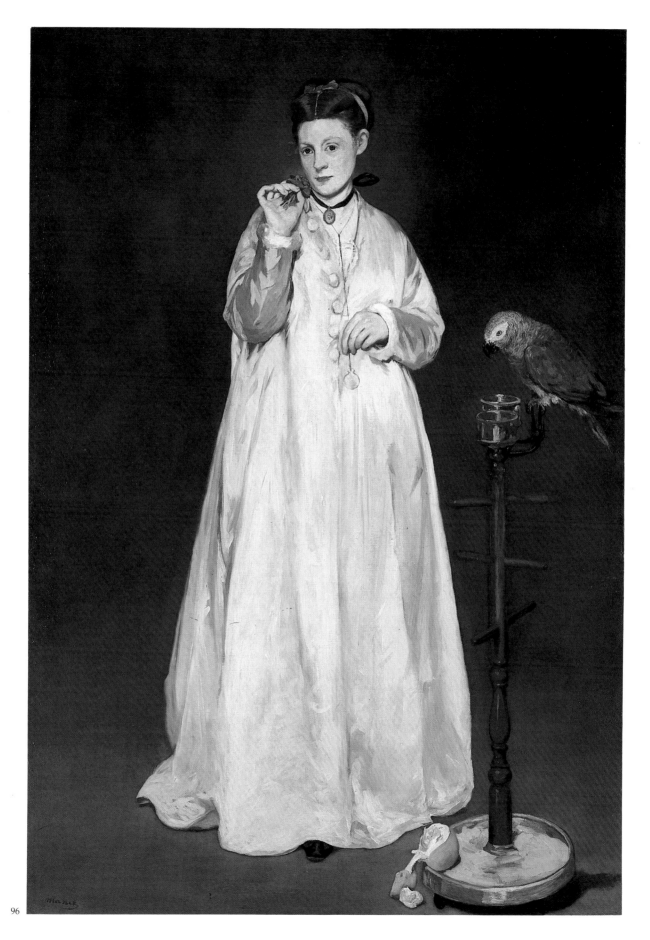

Tragic Actor (cat. 89) and *The Fifer* (cat. 93) were rejected by the jury for the Salon of 1866. For two months during the spring of 1866 Manet exhibited the rejected works for friends in his studio.[2] They were shown together with *The Guitar Player* (RW I 122), the bullfight pictures (RW I 107, 108), *A Matador* (cat. 92), and *Woman with a Parrot*. Thoré visited the studio and commented on the last named in his review of the Salon of 1866: "There was . . . a study of a young girl in a pink gown, which will probably be refused at the next Salon. Those pink tones against the gray background would challenge the subtlest colorists. It is true that it is a sketch, but so is Watteau's *Isle of Cythera* in the Louvre. Watteau could have perfected his sketch, but Manet is still struggling with this great pictorial problem: finishing certain parts of a painting in order to give greater strength to the whole. But one can see that Manet will eventually win the day, as have all the others who have been the victims of the Salon."[3]

Fig. a. Gustave Courbet, *Woman with a Parrot*, 1866. The Metropolitan Museum of Art, New York

Thoré's prediction that *Woman with a Parrot* would be refused for the Salon of 1867 was not entirely erroneous. Manet chose not to exhibit at the Salon that year, but he expected to be invited to show his work at the Exposition Universelle of 1867. When his name did not appear on the published list of artists selected, he retaliated, as had Courbet in 1855, by planning an exhibition of fifty of his own works. Manet erected a viewing space on the avenue de l'Alma, near the official exhibition. *Woman with a Parrot* was included, but the painting did not elicit any serious critical attention until, together with *Portrait of Emile Zola* (cat. 106), it was exhibited at the Salon of 1868.

In the reviews of the Salon, the picture was generally savaged. The critics paid particular attention to Manet's treatment of the face and head. Marius Chaumelin declaimed: "Manet, who should not have forgotten the panic caused several years ago by the black cat in the painting Ophelia [*sic*], has borrowed the parrot from his friend Courbet and placed it on a perch next to a young woman in a pink peignoir. These realists are capable of anything! It is too bad that this parrot is not stuffed as in the portraits of Cabanel, and that the pink peignoir is rather strong in color. The accessories even prevent one from looking at the face, but that's no loss. . . ."[4] Théophile Gautier, after describing the picture as "a graceful subject and one on which you should look with pleasure," wrote: "It is said that this young woman was painted from a model whose head is delicate, graceful, and lively, and adorned with the richest Venetian tresses that a colorist could desire. . . . The head that he gives us is perfectly ugly."[5] Paul Mantz similarly complained, "I suppose it was Manet's intention to create an orchestrated dialogue, a kind of duet, between the young woman's pink gown and the rosy hues of her face. He failed completely, because he does not know how to paint flesh."[6] Even Thoré, one of Manet's earliest advocates, objected to the way Manet painted the head when he mentioned *Woman with a Parrot* in his review of the Salon of 1868: "One hardly notices the head, even though it is seen full face and in the same light as the pink fabric; it is lost in the modulations of the coloring."[7] In short, most critics felt that, despite some well-executed passages in many of his paintings, Manet's technique was deficient and his compositions lacked focus. Indeed, Thoré quipped, "Manet sees color and light, and then he doesn't worry about the rest."[8] And Gautier inveighed, "When in a painting there is neither composition, nor drama, nor poetry, its execution must be perfect, and this is not the case."[9]

Technical and stylistic questions were so overwhelming that most critics paid no attention to the subject. Recently, both John Connolly and George

1. Zola 1867, *L'Artiste*, p. 59; Zola (Dentu), pp. 37–38.
2. Tabarant 1947, p. 124.
3. Bürger (Thoré) 1870, II, p. 318.
4. Chaumelin 1868, quoted in Tabarant 1947, p. 149.
5. Gautier 1868, quoted in Tabarant 1931, p. 150.
6. Mantz, quoted in Tabarant 1931, p. 150.
7. Bürger (Thoré) 1870, II, pp. 532–33.
8. Ibid., p. 531.
9. Gautier 1868, quoted in Tabarant 1931, p. 150.

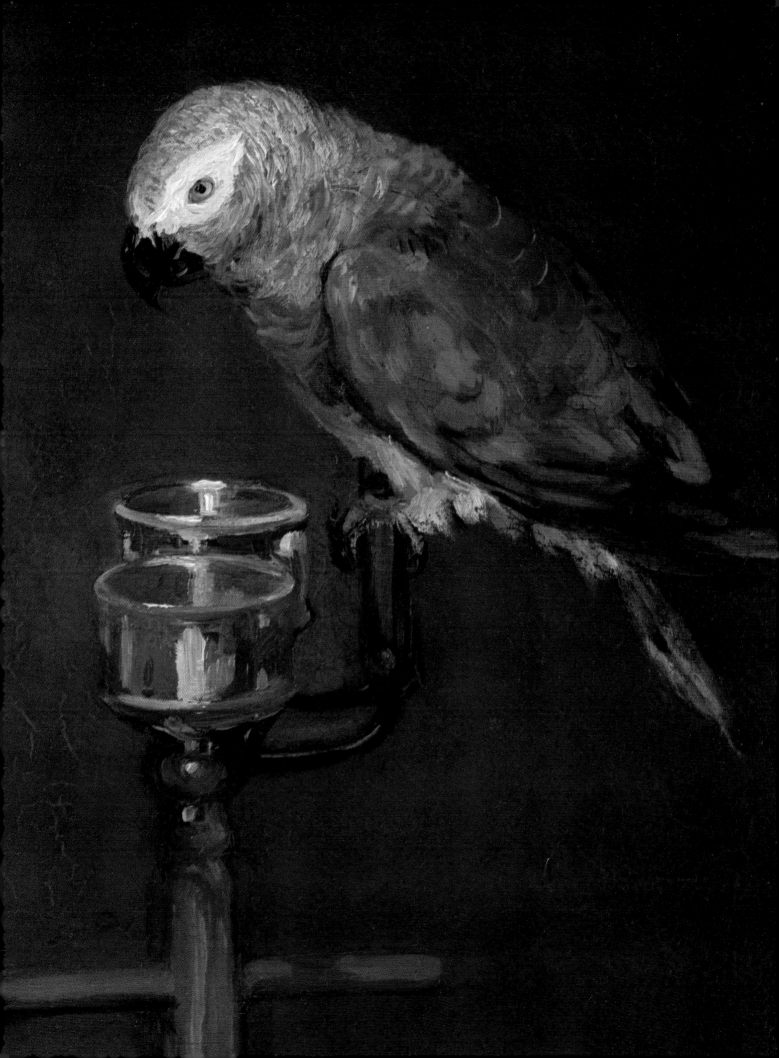

Mauner have suggested that the painting is an allegory of the five senses,[10] but Mona Hadler has offered the most plausible explanation: "One can speculate that Victorine's monocle is actually a man's monocle. Accordingly, the flowers could also be a gift from a man as they were in the *Olympia* . . . we are provided with the ambience and the clues to the romantic nature of the shared secrets behind the knowing stare of Victorine and her gray confidant. In accordance with the traditional iconography Victorine's parrot is her intimate companion, sees her in the process of dressing, and appears to share the secrets of her personal life."[11]

Hadler may also have discovered the generic source for *Woman with a Parrot* in having observed that a painting of the same subject by the seventeenth-century Dutch painter Frans van Mieris was illustrated in Charles Blanc's *Histoire des peintres*, "a book consulted frequently by Manet in the 1860s" (see cat. 6, 12),[12] but compositionally the painting seems to have no direct precedents. However, as Hamilton has observed, it was very probably perceived as Manet's reply to Courbet's *Woman with a Parrot* (fig. a), which was shown at the Salon of 1866 and interpreted in some circles as an answer to the challenge presented by Manet's *Olympia*, exhibited at the Salon of 1865 (cat. 64). Hamilton further points out: "That the problem was rather one of discovering subjects in modern life, and a treatment appropriate to them, went unobserved."[13]

10. Connolly 1972; Mauner 1975, p. 136.
11. Hadler 1973, p. 122.
12. Ibid., p. 118.
13. Hamilton 1969, p. 115.
14. Meier-Graefe 1912, p. 312.
15. Venturi 1939, II, p. 190.
16. Hoschedé sale, Paris, June 5–6, 1878.
17. Weitzenhoffer 1981, p. 127.

Provenance
DURAND-RUEL paid 1,500 Frs for this painting, which was one of the group he acquired directly from the artist early in 1872 (see Provenance, cat. 118). He then sold it to ERNEST HOSCHEDE (see Provenance, cat. 32) for either 2,000[14] or 2,500 Frs.[15] At Hoschedé's bankruptcy sale in Paris in June 1878, it sold for only 700 Frs to ALBERT HECHT (see Provenance, cat. 102).[16] Hecht sold the picture back to DURAND-RUEL, from whom it was acquired in 1881 by J. Alden Weir, acting as agent for the American collector ERWIN DAVIS (see Provenance, cat. 14). The picture was bought in for $1,350 at the auction Davis staged in New York on March 19–20, 1889,[17] and he donated it later that year to the Metropolitan Museum (inv. 89.21.3) along with Manet's *Boy with a Sword* (cat. 14). These were the first two works by Manet to enter a public collection in the United States.

C.S.M.

97. Reading

1865–73?
Oil on canvas
24 × 29¼" (61 × 74 cm)
Signed (lower right): Manet
Musée d'Orsay (Galeries du Jeu de Paume), Paris

This painting, identified in the 1883 posthumous inventory as "Portrait de Mme Manet et de M. Léon Koella,"[1] has been dated 1868,[2] but that dating is problematic. Suzanne Manet (born 1830) looks quite young compared to Léon (born 1852), who is obviously older than in *The Luncheon in the Studio* of 1868 (cat. 109). The intention was not to keep up the appearance, long encouraged by the Manet family, that Suzanne and Léon were sister and brother and not, as they were in fact, mother and son (see also cat. 12). Almost certainly, the explanation is that the work was executed at two different times.

There are many stylistic indications that the painting was originally done in 1865 and portrayed Suzanne Manet alone, at the age of about thirty-five, so that it might well be the canvas mentioned by Philippe Burty in 1866 and otherwise not identified: "Excellent study of a young woman in white muslin."[3]

Contrary to conventional portraiture, with the face lighted as by a searchlight, Manet finely modeled his wife's face *à contre-jour*. His manifest affection for the model inspired an unusual arrangement in this work, a

Exhibitions
Bordeaux 1866?; Paris, La Vie Moderne 1880, no. 10 (La Lecture); Beaux-Arts 1884, no. 46; Orangerie 1932, no. 34; Venice, Biennale 1934, no. 6; Orangerie 1952, without no.; London, Tate Gallery 1954, no. 9; Marseilles 1961, no. 12

Catalogues
D 1902, 97; M-N 1926 I, p. 109; M-N cat. ms., 108; T 1931, 138; JW 1932, 167; T 1947, 143; PO 1967, 123; RO 1970, 123; RW 1975 I, 136

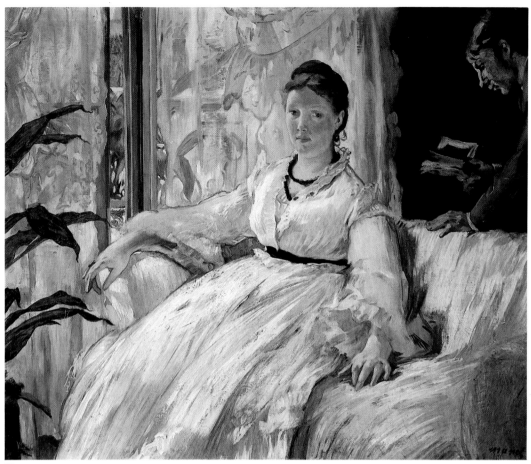

97

harmony of whites that is a technical triumph as well as a tribute to the lady's appealing serenity. Such a harmony may have been suggested to him by Whistler's *The White Girl* (National Gallery of Art, Washington, D.C.), which had been almost as much a *succès de scandale* at the Salon des Refusés in 1863 as *Le déjeuner sur l'herbe* (cat. 62). Proust relates that one day in 1862 or so, as they were taking a walk, Manet was fascinated by an interplay of whites: "Wreckers in white contrasted with the less white wall collapsing under their blows, enveloping them in a cloud of dust. Manet long remained absorbed in attentive admiration of the spectacle."[4]

Here we have the grace of Suzanne's fair complexion and full figure, swathed in white and set off by the black necklace and pendant earrings. Instead of sketching the hands as he often did, Manet gives us a firm rendering of a pianist's muscular fingers.

Everything—a different touch, for example, recalling the *Portrait of Stéphane Mallarmé* (cat. 149)—suggests that Manet returned to this work years later, adding the figure of Léon, then some twenty years of age, posed at the right with a book in his hand, and the green plant at the left. He may also have retouched the dress slightly at this time.

The summer sunlight from the window of the apartment, emphasizing the intense blue of the flowerpot on the balcony, renders this one of Manet's most "Impressionist" works previous to Monet or Renoir—one of the first in which, in this domestic scene, Manet is entirely freed from the art of the past.

259

Provenance
This picture remained in the possession of Manet and then of SUZANNE MANET (see Provenance, cat. 12) until she was reluctantly forced to part with it about 1890. A letter from the painter Ernest Duez to Winnaretta Singer (1865–1943), the rich young American heiress, amateur painter, and great admirer of Manet, who told her friends Duez and John Singer Sargent that she wanted to purchase one of his works, throws light on the Manet family's plight: "My dear Winnie, can you go tomorrow to 54, rue Lepic, around 11 o'clock to see M. Portier, who is doing business with Mme Manet. Sargent and I went to see this poor woman in Gennevilliers, where she lives amidst souvenirs of her husband. We saw the famous *Olympia* and the *Canotiers* [*Argenteuil*, cat. 139] there. The family will not part with them for less than 25,000 Frs, which is respectable but excessive. We discovered a portrait of her dressed all in white in a white drawing room. It is exquisite. It is one of Manet's nicest paintings. She consents to give it up, with regret, but she is forced to because her situation is not good. The canvas will be at Portier's, 54, rue Lepic, tomorrow. She is asking 4,000 Frs, but through Portier I can get it for 3,500 Frs. I think this is a good bargain that will not present itself again. Will you come? Let me know and I'll be there. Believe me, your devoted E. Duez."[5] WINNARETTA SINGER bought the picture immediately. She kept it all her life, and it was admired by visitors to her famous salon, particularly Marcel Proust. She later became the princesse de Polignac and bequeathed this picture, along with several others, including Monets, to the Musée du Louvre in 1944 (inv. RF 1944.17).[6]

F.C.

1. Rouart and Wildenstein 1975, I, p. 26.
2. Paris, Beaux-Arts 1884.
3. Burty 1866, p. 564.
4. Proust 1897, p. 170.
5. Archives, Musée du Louvre, Paris: undated [1855] letter sent with bequest painting.
6. M. de Cossart, *Une Américaine à Paris*, Paris, 1979, p. 22.

98. The Burial

1867–70?
Oil on canvas
28⅝ × 35⅝" (72.7 × 90.5 cm)
Inscribed (lower right): Certifié d'[Ed.] Manet / Vve Manet
The Metropolitan Museum of Art, New York

This unfinished painting depicts a funeral cortège moving along the foot of the hill known as the Butte Mouffetard at the southeast edge of Paris. In the background, the silhouettes of five easily identified structures are visible: from left to right are the Observatory, the church of Val-de-Grâce, the Panthéon, the belfry of Saint-Etienne-du-Mont, and the Tour de Clovis (now part of the Lycée Henri IV). According to Tabarant, the scene is situated specifically on the rue de l'Estrapade.[1] In the inventory of works in Manet's possession when he died, the picture was described as "Enterrement à la Glacière."[2] As Sterling and Salinger have observed, "If the Glacière really was the locale, Manet has shown the cupolas of the Observatory and the Val-de-Grâce closer together than they really are, no doubt in order to improve his composition."[3]

The presence of a grenadier of the Imperial Guard at the rear of the procession indicates that the funeral took place before the end of the Second Empire early in September 1870. Most authorities, including Tabarant, have dated the picture about 1870,[4] but in unpublished notes among Tabarant's papers, he placed it about 1867.[5] Stylistically, it resembles *The Church of the Petit-Montrouge, Paris*, 1870 (RW I 159), but similarities of brushwork are even stronger to those in *The Exposition Universelle of 1867* (RW I 123). The relationship of the *Exposition Universelle* to *The Burial* is especially intriguing, because if the latter was painted in 1867 it may depict the procession for the funeral of Manet's friend Charles Baudelaire. As George Mauner has pointed out, "On 2 September, Manet attended the poet's funeral, and the descriptions given by witnesses of that occasion, including the threatening summer storm and the small cortège moving toward the cemetery of Montparnasse, suggest Manet's painting *L'Enterrement*."[6] In the painting, there are only eleven figures following the funeral carriage, but a description provided by Charles Asseli-

Exhibitions
Washington 1982–83, no. 4

Catalogues
D 1902, 126; M-N cat. ms., 139; T 1931, 153; JW 1932, 184; T 1947, 158; PO 1967, 135; RO 1970, 135; RW 1975 I, 162

1. Tabarant 1931, p. 202, no. 153.
2. Rouart and Wildenstein 1975, I, p. 27.
3. Sterling and Salinger 1967, p. 44.
4. Tabarant 1931, p. 202, no. 153; Tabarant 1947, p. 158.
5. New York, Pierpont Morgan Library, Tabarant archives.
6. Mauner 1975, p. 120.
7. Crépet 1906, p. 275: from Charles Asselineau to Poulet-Malassis, September 6 or 7, 1867.
8. New York, Pierpont Morgan Library, Tabarant archives: Mme Manet's account book, cited in Tabarant 1947, p. 171.
9. Rewald 1973, pp. 197–213.
10. Tabarant 1947, p. 505.

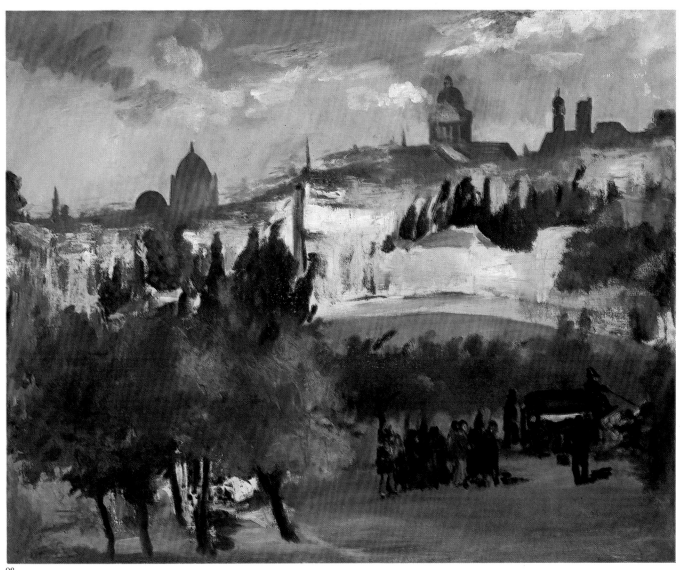

98

neau in a letter written to Poulet-Malassis on September 6 or 7 may explain the dearth of mourners: "Baudelaire will have had for his funeral the same bad luck as Alfred de Musset and Henri Heine. The time of year was against us, because many people were away from Paris, and since we had to distribute the [funeral] announcement on Sunday many people did not receive it until the next day when they returned from the country. There were about one hundred people at the church and fewer at the cemetery. The heat forced many people to follow at a distance. A thunderclap, which occurred as we entered the cemetery, nearly dispersed the rest."[7]

Provenance
This picture, listed among the "études peintes" (painted studies) in the inventory of Manet's studio, was sold by SUZANNE MANET to the dealer PORTIER (see Provenance, cat. 12, 122) in August 1894, for 300 Frs.[8] When Duret wrote his catalogue in 1902, the picture belonged to the painter CAMILLE PISSARRO (1830–1903), who acquired several oil studies by Manet about this time (RW I 274, 286). Pissarro had known Manet since the early 1860s and frequently attended Thursday

evening gatherings at the Café Guerbois.[9] Among the Impressionist artists close to Manet, only Pissarro refused on principle to attend a banquet organized by Léon Leenhoff to commemorate the first anniversary of the Manet retrospective at the Ecole des Beaux-Arts.[10] The picture was later acquired by AMBROISE VOLLARD (1868–1939), the great dealer who handled Renoir, Degas, and Cézanne. Vollard organized the first exhibitions of Van Gogh, Matisse, and Picasso at his galleries on the rue Laffitte; he published portfolios of artists'

prints and wrote books on Cézanne (1914), Renoir (1918), and Degas (1924), as well as his own memoirs (1936). In 1895, at his first small exhibition, he showed drawings by Manet obtained from the artist's widow. Vollard sold the present painting in 1909 to the Metropolitan Museum in New York for the modest sum of $2,319 (inv. 10.36).

C.S.M.

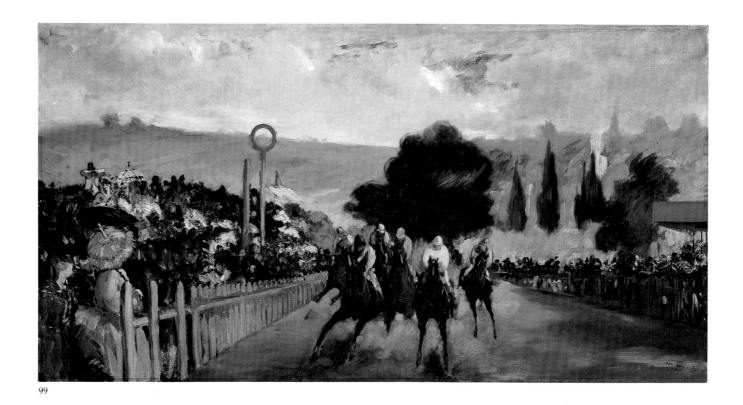

99

99. Races at Longchamp

1867?
Oil on canvas
17¼ × 33¼" (43.9 × 84.5 cm)
Signed and dated (lower right): Manet 186(7?)
The Art Institute of Chicago

This work depicts the stretch at the Longchamp racetrack in the Bois de Boulogne. The finish line is probably designated by the tall pole topped by a circular element at the left. The structure visible at the extreme right is the cantilevered roof of the Tribune Publique at the south end of the spectator stands. Out of view to the right are, in order, another Tribune Publique, a Tribune Reservée, the Tribune Impériale, a second Tribune Reservée, and a third Tribune Publique. The finish line was probably situated directly in front of the Tribune Impériale. The view down the track is from north to south toward the hills of Saint-Cloud, which are faintly visible in the distance.

 Races at Longchamp is the first work in the history of art to depict a racing scene with the horses coming directly toward the viewer. In all previous examples, notably Géricault's Racecourse at Epsom, 1821 (cat. 132, fig. a), as well as numerous French and English sporting prints, the horses are seen from the side, almost always in the flying-gallop position that artists favored prior to the 1878–81 publication in France of Eadweard Muybridge's photographs of horses in motion that were included in his studies of animal locomotion.[1] Indeed, in 1872 Manet reverted to a lateral view of horses at a flying gallop in The Races in the Bois de Boulogne (cat. 132).

Exhibitions
Paris, Manet's studio 1876?; Beaux-Arts 1884, no. 61; New York, Durand-Ruel 1895, no. 27; New York, Wildenstein 1937, no. 18; Philadelphia-Chicago 1966–67, no. 68; Washington 1982–83, no. 43

Catalogues
D 1902, 142; M-N 1926 I, pp. 138–39, no. 145; T 1931, 96; JW 1932, 202; T 1947, 101; PO 1967, 87A; RO 1970, 86A; RW 1975 I, 98

The revolutionary composition of *Races at Longchamp* apparently originated in a painting of 1864 that Manet cut up in 1865. A signed and dated watercolor of 1864 in the Fogg Art Museum (RW II 548; fig. a), believed to represent the composition of that painting, indicates that the Chicago picture is a variation on the image that comprises the right two thirds of the watercolor. Manet used two pieces of paper for the watercolor, and the section on the right contains only slightly more of the composition than the Chicago picture. Whether the presumably accidental compartmentalization of the composition in the watercolor first suggested the right side as the basis for an independent composition is impossible to determine, but the seam between the sheets of paper does isolate it as an image. The relationship between the watercolor and the Chicago picture, however, is hard to define precisely, because, as will be seen, the latter could be either a study made before or a variant made after a painting that Manet included in his independent exhibition of 1867 and that seems to have been a fragment of the 1864 composition.[2] Unfortunately, the painting shown in 1867 has since disappeared; it was apparently seen for the last time in 1871, when an inventory of the contents of Manet's studio was made.[3]

In a discussion of Manet's work in an article about the memorial exhibition held at the Ecole des Beaux-Arts in 1884, Josephin Péladan asserted that the *Races at Longchamp* was a sketch, "a nice sketch, one that could be a painting,"[4] but most subsequent authorities regard it as a finished work, dating it either 1864 or 1872. However, the date and whether it is a study, a sketch, or a finished painting depend largely on its relation to the lost painting *View of a Race in the Bois de Boulogne* that Manet included in the exhibition of his work that he organized in 1867.

The history of the latter painting seems to begin in a letter that the artist wrote in 1864 to the dealer Louis Martinet about an exhibition planned for the following year. Manet expressed his intention to send Martinet nine canvases, one of which he listed as "Aspect d'une course au bois de Boulogne."[5] However, according to a letter dated February 12, 1865, from Hippolyte Lejosne to Baudelaire, Manet eventually sent six works, of which only two were shown: "I haven't seen Manet for some days. . . . He has just taken his pictures out of the Martinet exhibition; he had sent six, and only two had yet been hung."[6] It has long been assumed that the painting cited in the letter of 1864 was exhibited in 1865, but there is insufficient evidence to determine if it was even included in the group of pictures sent. Since Manet seems to have cut it into fragments in 1865, it is possible that he did so before the show or that he held it back because of plans to alter it radically.

The watercolor of 1864 in the Fogg Art Museum is apparently either a study made before[7] or a record made after[8] "Aspect d'une course au bois de Boulogne," the work referred to in the letter of 1864. Evidently, Manet cut the 1864 painting into fragments the next year, because two small pictures (RW I 94, 95) seem originally to have been part of the 1864 picture.[9] As already stated, the right two thirds of the watercolor relates to the composition of the Chicago painting, but there are significant differences between them which indicate that the latter is not another fragment of the 1864 painting. As Reff points out, "Although [*Races at Longchamp*] shows the most important section of the large composition he exhibited [*sic*] in 1865, it cannot actually have belonged to it; it is painted in a more vigorous, sketchy style than the two surviving fragments, and it includes at the lower left two female spectators very close to those shown in one of the fragments." Reff further pro-

Fig. a. *Racecourse at Longchamp,* 1864, watercolor. Fogg Art Museum, Cambridge, Mass.

poses that *Races at Longchamp* is, instead, a kind of experimental variant executed in connection with the preparation of the large fragment for exhibition in 1867: "Since the dimensions of the Chicago picture [43.9 × 84.5 cm] and the one shown in 1867 [130 × 64 cm] are in the same proportion, roughly one to two, one may well have been a study for the other, painted in order to examine how a section of the earlier composition could be isolated to achieve greater compactness of design and intensity of expression."[10]

If this is correct, the date could be as early as that of the two surviving fragments, 1865, or as late as 1867. However, Reff notes stylistic similarities between the Chicago picture and Manet's *Exposition Universelle of 1867* (RW I 123), and deduces that "the last digit of the inscribed date [of *Races at Longchamp*], which is blurred but can be read as a five, a seven, or a nine . . . , would therefore be a seven." Harris, on the other hand, concludes that the Chicago picture "must be a further reworking of the right section of the original [1864] painting," motivated by Manet's "desire for simplification and unification."[11]

Regardless of exactly how and when Manet painted *Races at Longchamp*, the picture is characteristic of his tendency to move closer to the subject and to reduce the illusion of depth when reworking compositions. We are much closer to the oncoming horses than in the watercolor of 1864, and our space merges with that of the spectators at the left. There is a greater sense of immediacy, and the illusion of depth between foreground and background is considerably mitigated. In 1862, Manet achieved a similar increase in proximity to the subject in the *Portrait of Mme Brunet* (cat. 5) by cutting the painting at the bottom. And in 1878–79, he effected a similar result by cutting in two the unfinished *Brasserie de Reichshoffen* to create two canvases: *At the Café* (RW I 278) and *Corner in a Café-Concert* (cat. 172). He continued the process in *Girl Serving Beer* (cat. 173) by painting a second version in which he moved even closer to the subject and further reduced the illusion of depth by eliminating the diagonally receding tabletop.

In each of these instances, Manet created an effect analogous to that of a photographer telescoping toward a subject with a zoom lens; the area in focus grows in proportion to the framing edges, and the depth of field decreases. If this argument is correct, the composition of Manet's posthumously published lithograph *The Races* (cat. 101), in which the illusion of space is more pronounced and the horses are farther away than in the Chicago picture, suggests that the print must have preceded the painting.[12] Manet's final treatment of the oncoming horses is probably the watercolor *Races at Longchamp* (cat. 100), in which the image is reduced to five horses and jockeys.

1. Scharf 1974, p. 205.
2. Paris, Alma 1867, no. 25 (64 × 30 cm).
3. Rouart and Wildenstein 1975, I, p. 17.
4. Péladan 1884, p. 114.
5. Moreau-Nélaton 1926, I, p. 62.
6. Baudelaire, *Lettres à*, p. 215: from Hippolyte Lejosne, February 12, 1865.
7. Reff 1982, no. 42.
8. Harris 1966, p. 80.
9. Ibid., p. 79; Reff 1982, nos. 42, 43.
10. Reff 1982, no. 43.
11. Harris 1966, p. 81.
12. Ibid.; Reff 1982, no. 44.
13. New York, Pierpont Morgan Library, Tabarant archives: Mme Manet's account book.
14. Ibid.
15. Wildenstein 1974, I, p. 116.
16. Huth 1946, p. 239, no. 22.
17. Rouart and Wildenstein 1975, I, no. 98.
18. Saarinen 1958, pp. 3–34.

Provenance
This is presumably the "Courses à Longchamp" listed in the catalogue to the 1884 Manet retrospective as a loan from the English composer SIR FREDERICK DELIUS (1862–1924), although no installation photograph includes the work. A note in Manet's account book dated 1877 records the sale of a "Courses" to Delius for 1,000 Frs.[13] In 1880, another entry in Manet's account book reads "Courses—Ephrussi—1,000 [Frs],"[14] but there is no further record of such a work in the collection of CHARLES EPHRUSSI (1849–1905), the noted art historian, publisher of the *Gazette des Beaux-Arts*, and banker, who was Renoir's friend. Delius had purchased two still lifes from Monet in 1880 and had sold them to Durand-Ruel in 1896.[15] This was evidently about the time DURAND-RUEL (see Provenance, cat. 118) also acquired Manet's *Races at Longchamp*, which he exhibited in 1895 at his New York gallery. It should be noted, however, that Durand-Ruel exhibited a painting by Manet called "Racecourse" in New York in 1886;[16] perhaps this was *Races at Longchamp*. According to Rouart and Wildenstein, Durand-Ruel sold it in 1896 to POTTER PALMER,[17] the Chicago real-estate millionaire and owner of the palatial Palmer House hotel. His wife, Bertha Honoré Palmer, was a leading figure in Chicago society in the 1880s and 1890s and almost singlehandedly brought contemporary French painting to the Midwest. With advice from her friend Mary Cassatt, she hung a choice selection of nineteenth-century French paintings in the huge art gallery of her Gothic mansion. On her death in 1918, she left to her son and to the Art Institute of Chicago the selection of one hundred thousand dollars' worth of her art for the museum.[18] *Races at Longchamp* was among the works chosen (inv. 22.424).

C.S.M.

100

100. Races at Longchamp

1867–71
Pencil and watercolor
$7^{11}/_{16} \times 10^{5}/_{8}''$ (19 × 27 cm)
Atelier stamp (lower right): E.M.

NY Musée du Louvre, Cabinet des Dessins, Paris

Exhibitions
Ingelheim 1977, no. Z/10; Washington 1982–83,
no. 46

Catalogues
L 1969, 212; RW 1975 II, 544

This watercolor is apparently Manet's final distillation of the image of on-coming horses that first appears in the composition of a watercolor-and-gouache of 1864 (cat. 99, fig. a), which probably records a painting that Manet cut into fragments the following year.[1] Evidently he included a large fragment (130 × 64 cm) of the 1864 painting in his independently organized exhibition of 1867; *Races at Longchamp* (cat. 99) is related to the work shown in 1867, either as an experimental variant made before the exhibition[2] or, more likely, as "a further reworking of the right section of the original paint-ing."[3] As is discussed above (cat. 99), the images that follow the 1864 compo-sition seem to reflect progressive simplification and reduction. In the Louvre watercolor, Manet continues the process. The illusion of depth is minimal; the number of horses is reduced from six to five, and Manet focuses on these exclusively. A semicircle of pencil shading is used to delineate the wedgelike formation of oncoming horses; unlike the watercolor of 1864, the lithograph (cat. 101), the painting of 1867 (cat. 99), and the sketch attributed to Manet (RW I 97), in which the configuration of horses is more randomly organized, the Louvre watercolor treats the onrushing animals and their riders as a uni-fied entity contained by the pencil shading. All peripheral elements, includ-ing most of the surrounding space, have been eliminated, giving the group a monumentality that it does not have in any of Manet's other racetrack im-ages, with the exception of a small painting (32 × 41 cm) of the same subject

known only through an inadequate photograph taken in Manet's studio by Lochard (see RW I 96). However, minor adjustments in the watercolor, such as the more compact postures of the jockeys and the diminished diagonal thrust of the leading horses' front legs, suggest that the watercolor is a refinement of the image recorded in the Lochard photograph.

Reff points out that the Louvre watercolor may have been traced from another work, probably the painting in the Lochard photograph, and that the watercolor then served as the model for the small sketch in Washington (RW I 97).[4] The proposed relationship between the watercolor and the sketch is, however, only one possibility. Given Manet's predilection for progressive refinement, it seems equally likely that the isolated image of the horses and riders represents the last stage in a process that began in 1864, and that it comes after the compositions which include spectators, stands, and a view into the distance. It was probably done after the Chicago painting (cat. 99) but before 1872, when Manet undertook the wholly different lateral view of racing horses that he used for the composition of *The Races in the Bois de Boulogne* (cat. 132).

1. Harris 1966, pp. 78–82; Reff 1982, nos. 42, 43.
2. Reff 1982, no. 43.
3. Harris 1966, p. 81.
4. Reff 1982, no. 46.
5. New York, Pierpont Morgan Library, Tabarant archives.
6. Pellerin sale, Paris, June 10, 1954, album no. 4.

Provenance
This watercolor bears Manet's atelier stamp, affixed when the posthumous inventory was taken. It later belonged to AUGUSTE PELLERIN (see Provenance, cat. 109), who acquired a large number of Manet's drawings about the turn of the century, many of them apparently from Antonin Proust. In a letter dated May 10, 1897, Proust asserted he had purchased drawings by Manet from Vollard, added others, and sold all of them to Pellerin for 1,784 Frs.[5] This watercolor was in the fourth of five albums acquired by the Musée du Louvre at the Pellerin sale[6] in 1954 (inv. RF 30.451).

C.S.M.

101. The Races

1865–72
Lithograph
1st state: 14⅜ × 20¼" (36.6 × 51.3 cm); paper: 15⅛" (38.4 cm) ×
image: 20" (50.7 cm)
Bibliothèque Nationale, Paris

This lithograph, undoubtedly the most strikingly "modern" in concept and execution of all Manet's prints, is also the most problematical. It is neither signed nor dated, and it is not known if Manet intended to publish it or if the proofs in the first state are actually contemporary artist's proofs. Finally, its relationship with the lost canvas *View of a Race in the Bois de Boulogne*, of 1864, and with the gouache of the same composition as the painting (cat. 99, fig. a), as well as with the later variants (cat. 99, 100), remains to be clarified.

According to Harris, the lithograph must have been made between the gouache of 1864 and the oil of 1867(?), and certainly well before the very different *Races in the Bois de Boulogne* of 1872 (cat. 132).[1] The lithograph is a slightly modified version of the 1864 composition, and is closer in its free handling to the later variants of this composition (RW I 96, 97; cat. 99). The similarity to the 1864 gouache suggests that the lithograph was based on a photograph of the lost canvas. When a reversed tracing of the gouache is placed over an image of the lithograph reduced to the same scale, it becomes clear that the lithograph repeats, even as it transforms, many of the elements in the area behind the barrier: for example, the silhouettes of the two drivers, in their top hats, above the two heads in the carriage. To fill the area corresponding to the horse and rider in the gouache, Manet crayoned in another carriage full of spectators, and, at the place where the women with

Publications
Mme Manet 1884

Exhibitions
Beaux-Arts 1884, no. 166; Paris, Drouot 1884, no. 168; Philadelphia-Chicago 1966–67, no. 69; Paris, BN 1974–75, no. 137; Santa Barbara 1977, no. 4; Ingelheim 1977, no. 66; London, BM 1978, no. 16; Paris, Berès 1978, no. 76; Providence 1981, no. 37; Washington 1982–83, no. 44

Catalogues
M-N 1906, 85; G 1944, 72; H 1970, 41; LM 1971, 72; W 1977, 66; W 1978, 76

1st state (of 2). Before the reduction of the subject by 5 mm on the right and before the printer's name and address. One of two known proofs (see Provenance), on applied China paper. Moreau-Nélaton collection.

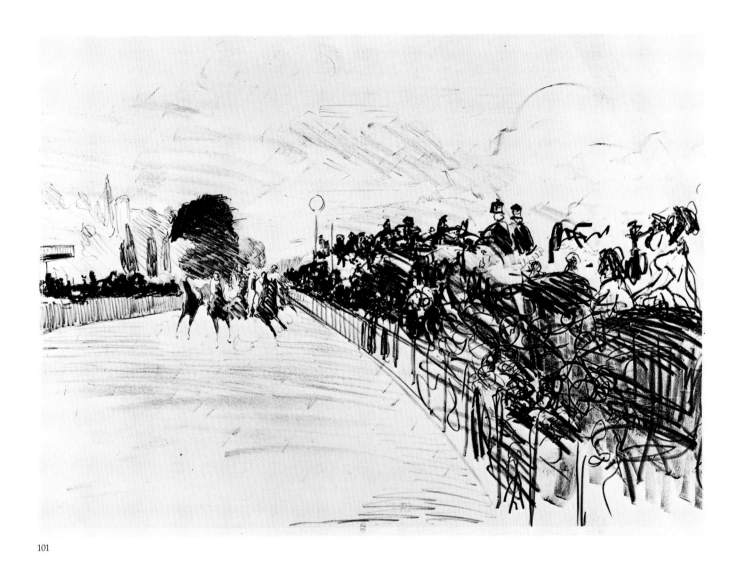

101

parasols (RW I 94, 95) were cut from the large canvas, he filled the corresponding blank area in the lithograph with a few furious scribbles.

Manet found a bold and simple way of completing his lithographic design. From the point where, in the gouache, three posts mark the end of the continuous barrier, a curving line swings down, well below the lower limit of the original composition, altering the shape of the racetrack, which is marked by a few roughly indicated posts. The curved shape created behind the barrier is filled with vigorously evocative, rather than descriptive, crayon strokes. This treatment intensifies the dynamic effect of the perspectival view, in which the horses appear to explode from the background toward the spectator. At the same time, the crayon marks reinforce the two-dimensional balance of the composition, since the rich black shapes of the distant spectators and horses beneath the large tree lie on the same visual plane and carry the same intensity as the vigorous "scribbling" in the foreground. As Ives has pointed out, Manet attains, with very different means, the same effect as Hiroshige in a landscape print that combines deep perspective with perfect surface balance.[2]

The changes in composition in relation to the gouache suggest that Manet had probably already decided to cut or modify his large canvas, even if he had not actually done so, but that he had probably not yet envisaged

the reduction of the composition as it appears in the painting exhibited here (cat. 99). Manet was remarkably adept at adapting his style to suit the project in hand: for *The Execution of Maximilian* (cat. 105) and *Civil War* (cat. 125, fig. a), he chose an impressive, restrained realism; for the poster advertising Champfleury's *Les Chats* (cat. 114), a graphic design of eye-catching originality; for the bibliophile edition of *The Raven* (cat. 151), a style of refined elegance. It is difficult to imagine for whom the lithograph *The Races* was intended; surely not for the collector of English sporting prints (see cat. 132).

In spite of its clear relationship to *The Balloon* of 1862 (cat. 44), particularly in the "scribbled" areas at the edges of the composition, this work can be more comfortably placed after 1865 and probably toward the end of the decade, when Manet's art found its full freedom of expression. Adapting both his style to the possibilities of the lithographic crayon technique and the composition of his painting to a new format, Manet produced a masterpiece of original graphic art that remained unequaled until the radical innovations of Toulouse-Lautrec, Degas, and the Nabi printmakers in the early 1890s. Melot has underlined its boldness as "one of the earliest experiments in the representation of movement, where the object in motion is subordinated to the effect of the movement itself, rendered by the 'empathetic' movement of the crayon."[3]

The Races was only published, together with four other lithographs (see cat. 105, 125, 130, fig. a), in 1884, when Mme Manet decided to issue an edition (see cat. 105). It seems unthinkable, in spite of the statements of the printer, Auguste Clot (see cat. 125), that no artist's proofs were made for Manet. The two known proofs in the first state,[4] before letters and above all before a narrow strip of the design along the right edge was removed, are printed on a warmer, more luminous applied China paper, and are of distinctly higher quality than the impressions from the posthumous edition, where the wash effect over the distant crowd on the left and the delicacy of the lines in the landscape background, behind the horses, have disappeared or are considerably diminished. A proof of the first state (as shown by a Lochard photograph[5]) was exhibited in January 1884 at the Ecole des Beaux-Arts,[6] three months before Lemercier registered the edition with the Dépôt Légal.

1. Harris 1966.
2. Ives 1974, nos. 28, 29.
3. Melot 1974, no. 134.
4. The proof exhibited here (repr. M–N and LM) and one in a private collection (Wilson 1977, no. 66; Wilson 1978, no. 76, repr.).
5. Lochard photograph no. 166: Paris, BN Estampes (Dc 300f, I, p. 18; Dc 300g, VIII).
6. Paris, Beaux-Arts 1884, no. 166.
7. Ives 1974, nos. 28, 29.
8. See Harris 1970, p. 123. Of the proofs cited by Guérin, only the one in Boston (now the Museum of Fine Arts) is known, a "doctored" proof, as stated by Harris.
9. B[iron] sale, Paris, April 13, 1910, lot 95 (290 Frs), acquired by O. Gerstenberg.
10. Manet sale, Paris, February 4–5, 1884, lot 168, "Courses," (70 Frs), acquired by Chabrier; Bodelsen 1968, p. 343.
11. Marx sale, Paris, April 27–May 2, 1914, lot 912 (repr.).

Provenance
This extremely rare proof of the first state was reproduced by MOREAU-NELATON in his 1906 catalogue without naming the owner—his usual practice with proofs in his own collection (see Provenance, cat. 9).

The existence of a first state of the composition of this print, before reduction, was only established in 1977–78,[7] and Guérin was in error in referring to proofs "before letters" from the posthumous edition (the letters are masked on the proof in the Bibliothèque d'Art et d'Archéologie, Paris) and to a second state with the subject reduced and the addition of a signature.[8]

Besides the proof belonging to Moreau-Nélaton (acquired before 1906) and the one acquired at the Biron sale in 1910,[9] a proof in the first state was exhibited at the Ecole des Beaux-Arts in 1884 (see text above); the same or another proof was apparently included in the sale of Manet's studio,[10] and a proof in the first state appeared in the Roger Marx sale in 1914.[11]

J.W.B.

102. Soap Bubbles

1867
Oil on canvas
39⅝ × 32" (100.5 × 81.4 cm)
Signed (lower right): Manet
Museu Calouste Gulbenkian, Lisbon

Léon Leenhoff, the boy with a sword (see cat. 14), recalled having posed for *Soap Bubbles* in September 1867, at the age of fifteen, when Tabarant interviewed him at the end of his life.[1] He appears younger than in *Peeling a Pear*

Exhibitions
Beaux-Arts 1884, no. 45; Orangerie 1932, no. 28; New York, Wildenstein 1937, no. 13; World's Fair 1940, no. 279

Catalogues
D 1902, 96; M-N 1926 I, p. 109; M-N cat. ms., 114; T 1931, 131; JW 1932, 148; T 1947, 136; PO 1967, 117; RO 1970, 117; RW 1975 I, 129

102

(RW I 130) or in *The Luncheon in the Studio* (cat. 109), and our date seems preferable to that of 1868, accepted since the 1884 retrospective.

Though painted very freely, the portrait is permeated with art-historical references, mingling the Holland of Hals, the Spain of Murillo, and the France of Chardin. The theme itself was by no means novel at mid-century, and several art historians have compared Manet's version both to Couture's painting (fig. a)[2] and to Daumier's lithograph.[3]

But the simplicity of the composition, the stone parapet, and the plain dark background hark back most of all to Chardin's *Soap Bubbles* (fig. b), which Manet had certainly seen on the occasion of the Laperlier sale, some months before beginning his own canvas, as Rosenberg has suggested.[4] He may also have recalled the painting of the same title by Mieris (Musée du Louvre, Paris).

Manet retains the traditional elements—the pipette with bubble about to burst, the tender years of the model—common to all these treatments of the *vanitas* theme, in which soap bubbles symbolize the precariousness of life. But he reverses the emphasis, giving the subject an unprecedented immediacy, and removing all trace of sentimentality. Chardin, too, had moved away from the sphere of allegory into that of realistic observation. Schapiro notes that he holds the pipette like a brush and the bowl like a palette,[5] an intriguing idea if we believe that Manet was pursuing the theme of *vanitas*, and answering the *memento mori* with an allusion to the *monumentum aere perennius* of art—his own art. But rather than a philosophical meditation or a moralism, as in Couture's painting, Manet's is a pictorial statement proper, a "naturalistic" reply to his master's work in which Manet deliberately empties the theme of its sentimental connotation and deliberately confronts, beyond the practices of his time, the great art of the seventeenth century.

Fig. a. Thomas Couture, *Soap Bubbles*, 1859. The Metropolitan Museum of Art, New York

1. Tabarant 1931, p. 177.
2. Schapiro, cited in Mauner 1975, pp. 133–35.
3. Hanson 1977, pp. 69–70.
4. Laperlier sale, Paris, April 11–13, 1867; Rosenberg 1979, no. 59.
5. Schapiro, cited in Mauner 1975, p. 135.
6. Notebooks of Henri Hecht (ed. Anne Distel), forthcoming.
7. Tabarant 1947, p. 144.
8. Tabarant 1931, p. 177.
9. Tomkins 1970, p. 309.

Provenance
Manet sold this picture in 1872 for 500 Frs to the brothers HENRI AND ALBERT HECHT,[6] two early collectors of Impressionist art who were close friends of Degas's and Duret's. The Hechts must have seen the picture in 1870 at Manet's or at Duret's, for Henri wrote Manet on January 12, 1872: "During the war our mutual friend Duret told us that 500 Frs was your price for the boy with soap bubbles, which pleased us so much. . . . If you still feel the same way. . . ."[7] Later the Hechts often bought Manet's work at auction (the Hoschedé sale, the Manet sale)—for example, the *Swallows* (RW I 190), the *Woman with a Parrot* (cat. 96), the *Croquet Game* (RW I 211), and *The Escape of Rochefort* (cat. 207). One of the brothers posed for the *Masked Ball at the Opéra* (cat. 138). *Soap Bubbles* subsequently passed by descent to Albert Hecht's son-in-law, M. PONTREMOLI, who sold it to GEORGES BERNHEIM (see Provenance, cat. 20) for 150,000 Frs in 1916.[8] The picture was with BERNHEIM-JEUNE (see Provenance, cat. 31) in Paris in 1918 and with DURAND-RUEL (see Provenance, cat. 118) in New York in 1919, when it was acquired

by ADOLF LEWISOHN (1849–1938). This New York financier and philanthropist's great collection included Degas's *Jacques Joseph Tissot*, purchased by the Metropolitan Museum in 1939, as well as Gauguin's *Ia Orana Maria*, Van Gogh's *Mme Ginoux* (*L'Arlésienne*), and a study for Seurat's *La Grande Jatte*, all of which were bequeathed to the museum in 1951 by his son SAM A. LEWISOHN.[9] CALOUSTE GULBENKIAN (1869–1955) bought the present painting for his foundation in 1943 (inv. 2361). It was among the last group of important purchases made by the famous industrialist, who had begun his collection—strongest in seventeenth- and eighteenth-century art—before World War I. His few other Impressionist paintings are Degas's important *Self-Portrait* (1862) and *Man with a Mannequin* (1880) and Renoir's portrait *Mme Claude Monet* (1872), which Manet apparently had in mind when he drew the pastel of his wife (cat. 143). Gulbenkian purchased one of Manet's best-known early pictures, the *Boy with Cherries* (RW I 18), as early as 1910.

F.C.

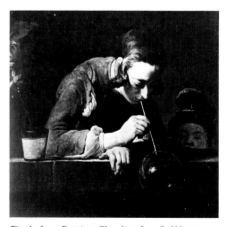

Fig. b. Jean-Baptiste Chardin, *Soap Bubbles*, ca. 1745. National Gallery of Art, Washington, D.C.

103

103. Boy Blowing Soap Bubbles

1868?
Etching, aquatint, and roulette
Plate: 10 × 8½″ (25.4 × 21.5 cm); image: 7¾ × 6½″ (19.8 × 16.4 cm)
P Bibliothèque Nationale, Paris
NY The New York Public Library

Exhibitions
Philadelphia-Chicago 1966–67, no.98; Ingelheim
1977, no. 62; Paris, Berès 1978, no. 60

Catalogues
M-N 1906, 36; G 1944, 54; H 1970, 63; LM 1971, 57;
W 1977, 62; W 1978, 60

While the significance of the painting of this subject (cat. 102) is a matter for speculation—is it a private allegory or simply a pretext for a piece of pure painting in the tradition of Chardin and Hals?—still less is known about Manet's intentions in making the print. It is known from only a few artist's proofs before its posthumous publication in 1890. Henri Guérard (see Provenance, cat. 16) owned several proofs from this plate, one of which has an inscription recording that he printed it.[1] It is not known when Guérard

began to replace Bracquemond as the technical expert who prepared and proofed Manet's copperplates, but Manet's renewed activity as an etcher, which one can place roughly between 1866 and 1870, may well have resulted from Guérard's influence. Whatever the reason, Manet planned the publication of a series of reproductive prints: *The Tragic Actor* (H 48) and the *Philosopher* (H 47) after the paintings of 1865–66 (cat. 89, 90), *The Smoker* (H 50) after the painting of 1866 (RW I 112), and even *The Dead Christ and the Angels* (cat. 76), of which Guérard kept the copperplate. The same may be true of this *Boy Blowing Soap Bubbles*, etched in 1868 or even later; a proof printed in colors (Art Institute of Chicago) would correspond with the taste and technical prowess of the young Guérard.

Manet may also have etched all these plates, with the exception of the later *Boy Blowing Soap Bubbles*, in anticipation of the success of his one-man exhibition in May 1867. All the other paintings were shown there, as well as the still life of a dead rabbit (RW I 118), of which he made a small print (H 62). It appears that Manet hesitated about selling Zola's brochure in his exhibition (see cat. 68, 69) and even suggested to the critic that they should wait until "the end, after a success, if there is one."[2] He may have prepared some reproductive prints, abandoned the idea of printing them at the time of the exhibition, and then, encouraged by Guérard, have done so later, even years later.

All these plates reveal Manet's intention to transcribe rather than translate an original painting. In the case of *Boy Blowing Soap Bubbles*, Manet attempted to render, through the use of line alone (to which he later added lavis aquatint), the purely painterly qualities, the rich texture and harmonious colors, of his canvas. It must be admitted that he was only partially successful: the plate lies halfway between a true reproductive print and an original graphic.

Provenance
The proof in the MOREAU-NELATON bequest (see Provenance, cat. 9) has the same watermark as a proof of *The Smoker* (Bibliothèque Nationale, Paris; see H 50), but there is no indication of their earlier provenance.

Although the other proof in the New York Public Library, already mentioned, has the note "tiré par Guérard," there is no clue to the provenance of this one. AVERY no doubt also acquired it, through LUCAS, from GUERARD himself (see Provenance, cat. 17, 16).

J.W.B.

1st state (of 4). Both proofs show strong false biting along the plate edges and particularly in the corners (possibly due to a rebiting in order to strengthen the original etched lines). P: On laid paper (watermark FRE . . .), in brown-black ink. Moreau-Nélaton collection. NY: On laid paper, in black ink. Avery collection.

1. The New York Public Library, proof on Japan paper.
2. See Appendix I, letter 6.

104. The Execution of the Emperor Maximilian

1867
Oil on canvas
77¼ × 102¼" (196 × 259.8 cm)
Museum of Fine Arts, Boston

On June 19, 1867, while the Exposition Universelle held sway in Paris, Maximilian of Austria, emperor of Mexico, was executed together with the Mexican generals Miramón and Mejía. The tragedy was keenly felt in France as soon as the news arrived, first with horror directed only against the Juarists in Mexico, then with indignation against Napoleon III, who, after imposing Maximilian's reign, proceeded to withdraw the French forces that could

Exhibitions
Salon d'Automne 1905, no. 17; Orangerie 1932, no. 27; Philadelphia-Chicago 1966–67, no. 84; Providence 1981, no. 29

Catalogues
D 1902, 101; M-N 1926 I, pp. 92–93; M-N cat. ms., 101; T 1931, 130; JW 1932, 138; T 1947, 132; PO 1967, 115; RO 1970, 115; RW 1975 I, 124

have maintained it. Personally piqued by the failure of his Alma show, critical of the Empire as were all the *boulevardiers*, and anxious to prove that in his own way he was capable of a painting in the grand historical mode, Manet had many reasons to take an interest in this drama and to decide to commemorate it in a large canvas.

He worked for more than a year, from the summer of 1867 to late 1868, on a succession of four oil paintings and a lithograph. His efforts were to develop, as more and more specific information through photographs and written reports became available to him, along the lines of his own reactions to the event and in terms of the plastic problems inherent in so ambitious a project, his first painting of this kind. The progress of this work and the successive changes punctuating it have been analyzed in a masterly way by Sandblad,[1] working from the testimony of Duret and Proust and—for the first time—searching the press reports to which Manet would have had access. The art historians who have studied the problem since have added chronological data, new iconological details, and interesting hypothetical suggestions, but nothing to contradict Sandblad in substance.[2]

The painting shown here is undoubtedly the first of the series; it was followed by the one whose reassembled fragments are in the National Gallery, London (RW I 126), then by the study in the Ny Carlsberg Glyptotek, Copenhagen (RW I 125), and last by the final composition, the largest and most finished, in the Städtische Kunsthalle, Mannheim (RW I 127; fig. a).

The course of events may be summarized as follows. After opening his independent exhibition on the avenue de l'Alma on May 24 and executing *The Exposition Universelle of 1867* (RW I 123) in June, Manet left for Boulogne in July. It is not known whether he was still in Paris on July 1, when awards for the Exposition Universelle were distributed at the Palais de l'Industrie. "The melancholy news had been circulating in Paris since morning," reported Ludovic Halévy. "The Emperor Maximilian shot by order of Juárez. What a tragic ending to that ruinous, bloody farce, the war in Mexico!"[3] Sandblad believes that Manet's chief point of departure was the detailed account that appeared in the press on August 10, so he would not have begun painting until his return in September, a return hastened by Baudelaire's death on August 31 and the interment on September 2. Jones, on the other hand, suggests that since the first somewhat detailed report of the drama appeared on July 8, Manet would have had time to work out this painting before his departure;[4] indeed, it is likely enough that he began to draft the painting but interrupted the task to go to Boulogne, realizing that there was no practical possibility of including it in the Alma exhibition then in progress. However this may be, whether painted in July or in September, the Boston version seen here was done in the heat of the moment; it is more full of movement, more charged with emotion, more dramatic even in its technique than the others of the series.

The general idea clearly owes much to Goya's *Third of May, 1808* (fig. b), which Manet had seen in Madrid two summers before, when it was in the Academia San Fernando. Curiously enough, Goya and Mexico had been linked five years earlier by Paul de Saint-Victor in a hostile article on Manet's Martinet show of 1863: "Imagine Goya gone to Mexico, running wild on the pampas, daubing canvases with crushed cochineal, and there you have M. Manet, the realist of the hour."[5]

The Boston version is the closest of the four to Goya, in its romantic spirit and in its warm tones, to be replaced by a cool harmony of grays,

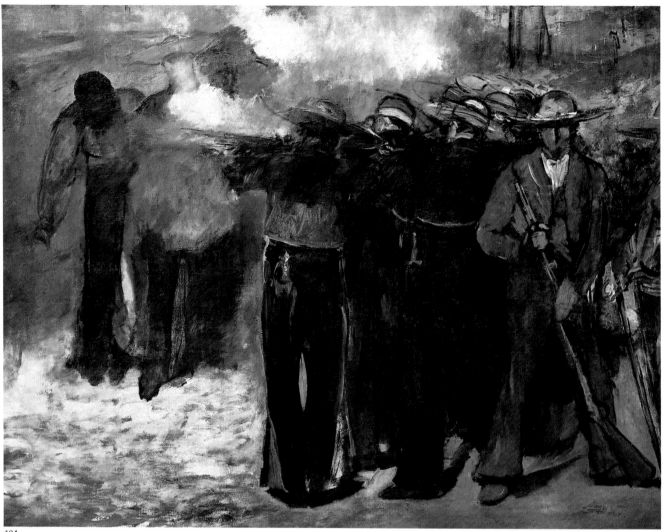

greens, and blacks in later versions. While Goya chose the moment the soldiers were taking aim, Manet depicts the ensuing fusillade, but the grouping, with firing squad to the right and victims on the left, a couple of paces apart, is the same. As in the naval *Battle of the Kearsarge and the Alabama* (cat. 83), a cloud of smoke shrouds the action, evoking rather than revealing it. The three victims are in their appointed positions: the Indian general Mejía, already hit, on the left; the emperor standing in the middle; and Miramón indistinct on the right. The officer loading his rifle, the emperor's executioner, is present at the extreme right as in later versions, but full face, the picture of indifference, the mindless avenging angel at rest before the deed. Interestingly, the only touch of red in the Boston version is the officer's sash, visually balancing the burst of flame—like his kepi in the final painting, the only manifestation of the hue of bloodshed.

 The scene is set in the open air; at the upper right and left, bits of sky appear over sketched ridges; in the Mannheim version, the background is essentially a high gray wall. By the end of July, Manet had the information already suggested in the Boston painting; for example, it was known that the emperor was wearing a Mexican sombrero, and for the uniforms Manet

would naturally have gone to the sources at hand, the accounts of the Mexican expedition published in *L'Illustration* over the preceding years—notably the detail of an anonymous engraving representing the Battle of Jiquilpán, cited by Sandblad, or a plate from *L'Histoire populaire illustrée de l'armée du Mexique*, by E. de la Bédolière, 1863, cited by Boime.[6] A recent restoration has revealed that Manet originally painted the soldiers' trousers red, tending to confirm Jones's hypothesis of an earlier date than is generally assumed for the commencement of the work, since by August 11, in *Le Figaro*, Albert Wolff described the soldiers from photographs in his possession: "The uniform is similar to the French uniform—kepi . . . white leather belt; the full-length trousers are of a darker fabric."[7] So upon his return in September, Manet reworked the painting, darkened the trousers while retaining their "Mexican" cut, and sought to convert the sombreros into kepis, at least in the central portion of the squad; he may have asked Wolff, with whom he was on friendly terms despite the critic's attacks on his work, to show him the photographs mentioned in the article, and in particular the portraits of the three victims. But he probably abandoned this painting late in September, as we are clearly informed by Théodore Duret: "When he found that a first composition and even a second did not conform to the data he eventually collected, he redid the work a third time in a finished and final form."[8] The second, intermediate version, done in late autumn 1867, would have been the dismembered canvas now in the National Gallery, and the final Mannheim canvas was probably preceded by the smaller Copenhagen study.

Fig. a. *The Execution of Maximilian*, 1868. Städtische Kunsthalle, Mannheim

The Boston painting, then, would be the "pilot" composition, and illustrates how the artist's immediate response was more emotional, less restrained, and how little by little a system of reserve, distance, and objectivity was interposed. With Manet, this process, as a rule, intellectually or intuitively preceded the painting, but here it is directly recorded on canvas. The painting reveals the ambiguities of successive enthusiasm and control—showing every evidence of the artist's emotion prior to the self-control of the final version.

The same ambiguity manifests itself in Manet's at once respectful and disrespectful attitude toward the theme. Respectful, for despite his frequent outbursts (reported by Proust)[9] against historical painting, Manet intended this as a historical painting in the grand tradition of the early nineteenth century, the tradition of David and Gros—and Goya. Current history, to be sure—reportage, but history. The format alone, the imposing scale, betrays an eagerness to create a major painting for the Salon. Respectful, too, in the composition, not particularly innovative, with a technique reminiscent of the sketches of Couture.

At the same time, Manet's whole conception is already in evidence, and will simply be developed and perfected in the later versions. The executioner at the right—depicted head on, feet planted wide apart, leaning on the weapon that will deal the death blow—here confronts the viewer, taking us to witness. The emperor stands erect, the "Christ-like" sacrifice, as art historians since Sandblad have observed. We know that Manet had long cherished an ambition to represent pain: "Minerva is all very well, Venus is all very well, but the heroic image and the image of love can never hold their own with the image of pain. This is the essence of humanity, its poetry."[10] He was speaking here of Christ on the cross, and told Proust he would like one day to attempt the subject. It is not unlikely that he had this in mind

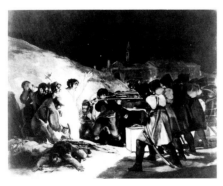

Fig. b. Francisco de Goya, *The Third of May, 1808*, 1815. Museo del Prado, Madrid

when he painted Maximilian between the two generals, a latter-day transcription, bitter and scornful, of Christ between the robbers, like him betrayed and suffering. The Boston grouping, as yet confused, was to be clarified in the more finished versions, though losing some of its mystery and passion. On the other hand, the sombrero, used symbolically in the Mannheim version, where it discreetly evokes a halo, is here simply local color.

Manet did not complete the final canvas (fig. a) to his satisfaction until late in 1868. Doubtless he would have decided to submit it to the Salon had he not been given to understand that it would not be accepted[11] (see cat. 105). However, the work became known in artistic circles. For example, we may agree with Boime in seeing a direct influence of Manet's idea on a painting by Gérôme, *The Execution of Marshal Ney, December 7, 1815* (Graves Art Gallery, Sheffield), shown at the 1868 Salon, in which the firing squad marches off, leaving Ney dead in front of a wall similar to the one in Manet's final canvas.[12]

The Mannheim version of *The Execution of the Emperor Maximilian* was shown in the United States from December 1879 to January 1880[13] by Manet's friend the French singer Emilie Ambre (see *Emilie Ambre in the Role of Carmen*, RW I 334) during her opera tour, but with indifferent success.

The triumph of Impressionism for a time checked the ambition to portray historic events, with the strange result that Manet's *Maximilian* series represents a last attempt to revive the grand historical manner. Manet's challenge was to be taken up at last by Picasso in *Guernica*, 1937 (Museo del Prado, Madrid), and, more literally, in *Massacre in Korea*, 1951 (fig. c), as Manet had taken up the challenge of Goya and the grand tradition. Renoir in his candor spoke the truth when, according to Vollard, he exclaimed before the canvas here exhibited, "This is pure Goya, and yet Manet was never more himself!"[14]

Fig. c. Pablo Picasso, *Massacre in Korea*, 1951. Musée Picasso, Paris

1. Sandblad 1954, pp. 109–59.
2. Scharf 1968; Fried 1969; Boime 1973; Johnson 1977; Griffiths 1977; Jones 1981.
3. L. Halévy 1935: July 2, 1867.
4. Jones 1981, p. 12.
5. Saint-Victor 1863, quoted in Moreau-Nélaton 1926, I, p. 45.
6. *L'Illustration*, February 11, 1865, cited in Sandblad 1954, p. 125.
7. Jones 1981, p. 14.
8. Duret 1902, p. 71.
9. Proust 1897, p. 132.
10. Ibid., p. 315.
11. See Appendix II, no. 5.
12. Ackerman 1967, pp. 169–70; Boime 1973, p. 189.
13. In New York, Clarendon Hotel; in Boston, Studio Building Gallery (Paris, Bibliothèque d'Art et d'Archéologie, Manet archives); see Chronology.
14. Vollard 1936, p. 72.
15. Tabarant 1947, p. 141.
16. New York, Pierpont Morgan Library, Tabarant archives.
17. Tabarant 1947, p. 141.
18. Letter published by Barbara Stern Shapiro in Boston, Museum of Fine Arts, *Mary Cassatt at Home* (exhibition catalogue), Boston, 1978, pp. 9–10, no. 8.

Provenance

This canvas remained rolled up in Manet's studio and was then taken by SUZANNE MANET (see Provenance, cat. 12) to Gennevilliers and later to Asnières. It subsequently passed to LEON LEENHOFF (see cat. 14), who stored it in the printing office he attempted to establish in Montmartre; "[at] 10 bis on the rue Amélie, then at 94, rue Saint-Dominique, it obstructed the small employees' dining room, until the day Léon Koëlla decided to mount it on the wall, where it could be appreciated, although it had suffered considerably, having been rolled the wrong way, with the painted surface inside, for many years," according to Tabarant's own eyewitness report.[15] AMBROISE VOLLARD (see Provenance, cat. 98) discovered it there in 1899 (after the cut-up London version [RW I 126] that Degas acquired from him). He purchased this "sketch" in July 1900 for 500 Frs, according to Léon;[16] 800 Frs, according to Vollard.[17] The painting probably underwent its first restoration at that time. In 1909, Vollard sold it to FRANK GAIR MACOMBER of Boston. A letter from Mary Cassatt sheds light on the circumstances of this purchase: "Dear Mr. Macomber, I am very much interested to know that you have bought the fine Manet and delighted that our chance meeting has led to the picture going to America. It has been one of the chief interests of my life to help fine things across the Atlantic."[18] Mr. and Mrs. Macomber gave the work to the Museum of Fine Arts, Boston, in 1930 (inv. 30.444). The picture was cleaned and restored in 1980.

F.C.

105. The Execution of Maximilian

1868
Lithograph
13⅛ × 17" (33.3 × 43.3 cm)
Signed (lower left): Manet

P Bibliothèque Nationale, Paris
NY The New York Public Library

Publications
Mme Manet 1884

Exhibitions
Paris, Drouot 1884, no. 169; Philadelphia-Chicago 1966–67, no. 86; Ann Arbor 1969, no. 29; Ingelheim 1977, no. 54; London, BM 1978, no. 15; Paris, Berès 1978, no. 77; Providence 1981, no. 33; Washington 1982–83, no. 74

Catalogues
M-N 1906, 79; G 1944, 73; H 1970, 54; LM 1971, 73; W 1977, 54; W 1978, 77

3rd state (of 3). With the printer's name and address, in its final form. Proofs on applied China paper. P: Dépôt Légal. NY: Avery collection.

Fig. a. Lochard photograph of 1883, *The Execution of Maximilian* (second version), 1867–68 (National Gallery, London). Bibliothèque Nationale, Paris

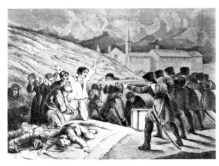

Fig. b. Wood engraving after Francisco de Goya, *The Third of May, 1808*, in Charles Yriarte, *Goya*, 1867

Like *The Races* (cat. 101), this lithograph is related to a number of paintings. Manet was working on the *Maximilian* series from the summer of 1867 to the winter of 1868–69, and he probably made his lithograph after he had abandoned the first version of the composition in oils (cat. 104) but before he began the sketch and large painting of the definitive version (RW I 125, 127). Sandblad was no doubt right in suggesting that the lithograph was largely based on the second version (RW I 126),[1] which was cut up by Léon Leenhoff. Three fragments have survived, and a photograph, probably taken by Lochard in 1883, shows the canvas still intact apart from a section missing on the left (fig. a).[2] Manet reversed his composition on the stone so that when printed it appears in the same direction as the painting.

A reading of the lithographic composition from right to left shows the soldier preparing the *coup de grâce* standing close to the firing squad, as in the sketch for the final version (RW I 125). Although the foreground is darker, as in the painting exhibited and (as far as one can tell from the Lochard photograph) in the second version, the contrasts of light and shade and the diagonal movements on the ground are less pronounced in the lithograph. The officer with his sword raised appears behind the firing squad, but does not figure in the final composition (cat. 104, fig. a).

In the lithograph Maximilian and his two Mexican generals stand close together, holding hands as they face the squad, from which they are now separated by a very short distance. While the emperor and General Mejía, on the left, are in more or less the same positions as in the final composition, Miramón has not yet adopted his final pose, with his left leg thrown back, emphasizing the diagonal that links and unites the three victims, at the same time isolating them from their executioners. The emperor wears a sombrero resembling that in cat. 104, later tipped backward to form a kind of halo in the final version. (No comparison is possible with the same area in the damaged second version.)

Finally, Manet introduced a wall into his lithographic composition. The base of the wall lies roughly at the level of the horizon in the second version (fig. a), and the top reaches almost to the upper edge of the composition. The wall appears to have been altered in the course of work to form an angle that suggests the confined space of a courtyard, the dark plane setting off the whiteness of the victims' faces, the smoke from the muskets, and Mejía's hand, dramatically clenched in a final reflex. Behind this dark wall, the crosses and tombstones of a cemetery are visible; over the wall to the right, a crowd "à la Goya," as Harris puts it,[3] presses forward to watch the scene.

While the crowd in Manet's lithograph is similar to that in several of Goya's *Tauromaquia* prints,[4] the poses and gestures of the more carefully

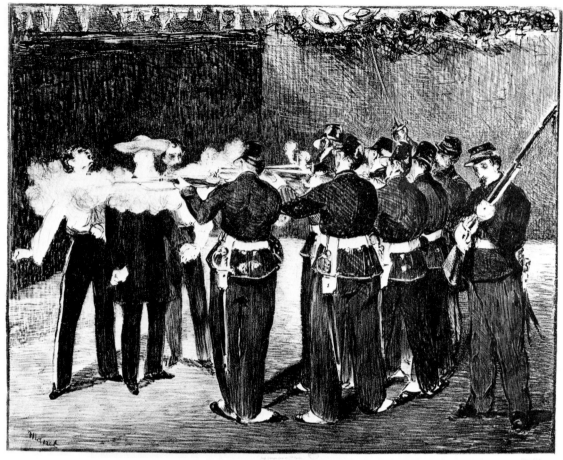

105

rendered figures in the definitive canvas (cat. 104, fig. a) recall certain plates of Goya's *Disasters of War*,[5] published in Madrid in 1863, a copy of which Manet is known to have owned.[6] An even more significant source, not only for the figures in the crowd but also for the development of the different versions of the composition, may have been a wood engraving after Goya's *Third of May, 1808*. This print appeared in Charles Yriarte's major monograph on the life and work of Goya, which was published in Paris and registered at the Dépôt Légal in April 1867,[7] two months before the execution of Maximilian in Mexico. More than any distant memories of Goya's painting in Madrid, this awkward but detailed reproductive print may have led Manet toward the solution of his composition: the desolate landscape is there, as well as background walls (though these are more distant in the Goya), the dramatic but arrested gestures (which are so overwhelming in their emotional force in Goya's painting), and even the diagonal movement on the ground, separating the two groups, and the sharpness of the shadows, which are accentuated in the rather crude wood engraving. All these elements may have played a role in the versions of the composition that followed the first large canvas.

There is no doubt about the depth and intensity of Manet's feelings concerning the dramatic events of June 19, 1867. In a letter to Duret he refers to the "mas[sacre]" and alters it to "execution."[8] Ruggiero drew attention, as Hanson and Griffiths had already done, to the political, anti-Napoleonic

motives underlying Manet's active concern with this theme.[9] There is, moreover, a parallel to be drawn between Manet's attitude and that of Goya, whom he took as his model, in the Spanish painter's response to the French invasion of Spain and the atrocities committed by the troops of Napoleon Bonaparte. Nevertheless, Manet appears to have realized that for purely pictorial as well as diplomatic reasons, as far as the Salon public was concerned, it was necessary to contain his emotion and mask his intention to criticize the true culprit, Napoleon III.

The technique of this lithograph is remarkable for its apparent restraint, and the handling corresponds to the dignified realism of the scene. Manet apparently intended to title it simply *The Death of Maximilian*,[10] a euphemistic title, even more neutral than that of "execution." Someone on Lemercier's staff must have sounded the alarm—"it speaks well for the work," as Manet commented—and he received a letter from the administration in January 1869 informing him that he should not go ahead with the edition, and that his painting—no doubt the definitive version—would not be accepted for the Salon. Griffiths has published documents that clarify the sequence of events,[11] and the whole dossier, as it is known to date from documents published in a variety of sources, is given here in Appendix II. It includes two important new texts that throw light on Zola's involvement, as well as Manet's, in the "Maximilian affair."

The note in *La Chronique des arts* of February 7 suggests that an edition had actually been printed and then refused by the Dépôt Légal authorities, although Manet's letters to Zola and Duret and the January 31 note in *La Tribune* refer to a ban on the *printing*, not the *publication*, of the lithographic image. In any event, Lemercier asked Manet for permission to efface the image on the stone. When Manet naturally enough refused, Lemercier finally returned the stone, and it remained in the artist's studio until his death. In the end, Lemercier's firm was to print the posthumous edition of the lithograph in 1884, together with other unpublished stones from the studio.

1. Sandblad 1954, p. 140.
2. Lochard photograph no. 309: Paris BN Estampes (Dc 300g, I).
3. Harris 1970, p. 152.
4. Francisco de Goya, *La Tauromaquia*, pl. 13, 20, 22, 26, 30.
5. Francisco de Goya, *Disasters of War*, pl. 18, 19, 21, 26, 28.
6. P. Gassier, *Goya dans les collections suisses*, (exhibition catalogue), Martigny, 1982, no. 65.
7. Yriarte 1867, "Le Deux Mai" (incorrect title), drawn by Bocourt and engraved by Dumont, opp. p. 86.
8. See Appendix II, no. 4.
9. *Edouard Manet and the "Execution of Maximilian"* (exhibition catalogue), Brown University, Providence, R.I., 1981, no. 33; Hanson 1970, p. 116; Griffiths 1977.
10. See Appendix II, no. 1.
11. Griffiths 1977.
12. Paris, Archives Nationales (F18 VI 86).
13. Harris 1970, p. 18.
14. Wilson 1977; Wilson 1978.
15. Wilson 1977, no. 73.
16. Rouart and Wildenstein 1975, I, p. 27.
17. Ibid., p. 28.
18. Paris, Archives Nationales (F18 2360 and 2361).
19. Paris, BN Estampes (Ye 79 fol.).
20. Letter from M. Komanecky, who was then curator, dated September 20, 1979.
21. *Edouard Manet and the "Execution of Maximilian,"* 1981, no. 33c, see note 9 above.

Provenance

The DEPOT LEGAL impression was registered on March 26, 1884, and later transferred to the Bibliothèque Nationale. The impression acquired by AVERY (see Provenance, cat. 17) has no indication of an earlier provenance. As it was published in 1884 for Manet's widow, in an edition of fifty impressions, Avery could easily have acquired it through LUCAS and perhaps GUERARD (see Provenance, cat. 17, 16), who was in close contact with Suzanne Manet and who owned more than one impression himself.

Appendix: "THE EXECUTION OF MAXIMILIAN" AND THE 1884 EDITION OF MANET'S LITHOGRAPHS

The size of the posthumous edition of Manet's unpublished lithographs has hitherto remained speculative. The registration of the edition of four lithographs, when the Dépôt Légal was created in the Censorship Bureau of the Ministry of the Interior, lists their publication as follows:

1884	600	26 mars	Lemercier	Exécution de Maximilien Tirage 50 Exempl.	1 lith.	[cat. 105]
	601	do	do	Courses Tirage 50 Exempl.	1 lith.	[cat. 101]
	602	do	do	Portrait de Femme	2 lith.	[H 73]
	603	do	do	Le même avec traits seulement Tirage 50 Exempl. de chaque		[H 74] [see cat. 130]

The figure of fifty impressions of each of the four lithographs, which is recorded in the original Dépôt Légal registers of the Ministry of the Interior,[12] can now be taken to define the edition. It was described by Harris, without documentary evidence, as an edition of one hundred impressions,[13] and this information was subsequently repeated.[14] Harris also erroneously included *Civil War* (H 72; cat. 125, fig. a) in the posthumous edition; it was actually published by Manet himself in 1874, at the same time as *Boy with Dog* (cat. 8).[15] A curious fact to emerge from consultation of the Dépôt Légal registers is that *The Barricade* (cat. 125), which has exactly the same characteristics as the lithographs of the registered edition, was not included with the other four, nor has extensive

checking of earlier and later deposits in the registers revealed a printing at a different date. Its absence appears to be confirmed by the lack of a Dépôt Légal impression in the Bibliothèque Nationale.

The inventory of Manet's effects, drawn up in June and December 1883, recorded among miscellaneous items from Manet's studio "thirty etched copperplates and five lithographic stones by M. Manet, estimated at 300 francs."[16] The minutes of September 1892 concerning the Manet-Leenhoff estate contain the following statement: "The lithographic stones no longer exist; the subjects drawn on these stones by M. Edouard Manet were printed in an edition of 250 impressions and paid for by Mme Manet. The designs thus printed were sold between 1886 and 1889 by Mme Manet to cover her expenses. . . . As to the copperplates, they still exist and are in Mme Manet's possession."[17]

If it is assumed that *The Barricade* was probably issued at the same time as the other four lithographs, in spite of its absence from the Dépôt Légal registers (and Clot's statements seem to confirm this; see cat. 125), the fifty impressions from five stones would give the total figure of 250, as recorded in the 1892 document. The Dépôt Légal proof of *The Execution of Maximilian* has a red date stamp 1884 and pencil registration number 600 and is one of the three proofs that a printer or publisher was bound to "deposit" when an edition was registered with the Censorship Bureau of the Ministry of the Interior. The works deposited were periodically transferred to the appropriate institutions—in the case of prints, two to the then Bibliothèque Impériale (now Bibliothèque Nationale) and one to the Beaux-Arts.[18] The prints were also registered at the Bibliothèque, sometimes in a more summary way, in registers known as the Etats des Dépôts de la Librairie.[19]

A further item of information concerning the *Maximilian* lithograph is that there exists at least one known impression with a variant form of the lettering below the subject. Instead of the usual "Imp. Lemercier et Cie, Paris," the printer's address appears in full, "rue de Seine 57 Paris," on a proof acquired in 1979 by the Philadelphia Museum of Art[20] and published in the catalogue of the exhibition devoted to Manet and the Maximilian theme.[21] It was in this form that Lemercier was indicated on the 1874 edition of *Civil War*, and it is conceivable that the extended letters were added to the Maximilian stone and then rejected in favor of a shorter version for all five lithographs.

J.W.B.

106. Portrait of Emile Zola

1868
Oil on canvas
57½ × 45″ (146 × 114 cm)
Signed (at right, on cover of pamphlet): MANET
Musée d'Orsay (Galeries du Jeu de Paume), Paris

When in 1885, two years after Manet's death, Emile Zola was making notes for *L'Oeuvre*, a novel based in large part on his experience in the art world at about the time of this portrait, he described himself, under the name of Sandoz, as follows: "Dark complexion, heavyset but not fat—at first. Head round and obstinate. Chin square, nose square. Eyes soft in mask of energy. Neckpiece of black beard."[1] Such, in fact, seems to have been Manet's idea of him eighteen years earlier.

Zola had become interested in painting like Cézanne, his boyhood friend, whom he had introduced to the artistic milieu of Paris early in the 1860s. He had very likely seen Manet's work with Cézanne at the Salon of 1861, where *The Spanish Singer* (cat. 10) and the portrait of Manet's parents (cat. 3) had attracted much attention among young artists.

Zola's first ventures into art criticism did not actually appear until 1865, but he saw the Salon des Refusés of 1863 and was kept abreast of avant-garde controversies by Cézanne and Guillemet. He mounted a thundering defense of Manet in his review in *L'Evénement* of the 1866 Salon, from which the painter had been excluded: "Since nobody is saying it, I will say it myself; I will shout it from the housetops. I am so sure that M. Manet will be accounted one of the masters of tomorrow that I think it would be a sound investment, if I were a wealthy man, to buy all his canvases today. . . . M. Manet's place is marked for him in the Louvre, like Courbet's, like that of any artist of strong and uncompromising temperament."[2]

Although Zola may have been taken to Manet's studio in April 1866, probably by Guillemet, to see the paintings rejected for the Salon (see cat. 93), the critic and the painter cannot yet have been well acquainted, but had

Exhibitions
Salon 1868, no. 1660 (Portrait de M. Emile Zola); Beaux-Arts 1883, no. 304; Beaux-Arts 1884, no. 42; Salon d'Automne 1905, no. 7; Berlin, Matthiesen 1928, no. 22; Paris, Bernheim-Jeune 1928, no. 6; Orangerie 1932, no. 30; Venice, Biennale 1934; Orangerie 1952, without no.

Catalogues
D 1902, 93; M-N 1926 I, pp. 99–100; M-N cat. ms., 109; T 1931, 132; JW 1932, 146; T 1947, 137; PO 1967, 118; RO 1970, 118; RW 1975 I, 128

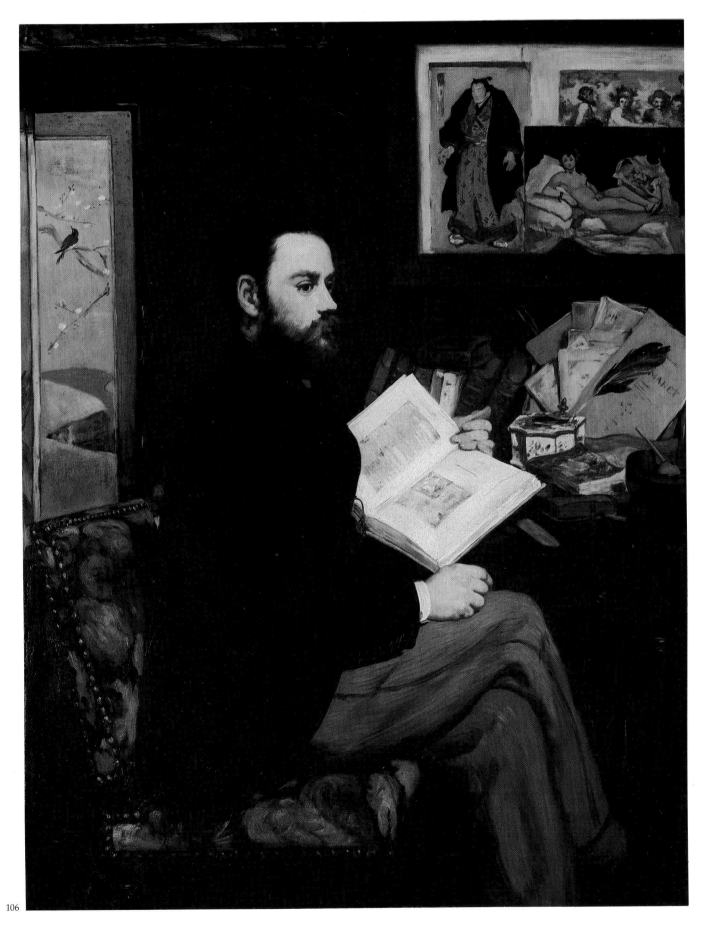

at most seen each other here or there, as indicated in Manet's letter of appreciation written on May 7, 1866, the very day the article appeared. The letter begins, "Dear Monsieur Zola, . . . how proud and happy I am to be championed by a man of your talent," and expresses Manet's desire to meet him: "If it suits you, I am at the Café de Bade every day."[3] Zola resumed and developed the themes of his defense later in the year in a longer paper, expanded with suggestions that came directly from the painter and published January 1, 1867—the same that was to appear in booklet form on the occasion of Manet's independent exhibition on the avenue de l'Alma (see cat. 69).[4]

This defense of Manet, equivocal though it may seem today in that Zola saw his advocacy chiefly as a means of propagating his own literary theories, was extremely gratifying to Manet himself. In appreciation, he offered to do the young man's portrait for the next Salon. Zola was then twenty-seven, eight years Manet's junior.

Zola posed in February 1868, as is attested by a letter written that month to Théodore Duret: "Manet is doing my portrait for the Salon."[5] It has often been said that the portrait was painted partly in Zola's study.[6] Zola himself, in his review of the Salon of 1868, at which the portrait was shown, described the sessions in Manet's studio: "I recall those long hours of sitting. In the numbness that overtakes motionless limbs, in the fatigue of gazing open-eyed in full light, the same thoughts would always drift through my mind, with a soft, deep murmur. The nonsense abroad in the streets, the lies of some and the inanities of others, all that human noise which flows, worthless as foul water, was far, far away. . . . At times, in the half-sleep of posing, I would watch the artist, standing before the canvas, face tense, eye clear, absorbed in his task. He had forgotten me, he didn't know I was there, he was copying me as he would have copied any human animal, with an attention, an artistic awareness, the like of which I have never seen. . . . All about me, on the walls of the studio, were hung those characteristically powerful canvases which the public has not cared to understand."[7]

Clearly it was in a very traditional way that Manet placed his model in a setting calculated to recall the subject's activities and tastes, which in fact represent—as has been noted[8]—not so much the author's as the painter's own. Art historians have identified the emblematic panoply surrounding him; in particular, Reff has surveyed the topic and offered some new suggestions.[9]

On the table, books have been arranged in meaningful disorder by the painter, giving prominence to the sky-blue pamphlet Zola had just issued in his defense, bearing Manet's name, in lieu of signature. The porcelain inkstand has been said to be Zola's own, similar to the one in Cézanne's *Black Clock* (Stavros S. Niarchos collection), and identified as the one still in the family;[10] but the pattern was by no means rare, and it is not necessarily the very same inkstand. Zola is posed with an open book, not looking at it, which seems to be a volume of Charles Blanc's *Histoire des peintres*, one of the works most constantly consulted by Manet in his studio.[11] The idea of the frame at the upper right with several prints or photographs slipped in had been used a year earlier by Degas in *The Collector of Prints* (fig. a). The image of *Olympia*, over Zola's tract, evokes his long and vigorous defense of what he called Manet's masterpiece, "the total expression of his temperament," and Olympia, with a gaze not full face as in the painting but turned toward Zola, seems almost to thank him, to give him a

Fig. a. Edgar Degas, *The Collector of Prints*, 1866. The Metropolitan Museum of Art, New York

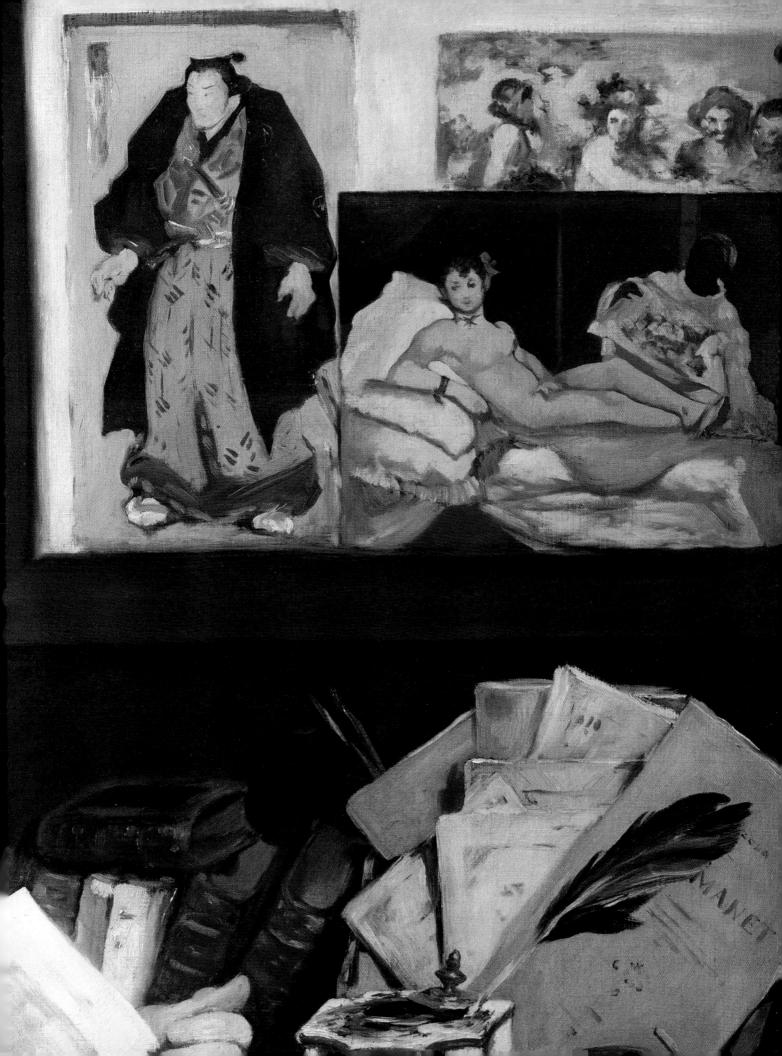

little wink. It is hard to tell whether this is a lost print or an enlarged photograph of one of the engravings, since they alone endow Olympia with a curled fringe of bangs absent in the painting. Above her is an engraving after *Los borrachos* by Velázquez, more likely the Nanteuil one than Goya's.[12] Might one go so far as to see an allusion in this to the Rougon-Macquart theories of hereditary alcoholism that Zola was outlining at the time? Or, in any case, a plastic symbol of the writer's style, since this Velázquez was described by the same Charles Blanc whose book Zola holds in his hand as "a prodigy of palpable reality, of sturdy, brutal, violent naturalism"?[13]

The Japanese print has long been identified; it is a portrait of a sumo wrestler by Kuniaki II (1835–1888), a Japanese contemporary of Manet's.[14] We do not assume an allusion to the artistic battles waged by Manet and Zola, since at the time it was generally supposed that such prints represented actors. In 1867, a taste for Japanese art was an indication of an acceptance of modernism in style, and Manet of all people must have been sensitive to qualities of flatness and "d'un bijou rose et noir" found in his Spanish figures (see cat. 50). It is notable that he shaded the wrestler's robe, blue in the original print, to brown. Nor does the Japanese screen with its light blue border have any specific reference to Zola (we would not adopt Mauner's interpretation that the print represents a samurai with a sword, alluding to Zola's literary immortality[15]). Such Japanese pieces were part of the studio decor. Painted gilt screens appealed to Manet as they had to Tissot, Fantin-Latour, and especially Whistler, who used them in portraits as early as 1863–64 (*The Princess from the Land of Porcelain, Rose and Silver*, Freer Gallery of Art, Washington, D.C.).

Compared to Whistler, or to the Degas of *The Collector of Prints*, mentioned above, who also placed the model in front of a Japanese screen or a frame with Japanese prints inserted, the *Portrait of Emile Zola* is remarkable for its geometrical composition: Zola's upper body erect, not to say rigid, set within three framed elements and forming, with his leg and hand, a sort of capital L, broken only by the slightly artificial perspective of the chair.

At the Salon of 1868, these specifically painterly qualities were generally acknowledged: "This portrait of our colleague Zola, who writes on arts and letters with spirited independence, has nevertheless overcome the wrath 'of the delicate souls.' It has not been found overly unsuitable or overly eccentric. The books, especially the wide-open illustrated volume, and other objects cluttering the wall and table are admitted to be astonishingly real. Certainly the execution is free and generous. But the chief merit of the Zola portrait, as of other works by Edouard Manet, is the light pervading this interior, the modeling and relief it distributes over all."[16]

But contemporaries were struck by the subject's faraway look: "The head looks apathetic and vague."[17] And indeed, we do miss the warmth that can be felt in the portrait of Astruc (cat. 94), who was much closer to Manet at the time. Castagnary objected to the flat painting of the face: "His portrait of M. Zola is one of the best at the Salon . . . unfortunately the face lacks modeling, and looks like a profile pasted on a background. . . . [Manet] sees black and white, and only with difficulty gets objects in the round."[18]

Others objected to an absence of realism, especially in the texture of the trousers, but the most interesting comment came from Odilon Redon, then very young, who on the contrary accused Manet of stopping short at realistic appearance: "This canvas is attractive, one cannot help looking at it . . . it bears the mark of originality, it arouses interest by its harmony, its

novelty, its elegance of tone. M. Manet's fault, and the fault of all who like him would rest content with a literal version of reality, lies in sacrificing the man and his thought to externals, to the triumph of the accessories . . . their human figures are without inner, spiritual life. . . ." He concluded that the Zola portrait is "more like a still life than the representation of a human being."[19]

The reason for the coldness of the face doubtless stems from Manet. Despite his esteem for Zola, whose later novels he was to admire sincerely,[20] and despite his gratitude at the time for Zola's journalistic support, he probably felt no very great affinity with the young author, more intent, less lively than himself—less Parisian, in a word. This carefully staged portrait does have a quality of constraint, reflecting a relative and circumstantial intimacy, and perhaps some slight reserve on the part of Manet, who did not necessarily see their respective artistic causes allied in the same struggle, as Zola proclaimed them to be when that same year he publicly dedicated *Madeleine Férat* to him: "Since fools have joined our hands together, let them never be put asunder. The public has willed my friendship for you; this friendship is now fixed and entire, and I should like to offer a public token thereof by dedicating this work to you." Manet, not given to hyperbole, direct, perceptive, unemphatic, but thoroughly aware of the merit of his own work, must assuredly have been only mildly amused by this public-relations strategy. Yet his letters to Zola, which he continued to write to the end of his life, evidence a growing friendship through the 1870s, though a shadow crossed it in 1879 (see Chronology and Appendix I).

As time went on, the novelist's support for Manet in 1866–68, the most unqualified and conspicuous recognition the artist received in his lifetime, must have seemed still more dramatic. The portrait of Zola, beyond any mutual reservations, gives evidence of esteem and friendship. When Fantin-Latour painted the *Studio in the Batignolles Quarter* (see p. 30, fig. 1), showing Manet at work with artists and critics of the Café Guerbois group just before the Franco-Prussian War of 1870, Zola appeared among the few standing near him, between Renoir and Bazille. He wears the same absent, myopic look, something more youthful and less assured than in the portrait by Manet, who perceived the man's power and obstinacy, his "forthright, frank, and honorable" character, which Manet had "long held dear," as he was to write many years later.[21]

1. Zola 1966, IV, p. 1364.
2. Zola 1959, pp. 65, 68.
3. See Appendix I, letter 1.
4. Zola 1867, *L'Artiste* and (Dentu).
5. John Rewald, *Cézanne et Zola*, Paris, 1936, p. 61.
6. Tabarant 1947, p. 145; Jean Adhémar, "Le Cabinet de travail de Zola," *Gazette des Beaux-Arts*, 6th ser., LVI (November 1960), pp. 285–98.
7. Zola 1959, p. 124.
8. Faison 1949, pp. 163–68.
9. Reff 1975, pp. 36ff.
10. J. Adhémar 1960, p. 287, see note 6 above.
11. Reff 1975, p. 36.
12. Ibid., p. 39.
13. Ibid., p 40.
14. Wiese, cited in Reff 1975, p. 39.
15. Mauner 1975, p. 127.
16. Bürger (Thoré) 1870, II, p. 532.
17. Paul Mantz, "Salon de 1868," *L'Illustration*, June 6, 1868, pp. 360–62.
18. Castagnary 1868, quoted in Moreau-Nélaton 1926, I, p. 99.
19. Roseline Bacou, *Odilon Redon*, 2 vols., Geneva, 1956, p. 45.
20. See Appendix I, letters 7, 11, 23, 44.
21. Ibid., letter 43.
22. Goncourt 1956, III, p. 1249.
23. Cited by M. Hoog in Paris, Grand Palais, *Centenaire de l'impressionnisme* (exhibition catalogue), Paris, 1974, no. 20.

Provenance
Given by Manet, probably as soon as it was finished, to EMILE ZOLA (1840–1902), this portrait and the paintings given to him by Cézanne were the only works of art in his house; visitors agreed in describing a predominance of bric-a-brac and accumulated objects not in the best taste. The portrait by Manet was not prominently on view at Médan, perhaps in deference to Mme Alexandrine Zola. This circumstance was noted by several contemporaries in the 1890s, notably J. K. Huysmans, who, Goncourt admitted, "goes out of his way to be uncharitable . . . and says that in this house, boasting only one work of art, Manet's portrait of Zola, it is relegated to a vestibule."[22] Interviewing Zola toward the end of his life, Adolphe Retté told him of his "admiration for the portrait Manet did of him, which adorned the billiard room," and reports Zola's reply (but this is hearsay, from a source hostile to Zola): "Yes, the portrait's not bad; all the same, Manet was no very great painter; his was a flawed talent."[23] After Zola's death in 1902, MME ZOLA kept the painting; in 1918, she donated it to the state, reserving a life interest. It went to the Musée du Louvre upon her death in 1925 (inv. RF 2205).

F.C.

107. Mme Manet at the Piano

1867–68
Oil on canvas
15 × 18″ (38 × 46 cm)
Musée d'Orsay (Galeries du Jeu de Paume), Paris

Suzanne Leenhoff (1830–1906) was by all accounts an excellent pianist, and Manet and those about him took great pleasure in hearing her play. He had known her since she was in her early twenties, giving piano lessons to his younger brothers. They lived together, very discreetly, from the time he left his parents' household, but they did not marry until October 1863, a year after his father's death. She had been something of a "secret" from his friends in the meantime, and Baudelaire wrote to Carjat on October 6, 1863, in astonishment, "Manet has just given me the most unexpected news. He's off to Holland tonight, and will return with *his bride*. There is some excuse for him though; it seems she's beautiful, very nice, and a really good musician."[1]

The daughter of an organist, Suzanne was by reputation a brilliant performer of classical music, and of modern German music (notably Schumann), then known to but few in France. Fantin-Latour recorded his enthusiasm in letters of October and November 1864 to Mrs. Edwards. He had heard several informal concerts at the home of Mme Paul Meurice, who with Suzanne Manet played Schumann and Beethoven four hands.[2]

Fantin-Latour and Whistler had each essayed the theme of a young pianist in the 1850s. Degas, probably in 1865 but in any case previous to this canvas, had done a portrait of Manet listening to his wife perform (fig. a).[3]

Exhibitions
Beaux-Arts 1884, no. 47; Orangerie 1932, no. 26; Orangerie 1952, without no.; London, Tate Gallery 1954, no. 8; Marseilles 1961, no. 10

Catalogues
D 1902, 98; M-N 1926 I, p. 95; M-N cat. ms., 105; T 1931, 134; JW 1932, 142; T 1947, 142; PO 1967, 122; RO 1970, 122; RW 1975 I, 131

Fig. a. Edgar Degas, *Edouard Manet and Mme Manet*, ca. 1865. Kitakyushu City Museum of Art

107

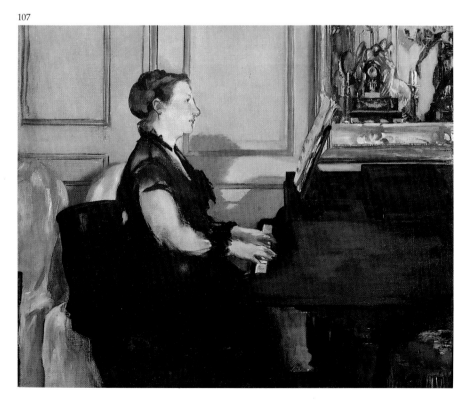

Fig. b. Engraving after Gabriel Metsu, *Dutchwoman Playing the Clavichord*, in Charles Blanc, *Histoire des peintres*

Degas presented it to Manet, who, apparently dissatisfied with Suzanne's face, cut it away—to Degas's understandable indignation, causing a short-lived rupture between the two friends. Suzanne's profile, less than felicitous in this painting, must have given Manet some trouble; not only did he eliminate Degas's attempt but he obliterated one of his own as well, made on another occasion (see cat. 164).

Manet here echoes the composition of the right-hand portion that he had cropped from Degas's canvas: "Manet, judging that he himself could do better, had coolly sliced away Mme Manet, all but a bit of skirt. . . . However, it must have been Degas's work that suggested one of Manet's masterpieces, *Mme Manet at the Piano*. Everyone knows how apt [he] was to be influenced."[4]

However, it would seem that Manet drew his primary inspiration from a little picture by Gabriel Metsu, shown in the municipal collections, and in any case reproduced in Charles Blanc's *Histoire des peintres* (fig. b).[5] Not only is the pose the same; the atmosphere, the soft facial expression, the fullness of the face, and even the outline of the nose are similar, while the delineation of the wood paneling behind Mme Manet recalls that of the frames in the background of Metsu's painting. By harking back to a work by Metsu, Manet was multiplying references to an art that was precious to him; moreover, Suzanne was herself Dutch, and he always associated her with northern European art, in *The Surprised Nymph* (cat. 19), for example. Further, Manet visited Holland several times; one of his first trips, very likely an escapade with Suzanne, took place in 1852, when he was barely twenty.[6]

The scene is the salon of Mme Manet *mère*, with whom the couple had been living at 49, rue de Saint-Pétersbourg for some months. The clock, according to Léon Leenhoff, would be the one presented to Manet's mother by the Bernadotte king of Sweden, Charles XIV, on the occasion of her wedding in 1831.[7]

It is interesting to note that at about the time of this painting, Suzanne Manet went regularly with Mme Paul Meurice to play the piano—Wagner especially—for Baudelaire, now unable to speak and half paralyzed, during the months preceding his death, when he was at the Chaillot clinic for hydrotherapy.[8]

1. Baudelaire 1973, II, p. 322.
2. Adolphe Jullien, *Fantin-Latour: Sa vie et ses amitiés, lettres inédites, et souvenirs personnels,* Paris, 1909.
3. Lemoisne 1946, no. 127.
4. Vollard 1938, p. 187.
5. Blanc 1861, I, "Metsu," p. 3.
6. Ten Doesschate Chu 1974, p. 45.
7. Tabarant 1931, p. 185.
8. Asselineau, cited in Tabarant 1947, p. 393.
9. New York, Pierpont Morgan Library, Tabarant archives: Mme Manet's account book.
10. Charles Stuckey, *Toulouse-Lautrec: Paintings* (exhibition catalogue), The Art Institute of Chicago, Chicago, 1979, p. 285.

Provenance
Manet never sold this intimate painting. In 1872—curiously, under the title "Jeune dame à son piano" (young woman at the piano)—he valued it in his notebook at 5,000 Frs, the same as *Lola de Valence* (cat. 50) and slightly less than *Music in the Tuileries* (cat. 38). It was not in the Manet sale, and SUZANNE MANET (see Provenance, cat. 12) did not part with it until November 23, 1894, for 5,000 Frs,[9] to Toulouse-Lautrec's friend MAURICE JOYANT (see Provenance, cat. 181). It probably served as inspiration for Lautrec's *Misia Natanson at the Piano*.[10] It was sold in March 1895 for 10,000 Frs (Camondo notebooks) to COMTE ISAAC DE CAMONDO (see Provenance, cat. 50). In 1908, he bequeathed it, along with his entire collection, to the Musée du Louvre, which it entered in 1911 (inv. RF 1994).

F.C.

108. Portrait of Théodore Duret

1868
Oil on canvas
17 × 13¾" (43 × 35 cm)
Signed and dated (lower left, reading upward): Manet 68
Musée du Petit Palais, Paris

Manet had met Théodore Duret by chance in a Madrid restaurant in 1865, under amusing circumstances recounted at length by Duret in his monograph—Manet loudly declaring his opinion of Spanish cuisine, and

turning on Duret, who he thought was ridiculing him, a sign of the state of his nerves after the *Olympia* scandal (see cat. 64): "[Manet] confessed to me that he had taken me for someone who recognized him and was trying to play a mean trick on him. At the thought of being overtaken in Madrid by the persecution he had fled in Paris, he lost his temper. Acquaintanceship, once commenced, became intimacy; we saw the sights of Madrid together."[1]

Théodore Duret (1838–1927), as a young man in the Cognac trade, began to take an interest in painting in 1862 and in 1867 published his first work of criticism, in which he was especially severe with his new friend: "Manet is not doing himself justice; he holds himself well below what he might be, by painting too fast and too carelessly."[2] He soon changed his mind, although apparently there had been no cloud on his growing friendship with Manet, who entrusted his canvases to Duret in 1870 at the time of the siege of Paris, and named him executor of his estate. Far from objecting to the sketchlike style of the Impressionists, as he had to Manet's, Duret presently became a fierce champion of the new painters by placing his pen at their service and by purchasing their works, of which he built an exceptional collection. He wrote the first major study of their work, *Histoire des peintres impressionnistes* (1878).

In the year of this portrait, Duret, an ardent republican, together with Zola, Pelletier, and Jules Ferry, had just founded a newspaper, *La Tribune française*, and Manet would often drop by at the offices. Duret tells how Manet painted his portrait in the rue Guyot studio: "When it was finished—or at least I thought it happily complete—I saw that Manet was still dissatisfied. He felt that something should be added. One day when I came in, he had me resume my pose, and placed beside me a low stool, which he proceeded to paint, with its garnet-red upholstery. Next it occurred to him to pick up a stitched volume and throw it under the stool, and he painted that, in its light green color. Yet again, he set a lacquer tray on top, with carafe, glass, and a knife. . . . Lastly, he added one object more—a lemon, surmounting the glass on the tray. I had been watching him make these successive additions, in some surprise, wondering what the reason might be, when I realized that I was witnessing in action his instinctive and, as it were, organic mode of seeing and feeling. Evidently, a canvas allover gray and monochrome was not to his liking. He missed the colors that might satisfy his eye, and not having put them in at first, he had added them afterward, in the manner of still life."[3] When he received the portrait, Duret wrote to Manet suggesting that he erase his signature "in full light" and sign "*invisibly*, in the shadow": "By so doing, you would give me a chance to elicit admiration both of the picture and of its painting. I could say, as occasion offered, It's a Goya, a Regnault, a Fortuny. A Fortuny!!! That would be the best of all. Then I would let the cat out of the bag, and the bourgeois caught in the trap would be forced to swallow it down."[4] Manet only half complied, signing the canvas again, in the same place but upside down. The reference to Fortuny, a fashionable painter (father of the couturier and decorator immortalized by Marcel Proust), is an echo of an "in" joke, and not without irony in retrospect, considering that the part of the rue Guyot where this portrait was painted is known today as the rue Fortuny.

The Hispanic flavor of this little canvas leaps to the eye, evoking Goya, as Duret suggests, rather than Velázquez. Once more, Charles Blanc's publication affords what may have been the inspiration, Goya's *Young Man in Gray* (fig. a),[5] with the same position reversed, and even the cane. Manet

Exhibitions
Beaux-Arts 1884, no. 43; Berlin, Matthiesen 1928, no. 23; Orangerie 1932, no. 29; Orangerie 1952, without no.; Marseilles 1961, no. 11; Philadelphia-Chicago 1966–67, no. 87

Catalogues
D 1902, 94; M-N 1926 I, pp. 100–101; M-N cat. ms., 110; T 1931, 133; JW 1932, 147; T 1947, 138; PO 1967, 119; RO 1970, 119; RW 1975 I, 132

Fig. a. Engraving after Francisco de Goya, *Young Man in Gray*, 1805–6, in Charles Blanc, *Histoire des peintres*

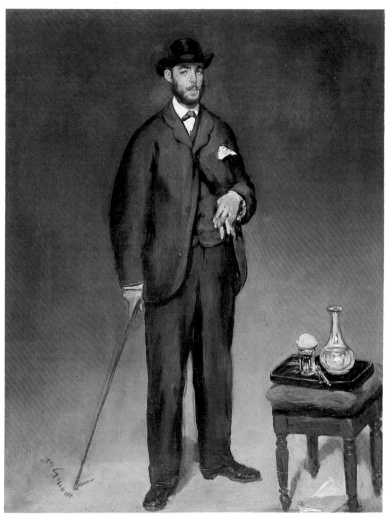

108

Fig. b. Francisco de Goya, *Manuel Lapeña, Marquis of Bondad Real*, 1799. The Hispanic Society of America, New York

was evidently making a deliberate reference to their shared experience of and enthusiasm for the paintings they saw together in Madrid. George Mauner has made a persuasive comparison also to Goya's portrait of Manuel Lapeña (fig. b) that Manet might have seen at the residence of the duke of Osuna.[6] The placement of the subjects, the cut of the coat, the rather stiff elegance are comparable. The paraphrase is still more striking in the position of the cane pointing at the signature. But Mauner no doubt pushes ingenuity of interpretation too far when, learning that Lapeña was a general of faint courage, he deduces that Manet meant to represent Duret, who had not yet championed his friend in the press, as equally timid. Manet, unaware of this trait in the Spanish duke, could not have chosen such devious means to express disappointment in the article cited above, nor would it have been in character. In the lemon, again, Mauner sees a sour allusion to the "false friend," and in the fact that the green book, which he supposes to be a work by Duret, lies on the floor, a token of the painter's exasperation. We cite this only as an instance of a certain tendency current today to overinterpret Manet's iconography, in fact too long neglected. In this particular case, we would take Duret's testimony, without attributing tortuous motivations to the artist or his subject.

Manet, who had dubbed Duret "the last of the dandies,"[7] enjoyed

289

emphasizing his well-known, slightly affected elegance, which together with his tall stature gave him a "British" look, and here the air of one paying a call and not quite at ease. In 1882, Whistler, a friend of both the critic's and the painter's, portrayed Duret hat in hand, a coat over his arm, giving the same impression of having stopped by just for a moment (Metropolitan Museum of Art, New York).

There is no allusion in this portrait to Duret's fascination with Far Eastern art; in 1871–72, he was able to make a world tour with his friend Cernuschi and help him put together the celebrated collection now in the Cernuschi Museum in Paris. Manet had already taken from Japan what interested him; Duret had not introduced him to it. It would rather have been Manet who helped to form his friend's taste, and when in 1885, under the title *Critique d'avant garde*, Duret reprinted his best critical pieces from about 1870 on—omitting, be it noted, the 1867 article quoted above—he dedicated the work "to the memory of my friend Edouard Manet."

1. Duret 1926, p. 46.
2. Duret 1867, p. 111.
3. Duret 1926, pp. 88–89.
4. Tabarant 1931, p. 183: Duret to Manet, January 20, 1868.
5. Blanc 1869, "Goya," p. 11.
6. Mauner 1975, pp. 104–8.
7. Fels 1963, p. 26.
8. Moreau-Nélaton 1926, I, p. 101.
9. Paris, Bernheim-Jeune, *Portraits d'hommes* (exhibition catalogue), Paris, 1907, no. 80.
10. Archives, Petit Palais, Paris.
11. Pers. comm., Dr. Charles Cachin, one of the heirs, under age at that time, of Théodore Duret.

Provenance
Manet presented THEODORE DURET with his portrait and received the following letter of thanks, dated Cognac, September 23, 1868: "My dear Manet, My position as a journalist not enabling me to recompense you for the portrait according to the artistic merit of your painting, and as I am reluctant to offer its market value, I am sending you from Cognac a small souvenir and token of gratitude. You will receive, at 49, rue de Saint-Pétersbourg, a case of old Cognac brandy, which you may with confidence invite your friends to taste."[8] This painting was one of the few Duret retained when a reverse in fortune in 1894 obliged him to sell his collection, including six paintings by Manet. He kept the work until January 1908, when he wrote to Lapauze, director of the Petit Palais, the museum of the city of Paris: "I should like to donate Manet's little portrait of me to your museum. I recently took it down to lend to an exhibition,[9] and now that I am about to hang it again, in a rather dark corner, it occurs to me that it would be better off with you."[10] It then entered the Petit Palais (inv. 485). A generous decision, and well advised, for following Duret's death in 1927, it was discovered that most of the works in his collection had recently been stolen and replaced by crude fakes, without his knowledge, for he had become blind. The inventory of the estate, which was drawn up to facilitate its division among Duret's heirs, revealed that the paintings were forgeries, and the painter Paul Signac, called in as a consultant, confirmed the opinion of the appraisers. After an investigation, proceedings were nonsuited for lack of proof—although there were strong suspicions—of the identity of the thief, and the court ordered the signatures obliterated and the paintings sold.[11]

F.C.

109. The Luncheon (The Luncheon in the Studio)

1868
Oil on canvas
46½ × 60⅝" (118 × 153.9 cm)
Signed (lower center, on tablecloth): E. Manet
Bayerische Staatsgemäldesammlungen, Munich

In spite of the various interpretations suggested over the past decade, this remains one of Manet's most enigmatic works. The circumstances of its creation are known through Tabarant,[1] who obtained the information from Léon Leenhoff, the principal figure in the painting.

Here is Léon again, an adolescent this time, seven years older than in *Boy with a Sword* (cat. 14), at Boulogne for the summer of 1868, in rented lodgings with windows overlooking the harbor. A sketch by Manet of the young man—his left hand closed as in the painting—with the seated figure smoking, and on the table the coffee cup, glass, and so forth (RW II 347),

Exhibitions
Salon 1869, no. 1617 (Le déjeuner); Brussels 1869, no. 755; Beaux-Arts 1884, no. 48; New York, Durand-Ruel 1895, no. 11; Exposition Universelle 1900, no. 447; Munich, Moderne Galerie 1910, no. 10; Paris, Bernheim-Jeune 1910, no. 10; Orangerie 1932, no. 31

Catalogues
D 1902, 110; M-N 1926 I, pp. 106–17; M-N cat. ms., 113; T 1931, 139; JW 1932, 149; T 1947, 139; PO 1967, 120; RO 1970, 120; RW 1975 I, 135

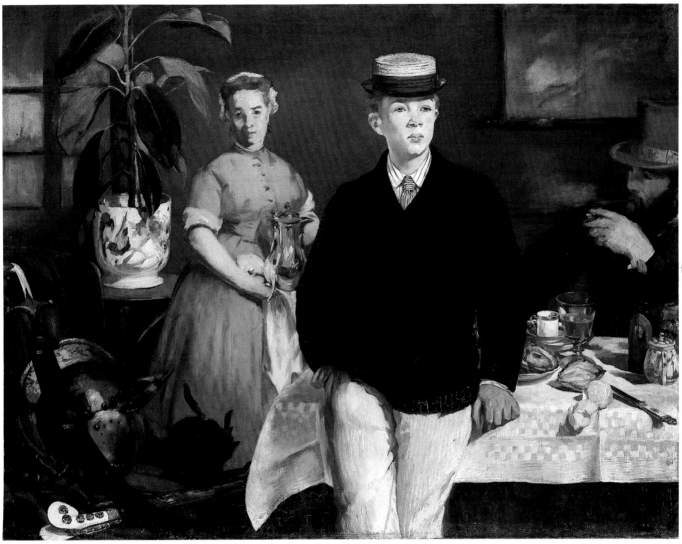

109

Fig. a. X-ray of the canvas

must, in fact, have been done after the finished work rather than as a study for it, since a recent X-ray shows that in the painting Léon's hand was originally open. According to Tabarant, there was a lost oil sketch; this was more probably Manet's roughing out of the final canvas.

The X-ray (fig. a)[2] sheds further light on the genesis of the composition. It seems that to begin with the picture really was painted in a studio setting, whence the traditional title: behind the table, the glazing of the studio, with its seven metal uprights, is clearly visible. Apparently the jardiniere was already in the composition, and behind it Manet utilized the uprights as part of the window. Over Léon's left shoulder, he used part of an upright for the picture frame. Léon's face was enlarged and his whole silhouette filled out, bringing him closer to the spectator.

All the figures have been satisfactorily identified. Behind Léon is a maid at the left—not Mme Manet as has been said[3]—and at the right, smoking a cigar, a Boulogne summer neighbor, Auguste Rousselin, a former pupil of Gleyre's and of Couture's, at whose studio Manet and he had met.[4] In his place, Claude Monet reportedly posed for the first few sittings.[5] The scene looks prosaic enough: the luncheon is over, coffee is served, the maid brings in—or takes away—a silver coffee pot. A man, still at the table, sits quietly smoking, and at center, leaning back against the table, the principal figure seems about to leave the house, boater on head. It is as though Manet had caught his models, Léon especially, "irked by their models' roles" and impatient with their protracted sittings.[6] No glance or word is exchanged among them, and only the maid looks out at us.

On the basis of a mistaken interpretation (that the man and woman in the background represent—really or symbolically—Manet and his wife, Suzanne Leenhoff, Léon's presumed father and his mother), the picture has been seen as a symbolic representation of young manhood coming of age.[7] Alien as it seems to what we know of Manet, this interpretation serves nonetheless to recall an interesting fact about Léon: he had just entered, if not the adult world, at least the world of work. For several months he had been a runner for the banking house of Degas's father.[8] That Manet, aware of the change in the boy, now past sixteen years of age, should pay him special attention, and perhaps feel some concern for his future, is not surprising. Of all Manet's portraits of Léon, this is indeed the most searching, the most specific. Here is a youth extremely concerned about his appearance (sporting perhaps the proceeds of his first earnings?). Boater, cravat, shirt, and velvet jacket are painted with particular care and brilliance, no doubt with some amusement. The face is closed, self-indulgent, lackluster; it cannot be said that Léon was to show a lively intelligence or any great respect for the work of the man he called, to the end of his life, his "godfather." Apart from Manet's affection for Léon, almost nothing is known of what he thought of his "son"—paternity has not been proved—or at least the child he reared, whether in their relations he was indulgent, protective, or impatient. This portrait is evidence only of a consuming curiosity reminiscent of Flaubert, whose L'Education sentimentale appeared the same year.

The meaning, if any, of the weaponry remains obscure. It is the only feature—once the glazing was eliminated—that might justify the name of "studio" for this bourgeois dining room, where it is quite out of place. But what studio? Manet's was by no means cluttered with the Oriental or military curios dear to so many painters of the time; indeed, it is known that he borrowed the helmet and scimitar from his studio neighbor the painter

Monginot.[9] Their presence serves to set the stage and to show by contrast that for Manet the studio was life itself, daily fare, the household cat (see cat. 111; cat. 113, fig. a). The still life of warlike attributes may be compared to a contemporary still life by Vollon, *Curiosités* (Musée de Lunéville).[10] Might there not be an ironic allusion here to the realistic painting, still tinged with romanticism, of his fellow artists?

The composition is new in kind for Manet, bringing together several elements painted from life—and much elaborated—that he had treated previously in similar ways: the highlight on Léon's face recalls the *Portrait of Victorine Meurent* (cat. 31), and the still life on the table at the right, especially the peeled lemon and the knife, is a quotation from earlier still lifes (cat. 80–82). It is difficult to follow Collins's reading of this painting as, from left to right, a chronology of Manet's artistic stages, a sort of "real allegory" in the manner of Courbet: left, the "romanticism" of the early 1860s, symbolized by the still life of arms and armor; center, "Baudelairean" modernity, with black cat fresh from the bed of Olympia, washing itself; right, proto-Impressionist realism, already akin to Monet and Renoir.[11]

The strangeness of the composition, in which the protagonists ignore each other, has distant echoes of Degas's *The Bellelli Family* (Musée du Louvre, Paris). But the idea of painting a table half cleared at the end of a meal obviously comes straight from the Netherlands, with no specific painting as necessarily the source of the composition. The quality of light and what appears to be a map on the wall of course suggest Vermeer, who had just been restored to grace by Théophile Thoré in a major series of articles for the *Gazette des Beaux-Arts* in 1866. Renoir had painted a similar subject two years before in *At the Inn of Mother Anthony* (fig. b), and that painting may actually have provided the idea for this *Luncheon* (Manet could have seen it in 1867 at Bazille's studio, where Renoir completed it late in 1866).[12] But whereas Renoir's scene is easy to interpret, the image grasped immediately—the maid really serving, the two men really taking their coffee and looking at each other as they speak, the one on our side of the table quite naturally with his back to us—with Manet, on the contrary, all is staged, posed, marshaled, down to the location of the rubber plant, filling a natural space. In contrast to Renoir's spontaneity and softness of touch, his is a work more mysterious, more violent in handling and more novel in arrangement, in the daring idea of placing in close-up before the table a figure cut off at the knees. Volume and depth are indicated only by a difference in handling, the background being sketchier. The domestic scene is made impressive by the bold black mass of the jacket in the foreground and by the geometrical strength of the cruciform composition, reinforced by the window at the left and the frame of the map hanging at the upper right.

At the 1869 Salon, which accepted this painting as well as *The Balcony* (cat. 115), critics generally admired the painterly qualities in the still life but deplored the "vulgarity" of the subject or, from the realists' standpoint, the implausibility of theme. Castagnary wrote: "M. Edouard Manet is a true painter. . . . Hitherto he has been more fanciful than observing, odd rather than compelling. . . . His subjects he takes from poetry or from his imagination, not from the ways of real life. Hence there is much that is arbitrary in his compositions. Looking at *The Luncheon,* for example, I see on a table where the coffee is served a half-peeled lemon and some raw oysters. . . . Similarly, the figures are distributed at random, with nothing of necessity or compulsion to determine their composition."[13] And Théophile Gautier

Fig. b. Pierre-Auguste Renoir, *At the Inn of Mother Anthony*, 1866. Nationalmuseum, Stockholm

asked: "But why these weapons on the table? Is this the luncheon that follows or precedes a duel?"[14]

The Luncheon in the Studio is, nevertheless, a key work in Manet's development, his first true "naturalist" scene, initiating a series that a decade later would lead to A Bar at the Folies-Bergère (cat. 211), a work somewhat analogous to this one.

The Impressionist prototype of a gathering at table, which was to culminate in Renoir's The Luncheon of the Boating Party, 1881 (Phillips Collection, Washington, D.C.), was being established at the same time; in late 1868, Claude Monet was painting his own Luncheon (Städelsches Kunstinstitut, Frankfurt), possibly suggested by Manet's canvas.[15] But here again, the naturalness of the composition contrasts with Manet's elaboration. Manet, as he was always to do, even in his "Impressionist" phase, concentrates all the energy in the principal figure or figures.

This is an essential difference between Manet and his friends, revealing a radically divergent attitude toward reality and nature. In Manet, there is no trace of pantheism but a passion for color and the texture of paint— shared by his young Impressionist friends—combined with an individualism and a use of the art of the past, drawing upon a heritage his friends did not possess. The Luncheon in the Studio, although a thoroughly modern work in its own time, cannot be fully understood without reference to Dutch art, and to Velázquez. As in the work of the painter of Las meninas (Museo del Prado, Madrid), the modulation of grays is particularly subtle, and the black velvet of the jacket in no way creates a "hole" in the center of the composition—a sort of pictorial gamble perhaps also inspired by the art of Japan.

Henri Matisse, who saw The Luncheon in the Studio at Bernheim's in 1910, was so taken with it that he referred to it thirty-six years later: "The Orientals used black as a color, notably the Japanese in their prints. Nearer home, in a certain painting by Manet, I recall that the black velvet jacket of the young man in a straw hat is a bold and luminous black."[16]

1. Tabarant 1931, p. 189.
2. Dr. H. F. von Sonnenberg, Director, Doerner Institut, Bayerische Staatsgemälde-sammlungen, Munich, pers. comm.
3. Kovács 1972.
4. Moreau-Nélaton 1926, I, p. 107.
5. Jamot and Wildenstein 1932, p. 149.
6. Stuckey 1981, p. 104.
7. Kovács 1972.
8. Tabarant 1947, pp. 153–54.
9. Tabarant 1931, p. 189.
10. Collins 1978–79, p. 109.
11. Ibid.
12. Champa 1973, p. 42.
13. Castagnary 1869.
14. Gautier 1869.
15. Seitz 1960, p. 80.
16. Henri Matisse, Ecrits et propos sur l'art, Paris, 1972, p. 203.
17. Manet et al., "Copie faite pour Moreau-Nélaton . . . ," p. 132.
18. Ibid., p. 75.
19. Meier-Graefe 1912, p. 314.
20. Havemeyer 1961, p. 225.
21. Meier-Graefe 1912, p. 316.

Provenance

As is seldom the case with Manet's works, we have almost the complete history of prices paid for this painting. In his inventory of 1872, Manet himself valued it at 10,000 Frs,[17] but he sold it the following year to FAURE (see Provenance, cat. 10) for 4,000 Frs.[18] The latter sold it twenty-one years later, in 1894, for 22,500 Frs, to DURAND-RUEL (see Provenance, cat. 118),[19] who sold it in 1898 to AUGUSTE PELLERIN (1852–1929) for 35,000 Frs. In the meantime, the dealer apparently offered or even sold it to MR. AND MRS. H. O. HAVEMEYER (see Provenance, cat. 33), since in her memoirs, Mrs. Havemeyer recalls that the canvas "hung upon the walls of our gallery until one day—for some reason I never understood—Mr. Havemeyer asked me if I objected to his returning it to the Durand-Ruels."[20] Pellerin, the margarine manufacturer who bought the painting in 1898, built a remarkable collection, noted for the number and quality of its Cézannes, among which he or his children bequeathed or donated to the Musée du Louvre such famous works as Still Life with Onions, Woman with a Coffee Pot, and Achille Emperaire. The present picture was included in the impressive group of works by Manet that he sold in 1910 to the dealers BERNHEIM-JEUNE, PAUL CASSIRER, and DURAND-RUEL (see Provenance, cat. 31, 13, 118) for a sum said to have totaled 1,000,000 Frs.[21] (For his drawings by Manet, see Provenance, cat. 100.) Cassirer sold The Luncheon in 1911 for 250,000 Frs as a gift to the Munich museums (inv. 8638) "by a collector, in memory of H. von Tschudi." The painting had in fact been exhibited in Munich twenty years earlier, at the great exhibition of 1891, and Hugo von Tschudi (1851–1911) had studied it and reproduced it in his book on Manet in 1902. Understandably, he was particularly interested in the work when it appeared on the German art market. He died before the purchase was made, but his wish was later fulfilled.

F.C.

110

110. Study of a Boy

1868
Red chalk
12¾ × 9⅛" (32.5 × 23.2 cm)
Signed (lower right): ed. Manet
Museum Boymans-van Beuningen, Rotterdam

Catalogues
L 1969, 232; RW 1975 II, 465

1. Alain de Leiris, "The Drawings of Edouard Manet." Ph.D. diss., Harvard University, Cambridge, Mass., 1957, p. 158.
2. Mongan 1962, no. 794.

This drawing, quite classical in workmanship, probably represents Léon Leenhoff. It may be related to—though not a preparatory study for—the chief figure of *The Luncheon in the Studio* (cat. 109). The characteristic face, with long, bowed upper lip, short nose, and somewhat protruding ears, is apparently Léon's at the time of *The Luncheon*; he may even be wearing the same clothes. Although the line and the shading of the face originally suggested an earlier dating to Leiris, about 1860,[1] both Agnes Mongan and he subsequently adopted this later date.[2]

Provenance
No trace of this drawing is known before its appearance in the collection of FRANZ KOENIGS (see Provenance, cat. 13) in Haarlem (he also owned *Annabel Lee: Young Woman by the Seashore*, cat. 152). It later belonged to D. G. VAN BEUNINGEN (see Provenance, cat. 13) of Rotterdam, whose gift provided the foundation for the museum's collection (inv. F. II 104).

F.C.

111. Sheet of Cat Studies

1868
Crayon and India ink wash
5 × 3¾" (12.7 × 9.5 cm)
Atelier stamp (near center): E.M.
P Musée du Louvre, Cabinet des Dessins, Paris

The cat making its toilet at the upper left is the one adding a humorous touch to the weaponry on the armchair in the left foreground of *The Luncheon in the Studio* (cat. 109), and reappearing in a print of the same period (cat. 113, fig. a). The cat lying down at the left, rolling, appears in the preliminary sketch for the lithograph *Cats' Rendezvous* (cat. 114, fig. c), which Manet did the same year, 1868, as a poster announcing publication of Champfleury's book *Les Chats* (see cat. 117). The third does not seem to have been used again, except for the whipping tail of the black cat on the roof in the lithograph.

These cat sketches inevitably remind one of Japanese prints. In fact, several cats from a leaf by Hiroshige (fig. a) are reproduced in facsimile in Champfleury's book (fig. b), and all the artists and writers around Manet—Bracquemond, Burty, Champfleury, Duret, Zola—were at the time fascinated by the art of Japanese prints, as these little drawings attest.

Catalogues
D 1902, p. 32; L 1969, 226; RW 1975 II, 617

1. Pellerin sale, Paris, June 10, 1954, album no. 3.

Provenance
Purchased by AUGUSTE PELLERIN (see Provenance, cat. 100), probably from Antonin Proust (see cat. 187), this drawing was included in album no. 3 at the Pellerin sale in 1954,[1] when it was acquired by the Musées Nationaux (inv. RF 30.380).
F.C.

111

Fig. a. Hiroshige, page of cat studies, in *Ryusai gafu*, ca. 1836, woodcut

Fig. b. Engraving after Hiroshige (attributed to Hokusai), in Champfleury, *Les Chats*, 1868

112a

112b

112a. Black Cat, Bristling

1868?
Pencil
4⅛ × 3⅛" (10.5 × 7.8 cm)
Atelier stamp (lower right): E.M.
P Musée du Louvre, Cabinet des Dessins, Paris

112b. Page of jottings, with a Cat

1868?
Pencil
3⅞ × 2¾" (9.8 × 7 cm)
Atelier stamp (lower center): E.M.
P Musée du Louvre, Cabinet des Dessins, Paris

112a
Catalogues
L 1969, 230; RW 1975 II, 643

112b
Catalogues
L 1969, 231; RW 1975 II, 644

1. Pellerin sale, Paris, June 10, 1954, album no. 3.

The undated drawing at the left recalls the diverting black cat of *Olympia* (cat. 64), stretching and tail in air. A rapid, trembling line, the prominent head, and the extended claws here portray a cat bristling with anger or fear, whereas in *Olympia* one has the impression of a cat just awakened and stretching. A light sketch of a cat's head is seen in the lower part of the sheet.

At the right, the line drawing of a cat from life dates from before 1870. Manet had jotted down Bazille's address in Montpellier; Bazille was killed very early in the Franco-Prussian War of 1870.

Provenance
Purchased by AUGUSTE PELLERIN (see Provenance, cat. 100), probably from Antonin Proust (see cat. 187), these drawings were bought by the Musées Nationaux at the Pellerin sale in 1954[1] (inv. RF 30.436 and 30.435).

F.C.

113. Cat Under a Chair

1868
India ink wash on paper with traces of pencil
8½ × 5¼" (21.5 × 13.2 cm)
Signed (lower right): E.M.
P Bibliothèque Nationale, Paris

The cat holds an important place in Manet's oeuvre as an amusing motif of domestic affection and nearly always as a signal of literary kinship: with Baudelaire in *Olympia* (cat. 64), with Champfleury in *Cats' Rendezvous* (cat. 114) and *Cat and Flowers* (cat. 117), and with Mallarmé in *Cat Under a Bench* (cat. 150).

In this drawing Manet uses brush and ink, Japanese fashion, and has sketched a cat—of some size, compared to the chair—crouched and watching something outside the field at lower left.

The piece is often dated 1880,[1] but the date suggested by Leiris is clearly correct, since the drawing is preparatory to the etching (H 64; fig. a), which also repeats the cat washing itself in *The Luncheon in the Studio* (cat. 109).

Exhibitions
Orangerie 1932, no. 112

Catalogues
T 1946, 650; L 1969, 225; RW 1975 II, 621

1. Rouart and Wildenstein 1975, II, no. 621.
2. Barrion, second sale, Paris, May 25–June 1, 1904, no. 1512.

Provenance
The stamp AB at the lower left on this sheet is that of the collector ALFRED BARRION (see Provenance, cat. 40). This work was sold among a group of his drawings in 1904[2] and was probably purchased at that time by MOREAU-NELATON (see Provenance, cat. 9), who bequeathed it to the Bibliothèque Nationale in 1927.

F.C.

113

Fig. a. *Cats*, 1868, etching

114. Cats' Rendezvous

1868
Lithograph
17¼ × 13⅛" (43.5 × 33.2 cm)
Signed (lower left): Manet
With letters (lower right; 2nd state): Lith. du Sénat, Barousse, Paris
Poster with typographical lettering
48¼ × 33¼" (122.5 × 84.5 cm)
Bibliothèque Nationale, Paris (poster with lithograph)

NY The New York Public Library (lithograph)

Publications
Rothschild 1868

Exhibitions
Poster: Ingelheim 1977, no. 57; *Lithograph:* Beaux-Arts 1884, no. 162; Paris, Drouot 1884, no. 165; Philadelphia-Chicago 1966–67, no. 90; Ingelheim 1977, no. 57; Paris, Berès 1978, no. 78

Catalogues
M-N 1906, 80; G 1944, 74; H 1970, 58; LM 1971, 74 (small poster); W 1977, 57; W 1978, 78

2nd state (of 2). With the name of the printer, Barousse. *Poster:* One of two known complete copies of the poster. Proof on wove paper laid onto violet paper with the typographical text. Dépôt Légal copy. *Lithograph:* Impression on applied China paper. Avery collection.

This striking poster first appeared in the streets of Paris after October 17, 1868 (the date of its registration in the Dépôt Légal). It advertised the publication by J. Rothschild of a little book by Champfleury, *Les Chats,* described on its title page as a work concerning the history and customs of cats, with observations and anecdotes, illustrated with fifty-two designs by Delacroix, Viollet-le-Duc, Mérimée, Manet, Prisse d'Avennes, Ribot, Kreutzberger, Mind, "Ok'sai" (for Hokusai), etc.[1] The illustration by Manet was a little woodblock reproduction (fig. a) after his lithograph or, more probably, after the preparatory gouache (RW II 619; fig. b), as indicated by the caption *Rendez-vous de chats, d'après un dessin d'Edouard Manet.* An article in *La Chronique illustrée* of October 25, announcing the publication of the book, referred to Manet's reproduction as "the most intriguing of all these intriguing illustrations."[2]

The poster itself must have caused something of a sensation. The *Chronique* article referred, only a week after the poster's appearance, to "Manet's celebrated drawing," and was accompanied by a full-size reproduction of the lithograph. Manet's cats appeared not only in the center of the large poster, where the strong contrasts of the black-and-white lithograph are set off against the violet ground and black lettering; they also decorated a small poster (almost as rare now as the large one) advertising the "Second Edition. . . . On sale here," in Parisian bookshops. The second printing of the book, still registered in 1868 (in spite of the date 1869 that appears on the title pages), was rapidly followed by a third. Guérin appears to have been unaware of the existence of the large poster, as well as of the reprinting of the original edition of the book, and maintained that the bookseller's poster advertised the new edition of 1870, which was in fact a deluxe edition illustrated with original graphics (see cat. 117).[3]

Champfleury, the great champion of realism and of Courbet, also sympathized with Baudelaire's views concerning the various aspects of "modern life." Manet had included both men in *Music in the Tuileries* (cat. 38) in 1862; and, in 1864, Fantin-Latour placed Champfleury at the center of his *Homage to Delacroix* (Musée d'Orsay-Galeries du Jeu de Paume, Paris), seated next to Baudelaire, with Manet standing between the two.[4]

Champfleury no doubt asked Manet to provide an illustration and the poster for his book, even though he does not refer to him in the chapter devoted to the "painters of cats." His book is a succession of anecdotes about cats, told with charm and verve; this particular chapter describes the cat in art, from the Egyptians to his own day. Noting in relation to the Japanese that "artists who are charmed by the delicate ways of cats are

Fig. a. Engraving after Manet, *Cats' Rendezvous,* in Champfleury, *Les Chats,* 1868

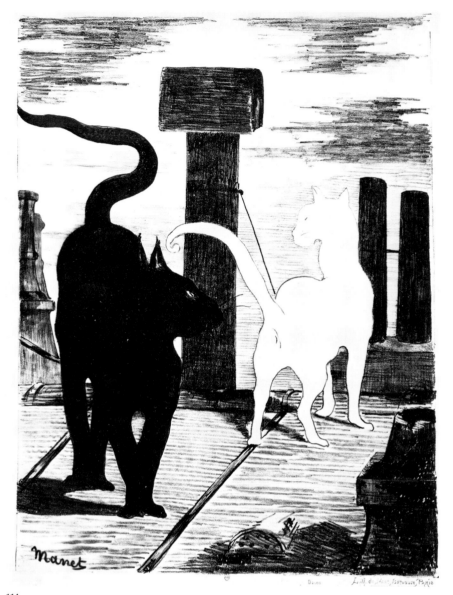

114

114 Poster

equally charmed by those of the gentle sex, and this dual sympathy is often allied to a passion for the strange and the fantastic," he compares Hoffmann and Goya, laments that the cats in Delacroix's drawings do not appear in his paintings—"the reason being that . . . he turns them into tigers!"—and makes interesting observations about Rouvière (see cat. 89), "another truly feline character," who studied cats and by whom he owned a painting that "enables one to understand certain movements of the actor, so remarkable in *Hamlet* for his wild, strange, caressing gestures."[5]

The book is full of illustrations, most of them "gillotage" reproductions, where portraits of Baudelaire (fig. d) and of Champfleury himself (fig. e) on the final page, appear accompanied by their familiar cats.[6] Every sort of feline is represented, from an Egyptian cat mummy to a scattering of cats extracted from a page in a Japanese illustrated book (see cat. 111, figs. a, b).

Champfleury attributes these cats to the "Japanese Painter Fo-Kou-Say (pronounced *Hok'sai*)," to whom he devotes his final chapter, and maintains that "his qualities are best explained by a comparison with Goya.

Fig. b. *Cats' Rendezvous*, 1868, watercolor and gouache, preparatory drawing for the lithograph. Present location unknown

He has Goya's caprice and fantasy; even his engraving style is sometimes markedly similar to that of the author of the *Caprichos*."[7] This statement applies equally well to Manet himself, whose sketches and prints (cat. 111, 114, 117) combine the qualities of the cats of Hokusai and Hiroshige,[8] and of Goya's menacing cats in the portrait *Don Manuel Osorio* (Metropolitan Museum of Art, New York), as well as those in the *Caprichos* prints.

The black cat in Manet's lithograph makes his first appearance on a sheet of sketches where he is lying on his back with his hind legs in the air (cat. 111); he is repeated, but this time with his white companion and the rooftop decor, in a little preliminary sketch (RW II 618; fig. c),[9] and finds his definitive pose in the watercolor-and-gouache study that belonged, together with the preliminary design, to Alphonse Dumas in 1884[10] but since its exhibition in 1930 has been known only through reproductions (RW II 619; fig. b).

This evolution, starting from a little sketch from life, is a particularly revealing demonstration of Manet's working method. Various sources have been suggested for the lithographic image. One of the most telling is a fan decorated with the supple, sinuous silhouettes of cats by Kuniyoshi.[11] But here the "sources" clearly came into play after the composition had already been established from observations from nature, and at a moment when Manet wanted to sharpen and refine his image through visual references suited to his theme. In the same way, the passage from reality—a rather down-to-earth reality—toward the abstraction of the final design suggests that any intended symbolism, such as proposed by Mauner,[12] would have been formulated as an intellectual game at a later stage, and possibly at someone else's suggestion. If there is an evocation of the *yin-yang* emblem in the opposition of black and white, in the opposing movements and complementary forms of the white tail and the black head, it is no doubt best understood on the level intended by the artist, who, according to Duret, "was greatly amused by this fantasy."[13]

Manet offers sly humor, an original presentation, elegant refinement in the treatment of an inherently inelegant subject—the mating of cats on a rooftop—and sheer delight in the voluptuous nature and barefaced, shameless sexuality of his cats. His lithograph is a tour de force of whimsical, mocking wit and of concise graphic tension.

1. Champfleury, *Les Chats—histoire, moeurs, observations, anecdotes*, Paris, 1869 (three editions registered with the Dépôt Légal in 1868, under the numbers 8082, 8474, and 9029: Paris, BN Imprimés).
2. The duc d'Aléria, "Les chats par Champfleury," *La Chronique illustré*, October 25, 1868, pp. 3–4 (repr. p. 4).
3. Guérin 1944, no. 74 (small poster); Harris 1970, p. 164, repeats Guérin's statements but misinterprets the French text.
4. Druick and Hoog 1982, pp. 171–78.
5. Champfleury 1869, pp. 117–28, see note 1 above.
6. Ibid., pp. 110, 287.
7. Ibid., pp. 276–78.
8. Weisberg 1975, nos. 39–40.
9. Guérin 1944, no. 74 (repr.).
10. See cat. 67, Provenance.
11. Ives 1974, p. 25, no. 18.
12. Mauner 1975, pp. 181–84.
13. Duret 1902, p. 126.
14. See note on the 1884 edition, following cat. 105.
15. Paris, Archives Nationales (F[18] VI 76); BN Estampes (Ye 79).
16. David-Weill sale, Paris, May 25–26, 1971, lot 173.

Provenance
The copy of the complete poster is one of two in the Bibliothèque Nationale, transferred there from the DEPOT LEGAL (see Provenance, cat. 105).[14] Both bear the Dépôt Légal stamp with the registration number 3808, corresponding to October 17, 1868.[15]

The impression of the lithograph on applied China paper, of which the edition size is unknown, was acquired by AVERY from an unknown source, probably through LUCAS (see Provenance, cat. 17). It is one of five or six recorded impressions; one of the others was dedicated by Champfleury to Nadar.[16]

J.W.B.

Fig. c. Study for *Cats' Rendezvous*. Private collection

Fig. d. Edmond Morin, *Charles Baudelaire*, in Champfleury, *Les Chats*, 1868

Fig. e. Edmond Morin, *Champfleury*, in Champfleury, *Les Chats*, 1868

115. The Balcony

1868–69
Oil on canvas
66½ × 49¼" (169 × 125 cm)
Signed (lower right): Manet
Musée d'Orsay (Galeries du Jeu de Paume), Paris

Manet is said to have had the idea for this painting in the summer of 1868, at Boulogne-sur-Mer, when he noticed some people on their balcony.[1] He had already essayed the theme of a woman on her balcony in *Angélina* (RW I 105), following his trip to Spain late in 1865. In the autumn of 1868, back from Boulogne, he had the models pose in the rue Guyot studio for this canvas, on which he worked in the winter of 1868–69.

The models were Manet's friends. The woman standing is Fanny Claus (1846–1877), a young concert violinist (a member of the Sainte-Cécile Quartet) and the future wife of Manet's friend the painter Pierre Prins.[2] She saw a good deal of the Manets, and she and Suzanne played music together. A preliminary sketch, owned at one time by Alfred Stevens (RW I 133), shows that Manet had at first given her the seated position in the foreground.

Behind Fanny Claus stands Antoine Guillemet (1842–1918), a painter of landscapes, chiefly in the Paris area, and friend of future Impressionists whom he met at the Académie Suisse. Through his Salon connections, he was helpful more than once to his controversial friends: to Manet, by supporting him for the award of a second-class medal at the Salon of 1881, putting him at last *hors concours*; and to Cézanne, who owed Guillemet his acceptance by the Salon of 1882. Behind Guillemet to the left, in half-darkness, is a boy bearing a ewer, and posed, according to himself, by Léon Leenhoff. Manet in fact took the motif from a much earlier painting (cat. 2).

In the foreground, seated, is Berthe Morisot (1841–1895), in her striking first appearance on a Manet canvas. Berthe and Edma Morisot had known Fantin-Latour and Bracquemond since about 1860, but apparently Berthe never actually made Manet's acquaintance until 1867, when Fantin-Latour introduced them at the Louvre, where Berthe was copying a Rubens.[3] The Morisot and Manet families were soon much together, the young women and their mother going to the Thursday evenings at the Manets', where Suzanne performed on the piano for the circle then including, among others, Astruc, Chabrier, Degas, Charles Cros, Zola at times, and Alfred Stevens. Manet, from Boulogne, confided in a letter of August 26, 1868, to Fantin-Latour: "I quite agree with you, the Mlles Morisot are charming. Too bad they're not men. All the same, women as they are, they could serve the cause of painting by each marrying an academician, and bringing discord into the camp of the enemy!"[4] This bantering tone does not in fact reflect the actual relationship of strong affection and artistic respect that was soon to develop between Manet and Berthe Morisot.

The young people—all three were between twenty-two and twenty-seven—rebelled somewhat against long sittings; nor did they feel overly flattered. Mme Morisot wrote to her daughter Edma in March 1869: "Antoine [Guillemet] says [Manet] has made him pose fifteen times, with no likeness to show for it, that Mlle Claus looks terrible, but that both,

Exhibitions
Salon 1869, no. 1616 (Le balcon); Brussels 1869, no. 754; London, Durand-Ruel 1873, no. 68?; Beaux-Arts 1884, no. 52; Paris, Drouot 1884, no. 2; New York, National Academy of Design 1886, no. 254; Berlin, Matthiesen 1928, no. 24; Paris, Bernheim-Jeune 1928, no. 9; Orangerie 1932, no. 32; Orangerie 1952, without no.

Catalogues
D 1902, 107; M-N 1926 I, pp. 105–6, no. 111; T 1931, 135; JW 1932, 150; T 1947, 141; PO 1967, 121; RO 1970, 121; RW 1975 I, 134

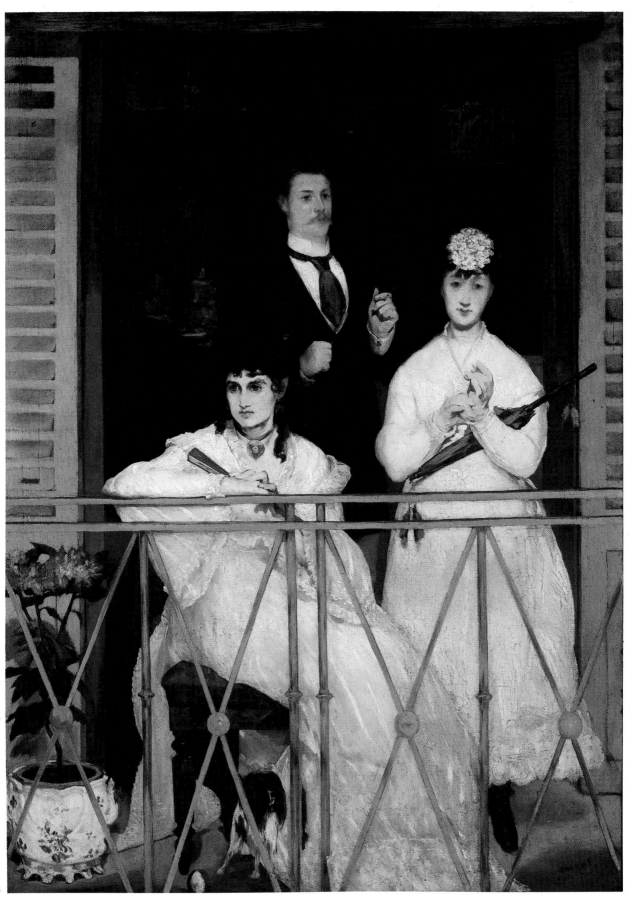

115

exhausted from standing in the pose, declare, 'It's perfect, no improvement needed.' They are all amusing enough, though not really to be taken very seriously. Manet appears quite mad, he is confident of a great success, then suddenly doubts assail him and he turns moody."[5]

Berthe Morisot, whose intent, pensive face seems so beautiful to us today, was thought, when the picture was shown, to have been wronged by the artist. A letter to her sister, telling of her visit to the Salon, where the painting was exhibited, gives us her own reaction: "His paintings, as always, create the impression of some wild fruit, a bit unripe even. I am far from disliking them . . . I look strange, rather than ugly. It seems that the term *femme fatale* has been circulated among the curious."[6]

The general plan of the painting is freely drawn from Goya's *Majas on the Balcony* (see fig. a), one or another version of which Manet had several opportunities to see; first at the age of sixteen, in the Galerie Espagnole at the Louvre, where the original version (private collection, Switzerland) was on exhibit[7] (notwithstanding Baudelaire, who, wishing to clear Manet of the charge of pastiche, maintained that he had never seen the Goyas in the Galerie Espagnole, being first too young and later away at sea; it was a case, rather, of a disconcerting "coincidence," similar to the "parallelism" between Baudelaire's work and that of Poe[8]). In any case, Manet could have seen versions on his 1865 trip to Spain at the Palacio San Telmo in Seville or in the June 1867 sale of the Salamanca collection of Spanish paintings, which all Paris, and surely Manet, attended; a *Manola on the Balcony*, then attributed to Goya, was sold (today it is considered a copy by Alenza).[9] Last but not least, the work was accessible through its engraved reproduction (fig. a) in Yriarte's book on Goya, which had appeared quite recently, in 1867, and surely did not escape Manet's attention, especially since he was personally acquainted with the author, whose name is found in his address book.[10]

In actual fact, while there are obvious analogies—size, two figures in light dresses in the foreground against a dark masculine silhouette, the decorative effect of the iron balcony occupying almost all the lower half of the painting—the differences are all the more striking, both in color—Goya's warm, Manet's cool—and in feeling. The *Majas on the Balcony* is a genre scene; the figures, leaning toward one another and overseen by watchful shadows, appear to be exchanging little secrets.

Other, more popular iconographic sources may have influenced Manet. First, there was Constantin Guys, who often represented Spanish women on their balconies, usually with an air of accosting the passerby, but with the balcony as prominent a part of the composition as here.[11] An interesting comparison has recently been made between Manet's composition and a romantic English lithograph representing young Parisian embroideresses on their balcony.[12]

This enigmatic work has given rise to interpretations that often reflect more the concerns of the time than the artist's intentions. Thus Fried sees the figures as an allegory of Manet's artistic background: Spain (Berthe Morisot), Japan (Fanny Claus), and the Netherlands (Guillemet).[13] But apart from Morisot's Andalusian look, there is no serious support for this interpretation, which schematizes in three individuals influences diffused throughout the art of the period and which might be said to err from excessive art historicism.

And yet there is something artificial about the scene. For one thing, Manet obviously could not have posed his three friends on the small *balcon-*

Fig. a. Engraving after Francisco de Goya, *Majas on the Balcony,* in Charles Yriarte, *Goya,* 1867

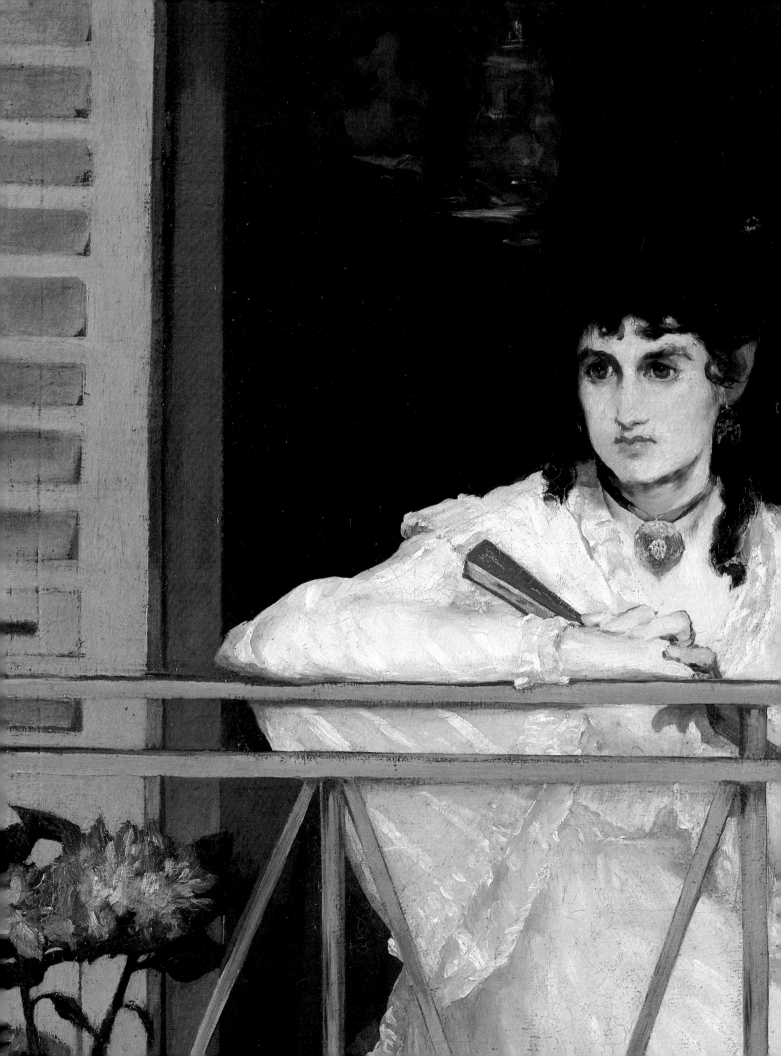

terrasse of his studio, with himself stationed outside. He probably did the preliminary sketch (cat. 116) from his garden, to set the composition, and then had his models pose in the studio, afterward adding the framing shutters—a motif previously used in *The Street Singer* (cat. 32)—and the railing.

The three persons, described as such lively sitters, seem abstracted, stiff, each bound up in a private world, under an objective but not humorless recording eye: the handsome man with the cigar, good-humored and pleased with life; young Fanny Claus, appealing, bashful, a trifle awkward; and Berthe Morisot, brooding and troubled, as she appears in her letters of that time. The frontal attitude, so characteristic of Manet's portraiture, creates an image without movement, fixed and mysterious. The three models look in different directions, and the background, revealing the boy bearing the ewer, and a rather vague decor with the suggestion of a still life on the wall, affords no more of a clue to the action than does the blue hydrangea in its porcelain planter at the lower left. Even so, this last has elicited a metaphysical interpretation from Mauner, who takes it for a symbol of *vanitas* and an allusion to the passage of time, the potted plant resembling the funerary allegories of German Renaissance prints.[14]

Certainly Manet organized his group and its surroundings with the utmost care, leaving nothing to chance; but representational purposes often merge with plastic solutions. The hydrangea (missing from the sketch) both accentuates the *plein-air* idea and softens the hard green louvers with white and light blue. The dog and the little ball—recalling the cat and the orange in *Young Woman Reclining* (cat. 29)—are at once emblems of Manet's art, a touch of animation at the base of an otherwise rigid composition, a complement to Berthe Morisot's finery, and a playful reminder of Goya's little dogs, like the one in the *Duchess of Alba* (fig. b)[15]—with the difference that the small bow is tied on the tousled head of Manet's dog, and adorns one leg of Goya's. The stationary ball is at the same time a patch of color, an ironic period to Morisot's grave presence, and a tribute to the passing moment, marking the realism of the scene and setting it in a carefree, leisurely atmosphere; it should be noted that Monet used the same ball motif in his *Luncheon*, 1868–69 (Städelsches Kunstinstitut, Frankfurt).[16]

Fig. b. Engraving after Francisco de Goya, *The Duchess of Alba*, in Charles Yriarte, *Goya*, 1867

This is a scene of modern life—of "high life"—but not a genre scene. These elegant people seem rather to be in a box at the theater than on a balcony, playing a worldly game the point of which is to be seen rather than to watch. But nothing happens; the image is only one of a particular moment bringing together three very individualized, apparently unrelated persons. They have the air of holding a pose, but everything takes place as in a snapshot, in which people in animated conversation a second earlier unfortunately look away at precisely the moment the shot is taken, and retain forever an uncompleted gesture or a glance in another direction. Something is going to happen, or has just happened.

While not an allegory recapitulating Manet's artistic development as Fried suggests, nor a *memento mori* in Mauner's sense, *The Balcony* is a striking image because it shares the realistic intentions of the time—though at a different social level from Courbet's—while revealing itself on close examination to be totally unrealistic, even for critics of the period.

Fig. c. René Magritte, *Perspective: The Balcony by Manet*, 1949. Museum voor Schone Kunsten, Ghent

The picture is still arresting today, particularly in the violence of the greens of the railing and shutters, and of the blue of the cravat. It could hardly fail to shock in its own time. The modernity of the subject, the im-

mediacy of an inexplicable scene, the simplification of the faces, the play of two large pale shapes against a dark background, the flat treatment of forms on the picture plane—all had an effect of provocation: "Do close that window! What I'm telling you, M. Manet, is for your own good" was the caption of Cham's caricature.[17] Although Castagnary, the voice of realism, and Paul Mantz, official critic for the *Gazette des Beaux-Arts*, treated Manet with more respect than at past Salons, acknowledging his talent, his sense of color, and his values, the critics had basically the same objection: "On this balcony I see two women, one quite young. Are they sisters? Are they mother and daughter? I cannot tell. And then, one is seated and seems to have taken her place merely to enjoy the view of the street; the other is putting on her gloves as if to leave. These conflicting postures baffle me."[18] As for Wolff, he waxed indignant at "this uncouth art, where, as in the green shutters of *The Balcony*, [Manet] lowers himself to engaging in competition with house painters."[19]

What baffled the critics then is exactly what fascinates us today. The strangeness and poetry of the scene, the psychological (in Morisot's case, magnetic) presence of the protagonists, the rawness of the green plastered against the extreme delicacy of the whites, the aggressively blue cravat—all this, more than a century later, has lost nothing of its power. The reactions of two artists are worth noting. In 1950, Magritte painted a picture in which he used the same setting (fig. c), transforming the three figures into coffins (Morisot's is even seated); this paid homage to Manet's painting, while at the same time satisfying the need to "kill off the old masters," and echoing perhaps the absent, "dead" look of the principals. And J. P. Riopelle's exclamation "A real cravat, if you attached it [to the picture], would not be more outrageous than this blue cravat against the green!"[20] shows that the work had sustained its powers of provocation into the days of Pop Art.

1. Moreau-Nélaton 1926, I, p. 105.
2. Prins 1949, p. 26.
3. Angoulvent 1933, p. 22.
4. Moreau-Nélaton 1926, I, p. 103.
5. Morisot 1950, p. 25.
6. Ibid., pp. 26–27.
7. Baticle and Marinas 1981, p. 24.
8. Baudelaire 1973, II, p. 386: to Bürger (Thoré), about June 20, 1864.
9. Salamanca sale, Paris, June 3–6, 1868; Jean Adhémar, "A propos du 'Balcon' de Manet," *Bulletin des Musées de France*, no. 10 (December 1955), p. 158.
10. Manet et al., "Copie faite pour Moreau-Nélaton . . . ," p. 143.
11. Paris, Musée des Arts Décoratifs, *Un Peintre de la vie aux XIXᵉ siècle, Constantin Guys 1802–1892* (exhibition catalogue), Paris, 1937, nos. 369, 370.
12. S. D. Peters, "Examination of another source for Manet's 'The Balcony,'" *Gazette des Beaux-Arts*, 6th ser., XCVI (December 1980), pp. 225–26.
13. Fried 1969, pp. 59–60.
14. Mauner 1975, p. 129.
15. Yriarte 1867, p. 35 (repr.), *Majas au balcon*, p. 90 (repr.).
16. Stuckey 1981, p. 107, no. 39.
17. Cham, in *Le Monde illustré* 1869, p. 365.
18. Castagnary 1869, *Le Siècle*.
19. Wolff 1869, cited in Tabarant 1947, p. 160.
20. Schneider 1967, p. 199.
21. Bazire 1884, p. 128.
22. Rouart and Wildenstein 1975, I, p. 17.
23. Manet sale, Paris, February 4–5, 1884, no. 144; Bodelsen 1968, p. 344.
24. Rewald 1973, pp. 570, 572.
25. Tabarant 1921, p. 405.

Provenance

This work remained in Manet's possession until his death and hung beside *Olympia* (cat. 64) in his studio on the rue d'Amsterdam.[21] Manet valued it at 10,000 Frs in his 1872 inventory.[22] The painter GUSTAVE CAILLEBOTTE (1848–1894) bought it at the studio sale in 1884 for 3,000 Frs.[23] It remained, until Caillebotte's death, in his studio, at Petit Gennevilliers near Argenteuil, where his Impressionist friends could see it. It was the gem of the prestigious Caillebotte bequest, which brought Impressionism to the Musée du Luxembourg, the Paris modern art museum of the period. This eminent painter, who took part in the Impressionist exhibitions from 1876 on, and who is unhappily underrepresented today in French museums, was wealthy enough to buy paintings from his friends, with a discrimination that eventually endowed the Musée du Louvre with, among others, seven pastels by Degas; six paintings by Renoir, including *Dancing at the Moulin de la Galette*, *The Swing*, and *Nude in the Sun*; eight Monets, including *Gare Saint-Lazare*, *The Lunch-* *eon*, and *Regatta at Argenteuil*; seven Pissarros, including *The Red Roofs*; five Sisleys, including *Street in Louveciennes*; and two Cézannes, including *L'Estaque*. The official artists' opposition to Caillebotte's bequest of 1894 is well known; the bequest was unanimously accepted by the committee of the Musées Nationaux, on the condition that the legacy be reduced by half, the selections being made in some instances by the artists themselves (Monet, for example).[24] The outrage of those who felt that the invasion of the Louvre by the Impressionists meant the end of academic supremacy was paralleled by that of members of the more progressive artistic circles over the state's rejection of part of the bequest.[25] Thus, out of four Manets, two were accepted, *The Balcony* and *Angélina* (RW I 105), and two were refused, *The Game of Croquet* (RW I 173) and *The Races* (RW I 96). *The Balcony* finally entered the Musée du Luxembourg in 1896 and the Louvre in 1929 (inv. RF 2772). It was cleaned in 1983.

F.C.

116

116. *Study for* The Balcony

1868
Pencil and ink wash
4¼ × 3¼″ (10.8 × 8.2 cm)
Inscribed (lower left, by Suzanne Manet): E. Manet
Collection Mr. and Mrs. Alexander Lewyt, New York

This sketch establishes the general composition of the painting (cat. 115) but gives more importance to the shutters, which were to have been the essential background. Manet must have felt that the great expanse of bright green would prove troublesome, and in the painting he folded the shutters partway. He also centered the composition higher so as to place the viewer on the same level as the spectators on the balcony, a less realistic device since in the painting the viewer is as if suspended in mid-air. In the drawing, he has marked out in wash the approximate final framing. The little dog under the bench seems to have been taken from life at the very first. The jardiniere, however, was added. There are a few strokes to indicate that Berthe Morisot was holding an open parasol over her right shoulder.

Exhibitions
Philadelphia-Chicago 1966–67, no. 104

Catalogues
T 1931, 34a; T 1947, 582; L 1969, 233; RW 1975 II, 346

1. Rouart and Wildenstein 1975, II, no. 346.

Provenance
This drawing, perhaps given to Berthe Morisot, was once in the collection of the ROUART family (see Provenance, cat. 3). It is supposed to have belonged later to the COMTESSE GREFFUHLE,[1] who presided over one of the most brilliant salons in Paris at the end of the century. A patroness of musicians, she served as the model for Marcel Proust's duchesse de Guermantes. The work passed through the Parisian art market several times between 1927 and 1935 (BERNHEIM-JEUNE, see Provenance, cat. 31; DABER), and in 1938 belonged to M. CAMILLE MARTIN in Asnières (archives, Musée d'Orsay, Paris). F.C.

117 (1st state)

117 (2nd state)

117. Cat and Flowers

1869
Etching and aquatint
Plate: 8 × 6″ (20.3 × 15.2 cm); image: 6⅞ × 5⅛″ (17.3 × 13 cm)
Signed (lower left, below the subject; 2nd state): Manet
Engraved with title (below; 4th state): LE CHAT ET LES FLEURS;
engraved with title of book (above; 5th state)

P Bibliothèque Nationale, Paris (1st state)
NY The New York Public Library (2nd state)

Publications
Champfleury, *Les Chats*, Rothschild 1870, opp. p. 40

Exhibitions
Philadelphia-Chicago 1966–67, no. 89; Ingelheim 1977, no. 63; Paris, Berès 1978, no. 59

Catalogues
M-N 1906, 19; G 1944, 53; H 1970, 65; LM 1971, 53; W 1977, 63; W 1978, 59

1st state (of 6). Before extensive re-etching and the signature. One of two known proofs, on thin Japan paper. Retouched with brush and blue-black ink wash. Hazard collection.

The last paragraph of Champfleury's book about cats (see cat. 114) expressed the hope that if "the present volume finds favor with the public, . . . the author will make every effort to improve his work in terms of both text and illustrations."[1] Its success, as already demonstrated, was considerable: it returned to press twice between October and the end of the year, 1868. After reprinting the original, small-format publication, Champfleury and his publisher, Rothschild, decided to produce a deluxe edition enhanced with original prints. In July 1869, Champfleury wrote in a letter: "My dear Manet, my publisher has asked me whether the etching you have been good enough to undertake is ready. It's a matter of placing advertisements abroad and producing a prospectus and posters on which the various prints will appear,

309

and this time Rothschild wants to organize things in advance. . . . "[2]

Manet was working on his painting *The Balcony* (cat. 115) at the time, and he adopted a similar motif for his etching. Iron balcony railings, plants in a jardiniere, and an animal—in the painting, a little dog; in the print, a cat—are common to both compositions. In these works, Manet appears to fuse the two sources of inspiration mentioned by Champfleury: Goya and Japan. The previous year he had made an etching and aquatint for Philippe Burty, which is almost a pastiche of some of Goya's *Caprichos* plates:[3] *Exotic Flower* (H 57), which appeared in the sumptuously produced *Sonnets et eaux-fortes*. While the etching exhibited here is technically close to Goya's prints, the subject is much more influenced by Japonisme, and also evokes the effect of a close-up and photographic snapshot, with the head and front paws of the cat filling half of the composition. Ives has related the composition to two pages from the *Manga* of Hokusai, one showing a weasel among bamboo, and the other a cat catching a mouse in front of a panel of wooden slats.[4]

No preparatory drawing is known, and the plate is already aquatinted in the surviving artist's proofs. As Harris noted in connection with the *Cats' Rendezvous* (cat. 114),[5] Manet again combines East and West here, in a composition that emphasizes the two-dimensional plane through the insistent lines of the balcony and the linear rhythms of the flowers, but the drawing style is distinctly realistic in places, particularly in the cat. The wash retouches and pen-and-ink additions are evidence of an attempt, which is perhaps only partially successful, to harmonize these two tendencies. The print appeared in the "second deluxe edition" of Champfleury's *Les Chats*, which appeared in 1870.

2nd state. With the signature; with additional etched hatching on the ground and vase; still before further work, notably the crisscross wire guard between the railings, added here in pen and blue ink, also used to shade the cat, the vase, and the ground. Pencil inscription (lower right): "le chat très rare HG." Avery collection.

1. Champfleury, *Les Chats—histoire, moeurs, observations, anecdotes,* Paris, 1869.
2. J. Adhémar 1965, p. 232.
3. Francisco de Goya, *Los Caprichos,* pl. 5, 15.
4. Ives 1974, pp. 26–27, nos. 19–21.
5. Harris 1970, p. 164.
6. Hazard, third sale, Paris, December 12–13, 1919, lot 253 (incorrectly titled "Les chats").
7. Degas collection, second sale, November 6–7, 1918, lot 252 (now Nationalmuseum, Stockholm).

Provenance
1st state. The proof belonged to N. A. HAZARD (see Provenance, cat. 57) and appeared in the sale of his collection in 1919[6] with the description "très rare épreuve d'un 1er état, *non décrit, avant divers travaux,* retouchée" (very rare proof of a 1st state, *undescribed, before rework,* retouched). It was indeed unknown to Moreau-Nélaton, whose 1906 catalogue only cites the proof, in the second state, in Degas's collection.[7] MOREAU-NELATON (see Provenance, cat. 9) acquired the proof for 220 Frs, and it came as part of his bequest to the Bibliothèque Nationale.
2nd state. The proof has an inscription initialed "HG," for Henri Guérard. It was no doubt acquired by LUCAS, possibly from GUERARD or through him from SUZANNE MANET, for AVERY (see Provenance, cat. 17, 16, 12).

J.W.B.

118. Moonlight over Boulogne Harbor

1869
Oil on canvas
32¼ × 39¾" (82 × 101 cm)
Signed (lower left): Manet
Musée d'Orsay (Galeries du Jeu de Paume), Paris

For the summer of 1869 (1868 according to Proust, whose datings are not always reliable),[1] Manet and his family took rooms on the second floor of the Hôtel Folkestone, overlooking the harbor, and there he worked on a series of views from his window, of which this is one.

Exhibitions
Brussels 1869, no. 756; London, Durand-Ruel 1872, no. 24; Beaux-Arts 1884, no. 49; Exposition Universelle 1889, no. 496; Orangerie 1932, no. 39; Orangerie 1952, without no.

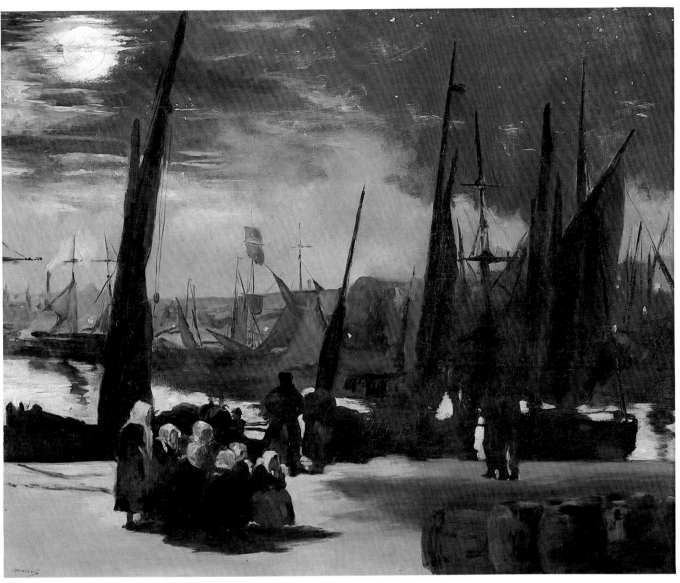

118

Catalogues

D 1902, 112; M-N 1926 I, p. 111; M-N cat. ms., 118; T 1931, 144; JW 1932, 159; T 1947, 160; PO 1967, 128; RO 1970, 128; RW 1975 I, 143

The presence of the group of women in Boulonnais headdress on the quay, waiting to take the catch to the fish market, indicates that the boats have returned from the night's fishing. This prosaic scene Manet transformed into a mysterious, dramatic chiaroscuro reminiscent of seventeenth-century Dutch and Flemish nocturnal landscapes and of the moonlit seascapes of Joseph Vernet, which were then on view at the Louvre. Furthermore, it is known that Manet himself owned a *clair de lune* by Van der Neer, because he offered it to Haro for the Salamanca sale in 1867: "I see advertised a Salamanca sale to be held by you. Could you put in a first-rate little Van der Neer of mine, representing a moonlight scene?"[2] And a few days later he wrote, "Since the catalogue is already out, I should prefer to await another opportunity." Probably, therefore, he still had the painting in 1869. At all events, between 1860 and 1880 some fifty Van der Neers on similar themes were sold in Paris; Alfred Stevens bought one in 1867.[3]

Some changes in the course of work on the canvas, revealed by

X-ray (the moon was at first lower, and the dark silhouettes of boats at the right were added afterward), illustrate Manet's care for composition and effect, taking a scene from life and then reworking it in the studio. Later, in the series of drawings related to illustrations for Poe's works, we shall encounter other eloquent nocturnes (cat. 154, 155).

Provenance

On January 11, 1872, PAUL DURAND-RUEL (1831–1922), visiting the studio of Alfred Stevens, was struck by two canvases, *The Salmon* (cat. 82, fig. a) and this *Moonlight over Boulogne Harbor*.[4] Manet had entrusted them to his friend Stevens, a successful and well-connected painter, in the hope of attracting a buyer, as he was selling almost nothing at the time. The very next day, Durand-Ruel went to see Manet and selected twenty-two other canvases, purchasing the entire lot for the remarkable price of 35,000 Frs. The price of *Moonlight* is given as 1,000 Frs in Manet's account book[5] and as 800 Frs in the dealer's memoirs,[6] the difference being the discount Manet gave on the total price. Durand-Ruel owned a well-established family gallery in the rue Laffitte, specializing in the Barbizon school, and after meeting Monet and Pissarro in London in 1870, became enthusiastic about the fresh style of the artists later called Impressionists. Upon his return to Paris, he became interested in other artists of their circle, including Manet. He not only became Manet's favorite dealer after discovering his work in Stevens's studio but helped to make him known through exhibitions in Paris, London, and New York at the end of the century. He wrote fascinating memoirs about his activities as an art dealer.[7] FAURE (see Provenance, cat. 10) bought *Moonlight over Boulogne Harbor* for 7,000 Frs on January 3, 1873,[8] and sold it late in 1889 for 33,000 Frs[9] (he lent it to the Exposition Universelle of 1889) to CAMENTRON (see Provenance, cat. 50). COMTE ISAAC DE CAMONDO (see Provenance, cat. 50) bought it in 1899 for 65,000 Frs,[10] and in 1908, he bequeathed it to the Musée du Louvre, where it has been exhibited with his other outstanding Manets since 1914 (inv. RF 1993).

F.C.

1. Proust 1897, p. 175.
2. Paris, Bibliothèque d'Art et d'Archéologie, letters from artists to the Haro family.
3. Charles Stuckey, pers. comm., 1982.
4. Duret 1919, pp. 97–98.
5. Manet et al., "Copie faite pour Moreau-Nélaton . . . ," p. 131.
6. Meier-Graefe 1912, pp. 310–16; Venturi 1939, II, pp. 189–92.
7. Venturi 1939, passim.
8. Callen 1974, p. 162.
9. Tabarant 1947, p. 165.
10. Meier-Graefe 1912, p. 310.

119. The Pier at Boulogne

1869
Oil on canvas
23½ × 28¾" (60 × 73 cm)
Signed (lower right, on buoy): Manet
Private Collection, Paris

The bridged double wooden pier of Boulogne Harbor interested other painters in the nineteenth and early twentieth centuries (Boudin, Lebourg, Marquet, Vallotton), but Manet's point of view is unusual; he makes use of the curious occultation of fishing boats passing between the piers and seeming to ride on the structure rather than on the hidden water. Also peculiar to Manet is the very strong horizontal emphasis in the lower third of the composition, characteristic of a majority of his works.

Rewald cites Manet's Boulogne landscapes as the first in which he attacks "problems which had already preoccupied his friends at the Café Guerbois: to retain his impressions in small, rapidly painted canvases . . . the works he executed there lost that element of a 'museum souvenir'"[1] However, a composition like this one, imposing a highly personal construct upon nature, is not purely Impressionist but prefigures the simplifying art of the Nabis.

A sketchbook done at Boulogne in the summer of 1869 contains several drawings used for this painting, and another version of the pier (RW I 144). Specifically, there are sketches of the figures at the railing (RW II 139–41) and studies of the pilings (RW II 142–45).

Exhibitions
Beaux-Arts 1884, no. 51; New York, Wildenstein 1937, no. 16; New York, Wildenstein 1948, no. 18

Catalogues
D 1902, 116; M-N 1926 I, p. 111; M-N cat. ms., 119; T 1931, 145 (71 × 92 cm, dimensions with frame?); JW 1932, 161; T 1947, 148; PO 1967, 127B; RO 1970, 127B; RW 1975 I, 145

1. Rewald 1973, pp. 223–24.
2. Manet et al., "Copie fait pour Moreau-Nélaton . . . ," p. 131.

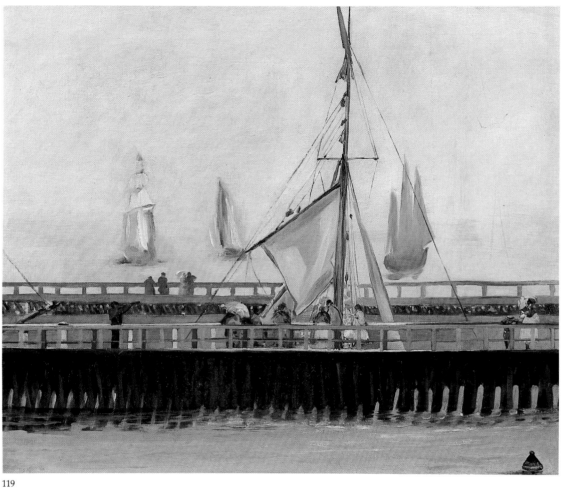

119

Provenance
Purchased for 600 Frs from Manet by DURAND-RUEL (see Provenance, cat. 118) in January 1872,[2] this painting passed to FELIX GERARD (see Provenance, cat. 81), who lent it to the 1884 retrospective. From 1904 on, it remained for many years in Dresden, in the famous collection of OSKAR SCHMITZ, who also owned *The Milliner* (cat. 213) and a very fine group of Impressionist and Post-Impressionist works (six Cézannes, Van Gogh's *The Langlois Bridge*, Degas's *Women Ironing*, etc.). The present painting was purchased in the late 1920s by NATHAN WILDENSTEIN (1851–1934), founder of the Paris gallery later directed by his son Georges (1892–1963) and his grandson Daniel (who, with Denis Rouart, wrote the most recent catalogue raisonné of Manet's oeuvre). The work returned to Paris shortly after World War II, when it belonged to the celebrated *parfumeur* and collector J. GUERLAIN.

F.C.

120. Boats at Sea, Sunset

1872–73
Oil on canvas
16½ × 37″ (42 × 94 cm)
Musée des Beaux-Arts, Le Havre

Exhibitions
Paris, Drouot 1884, no. 79

Catalogues
D 1902, 118; M-N cat. ms., 124; T 1931, 149; JW 1932, 178; T 1947, 152; PO 1967, 129; RO 1970, 129; RW 1975 I, 150

The unusual format and surprising composition of this seascape render it one of Manet's most Japanesque paintings. The dating is somewhat uncertain. The horizontal treatment would relate it to the 1869 marine paintings *The Pier at Boulogne* (cat. 119) and *The Beach at Boulogne* (RW I 148), and this probably accounts for the 1869 dating in the Tabarant and Wildenstein

313

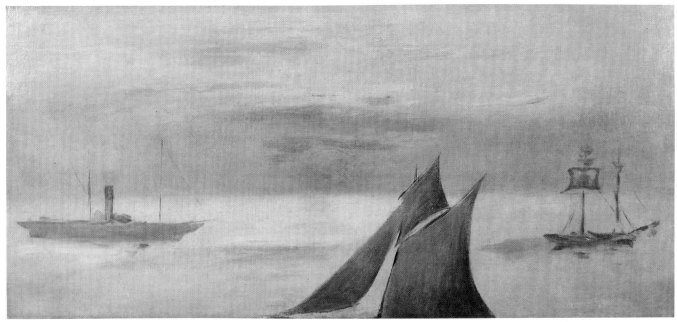

120

catalogues raisonnés, despite the annotation made presumably by Léon Leenhoff on Lochard's photograph: 1870.[1] But it is far more likely to have been done in 1872 or 1873, during a stay at Berck-sur-Mer. First there is its special allusive style, reminiscent of *Berck Beach at Low Tide* (RW I 198). And furthermore, it seems very closely derived from a watercolor, traditionally dated 1873 (RW II 252), of which it would represent the upper portion only, whether because Manet cropped the subject for the canvas or because he cropped the canvas afterward to achieve the truncated sail effect in the foreground. Such procedures were standard in the art of Hiroshige (fig. a) and much imitated in Japanesque prints of the 1890s.[2]

If this canvas is placed in 1872–73, the question arises whether Manet had already seen the two "impressions," *Sunrise* and *Sunset*, one of which Monet included in the first Impressionist exhibition of 1874 and which gave the Impressionists their name, and whether Manet's new choice of topic was a coincidence or a response.

1. Manet et al., Lochard album.
2. Siegfried Wichman, *Japonisme: The Japanese Influence on Western Art in the 19th and 20th Centuries*, trans. Mary Whitall, New York, 1981, pp. 242–43.
3. Manet sale, Paris, February 4–5, 1884, no. 79; Bodelsen 1968, p. 343.
4. Anonymous sale, Paris, March 30, 1938, no. 24.

Provenance
This picture was no. 79 in the Manet sale in 1884 (the dimensions given in the catalogue, 24 × 96 cm, are incorrect), when it was purchased for 135 Frs by a certain M. ROMANOFF.[3] Acquired by the dealer ETIENNE BIGNOU (see Provenance, cat. 216), it later belonged to the British art critic PERCY MOORE TURNER (1877–1950) of London and then to LORD IVOR SPENCER-CHURCHILL, who sold it at auction in 1938.[4] From the LABOUCHERE collection in Paris, it went to Germany during the Occupation; it was recovered by the French government after the war and was assigned to the Musées Nationaux by the Office of Private Property, under the Ministry of Foreign Affairs, in 1951. The Musée du Louvre transferred it to the Musée des Beaux-Arts in Le Havre in 1961 (inv. MNR 873).

F.C.

Fig. a. Hiroshige, plate from the series *Famous Places of the Sixty-Odd Provinces*, 1853–56, woodcut

121. Repose: Portrait of Berthe Morisot

1870
Oil on canvas
58¼ × 43¾″ (147.8 × 111 cm)
Signed (lower right corner of framed print): Manet
Museum of Art, Rhode Island School of Design, Providence

Exhibitions
Salon 1873, no. 998 (Le repos); Beaux-Arts 1884, no. 57; New York, Durand-Ruel 1895, no. 1; Philadelphia-[Chicago] 1966–67, no. 106

Catalogues
D 1902, 125; M-N 1926 I, p. 122, II, p. 4; M-N cat. ms., 130; T 1931, 139; JW 1932, 183; T 1947, 154; PO 1967, 131; RO 1970, 131; RW 1975 I, 158

In the early summer of 1870, a little more than a year after *The Balcony* (cat. 115) was painted, Berthe Morisot posed for the second in Manet's series of dazzling portraits of her. Stylistically and psychologically, *Repose* is one of the most interesting. Manet had just portrayed Eva Gonzalès in a white gown, at her easel, brushes and palette in hand (RW I 154). At the time, Morisot wrote to her sister, in some impatience: "Manet is lecturing me, and holds up that eternal Mlle Gonzalès as an example . . . she gets things done, whereas I accomplish nothing. Meanwhile, he's starting her portrait over again, for the twenty-fifth time. She sits every day, and in the evening her hair has to be washed with soft soap. What an inducement that is for people to pose for him!"[1] A few months later, however, she agreed to sit.

Berthe Morisot was then going through a time of uncertainty, personally—at nearly thirty, she was unmarried, doubtless a stigma in her social milieu—and professionally. Although it has been freely hinted that her feelings for Manet were stronger than those of mere friendship,[2] her apparent jealousy of Eva Gonzalès seems to have been primarily professional. Evidently she had no cause for uneasiness; Manet greatly admired both her and her work, especially the landscapes recently done, in a bright palette, at Lorient.[3] A few days later, she was reassured: "The Manets came to see us Tuesday evening, I showed them the studio; to my great surprise and pleasure, I received the highest praises—decidedly better, it seems, than Eva Gonzalès. Manet is so frank, there can be no mistake, I am sure he was very much pleased. Only, I remember what Fantin says: 'He always approves of the painting of people he likes'; then he spoke to me of finishing my work, and I admitted that I don't quite know what I can do. . . ."[4] Manet did not in fact paint her holding a brush, like Eva Gonzalès, but a fan, an attribute he was to choose for her repeatedly—in *The Balcony* (cat. 115) and in *Berthe Morisot with Fan* (RW I 181; cat. 145). Ten years later, however, though he was no longer painting her, he sent her for New Year's, instead of the usual delicacies, the encouraging present of an easel.[5]

Berthe Morisot's daughter, Julie Rouart-Manet, reports that her mother had bad memories of the sittings, that her left leg, half drawn back under the skirt, used to stiffen painfully, but Manet would not allow her to move, lest the skirt be disarranged.[6]

More than any earlier portrait, he gave this one a sketchy, *non finito* treatment—a practice he accused Berthe Morisot herself of carrying to excess, but a style appropriate enough to her, since she was to become more involved than he in the frays of the Impressionist group.

Here Manet again shows us a pensive, troubled young woman, as she retrospectively described herself to her brother shortly after her mar-

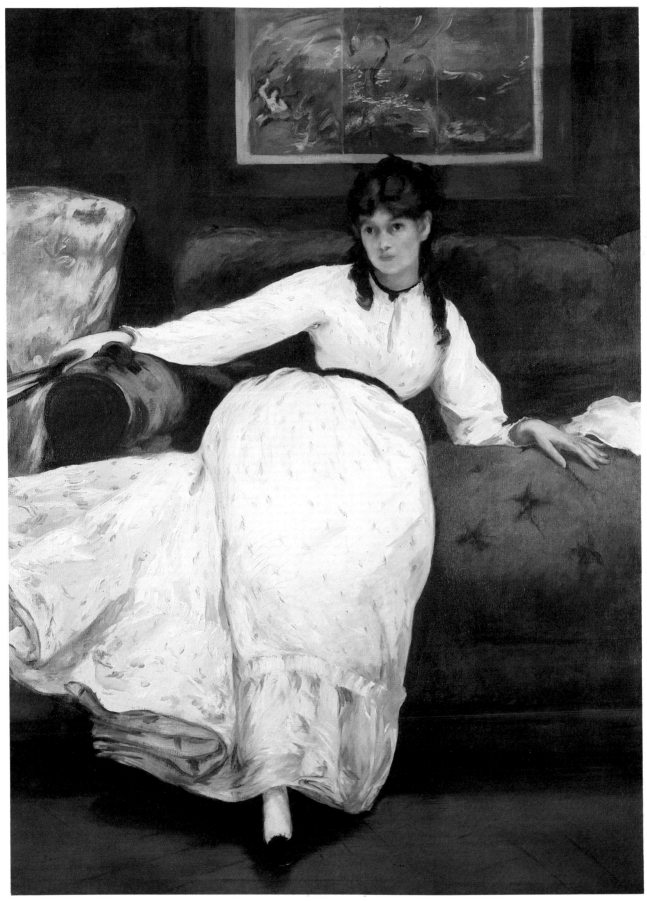

riage, in 1874: "I've come back to the reality of life, after subsisting for quite a long time on illusions that never made me very happy. . . . "[7]

These doubts, these dark reveries, Manet expressed in the face, while in the pose, the dress, the coiffure, he captured a mingling of high expectation and momentary dejection, of distinction and bohemian carelessness. The overstuffed couch and the Japanese triptych above[8] likewise suggest Morisot's personality, poised between bourgeois comfort and the hazards of artistic experience.

Although the painting was completed in the rue Guyot studio,[9] it would seem that Morisot's studio was the setting for the early stages, with the red couch mentioned in a letter from Puvis de Chavannes to Berthe Morisot.[10] It is interesting to note, from an X-ray analysis,[11] that Manet had first tried a more erect and frontal pose, as in his recent *Luncheon in the Studio* (cat. 109). The head was higher and more centered; and apparently the arrangement of the skirt remained in the original state, accounting for the exaggerated hip line. Manet added a strip at the top of the canvas to give more importance to the print on the wall. It is not known whether these changes were made at the time or after the Franco-Prussian War, when Manet decided to show the work at the 1873 Salon. The latter hypothesis seems more plausible, since if he had been completely satisfied he could have shown it in 1872, with the *Battle of the Kearsarge and the Alabama* (cat. 83).

There had been no Salon in 1871, under the Commune, but in 1873 Manet submitted this canvas (on loan from Durand-Ruel) together with *Le bon bock* (RW I 186), which he had just completed. For the first time in Manet's life, critical response to his work was laudatory, but it was by virtue of the latter painting, more conventional in its genre subject and treatment, for which *Repose* served rather as a foil. Criticisms of Manet, as always, focused on two aspects: inadequate definition of the pose and "slipshod" technique. "Not painted, not drawn, not standing up, not sitting down"—Francion's description summed up the critical verdict on the hapless *"Berthe."*[12] Paul Mantz declared, "The head and hands are in a merely indicated, unexecuted state."[13] One man of the hour, Charles Garnier, architect of the Opéra and sometime critic, was especially virulent: "He is the head of his school, if such daubery can be called a school."[14] Again: "Slapdash, uncouth daubing."[15] "A forlorn, miserable creature, and miserably dressed . . . from woebegone face to tiny foot, she is wilted, wretched, and ill-humored as can be."[16]

The most illuminating comment, though, is Castagnary's, less venomous, more prescient; he had just praised Manet's progress in *Le bon bock*, and noted that the earlier *Repose* dated from a "time when M. Manet did not expect much of himself. He has shown this kind of sloth more than once; he is after an impression, he thinks he has caught it on the wing, and he stops. He leaves it at that."[17] This, announced a year ahead of time, was the reception that awaited Monet and his friends, including Morisot. It is both pleasing and fitting that she who inspired this prophetic remark became a principal link between Manet and Impressionism.

Writing in the public press, Théodore de Banville alone, though of an older generation, represented the "modernist" view, and the taste of Manet's friends, who preferred to *Le bon bock* this "attractive portrait . . . that persuades through an intense spirit of *modernity*—if I may be allowed a barbarous term, now indispensable. Baudelaire was indeed right to esteem M. Manet's painting, for this patient, sensitive artist is perhaps the only one to echo the exquisite feeling for *la vie moderne* expressed in *Les Fleurs du mal.*"[18]

1. Morisot 1950, pp. 33–34: August 13, 1870.
2. Perruchot 1959, p. 200.
3. Morisot 1950, p. 33: Tuesday, [June] 14, 1870.
4. Ibid., p. 35.
5. Ibid., p. 100.
6. Davidson 1959, pp. 5–9.
7. Morisot 1950, p. 80.
8. Print by Kuniyoshi, identified by J. M. Kloner (1968), cited in Ives 1974, p. 33, no. 6.
9. Tabarant 1947, p. 69.
10. Morisot 1950, p. 7, cited in Davidson 1959, p. 7.

Probably in 1872, when he sold the canvas to Durand-Ruel, Manet gave his model a photograph of the painting, inscribed "à Mlle Berthe Morisot, bien respectueusement E. Manet."[19]

Provenance
This painting was one of the group of twenty-four canvases purchased by DURAND-RUEL (see Provenance, cat. 118) in 1872; he must have thought it an important work, for he paid 3,000 Frs for it, according to Manet's notebook,[20] or, according to Durand-Ruel, 2,500 Frs, more than for *Music in the Tuileries* (cat. 38) or *Woman with a Parrot* (cat. 96).[21] In 1880, he exchanged it for a Daumier with THEODORE DURET (see cat. 108), who knew the picture well, as Manet had entrusted it to him along with other works during the siege of 1870.[22] Duret was forced to include it in the sale of his collection at Georges Petit's on March 19, 1894, where Berthe Morisot, then Mme Eugène Manet, herself attempted to purchase it. The agent charged with bidding on her behalf failed to secure it, however.[23] According to the sale records, the work went to FAURE (see Provenance, cat. 10) for 11,000 Frs;[24] it later returned to DURAND-RUEL, who exhibited it in his New York gallery in 1895, when New York society had the opportunity of seeing it before their Paris counterparts. Purchased by GEORGE VANDERBILT (see Provenance, cat. 89) in 1898,[25] it next passed to his widow, who, as MRS. EDITH STUYVESANT VANDERBILT GERRY (see Provenance, cat. 89), bequeathed it to the museum in Providence (inv. 59.027).

F.C.

11. Kermit Champa, letter to Franklin Robinson, director, Museum of Art, Rhode Island School of Design, November 12, 1981.
12. Francion 1873.
13. Mantz 1873, quoted in Tabarant 1947, p. 208.
14. Garnier, quoted in Tabarant 1947, p. 209.
15. Duvergier de Hauranne 1873, quoted in Tabarant 1947, p. 210.
16. Silvestre, quoted in Tabarant 1947, p. 207.
17. Castagnary, quoted in Tabarant 1947, p. 208.
18. Banville, quoted in Tabarant 1947, p. 206.
19. Clément Rouart, pers. comm., November 1982.
20. Manet et al., "Copie faite pour Moreau-Nélaton . . . ," p. 130.
21. Meier-Graefe 1912, p. 312.
22. Tabarant 1947, pp. 182–83.
23. Morisot 1950, p. 179.
24. Duret sale, Paris, March 19, 1894, no. 19; Bodelsen 1968, p. 345.
25. Venturi 1939, II, p. 191.

122. In the Garden

1870
Oil on canvas
17½ × 21¼" (44.5 × 54 cm)
Signed (lower right): Manet
NY The Shelburne Museum, Shelburne, Vermont

In May 1870, Berthe Morisot wrote to her sister Edma Morisot Pontillon that Manet hoped Berthe could arrange to have the Morisots' friend Valentine Carré pose for him: "I went round the Salon one day with that large woman Valentine Carré. Manet caught sight of her and is lost in admiration; he's been after me ever since to come and have her pose for something in his studio. I don't more than half like the idea, but when he gets an idea in his head he's like Tiburce [Berthe and Edma's brother]: it must happen immediately."[1] According to Dennis Rouart, at Berthe's suggestion Manet asked Valentine to pose, with Tiburce Morisot on the grass behind her, in the garden of the Morisot house at 16, rue Franklin. But Valentine's mother found this objectionable, and Edma, who had arrived at her parents' house for a visit, replaced Valentine as Manet's model. Rouart informs us, however, that Manet executed "a head, more or less flawed, neither Valentine's nor Edma's."[2] If Edma did in fact pose, the child in the carriage is probably her eldest daughter, who was born only a few months before.

Prior to Rouart's publication of the Morisot correspondence, Meier-Graefe and Moreau-Nélaton identified the sitters as Edma, her daughter, and Tiburce,[3] but Jamot and Wildenstein tell us that Edma and a certain Mme Himmes posed successively for the picture.[4] Other authors, however, assert that the models were the artist Giuseppe de Nittis, Mme de Nittis, and their child.[5] According to Tabarant, the picture was painted at the Nittis summer

Exhibitions
Beaux-Arts 1884, no. 58; New York, Durand-Ruel 1913, no. 9; Orangerie 1932, no. 44

Catalogues
D 1902, 131; M-N 1926 I, p. 114, II, pp. 48, 114, 128; M-N cat. ms., 129; T 1931, 159; JW 1932, 179; T 1947, 164; PO 1967, 140; RO 1970, 140; RW 1975 I, 155

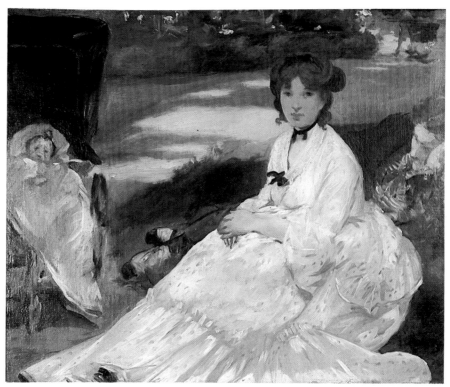

122

house in Saint-Germain-en-Laye, and Manet gave it to Giuseppe de Nittis in exchange for one of the latter's works.[6] There is in fact a letter from Nittis to Manet that is thought to be a thank-you note for the painting, although no picture is mentioned in the text.[7] However, we do know that following Nittis's death in August 1884, his widow visited Mme Manet and proposed that they re-exchange the two pictures (see Provenance). Evidently Mme Manet agreed, but even if Nittis once owned *In the Garden*, there is no documentation traceable to either family indicating that the Nittis family posed for it.

Bazire, Tschudi, Meier-Graefe, and Moreau-Nélaton believe that *In the Garden* is the first work Manet started and finished *en plein air*.[8] Indeed, the subject and the hitherto undemonstrated fascination with effects of natural light suggest that this may be the case. In 1884, Bazire adopted the extreme position that *In the Garden* initiated the Impressionist movement: "Light inundates the painting; it is translated in all its values, and dissolves in reflections and patches. The landscape lives and is vibrant with light; the air moves, and now we are far away from those well-groomed trees in conventional paintings that are approved and promulgated by tradition. This revelation is a revolution. The school of *plein-air* painting originates with this picture, which others followed and built on."[9] Although *In the Garden* can hardly be said to embody the extraordinary significance attributed to it by Bazire, it is undoubtedly an important picture in the context of Manet's own development. The palette, the emphasis on the interplay of natural light and shadow, the vigorous, open brushwork, and the subject itself indicate that Manet had looked carefully at the work of such younger colleagues as Monet and Renoir.

The composition is particularly noteworthy. Manet's point of view permitted him to silhouette the woman against a background that is deliberately ambiguous. The illusion of a rising ground plane minimizes the sense of

depth behind the figures, causing the background to appear closer to the picture plane than it actually is. The result is a subtle tension between the illusionistic and the abstract goals of the painting. During the 1870s, the conflict between the realist and the formal aspects of such works became increasingly characteristic of the Impressionist movement in general.

The artist's vantage point, the illusion of a rising ground plane, and the abrupt cutting of the composition at the edges of the canvas are features that reappear in *On the Beach*, 1873 (cat. 135), and *Boating*, 1874 (cat. 140). They abet the impression that the images are spontaneous and unplanned, as seemingly accidental in composition as the photographs which soon became commonplace with the invention of easily carried cameras, fast film, and lenses of different and variable focal lengths. In the 1870s, however, such images were limited to the realm of painting.

The sense of immediacy in *In the Garden* results largely from the fact that the space of the figures in the foreground seems contiguous with that of the viewer, an effect enhanced by the cropping of the baby carriage, the woman's skirt, and the man's head and shoulders. Moreover, the seemingly random character of the composition is integral to its convincingness. The partially blocked figure of the man contributes significantly to the sense of realism. At first, he seems to have been included simply because he was there, like an extraneous or incidental detail in the background of a photograph; but on closer examination, he is seen to affect the mood and possibly the meaning of the painting. In contrast to his wife, he seems bored, detached, and perhaps withdrawn, lending a curious twist to an otherwise wholly conventional subject. It was probably his presence that led Theo van Gogh, in a letter to his brother Vincent, written in 1889, to remark: "This is certainly not only one of the most modern paintings, but also one in which there is the most advanced art. I think the pursuits of Symbolism, for example, need proceed no further than this canvas, in which the symbol is uncontrived."[10]

1. Morisot 1950, p. 50: to Mme Pontillon, May 1870.
2. Ibid.
3. Meier-Graefe 1912, p. 208 n. 1; Moreau-Nélaton 1926, I, p. 114.
4. Jamot and Wildenstein 1932, no. 179.
5. Tschudi 1902, p. 22; Laran and Lebas 1911, pp. 69–70; Proust 1913, p. 57; Tabarant 1930, pp. 70–71; Tabarant 1931, p. 209; Tabarant 1947, p. 180.
6. Tabarant 1947, p. 180.
7. Tabarant 1931, p. 209.
8. Bazire 1884, p. 65; Tschudi 1902, pp. 22–23; Meier-Graefe 1912, p. 208; Moreau-Nélaton 1926, I, p. 114.
9. Bazire 1884, p. 65.
10. Van Gogh 1954, IV, p. 280: December 8, 1889.
11. Tabarant 1931, p. 209.
12. Ibid., pp. 70–71.
13. Rouart and Wildenstein 1975, I, p. 26.
14. Otrange-Mastai 1956, p. 169.
15. New York, Pierpont Morgan Library, Tabarant archives.
16. Rewald 1973, p. 518.
17. Vollard 1936, pp. 53–54.
18. Blot 1934, p. 14.
19. Goupy sale, Paris, March 30, 1898, no. 21.
20. Weitzenhoffer 1982, p. 296.
21. Saarinen 1958, pp. 287–306; R. L. Green and K. E. Wheeling, *A Pictorial History of the Shelburne Museum*, Shelburne, Vt., 1972.
22. Otrange-Mastai 1956, pp. 168–73.
23. Tabarant 1947, pp. 524–27.

Provenance

This picture was given as a present to GIUSEPPE DE NITTIS (1846–1884), the Neapolitan painter who had exhibited with the Impressionists in 1874 and who had invited the Manets to spend the summer of 1870 at his country house in Saint-Germain-en-Laye, outside Paris. Tabarant published a letter of thanks from Nittis, which was presumably in response to the gift of this painting.[11] After the death of Nittis, his widow approached Manet's widow to offer the picture in return for one that Nittis had given to Manet.[12] Tabarant, who got this information from Vollard, claimed that the work by Nittis was a landscape done in Paris, yet, as Otrange-Mastai pointed out, the only work by Nittis listed in Manet's studio inventory (as being in the apartment of Manet's mother)[13] was a pastel portrait of a young woman, valued at 200 Frs.[14] A letter of November 1889 indicates that SUZANNE MANET (see Provenance, cat. 12) sold *In the Garden* to the dealer ALPHONSE PORTIER,[15] who after working for Durand-Ruel[16] had become a modest independent dealer, operating out of his own house.[17] He was perhaps the first dealer to approach Suzanne Manet directly for drawings and prints by her husband that were left in the estate. He

sold *In the Garden* to the collector EUGENE BLOT (see Provenance, cat. 63) on credit for 2,000 Frs,[18] but Blot could not raise that sum and returned the work to the dealer, who then sold it to GUSTAVE GOUPY. At Goupy's sale in Paris in 1898,[19] DURAND-RUEL bought it for 22,000 Frs for MR. AND MRS. H. O. HAVEMEYER (see Provenance, cat. 118, 33).[20] Upon Mrs. Havemeyer's death in 1929, many of the finest works in the collection went to the Metropolitan Museum; the rest were divided among her three children. This picture went to her youngest daughter, Electra, MRS. J. WATSON WEBB (1888–1960), the pioneering collector of Americana who with her husband cofounded the Shelburne Museum in 1947.[21] Mrs. Webb's daughter, also named Electra (MRS. DUNBAR W. BOSTWICK), inherited the picture and presented it to the Shelburne Museum in December 1981.

Another version of this subject, painted on a pine panel measuring 43 × 55 cm, was published by Otrange-Mastai.[22] Although this version bears the stamp of Suzanne Manet's estate, it may be among the copies made for her, allegedly as souvenirs, by her nephew, Edouard Vibert (see Provenance, cat. 164). Tabarant discusses this problematic group of pictures.[23]

C.S.M.

320

123. Queue at the Butcher Shop

1870–71
Etching
Plate: 9⅜ × 6¼″ (23.9 × 16 cm); image: 6¾ × 5⅞″ (17.1 × 14.8 cm)
The New York Public Library (proof)
P Bibliothèque Nationale, Paris (copperplate)

Exhibitions
Philadelphia-Chicago 1966–67, no. 114; Ann Arbor 1969, no. 32; Paris, BN 1974–75, no. 146; Ingelheim 1977, no. 71; Paris, Berès 1978, no. 64; Providence 1981, no. 39

Catalogues
M-N 1906, 45; G 1944, 58; H 1970, 70; LM 1971, 60; W 1977, 71; W 1978, 64

1st state (of 2). Proof on heavy laid paper (watermark MBM), probably posthumous, but perhaps before the 1890 edition. With an inscription by Guérard. Avery collection.

Copperplate. With the holes pierced at top and bottom of the plate. With the stamp of the maker, P. Valant, on the verso. Suzanne Manet, Dumont, Strölin collections.

Having sent his mother and his wife with Léon to a place of safety in the Basses-Pyrénées, Manet remained in Paris throughout the siege of the city by the Prussian army, from September 1870 to February 1871. He enrolled, as did Degas, in the National Guard and became a volunteer gunner in the artillery, although he was soon transferred to an administrative post. All this activity is recounted in his letters to his wife and above all to Eva Gonzalès, of whom he was very fond and whose absence he regretted.[1] When Paris was completely surrounded, the letters were sent by balloon across the enemy lines, and they give a very vivid impression of the waiting, the growing lack of provisions, and the military action seen from afar or experienced at close quarters when the shells fell in the streets of the capital.

Many of Manet's friends had fled as the enemy began to lay their siege; he mentions Champfleury's flight, for example, as evidence of the "collapse of normal life," adding, "there is fighting at the stations to get away," and he later refers bitterly to the departure of "many cowards . . . alas, among our friends Zola, Fantin, etc." By the end of September he was writing to his family that "one doesn't drink café au lait any more, the butcher shops open only three times a week, and there are queues in front of

123

their doors from four in the morning, and the last in line get nothing. We only have one meal with meat. . . . " Three weeks later, on November 19, he wrote Eva, "We are beginning to suffer here, horse meat is regarded as a delicacy, donkey is wildly expensive, there are dog, cat, and rat butcher shops," and on December 22, to his family, "We get very little to eat, brown bread, sometimes meat."

He informed Eva, in his November 19 letter, that "my soldier's bag is equipped with my [paint]box and my country easel, . . . and I'm going to take advantage of the facilities to be found on every side." In spite of this declaration, however, hardly any works are known, beyond a sketch on a notebook page (RW II 317), which may date from the period of the siege. *Queue at the Butcher Shop* was of all subjects the most symbolic of the hardships of the siege. Daumier featured it in a wood engraving for *Le Charivari* of December 8, showing "the queue for rat meat" in front of the street gullies.[2] It nevertheless seems unlikely that Manet actually etched his print during the siege. Its composition is very abstract, possibly influenced, as Ives has suggested,[3] by a page from Hokusai's *Manga*. Yet this scene of women—there appears to be only one man—bundled up against the winter cold is also intensely "experienced." Huddled together—those who have them holding umbrellas—they are waiting, perhaps since "four in the morning," in front of the narrow door guarded by a soldier, whose presence is indicated by the point of his bayonet.

Since Rosenthal, who referred to a "frankly impressionist page,"[4] critics have agreed that it represents a synthesis of Goya and Japonisme. As far as Goya is concerned, *Queue at the Butcher Shop* recalls above all the desolate scenes of the 1811–12 famine in Madrid depicted in the *Disasters of War*, where young women and old are waiting or helping each other, or where a crowd in the background watches expectantly.[5] Manet is known to have owned a set of Goya's prints (see cat. 105). It would hardly be surprising if he looked to Goya, the witness of the "fatal consequences of the bloody war in Spain with Bonaparte,"[6] as a model for his depiction of the miseries provoked by the fight against "those Prussian blackguards."[7] Manet had already used Goya as his model for his campaign against Napoleon III in his depictions of the execution of Maximilian (see cat. 104, 105).

If Manet had planned to publish his plate as one of the numerous "souvenirs of the siege" produced by other printmakers, such as Lalanne, he did nothing about it. It has even been suggested that he left the etching unfinished,[8] but a design so vigorously etched on the copperplate would surely have revealed traces in the unworked areas of any intended additions. Indeed, it is through its ambiguities, through what Rosenthal calls "the elements [that are] deliberately fused" after having been "clearly analyzed,"[9] and by the remarkable balance between "positive" and "negative" forms that Manet's print represents what Melot considers "the crowning achievement of his art as an etcher."[10] There are few, if any, contemporary proofs (it is not known whether the proofs cited by Guérin were printed in Manet's lifetime). The remarkable differences in inking probably testify to the difficulty of printing the plate, which was undoubtedly pitted and defective, as shown in the proof exhibited. This example is strongly printed in black ink, whereas others are grayish and print with a very soft effect.

1. Manet 1935, pp. 17, 20, 22: to his family; Wilson 1978, no. 107: to Eva Gonzalès.
2. *Edouard Manet and the "Execution of Maximilian"* (exhibition catalogue), Brown University, Providence, R. I., 1981, no. 38.
3. Ives 1974, no. 21; see also Weisberg 1975, nos. 5a, 42.
4. Rosenthal 1925, p. 146.
5. Francisco de Goya, *Disasters of War*, pl. 48–62, 74, 76, 77.
6. Title given by Goya to the *Disasters of War* series.
7. Manet 1935, p. 13: to Suzanne Manet, September 30.
8. Harris 1970, p. 188.
9. Rosenthal 1925, p. 146.
10. Melot 1974, p. 62.

Provenance
The inscription "la queue à la boucherie pendant le siège de Paris 1870–71. Eau-forte de Manet. HG" was probably added by GUERARD at the request of LUCAS for his client AVERY (see Provenance, cat. 16, 17). Since there are impressions of several other plates on the same paper, which appear to predate the edition made for Manet's widow in 1890, it is impossible to tell whether it came from SUZANNE MANET (see Provenance, cat. 12) or from Guérard himself, to whom she might have lent the plate.

The copperplate is part of the group of plates transferred to the Bibliothèque Nationale following the confiscation of the property of the dealer STROLIN, the successor of DUMONT (see Provenance, cat. 11), who had acquired them from SUZANNE MANET.

J.W.B.

124. The Barricade (recto)
The Execution of Maximilian (verso)

1871?
Pencil, ink wash, watercolor, and gouache (recto);
black chalk (verso)
18¼ × 12¾" (46.2 × 32.5 cm)
Atelier stamp (lower right): E.M.
P Szépmüvészeti Múzeum, Budapest

Exhibitions
Beaux-Arts 1884, no. 119; Paris, Drouot 1884,
no. 137; Providence 1981, App. 3a, 3b (not ex-
hibited); Washington 1982–83, no. 72

Catalogues
T 1931, 41; T 1947, 590; L 1969, 342/343; RW 1975 II,
319

Manet left Paris on February 12, 1871, after the end of the war and the siege of Paris (see cat. 123). He rejoined his family at Oloron-Sainte-Marie, near Arcachon (see cat. 127, 128), and they journeyed back to Paris in stages, staying in Le Pouliguen for "one month" according to Léon Leenhoff: "He did not paint there. We were still waiting for the end of the Commune. We stayed for a week at Tours. Then we returned to Paris."[1] Was Manet in fact in the capital during the last days of the Commune, the week of May 21–28, 1871, known as "la semaine sanglante" (the week of blood)?

In a letter of June 5, Mme Morisot informed her daughter Berthe: "Tiburce [Berthe's brother] ran into two 'Communards' just at the time they were all being shot—Manet and Degas! Even now they continue to condemn the drastic means of repression. I think they are mad, don't you?"[2] Although this letter suggests that Manet was in Paris during the period of the summary executions, Manet himself wrote to Berthe on June 10, saying, "We have been back in Paris for several days now."[3] It seems unlikely that by "several days" he could have meant more than two weeks, the time elapsed since the end of the "semaine sanglante."

The large drawing of *The Barricade* records scenes that were probably still quite recent; no doubt either Manet saw them himself or experienced them through firsthand accounts and newspaper reports, prints, and photographs. But even if he was in fact in Paris when the shooting was still going on, he sought to express his anger and sense of outrage in a monumental composition based on an already fully worked-out idea that he may have made in preparation for a large new Salon painting.

The scene of the execution of Communards in front of a barricade is derived from the lithograph *The Execution of Maximilian* (cat. 105), which Manet had been prevented from publishing in 1869. He either reused an original working drawing made for the Maximilian lithograph, or made a tracing from the lithograph, then transferred it, by pressure, onto a sheet of strong wove paper about the same size as the print. Clear traces of the indented outlines of the figures from *The Execution of Maximilian* appear on one side of the drawing. The composition appears in reverse, and the figures of the three victims and one of the soldiers have been redrawn in outline over the indented contours with black chalk or lithographic crayon. On the other side of the sheet, all the "Maximilian" figures appear in pencil and are visible to the naked eye or when the sheet is held against the light, beneath the wash and gouache of *The Barricade* composition. The pencil outlines of the Mexican firing squad—the tall caps, short jackets, and long trousers—are apparent beneath the French army uniform of greatcoat, breeches, and gaiters, and there is even a trace of the officer's raised sword. As for the victims,

124 (recto)

124 (verso)

General Mejía's legs are still visible beneath the superimposed barrel on the left; Maximilian and Miramón's clasped hands are faintly visible, although their lower legs are covered with wash and their heads are obliterated by a layer of white gouache representing the smoke from the muskets. Just above Maximilian's head, almost completely effaced, Manet has added that of the defiant Communard whose arm is raised; and he has transformed Mejía's head, which was thrown back, into the drooping head of the Communard struck by a fusillade of bullets.

Of the major alterations made to the schematic *Maximilian* composition, the most radical was the change of format from horizontal to vertical.

By pasting on an additional piece of laid paper, Manet increased by half the height of the original sheet. He then freely sketched in the cityscape background with ink wash and watercolor. Because the ink wash is transparent, the composition's point of departure and its complex development are clearly apparent. On the surface, gray-blue touches of gouache extend onto the upper sheet along the corner of the building at the left edge and up to the balcony level of the building in the center. The areas of red watercolor—the only real note of color in the drawing—are limited to the soldiers' caps, greatcoat facings, and breeches, recalling the symbolic use of red in the paintings of *The Execution of the Emperor Maximilian* (cat. 104).

It is difficult to judge the element of "reality" in this scene based on an existing composition, with an added decor, and in which the influence of Goya's *The Third of May, 1808* (see cat. 105, fig. b) and *Disasters of War* etchings still makes itself felt in the figures of the victims.[4] The elements necessary to the transposition of *The Execution of Maximilian* into the context of the civil war and the "semaine sanglante" in Paris are in fact present in an anonymous photograph of the period, which shows the destruction of the great barricade that blocked the rue de Rivoli at the corner of the rue Saint-Martin (fig. a).[5] Although it cannot be proven that Manet never actually saw an execution or that he relied on this particular photographic source, a document of this kind (widely available at the time) would certainly have enabled him to create the appropriate setting for his drama—the corner of the building on the left and the remains of the barricade with the lamp post behind, the façades of the buildings on the right, in the drawing brought much closer or observed in a narrower street, which form the freely brushed background to the scene.

It has been considered strange and yet another example of Manet's lack of imagination that he should have reused an old composition for this scene recording the collapse of the Commune. However, it would appear that he deliberately turned to a source that represented, in a very similar context, a great expenditure of time and energy in order to express strong feelings in a "totally sincere" composition (to use his favorite expression, as quoted by Antonin Proust and others) and that he had been unable to show in Paris. Like Delacroix returning in 1830 to his studies of the early 1820s on the theme of Greece rising against the Turkish domination in order to transform them into the allegory of *Liberty Leading the People* (Musée du Louvre, Paris),[6] so Manet returned to his *Execution of Maximilian*, with which he had censured the policies of Napoleon III, in order to create this image condemning what Mme Morisot called "drastic means of repression."

Probably intended as a sketch for a large canvas, the composition was also repeated in a lithograph (cat. 125). Manet still had in his studio the three large canvases of *The Execution of the Emperor Maximilian* (see cat. 104). Having been prevented from showing the final version at the Salon of 1869, he may have considered reworking one of the versions, adding a piece of canvas to it as he had added paper to his drawing, in order to create a grand new Salon painting on a theme from recent history, the civil war in France.

According to Tabarant, Manet experienced a nervous depression after the war; Dr. Siredey was called in to treat him, and it was not until the spring of 1872 that he was able to return seriously to work.[7] If Manet had in fact intended to send a painting of *The Barricade* to the Salon that year, nothing came of the project. But the decision to exhibit an earlier painting, *Battle of the Kearsarge and the Alabama* (cat. 83), painted in 1864 and already

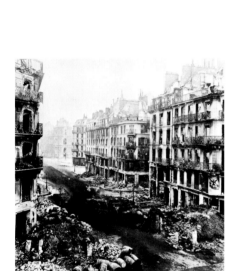

Fig. a. Photograph of the barricade destroyed, rue de Rivoli, May 23–24, 1871 (detail). Bibliothèque Nationale, Paris

1. Manet et al., "Copie faite pour Moreau-Nélaton . . . ," p. 69.
2. Morisot 1950, p. 58.
3. Ibid., p. 59.
4. Francisco de Goya, *Disasters of War*, pl. 15, 32.
5. Ruggiero 1981, p. 31, fig 5.
6. H. Toussaint, "La liberté guidant le peuple de Delacroix," (archives, department of paintings, Musée du Louvre, Paris).
7. Tabarant 1935, p. 33.
8. Manet sale, Paris, February 4–5, 1884, no. 137, "La Guerre Civile"; Bodelsen 1968, p. 343 (*procès verbal:* "Derrière la barricade").
9. Dollfus sale, Paris, March 4, 1912, no. 72.

in January 1872 sold to Durand-Ruel (from whom Manet had to borrow it for the Salon show), may have served as a kind of substitute. For his image of the civil war in France—*The Barricade*—unfinished or never begun on canvas, he may have deliberately provided this alternative image of civil war, in this case the American War Between the States.

Provenance
This drawing was included in the 1884 studio sale and was acquired for 205 Frs by JEAN DOLLFUS (1823–1911),[8] an industrialist from Alsace, who was one of the early admirers of Impressionism. It reappeared at his sale in 1912[9] and passed to the collection of PAL VON MAJOVSZKY in Budapest, who included it in the gift of 1935 to his city's museum (inv. 1935.2734).

J.W.B.

125. The Barricade

1871?
Lithograph
18¼ × 13⅛" (46.5 × 33.4 cm)
Museum of Fine Arts, Boston

Manet repeated the composition of the large drawing *The Barricade* (cat. 124) in a lithograph that remained unpublished during his lifetime. The lithograph was probably made with the help of a tracing from a photograph of the drawing, since the figures in the print are smaller. The lithograph in fact shows two different drawing methods. The contours of the figures, particularly the soldiers, were clearly made from a tracing (and include the head of the officer with a raised sword in the *Maximilian* composition, which Manet began to draw but then abandoned). The setting, however, is a free translation of that in the drawing: the barrel is brought forward to leave a space in front of the victims; the barricade is more clearly defined behind the white-faced Communard, who no longer appears with arm raised; and the background buildings, in particular, are drawn with remarkable freedom, probably because they were so sketchily indicated in the drawing. In the print, the edge of the lithographic crayon was used in broad strokes to create an effect of walls inundated with light contrasting with those in shadow, which serve as a dark foil to the drama.

The lithograph provides evidence of the original appearance of the drawing, now extensively restored at the lower edge and no doubt considerably trimmed all around: its composition must have corresponded to that of the lithograph (in which the head of the "missing" soldier on the left must have been traced from a lost section of the drawing). The lithographic proof in the first state, before letters and the removal of lines extending beyond the edges of the composition, has an extraordinary richness. An artist's proof dedicated by Manet to Tiburce Morisot also exists.[1] (Tiburce was Berthe's brother, whose meeting with the "two 'Communards' . . . Manet and Degas!" Mme Morisot recounted in a letter to her daughter (see cat. 124). Although it remained unpublished, Manet must have had a number of proofs; in the case of *The Execution of Maximilian* (cat. 105), his letter to Lemercier refers to his having received at least three (see Appendix II, no. 8).

Moreau-Nélaton quoted the printer Clot, "who was responsible for proofing this lithograph at Lemercier's printing works in 1884 and who

Publications
Mme Manet 1884?

Exhibitions
Beaux-Arts 1884, no. 164; Paris, Drouot 1884, no. 170, not in cat.; Philadelphia-Chicago 1966–67, no. 115; Ann Arbor 1969, no. 34; Ingelheim 1977, no. 72; London, BM 1978, no. 17; Paris, Berès 1978, no. 80; Providence 1981, no. 41; Washington 1982–83, no. 73

Catalogues
M-N 1906, 81; G 1944, 76; H 1970, 71; LM 1971, 77; W 1977, 72; W 1978, 80

1st state (of 2). One of the very rare proofs before removal of the lines extending into the borders; before letters indicating Lemercier's name. On applied China paper. Allen collection.

Fig. a. *Civil War*, 1871–73, lithograph. Bibliothèque Nationale, Paris

125

owned a proof of it in the first state," as saying that "the stone had not been prepared for an edition prior to this date and had not been through a press before Manet's death. The printing of an edition was in any event contemporary with the posthumous exhibition at the Ecole des Beaux-Arts."[2] The edition of this lithograph, which is not recorded in the Dépôt Légal, must therefore have been made at the same time as the other four stones that had remained, unpublished, in the artist's studio (see appendix to cat. 105).

If Manet did in fact intend to make an oil painting of this composition for the Salon of 1872 (see cat. 124), he would quite probably have planned to publish the lithograph at the same time. Although this subject remained unpublished, he made another lithograph on a similar theme, which was printed by Lemercier and published in an edition of one hundred

in February 1874, at the same time as the lithograph of *Boy with Sword* (cat. 8). According to Duret, Manet saw the figure of the dead National Guard soldier in *Civil War* (H 72; fig. a) "at the corner of the rue de l'Arcade and the boulevard Malesherbes; he made a sketch on the spot."[3] This statement should nevertheless be regarded with some suspicion, since the dead soldier is remarkably similar to Manet's *Dead Toreador* (cat. 73), and the monumental composition is cast in a heroic mold that recalls both Delacroix's *Liberty Leading the People* and Daumier's lithograph *La rue Transnonain*—two works whose symbolic or allegorical character transcends the realism of the actual events portrayed. The same is true of *The Barricade*. Here Manet created a grand new historical subject from his own imagery.

1. Harris 1970, p. 190.
2. Moreau-Nélaton 1906, no. 82.
3. Duret 1902, p. 127.

Provenance
The early provenance of this proof is unknown; it was acquired by W. G. RUSSELL ALLEN (see Provenance, cat. 128) and given to the Museum of Fine Arts, Boston, in 1925 (inv. 25.717).

J.W.B.

126. Bazaine Before the Council of War

1873
Pencil
7¼ × 9⅜" (18.5 × 23.8 cm)
Atelier stamp (lower right): E.M.
Museum Boymans-van Beuningen, Rotterdam

This drawing was done by Manet from life, on a double spread of a notebook with squared paper, at the hearing in the trial of Marshal Bazaine. "One day, during Bazaine's trial, we went to the Trianon, Manet and I, with a group of

Catalogues
D 1902, pp. 133–34; M-N 1926 II, p. 26; L 1969, 412; RW 1975 II, 352

126

friends," reported Théodore Duret. "That was the first time we had been there, and I remember that we long contemplated, in silence, the imposing spectacle of the Council of War. Manet's eyes were fixed on the accused, and suddenly, taking from his pocket the little book that never left him, he began drawing. He thus made several slight sketches, showing Bazaine by himself, or surrounded as he was at the hearing. One single, round stroke was all he needed for the head, and he added two or three dots for the mouth and eyes. . . . He showed us his sketches, saying, 'But look at that billiard ball!' . . . They showed the real Bazaine . . . the one Manet had seen and caught, the man of small understanding, with his 'billiard ball' head,"[1] and not "the illustrious" Bazaine, the Bazaine who was to become, after the defeat, "the archtraitor." Duret had caught Manet in the act of dedramatization when passions were running high during a treason trial before the Council of War inquiring into the defeat of 1870.

On the reverse of this drawing there are two more sketches: left, the back view of a cat; right, a detail of Bazaine, alone. From the drawing shown here, Manet did a tracing (RW II 351), probably intended as a transfer for a lithograph that was never executed. Also from the same notebook, there is a more finished version of Bazaine, touched with India ink and inscribed "Marshal Bazaine, done from life at Versailles" (RW II 350).

1. Duret 1926, pp. 173–74.
2. Manet sale, Paris, February 4–5, 1884, no. 146; Bodelsen 1968, p. 343.
3. Degas collection, first sale, March 26–27, 1918.

Provenance
This drawing appeared in the Manet sale in 1884 and was sold to MOYSE.[2] It later belonged to EDGAR DEGAS (see Provenance, cat. 15) and was no. 219 at his sale in 1918,[3] when it was purchased by the gallery BERNHEIM-JEUNE (see Provenance, cat. 31). After passing through the hands of PAUL CASSIRER (see Provenance, cat. 13), it was in the collection of FRANZ KOENIGS (see Provenance, cat. 13) from 1928. The museum acquired it in 1932 (inv. F. 11.107).

F.C.

127. Interior at Arcachon

1871
Oil on canvas
15½ × 21⅛" (39.4 × 53.7 cm)
Signed (at right, behind the table): Manet
Inscribed (on book on table): Manet (?)
NY Sterling and Francine Clark Art Institute, Williamstown, Massachusetts

Catalogues
D 1902, 137; M-N 1926 I, p. 129, no. 138; T 1931, 164; JW 1932, 193; T 1947, 179; PO 1967, 150; RO 1970, 150; RW 1975 I, 170

During the Franco-Prussian War of 1870–71, Manet served in Paris with an artillery detachment of the National Guard. The siege of Paris ended early in 1871, and on February 9 he wrote Zola that he planned to rejoin his family at Oloron-Sainte-Marie, where they had sought refuge the previous September: "I will leave during the next few days to rejoin my wife and my mother who are at Oloron in the Basses-Pyrénées."[1] According to Tabarant, Manet left Paris on February 12.[2] He stayed at Oloron for only a few days, and on February 21 arrived for a week-long stay in Bordeaux, where he painted a view of the harbor (RW I 164), his first important work since the previous summer. On March 1, Manet and his family arrived at Arcachon, a town on the Bay of Biscay, about thirty miles southwest of Bordeaux. Manet rented a furnished house, the Chalet-Servanti at 41, avenue Sainte-Marie, and stayed for a month.

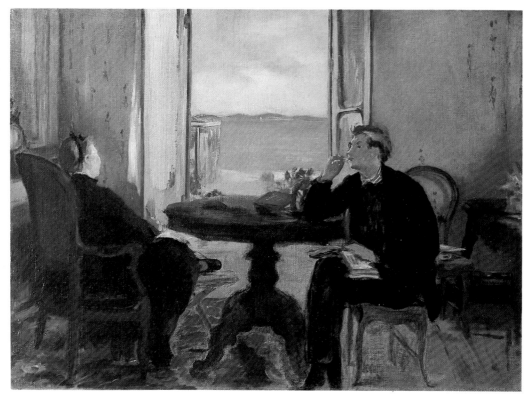

127

At Arcachon he painted several small, loosely executed works, mostly beach scenes and harbor views. The subject and composition of *Interior at Arcachon* are rare in Manet's work in general, and, with the exception of *La pêche* (cat. 12), it is the only painting that includes both his wife and his son, Léon Leenhoff. Such scenes are more typical of Degas than Manet, but even Degas's unceremonious *Manet Listening to His Wife Play the Piano* (cat. 107, fig. a)[3] is dissimilar in mood and composition. Coincidentally, Degas gave that picture to Manet, but reclaimed it after discovering that Manet had cut the canvas at the right side along a line that excised Mme Manet's face. Degas's goal in such works, as stated in a notebook of 1868–72, was to "make portraits of people in familiar and typical positions, above all, [and to] give their faces the same range of expression one gives their bodies."[4] Manet, on the other hand, tends to emphasize public rather than private aspects of individuals, interpreting the world through the eyes of a *flâneur*, whereas Degas seems to see through the lens of an unseen camera.

In *Interior at Arcachon*, Mme Manet seems to contemplate the view through the French doors, but the drawing of the same subject (cat. 128) indicates that she is writing. In the drawing, it is clear that the object beside her on the table is an inkwell; there is a pen in her hand; and her gaze is directed downward. Although Léon is momentarily lost in thought, he, too, may be writing or making notes in the book in his lap, because the object in his right hand seems to be a pen. Mme Manet and Léon seem perfectly comfortable in each other's presence, but both are entirely absorbed by their respective interests. This kind of insularity is typical of many of the figures in Manet's paintings and is exemplified by such works as *On the Beach*, 1873 (cat. 135); *The Swallows*, 1873 (RW I 190); *Argenteuil*, 1874 (cat. 139); *Café-Concert*, 1878

1. See Appendix I, letter 18; Rouart and Wildenstein 1975, I, p. 17.
2. Tabarant 1947, p. 184.
3. Lemoisne 1946, II, no. 127.
4. Degas, quoted in Nochlin 1966, p. 62.
5. Rouart and Wildenstein 1975, I, p. 26.
6. Tabarant 1930, p. 71.
7. Letter from Charles Durand-Ruel, December 13, 1982 (archives, department of European paintings, The Metropolitan Museum of Art, New York).
8. Havemeyer 1961, p. 400.
9. *Highlights: Sterling and Francine Clark Art Institute*, Williamstown, Mass., 1981, pp. 7–8.

The early history of this picture is unclear. It may correspond to the work mentioned in the inventory compiled after Manet's death as "Portrait of Mme Manet and of M. Léon Koëlla" located in the apartment of Manet's mother,[5] but that entry more likely refers to *Reading* (cat. 97). The photograph by Lochard (no. 160 bis) is, therefore, the earliest documentation for this picture. According to Tabarant, MR. AND MRS. H. O. HAVEMEYER (see Provenance, cat. 33) acquired the picture from Durand-Ruel,[6] but it does not appear in the dealer's stock books.[7] The Havemeyers must have made the acquisition prior to 1902, since H. O. Havemeyer is listed as the owner in Duret's catalogue. Following Mrs. Havemeyer's death in 1929, the picture apparently went to her daughter Electra, MRS. J. WATSON WEBB (see Provenance, cat. 122), who is listed as the owner in the catalogue of her parents' collection.[8] Mrs. Webb sold it to M. KNOEDLER & CO. (see Provenance, cat. 172) on April 1, 1943, and Knoedler sold it on April 12 to ROBERT STERLING CLARK (1877–1956) of New York. Clark, who with his brother Stephen C. Clark was heir to the Singer Sewing Machine fortune, began to collect old master pictures in 1912 and soon afterward began to acquire works by the French Impressionists. He owned thirty-seven paintings by Renoir, his favorite artist. He and his wife founded the Sterling and Francine Clark Art Institute in Williamstown, Massachusetts, which opened in 1955, to house their collection.[9]

C.S.M.

(cat. 169); and *In the Conservatory,* 1879 (cat. 180).

There are numerous compositional differences between the painting and the related drawing (cat. 128). The painting shows more of the room, both vertically and laterally, and the figure of Léon is smaller and farther away. In contrast, the drawing indicates that Manet wanted to focus the composition more emphatically on Léon. In order to do so, he increased his size relative to the composition and reduced the area of the room shown, thereby effecting changes of space and scale analogous to those made in the 1864–67 racetrack pictures (cat. 99, 100) and the two versions of *Corner in a Café-Concert* (cat. 172, 173).

If he had made the changes in the painting that are indicated in the drawing, Léon would have become in effect the subject of the painting and Mme Manet's role would have become almost incidental. This is particularly interesting because in all subsequent paintings for which she modeled, with two exceptions (cat. 97, 181), either she is seen from behind (as she is here), or her face is obscured (e.g., cat. 135), or the painting is unfinished. Technical evidence indicates that Manet began to paint her face in the unfinished portrait in the Metropolitan Museum (RW I 117) and scraped it off three times before finally abandoning the picture. In addition, X-ray examination shows that before he painted over the portrait of Suzanne that is covered by his self-portrait (cat. 164), he scraped off her face with a palette knife after the paint was dry.

128. Interior at Arcachon

1871
Pencil, pen and ink, watercolor, and sepia wash
7¼ × 9¼" (18.5 × 23.5 cm)
Inscribed (on reverse, by Suzanne Manet): Je certifie que cette esquisse a été faite par mon mari Edouard Manet, à Arcachon en 1871. Mme Edouard Manet.
Fogg Art Museum, Harvard University, Cambridge, Massachusetts

This work is a study for the painting of the same subject (cat. 127). Two other drawings (RW II 349, 388) are sometimes mentioned in connection with the painting, but, despite the similarity of subject matter, on purely visual grounds they seem unrelated.

Leiris states: "From 1870, Manet seldom felt the need to elaborate a preliminary composition in drawing form. When he did so, the drawing was reproduced, practically unchanged in design and detail, in the medium of oils. The drawing of *Intérieur à Arcachon* of 1871 is a characteristic example. The corresponding painting reproduces it faithfully in all essentials."[1] However, there are significant differences which suggest that the drawing was reworked after the painting was finished. If this is correct, the drawing, which at first served as a study, should be considered a refined version of the composition of the painting.

Such discrepancies as the absence in the painting of the boat on the

128

water and the fence visible through the French doors are relatively unimportant. More significant are the increase in Léon's size relative to the rest of the composition, particularly the figure of Mme Manet, and the decrease in the area of the room that is shown. In the painting, Léon and Mme Manet are nearly equal in size and compositional importance, but in the drawing Léon is clearly the focus of the composition. Furthermore, the composition of the drawing is a somewhat contracted view of the room compared to that of the painting. The framing edges are closer to the figures, and the furniture to the right behind Léon is not included. The changes are more subtle than but analogous to the differences between Manet's 1864 racetrack composition (cat. 99, fig. a) and *Races at Longchamp* (cat. 99). The process of simplification and reduction that led to the latter seems also to be reflected in the Fogg Museum's *Interior at Arcachon*. In both, a principal element has been moved forward and made the focus of the composition.

The key to understanding the evolution of the composition of the drawing may be Léon's chair. As is easily seen, Manet drew it and then added the figure. Originally, the composition of both the drawing and the painting may have included only Mme Manet facing an empty chair on the opposite side of the table. The paint surface to the right of the table seems to have been scraped or wiped, suggesting that changes were made to accommodate the figure of Léon. After finishing the painting, which in some respects seems tentative and unresolved, Manet probably further experimented with the composition by reworking the drawing. Having added the somewhat larger figure of Léon to the empty chair, Manet may also have adjusted Mme Manet's posture and the view of her face, in order to further subordinate her compositional importance to that of her son. It seems likely, therefore, that the drawing served as both a preparatory study and a means of creating a more advanced stage of the composition of the painting.

1. Leiris 1969, p. 33.
2. Meier-Graefe 1912, pl. 110.

Provenance
On the reverse of this sheet, probably at the time of its sale, Manet's widow added a note certifying that her husband made the sketch at Arcachon in 1871. By 1912, it was in the collection of PIETRO ROMANELLI of Paris.[2] W. G. RUSSELL ALLEN (1882–1955) later acquired the work, presumably before 1939, when it was lent anonymously to an exhibition of works from New England collections at the Museum of Fine Arts, Boston. Russell Allen, a quiet bachelor of independent means who assembled an immense graphic art collection of surprising diversity, had been a member of the visiting committee in the department of prints at the museum in Boston since 1922 and a trustee since 1936. During his lifetime, he gave the museum many works from his collection, including a copy of the 1875 edition of Poe's *The Raven* illustrated by Manet (see cat. 151). At his death in 1955, the museum received many more works from his collection, but this watercolor went to his alma mater (inv. 1957–59).

C.S.M.

129. The Brunette with Bare Breasts

1872
Oil on canvas
23½ × 19¼″ (60 × 49 cm)
Signed (lower left): Manet
Private Collection

Exhibitions
Beaux-Arts 1884, no. 66; Paris, Bernheim-Jeune 1928, no. 30; Orangerie 1932, no. 59; Marseilles 1961, no. 17

Catalogues
D 1902, 149; M-N 1926 II, p. 135; M-N cat. ms., 199; T 1931, 172; JW 1932, 258; T 1947, 190; PO 1967, 161; RO 1970, 161; RW 1975 I, 176

This superb nude study, with the breast presented in the manner of an eighteenth-century sculptured sphinx, poses more than one riddle. The model, whose identity is unknown, was probably a professional, as in *The Blonde with Bare Breasts* (cat. 178). The almost identical dimensions of the two works suggest that they are a pair, as was noted by Moreau-Nélaton, who dated them both 1875 and was followed in this by the early catalogues raisonnés. Although it has been thought that one woman posed for both

129

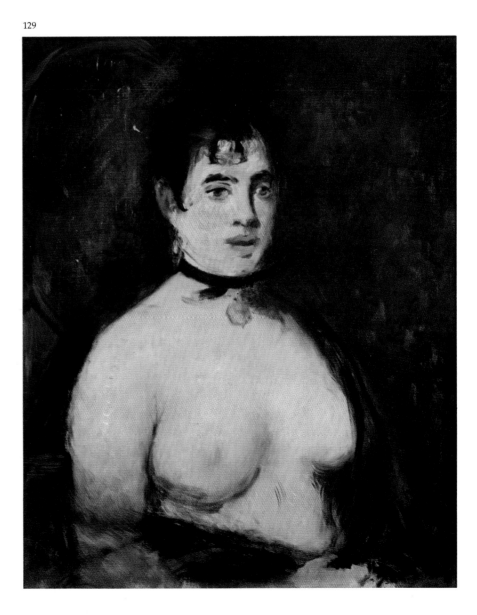

paintings,[1] it is hard to believe that the model is the same; here the face appears heavier, the neck shorter, and the style is evocative of an earlier period, both in handling and in the use of contrasting values. Tabarant dates the canvas 1872, relying on a photograph reportedly taken by Godet that year.[2] This is, in any case, the date used in the 1884 retrospective, and the one to which we subscribe.

The woman is turned away from an oval mirror, sketched at the upper left; a black ribbon, with ornament, recalling the black ribbon of Olympia (cat. 64), accentuates the whiteness of the neck and sets off the dark beauty's somber gaze. The high-piled coiffure is the link between that of a Constantin Guys prostitute and the chignon of a Toulouse-Lautrec.

1. Charles F. Stuckey has suggested that the brown hair is a wig (pers. comm., 1982).
2. Tabarant 1947, p. 201.
3. Rouart sale, Paris, December 9, 1912, no. 236.

Provenance
This work was acquired, probably during Manet's lifetime, by the manufacturer, art collector, and painter HENRI ROUART (1833–1912), who exhibited with the Impressionists in 1874. He was a friend from childhood of Degas's, and his son Ernest was to marry Berthe Morisot's daughter, Julie Manet. ERNEST ROUART (see Provenance, cat. 3) bought in this painting for 97,000 Frs at his father's first sale in 1912.[3] It remained in the family until 1977.

F.C.

130. Berthe Morisot with a Bunch of Violets

1872
Oil on canvas
21¾ × 15″ (55 × 38 cm)
Signed and dated (upper right): Manet 72
Private Collection

The following commentary on one of Manet's most visibly inspired works is by the poet Paul Valéry, Berthe Morisot's nephew by marriage, who was well acquainted with this portrait in particular.

"I place nothing in Manet's oeuvre higher than a certain portrait of Berthe Morisot, dated 1872.

"Against the light neutral background of a gray curtain, the face is painted slightly smaller than life.

"Before all else, the *Black*, the absolute black, the black of a mourning hat, and the little hat's ribbons mingling with the chestnut locks and their rosy highlights, the black that is Manet's alone, affected me.

"It is held by a broad black band, passing behind the left ear, encircling and confining the neck; and the black cape over the shoulders reveals a glimpse of fair skin at the parting of a white linen collar.

"These luminous deep black areas frame and present a face with eyes black and too large, and expression rather distant and abstracted. The paintwork is fluid, easy, obedient to the supple handling of the brush; and the shadows of this face are so transparent, the light so delicate, that the tender, precious substance of Vermeer's head of a young woman, in the museum at The Hague, comes to mind.

"But here the execution seems more ready, more free, more immediate. The modern moves swiftly, and would act before the impression fades.

Exhibitions
Salon d'Automne 1905, no. 10; Orangerie 1932, no. 47; Marseilles 1961, no. 14

Catalogues
D 1902, 184; M-N 1926 I, p. 140; M-N, cat. ms., 148; T 1931, 176; JW 1932, 208; T 1947, 187; PO 1967, 158; RO 1970, 158; RW 1975 I, 179

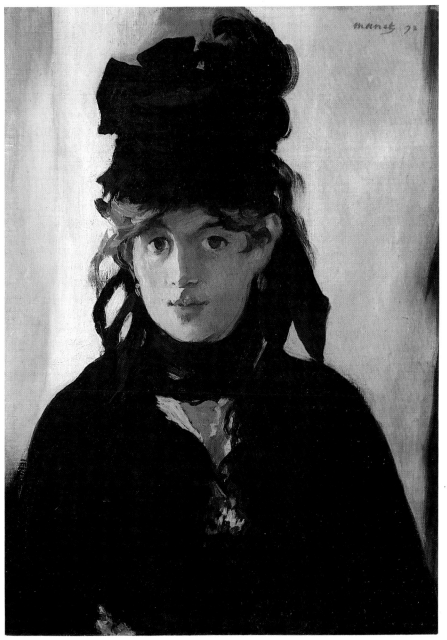

130

"The full power of these blacks, the cool simple background, the clear pink-and-white skin, the strange silhouette of the hat, in the 'latest fashion,' and 'youthful'; the tangle of locks, ties, and ribbon encroaching on the face; those big eyes, vaguely gazing in profound abstraction, and offering, as it were, *a presence of absence*—all this combines for me into a unique sense . . . of *Poetry*. Let me try to explain.

"Many an admirable canvas is not necessarily poetic. Often the masters painted great works of no sonority.

"It sometimes happens even that the poet is born late in one who has been a master painter only. Such was the case with Rembrandt, who from the perfection of his very earliest works at last attained the sublime degree, where art itself is forgotten, becomes imperceptible, its supreme object

being grasped directly, so that enchantment absorbs, conceals, or consumes the sense of wonder and of means employed. So it is that sometimes the charm of music causes sound itself to be forgotten.

"Now I may say that the portrait of which I speak is a *poem*. By the strange harmony of colors, the dissonance of their force; by the contradiction between frivolous detail now outmoded and the hint of timeless tragedy in the face, Manet creates a resonance, compounds the solidity of his art with mystery. With the physical likeness of his model he interweaves the precise cadence proper to this particular person, firmly stating the distinctive and essential charm of Berthe Morisot."[1]

Soon after, Manet made two lithographs and an etching (H 73–75). The etching accentuates the anxious tone in the portrait. The first lithograph plays on the fine contrasts of black and white, setting off the fair face and black eyes, while the other (fig. a) emphasizes the silhouette of the extravagant hat.

This is one of the few portraits by Manet in which the face is not flattened by direct frontal lighting but is strongly lighted from one side, with shadow invading the other. It was a particularly anguished time for Berthe Morisot; she wrote to her sister Edma, "I'm sad as sad can be. . . . I'm reading Darwin; hardly a woman's book, still less a girl's; what I see most clearly is that my state is unbearable from any point of view."[2] But in the portrait, rather than depression her face shows curiosity and involvement, rapt attention to the artist portraying her, a profound complicity, as though they were in the midst of a lively discussion. And it is a fact that her ideas interested her artist friends as much as did her person: "You will . . . please write to me everything that enters your brain," wrote Puvis de Chavannes, "—that brain in its strange and enchanting case."[3]

1. Valéry 1932, pp. xiv-xvi.
2. Morisot 1950, p. 73.
3. Ibid., p. 65.
4. Duret sale, Paris, March 19, 1894, no. 22.
5. D. Halévy 1960, pp. 115–16.
6. Morisot 1950, p. 185.

Provenance
Acquired by THEODORE DURET (see cat. 108), this painting appeared in 1894 at the sale he was forced to hold,[4] for which Degas so reproached him.[5] BERTHE MORISOT (see Provenance, cat. 3) purchased it at that time, one year before her death; she had tried but failed to buy Manet's portrait of her, *Repose* (cat. 121). At the same sale, a picture she had painted, *Young Woman Dressed for a Ball*, was acquired for the Musée du Luxembourg and later entered the Musée du Louvre (Galeries du Jeu de Paume). This portrait of Berthe Morisot was kept all her life by JULIE ROUART-MANET (see Provenance, cat. 3), her daughter, to whom she wrote a brief letter of farewell the day before her death, containing some unusual requests, including the following: "You will tell M. Degas that should he open a museum, he must select one Manet."[6]

F.C.

Fig. a. *Berthe Morisot*, 1872–74, lithograph. Bibliothèque Nationale, Paris

131

131. The Bunch of Violets

1872
Oil on canvas
8¾ × 10¾" (22 × 27 cm)
Inscribed (at right, on white sheet): A Mlle Berthe [Mo]risot [?] /
E. Manet
Private Collection

Exhibitions
Marseilles 1961, no. 13

Catalogues
M-N cat. ms., 157; T 1931, 177; JW 1932, 209;
T 1947, 188; PO 1967, 159; RO 1970, 159; RW 1975
I, 180

This masterpiece of concision, a message of friendship and a chivalrous tribute to Berthe Morisot, prefigures the little still lifes (cat. 188, 189) often sent by Manet to his intimates in his last years.

One may reasonably suppose that Manet painted this small canvas as a compliment to the sitter for the portrait (cat. 130), where we see the same bunch of pale blue violets worn as a corsage. Both the objects represented are recurrent attributes of Berthe Morisot, the flowers having perhaps some meaning that escapes us. The violet was of course a popular symbol of modesty, but Morisot's strong personality was moody rather than timid or withdrawn. The fan, its red lacquer guard contrasting with the delicate blue bouquet, is a feature of nearly all the portraits of Berthe Morisot (see cat. 145), and in *Berthe Morisot with Fan* (RW I 181), she coquettishly, rather than shyly, hides her face behind it. The triad—note, bouquet, fan— evokes the elegant refinement and distinction of the addressee.

Provenance
Manet gave this painting to BERTHE MORISOT (see Provenance, cat. 3), probably to thank her for having posed for her portrait (cat. 130). Her daughter, JULIE ROUART-MANET (see Provenance, cat. 3), always refused to part with it; the work has never been on the market and has rarely been exhibited.

F.C.

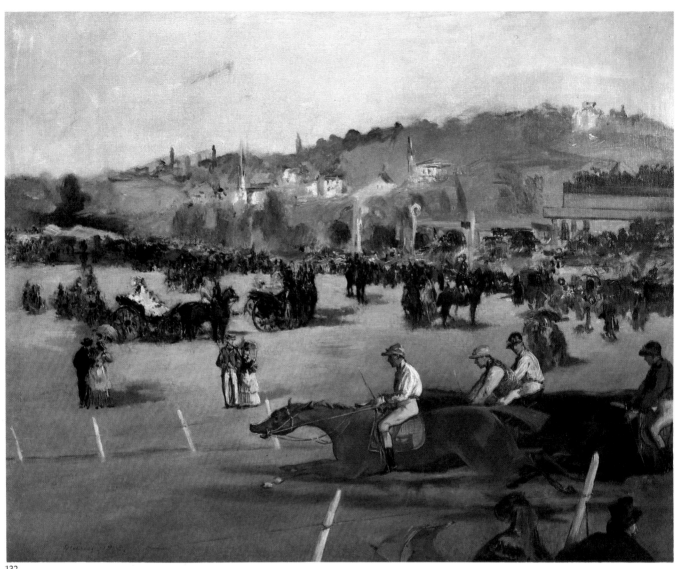

132

132. The Races in the Bois de Boulogne

1872
Oil on canvas
28¾ × 36¼" (73 × 92 cm)
Signed and dated (lower left): Manet 1872
Collection Mrs. John Hay Whitney

Manet's interest in racing subjects is traceable to 1864, but with the exception of *Races at Longchamp* (cat. 99) he did not return to the theme again until 1872, when the painting now in the Whitney collection was commissioned by an individual whom Tabarant identifies only as a sportsman named Barret.[1] According to Rewald, "the picture is said to have been painted partly from nature, Manet working from the windmill which still stands near the race-track

Exhibitions
Beaux-Arts 1884, no. 62; New York, Durand-Ruel 1913, no. 10; New York, Rosenberg 1946–47, no. 5

Catalogues
D 1902, 143; M-N 1926 I, pp. 138–39; M-N cat. ms., 146; T 1931, 178; JW 1932, 203; T 1947, 194; PO 1967, 164; RO 1970, 164; RW 1975 I, 184

Fig. a. Théodore Géricault, *Races at Epsom*, 1821. Musée du Louvre, Paris

Fig. b. Edgar Degas, *Manet at the Races*, ca. 1869–72, pencil. The Metropolitan Museum of Art, New York

1. Tabarant 1947, p. 202.
2. John Rewald in London, Tate Gallery, *The John Hay Whitney Collection* (exhibition catalogue), London, 1960–61, no. 35.
3. Meier-Graefe 1912, p. 210.
4. Blanche 1925, p. 42; Richardson 1958, p. 124; Harris 1966, p. 81.
5. Rewald 1973, p. 160; Lemoisne 1946, II, p. 38, nos. 75–77.
6. Moreau-Nélaton 1926, I, p. 139; Richardson 1958, p. 124.
7. Meier-Graefe 1912, p. 210; René Huyghe, "Manet, peintre," *L'Amour de l'art*, 13 (May 1932), p. 175; Harris 1966, p. 81.
8. Richardson 1958, p. 124.
9. Baudelaire 1965, p. 9.
10. Ibid., p. 39.
11. Lemoisne 1946, II, pp. 128–29, nos. 168, 169.
12. Proust 1913, p. 94: from Manet, April 10, 1879.
13. Tabarant 1947, p. 202.
14. Callen 1974, pp. 171, 178, no. 85.
15. Huth 1946, p. 239, no. 22.
16. Letter from Charles Durand-Ruel, December 13, 1982 (archives, department of European paintings, The Metropolitan Museum of Art, New York).
17. Rewald 1973, *Gazette des Beaux-Arts*, p. 108.

in the Bois de Boulogne,"[2] but the windmill lies at the top of the turn at the north end of the track, and Manet's vantage point seems farther to the east, looking southwest across the infield toward the south end of the spectators' stands.

Meier-Graefe suggests that Degas's racing scenes were influenced by those of Manet,[3] but Blanche, Richardson, and Harris believe that Degas's racetrack paintings provided an example for Manet.[4] Degas was in fact the first to execute such pictures,[5] but his early treatments of the theme are relatively small and very different in spirit and compositional type from those by Manet. Moreau-Nélaton and Richardson maintain that the top-hatted figure in the lower right corner of the painting is in fact Degas, and that by including him in the painting Manet acknowledged his debt to his friend.[6]

Meier-Graefe, Bazin, and Harris cite the probable influence of Géricault's *Races at Epsom* (fig. a), a painting the Louvre acquired in 1866.[7] Richardson also underscores the importance of English sporting prints, a source that Manet himself allegedly admitted: "Unlike Degas, who knew from experience exactly how a horse's body was articulated, Manet copied his stylized animals from English sporting-prints. 'Not being in the habit of painting horses,' he said to Berthe Morisot, 'I copied mine from those who knew best how to do them.'"[8] Questions of sources and influences seem less important, however, than the fact that both Degas and Manet were attracted by the racetrack as a subject appropriate to paintings about modern life. Indeed, the anonymous, faceless figures in the crowd at Longchamp could serve as illustrations of "the perfect *flâneur*" as defined in Baudelaire's essay "Le Peintre de la vie moderne."[9] The spectator-filled carriages recall his description of "innumerable carriages, from which slim young men and women garbed in the eccentric costumes authorized by the season, hoisted up on cushions, on seats, or on the roof, are attending some ceremony of the turf which is going on in the distance."[10]

We know that on at least one occasion Degas and Manet spent a day together at the track, because Degas drew Manet accompanied by a woman looking through binoculars (fig. b). Oil sketches of the woman show that she wears a type of hat and apron dress fashionable between 1869 and 1872.[11] Whether Manet and Degas went to the races together earlier and whether they exchanged ideas about painting racing subjects are not known.

Manet never again undertook a painting with a horseracing theme. However, in 1879 he wrote to the prefect of the Seine to propose a series of paintings representing "the public and commercial life of our day" to decorate the Municipal Council Hall in the new Hôtel de Ville. One of the five themes that he intended to treat was "Paris Racetracks and Gardens." Apparently the letter was never answered.[12]

Provenance
According to Tabarant, this work was commissioned by a sportsman named BARRET, who paid 3,000 Frs for it in October 1872.[13] The painting next entered the collection of FAURE (see Provenance, cat. 10), who sold it to DURAND-RUEL (see Provenance, cat. 118) on May 12, 1893, for 9,000 Frs,[14] although he had possibly already lent the picture to the dealer for a commercial exhibition in New York in 1886.[15] Durand-Ruel sold it the same day for $3,000 to Whittemore of Connecticut,[16] almost certainly HARRIS WHITTEMORE, SR. (1864–1927), of Naugatuck, son of the wealthy philanthropist John Howard Whittemore and heir to his iron manufacturing firm. With the help of Mary Cassatt, he was one of the first Americans to assemble a distinguished collection of modern French pictures,[17] including several other Manets (RW I 103, 174) and Whistler's *The White Girl*. Following the death of Harris Whittemore, Sr., *The Races in the Bois de Boulogne* remained within the family. His sister GERTRUDE B. WHITTEMORE (died 1941) lent the picture to an exhibition in 1935, and in the following year the J. H. WHITTEMORE CO. sold it on joint account to PAUL ROSENBERG and M. KNOEDLER & CO. (see Provenance, cat. 172), from whom the present owner purchased it in April 1945.

C.S.M.

133. The Railroad

1872–73
Oil on canvas
36½ × 45" (93 × 114 cm)
Signed and dated (lower right): Manet / 1873
National Gallery of Art, Washington, D.C.

The Gare Saint-Lazare was, in the iconography of Impressionism, the privileged locale of the wonder of industrialization. Caillebotte in 1876, with his views of the Pont de l'Europe (fig. a), and above all Monet in 1876–77, with the *Gare Saint-Lazare* series (fig. b), were to paint the new poetry of smoke and steel; but to Manet belongs the distinction of first seizing upon this modern image, in a masterpiece of his own, earlier by several years.

We know exactly when he executed this painting from an article by Philippe Burty that appeared in the autumn of 1872 about his visits to artists' studios: "The swallows are gone. The artists return. . . . [Manet] has in his studio, not quite finished, a double portrait, sketched outdoors in the sun. A young woman, wearing the blue twill that was in fashion until the autumn. . . . Motion, sun, clear air, reflections, all give the impression of nature, but nature subtly grasped, and finely rendered."[1]

Often Manet must have contemplated the spectacle of the railroad from his studio at 4, rue de Saint-Pétersbourg. His vision is, as always, direct yet subtle. Unlike Monet, he was not drawn to a lyrical, airy image of the new objects of beauty—the smoke of the locomotive engine, the glass-roofed station. Manet's scene is organized, controlled, detached from the immediacy of direct experience.

His models are Victorine Meurent, appearing ten years after posing for *Olympia* (cat. 64), and the young daughter of his friend Alphonse Hirsch,[2] whose studio was situated at the intersection of the rue de Rome and the rue de Constantinople, where the Pont de l'Europe begins, overlooking the Gare Saint-Lazare. They are at once present and not present, one by her reserved expression, the other by having her back turned to the viewer. Carefully placed, they are separated from the track by iron railings that divide the background of the composition into twelve vertical sections.

Hostile and mocking criticism focused on this feature: "The unfortunates, thus painted, tried to get away, but [the artist] prudently put up a fence to cut off all retreat" (fig. c) and "Two sufferers from incurable Manet-mania [*Monomanétie*] watch the cars go by, through the bars of their madhouse" were the captions of cartoons by Cham and Lemand.[3] The insistent grillwork creates a partition between two worlds, as in *The Balcony* (cat. 115), but there the elegant, mysterious figures are on the other side of the barrier. Here the viewer is invited to share, with Victorine and the little girl, intimations of a new world.

At the right, the child, beautifully dressed and coiffed, watches a train coming into the station. Victorine, with the inevitable ribbon about her neck, raises an indifferent glance from the open book on her lap; a small puppy sleeps on her right arm, recalling the little dog at the feet of Venus in Titian's *Venus of Urbino*, the source for Manet's *Olympia*. The flowered hat, the navy blue outfit, and the bunch of grapes on the low wall to the right

Exhibitions
Salon 1874, no. 1260 (Le chemin de fer); Beaux-Arts 1884, no. 68; New York, Durand-Ruel 1895, no. 25; World's Fair 1940, no. 15; Washington 1982–83, no. 10

Catalogues
D 1902, 152; M-N 1926 II, fig. 181; M-N cat. ms., 176; T 1931, 185; JW 1932, 231; T 1947, 210; PO 1967, 180; RO 1970, 181; RW 1975 I, 207

Fig. a. Gustave Caillebotte, *The Pont de l'Europe*, 1876. Petit Palais, Musée d'Art Moderne, Geneva

Fig. b. Claude Monet, *The Gare Saint-Lazare*, 1877. Musée Marmottan, Paris

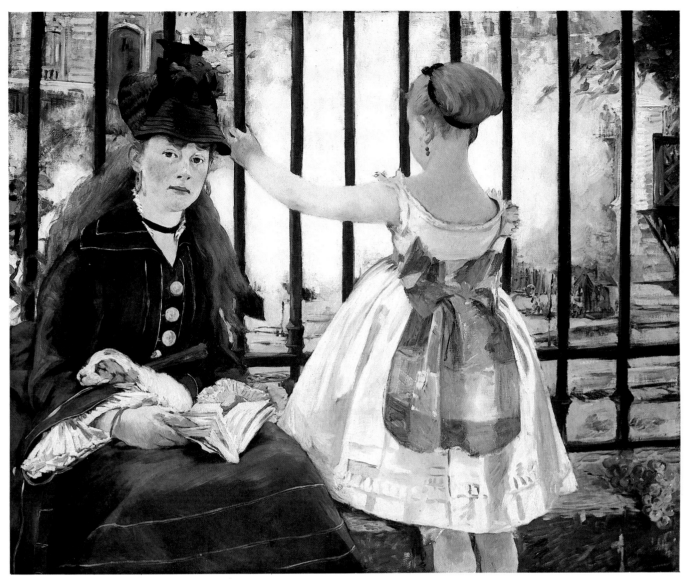

133

Fig. c. Cham, "Le Salon pour rire," in *Le Charivari*, May 15, 1874

suggest a warm September day. The image is peaceful, an eclogue with accompaniment of smoke and clangor, testifying, as noted by Peter Gay,[4] to a harmonious and serene vision of the industrial world, both by choice and treatment of subject and by the use of brilliant colors—blue, touches of red, and white steam over all—cheerfully punctuated by the iron bars.

With Dorival, one might see this division of the space by bars as reminiscent of Japanese prints, such as those of Utamaro, who showed landscapes in perspective behind frame skeletons of houses (fig. d).[5] However, there is nothing Japanese in this frontal view, strictly adhering to the picture plane, such as is found so persistently throughout Manet's oeuvre.

Although the painting may well have been done from life, *en plein air*, the grill literally and figuratively delimits Manet's relation to the universe of Impressionism. This artist is not absorbed in the landscape (or, rather, cityscape) but subjects it to contemplation by persons of his own milieu. Here, fully clothed, is the heroine of *Le déjeuner sur l'herbe* (cat. 62), while the little girl with blue sash is the figurative sister of the one at play in the fore-

341

ground of *Music in the Tuileries* (cat. 38). The precise organization of the space is far removed from the snapshot quality of Impressionism.

Yet, ironically, though represented at the Salon in the very year of the first dissident exhibition of those forthwith to be called "Impressionists," Manet, by virtue of this painting, was perceived as their leader, their representative in the marble halls. "I really wonder," wrote Jules Claretie, "whether M. Manet is out to win a wager when I see at the Salon such a sketch as the one he calls *The Railroad*. . . . M. Manet is one of those who hold that art can and should stop short with the *impression*. . . . For that is the whole secret of your *impressionnalistes*—they rest content with shorthand indications, dispensing with effort and style."[6] All the same, critics in general were quite approving, in particular Castagnary, who had in the past been so harsh in his judgments.[7]

The Railroad was the only Manet work accepted by the Salon jury that year, *Polichinelle* (RW I 213) and *Masked Ball at the Opéra* (cat. 138) having been rejected. It is hard to say why this one was accepted and not the others; perhaps there is an echo here of a distinction, difficult to appreciate today, made by J. de Biez, who published the first study of Manet following his death: "I am aware of the objections to this painting. The poses are a trifle academic. The composition as a whole, purists say, departs rather too far from natural attitudes in favor of the banal. . . . Since I take *The Railroad* to be the overture to the mature phase, I am inclined to grant the point."[8]

At that moment, indeed, Manet was still opposed on the one hand by the jury and the critics, and already opposed on the other by the *peinture claire* radicals; these latter perceived the limits placed by their senior on his commitment to the "new painting," for which he himself had prepared the way.

Fig. d. Utamaro, *Young Women at the Inn*, triptych (detail), ca. 1795, woodcut

1. Burty 1872, p. 220.
2. Tabarant 1931, p. 237.
3. Cham, in *Le Charivari*, 1874.
4. Gay 1976, pp. 104–5.
5. Dorival (1976) 1977, pp. 35–36.
6. Claretie 1876, p. 260.
7. Castagnary 1874.
8. Biez 1884, quoted in Courthion 1953, I, pp. 170–71.
9. Callen 1974, pp. 163–64.
10. Meier-Graefe 1912, p. 314.
11. Havemeyer 1961, p. 240.

Provenance
As soon as it was completed, this picture was purchased by the singer FAURE (see Provenance, cat. 10),[9] who lent it to the Salon of 1874. He sold it after 1890 to DURAND-RUEL (see Provenance, cat. 118).[10] The latter sold it in 1898 for 100,000 Frs to MR. AND MRS. H. O. HAVEMEYER (see Provenance, cat. 33) of New York. In her memoirs, Mrs. Havemeyer wrote: "We bought it because we thought it a great picture and one of Manet's best."[11] In 1956, HORACE HAVEMEYER gave it to the National Gallery of Art, in memory of his mother, Louisine Havemeyer (inv. 1454).

F.C.

134. The Railroad

1873–74
Photograph heightened with watercolor and gouache
7 × 8¾" (18 × 22 cm)
Atelier stamp on mount (lower left): E.M.
Collection Durand-Ruel, Paris

Manet used a photograph taken by Godet of the painting (cat. 133) as the basis for a watercolor.[1] We may imagine that, having sold the work promptly, he wished to make an accurate record of it. Manet's relation to photography is entirely different from that of Degas, himself a photographer, who sought in his compositions and in the attitudes of his figures to

Exhibitions
Paris, Berès 1978, no. 13; Washington, 1982–83, no. 11

Catalogues
T 1931, 52 (watercolors); T 1947, 599; RW 1975 II, 322

342

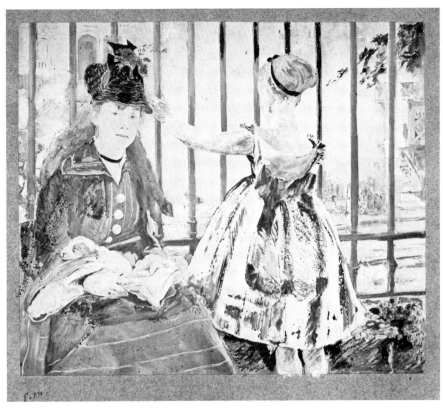

134

re-create a snapshot effect. Manet's approach, in which all is posed and constructed, is quite another matter. His friendship with Nadar doubtless stimulated his interest in the new medium, and it seems he took some family photographs.[2] But, notwithstanding the ingenious hypotheses of Scharf, who sees the methods developed by Nadar in the photographing of models as a possible source of Manet's strongly contrasted lighting, centered on the face,[3] it should be borne in mind that photography was not for Manet a new source of inspiration. He used it merely as a substitute for direct observation: to paint *The Execution of the Emperor Maximilian* (cat. 104, 105), for example; when engraving the portraits of Poe (cat. 59, 60) and Baudelaire (cat. 54–58); or as an aid in rendering a drawing or engraving. Most of all, he used photography, more traditionally, to record a work of art, another's or his own, though in this instance he reworked the photograph in watercolor, thus creating a fresh original.

1. Tabarant 1931, p. 535.
2. Julie Rouart-Manet, pers. comm. to Mrs. M. Curtiss, cited in Farwell (1973) 1981, p. 297 n. 61.
3. Scharf 1974, p. 62ff.

Provenance
The atelier stamp, affixed shortly after Manet's death, indicates that he kept this watercolored photograph during his lifetime. The family later sold it to CAMENTRON (see Provenance, cat. 50), who sold it in turn to DURAND-RUEL (see Provenance, cat. 118).

F.C.

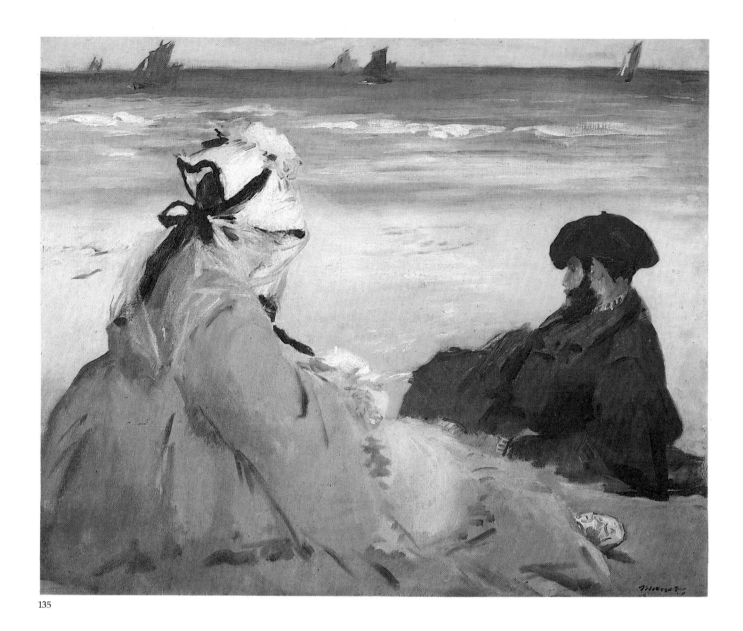

135

135. On the Beach

1873
Oil on canvas
23½ × 28⅞" (59.6 × 73.2 cm)
Signed (lower right): Manet
Musée d'Orsay (Galeries du Jeu de Paume), Paris

This picture was painted in the summer of 1873, probably from life—since there is sand in the paint—during the three weeks spent at Berck-sur-Mer by Manet and his family. The two figures sitting on the beach are Suzanne Manet, reading, her face protected from wind and sand by a veil tied over her hat, and the painter's brother Eugène, soon (1874) to be married to Berthe Morisot. Eugène's attitude is the same as in *Le déjeuner sur l'herbe* (cat. 62), ten years earlier. Manet painted several outdoor scenes the summer of

Exhibitions
Beaux-Arts 1884, no. 71; Orangerie 1932, no. 53; Marseilles 1961, no. 15; Washington 1982–83, no. 155

Catalogues
D 1902, 161; M-N 1926 II, p. 5; M-N cat. ms., 158; T 1931, 188; JW 1932, 224; T 1947, 197; PO 1967, 167; RO 1970, 167; RW 1975 I, 188

1873; the one he decided to submit to the Salon of 1874 was *The Swallows* (RW I 190), also representing Mme Manet. That painting was rejected by the jury; the perspective was more traditional, but the Impressionist handling more pronounced. Here the composition, with its elevated horizon, is defined above by a stripe of blue, recalling the bands of color at the top of Japanese prints, and the foreground is occupied by the two flat gray and black triangles of the figures, in one of Manet's most Japanesque works.

The theme of Parisians at the seashore was not new. Boudin had made a specialty of it, but in a quite different way, placing his figures at a greater distance, tiny bits of color between sky and sand.

If Manet was inspired by analogous work of another artist, it would rather have been that of Claude Monet, with whom he was associated especially at this time, and it may perhaps be that Monet's recent series of beach scenes, including *The Beach at Trouville* (National Gallery, London) and *On the Beach at Trouville* (Musée Marmotton, Paris), both painted in 1870, suggested the motif to Manet.

Nevertheless, the differences are highly significant. With spontaneous placements arbitrarily framed, the play of parasols and reflected light, and the open sky, Monet creates an impression of sea air, of a fleeting moment. Manet offers a vision more monumental, more confined, compressing the sky into a narrow, breathless strip punctuated by black sails setting off the ultramarine blue and emerald green streaks of the water. There is no resort frivolity in this powerful image of the sea, matched in gravity by the two contemplative figures.

1. Duret 1924, p. 67.
2. Manet et al., "Copie faite pour Moreau-Nélaton . . . ," p. 75.
3. Rouart sale, Paris, December 9, 1912, no. 237.
4. J. F. Revel, "Jacques Doucet, couturier et collectionneur," *L'Oeil,* no. 84 (December 1961), pp. 44–51+.

Provenance
Théodore Duret recounts that HENRI ROUART (see Provenance, cat. 129), not owning any of Manet's works, asked him to obtain a picture at the artist's studio: "I chose *On the Beach,* and wishing to help Manet all I could, I offered what I considered a high price, 1,500 Frs." The price was agreed to. "I sent the money to Manet, who was much pleased. When Rouart's friends learned what I had got for it, they said I had abused his kind nature."[1] The purchase took place on November 8, 1873.[2] The work was included in the Rouart sale in 1912[3] and was bought for 92,000 Frs by M. FAJARD. The couturier and art patron JACQUES DOUCET (1853–1929) later acquired it, and early in the 1920s, he had a black-and-red lacquer Art Deco frame made for it, probably by Legrain, who had executed other frames and bindings for Doucet's apartment on the avenue du Bois, decorated by Iribe. The painting was shown in this frame in an exhibition of French painting held at the Musée des Arts Décoratifs in May 1925. In 1913, Jacques Doucet had sold his famous collection of eighteenth-century art to purchase contemporary works. Before buying Picasso's *Demoiselles d'Avignon,* Rousseau's *The Snake Charmer,* and Matisse's *The Goldfish,* he went through an intermediate phase of collecting Impressionist works, probably before 1919, when André Breton began to advise him. "One after the other," Doucet said near the end of his life, "I built my grandfather's collection, my father's, and my own." The Manet undoubtedly was part of his "father's" collection.[4] The painting passed by inheritance to JEAN T. DUBRUJEAUD, who gave it to the Musée du Louvre in 1953 (inv. RF 1953.24) with a life interest in his son, M. ANGLADON-DUBRU-JEAUD, who renounced his rights in 1970. Thus the work went to the Galeries du Jeu de Paume, together with an important portrait by Degas, *Mme Jeantaud Before the Mirror.*

F.C.

136. Exhibition of Paintings

1876?
Wash and watercolor over pencil
5½ × 3½″ (14 × 9 cm)
P Musée du Louvre, Cabinet des Dessins, Paris

Titled *Au Salon* by Leiris and dated 1873 by Rouart and Wildenstein, this charming sketch was in all likelihood not made at the Salon, since the picture at the upper left is quite recognizably *On the Beach* (cat. 135), which was never there and was not painted until the following summer. Manet probably made it at the time of the exhibition organized April 1876 in his own studio. The exhibition was so popular it was rumored that up to 4,000 visitors attended; in any case, witnesses recalled people standing in line to get in. We may easily imagine Manet's Salon rejects, *The Artist* (cat. 146) and *The Laundry* (RW I 237), flanked by works from previous years, some of which had never been shown before or were no longer in Manet's possession (*On the Beach*, for instance, now belonged to Henri Rouart). In the watercolor, light touches of yellow suggest gilt frames; there is also an easel at the left, and a dark ceiling answering to descriptions of the studio, "an enormous room paneled in old blackened oak, with a ceiling of alternating beams and coffers of dark color,"[1] so that this may indeed be Manet's studio at 4, rue de Saint-Pétersbourg.

Catalogues
L 1969, 411; RW 1975 II, 355

1. Fervacques, quoted in Moreau-Nélaton 1926, II, p. 8.
2. Pellerin sale, Paris, June 10, 1954, album no. 5.

Provenance
This drawing belonged to AUGUSTE PELLERIN (see Provenance, cat. 100) and was included in album no. 5 at his sale in 1954,[2] when it was purchased by the Musées Nationaux for the Louvre (inv. RF 30.528).

F.C.

136

137. Lady with Fans
Portrait of Nina de Callias

1873–74
Oil on canvas
44½ × 65¼" (113 × 166 cm)
Signed (lower right): Manet
Musée d'Orsay (Galeries du Jeu de Paume), Paris

Exhibitions
Beaux-Arts 1884, no. 77; Paris, Drouot 1884, no. 13; Salon d'Automne 1905, no. 11; Paris, Bernheim-Jeune 1928, no. 28; Orangerie 1932, no. 54; Venice, Biennale 1934, no. 8; Orangerie 1952, without no.; London, Tate Gallery 1954, no. 11; Philadelphia-Chicago 1966–67, no. 122

Catalogues
D 1902, 182; M-N 1926 II, pp. 16–17, no. 177; T 1931, 213; JW 1932, 237 bis; T 1947, 224; PO 1967, 192; RO 1970, 194; RW 1975 I, 208

The last, but not the least stunning, of a long series of "reclining ladies" painted by Manet (cat. 27, 29, 64, 143) was a Baudelairean character, temperamental, gifted, generous, alternately euphoric and depressed, a neurotic whom alcohol brought to insanity and to death at the age of thirty-nine, a year after Manet died. Marie-Anne Gaillard (1844–1884), called Nina de Villard, was paradoxically known by the name of a momentary husband, Hector de Callias, writer and Le Figaro journalist.

At the time of this portrait, Nina was no more than thirty, and presided over one of the most brilliant literary and artistic salons in Paris, where poets—Parnassians, early Symbolists—musicians, and painters forgathered. She herself was an excellent musician, a pianist and composer. Baude de Maurecelay, an eyewitness, described a setting that Manet, introduced there by Charles Cros,[1] always found agreeably entertaining: "When [Catulle] Mendès and I . . . arrived at Nina's, all were at table. . . . The diners, some twenty in number, made place for us, and conversation resumed, gay and boisterous. Mme Gaillard, very *grande dame*, was seated opposite her daughter. At Nina's left—the side of the heart—shone Charles Cros, successor to Bazire as court favorite; then Léon Dierx, Germain Nouveau, Raoul Ponchon, Forain, Maurice Talmeyr, Jean Cabaner the eccentric musician. Among the ladies, Augusta Holmès, Mme Manoël de Grandfort of *La Vie parisienne*, Marie L'Héritier of the Théâtre Ventadour, and Henriette Hauser, known as Citron [Lemon], the favorite of the prince of Orange. . . .

"Coffee over, there was a rush for the staircase to the salon on the floor above. Nina took over the piano and played with all her heart, a composition by César Franck, while the gentlemen smoked their cigarettes. Raoul Ponchon, by popular demand, recited his latest verses, as did Léon Dierx and Charles Cros. Soon the after-dinner guests began to arrive: François Coppée, Anatole France, Léon Valade, Camille Pelletan, the younger Coquelin, Marcelin Desboutin, Jean Richepin, Léon Boussenard. At last, the door opened and Villiers de l'Isle-Adam entered. He kissed Nina's hand and sat down with her."[2] To this list of regulars should be added Verlaine, Leconte de Lisle, Maurice Rollinat, Mallarmé, and of course Manet.

Manet re-created in his studio[3] the Japanesque bric-a-brac of the small town house in which she lived at 82, rue des Moines; Nina posed in one of the "Algerian" costumes in which she liked to receive. The hanging is that of the studio wall, seen also in *Mallarmé* (cat. 149) and *Nana* (cat. 157), in the latter case with the same embroidered bird. This supposed crane (*grue*), which is perhaps an ibis, has been seen as an allusion to the model's demimondaine status;[4] but Manet would not have made that mistake. Nina de Callias no doubt lived what might be called an unconventional life, but she

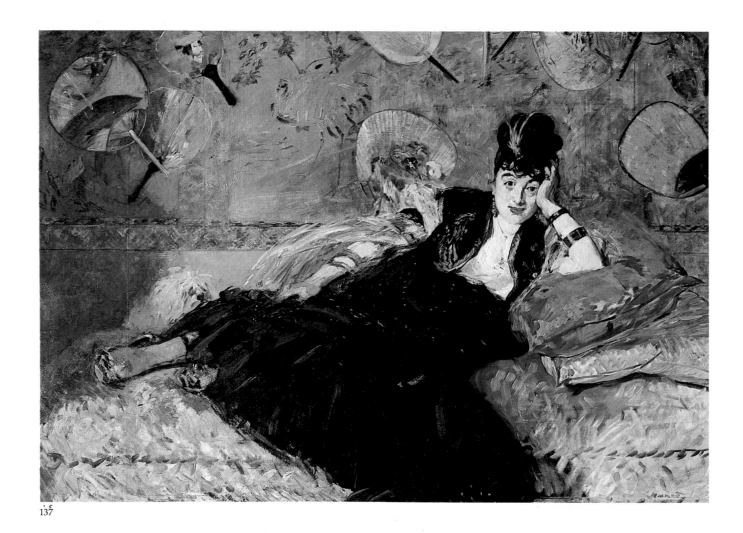

was quite the opposite of a *grue*; herself of very comfortable independent means, she entertained at table, the year round, a crew of penniless artists and writers, and her known lovers—Bazire, Villiers de l'Isle-Adam, Charles Cros—were all on the edge of poverty.

The Japanese fans do not seem to have any symbolic meaning. In pinning them up around Nina for the occasion, Manet had no purpose other than to create a decor that had become almost commonplace, similar to those painted ten years earlier by Whistler and James Tissot, and more recently by Renoir in the portrait *Mme Claude Monet Reading*, 1872 (Clark Art Institute, Williamstown, Mass.). Claude Monet was soon to make use of the motif in *La japonaise*, 1876 (Museum of Fine Arts, Boston).

Are we to see in this painting, as Reff suggests, an echo of *Olympia* (cat. 64)? The two figures are separated by only ten years in time; but except for the reclining pose, the resting on one arm, and an animal at the feet (here, a griffon), there is everything to separate them—style, brushwork, feeling. This face, especially, is one of Manet's liveliest; it bespeaks amusement, complicity, curiosity, and a touch of wistfulness and waywardness on the part of her whom Charles Cros called "la reine des fictions" (the lady of misrule),[5] and whom Verlaine celebrated for her

1. Tabarant 1947, p. 229.
2. Baude de Maurecelay, quoted by J. Bertaut in *Le Figaro littéraire*, February 9, 1957.
3. Tabarant 1947, pp. 229–30.
4. Reff 1976, pp. 83–84.
5. Charles Cros, *Le Coffret de santal*, Paris, 1873–75.
6. Tabarant 1947, p. 228: written on Nina de Villars's album.

7. Rouart and Wildenstein 1975, I, p. 27, no. 10, "Tableaux et études."
8. Manet sale, Paris, February 4–5, 1884, no. 13; Bodelsen 1968, p. 344.
9. Rosamond Bernier, "Dans la Lumière impressionniste," *L'Oeil*, no. 53 (May 1959), pp. 39–47.

. . . esprit d'enfer,
avec des rires d'alouettes,
ses cheveux noirs tas sauvage où
scintille un barbare bijou
la font la reine—et la font fantoche.[6]

. . . infernal wit,
with soaring laugh of meadow lark,
her raven locks heaped wild where
glints some barbaric jewel rare
do make her queen—and make her harlequin.

Provenance

Estimated at 1,200 Frs in the posthumous inventory,[7] this picture was bought at the Manet sale in 1884 for 1,300 Frs[8] by Jacob on behalf of EUGÈNE MANET (see Provenance, cat. 3), Berthe Morisot's husband. Their daughter, JULIE MANET (see Provenance, cat. 3), recalled that as a child she always saw it in the dining room along with *Boy with Cherries* (RW I 18) and the portrait of the artist's parents (cat. 3).[9] With her husband, ERNEST ROUART, she gave it to the Musée du Louvre in 1930 (inv. RF 2850) on the occasion of the museum's purchase of Berthe Morisot's *The Cradle*.

F.C.

138. Masked Ball at the Opéra

1873–74
Oil on canvas
23½ × 28¾" (60 × 73 cm)
Signed (lower right, on dance program): Manet
National Gallery of Art, Washington, D.C.

Exhibitions
Beaux-Arts 1884, no. 69; New York, Durand-Ruel 1895, no. 29; Washington 1982–83, no. 39

Catalogues
D 1902, 153; M-N 1926 II, pp. 7, 9–12, 47, 114, 129; M-N cat. ms., 170; T 1931, 203; JW 1932, 219; T 1947, 219; PO 1967, 188A; RO 1970, 190A; RW 1975 I, 216

On March 20, 1873, as in every year at mid-Lent, the famous masked ball took place at the Opéra, and ten days later another masked ball, the Bal des Artistes: "Imagine . . . the opera house packed to the rafters, the boxes furnished out with all the pretty showgirls of Paris, the lobby filled with charming ladies in charming costume."[1] Manet, it seems, attended, made sketches, and conceived the idea for a painting, which he then executed in the course of several months. A chronicler of the day, Fervacques, described the canvas as he saw it in the studio: "Between the massive pillars of the amphitheater wall, where the swells stand *en espalier,* and the lobby entrances separated by the legendary red velvet panels, there ebbs and flows a tide of black cloth on which floats an occasional Pierrette or *débardeuse* ["stevedorette"]. Hooded dominoes, faces screened in fourfold lace, swim about in the human sea, shoved, squeezed and jostled, examined by a hundred curious hands. Poor young things run the gamut of these perils, shedding a scrap of lace here, there a flower of white lilac. . . .

"Groups form in diverse attitudes. An impudent Gavroche, a blossom sprung from between two gutter cobbles and—mystery of mysteries—lovely as a Grecian statue, in a state of undress to challenge the Sixth Commandment, pantalooned in a red velvet rag no bigger than a man's hand, with plenty of buttons to be sure, and with cap set at forty-five degrees on her powdered tangle of hair, leads a troupe of white-tied revelers. There they all are, alight with Corton and truffles, with moist lip and sensual eye, with gold chains across their vests and rings set with gems on their fingers. Hats tilted back with an air of conquest: they are rich, that is clear, with pockets full of louis d'or, and they have come to enjoy themselves. Enjoy themselves they do. They would take liberties with their sisters, if any happened by.

"Their adversary knows this. She looks them in the face, proud, re-

solved to strike back hard and high, an Hervé for a Rabelais, a Molière for a Gavarni. Brazen-throated, unabashed, this offspring of Mère Angot will yield but to reasons of full weight, and meanwhile, whip, whap, the coarse words rain from her ready mouth. . . .

"Perhaps there is not all this in the painting; perhaps there is more besides? At any rate, it is a work of high merit, alive, thoughtful, and admirably rendered. We shall see, at the next Salon, whether the public is of my opinion."[2]

The scene is the Opéra on the rue Le Peletier—the present Opéra being still under construction. Significantly, Manet chose a part of the building that afforded him his accustomed strictly horizontal composition, under a balcony extending the length of the painting: "The scene is not the hall, where the dancing was, but the promenade behind the boxes."[3] Mallarmé, describing the painting at length the following year, interpreted this particular choice of location as a means of individualizing what would have been a blurred throng in the great hall: "The clashing discord of fancy dress and the frenzied movement, of no time and no place, would not have offered to plastic art a store of authentically human attitudes. Thus, the costumes merely break up the monotony of black frock coats with some fresh floral tones; and they disappear sufficiently to render the congestion of lobby strollers a showcase for the display of a modern crowd, which could not be portrayed except with these few bright notes for embellishment."[4]

The composition was obviously inspired by the first-act scene—a masked ball—of the Goncourt brothers' play Henriette Maréchal, as Edmond de Goncourt himself mentioned in his diary.[5] The production in 1865 had created a public scandal. Darragon has recently found records of the stage setting, corroborating Goncourt's remark; he also points out that Manet may have felt sympathetic, just at the time of the Olympia uproar (see cat. 64), to the authors of a work derided for its "modern" realism of dialogue and subject matter.[6]

Following the sketches done from life,[7] of which only a wash (RW II 503) and two painted sketches (RW I 214, 215) survive, Manet was a long time completing the work in his studio. As with Music in the Tuileries (cat. 38), of which this picture is reminiscent in more ways than one, Manet posed groups of his male friends, more of whom came to see him on the rue d'Amsterdam than formerly on the rue Guyot, as Duret testifies: "He was no longer on the periphery, but really in Paris. So the isolation in which he had previously lived and worked was at an end. His friends stopped in more often. His studio was also frequented by quite a few prominent men and women attracted by his renown and the pleasure of his company, who would call, and upon occasion consent to pose. Wishing to depict life in all its aspects, he now had access to uniquely Parisian topics unavailable to him on the rue Guyot. Thus in 1873 he painted his Masked Ball, or Ball at the Opéra, a canvas of small size that took him a long time."[8] Duret himself posed, as did Paul Roudier, the composer Emmanuel Chabrier, the collector Albert Hecht, and the painters Guillaudin and André;[9] however, it is difficult to identify them. The Polichinelle at the extreme left is said to have been posed by André, but the oddly caricatured masculine faces resist identification. We know that Duret was tall; his may be the first figure in profile from the left. Beside him, full face, with bearded chin, Chabrier has been identified,[10] but he would more likely be the full-face figure in front of the right-hand pillar, a feminine domino's hand resting on his shoulder.[11] The man in the center, face inclined over the masked

Fig. a. El Greco, Burial of the Conde de Orgaz (detail). Santo Tomé, Toledo

350

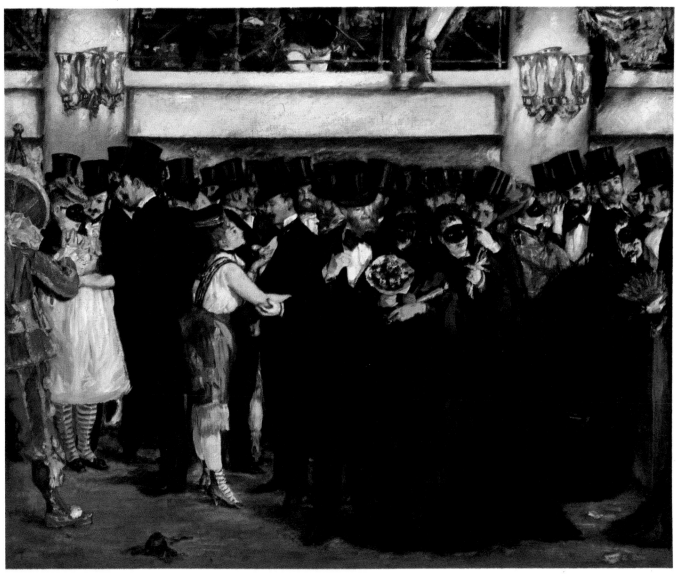

138

woman's bouquet, would be Guillaudin. The second figure from the right, with blond beard, is Manet himself, with the dance card bearing his signature fallen to the floor at his feet.[12]

None of the five women has been identified. Clearly Manet enjoyed the contrast between the men and the women. The gentlemen's dark habits are surmounted by a ballet of top hats in close order, radicalizing a decorative effect anticipated in *Music in the Tuileries,* and welding the masculine attendance into one block. The women, bright sparks of color, endearingly whimsical in the uniformed ranks, are decked out in the witty, charming accessories in which Manet took delight: striped Columbine stockings, dainty laced shoes, gold-fringed comic-soldier breeches. They are typified in the leg intercepted at the top edge of the picture, belonging, one imagines, to a *pierreuse* astride the mezzanine railing above.

Some features of this work recur later in Manet's oeuvre: the woman in profile with laced boots anticipates *Nana* (cat. 157), and the little legs in midair are echoed by those of the trapeze artist in *A Bar at the Folies-Bergère* (cat. 211).

Of the men, only the Polichinelle, seen in violent color from the rear, seems to partake, with the flowers of the central bouquet, in the petulant, joyous feminine universe, alone sharing the festival atmosphere of the famous balls at the Opéra. The masculine array otherwise suggests a funeral gathering rather than a wild party. And indeed, Manet was, as it happens, commemorating the demise of a landmark. The Opéra on the rue Le Peletier was totally destroyed by fire in October 1873, while Manet was still working on this painting.

Leiris has seen a possible iconographic source in the celebrated *Burial of the Conde de Orgaz* by El Greco (fig. a), which Manet had seen with Duret at Toledo in the summer of 1865.[13] Leiris points out analogies with the line of ruffed heads above Orgaz's body, the priest's pale back at the right corresponding to the Polichinelle, and the leg of El Greco's angel overhead, so that *Masked Ball at the Opéra* becomes an ironic modernist version of a sacred theme. Comparison of these elements one by one may seem strained; and one might equally find possible sources in the countless drawings and watercolors of opera balls by Gavarni under the Second Empire, for the most part representing a more agitated, more colorful, less static scene.

In selecting the lobby of the Opéra, Manet deliberately adopted a comparatively quiet spot, described as such twenty years before, in 1852, by E. Texier in his account of the opera ball: "You will witness a scene recalling the ancient bacchanalia, and lasting from midnight until five in the morning. Leave the hall and make your way into the lobby. There, no Pierrettes in short skirts, no half-clad *débardeuses*, but a sea of dominoes and black full dress; the lobby is the very antithesis of the hall. Gentlemen grave as judges, somber as undertakers, have been on the prowl for hours, seeking adventure."[14] And in 1865, in the prologue recited before the scene of the opera ball on which the curtain rose for *Henriette Maréchal*, Théophile Gautier had noted the disappearance of masculine fancy dress from the costume ball:

Bientôt il nous faudra pendre au clou dans l'armoire	Soon we must hang away in wardrobe press
Ces costumes brillants de velours et de moire	Our velvet and our mohair gala dress—
Le carnaval déjà prend pour déguisement	Carnival clowns the garb now emulate
L'habit qui sert au bal comme à l'enterrement.[15]	Wherein we grace the ball, and lie in state.

1. Anonymous, in *Le Figaro*, April 1, 1873, quoted in Tabarant 1947, p. 204.
2. Fervacques 1873, quoted in Moreau-Nélaton 1926, II, pp. 9–10.
3. Duret 1902, p. 88.
4. Mallarmé 1945, p. 697.
5. Goncourt 1956: November 20, 1873.
6. Eric Darragon, "Le Bal de l'Opéra, espace et réalité post-romanesques chez Manet en 1873," *L'Avant-Guerre sur l'art*, no. 3 (1983).
7. Tabarant 1931, p. 251; Tabarant 1947, p. 231.
8. Duret 1902, p. 88.
9. Bazire 1884, p. 139; Duret 1906, pp. 110–11.
10. Reff 1982, no. 39.
11. R. Delage, *Iconographie musicale*, Paris, 1982, p. 62.
12. Leiris 1980, p. 98.
13. Ibid., pp. 95–96, 99.
14. Edmond Texier, *Tableau de Paris*, Paris, 1852, chap. V, "Le Carnaval," p. 47.
15. Edmond and Jules de Goncourt, *Henriette Maréchal*, Paris, 1879, prologue by T. Gautier, p. 28.
16. Tabarant 1931, p. 250.
17. Faure sale, Paris, April 29, 1878, no. 40.
18. Tabarant 1947, p. 234.

Provenance
This painting, which Manet titled "Bal masqué à l'Opéra" in his account book, was among the first group of works purchased from the artist by the singer FAURE (see Provenance, cat. 10), on November 18, 1873. He paid 6,000 Frs for the unfinished *Masked Ball at the Opéra*, the same price as for the famous *Le bon bock* (RW I 186).[16] The present picture was included in the Faure sale in 1878[17] but remained unsold. He still owned it at the time of the posthumous exhibition in 1884. In 1894, he sold the painting to DURAND-RUEL[18] (see Provenance, cat. 118), who sold it in 1895 to MR. AND MRS. H. O. HAVEMEYER (see Provenance, cat. 33). The family kept the work for nearly a century, until 1982, when Mrs. Havemeyer's heirs gave it to the National Gallery of Art in Washington, D.C.

F.C.

139. Argenteuil

1874
Oil on canvas
59¾ × 45¼" (149 × 115 cm)
Signed and dated (lower right): Manet 1874
P Musée des Beaux-Arts, Tournai

Exhibitions
Salon 1875, no. 1412 (Argenteuil); Beaux-Arts 1884, no. 75; Paris, Drouot 1884, no. 4; Exposition Universelle 1889, no. 490; Orangerie 1932, no. 55

Catalogues
D 1902, 171; M-N 1926 II, p. 23; M-N cat. ms., 183; T 1931, 214; JW 1932, 241; PO 1967, 193; RO 1970, 195; RW 1975 I, 221

Manet had chosen not to exhibit with the Indépendants when their first group show opened on April 15, 1874, two weeks before the Salon. Nevertheless, he was seen as their leader; soon to be called "Impressionists," they were known for the moment as "la bande à Manet." In the summer, he visited the family house at Gennevilliers, not far from Monet at Argenteuil (see cat. 141); Renoir often joined the little group. In this holiday atmosphere, Manet painted *Argenteuil*, perhaps the most truly Impressionist work of his career. Monet and his wife at first posed in their studio boat, for a painting probably intended by Manet for the Salon—a "militant" demonstration, one might say, on behalf of the Impressionists. Neither version of this project (RW I 218, 219) was completed, Manet having scruples about posing his friends for long periods of time.[1] He summoned other models from Paris for a new canvas.

A boatman and his companion sit on a mooring dock, some sailboats alongside, and a very blue Seine separating them from Argenteuil on the far bank, where houses and a small factory chimney are seen. There is a semblance of intimacy between the two figures—something that is rare in Manet's oeuvre—at least in the expression of the young man, posed by Rodolph Leenhoff, Manet's brother-in-law; the woman's face—the identity of the model is not known—seems remarkably inexpressive, unless of summer lethargy or profound boredom. Reportedly the model complained that "posing for M. Manet was no joke—some rough sessions."[2] All Manet's verve, joyously and firmly spread over the canvas, and displayed especially in the unusual treatment of the dress and the bouquet, seems to have been drained out of the faces. "Boatmen came from various walks of life," wrote Duret, a contemporary witness, "but the women they brought with them all belonged to the class of second-rate ladies of pleasure. Such is the one in *Argenteuil*. Now Manet, sticking as close as possible to life, never put anything into a face but what nature put there, so he represented this boating woman, with her commonplace features, sitting idle and indolent. He faithfully rendered the *grue* that his observation from life suggested."[3]

There is no documentary evidence, but it is quite likely that this work was in part executed *en plein air*; according to Rewald, it was the first time: "It was in Argenteuil, where he watched Monet paint, that Manet was definitely convinced by work done out-of-doors."[4]

In *Argenteuil*, Manet immediately mastered the shimmering Impressionist touch in the outpouring of light on the open-air scene of summer. The faces, shaded by the hats, are more delicately modeled than in most of his previous portraits, and by simple means, like a virtuoso, he captured the vibrant colors of landscape and costume, as though challenging his Impressionist friends on their own ground.

Nevertheless, despite the vivid colors and flickering light in the picture, there is, as always, a rigorous composition, here the organization around

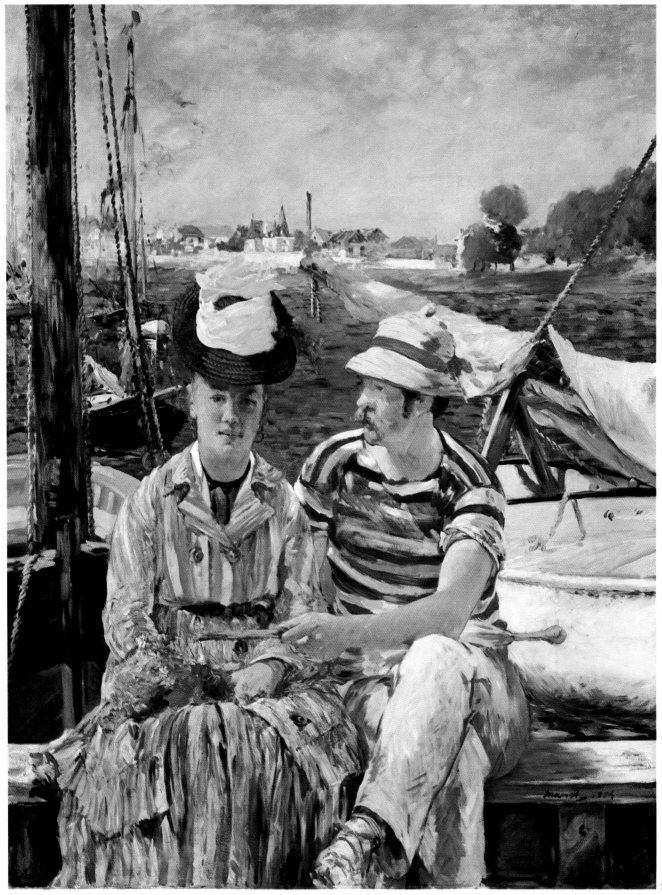

139

1. Moreau-Nélaton 1926, II, pp. 22–23.
2. Anonymous, in *La Gironde* (Bordeaux), April 21, 1876.
3. Duret 1902, p. 107.
4. Rewald 1973, p. 341.
5. Gaillardin, in *Le Soir*, May 6, 1875, quoted in Tabarant 1947, p. 263.
6. Rousseau, in *Le Figaro*, May 2, 1875, quoted in Tabarant 1931, p. 264.
7. Chesneau, in *Paris-Journal*, May 11, 1875, quoted in Tabarant 1947, p. 264.
8. Castagnary 1875, quoted in Tabarant 1947, p. 265.
9. Claretie 1876, p. 337.
10. Moreau-Nélaton 1926, II, p. 30.
11. Eudel 1884, p. 2.
12. Stéphane Mallarmé, *Les "Gossips" de Mallarmé; "Athenaeum" 1873–1876*, ed. Henri Mondor and Lloyd James Austin, Paris, 1962, pp. 70–72.
13. Rouart and Wildenstein 1975, I, p. 27, no. 7, "Tableaux et études."
14. Manet sale, Paris, February 4–5, 1884, no. 4; Bodelsen 1968, p. 342.
15. Tabarant 1947, pp. 266–67.
16. S. Pierron, *Collection Henri van Cutsem*, Paris, 1926, unpaginated.
17. Signed receipt, Mme Manet to Henri van Cutsem (archives, Musée des Beaux-Arts, Tournai), kindly provided by Baron S. L. Bailly de Tilleghem, curator.

the bright blue of the water of a system of verticals (mast at the left, woman in full front view, factory chimney) and horizontals (parapet, rolled parasol held by the boatman, the Argenteuil embankment), all parallel to the sides of the canvas. The fine striping of the dress opposes that of the boatman's jersey—a subtle echo in the center of the canvas of the vertical and horizontal framework. Manet seems to dwell on choice details of color: the bunch of daisies and poppies held by the woman, the black straw hat trimmed in white netting, the touches of red in the straps of the young man's espadrille, matching the band of his straw hat—identical to the one then worn by Monet (see cat. 142). A *plein-air* scene in the lively, dazzling style of his young friends, but at the same time deliberate, composed: a work destined to be shown at the next Salon.

Critics there received it with the sarcasm customarily elicited by Manet (see fig. a), and augmented by their reaction to his Impressionism. Thus Gaillardon: "We had a ray of hope after *Le bon bock*, but it is all too obvious that the *Canotiers d'Argenteuil* is a disaster. M. Manet is nothing but an eccentric after all."[5] And Rousseau: "Marmalade from Argenteuil spread on an indigo river. The master returns as a twentieth-year student."[6] Chesneau, however, came to Manet's defense: "Year after year, for three years now, he has outdone himself. . . . He paints water blue. That is the great complaint. However, if the water is blue on certain days of bright sunshine and wind, must he paint it the traditional green color of water? . . . They hiss, I applaud."[7] Castagnary was among those who were beginning to recognize the merits of Manet's work, however scandalous, and compared it to that of Cabanel, the great success of the Salon that year: "What Manet paints is contemporary life. As to that, I suppose, there is nothing to be said; the *Canotiers d'Argenteuil* is a good bet over *Tamar in the House of Absalom*, certainly it holds more interest for us."[8] And the chronicler Claretie, though he himself considered the painting a mere daub, reported an opinion then voiced among the avant-garde: "The Impressionists start from Baudelaire. . . . M. Edouard Manet . . . sets the tone, marks the cadence. He is the drill sergeant. The painter of *Le bon bock* this year showed a canvas that he calls *Argenteuil*, and the *plein-air* school loudly proclaims it a masterpiece."[9]

Provenance

Moreau-Nélaton's father wrote Manet about buying this painting, but he found the price (6,000 Frs) excessive.[10] Perhaps it was meant to discourage any prospective purchaser, for according to a contemporary witness, Manet never wanted to be separated from the work,[11] although he did hope to exhibit it in London.[12] The picture was valued at 1,800 Frs in the posthumous inventory[13] and bought in for 12,500 Frs by SUZANNE MANET (see Provenance, cat. 12) at the sale in 1884.[14] She sold it in 1889 for a slightly higher price, 15,000 Frs (and not 14,000 Frs as Tabarant says[15]), to the Belgian painter, patron, and collector HENRI VAN CUTSEM (1839–1904), a remarkable individual of whom it has been said that "in his acquisitions, Henri van Cutsem listened only to his own instinct, refusing any advice."[16] He was one of the subscribers for the purchase of *Olympia* (see Provenance, cat. 64). Van Cutsem paid for the present picture in eight installments, made between September 26, 1889, and February 28, 1890.[17] The first receipt indicates that he had reserved the painting and made the first payment while it was still at the Exposition Universelle of 1889. The Van Cutsem collection, which included an important group of French paintings from the second half of the nineteenth century (Fantin-Latour, Monet, Seurat, etc.), was bequeathed to the city of Tournai through his heir, the sculptor GUILLAUME CHARLIER (1854–1925). From 1905, the collection, including *Argenteuil* and *Chez le père Lathuille* (RW I 291), was exhibited at the city hall, and in 1928, it was installed in the museum designed especially for it by the Art Nouveau architect Horta (inv. 438).

F.C.

Fig. a. Bertall, "We thank . . . M. Manet for having injected a happy note into this rather sad Salon. . .," in *L'Illustration*, May 29, 1875

140. Boating

1874
Oil on canvas
38¼ × 51¼" (97.2 × 130.2 cm)
Signed (lower right): Manet
The Metropolitan Museum of Art, New York

Boating was painted in Argenteuil during the summer of 1874, when Manet spent several weeks, apparently in July and August, at his family's property in Gennevilliers, on the opposite bank of the Seine. Monet was living in a rented house in Argenteuil, which Manet is believed to have helped him find in 1871 (see cat. 141). The two painters saw each other often that summer, and Manet attempted twice to paint Monet and his wife, Camille, while Monet worked aboard his floating studio (RW I 218, 219; cat. 142, fig. b). According to Moreau-Nélaton, after Manet abandoned his second attempt, believed to be the example in Stuttgart (RW I 218), he secured other models and painted *Argenteuil* (cat. 139) and *Boating*.[1] The man in both works is Rodolphe Leenhoff, Manet's brother-in-law; the woman remains unidentified. She wears the same hat worn by Mme Manet in *On the Beach* (cat. 135) and *The Swallows* (RW I 190) and by Camille Monet in *The Monet Family in the Garden* (cat. 141), but she resembles neither painter's wife.

Although *Boating* is often cited as evidence of Manet's espousal of the tenets of Impressionism, the composition and the subject are without precedent. The lightened palette and the type of *plein-air* subject suggest that although Manet was very much aware of the work of such artists as Monet and Renoir, the influence of Impressionism is subtler and less easily defined than is generally acknowledged. Renoir's and Monet's palette, brushwork, and subject matter were different, and neither had ever painted a similarly structured work. Affinities between their work and Manet's are far more evident in the less ambitious *Banks of the Seine at Argenteuil* (RW I 220), also painted during the summer of 1874. The painting that most resembles *Boating* is in fact a work executed twenty years later, Mary Cassatt's *The Boating Party*, 1893–94 (National Gallery of Art, Washington, D.C.).

The size, theme, and finish of *Boating* suggest that Manet may have considered it for submission to the Salon of 1875, where he exhibited *Argenteuil*, a work of similar subject and importance. He included *Boating* in the exhibition that he held in his studio in 1876, but did not exhibit it at the Salon until 1879. According to Tabarant, that year Manet was uncertain which picture to send to the Salon jury with *In the Conservatory* (cat. 180), and, in reviewing earlier work, he found that *Boating* made the strongest impression. Tabarant maintains that Manet placed it on an easel and contemplated it for fifteen days before deciding to send it to the jury.[2]

The response of the critics to Manet's entries was predictably hostile. Arthur Baignères lamented that Manet had never "learned that one can draw the forms in front of one instead of first coloring them; he would have known that we have behind our eyes a brain which thinks, and that it is better to use both than to rely only on the first."[3] Zola's review stated flatly that Manet had not fulfilled the promise of his early work, and that his technical abilities were not equal to his ambitions: "He continues to be an excitable schoolboy, seeing clearly enough what is there in real life but unsure in his ability to render his

Exhibitions
Paris, Manet's studio 1876; Salon 1879, no. 2011 (En bateau); Beaux-Arts 1884, no. 76; Exposition Universelle 1889, no. 498; New York, Durand-Ruel 1913, no. 13; Philadelphia 1933–34, without no.; Philadelphia-Chicago 1966–67, no. 125

Catalogues
D 1902, 181; M-N 1926 II, pp. 24, 57; M-N cat. ms., 188; T 1931, 215; JW 1932, 244; T 1947, 226; PO 1967, 194; RO 1970, 196; RW 1975 I, 223

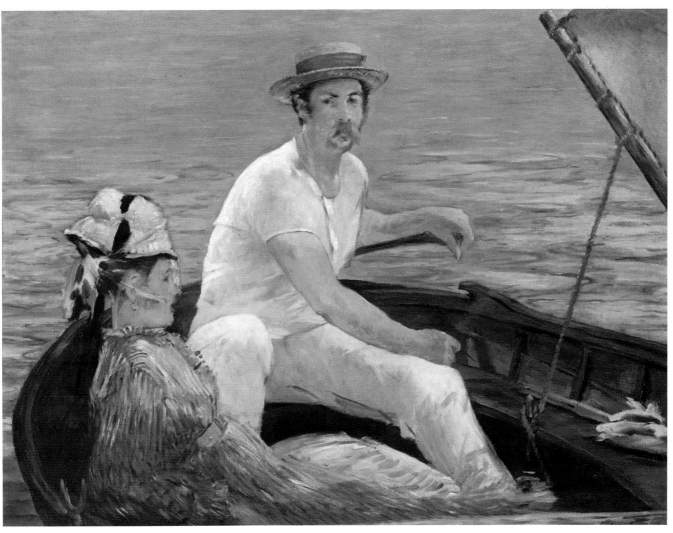

140

impressions fully and definitively. That is why, when he starts out, one never knows how he will reach the goal or if he will get there at all. He works at random. When one of the paintings succeeds, it's extraordinary: absolutely true and exceptionally skillful; but sometimes he misses the mark, and then his canvases are flawed and uneven. In short, during the last fifteen years we have seen no other painter with greater subjective ability. If his technical side equaled the correctness of his perception, he would be the great painter of the second half of the nineteenth century."[4]

The doubts expressed by Zola and Baignères were not shared by the novelist and critic Joris Karl Huysmans. For example, while Baignères described Guillemet's hands in *In the Conservatory* as "some formless spots," Huysmans praised the same hands as "boldly drawn with a few strokes." In fact, Huysmans's review of the Salon was clearly intended as a rebuttal: "The very blue water still exasperates some people. Water is not that color? But indeed it is, at certain times, as well as shades of green, gray, with reflections of primrose, buff, or slate, and many more. . . . Manet, thank God, has never known the stupid prejudices maintained in the academies. He paints and distills nature as it is and as he sees it. The woman dressed in blue, sitting in

a boat cropped by the frame as in certain Japanese prints, is well placed, in full light, and is defined energetically, as is the white-clad helmsman against the harsher blue of the water. Paintings such as these, alas, we shall seldom find at this tedious Salon."[5] Louis Gonse, in a review of the memorial exhibition held at the Ecole des Beaux-Arts in 1884, adopted an even stronger position: "One can even submit these *plein-air* pictures to still another test, that of photography. Stripped of their color, the values remain correct, the space is convincing, and the forms exist in a kind of realistic atmosphere that gives the illusion of a photograph taken from nature."[6]

Of course, *Boating* is not photographically correct, nor could Gonse have known if it were, because neither the film nor the lens necessary to capture the image existed in 1874. The abrupt cropping of the composition, the patternlike treatment of the water in the middle ground, and the rising background plane suggest that Huysmans's reference to Japanese prints is more appropriate than Gonse's remarks about photography. Furthermore, the improbable position of the boom in relation to the rest of the boat and the slightly distorted curve of the stern in relation to the port gunwale are additional indications that the compositional peculiarities are intentional and result from aesthetic considerations.

Several details indicate that Manet wished especially to mitigate the viewer's sense of depth. For example, the background rises parallel to the picture plane and blocks the view into the far distance; there seems to be little or no space between the foreground elements and the water; and, despite the angle of the boat, the woman appears in perfect profile perpendicular to the picture plane as if she were a cutout. In addition, pentimenti and X-rays reveal that Leenhoff originally held the rope in his right hand; by moving the rope to the right, Manet reduced the angle and considerably diminished a clear indication of depth. Finally, the sail, the boom, and the rope appear to lie parallel to the picture plane, but the angle of the boat and the position of the cleat indicate that this could not be the case.

In view of the many compositional and spatial ambiguities, the objections voiced by Zola, Baignères, and others are understandable. They failed to observe, however, that the goals of serious art were changing. Zola mistook calculation and precocious formal experimentation in Manet's art for subjective and technical error. In fact, the picture clearly anticipates the tenor of French art in the late nineteenth century described by Maurice Denis when he wrote: "Remember that a painting—before it is a battle horse, a nude woman, or some anecdote—is essentially a flat surface covered with colors assembled in a certain order."[7]

1. Moreau-Nélaton 1926, II, pp. 23–24.
2. Tabarant 1947, p. 345.
3. Baignères 1879, quoted in Hamilton 1969, p. 214.
4. Zola 1959, p. 227.
5. Huysmans 1883, pp. 35–36.
6. Gonse 1884, p. 146.
7. Denis, quoted in Nochlin 1966, p. 187.
8. Moreau-Nélaton 1926, II, p. 57.
9. Rewald 1973, *Gazette des Beaux-Arts*, p. 106.
10. Rouart and Wildenstein 1975, I, p. 186.
11. Havemeyer 1961, p. 225.

Provenance
Boating was bought from the Salon of 1879 for 1,500 Frs by VICTOR DESFOSSÉS,[8] an important Parisian collector who also owned Courbet's *Studio* and works by Monet, Pissarro, and Sisley.[9] In 1889, Desfossés lent the picture to the Exposition Universelle in Paris. DURAND-RUEL acquired it in 1895[10] and immediately sold it to MR. AND MRS. H. O. HAVEMEYER (see Provenance, cat. 33). In her memoirs, Mrs. Havemeyer recalls that her friend Mary Cassatt, who often advised her on art purchases, called *Boating* "the last word in painting."[11] Mrs. Havemeyer bequeathed the picture to the Metropolitan Museum in 1929 (inv. 29.100.115).

C.S.M.

141

141. The Monet Family in the Garden

1874
Oil on canvas
24 × 39¼″ (61 × 99.7 cm)
Signed (lower right): Manet
The Metropolitan Museum of Art, New York

Manet never participated in any of the Impressionists' group exhibitions held between 1874 and 1886, but he maintained close ties with several of the artists. He was particularly fond of Monet, whom he assisted financially from time to time. According to Paul Tucker, following Monet's return from England after the Franco-Prussian War and the subsequent violent political upheaval known as the Commune, Manet may have helped him find the first of two houses that he rented in Argenteuil.[1] Monet lived in the first house, at 2, rue Pierre Guienne, from the winter of 1871 until the end of September 1874. On May 27, 1874, Monet informed Manet that he was going to move ("I am detained in the country and am very busy with my move from the studio"), but he did not sign the lease for the second house until June 18, and the lease stipulated that occupancy would not begin until October 1.[2]

Exhibitions
Paris, Toul 1878; Exposition Universelle 1900, no. 45; Berlin, Cassirer 1910; Munich, Moderne Galerie 1910, no. 8; Paris, Bernheim-Jeune 1910, no. 6

Catalogues
D 1902, 176; M-N 1926 II, pp. 24–25, 116; M-N cat. ms., 186; T 1931, 222; JW 1932, 245; T 1947, 233; RO 1970, 199; RW 1975 I, 227

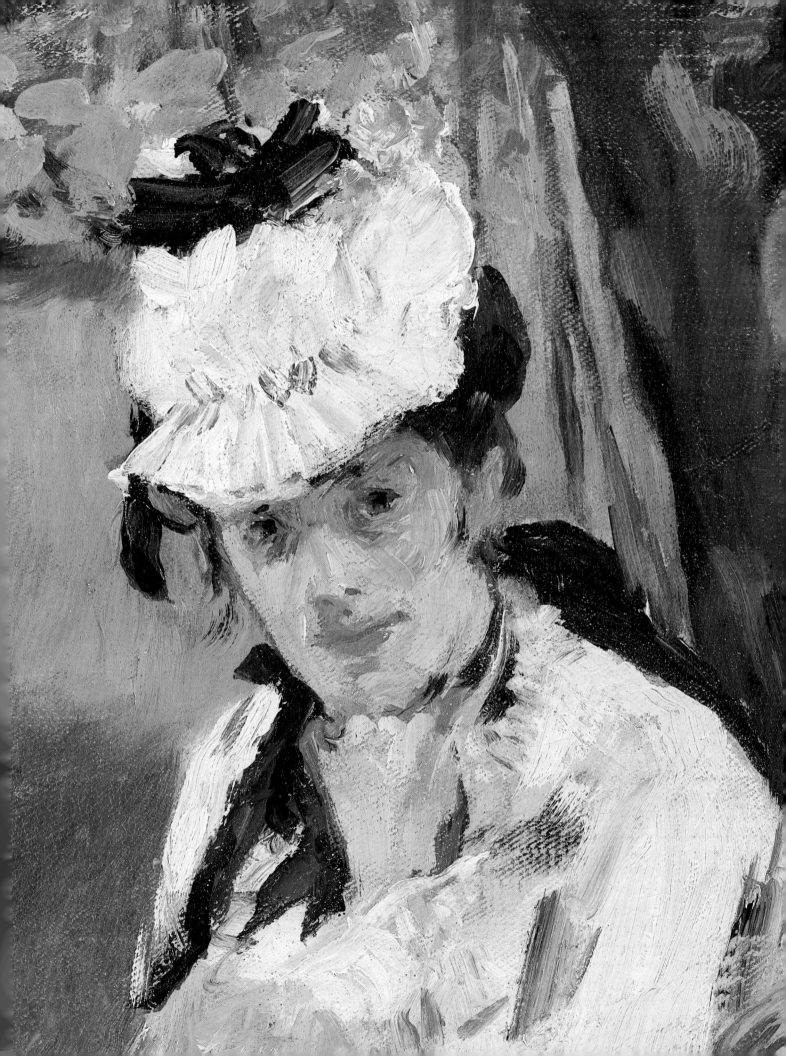

During July and August 1874, Manet evidently spent several weeks at his family's property in Gennevilliers, on the opposite side of the Seine. In a letter dated July 23, Zola reported to Antoine Guillemet: "I do not see anybody, am without any news. Manet, who is painting a study at Monet's in Argenteuil, has disappeared. And since I don't often go to the Café Guerbois, that's about all the information I have."[3] The "study" mentioned is very probably *The Monet Family in the Garden.*

While Manet painted the Monet family, Monet painted Manet at his easel (fig. a).[4] And Renoir, who arrived chez Monet just as Manet was beginning to work, borrowed paint, brushes, and canvas from Monet, positioned himself next to Manet, and painted *Mme Monet and Her Son in Their Garden at Argenteuil* (fig. b): "I arrived at Monet's at precisely the moment Manet was preparing to do the same subject; can you imagine my passing up such an opportunity, with the models all set up?"[5]

Monet's account, quoted by Marc Elder, is probably the most accurate of several that describe what took place that day. His remarks begin with a comment about Renoir's painting of his wife and son, a work that remained in his possession throughout his life: "This delightful painting by Renoir, of which I am the happy owner today, portrays my first wife. It was done in our garden at Argenteuil. One day, Manet, enthralled by the color and the light, undertook an outdoor painting of figures under the trees. During the sitting, Renoir arrived. He, too, was caught up in the spirit of the moment. He asked me for palette, brush, and canvas, and there he was, painting away alongside Manet. The latter was watching him out of the corner of his eye, and from time to time came over for a closer look at the canvas. Then he made a face, passed discreetly near me, and whispered in my ear about Renoir: 'He has no talent, that boy! Since you're his friend, tell him to give up painting!...' Wasn't that amusing of Manet?"[6]

Despite several authors' insinuations to the contrary, Manet's comment about Renoir was probably made in a good-natured manner. Tabarant dismisses Manet's remark as a fabrication perpetrated by Vollard in the 1920 edition of his book that purported to be an account of a dialogue between himself and Renoir,[7] but it is unlikely that Elder would have published his conversation with Monet while the latter was still alive if it was not essentially correct. Rewald has suggested that the remark, "if it was actually made, can only reflect Manet's irritation at a moment of rivalry before the same subject, for he seems to have been genuinely fond of Renoir and had heretofore frequently expressed liking for him, particularly when he had urged Fantin to put Renoir close to him for the composition of *A Studio in the Batignolles Quarter. . . .*"[8] Indeed, Manet's comments must have been intentionally ironic, because during the summer of 1874, his own work had begun to reflect the influence of his younger colleagues—his palette had lightened, and he showed a greater interest in the kinds of subjects we associate with orthodox Impressionism.

The three works executed by Manet, Monet, and Renoir in the garden at Argenteuil were evidently painted very rapidly. Each artist used thinned, fluid paint that was applied vigorously and quickly. But *The Monet Family in the Garden* is both more deliberate and more ambitious than the other two. The spontaneity so evident in the Renoir is less pronounced, and the figure of Mme Monet seems to consciously echo the seated figure in the foreground of Monet's *Women in the Garden,* 1866–67 (Musée d'Orsay-Galeries du Jeu de Paume, Paris), for which Camille Monet was also the model. Manet knew

Fig. a. Claude Monet, *Manet Painting in Monet's Garden,* 1874. Present location unknown

Fig. b. Pierre-Auguste Renoir, *Mme Monet and Her Son in Their Garden at Argenteuil,* 1874. National Gallery of Art, Washington, D.C.

Monet's picture exceedingly well, since he owned it from 1876, when he acquired it from Bazille's parents in exchange for a portrait of their son by Renoir, to 1878, when, during a short-lived disagreement, he returned it to Monet in exchange for *The Monet Family in the Garden.*

The surface, too, was more carefully developed. In some areas, Manet applied thinned paint that he scraped or wiped away, leaving a translucent film of green underpaint. Thicker, more opaque paint was applied over such areas in some places but not in others. The resulting image is a carefully orchestrated combination of paint films that belies the casual appearance of the painting; note, for example, the finesse with which Manet uses the same red in the cock's comb, the flowers, the fan, and Camille's and Jean's hats and shoes.

Even the hat worn by Mme Monet underscores the deliberateness of the composition. Evidently Manet provided the hat as a prop, because it belonged to his wife. Mme Manet wears the hat in *On the Beach* (cat. 135) and *The Swallows* (RW I 190), but it also appears on models in *Banks of the Seine at Argenteuil* (RW I 220) and *Boating* (cat. 140).

On two other occasions during the summer of 1874, Manet attempted to execute important paintings in which Claude and Camille Monet served as his models (RW I 218, 219). According to Moreau-Nélaton, Monet was too busy to spend the necessary time posing for Manet, so the latter found different models and instead painted *Argenteuil* (cat. 139) and *Boating*, which were exhibited at the Salons of 1875 and 1879 respectively.[9] It is tempting to speculate that Manet had hoped to use the Monets as models for a Salon picture, and that *The Monet Family in the Garden*, like the two versions of Monet painting in his floating studio, represents a preliminary step toward the realization of his goal.

1. Tucker 1982, pp. 18–19.
2. Walter 1966, pp. 336–37.
3. Zola 1959, pp. 25–26.
4. Wildenstein 1974, I, no. 342.
5. Vollard 1920, p. 74.
6. Elder 1924, p. 70.
7. Tabarant 1947, pp. 252–57.
8. Rewald 1973, p. 342.
9. Moreau-Nélaton 1926, II, p. 23.
10. Elder 1924, pp. 70–71.
11. Poulain 1932, p. 103.
12. Manet et al., "Copie faite pour Moreau-Nélaton . . . ," p. 76.
13. Jeanniot 1907, p. 847.
14. Moreau-Nélaton 1926, II, p. 45.
15. Meier-Graefe 1912, p. 316.

Provenance
In 1876, the parents of the painter Frédéric Bazille (1841–1870), who was killed in the Franco-Prussian War, arranged with Manet to exchange Renoir's portrait of their son (1867), which he owned, for a large, important painting by Monet, *Women in the Garden,* 1866 (both Musée d'Orsay-Galeries du Jeu de Paume, Paris). Painfully aware of Monet's economic plight at this time, Manet evidently feigned some annoyance as a pretext to return *Women in the Garden* to its author in exchange for his own little picture of the Monet family in their garden at Argenteuil, which he had given to MONET immediately after he painted it. As Monet explained, "Manet was delightful, but peculiar and so irascible! . . . He recovered from his bad mood later, and all was forgotten."[10] According to Poulain, they were reconciled within a week, but Manet had already sold *The Monet Family in the Garden.*[11] In fact, Manet's account book indicates that he sold the picture in 1878 for 750 Frs to the dealer TOUL,[12] who exhibited it from October.[13] If the dispute between Manet and Monet occurred at this later date, the exchange of works with Monet may have had something to do with the fact that Manet was forced to move to a smaller studio and wanted to divest himself of belongings that would take up necessary work space.[14] *The Monet Family in the Garden* was later bought by AUGUSTE PELLERIN (see Provenance, cat. 109). Acquired by BERNHEIM-JEUNE, PAUL CASSIRER, and DURAND-RUEL (see Provenance, cat. 31, 13, 118) in 1910 with other works by Manet from Pellerin's collection, this picture was sold by Cassirer along with *The Artist* (cat. 146) for 300,000 Frs[15] to EDUARD ARNHOLD of Berlin (see Provenance, cat. 29). M. KNOEDLER & CO. (see Provenance, cat. 172), New York, bought it from a Swiss collector in February 1964 and sold it the same month to MRS. CHARLES S. PAYSON (see Provenance, cat. 5), who bequeathed it to the Metropolitan Museum in 1975 (inv. 1976.201.14).

C.S.M.

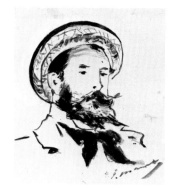

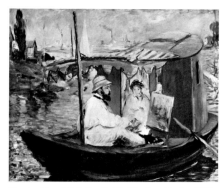

142

142. Claude Monet

1874?
Brush and India ink
6¾ × 5⅜" (17 × 13.5 cm)
Musée Marmottan, Paris

This drawing seems to have been executed at about the same time as Manet's brush-and-India-ink portrait of Monet that was used to illustrate the catalogue of Monet's exhibition at the Galerie de La Vie Moderne in 1880 (RW II 486; fig. a). Furthermore, the drawing is reminiscent of the profile view of Monet facing in the opposite direction in Manet's *Monet Painting in His Floating Studio*, 1874, in Munich (RW I 219; fig. b). The hat worn by Monet in both works appears to be the same, although the brim is turned up in the drawing. It is difficult to determine if the same hat appears again in the drawing used to illustrate the 1880 catalogue, but the high collar and the loosely tied cravat worn by Monet in that work are not unlike those worn by Monet in the Munich painting. The implication, of course, is that the two brush drawings were made during the summer of 1874, when Monet and Manet were both working in Argenteuil (see also cat. 139–41).

Catalogues
RW 1975 II, 485

Provenance
Probably given by Manet to CLAUDE MONET (it does not bear the atelier stamp that was applied to works on paper in Manet's estate), this drawing was listed as no. 36 in the posthumous inventory of his son MICHEL MONET, drawn up at Sorel-Moussel on February 25, 1966. Michel Monet bequeathed the drawing, along with his entire collection, to the Institut de France, which deposited it in the Musée Marmottan (inv. 5036).

C.S.M.

143. Mme Manet on a Blue Couch

1874
Pastel on paper, mounted on cloth
25½ × 24″ (65 × 61 cm)
Inscribed (lower right, by Suzanne Manet): E. Manet
P Musée du Louvre, Cabinet des Dessins, Paris

Exhibitions
Orangerie 1932, no. 89; Orangerie 1952, without no.

Catalogues
D 1902, 1 (pastels); M-N 1926 II, p. 50; M-N cat. ms., 351; T 1931, 3 (pastels); JW 1932, 311; T 1947, 455; PO 1967, 238; RO 1970, 239; RW 1975 II, 3 (pastels)

It is difficult to say when Manet took up the medium of pastel, so prevalent in the eighteenth century but not much used since, unless by Boudin, Delacroix, or Millet, usually in landscape. It would seem that there was a revival of interest in pastel in Impressionist circles, though it is not clear who started it. This important topic requires further research. Here, for example, are we to see an influence of Degas, who by this time had done several pastel portraits,

143

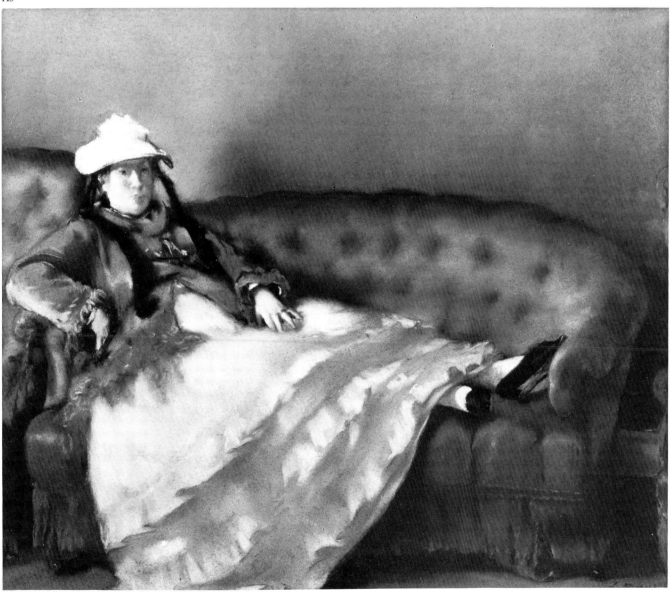

among them *Thérèse de Gas*, 1869, and more recently *Mme René de Gas*, 1873?[1] So Degas himself implied later on.[2]

Whether under the influence of his friend or not, Manet used this medium chiefly for portraits, between 1879 and 1883, producing, according to Bazire, his first historian and biographer, a considerably larger number than have been traced and catalogued: "The list is endless. . . . models . . . were multiplied, and for every one that sat, there are three, four, six likenesses."[3] Bazire counts over 130, whereas Rouart and Wildenstein's catalogue raisonné records 89.

Here, this admirable picture of his wife reclining is treated like an oil painting, covering the whole area, but using the liveliness of pastel to lend the materials and colors of the white skirt, the bright blue couch, and the ruddy background an intensity and softness unattainable with oil on canvas, and recalling the lovely eighteenth-century domestic pastels of Chardin or Liotard.

It is interesting to see how Manet, deliberately or not, gives his conventionally clad wife—apparently just back from an outing in her polished shoes and light bonnet—the very pose of *Olympia* (cat. 64), at least in the bust and arms.

This pastel is customarily dated by the testimony of Théodore Duret: "His first pastel dates from 1874. It is a portrait of his wife resting on a couch."[4] But Rewald proposes the year 1878,[5] which would be as plausible stylistically. However, this same bonnet with black strings, painted by Manet many times before (see cat. 135), is also found in a pastel showing Mme Manet in profile (RW II 2), dated 1873–74 apparently by the model herself. And our pastel, "picturesque" as it is, echoes a theme Manet's Impressionist friends had often essayed quite early in the 1870s—a woman in indoor or street dress, resting casually on a couch: *Mme Monet on a Couch*, 1871, by Monet (Musée du Louvre, Paris); *Mme Claude Monet Reading*, 1872, by Renoir (Clark Art Institute, Williamstown); and *Mme Monet on a Couch*, also by Renoir (fig. a).

In this pastel, even more than in his canvases of the same period, Manet is strangely less concerned with effects of light and textures of materials than with strong color contrasts, unhighlighted, and broad expanses of color.

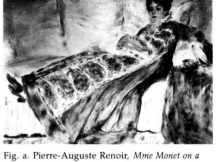

Fig. a. Pierre-Auguste Renoir, *Mme Monet on a Couch*, 1872. Museu Calouste Gulbenkian, Lisbon

1. Lemoisne 1946, nos. 255, 318.
2. D. Halévy 1960, p. 110.
3. Bazire 1884, p. 120.
4. Duret 1902, p. 175.
5. Rewald 1947, p. 42.
6. Rouart and Wildenstein 1975, I, p. 26.
7. Vollard 1937, p. 71.
8. Degas collection, first sale, Paris, March 26–27, 1918, no. 221.

Provenance
This pastel is listed in Manet's posthumous inventory, among works located in Suzanne Manet's apartment, as "Portrait de Mme Manet, au pastel" (portrait of Mme Manet, in pastel),[6] but it was not included in the sale in 1884. EDGAR DEGAS (see Provenance, cat. 23) later acquired it; exactly when is not known, but probably from VOLLARD (see Provenance, cat. 98) after 1894, as the dealer seems to indicate in his comments on Degas's sale: "At this same sale could also be seen, among other works by Manet, *The Ham* and *Mme Manet in White on a Blue Couch*; these are two exceptional works which in 1894, that is, more than ten years after the painter's death, were still in the hands of his widow awaiting a purchaser."[7] At the sale of Degas's collection,[8] the Musée du Louvre bought the pastel for 62,000 Frs (inv. RF 4507).

F.C.

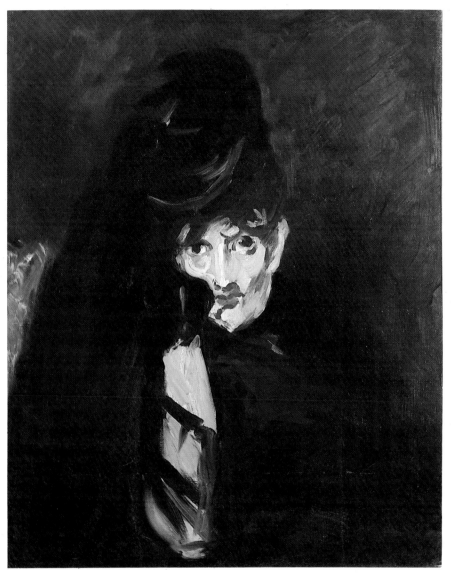

144

144. Portrait of Berthe Morisot with Hat, in Mourning

1874
Oil on canvas
24½ × 19¾" (62 × 50 cm)
Private Collection

Catalogues
D 1902, 185; M-N 1926 I, p. 140; M-N cat. ms., 151;
T 1931, 186; JW 1932, 238; T 1947, 223; PO 1967, 190;
RO 1970, 192; RW 1975 I, 228

This portrait, of an extraordinary dramatic intensity that takes it almost to the brink of caricature, shows us Berthe Morisot, haggard of feature and in mourning—black hat and veil—shortly after the death of her father, Tiburce Morisot, in January 1874. Years of illness had preceded his death, and had affected Berthe deeply; a year later, she wrote to her brother: "Today is the 24th of January, a sorrowful day, the anniversary of poor Father's death. What heartache at the thought of those terrible last years, his long sufferings, and

what regret to have been unable to make his last moments happier."[1]

Manet captures an expression—here at an extreme—that is never far from Berthe Morisot's face: a kind of wild sadness and anxiety that may have been a deeply ingrained personality trait, like a shadow of death over her beauty, so that she is the true Baudelairean heroine of Manet's oeuvre. Her own life was in fact melancholy, marked until her death at the age of fifty-four, in 1895, by a long series of bereavements: her father (1874), her mother (1876), Edouard Manet (1883)—his death particularly affected her, and she felt it as the end of her own youth[2]—her friend and rival Eva Gonzalès (1883), and lastly her husband, Eugène Manet (1892).

It is not clear how to interpret what seem to be black bands around the arm; very likely they are simply the design on the sleeve of her dress. She rests her head against her black-gloved fist. Her lined face appears much older than the two years between this portrait and *Berthe Morisot with a Bunch of Violets* (cat. 130) would account for, and the watercolor *Berthe Morisot with Fan* (cat. 145) shows her usual appearance restored.

This portrait, with its tension, anguish, and fury, as one might say, is quite exceptional in Manet's work, and its "expressionism" belies all those blank faces that populate his pictures.

1. Morisot 1950, p. 80.
2. Ibid., pp. 114–15.
3. Rouart and Wildenstein 1975, I, p. 27.
4. Tabarant 1947, p. 238.
5. Degas collection, first sale, March 26–27, 1918, no. 76; Tabarant 1947, p. 236.

Provenance
This portrait was no. 45 in the list of "tableaux et études" (paintings and studies) in Manet's posthumous inventory;[3] his widow presented it to DR. GEORGES DE BELLIO (1828–1894) in thanks for his attendance on Manet at the beginning of his illness in the summer of 1883.[4] The picture subsequently belonged to his daughter and son-in-law, M. AND MME DONOP DE MONCHY, and was later acquired by EDGAR DEGAS (see Provenance, cat. 23). Degas not only admired and collected Manet's work, but was also very attached to Berthe Morisot, with whom he had probably been in love. Perhaps he obtained this portrait after her death in 1899, which deeply affected him. When the work appeared at Degas's sale in 1918,[5] it was sold for 27,600 Frs to BERNHEIM-JEUNE (see Provenance, cat. 31). VOLLARD (see Provenance, cat. 98) later acquired it and sold it to the great Swiss collector of Impressionist and Nabi works, EMILE HAHNLOSER, before 1931, when Tabarant listed him as the owner in his catalogue.

F.C.

145. Berthe Morisot with Fan

1874
Watercolor
8 × 6½" (20.3 × 16.5 cm)
NY The Art Institute of Chicago

This watercolor is almost certainly a study for the delightful, strong portrait of the same title (RW I 229) that Manet painted shortly before Berthe Morisot became his sister-in-law; it is probably the last he did of her.[1]

A more precise dating would be difficult. The year 1874 was crucial in Morisot's life, marked by three major events: she lost her father in January; she entered the first Impressionist exhibition in the spring; and she married Manet's brother Eugène in December. The watercolor, like the painting, very likely dates from the autumn, and shows her still in mourning, in black muslin evening dress.

Exhibitions
Berlin, Cassirer 1906, no. 22; Stuttgart 1906, no. 18; Munich, Heinemann 1907, no. 20; Philadelphia-Chicago 1966–67, no. 110

Catalogues
T 1931, 59; T 1947, 611; L 1969, 434; RW 1975 II, 391

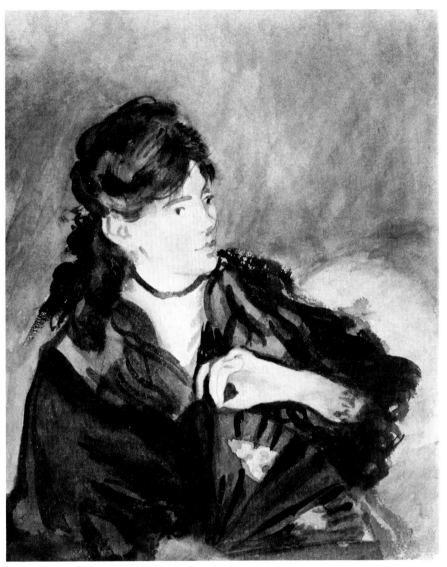

145

1. Tabarant 1947, p. 258.
2. Ibid.

The green background indicates the palms that appear in the painting, behind the light-colored couch on which Morisot is seated, with her left hand opening the fan held in the right. In contrast to the other frontal portraits, this one shows her in three-quarter view, subtly delineating the fineness of the expressive face. As in all his portraits of Berthe Morisot, Manet emphasizes the elegance of her long hands.

Provenance
In 1906–7, this sheet was exhibited as part of the FAURE (see Provenance, cat. 10) collection. In 1910, it belonged to the Berlin dealer PAUL CASSIRER (see Provenance, cat. 13),[2] from whom it was acquired by FRAU MARGARETE OPPENHEIM; it later appeared in New York with the dealer and collector JUSTIN K. THANNHAUSER (see Provenance, cat. 156). The Joseph and Helen Regenstein Foundation gave it to the Art Institute of Chicago in 1963 (inv. 1963.812).

F.C.

146. The Artist

1875
Oil on canvas
75⅝ x 50⅜" (192 x 128 cm)
Signed and dated (lower right): Manet / 1875
NY Museu de Arte, São Paulo

In 1875, the painter and etcher Marcellin Desboutin (1823–1902) modeled for *The Artist*, probably in Manet's studio at 4, rue de Saint-Pétersbourg. We do not know when Manet and Desboutin met, but it may have been at the Café Guerbois, which Desboutin began to frequent about 1870.[1] Later, Desboutin began to patronize the Café de la Nouvelle-Athènes and was soon joined by others from the Guerbois, including Manet, Degas, Renoir, Monet, Pissarro, and several critics and writers. In 1876, Desboutin and the actress Ellen Andrée served as the models for Degas's famous *Absinthe* (Musée d'Orsay-Galeries du Jeu de Paume, Paris), which shows them seated at a table at the Nouvelle-Athènes. By then, Desboutin must have been quite well known as the figure in the "portrait" by Manet that, in addition to *The Laundry* (RW I 237), had been refused for the Salon of 1876.

The double rejection came as a shock, because Manet had exhibited work at every Salon since 1868. The jury consisted of fifteen artists, thirteen of whom voted against him; only Henner and Bonnat dissented.[2] Laran and Lebas suggest that Manet may have encountered difficulty because of his outspoken opinions about certain academic painters, notably Meissonier, who sat on the jury that year.[3] However, an unsigned article published in *Le Bien public* indicates that Manet was the victim of years of accumulated hostility: "Both his paintings, *The Laundry* and a portrait, were 'blackballed.' . . . Here is what we have learned since this morning: When Manet's paintings came up for consideration, one member of the jury cried out: 'This is no longer necessary. We have given Manet ten years to mend his ways; he will not mend his ways; on the contrary, he digs in! Reject!' 'Let's reject him! Leave him alone with his pictures!' shouted other jurors. Only two painters tried to defend the creator of *Le bon bock*."[4]

Manet responded by exhibiting the two pictures in his studio for two weeks prior to the opening of the Salon. As he had in his independent exhibition in 1867, he appealed directly to the public and the critics. Invitations were sent out that read: "*Faire vrai et laisser dire.* M. Manet requests the honor of your company to view his paintings rejected by the jury of 1876. The pictures will be exhibited in his studio, from April 15 until May 1, from 10 until 5 o'clock, 4, rue Saint-Pétersbourg, on the ground floor."[5] Despite numerous rude remarks written in the guest book that visitors were invited to sign, the studio show was a great success.[6] There were enormous crowds, and after having seen *The Laundry* and *The Artist* several critics assailed the jury's decision. For example, the influential Armand Silvestre wrote: "Manet, as everyone agrees, paints certain details with unquestionable mastery, and of his two paintings this year, the *Portrait* contains such a detail: the large hound drinking. Velázquez might have claimed it. Can it be that the jurors think the public is not interested in these endeavors? Surely the throngs at Manet's independent exhibition prove the contrary."[7] Castagnary, another well-known critic,

Exhibitions
Paris, Manet's studio 1876; Beaux-Arts 1884, no. 78; Exposition Universelle 1900, no. 446; Berlin, Cassirer 1910; Munich, Moderne Galerie 1910, no. 1; Paris, Bernheim-Jeune 1910, no. 8

Catalogues
D 1902, 189; M-N 1926 II, p. 36; M-N cat. ms., 202; T 1931, 225; JW 1932, 259; T 1947, 236; RO 1970, 202; RW 1975 I, 244

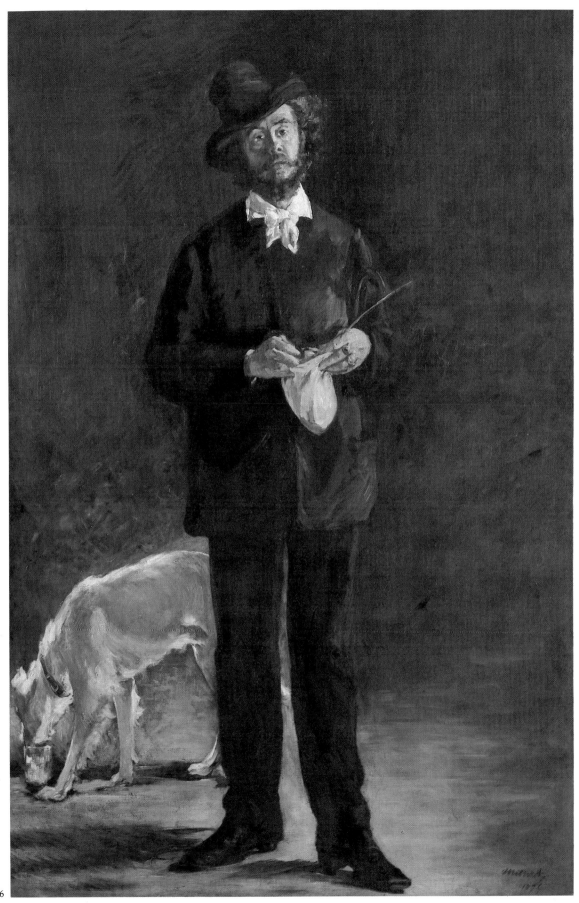

also impugned the jury's decision and, like Silvestre, was especially astonished by the rejection of *The Artist*. Moreover, echoing the subtle assertion of the article in *Le Bien public*, he suggested that the popularity of *Le bon bock* (RW I 186), exhibited at the Salon of 1873, may have adversely affected the jury: "To reject Manet is not a good move. . . . He occupies a position of greatness in contemporary art, albeit different from that of Bouguereau, for example, whom I see among the members of the jury. . . . The portrait this year, his portrait of Desboutin that you have rejected, would have been one of the strongest pictures at the Salon. But the success of *Le bon bock* has frightened you; you did not want to see it repeated on a large scale. Idiocy! The public, who only half trust you, ran to his studio, and the crowded viewings have amply compensated him for your boorish rejection."[8]

The positive reception accorded *Le bon bock* in 1873 was obviously a source of continuing concern to many, but even more important was the authority now accorded Manet, the de facto leader of the Impressionist movement. The success of *Le bon bock* had obviously created the kind of legitimacy that the Salon jury and conservative critics, such as Junius, feared. The refusal of both works submitted by Manet in 1876 was very likely an attempt to undermine "the ferment of Impressionism" and its "intellectual ringleader."[9]

During April, the Impressionists had opened their second group show, which led the critic Bernadille to ask sarcastically why Manet had not exhibited *The Laundry* and *The Artist* with his fellow renegades: "But why didn't he favor the exhibition of his colleagues and friends the Impressionists with his two canvases? Why go it alone? It's sheer ingratitude. What an impression Manet's presence would have made at the gathering place of these clever mavericks of painting. . . ."[10] Bernadille's comments, too, underscore the fact that in certain circles Manet was regarded as the center of the modern movement. It seemed natural that he should exhibit with the other firebrands, and in fact the Impressionists had invited him to do so. However, one can easily see that *The Artist* follows in the same tradition as Manet's full-length single-figure compositions of the 1860s. Although in this painting Manet is less directly dependent on the precedent of Velázquez, he continued to think of himself as an artist who painted the modern equivalents of seventeenth-century Spanish portraits. He was more than a realist, an Impressionist, and a painter of subjects from modern life, because while he was all of these he also worked consciously within a grand tradition that simultaneously challenged and sought the admiration of the establishment.

The Artist is in many ways similar to *The Tragic Actor* (cat. 89). They are nearly the same size, the figures hold analogous poses and stare contemplatively into space in the same direction, and the ground plane in each dissolves into an ambiguous background in the manner that Manet had favored since the early 1860s. However, in *The Artist* Manet has overcome the somewhat self-conscious dependence on Spanish painting that characterizes the earlier work. The rich blacks and grays have been replaced by blues and browns. The paint handling is looser and brushier, more improvised than that of *The Tragic Actor* and other full-length figure pictures of the 1860s, such as the *Philosopher* (cat. 90); in a picture executed in the 1860s, one would never have seen the exuberant flurry of blond and tan brushstrokes used to paint the dog.

In *The Artist*, there is also a marked emphasis on feeling that is absent in many earlier full-length figure paintings. Manet presents Desboutin as a particularly sympathetic and dignified figure. Degas probably chose Desboutin

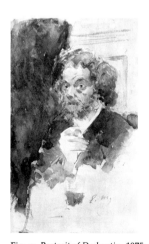

Fig. a. *Portrait of Desboutin*, 1875, watercolor. Fogg Art Museum, Cambridge, Mass.

1. Rewald 1973, p. 235.
2. Tabarant 1947, p. 279.
3. Laran and Lebas 1911, p. 85.
4. Anonymous, in *Le Bien public*, April 6, 1876.
5. Moreau-Nélaton 1926, II, p. 37.
6. Tabarant 1947, pp. 280–81.
7. Silvestre 1876, quoted in Tabarant 1947, p. 285.
8. Castagnary 1876, quoted in Tabarant 1947, p. 287.
9. Junius 1876, quoted in Tabarant 1947, p. 286.
10. Bernadille 1876, quoted in Tabarant 1947, p. 285.
11. Weisberg 1980, pp. 286–87.
12. Proust 1897, p. 206.
13. Blanche 1912, p. 154.
14. J. Manet 1979, p. 213.

Provenance
The Artist was lent to the 1884 Manet retrospective by HUBERT DEBROUSSE, who also lent *The Water Drinker* (RW I 43). Evidently, he acquired *The Artist* shortly after Manet's private studio exhibition in 1876. Manet's account book for that year is missing, and the transaction for this picture was not recorded at a later date. Julie Manet saw the painting on January 29, 1899, when she visited the collection of AUGUSTE PELLERIN (see Provenance, cat. 109).[14] In 1910, Pellerin sold a group of his Manets to BERNHEIM-JEUNE, PAUL CASSIRER, and DURAND-RUEL (see Provenance, cat. 31, 13, 118), and later the same year EDUARD ARNHOLD (see Provenance, cat. 29) of Berlin paid 300,000 Frs for *The Artist* and *The Monet Family in the Garden* (cat. 141) together. WILDENSTEIN & CO. (see Provenance, cat. 119) acquired the painting in 1954 and sold it the same year to the museum in São Paulo.
C.S.M.

for *Absinthe* because he looked the role, but Manet seems to have painted him because he admired him. Born to an aristocratic family, Desboutin was educated as a lawyer before enrolling at the Ecole des Beaux-Arts in 1845, had traveled widely, and lived in Florence for about fifteen years before returning to Paris to make his living as an artist.[11] In 1875, he was just one of many impoverished, struggling artists associated with the Impressionist movement. It was the year the Impressionists held the abortive auction of their work, and nearly all of them worried about money. The genteel poverty suggested by Desboutin's clothes must have been typical of the group. Serious and dignified, he represents the artists Manet admired and saw daily, and with whom he identified personally. According to Antonin Proust, Manet said, "I made no claim to have summed up an epoch, but to have painted the most remarkable type in that part of the city. I painted Desboutin with as much feeling as I painted Baudelaire."[12]

Apparently, the picture was subject to the kind of revision and reworking that is typical of Manet's technique. Jacques-Emile Blanche recalled being taken to Manet's studio at the age of thirteen or fourteen: "We had been invited to see a portrait of Desboutin, with the pink dog; but, I recall, to the right of the figure there was a green garden chair, an X-shape that I found very striking and of which there is no longer any trace in the picture which has since been exhibited."[13]

According to Rouart and Wildenstein, a watercolor portrait of Desboutin's head and shoulders (RW II 474; fig. a) was Manet's "first thought" for the painting.

147. The Grand Canal, Venice

1875
Oil on canvas
22½ × 18⅞" (57 × 48 cm)
Signed (at left, on hull of gondola): Manet
Private Collection

Exhibitions
Paris, Durand-Ruel 1906, no. 19; London, Sulley 1906, no. 17; New York, Wildenstein 1937, no. 21; Philadelphia-Chicago 1966–67, no. 126

Catalogues
D 1902, 205; M-N 1926 II, p. 25, no. 191; T 1931, 239; JW 1932, 246; T 1947, 243; PO 1967, 207; RO 1970, 208; RW 1975 I, 230

In early September 1875, Manet and James Tissot decided to take a trip to Venice.[1] Tissot, who had been living in London since fleeing Paris in 1871 during the Commune, planned to meet Manet and his wife in Paris and travel with them to Italy. Manet's plans were contingent upon the sale of one of his paintings to a wealthy American collector who had been referred by Tissot. On September 19, Manet reported to Mallarmé that the American had not arrived, but evidently the collector appeared shortly thereafter, because Manet left for Venice about two weeks later. The visit seems to have lasted for about a month, since by mid-November Tissot had returned to London. On November 15, he wrote to Manet in Paris and referred to the view of the Grand Canal now known as *Blue Venice* (cat. 148), which he had acquired from his friend and taken back to London.

Virtually all the information we have about Manet in Venice is based on a brief witness account by the painter Charles Toché, recorded by Ambroise

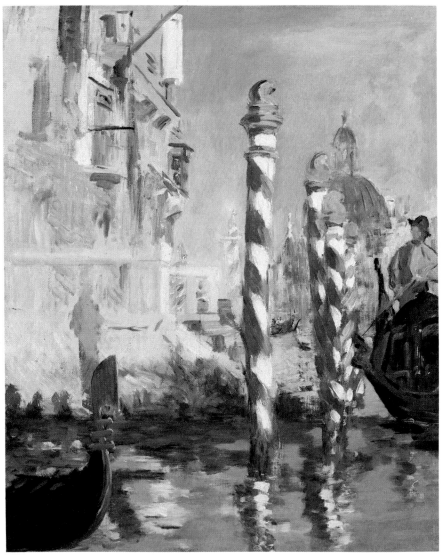

147

Vollard. Toché met Manet by chance at the Café Florian but subsequently saw him often during his stay, and sometimes accompanied him when he painted: "In Venice I used to go and join him almost every day. The lagoons, the palaces, the old houses, scaled and mellowed by time, offered him an inexhaustible variety of subjects. But his preference was for out-of-the-way corners. I asked him if I might follow him in my gondola. 'As much as you like,' he told me. 'When I am working, I pay no attention to anything but my subject.'"[2] Although Toché suggests that Manet painted several different sites, the only known works with Venetian subjects are *The Grand Canal, Venice* and *Blue Venice,* neither of which can be characterized as an "out-of-the-way corner."

Apparently, Toché was present on at least one occasion when Manet was working on *The Grand Canal:* "I shall not forget Manet's enthusiasm for that motif: the white marble staircase against the faded pink bricks of the façade, and the cadmium and greens of the basements. Oscillations of light and shade made by the passing barges in the rough water that drew from him the exclamation, 'Champagne-bottle ends floating!' Through the row of gigantic twisted posts, blue and white, one saw the domes of the incomparable Salute, dear to Guardi. 'I shall put in a gondola,' cried Manet, 'steered by

374

a boatman in a pink shirt, with an orange scarf—one of those fine chaps like a Moor of Granada.'"[3]

Of course the gondolier does not wear an orange scarf, which suggests that either Manet never painted it in or he changed the picture. Pentimenti and evidence of scraping indicate that he did in fact make changes and revisions. Toché himself tells us that Manet had difficulty with the painting and started it over several times; in reply to Vollard's observation that "any picture by Manet certainly suggests brushstrokes put down definitely, once and for all," he rejoined, "Wait a bit! That was what I thought before I had seen him at work. Then I discovered how he laboured, on the contrary, to obtain what he wanted. The *Pieux du Grand Canal* [*Poles of the Grand Canal*] itself was begun I know not how many times. The gondola and the gondolier held him up an incredible time. 'It's the devil,' he said, 'to suggest that a hat is stuck firmly on a head, or that a boat is built of planks cut and fitted according to geometrical laws!' "[4]

One can also see that Manet scraped off and repainted the dome of Santa Maria della Salute in the right background, moving it from a position slightly higher and to the right, and that he did not repaint the smaller dome, still visible as a pentimento. If the blue-and-white poles in this picture are the same as those in *Blue Venice*, Manet's gondola was moored near the Rio del Santissimo. From that vantage point, he should have been able to see the rear dome of the Salute. Its absence suggests that he may have made changes in the painting in his Paris studio that were more strongly motivated by compositional concerns than the exigencies of realism. The background of *Blue Venice* seems also to have been finished in the studio. Apparently, both pictures were subject to the ongoing revisions and reworking typical of Manet's working method.

1. Tabarant 1947, p. 270.
2. Vollard 1936, p. 136.
3. Ibid., p. 149.
4. Ibid., p. 151.

Provenance
FAURE (see Provenance, cat. 10) acquired this picture from the artist, evidently shortly after it was completed in 1875, a year for which Manet's account book is missing. Following an exhibition of Faure's collection at DURAND-RUEL (see Provenance, cat. 118) in 1906, the dealer acquired the picture for 35,000 Frs on August 10 and sold it the same day to ETHEL SPERRY CROCKER of San Francisco. Her husband, WILLIAM H. CROCKER (1861–1937), was the son of Charles Crocker, one of San Francisco's "Big Four" who financed the construction of the Central and Southern Pacific Railroads, and the nephew of California Supreme Court Justice Edwin B. Crocker, founder of the Crocker Art Museum in Sacramento. Following Mrs. Crocker's death, the picture remained in the family's possession. It later appeared as the property of the PROVIDENT SECURITY COMPANY in San Francisco and subsequently passed to the present owner.

C.S.M.

148. The Grand Canal, Venice (Blue Venice)

1875
Oil on canvas
23⅛ × 28⅛" (58.7 × 71.4 cm)
Signed (extreme right, at bottom of pole): Manet
NY The Shelburne Museum, Shelburne, Vermont

Exhibitions
Beaux-Arts 1884, no. 79; New York, Durand-Ruel 1895, no. 16; New York, Durand-Ruel 1913, no. 15; Orangerie 1932, no. 56; Philadelphia 1933–34, without no.; Philadelphia-Chicago 1966–67, no. 127

Catalogues
D 1902, 204; M-N 1926 II, p. 25; M-N cat. ms., 190; T 1931, 238; JW 1932, 247; T 1947, 242; PO 1967, 206; RO 1970, 207; RW 1975 I, 231

Despite Charles Toché's assertion that in the fall of 1875 Manet painted several sites during his stay in Venice,[1] the only examples known to have existed are this picture, dubbed *Blue Venice* by Mrs. H. O. Havemeyer, and *The Grand Canal, Venice* (cat. 147). According to Mrs. Havemeyer, Manet informed Mary Cassatt that *Blue Venice* was painted during the last two days of his visit: "Manet told me [Mary Cassatt] . . . that he had been a long time in Venice. I believe he spent the winter there and he was thoroughly discouraged and depressed at his inability to paint anything to his satisfaction. He had just decided to give it up and return home to Paris. On his last afternoon in Venice, he took a fairly small canvas and went out on the Grand Canal just to make a sketch to recall his visit; he told me he was so pleased with the result of his afternoon's work that he decided to remain over a day and finish it."[2]

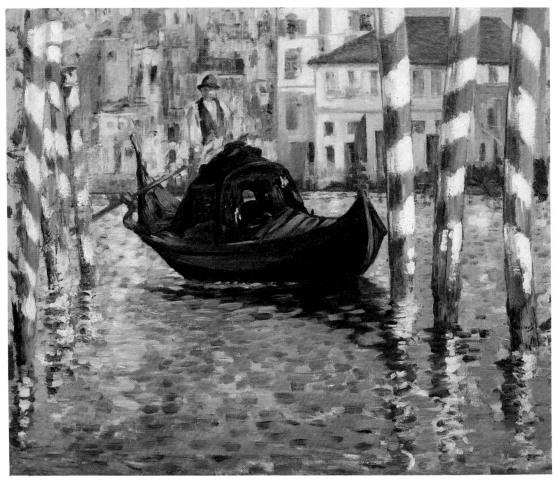

148

This information is at least partly apocryphal. As Richardson has pointed out, "the buildings in the left background were presumably done from memory, for they neither look Venetian nor fit with the rest of the scene."[3] The buildings visible in the right background are the edge of the unfinished eighteenth-century Palazzo Venier dei Leoni (now the Peggy Guggenheim Museum), a "modern" building that until recently was the site of the American Consulate, and the fifteenth-century Palazzo Dario. To the left of the Palazzo Dario are a succession of small palazzi that Manet has replaced with structures that do not in fact exist. It seems likely, therefore, that he finished the painting in Paris, not on the last day of his stay in Venice.

When *Blue Venice* was exhibited for the first time in the 1884 memorial exhibition devoted to Manet's work at the Ecole des Beaux-Arts, Louis Gonse praised it as one of several works in which Manet had achieved an effect corresponding exactly to that of natural light, and asserted that Manet's value scale was photographically correct: "One can even submit these *plein-air* pictures to still another test, that of photography. Stripped of their color, the values remain correct, the space is convincing, and the forms exist in a kind of realistic atmosphere that gives the illusion of a photograph taken from nature."[4] In an article inspired by the same exhibition, Josephin Péladan adopted an equally enthusiastic but very different point of view. He admired the picture as a "symphony in blue major," but emphasized that *Blue Venice* could hardly be discussed in terms of realism: "A singular little canvas gives us a

1. Vollard 1937, p. 160ff.; see cat. 147.
2. Havemeyer 1961, p. 226.
3. Richardson 1958, p. 126, no. 51.
4. Gonse 1884, p. 146.
5. Péladan 1884, p. 114.
6. Zola 1867, *L'Artiste*, p. 51; Zola (Dentu), p. 24.
7. Moreau-Nélaton 1926, II, p. 25ff.
8. Tabarant 1931, p. 29: from Tissot to Manet, November 15, 1875.
9. Havemeyer 1961, p. 226.

Provenance
An inscription on a photograph of this picture indicates that Manet sold it to TISSOT for 2,500 Frs on May 24, 1875.[7] The date is obviously erroneous, and the price is questionably high, given the fact that Tissot was a friend, actively engaged in finding clients for Manet. The painter JAMES TISSOT (1836–1902) had been a fellow student with Degas at the Ecole des Beaux-Arts, and he remained friendly with the Batignolles artists even after moving to London in 1871. After his trip to Venice with Manet, he wrote him from London: "I

have just done some good business with a young dealer who, after having seen your painting of Venice, which I have here, wants to meet you."[8] The picture first appears in DURAND-RUEL's Paris stock books on August 25, 1891, although Paul Durand-Ruel (see Provenance, cat. 118) had probably acquired it earlier. On April 8, 1895, the New York branch of the firm sold it to MR. AND MRS. H. O. HAVEMEYER (see Provenance, cat. 33). In her memoirs, Mrs. Havemeyer describes Mary Cassatt's delighted reaction to the purchase.[9] On Mrs. Havemeyer's death in 1929, her daughter MRS. J. WATSON WEBB (see Provenance, cat. 122) inherited the picture, which entered the Shelburne Museum with her bequest in 1960.

C.S.M.

look at the Grand Canal: the water is indigo, the sky also indigo, and the white mooring poles are blue-striped: this symphony in blue is neither ridiculous nor inaccurate. In Venice I have known afternoons of that color, but Manet has pushed his impression to the point of fantasy. Looking beyond the exertions of this poor fellow who is so fascinated by light, one senses a desire for actual daylight, for the ideal and exact equivalent. All the would-be naturalists are fakers—Courbet is the Bolognese, Zola is the ox that sees the Tour Saint-Jacques in every paving stone, and Manet is a chromatic fantasist."[5] It seems that Gonse has merely exaggerated the interpretation suggested by Zola, who observed in 1867 that Manet was "guided in his choice only by his desire to create fine brushstrokes and beautiful juxtapositions of color."[6]

149. Portrait of Stéphane Mallarmé

1876
Oil on canvas
10⅝ x 14⅛" (27 x 36 cm)
Signed and dated (lower left): Manet 76
Musée d'Orsay (Galeries du Jeu de Paume), Paris

Exhibitions
Beaux-Arts 1884, no. 87; Paris, Bernheim-Jeune 1928, no. 8; Orangerie 1932, no. 61; London, Tate Gallery 1954, no. 13; Marseilles 1961, no. 20; Ingelheim 1977, without no. (p. 32)

Catalogues
D 1902, 220; M-N 1926 II, p. 48; M-N cat. ms., 226; T 1931, 244; JW 1932, 265; T 1947, 265; PO 1967, 224; RO 1970, 225; RW 1975 I, 249

A writer, Georges Bataille, commented not long ago on the marvelous success of this portrait of the poet: "In the history of art and of literature, this painting is outstanding. It radiates the friendship of two great minds; within the space of this canvas, there is no place for the cares that beset mankind. The buoyancy of flight, the subtlety that alike dissects form and phrase, here scores a clear victory. The airiest spirituality, the blending of remote possibilities, ingenuities, and niceties compose the most complete image of the child's play that ultimately is man, once he achieves weightlessness."[1]

The relationship between Mallarmé and Manet began at least as early as 1873, the year of the poet's arrival in Paris; a letter from John Payne to Mallarmé dated October 30, 1873, mentions their recent visit to the painter's studio.[2] They had been introduced some months earlier, either by Philippe Burty or by Nina de Callias (see cat. 137). In any case, their acquaintance soon became close and intense, so that Mallarmé wrote to Verlaine, in a thumbnail biography, "I saw my dear Manet every day for ten years, and I find his absence today incredible."[3] Indeed, coming home from the Lycée Fontane (today the Lycée Condorcet), where he taught English, Mallarmé would stop almost daily for a chat in the late afternoon with Manet and his little circle of friends. Manet's studio was the place for meeting people—a necessity for Mallarmé—Zola, Monet, Morisot, through whom he gained contact with the Impressionists, especially those who became, after Manet, his closest friends: Degas and Renoir. At Manet's, he also met Méry Laurent (see cat. 215).

The date of the portrait is pinpointed by a letter of October 19, 1876, from Mallarmé to Arthur O'Shaughnessy: "Manet is doing a little portrait of me just now."[4] The poet is posed on the couch in the rue de Saint-Pétersbourg studio, in front of the same Japanese—or Japanesque—hanging as appears in *Lady with Fans: Portrait of Nina de Callias* (cat. 137) and *Nana* (cat. 157). Manet

149

takes him in casual conversation, smoking one of his beloved cigars, about
which Mallarmé later wrote a poem. Held in the hand as here, it enhances
the image of thoughtful reverie.

Toute l'âme résumée	All the soul in summary
Quand lente nous l'expirons	When it slowly from us breathes
Dans plusieurs ronds de fumée	Several wreaths of smoke to be
Abolis par d'autres ronds	Soon dispelled by other wreaths
Atteste quelque cigare	May betoken some cigar
Brûlant savamment pour peu	Burning sagely all the while
Que la cendre se sépare	Though the ash be loath to part
De son clair baiser de feu.[5]	From its glowing kiss of fire.

The Mallarmé of this portrait is thirty-four, ten years Manet's junior.
For the young poet, the painter is not only an avant-garde hero of fifteen
years' standing but in particular distinguished by a close association with the
writer whom Mallarmé most admired, Charles Baudelaire. The cordial friend-
ship between the two men was founded on several common traits, attributed
to each by all reports: cultivated charm, distinction of mind, the gift of con-
versation, and a certain "situation of rejection. . . . Manet's response to him
was fraternal encouragement," as Henri de Regnier wrote in his recollections
of Mallarmé. "Sensible of the artist's genius, he was equally so of the man's
charm. . . . I always heard him speak of Manet with deep admiration and
affectionate friendship."[6]

Another bond between the confirmed *boulevardier* and the newly
minted Parisian was their admiration for women and for their elegance of
dress. Manet's own elegance, not to say foppishness, was a byword, and his
interest in feminine attire no less so, as his works attest, from *The Balcony* (cat.
115) to *In the Conservatory* (cat. 180) and *Autumn* (cat. 215). As for Mallarmé,
as we know, he wrote a fashion column, under the pseudonym "Miss Satin,"

378

1. Bataille 1955, p. 25.
2. Mondor 1942, p. 344.
3. Mallarmé 1965, II, p. 303: to Verlaine, November 16, 1885.
4. Ibid., p. 130: to O'Shaughnessy, October 19, 1876.
5. Mallarmé 1945, p. 73.
6. Henri de Régnier, "Les Portraits de Mallarmé," in *Faces et profils*, Paris, 1931, p. 73ff.
7. Natanson 1948, p. 101.
8. Paris, Bibliothèque d'Art et d'Archéologie, Manet archives: Suzanne Manet to Mallarmé, October 21, 1883.
9. Formerly Sicklès collection: Manet to Mallarmé, April 1874; Wilson 1978, no. 105.
10. Mallarmé 1876.

Provenance

Manet presented this portrait to MALLARME, and it hung in the poet's dining room on the rue de Rome, where for more than twenty years it could be admired by visitors to his famous Tuesday salons. After his death in 1898, the portrait remained in the family, at Valvins, belonging first to MME MALLARME and then to their daughter GENEVIEVE MALLARME (1864–1919), who was the wife of DR. EDMOND BONNIOT. The Musée du Louvre acquired it in 1928 from Dr. Bonniot, with the assistance of the Friends of the Louvre and of M. Pierre David-Weill (inv. RF 2661). Mallarmé's portrait was subsequently exhibited with another work acquired by the same committee, the "Laborde head" from the Parthenon. Such company would have displeased neither Manet nor Mallarmé, who had adapted an illustrated mythology, *Les Dieux antiques* (*The Ancient Gods*), in 1880. This is the first exhibition of the *Portrait of Stéphane Mallarmé* in the United States.

F.C.

no doubt much to the amusement of Manet, his initiator, as it were, into the realm of Parisian style.

They were not in any case on terms of absolute equality; Thadée Natanson, to whom Mallarmé talked about Manet a good deal, reported: "Throughout those ten years of intimacy, always ardent on Mallarmé's part, almost patronizing on Edouard Manet's, Mallarmé had the greater love, gave more of himself. . . . It was always Mallarmé who came to the rue de Saint-Pétersbourg; I am not aware that Manet was ever in the rue de Rome. The painter was grateful to the writer for his articles, but no more so than was Delacroix to Baudelaire for his."[7] That interpretation is rendered questionable by a letter from Suzanne Manet to Mallarmé some months after the painter's death, in which she wrote, "You were really his best friend, and he loved you dearly."[8]

Mallarmé, great admirer of Manet's painting that he was, had just at the time of this portrait devoted two long articles to Manet. One, "Le Jury de Peinture pour 1874 et M. Manet," written when the jury had rejected two of the three paintings Manet had sent to the Salon, earned him a note of thanks from the artist: "My dear friend. Thank you. If I had a few champions like you, I could just laugh off the jury."[9] The other, far more important, "The Impressionists and Edouard Manet," appeared in English translation only, about the time of the portrait; it was translated back into French a century later, the original text having been lost.[10]

Mallarmé enlisted Manet's collaboration on several occasions, to illustrate both his own poems and his translations of Poe (see cat. 151, 152).

Of the many portrait paintings and engravings of Mallarmé (by Gauguin, Munch, Renoir, Whistler), Manet's was unanimously considered the best likeness by contemporaries, even those who met Mallarmé later, when he was somewhat altered by age. The picture was familiar to most writers of the Symbolist generation, because Verlaine reproduced it as a frontispiece for the chapter on Mallarmé in *Les Poètes maudits* (1886).

150. Cat Under a Bench

1875–82
Pencil and ink wash on squared paper
4⅝ x 4¾" (11.9 x 12 cm)
P Bibliothèque Littéraire Jacques Doucet, Paris

Catalogues
RW 1975 II, 626

This charming drawing of a cat resting under a stone bench represents Mallarmé's cat, according to a tradition passed down through its successive owners (see Provenance). Curiously, however, it seems that Manet never visited Mallarmé's country house at Valvins. Possibly this was a cat that made friends with Mallarmé at Manet's during the summers the painter spent near Paris— at Bellevue in 1880 or at Versailles in 1881.

We might note that Manet's cats are often associated in some way with his writer friends—Baudelaire, for example (cat. 64), and Champfleury (cat. 114, 117).

150

Provenance
This drawing (not included in Leiris's catalogue) apparently belonged to MERY LAURENT (see cat. 215), who is said to have given it to the Symbolist poet GEORGES RODENBACH (1855–1898), telling him that it represented "Mallarmé's cat." The drawing's next owner, Mallarmé's biographer HENRI MONDOR, probably bought it from Mme Rodenbach. According to information kindly provided by M. Chapon, Mme Rodenbach confirmed this tradition. The drawing was bequeathed with Henri Mondor's estate to the Bibliothèque Littéraire Jacques Doucet in 1968 (inv. 113).

F.C.

151. The Raven

1875

Transfer lithographs for the poster, slipcase, and cover, the ex libris, and the four illustrations for "LE CORBEAU. THE RAVEN poëme par EDGAR POE traduction française de STEPHANE MALLARME avec illustrations par EDOUARD MANET. Paris, Richard Lesclide, éditeur, 61, rue de Lafayette, 1875."

P Bibliothèque Nationale, Paris

NY The New York Public Library
Raven's head in profile. Poster, slipcase, and cover
Image: 6⅜ × 6¼" (16.2 × 15.8 cm)
Raven in flight. Ex libris
Image: 2⅜ × 8⅛" (6 × 24 cm)
"Once upon a midnight dreary . . . "
Image: 10⅞ × 14½" (27.5 × 37 cm)
"Open here I flung the shutter . . . "
Image: 15⅛ × 11⅛" (38.5 × 30 cm)
"Perched upon a bust of Pallas . . . "
Image: 18¾ × 12½" (47.5 × 31.6 cm)
"That shadow that lies floating on the floor . . . "
Image: 11⅜ × 10⅞" (29 × 27.6 cm)
Illustrations signed (below): E.M.

LE CORBEAU

(THE RAVEN)

Poème d'Edgar POE

Traduit par Stéphane MALLARMÉ

Illustré de cinq Dessins de MANET

TEXTE ANGLAIS ET FRANÇAIS

Illustrations sur Hollande ou sur Chine

AU CHOIX

Couverture et Ex-Libris en parchemin. — Tirage limité.

PRIX 25 FRANCS.

Avec Épreuves doubles sur Hollande et Chine : 35 francs.

Cartonnage illustré, en sus : 5 francs.

151 Poster

151 Raven's head in profile (detail of poster)

Publications
Poe, *The Raven*, Lesclide 1875

Exhibitions
Philadelphia-Chicago 1966–67, no. 133; Ingelheim 1977, nos. 95–100; London, BM 1978, nos. 25–29; Paris, Berès 1978, no. 89

Catalogues
M-N 1906, 90–94; G 1944, 85–86; L 1969, 440, 441, 443–46; H 1970, 83; LM 1971, 82, 84; W 1977, 95–100; W 1978, 89

Poster. With the raven's head in profile and the letters in red and black. On parchment. P: Moreau-Nélaton collection. NY: Avery collection.

Ex libris. On thin parchment. P: Moreau-Nélaton collection. NY: With the manuscript dedication to O'Shaughnessy. O'Shaughnessy, Rossetti, Avery collections.

Illustrations. Proofs on China paper. P: Moreau-Nélaton collection. NY: O'Shaughnessy, Rossetti, Avery collections.

On May 27, 1875, Manet wrote to Mallarmé, "My dear friend, do come to the studio this evening at 5 o'clock to sign your copies."[1] The "copies" were the authors' copies of the book on which the young poet and the artist had collaborated over the preceding months—Mallarmé with his prose translation of Edgar Allan Poe's great poem *The Raven*,[2] Manet with his brush-and-ink transfer lithograph illustrations. The book was completed and given its "achevé d'imprimer" on May 20, and on June 2 Mallarmé wrote to Léon Cladel in the hope that he would publicize *The Raven*, "presenting the publication as something very fashionable, very Parisian, and so on."[3] The ex libris in the copy from the New York Public Library has a beautifully lettered inscription in Mallarmé's hand: "To M. O'Shaughnessy / Copy presented by MM. S. Mallarmé and E. Manet."[4] This dedicated copy (see Provenance) was subsequently owned by the Pre-Raphaelite artist Dante Gabriel Rossetti, who gave his opinion of it in a letter in 1881: "Bye the bye, my own memento of O'S [O'Shaughnessy] is a huge folio of lithographed sketches from the Raven, by a French idiot named Manet, who certainly must be the greatest and most conceited ass who ever lived. A copy should be bought for every hypochondriacal ward in lunatic asylums. To view it without a guffaw is impossible."[5]

Was this the general reaction, outside a very small circle of initiates? Curiously, Rossetti seems already to have received, through John Payne, one of the copies that Mallarmé sent to his poet friends. Another copy went to Swinburne, who responded with a letter in French on July 7, recalling his

151 Ex libris with dedication to O'Shaughnessy. New York Public Library

visit to Manet's studio in 1863 and expressing his pleasure at the sight of "these marvelous pages where the greatest of American poets is so perfectly translated twice over, thanks to the collaboration of two great artists."[6] On September 1, O'Shaughnessy wrote to say that a short notice on *The Raven* would appear in *The Athenaeum*,[7] and, on September 9, Manet wrote to Mallarmé regretting his absence from Paris, since an American publisher had written with a proposal to take an edition of 500 to 1,000 copies. Manet viewed this unidentified publisher as a possible "hen with golden eggs for us," since the two friends had planned a whole series of publications,[8] one of which was announced by Lesclide on the back cover of *The Raven*: "To appear shortly: The City in the Sea. Poem by Edgar Poe illustrated and translated by MM. Edouard Manet and Stéphane Mallarmé." The "City in the Sea" project came to nothing, while the exquisitely produced edition of Mal-

151 "Once upon a midnight dreary . . . "

151 "Open here I flung the shutter . . . "

151 "Perched upon a bust of Pallas . . . "

larmé's *L'Après-midi d'un faune*, illustrated with Manet's wood engravings (H 84), was published by Derenne in April 1876.[9]

Mondor and Aubry considered it inevitable that *The Raven* should have met with little success: "The voluminous proportions of the book; the illustrations by Manet, still a very controversial figure in 1875; the unusual nature of Edgar Poe's poem for the average reader; and the still virtually unknown name of Mallarmé all conspired to discourage possible buyers of a work published in a limited edition (240 copies) at a price that today appears more than reasonable."[10]

Just as Baudelaire had been involved over many years with his plans to publish Poe's works (see cat. 59, 60), Mallarmé, too, committed himself as early as 1862 to the publication of his prose translations of Poe's poetry. Manet apparently became involved in the project in late 1874 or early 1875, when he made the trial *Head of a Raven* (H 83g).[11] No doubt the two friends were as demanding and "difficult" as Baudelaire where their publications were concerned. In 1881, when Mallarmé was planning the publication of his complete translations of Poe's poems, illustrated with "eight very fine compositions by the artist Manet, my friend, of which several are already well known, having appeared in a translation . . . of *The Raven* . . . ," he described himself as a "frenetic bibliophile (and, I must confess, demanding, but sure of coming to an understanding with you in order to achieve something truly distinctive)."[12]

151 "That shadow that lies floating on the floor . . . "

As far as *The Raven* was concerned, the publisher, Lesclide, had to yield to the refined tastes of both poet and artist: "Highly alarmed by the black silk with which you intend to cover the boards," Manet wrote, demanding "a parchment, a soft green or yellow paper, close to the color of the cover."[13] The publication appeared, in accordance with the description on the poster, with Mallarmé's prose translation opposite Poe's verses, and Manet's illustrations on laid or China paper, with a parchment cover and ex libris. The illustrated slipcase mentioned in the letter to Lesclide, also in parchment, as Manet had dictated, could be purchased for an additional 5 francs.

Manet used the transfer lithography technique, which he had already tried a year earlier (see cat. 168). It was a method ideally suited to the brush-and-ink drawing style that he developed and mastered during this period (see cat. 154, 155, 159–63). He brushed in his designs with transfer ink on sheets of paper that Lefman, the specialist printer for this technique, then transferred to zinc plates for printing. Surviving proofs show changes in the designs,[14] and, although little is known of the technical details of zinc lithography at that period, it is clear that Manet followed the transfer process closely and was able to modify and rework his compositions.

Manet's illustrations were inserted between the double pages of text, and he responded to Poe's evocative verses and Mallarmé's translations with images of Mallarmé himself in the role of the poet recalling his "lost Le-

1. Mallarmé (1945) 1979, p. 1519.
2. Ibid., pp. 190–93.
3. Ibid., p. 1519.
4. "A M. O'Shaughnessy, Exemplaire offert par MM. S. Mallarmé et E. Manet."
5. D. G. Rossetti and Jane Morris, Their Correspondence, ed. J. Bryson, Oxford, 1976, p. 174, quoted in F. Carey and A. Griffiths, From Manet to Toulouse-Lautrec (exhibition catalogue), British Museum, London, 1978, p. 42.
6. Algernon Swinburne, The Letters of Algernon Charles Swinburne, London, 1918, I, p. 226, quoted in Mallarmé (1945) 1979, pp. 1521–22.
7. Mallarmé (1945) 1979, p. 1521.
8. Wilson 1978, no. 105.
9. Ibid., no. 90.
10. Mallarmé (1945) 1979, p. 1521.
11. Wilson 1977, no. 93.
12. Mallarmé (1945) 1979, pp. 1519–20.
13. Wilson 1978, no. 89.
14. Guérin 1944, no. 86 b, c, 1st and 2nd states; Harris 1970, no. 83, figs. 163 c–e; Wilson 1977, no. 98, 1st and 2nd states.
15. Mallarmé 1965, II, p. 72 n. 3.
16. Paris, Bibliothèque d'Art et d'Archéologie: O'Shaughnessy to Manet, May 20, 1876.

Provenance
P: The poster and the complete copy acquired by MOREAU-NELATON (see Provenance, cat. 9) come from an unknown source, and the ex libris does not identify the original owner.
NY: This was the copy offered by Mallarmé and Manet to ARTHUR O'SHAUGHNESSY (1844–1881), an English poet who spent his short life working at the British Museum, London, first as assistant librarian and then in the zoology department. He was a disciple and imitator of Swinburne, was very active in literary and artistic circles, and was a reviewer for The Athenaeum.[15] After a visit to Manet's studio in 1876, O'Shaughnessy wrote the artist, expressing particular admiration for The Execution of Maximilian (see cat. 104, 105) and thanking Manet for sending him a copy of L'Après-midi d'un faune.[16] After O'Shaughnessy's early death, this copy passed to DANTE GABRIEL ROSSETTI (1828–1882), the Pre-Raphaelite painter and poet who described Manet's work in the unflattering terms already quoted. It might be expected that he would have hastened to rid himself of a work that so little appealed to him. If he kept it until his death, it would have been acquired by AVERY (see Provenance, cat. 17) in London or in Paris.

J.W.B.

nore." The first stanza describes the scene "upon a midnight dreary," where the poet, pondering "weak and weary, / Over many a quaint and curious volume of forgotten lore," suddenly raises his head as he hears "a tapping, / As of someone gently rapping—rapping at my chamber door." The drawing here is quite realistic and shows the poet at his desk beneath the lamp. The presence of a cane and top hat on a chair is a humorous touch: it can only belong, one imagines, to the artist who observes and creates the scene.

Next follows the illustration of the impressive entrance of the raven: "with many a flirt and flutter, / In there stepped a stately Raven of the saintly days of yore." Manet takes liberties here with the scene set in the poem; instead of flinging open the shutter, as in the verse, the poet draws his French window inward, and the bird appears in silhouette against a clear sky, above a very Parisian skyline of rooftops and chimney pots. Poe's "midnight dreary . . . in the bleak December" is not suggested here, although Manet reworked this plate, as already mentioned, to make the cityscape darker and gloomier. The design is interpreted with broad, vibrant brushstrokes that, like the shadows surrounding the figure of the poet, suggest the ineluctable, menacing approach of the fateful bird.

In the third illustration, the raven is installed on the bust of Pallas, repeating his sinister "Nevermore." Here Manet follows the text very closely, inventing a remarkable image to express the confrontation between bird and narrator, as described in the poem:

Straight I wheeled a cushioned seat in front of bird and bust and door;
Then, upon the velvet sinking, I betook myself to linking
Fancy unto fancy, thinking what this ominous bird of yore—
What this grim, ungainly, ghastly, gaunt and ominous bird of yore
 Meant in croaking "Nevermore."

.

This and more I sat divining, with my head at ease reclining
On the cushion's velvet lining that the lamp-light gloated o'er,
But whose velvet violet lining with the lamp-light gloating o'er,
 She shall press, ah, nevermore!

Here, in addition to the precise representation of the actual elements in the poem—bird, bust, door, chair with velvet-lined cushion—Manet creates, through the play of the cast shadows and the brushstrokes filling the air, the impression of a stifling, invading presence, expressed in the poem by the line "Then, methought, the air grew denser, perfumed from an unseen censer."

The last image is almost indecipherable in the density of its real and abstract references. The bottom of the door, an empty chair, and the shadows that menace like living evil spirits are brushed in with a suggestive force that defies description and is without analogy in other contemporary works:

And the Raven, never flitting, still is sitting—still is sitting
On the pallid bust of Pallas just above my chamber door;
And his eyes have all the seeming of a Demon's that is dreaming,
And the lamp-light o'er him streaming throws his shadow on the floor;
And my soul from out that shadow that lies floating on the floor
 Shall be lifted—nevermore!

152. Annabel Lee
Young Woman by the Seashore

1879–81
Pencil and India ink wash, on squared paper
18¼ x 11⅜″ (46.2 x 29 cm)
Inscribed (lower right, by Manet?): Edouard Manet/Etude pour Jeanne
Museum Boymans-van Beuningen, Rotterdam

This drawing is a project for an illustration of Mallarmé's translation of the poem "Annabel Lee," by Edgar Allan Poe.[1] Manet did not really attempt to interpret the poem graphically but simply used a study for an earlier canvas that portrayed Jeanne Gonzalès, younger sister of Eva. The study is inscribed "Etude pour Jeanne," and the squaring identifies it with the *Young Woman in a Garden* of 1879 (RW I 315; fig. a). The painting is cut off exactly where Manet stopped numbering the squares: 14 vertically, 10 across.

 There are two other versions of the drawing, not squared up, and apparently done later, since they are cropped where Manet's numeration ends, under the pouf of the skirt at the bottom (RW II 436, 437). Perhaps when

Catalogues
T 1947, 671; L 1969, 591; RW 1975 II, 435

152

Fig. a. *Young Woman in a Garden*, 1879. Photograph Copyright 1983 by The Barnes Foundation, Merion, Pa.

1. Tabarant 1947, p. 417.
2. Formerly Sicklès collection: Manet to Mallarmé, July 30, 1881; Wilson 1978, no. 105.

Manet was thinking about illustrating Mallarmé's translations of Poe, he retrieved a drawing he thought he might adapt to the theme of the poem, possibly using a line of Poe's such as "She was a child . . . , / In this kingdom by the sea," and adding a vague seaside background. He told Mallarmé, "You know how happy I am to undertake any project with you, but today it's beyond my strength, I don't feel able to do what you ask properly. I've no models, and above all no imagination. . . ."[2]

Provenance
We do not know when this drawing left Manet's studio. It first appeared in Paris with CH. A. DE BURLET, then in Berlin with PAUL CASSIRER (see Provenance, cat. 13). Next, in 1926, it belonged to FRANZ KOENIGS (see Provenance, cat. 13) of Haarlem. D. G. VAN BEUNINGEN (see Provenance, cat. 13) purchased it in 1941 for the museum (inv. F II 20).

F.C.

153. Annabel Lee

1879–81
India ink wash
11⅞ × 16⅛" (30.1 × 40.9 cm)
Atelier stamp (lower right): E.M.
Statens Museum for Kunst, Copenhagen

Exhibitions
Beaux-Arts 1884, no. 173; Paris, Drouot 1884, no. 143

Catalogues
T 1947, 672; L 1969, 593; RW 1975 II, 438

This drawing, like the previous one, is somewhat artificially connected with the illustrating of Poe's "Annabel Lee" in Mallarmé's translation, having been reproduced after Manet's death in Vanier's second edition of 1889. Eva Gonzalès's younger sister Jeanne, the second daughter of Manet's friend the writer

153

Emmanuel Gonzalès, is here posed in the same dress as in the drawing, where she is shown standing (cat. 152), and the two were certainly done on the same day. She was quite young, and Manet could easily have been reminded of his sketches of her when looking through recent drawings for some evocation of Poe's "child" in the "kingdom by the sea." All the same, this is not the poet's romantic child of nature, but an elegant young Parisienne at the seashore.

Manet's last stay on the Channel coast was at Berck in 1873, and it would not seem that these drawings were made at that time and place. It is conceivable that Manet, in 1879–81, sketched the girl in his garden, and added an imagined sea, as he did in other sketches and letters in 1880—*Young Woman at the Seashore* (RW II 414), for example, and *Isabelle Diving* (cat. 192).

1. Manet sale, Paris, February 4–5, 1884, no. 143; Bodelsen 1968, p. 342.

Provenance
This drawing was purchased for 105 Frs at the Manet sale in 1884[1] by MARCEL BERNSTEIN, the father of Henry (see cat. 209). It later appeared with FIQUET and then with GUIOT, who sold it to the museum in Copenhagen in 1927 (inv. 10.280).

F.C.

154. At the Window

1875
Pencil and black ink wash
10⅝ × 7⅜" (27 × 18.8 cm)
NY Musée du Louvre, Cabinet des Dessins, Paris

154

Catalogues
L 1969, 378; RW 1975 II, 402

This drawing is doubtless related to Manet's illustrations for Mallarmé's translation of Edgar Allan Poe's "The Raven," in particular the scene at the window (see cat. 151). Early in the 1870s, Manet often used ink wash with a free, expressive brush, the black applied quickly, leaving white areas that are always eloquent and significant—here the moon and the silhouette at the balcony rail, accenting the dark of night. The catalogues raisonnés describe the figure as "a woman seated," but this is questionable. More likely, the drawing is a preliminary study for the transfer lithograph, which represents not a woman but a man, and not at the seaside, as might be imagined here, but facing a Paris skyline. Later drawings exemplify Manet's predilection for this free wash technique and powerful brushwork (see cat. 159, 163).

1. Pellerin sale, Paris, June 10, 1954, album no. 4.

Provenance
This drawing went from SUZANNE MANET to AUGUSTE PELLERIN (see Provenance, cat. 12, 100). The museum purchased it at his sale in 1954,[1] among the drawings in album no. 4 (inv. RF 30.465).

F.C.

155. Seascape by Moonlight

1875
Pencil and black ink wash
7¾ × 7" (19.8 × 17.9 cm)
P Musée du Louvre, Cabinet des Dessins, Paris

155

Manet had previously shown a special interest in nocturnal seascape, observed from life (cat. 118). This wash might conceivably recall a momentary view of fishing boats going out at night in the summer of 1873, spent at Berck-sur-Mer, but more likely it was drawn from imagination when Manet was working on his illustrations for "The Raven" (cat. 151). As in the sketch of the moonlit figure (cat. 154), we see the same sweep of the brush, the same use of generously applied blacks and of areas of white.

Provenance
Same provenance as for the preceding entry (inv. RF 30.504).

F.C.

Catalogues
L 1969, 377; RW 1975 II, 246

156. Before the Mirror

1876–77
Oil on canvas
36¼ × 28⅛″ (92.1 × 71.4 cm)
Signed (lower right): Manet
The Solomon R. Guggenheim Museum, New York

When Manet exhibited this painting in his private show at the gallery La Vie Moderne, which was supported by Georges Charpentier, publisher of the naturalist writers and devotee of the Impressionists, the "modernist" context was a very special one. The suggestiveness of the subject has softened considerably in the course of a century, but it had an erotic charge frequently exploited in eighteenth-century engravings and in romantic lithographs (those of Bassaget and Tassaert, for example, or of Vallou de Villeneuve, fig. a). At the time, the iconography of the corset was widespread, often in caricature form, in such popular gazettes as *La Vie parisienne,* and also provided motifs for much pornographic imagery.[1]

Manet's use of the popular theme anticipates *Nana* (cat. 157), but in a manner harking back to romantic prints, where the woman undressing—or dressing—is seen from the back. Manet here emphasizes the plump white neck and shoulders preferred by the taste of the period. The standing mirror is of the same model as those in the romantic lithographs, but the differences are the more apparent: first, the composition, which is more centered on essentials—back, corset, chignon, mirror—imparting a spontaneity, the feeling of an *instant vécu,* far removed from the genre scenes of the 1830s, with their look of having been staged for the benefit of a voyeur; second, and more important, the technique. Never before had Manet exhibited a canvas in which the spirit of a sketch was retained to this degree; never had he played with such *brio* and ease on the brushstroke, no longer troubling to make its almost restless hatching subservient to a form. One may long ponder the sense of the strokes of color at the upper left of the mirror before realizing that, the glass being slightly tilted forward, they hint at a reflection of the breast and of the corset and the arm. The upsweep of hair becomes a swirling motif, as in the erotic monotypes by his friend Degas done at about the same time. The drap-

Exhibitions
Paris, La Vie Moderne 1880, no. 8 (Devant la glace); Paris, Drouot 1884, no. 43; Vienna, Miethke 1910, no. 6

Catalogues
D 1902, 213; M-N 1926 II, p. 43; M-N cat. ms., 216; T 1931, 246; JW 1932, 278; T 1947, 255; PO 1967, 216; RO 1970, 217; RW 1975 I, 264

Fig. a. Vallou de Villeneuve, *The Corset,* ca. 1829, lithograph

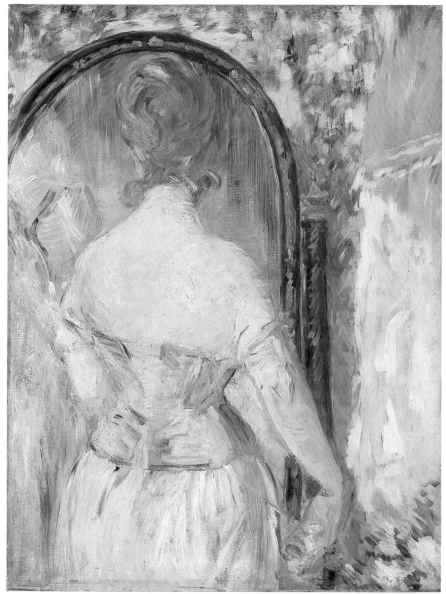

156

ery and curtain are but an excuse for a euphoria of color and movement, such that understandably an art critic today might see in it a distillation of Manet's pictorial modernity, a euphoria of pure painting.[2] It is true that here, as often with Manet, we observe a brushwork on the borderline of the facile and saved from vulgarity only by his unfailing taste, a borderline not always respected by his imitators.

In 1880, when this canvas was shown at La Vie Moderne, critics had more to say about the two pictures in the Salon, which opened some weeks later—the *Portrait of M. Antonin Proust* (cat. 187) and *Chez le père Lathuille* (RW I 291); but J. K. Huysmans may have had this work in mind when, in reporting on the exhibition at which *Before the Mirror* was shown, he spoke of his "luminous work, cleansed of the grime and tobacco stains that have so long dirtied our canvases, . . . with a manner often caressing beneath its braggart appearance, a spare but intoxicated drawing, a bouquet of lively patches in a blond, silvery painting."[3]

The dating of the picture is left doubtful by Duret (all the works from 1855 to 1877 are listed together); it is sometimes dated 1876, sometimes 1877. It should be placed, it seems, in the same period as *Nana*, begun late in 1876, especially since the model so much resembles Henriette Hauser (see cat. 157).

Provenance
This painting was listed among works in Manet's studio in the inventory drawn up following his death.[4] It was purchased at the posthumous sale in 1884 for 700 Frs by DR. ALBERT ROBIN (1847–1928),[5] a renowned histologist who was a collector of modern painting and a friend of Manet's, Méry Laurent's, Mallarmé's, and Dr. Proust's, the father of Marcel.[6] Dr. Robin lived in the same apartment building as Manet, as these lines, written by Mallarmé on an envelope, indicate:

Prends ta canne à bec de corbin
Vieille Poste (ou je vais t'en battre)
Et cours chez le docteur Robin
Rue, oui, de Saint-Pétersbourg 4.[7]

Old Postman, ply thy cane apace
(Or I will beat thee with it sore)
And run to Doctor Robin's place,
Rue de Saint-Pétersbourg, yes, 4.

At the Manet sale, Robin also bought *Portrait of Irma Brunner* (cat. 217), the *Singer in a Café-Concert* (RW I 281), and *Nana* (cat. 157), as well as *A Path in the Garden at Rueil* (cat. 219), which was included in his important bequest of works by Manet to the Musée des Beaux-Arts in Dijon in 1929. He must have sold the present painting, which remained on the market for about twenty years with BERNHEIM-JEUNE, PAUL CASSIRER, GERARD (1901), DURAND-RUEL (1902), KNOEDLER (1910), and DURAND-RUEL (1916) (see Provenance, cat. 31, 13, 81, 118, 172). It was purchased by the collector JOSEPH F. FLANAGAN of Boston in 1917 and brought $12,500 at his sale.[8] The dealer JUSTIN K. THANNHAUSER (1892–1965) of Munich must have had it by 1925, as he lent it to Bernheim-Jeune, Paris, in February 1926. As a young man, before World War I, Thannhauser was the leading dealer of modern art in Munich, exhibiting work by Picasso, Gauguin, and Manet (the Pellerin collection in 1910; see Provenance, cat. 109); the first Blaue Reiter exhibition was held in his gallery in 1911. After the war, he promoted the art of Picasso, the Cubists, the Bauhaus painters, and Matisse, in his galleries in Berlin, Lucerne, and Munich. Nazism drove him to Paris in 1933 and to the United States in 1941. *Before the Mirror* was among the canvases in the superb collection that he gave, through his foundation, to the Solomon R. Guggenheim Museum in 1965 (inv. 78.2514 T 27).[9]

F.C.

1. David Kunzle, "The Corset as Erotic Alchemy: From Rococo Galanterie to Montaut's Physiologies," *Art News Annual*, XXXVIII (1972).
2. Schneider 1972, p. 8.
3. Huysmans 1883, p. 157.
4. Rouart and Wildenstein 1975, I, p. 27, no. 20, "Tableaux et études."
5. Manet sale, Paris, February 4–5, 1884, no. 43; Bodelsen 1968, p. 342.
6. Painter 1966, I, p. 280.
7. Mallarmé 1945, p. 92.
8. Flanagan sale, New York, January 14, 1920, no. 65.
9. V. E. Barnett, *The Guggenheim Museum: Justin K. Thannhauser Collection*, New York, 1978.

157. Nana

1877
Oil on canvas
60¾ × 45¼" (154 × 115 cm)
Signed and dated (lower left): Manet 77
Kunsthalle, Hamburg

It was during the winter of 1876–77 that Manet again approached the theme, in a naturalist mode and without reference to the past, of the courtesan, nearly fifteen years after *Olympia* (cat. 64). The title and the subject might suggest that the painting was an illustration for Zola's novel *Nana*, but the first chapters of the novel were not written until a year and a half later, in autumn 1878, and the first publication began in October 1879, serially, in *Le Voltaire*. The character Nana, however, appears in the last installments of *L'Assommoir*, published in *La République des lettres* in autumn 1876. Nana, red-haired and fresh, was at the very beginning of her career: "Since the morning, she had spent hours in her chemise before the bit of looking glass hanging above the bureau . . . she had the fragrance of youth, the bare skin of child and of woman."[1] And the gentleman in the picture waiting, stick in hand, prefigures Count Muffat in the story.

Exhibitions
Paris, Giroux 1877; Paris, Drouot 1884, no. 11; New York, Durand-Ruel 1895, no. 2; Berlin, Cassirer 1910; Munich, Moderne Galerie 1910, no. 9; Paris, Bernheim-Jeune 1910, no. 10; Saint Petersburg 1912, no. 402; Hamburg 1973

Catalogues
D 1902, 217; M-N 1926 II, pp. 43, 52, 107, 117; M-N cat. ms., 215; T 1931, 247; JW 1932, 275; T 1947, 270; RO 1970, 230; RW 1975 I, 259

Indeed the subject itself was in the air. It was one of the themes of naturalism that writers and painters—from Goncourt to Degas, from Zola to Manet—were all using, and quite possibly Manet began his painting before he ever read *L'Assommoir* or heard Zola speak of it. But that Zola, in any case, gave him the idea for the title at the time of the Salon, in May 1877, is clear. Manet greatly admired *L'Assommoir*; a letter dated April 28 from the duchess of Castiglione-Colonna thanks Manet for sending her a copy autographed for her by the author.[2] That was within a few weeks of the opening of the Salon.

Some years later, Félicien Champsaur, who had been associated with both the painter and the writer, summed up his views of their mutual influence in the development of Nana: "When M. Zola's novel *L'Assommoir* appeared, M. Manet painted a Nana, following the impression given in the book—eighteen years old, grown up, and already a tart. Essentially a Parisienne, one of those girls, plump with good living, small, elegant or provocative. . . . Afterward, Nana gained stature. She was transformed in the mind of her father, M. Zola, into a fine figure of a woman, blond, buxom, magnificent, of a country freshness, not much like M. Manet's Nana. Who is right, the Impressionist or the naturalist?"[3]

A repeat of the theme of the courtesan, Manet's *Nana* is no longer the fateful Baudelairean prostitute of *Olympia* but a contemporary *cocotte* at her toilet, whose sideways glance—caught between a pat of the powder puff and a touch of lip rouge—expresses her amused contempt for the "protector" who sits waiting. The composition revolves around its center—the petticoated hip between the bright blue of the corset and the embroidered stockings. The rounded contours of Nana's body are echoed in the lines of the couch, wrapping her in a play of feminine curves and countercurves that is accentuated by the softness of the two cushions, white and green.[4] But the central figure is confined, according to Manet's usual practice, in a rigorous scheme of verticals and horizontals—the dark-clad man in top hat, half cut away by the edge of the canvas, is a foil for her joyous, mocking femininity: How can men be so stupid! she seems to say.

Thus, not without humor, the flowerpot in the bright Veronese green jardiniere horizontally balances the masculine visage with top hat, and the petticoat on a chair balances the bent trousered knee and the walking stick. Nana's saucy face above is vertically balanced by the well-stretched embroidered stocking and the dress slipper, a feature repeated several times in Manet's watercolored notes and drawings (cat. 198, 199).

According to Bazire, the male figure was added later.[5] The unusual way the figure is cut off by the edge of the picture has been attributed to the influence of Japanese prints.[6] Manet had adopted this device before; it had been a characteristic feature of his oeuvre since the 1860s—for example, the figure at the extreme right in *The Old Musician* (RW I 52). Such cut-off figures were to become a leitmotif in the work of Degas.

Manet's model was Henriette Hauser, a young actress whom he probably met at the house of Nina de Callias (see cat. 137). Then the mistress of the prince of Orange, who had nicknamed her "Citron" (Lemon), she was a popular boulevard figure. As in the portrait of Nina, some historians have interpreted the crane (*grue*), or ibis (see cat. 137), in what was probably a wall hanging as an allusion to the loose morals of the subject, since by that time the word *grue* was used to refer to a high-class prostitute.[7] The hypothesis is tempting, but not very plausible. In the first place, the fabric was part of the regular decor of Manet's studio; it recurs in several paintings, including the

portrait of Nina de Callias, as we have seen, and—though without the bird—the portrait of Mallarmé (cat. 149). Second, it must be doubted that Manet, the mischievous but gallant man-about-town, would have cast so direct a slur on a woman whom he met frequently in society or the demimonde.

It is nevertheless certain that Manet arranged the setting. After his death, visitors to his studio, among them Jacques-Emile Blanche, recognized Nana's standing mirror and other accessories.[8] Suzanne Manet gave the mirror to Eva Gonzalès's sister Jeanne in remembrance of the artist.[9]

The cruciform composition of the painting is executed in a quite free and dynamic brushwork, often following form and contour, and this associated Manet with Impressionism in the public mind. For this reason, and because the subject was thought indecent, the work was rejected for the Salon, but the public saw it for a time in the window of the Giroux shop at 43, boulevard des Capucines — "knickknacks, pictures, fans" — where it reportedly caused near riots: "From morning to night, crowds gather before this canvas, and . . . it draws screams of indignation and derision from a mob stultified by the daubs that the Cabanels, Bouguereaus, Toulmouches, and the rest see fit to hang on the line in the spring of each year," wrote Huysmans, who clearly linked Manet with Zola: "Manet is absolutely right to give us in his Nana a perfect specimen of the type of girl his friend and our *cher maître,* Emile Zola, will depict for us in a forthcoming novel."[10] In the Paris press, Jules de Marthold alone undertook the defense of *Nana,* in the name of literary naturalism. Marthold compared Manet's strategy with Flaubert's, as well as Balzac's: "The great condition for surviving is to *be of one's own time.* . . . We can number the modernists who have eternalized their epochs, but every epoch nevertheless has its own. This century, so far, has had two. The first is called Balzac, the second is named Manet. . . . M. Manet's high crime is not so much that he paints modern life as that he paints it *life size* . . . only the Romans are allowed that. Nero, but not Maximilian; Roscius, but not Rouvière; Lesbia, but not Nana . . . helmets, but not hats!"[11] Indeed, the real success of this painting displayed in a shop window was, in every sense of the phrase, a *succès de boulevard,* as witness Robida's caricature in *La Vie parisienne* of May 12, 1877 (fig. a).

Werner Hofmann, in the exhibition he organized in 1973, assembled around *Nana* and the personality of Zola a voluminous series of textual and iconographic references relating the subject of the painting to traditional and popular representations of the theme of the seductress, often at her toilet, in the company of an admirer, usually older than she.[12] Nana thus belongs to a rich iconographic lineage, halfway between Hans Baldung Grien and Edvard Munch. These are interesting and suggestive inquiries, but they are more appropriate to Zola than to Manet. In Zola, as Thomas Mann observed, Nana, "that Second Empire Astarte," is elevated into "symbol" and "myth"; her very name, "one of mankind's primeval voluptuous stammerings, recalls the Babylonian Ishtar. . . ."[13]

In Manet, nothing of the kind; there is nothing really epic about his Parisian *cocotte.* Citron is no Blue Angel. With no bitter or tragic connotation, the artist here takes up, and elevates to a masterpiece, the erotic and ironic tradition exploited by eighteenth-century popular engraving and by the romantic illustrations of Gavarni, Guys, and Tassaert, which in his own time nourished the popular caricatures of Bertall and Robida.

At this same time, about 1877–79, Degas was confining his observations in the world of prostitution to the intimacy of his monotypes: cruder

Fig. a. Robida, caricature in *La Vie parisienne,* May 12, 1877

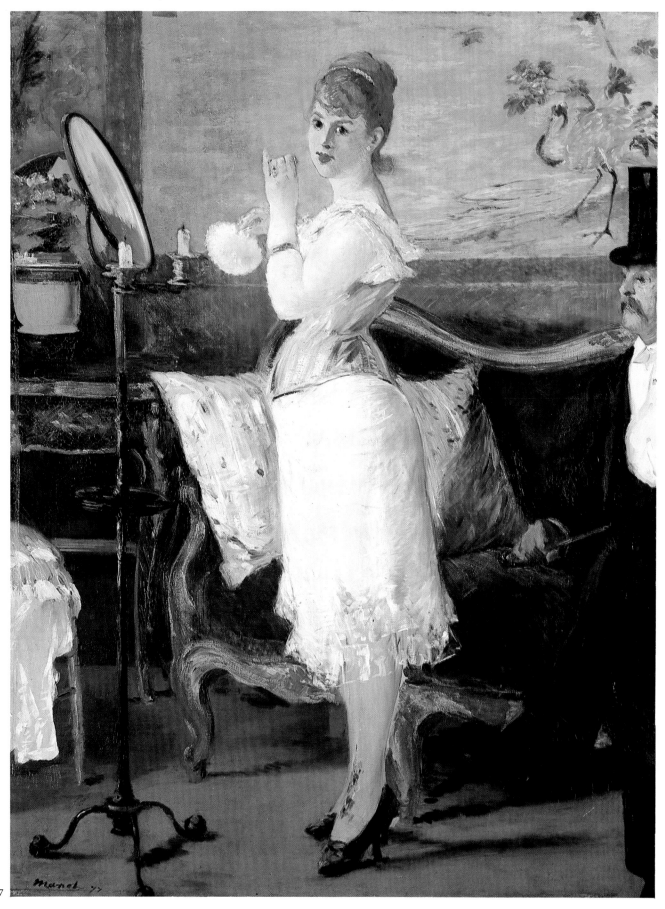

scenes of brothels with the same gentleman waiting, seated and top-hatted, but with a low-class prostitute naked and sprawled on a couch. The further development of the theme may be traced in the vulgarities of a Forain but most notably in the acid mode of Toulouse-Lautrec's series of lithographs *Elles*—especially *La conquête de passage*—which appeared in 1896.

In thus showing, without moralizing but with frankness and humor, a scene of contemporary life thitherto reserved for pornographic photography and caricature, Manet knew he was challenging the jury of the Salon. He put together all the grounds for scandal: theme; disproportionate size for a so-called genre subject; an easily recognizable model who was the talk of Paris; and, for good measure, a free technique and a clear and violent palette that associated him directly with the scandal of Impressionism.

Provenance

After being rejected by the Salon of 1877, this picture remained in Manet's studio.[14] At the posthumous sale, it was acquired for 3,000 Frs by DR. ROBIN (see Provenance, cat. 156).[15] Robin sold it for 8,000 Frs to DURAND-RUEL (see Provenance, cat. 118), who sold it the same year for 15,000 Frs to HENRI GARNIER.[16] At the Garnier sale in 1894,[17] *Nana* was bought for 9,000 Frs by DURAND-RUEL, who sold it for 20,000 Frs to the collector AUGUSTE PELLERIN (see Provenance, cat. 109).[18] The painting was among the group of works by Manet that Pellerin sold in 1910 to DURAND-RUEL, BERNHEIM-JEUNE, and PAUL CASSIRER (see Provenance, cat. 118, 31, 13). Following the traveling exhibition organized by the three dealers in Germany, Cassirer sold it for 150,000 Frs to the Hamburg collector TH. BEHRENS (no relation to the architect), from whom Gustav Pauli (1866–1938), director of the Hamburg Kunsthalle since 1914, bought it in 1924 for the museum (inv. 2376). This purchase was not effected without difficulty—being a matter of 150,000 Frs—and Pauli instigated a press campaign to persuade the city of Hamburg to buy the picture. According to Hofmann, the German nationalists put up some resistance, but Pauli invoked the Francophile tradition of Frederick the Great; to the city's merchants the state councillor Lipmann addressed the economic argument that such an investment could allow for a profitable resale later. A campaign mounted by artists and critics, including Liebermann, Meier-Graefe, and Adolph Goldschmidt, also endorsed the purchase, which was finally approved by the voters.[19] Under the Nazis, it was thanks to the courage of the curator of the period (Pauli having been forced to resign for his purchases of contemporary art) and above all to the mayor of the city, Krogman, that the painting was not included in sales of "degenerate art."

F.C.

1. Zola 1962, II, p. 710.
2. Paris, Bibliothèque d'Art et d'Archéologie, Manet archives.
3. Champsaur, in *Les Contemporains*, June 16, 1881, p. 29.
4. Hopp 1968, p. 81.
5. Bazire 1884, p. 100.
6. Weisberg 1975, p. 120.
7. Reff 1964, p. 120; Hanson 1977, pp. 87, 130.
8. Blanche 1912, p. 160.
9. Manet et al., "Copie faite pour Moreau-Nélaton . . . ," p. 45.
10. Huysmans 1877, quoted in Tabarant 1947, pp. 305–6.
11. Jules de Marthold, in *La Vie moderne*, April 15, 1877? quoted by the author in *La Lithographie*, October 1900.
12. Hofmann 1973.
13. Thomas Mann, *L'Artiste et la société*, Paris, 1973, pp. 286–88.
14. Rouart and Wildenstein 1975, I, p. 27, no. 6, "Tableaux et études."
15. Manet sale, Paris, February 4–5, 1884, no. 11; Bodelsen 1968, p. 342.
16. Meier-Graefe 1912, p. 314.
17. Garnier sale, Paris, December 3–4, 1894.
18. Meier-Graefe 1912, p. 314.
19. Hofmann 1973, p. 10.

158. The Rue Mosnier with Pavers

1878
Oil on canvas
25¼ × 31½" (64 × 80 cm)
Signed (lower left): Manet
Fitzwilliam Museum (anonymous loan), Cambridge

From 1872 until early July 1878, Manet occupied a studio on the second floor at 4, rue de Saint-Pétersbourg (today the rue de Léningrad), with a view down the rue Mosnier (rue de Berne since 1884), newly laid out, and described in Zola's *Nana* a few months after the date of this canvas as a somewhat disreputable thoroughfare: "Mme Robert lived in the rue Mosnier, a quiet new street in the quartier de l'Europe, no shop fronts, but fine houses, with narrow little apartments inhabited by ladies. It was five o'clock; along the deserted sidewalks, in the aristocratic peace of the tall white houses, stockbrokers' and merchants' coupés stood by, while men walked quickly, raising their eyes to the windows where women in peignoirs seemed to wait. Nana refused at first to go up."[1] One might perhaps speculate that this passage in Zola's novel was inspired by Manet's amused descriptions of the street.

Exhibitions
Salon d'Automne 1905, no. 21

Catalogues
D 1902, 243; M-N 1926 II, pp. 46, 57; M-N cat. ms., 222; T 1931, 227; JW 1932, 291; T 1947, 290; PO 1967, 247; RO 1970, 248; RW 1975 I, 272

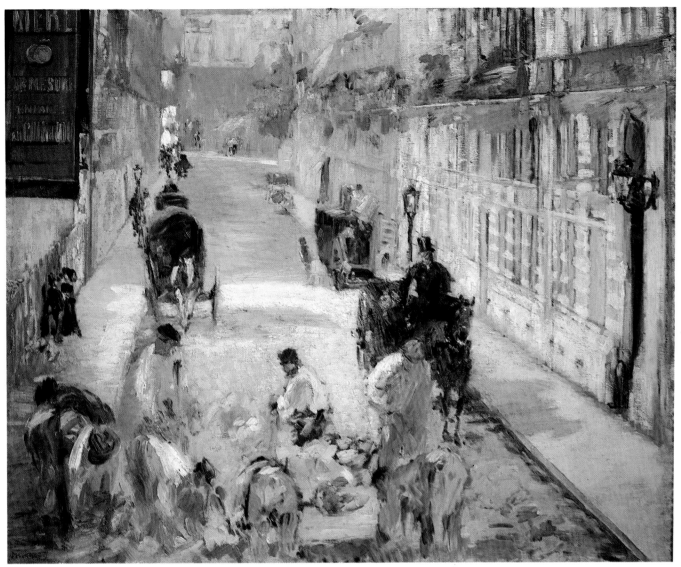

158

Shortly before his departure from this "slice of life" observatory, Manet painted two views of the rue Mosnier with flags flying (RW I 270; fig. a; RW I 271). Flags were thus displayed throughout Paris on June 30, 1878, the national holiday for the Exposition Universelle. On the same day, Monet portrayed other, similar scenes: *Rue Montorgueil* (Musée d'Orsay-Galeries du Jeu de Paume, Paris) and *Rue Saint-Denis* (Musée des Beaux-Arts, Rouen). Our canvas is the third in Manet's "series," as catalogued by Rouart and Wildenstein, "*La rue Mosnier, dit aux paveurs,*" following the other two. In actual fact, it is more likely the first in order; judging by the light and the acid green of the balcony foliage and the tree down the street, it would be spring or very early summer; the men are completing the street work, and the job was finished by the time of the national holiday. But in any case, Manet's interest in the view commanded by his window considerably antedated his departure from the studio, as his drawings show (see cat. 159–63).

In technique and subject matter, Manet is here very close to the Impressionists. Monet had painted a series of Parisian scenes in 1867 and

1873. But as in Pissarro's *Boulevards* of the 1880s, Monet's point of view is higher, with a panorama effect, an indistinct bustle of humanity far below, and an opening to the sky above; or else it is at ground level, the sky even more predominant but the passersby not more clearly discernible. With Manet, in this painting and in the other two, the line of sight is virtually horizontal, and the emphasis is on the human figures, more individualized, caught in mid-step. The significance of the disabled man in the "flag" painting (fig. a; see also cat. 163) has been pointed out by Collins;[2] in the present canvas, too, there is good reason to examine the subject matter more closely.

As in the other two *Rue Mosnier* canvases, the absence of sky should be noted—an approach very different from that of the Impressionists. For Manet, the street was not an element of cityscape but a locus of city life. He admired Monet and Renoir especially, among the young Impressionists, and very likely the theme was inspired by Monet. But a landscape, seascape, or cityscape claimed Manet's attention only insofar as it was a setting for human activity. His vision was not one of pastoral or unanimist contemplation; when he painted the Trocadéro (RW I 123), it was as the site of the Exposition Universelle; when he depicted the Panthéon, the occasion was a funeral (cat. 98). There had to be flags flying, or pavement being laid, if a street was to be chosen as a subject.

For Manet—spectator, *flâneur*, confirmed city dweller—Paris was never scenery but was a place of life, of involvement, of wonder. During the 1860s, Parisians witnessed the work of Haussmann—scenes of demolition, construction, and road work. Paris was a perpetual construction site, and these humble pavers of the rue Mosnier are a record in art of the fifteen-year metamorphosis experienced by Manet. In this image of labor, there is not the least sentimentality, not the slightest intention to moralize, such as might have been indulged in, in an anecdotal vein, by a Béraud or a Raffaelli, but rather an involvement beyond the interest of a genre scene, a curiosity illuminating even the bright black silhouettes of the hackney coaches—standing in wait, if Zola is to be believed, for gentlemen on pleasure bent—the gas lamps, the advertisement at the upper left ("children outfitted to measure in the latest fashion"), and the little house-moving scene beyond the carriage on the right.

Manet's fascination with the life of Paris was to grow; it is known that the following year he submitted a proposal to the prefect of the Seine for decorating the Municipal Council Hall in the Hôtel de Ville—not with allegories of historic, monumental Paris but with scenes of everyday Paris: "To paint a series of compositions representing, to use an expression now hackneyed but suited to my meaning, 'the belly of Paris,' with the several bodies politic moving in their elements, the public and commercial life of our day. I would have Paris Markets, Paris Railroads, Paris Port, Paris Under Ground, Paris Racetracks and Gardens. For the ceiling, a gallery around which would range, in suitable activity, all those living men who, in the civic sphere, have contributed or are contributing to the greatness and the riches of Paris."[3] One can half imagine, from *The Rue Mosnier with Pavers*, what Manet's conception was like; apparently he received no reply, and the project never came to fruition.

1. Zola 1960–67, p. 1299.
2. Collins 1975, p. 710.
3. Letter of April 10, 1879, quoted in Bazire 1884, p. 142; Proust 1913, p. 94.
4. Manet et al., "Copie faite pour Moreau-Nélaton . . . ," p. 79.
5. Chocquet sale, Paris, July 1–4, 1899, no. 70, 10,500 Frs; John Rewald, "Chocquet et Cézanne," *Gazette des Beaux-Arts*, 6th ser., LXXIV (July 1969), pp. 33–96.
6. Gimpel 1963: May 28, 1924.

Provenance
Manet sold this picture for 1,000 Frs to the collector ROGER DE PORTALIS (died 1912),[4] who in turn sold it to VICTOR CHOCQUET (1821–1891). Chocquet, an important official in the customs bureau and an enthusiastic collector of Impressionist works, owned a superb group of Cézannes (thirty-two at the time of his sale), Delacroixs (twenty-two), and several fine Manets, including *Monet in His Studio* (RW I 219) and *Branch of White Peonies, with Pruning Shears* (cat. 78). *The Rue Mosnier with Pavers* was included in the Chocquet sale

in 1899,[5] after which it remained for nearly twenty-five years on the market, with DURAND-RUEL, BERNHEIM-JEUNE, and PAUL ROSENBERG (see Provenance, cat. 118, 31) in Paris and PAUL CASSIRER (see Provenance, cat. 13) in Berlin, who sold it to G. HOENTSCHEL. According to Gimpel, the dealers GEORGES BERNHEIM (see Provenance, cat. 20) and BARBAZANGES, who had purchased the painting from Hoentschel, asked 850,000 Frs for it in 1924.[6] Through the dealers ETIENNE BIGNOU of Paris and ALEX REID & LEFEVRE of London (see Provenance, cat. 216), it joined the extraordinary collection of SAMUEL COURTAULD (see Provenance, cat. 211) the same year. It passed by inheritance to the RT. HON. LORD BUTLER.

It is interesting that the two great collectors who owned this painting, Chocquet of Paris and Courtauld of London, were both chiefly attracted to Manet's work of the last ten years, that of his so-called Impressionist period.

F.C.

159. The Rue Mosnier

1878
Pencil and India ink wash
7½ × 14¼" (19 × 36 cm)
Initialed(?) (along upper right edge): M

P Szépmüvészeti Múzeum, Budapest

While not really a study for *The Rue Mosnier with Pavers* (cat. 158), this drawing from life is very much like the lower section of that composition, omitting the street pavers. With the wide format, Manet rendered this view of the street as felt by a pedestrian walking quickly, head down against the rain, taking in only short, fleeting images. This is a snapshot of street life in a light rainfall—umbrellas, hackneys, the errand girl rushing across in the foreground with hatbox to be delivered. The allusive line and nervous hatchings remind one of Japanese drawings and of the Parisian sketches of Pierre Bonnard fifteen years later.

Catalogues
T 1947, 624; L 1969, 503; RW 1975 II, 328

1. S. Meller, *Handzeichnungen des XIX Jahrhunderts aus der Sammlung Pál von Majovszky. Graphische Künste*, 1919, p. 11.

Provenance
According to the museum in Budapest, this drawing once belonged to ROGER MARX (see Provenance, cat. 35); it did not appear in his sale in 1914. By 1919, it was in the collection of PAL VON MAJOVSZKY,[1] who also owned *The Barricade* (cat. 124), and it entered the museum in 1935 (inv. 1935.2735).

F.C.

159

160. The Rue Mosnier with Gas Lamp

1878
Pencil and India ink wash
10⅞ × 17⅜" (27.6 × 44.2 cm)
Atelier stamp (lower right): E.M.
The Art Institute of Chicago

Exhibitions
Philadelphia-Chicago 1966–67, no. 142; Washington
1982–83, no. 87

Catalogues
L 1969, 502; RW 1975 II, 327

The left side of the rue Mosnier is presented here, with the fence beyond which the railroad yards, where a locomotive puffs along, are seen down to the left. The human figures are indicated by their movements rather than their shapes; thus the woman in the foreground setting her course toward the hackney coach is drawn in a few quick strokes of the brush. In the center, a knife grinder is penciled in. The drawing does not correspond closely to any one of the *Rue Mosnier* canvases, and perhaps it notes an idea for a more panoramic and populous version never executed. But Manet preferred more centered compositions, and this little glimpse from his window indicates how painstakingly he worked on preliminary sketches before adopting the angle of view for the painting (cat. 158).

Provenance
The first collector who is known to have owned this drawing is JACQUES DOUCET (see Provenance, cat. 135). In 1945, MRS. ALICE H. PATTERSON gave it to the Art Institute of Chicago, in memory of Tiffany Blake (inv. 4515).

F.C.

160

D
161

161. Hackney Cab

1878
Pencil
6⅝ × 5⅛″ (16.8 × 13 cm)
Atelier stamp (lower right): E.M.
NY Musée du Louvre, Cabinet des Dessins, Paris

This lively little pencil sketch of a standing cab may have been done from Manet's studio window, which looked down the rue Mosnier. It is probably a study for the fiacre seen from the front at right center in *The Rue Mosnier with Pavers* (cat. 158), but here the driver holds his whip in hand.

Another, quite similar sketch, still less detailed, was probably made not long before in the same notebook (RW II 325).

Exhibitions
Marseilles 1961, no. 44

Catalogues
L 1969, 482; RW 1975 II, 323

1. Pellerin sale, Paris, June 10, 1954, album no. 4.

Provenance
This drawing, inherited by SUZANNE MANET (see Provenance, cat. 12), was acquired by AUGUSTE PELLERIN (see Provenance, cat. 100) and was purchased at the Pellerin sale[1] by the Musée du Louvre in 1954 (inv. RF 30.350).

F.C.

162

162. Hackney Cab from Rear

1877–78
Black chalk and blue ink wash
4⅜ × 3¼" (11.2 × 8.3 cm)
Initialed (lower left): E.M.

P Bibliothèque Nationale, Paris

Exhibitions
Orangerie 1932, no. 114

Catalogues
L 1969, 481; RW 1975 II, 326

A quick brush drawing—perhaps, like the preceding, done in the rue de Saint-Pétersbourg studio—of a hackney with half-open top, known as a victoria; the same vehicle is seen from the back in the right foreground of one of the two versions (RW I 271) of *The Rue Mosnier with Flags*.

Provenance
This drawing belonged to the collector ALFRED BARRION (see Provenance, cat. 40) and appeared at his sale in 1904, in lot 1512: "Voiture, vue de dos. Signé E.M." (Carriage, seen from the rear. Signed E.M.). It was acquired by MOREAU-NELATON (see Provenance, cat. 9), who bequeathed it to the Bibliothèque Nationale in 1927.

F.C.

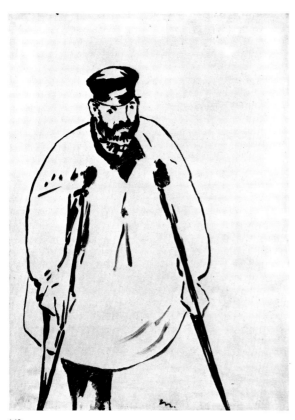

163

163. Man on Crutches

1878
India ink wash
10⅝ × 7¾" (27.1 × 19.7 cm)
Initialed (lower center): M.
The Metropolitan Museum of Art, New York

This man, a local character in the quartier de l'Europe, had in all probability lost his leg in the Franco-Prussian War of 1870. He is seen from the back in *The Rue Mosnier with Flags* (cat. 158, fig. a), where, as Collins has noted, his image contrasts with the joyful display of banners for the national holiday— the two faces of war, seeming to express Manet's skepticism of the current triumphal nationalism symbolized by the flags.[1] In this drawing, he is seen full face, in workingman's blue blouse and visored cap. There is nothing here of the picturesque, no particular expression in the face, but the strong, concise line and compositional monumentality project a forceful image of the person.

A related drawing (RW II 478) represents the same figure walking away, in the more stooping position of *The Rue Mosnier with Flags*. That drawing was a draft for the illustrated cover of "Les Mendiants," a song by Manet's friend Cabaner, with words by Jean Richepin. The print for which the drawing was intended may never have been produced; at all events, it has not come to light.[2]

Exhibitions
Beaux-Arts 1884, no. 174; Paris, Drouot 1884, no. 154; New York, Wildenstein 1948, no. 51; Philadelphia-Chicago 1966–67, no. 143; Washington 1982–83, no. 88

Catalogues
M-N 1926 II, p. 46; T 1931, 71 (watercolors); JW 1932, mentioned 289; T 1947, 623; L 1969, 505; RW 1975 II, 479

1. Collins 1975, pp. 709–14.
2. Wilson 1978, no. 14.
3. Manet sale, Paris, February 4–5, 1884, no. 154; Bodelsen 1968, p. 343.
4. Anonymous sale, Paris, April 24, 1944.

Provenance
This drawing remained in Manet's studio, and at the sale in 1884, it was knocked down for 46 Frs to the expert Jacob,[3] acting as agent for an unknown collector. It was subsequently untraced until 1944, when it reappeared at auction in Paris[4] and was acquired by M. GUIOT. The Metropolitan Museum purchased it in 1948 (inv. 48.10.2).

F.C.

164. Self-Portrait with a Palette

1878–79
Oil on canvas
32⅝ × 26⅜" (83 × 67 cm)
Private Collection, New York

Exhibitions
Berlin, Cassirer 1910; Paris, Bernheim-Jeune 1910, no. 16; New York, Wildenstein 1937, no. 25; Philadelphia-[Chicago] 1966–67, no. 144; Washington 1982–83, no. 1

Catalogues
D 1902, 245; M-N 1926 II, pp. 50–51; M-N cat. ms., 236; T 1931, 299; JW 1932, 294; T 1947, 320; RO 1970, 274; RW 1975 I, 276

Self-portraits are rare in Manet's oeuvre. There is a disputed caricature of 1856–58,[1] and Manet included himself in *La pêche* (cat. 12), *Music in the Tuileries* (cat. 38), and *Masked Ball at the Opéra* (cat. 138), but the only true self-portraits are two works believed by most authorities to have been painted in either 1878 or 1879: *Self-Portrait with a Palette* and *Self-Portrait with a Skullcap* (RW I 277; fig. a). Duret and Moreau-Nélaton indicate that the latter was painted first,[2] but Tabarant asserts that *Self-Portrait with a Palette*, "which all his friends were summoned to see," is the earlier of the two.[3]

Mme Manet considered both self-portraits *ébauches* (sketches),[4] but in *Self-Portrait with a Palette* only the artist's left hand and arm, the brushes, and possibly the palette are unfinished. *Self-Portrait with a Skullcap* is far less finished, and the term *ébauche* is, therefore, understandable. However, when Mme Manet sold them in 1899, it is clear that the *Self-Portrait with a Skullcap* was the more esteemed work (see Provenance). Neither picture seems to have been very popular, and the price realized by *Self-Portrait with a Palette* indicates that for a long time many people shared the opinion voiced by Moreau-Nélaton in 1926: "A certain coldness vitiates this work, as well as the other attempt [*Self-Portrait with a Skullcap*] I mentioned. Too much passion informed the hand that painted it so freely, making it impossible for the artist to seriously address the subject before him."[5]

The picture has proven more appealing to the modern eye. Hamilton has described it in terms of "penetrating analysis,"[6] and Reff recently reminded us of the particular significance of Manet's decision in the late 1870s to attempt two paintings of a kind that he had avoided for most of his career: "That he twice represented himself in 1879 as a stylish and successful Parisian artist becomes more meaningful when we learn that in this very year [quoting Duret], 'Manet, at the height of his career, had achieved the kind of renown that rightfully belonged to him during his lifetime. He was one of those who were most in the public eye in Paris.' He had, in effect, been recognized at last as the Parisian painter *par excellence*."[7] Moreover, Mauner has noted that there are similarities between Manet's pose in *Self-Portrait with a Palette* and that of Velázquez as he portrayed himself in *Las meninas* (fig. b).[8] Evidently, Manet saw himself as the modern equivalent of the elegant, worldly master of the seventeenth-century Spanish court.

Self-Portrait with a Palette is as much a painting of a subject from modern life as it is a self-portrait. Indeed, this image of a stylish gentleman painter could serve as an illustration of the dandy as defined by Baudelaire in "Le Peintre de la vie moderne." Despite Manet's unabashed admiration for values rooted in the artificial and the superficial, this picture is a celebration of character and distinctiveness or, in Baudelaire's words, "of what is finest in human pride, of that compelling need, . . . only too rare today, for combating and destroying triviality."[9]

X-ray photographs reveal that Manet painted *Self-Portrait with a Palette*

Fig. a. *Self-Portrait with a Skullcap*, 1878–79. Bridgestone Museum of Art, Tokyo

Fig. b. Velázquez, *Las meninas*, 1656 (detail). Museo del Prado, Madrid

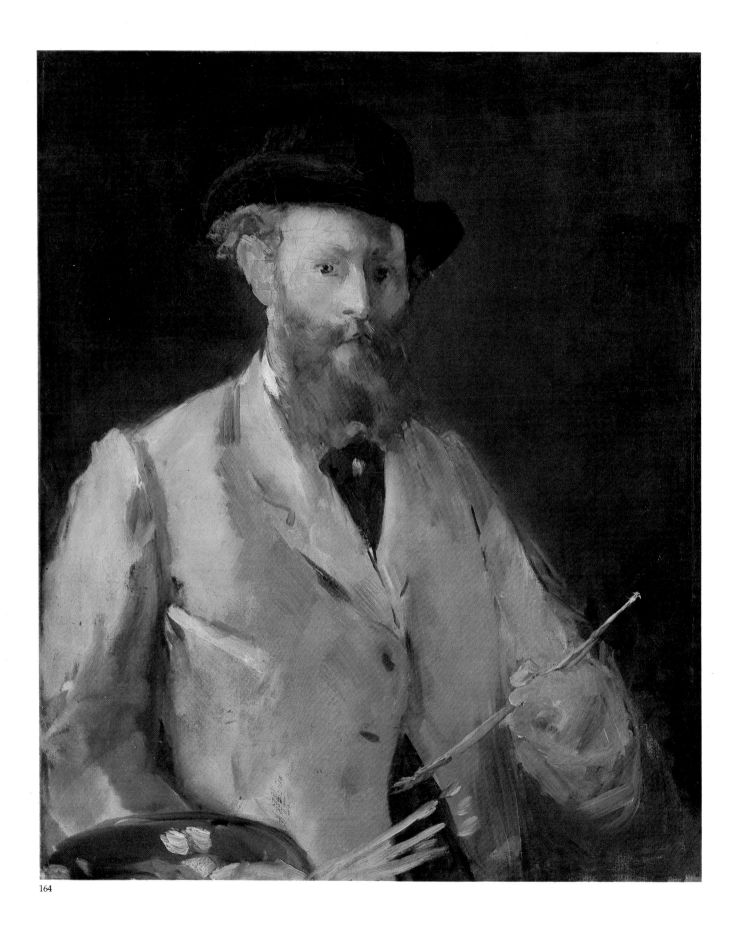

164

over a portrait of his wife, Suzanne, in profile, that is reminiscent of *Mme Manet at the Piano* (cat. 107).

Provenance

Bazire saw this picture in Manet's studio just after his death.[10] This canvas and Manet's full-length self-portrait (RW I 277) were hung on either side of *Hamlet* (RW I 257). In the studio inventory, it was valued at 300 Frs.[11] Curiously, it was not included in the 1884 retrospective, and Manet's widow withheld it from the studio auction, presumably for sentimental reasons. Evidently, she began to think of selling the two self-portraits (which she considered *ébauches*, or sketches) about 1897, probably on the advice of Antonin Proust (see Provenance, cat. 187). On February 12, 1897, he wrote her that neither Faure (see Provenance, cat. 10) nor Pellerin (see Provenance, cat. 109) was interested and advised her to frame the two pictures.[12] On May 10, 1897, Proust wrote again to say that Pellerin had decided to come to Asnières to see a self-portrait; which one is unclear. Considering the lack of interested buyers for the two self-portraits, it is difficult to understand Suzanne Manet's motives for transferring ownership of them on February 2, 1899, to her widowed sister MARTIENA LEENHOFF, although Tabarant explains that the latter was in financial distress.[13] Toward the end of 1899, Suzanne Manet and Proust renewed their efforts to sell these self-portraits. Pellerin was interested only in the full-length version, not at all in this one, which Proust thought should be offered to the German dealer Paechter. Proust later wrote that Vollard might be interested in the bust-length version. A note in Mme Manet's account book for 1899 records the outcome: she sold both self-portraits to PAECHTER (see Provenance, cat. 27), the full-length for 6,000 Frs and this one for a mere 1,000 Frs. Oddly enough, in his catalogue of 1902, Duret listed PELLERIN as the owner of the bust-length portrait and gave it particular significance by reproducing it as a colorplate. In May 1910, the picture was lent to an exhibition at the Galerie Georges Petit in Paris by the MARQUISE DE GANAY, probably Emilie, dowager marquise de Ganay, whose husband, Etienne, is listed in Manet's address book.[14] Yet in June 1910, the picture was included in an exhibition of Pellerin's collection organized by Durand-Ruel, Bernheim-Jeune, and Paul Cassirer, who had just jointly purchased works by Manet from this collection (see Provenance, cat. 109). Evidently, Pellerin had sold *Self-Portrait with a Palette* to the marquise shortly before selling his other Manets to the dealers, who included it in the exhibition to give a comprehensive view of his extraordinary collection. The marquise still owned the work in the early 1920s.[15] By 1931, it belonged to DR. JAKOB GOLDSCHMIDT of Berlin,[16] president of the Darmstaedter und Nationalbank. In 1936, he took his fine collection of nineteenth-century French paintings and settled in New York, where he died in 1955. At his sale in 1958, *Self-Portrait with a Palette* was acquired by J. SUMMERS for £65,000.[17]

A copy of this portrait appeared on the art market at the beginning of the century, apparently painted by Edouard Vibert, Suzanne Manet's nephew, who died on August 18, 1899, at the age of thirty-two. Vibert evidently copied quite a few of Manet's works for his aunt, who wanted souvenirs of the originals that she had to sell.[18]

C.S.M.

1. Tabarant 1947, p. 24.
2. Duret 1902, p. 256; Moreau-Nélaton 1926, II, p. 50.
3. Tabarant 1947, p. 355.
4. Ibid., p. 357.
5. Moreau-Nélaton 1926, II, p. 51.
6. George Heard Hamilton, "Is Manet still 'Modern'?" *Art News Annual*, XXXI (1966), p. 104.
7. Reff 1982, no. 1.
8. Mauner 1975, pp. 149–50.
9. Baudelaire 1965, p. 28.
10. Bazire 1884, pp. 132–33.
11. Rouart and Wildenstein 1975, I, p. 27, no. 29, "Tableaux et études."
12. New York, Pierpont Morgan Library, Tabarant archives.
13. Tabarant 1947, p. 357.
14. Manet et al., "Copie faite pour Moreau-Nélaton . . . ," p. 137.
15. Emil Waldmann, *Edouard Manet*, Berlin, 1923, p. 99.
16. Tabarant 1931, p. 349, no. 299.
17. Goldschmidt sale, London, October 15, 1958.
18. Tabarant 1947, pp. 356–58, 524–27.

165. The Plum

Exhibitions
Paris, La Vie Moderne 1880, no. 4 (La Prune); Beaux-Arts 1884, no. 86; Orangerie 1932, no. 64; Venice, Biennale 1934, no. 10; New York, Wildenstein 1948, no. 23

Catalogues
D 1902, 227; MN 1926 II, p. 53; M-N cat. ms., 243; T 1931, 256; JW 1932, 293; T 1947, 279; PO 1967, 233; RO 1970, 234; RW 1975 I, 282

1878?
Oil on canvas
29 × 19¾" (73.6 × 50.2 cm)
Signed (at left, on tabletop): Manet
National Gallery of Art, Washington, D.C.

According to Tabarant, *Nana* (cat. 157) was the first of "a 'naturalist' series" depicting "the most interesting characters" of Paris in the early years of the Third Republic. It was a time, he tells us, when "life became easy and assumed an aspect of pleasure, a tart, low-life flavor. The music halls were very much in vogue, from Montmartre to the Point-du-Jour. Intrigue smiled everywhere."[1] Also included in the "'naturalist' series" were *The Plum* and *Skating* (RW I 260).

Moreau-Nélaton suggests that the setting for *The Plum* is the Nouvelle-Athènes, the café that Manet, Degas, Monet, and others had favored since the early 1870s.[2] Tabarant, Rewald, and Reff agree, but Reff observes that the background in Manet's painting differs from those of two works known

1. Tabarant 1947, p. 314.
2. Moreau-Nélaton 1926, II, p. 53.
3. Tabarant 1947, p. 314; Rewald 1973, pp. 398–99; Reff 1982, no. 18.
4. Moore 1898, p. 31.
5. Reff 1982, no. 18.
6. Ibid.; Richardson 1958, p. 127, no. 55.
7. See Novelene Ross, *Manet's "Bar at the Folies-Bergère" and the Myths of Popular Illustration*, Ann Arbor, 1982, pp. 43, 45.

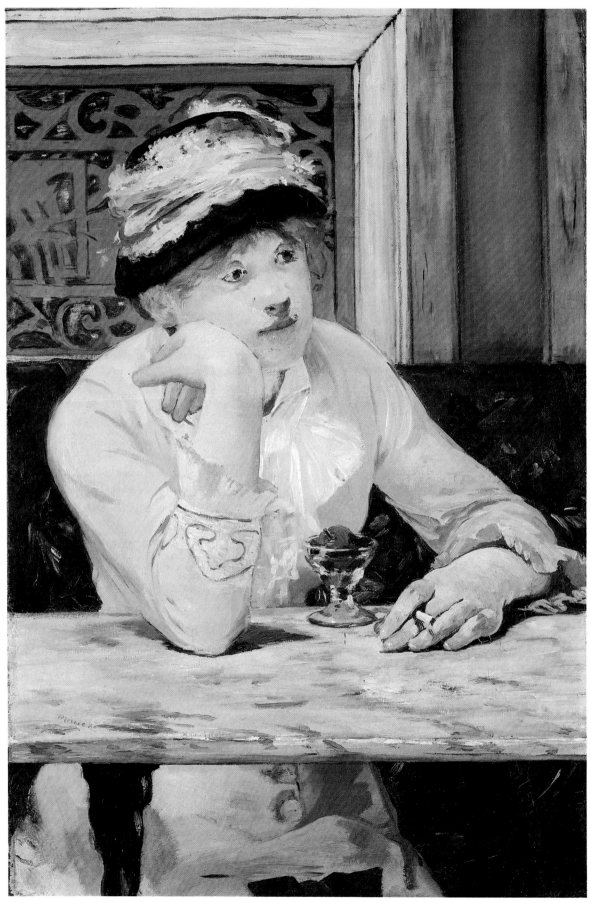

8. For example, Tabarant 1947, p. 314, dates it 1877; Rouart and Wildenstein 1975, I, no. 282, assign it to 1878; and Reff 1982, no. 18, places it in 1877–78.
9. Manet et al., "Copie faite pour Moreau-Nélaton. . . ," p. 80.
10. Venturi 1939, pp. 152–55.
11. Gimpel 1966, p. 121.
12. Walker 1975, pp. 31–34, 45–46.

Provenance
CHARLES DEUDON had begun to buy Impressionist pictures in the early 1870s, the best known of which is surely Monet's *Gare Saint-Lazare* (Fogg Art Museum, Cambridge, Mass.); he acquired *The Plum* directly from Manet in 1881, for 3,500 Frs.[9] In 1899, Deudon was offered any price he cared to name for *The Plum*; to discourage further inquiries, he valued it at 100,000 Frs.[10] The Paris art dealer PAUL ROSENBERG, who acquired Deudon's collection in 1919, considered *The Plum* its finest picture and set its price at 500,000 Frs.[11] By 1928, it belonged to MR. AND MRS. ARTHUR SACHS, who still owned it in 1955. By 1966, it was in the collection of MR. AND MRS. PAUL MELLON. Mr. Mellon's father, Andrew W. Mellon (1885–1937), whose vast fortune derived from Pittsburgh coal, real-estate, and banking concerns, founded the National Gallery of Art in Washington, D.C., which opened in 1941. Paul Mellon (born 1907) inherited his father's interest in collecting and began by acquiring Impressionist and Post-Impressionist paintings, including a small group of superb Manets, among them this picture, *The Beach at Boulogne* (RW I 148), *Rue Mosnier with Flags* (RW I 270; cat. 158, fig. a), and *George Moore in the Artist's Garden* (RW I 297). He has continued his father's support for the National Gallery, serving as trustee and president and financing the East Building, which opened in 1978.[12] Mr. and Mrs. Mellon gave *The Plum* to the National Gallery in 1971 (inv. 25.85).

C.S.M.

to depict the café interior, Degas's *Absinthe*, 1876 (Musée d'Orsay-Galeries du Jeu de Paume, Paris) and Zandomeneghi's *At the Café de la Nouvelle-Athènes*, 1885 (private collection, Italy). Reff concludes that "Manet devised his own [background] for purely pictorial reasons."[3] The composition may have been inspired by an actual experience in a café, but the painting was undoubtedly executed in Manet's studio, where, as George Moore tells us, the artist kept "a marble table on iron supports, such as one sees in cafés."[4] In fact, the table in *The Plum* is probably the same one that Moore leans on in *George Moore at the Café* (cat. 175).

Reff proposes that the young woman who modeled for *The Plum* is the actress Ellen Andrée, who also appears in Degas's *Absinthe*, but the similarity between the figure in *The Plum* and other images known to represent Andrée is marginal.[5]

Having forgotten to light her cigarette, and apparently uninterested in the brandy-soaked plum before her on the table, the young woman seems lost in thought. Reff and Richardson call her a prostitute,[6] but she bears little similarity to the dissipated, ruined figure in Degas's *Absinthe*. It is possible that she is a *grisette*, a young working-class woman who often dressed above her station and frequented cafés, café-concerts, and other places of public entertainment.[7] In any case, such musing, introverted figures, who appear so often in Manet's work, seem to embody significances that transcend the limitations of the specific situation in which they are depicted. Moreover, they are typical of the inward-looking individuals who become increasingly common in late nineteenth-century European art.

The Plum is usually dated 1877 or 1878.[8] Indeed, the marked interest in café subjects that occurs in Manet's work in 1878 (see cat. 169) suggests that *The Plum* could easily have been painted that year, although there are no references to it until 1880, when it was included in Manet's exhibition of scenes and subjects from contemporary life at the gallery on the premises of the illustrated magazine *La Vie moderne*.

166. A Café in the Place du Théâtre Français

1877–78
Brush and India ink over pencil on squared paper
5⁹⁄₁₆ × 7³⁄₈" (14.1 × 18.7 cm)
Atelier stamp (lower right): E.M.
Handwritten indications of color

P Musée du Louvre, Cabinet des Dessins, Paris

Exhibitions
Marseilles 1961, no. 45

Catalogues
T 1931, 114 (watercolors); T 1947, 677; L 1969, 520; RW 1975 II, 528

In the fall of 1881, Manet was extremely active following his return to Paris in early October from Versailles, where he had spent the summer.[1] He reopened his studio, set to work, saw friends, and visited the cafés. Apparently he hoped to dispel rumors that his failing health had finished him as an artist. Tabarant places *A Café in the Place du Théâtre Français* in this period but provides no documentation; Leiris does not comment on the drawing but dates it about 1880; and Rouart and Wildenstein assign it to 1880–81.[2]

166

The identification of the subject depends on an entry in the sale catalogue of the collection of Armand Doria, May 5, 1899, in which the drawing is titled *La place du Théâtre Français vue à travers la glace d'un café*.[3] Evidently it was executed rapidly from life on facing pages in a small sketchbook that Manet probably carried in his pocket. He seems from the beginning to have intended it for later use, because he included pencil-written notes indicating the color of various objects and parts of the room. Although the drawing relates directly to a pastel (RW II 64; fig. a), many changes and modifications in the composition of the latter suggest that the drawing provided Manet with only a preliminary interpretation that he reworked and refined in the studio. For example, he substituted a different woman for the one seated at the table in the left foreground, added a top-hatted gentleman smoking a cigarette across the table from her, extended the composition at the right to show more of the empty table, and considerably altered the background, which opens onto an entertainment establishment similar to the Folies-Bergère.

Although the style of the drawing bears no relation to the work of Degas, the pastel seems indebted to the style and composition of Degas's *Women in Front of a Café* (fig. b), which Manet must have seen in 1877 at the Impressionists' third group exhibition. If this is correct, the date of the sketchbook drawing may be earlier than 1880–81, as is generally thought. Furthermore, the sustained interest in café subjects that appears in Manet's work about 1878 may have been inspired by the Degas exhibited in 1877.

1. Tabarant 1947, p. 421.
2. Ibid., p. 432; Leiris 1969, no. 520; Rouart and Wildenstein 1975, II, no. 528.
3. Doria sale, Paris, May 5, 1899, no. 296.
4. Ibid.
5. Pellerin sale, Paris, June 10, 1954, album no. 5.

Provenance
This drawing was presumably sold by SUZANNE MANET (see Provenance, cat. 12). It belonged to COMTE ARMAND DORIA (1842–1896), who bought many Impressionist pictures, including Cézanne's *House of the Hanged Man* (Musée d'Orsay-Galeries du Jeu de Paume, Paris). At the Doria sale in 1899,[4] the drawing was acquired by AUGUSTE PELLERIN (see Provenance, cat. 100) for 350 Frs. It was in the last of five albums from Pellerin's collection purchased at auction in 1954[5] by the Musée du Louvre (inv. RF 30.527).

C.S.M.

167

167. Café Scene

ca. 1878
Pencil on squared paper
5⅜ × 7⅜″ (14.2 x 18.7 cm)
Atelier stamp (lower right): E.M.
Handwritten indications of color
NY Musée du Louvre, Cabinet des Dessins, Paris

Catalogues
L 1969, 465; RW 1975 II, 500

This small pencil study, executed from life on facing pages of a sketchbook, is one of relatively few drawings of café themes by Manet. Of the handful of known examples, some were useful in connection with more finished India ink drawings (see cat. 170, 171) or with the compositions of pictures (see cat. 166), but others, such as *Café Scene,* were apparently never put to further use. The indications of color in Manet's hand suggest that initially he thought the subject had potential as a painting.

1. Pellerin sale, Paris, June 10, 1954, album no. 4.

Here we see a woman with a small dog or cat seated at a table opposite a top-hatted figure. The definition of the man is limited to a cursory outline and some shading that succinctly indicate a characteristic type. The rendering of the woman is only slightly more elaborate, but with a few inflected lines Manet has given her face a specific expression. The technique is a kind of visual shorthand that the artist developed early in his career, thus making it difficult to date such drawings if they cannot be related to specific paintings. This example is probably from a group of café-related scenes that are generally believed to have been done in the late 1870s.

Provenance
This sketch was among the works inherited by SUZANNE MANET (see Provenance, cat. 12). It passed into the collection of AUGUSTE PELLERIN (see Provenance, cat. 100), and at the Pellerin sale in 1954,[1] it was in the fourth of five albums acquired by the Musée du Louvre (inv. RF 30.403).

C.S.M.

168

168. At the Café (Interior of the Café Guerbois?)

1874
Transfer lithograph
10⅜ × 13⅛″ (26.3 × 33.4 cm)
Signed (lower right): Manet
Museum of Fine Arts, Boston

Although it is well known that cafés played a major role in the artistic and literary life of Manet's day, his own relationship with this world in which he spent so much time is recorded in just a handful of documents: rare accounts by friends, several sketches in his notebooks (cat. 61, fig. a; cat. 166, 167), and a few paintings in which he portrayed his friends (cat. 175, 176) or the settings in which their meetings took place (cat. 165, 172–74). While the Brasserie de Reichshoffen served as the point of departure for two indoor café scenes (see cat. 172, 173), the idea for the portrait of George Moore (cat. 175) came from their meeting at the Café de la Nouvelle-Athènes in 1879. The Café Guerbois, patronized by the avant-garde artists and writers some ten years earlier, appears only rarely in descriptions or illustrations. This print by Manet probably numbers among these few depictions.

　　A proof of another version of the composition (New York Public Library; see H 67) was inscribed, probably by Henri Guérard, "Interior of the Café Guerbois."[1] Reff quotes from a short story by Duranty, written in 1869, in which the description of that café could apply to the billiard room seen here in the background.[2] Although the inscription on Manet's print may suggest a plausible location, it does not prove it.

Publications
Unidentified periodical, 1875

Exhibitions
Philadelphia-Chicago 1966–67, no. 93; Ingelheim 1977, no. 64, Addenda; Paris, Berès 1978, no. 85; Washington 1982–83, no. 23

Catalogues
M-N 1906, 88; G 1944, 81; H 1970, 66; LM 1971, 76; W 1977, 64; W 1978, 85

One of seven or eight known proofs, on wove paper. Marx, Bliss collections.

A pen drawing signed and dated the same year as Duranty's short story (RW II 502; fig. a) is said to have belonged to the critic Jules Castagnary. The drawing and the two versions of the print pose a number of problems. Like the illustrations for *The Raven* (cat. 151), the prints are transfer lithographs, made from special ink drawings transferred onto zinc plates; one of these lithographs was drawn with the pen, like the drawing, and the other with a brush (H 67). The former was published in a periodical which has so far remained unidentified; one of the few known proofs has been cut from a printed page with an illustration by Bertall on the verso, titled *Plus de carnaval* (*No More Carnival*), with the printer's imprint "Lefman sc" dated February 16, 1874, and a text titled *Le Troubadour carnavalesque* (*The Carnival Troubadour*) and dated Paris, February 21, 1874.[3]

Although this version of the print closely resembles the drawing, Manet probably began with the less successful brush-drawn lithograph.[4] If this is so, the role of the pen-and-ink drawing is unclear. There is no other comparable drawing in Manet's oeuvre, with the exception of the very different *Interior at Arcachon* (cat. 128) of 1871 and the pen-and-ink drawing after the *Portrait of M. Pertuiset* of 1881 (cat. 208, fig. b). For his sketches from life—the seated man at the center of this composition, for example (RW II 501; fig. b)—Manet normally used a pencil (cat. 166, 167), although the use of the brush with ink or watercolor is recorded from the early 1860s (cat. 23, 28) and particularly with India ink from 1870 onward (cat. 159, 160, 163).

The brush lithograph was probably followed by this pen-drawn version, much more "readable" and better adapted to the printing process. The lines are lively and incisive, freely and confidently drawn. In spite of the date on the drawing, the handling of the print appears closer to that of the graphic works of the mid- to late 1870s: the plates of *The Raven* (cat. 151) of 1875, the wash drawing for *Le bouchon* (RW II 510) of 1878, and the brush drawing (RW II 524) and print (H 87) which are related to two paintings of 1879, *Corner in a Café-Concert* (cat. 172) and *Girl Serving Beer* (cat. 173). It should be pointed out, however, that there are so few securely dated examples of Manet's drawings between 1862 (see cat. 39) and 1882 (see cat. 214, fig. a) that it is often extremely difficult to assign a specific date to individual works.

The first café scene in Manet's work appears to be the one in the background of *The Street Singer* (cat. 32), where through the open swing doors can be glimpsed a waiter's white apron, the back of a chair, and a number of heads—one of them with a top hat. Later on come the variations on the theme of the Brasserie de Reichshoffen (RW I 278; cat. 172, 173) of 1879, followed by the final, great image of *A Bar at the Folies-Bergère* (cat. 211), of 1881–82. The transfer lithograph of this café was published in 1874, and it combines the "realism" of the 1860s and the "Impressionism" of Manet's later years. The waiter stands looking on with intent, amused interest at the card game in progress. The diminishing perspective of the card table is prolonged by the succession of billiard tables and their lamps in the background, almost giving the effect of a scene reflected endlessly in a mirror. At the center, an overcoat and top hat hanging on the wall establish the right edge of the view extending into the background space. Farther to the right, parallel planes—walls, doors, and perhaps part of a staircase—serve as a foil to the three standing figures. Caught in a lively pose, the waiter, with his almost cartoon-style sharp profile, is echoed by the distant figure of the billiard player waiting his turn.

Fig. a. *Café Interior,* 1869, pen and ink. Fogg Art Museum, Cambridge, Mass.

Fig. b. *Café Scene,* ca. 1868–74, pencil. Musée du Louvre, Cabinet des Dessins, Paris

In this multifigure composition Manet creates a complex play of spatial effects, balanced by an insistence on purely graphic qualities and linear accents that hold all the elements on the surface. The scene was undoubtedly based on sketches from life (fig. b) and has great immediacy and humor. The lack of information about the creation of the print for publication remains tantalizing.

Provenance
This proof appeared at the sale of the ROGER MARX collection (see Provenance, cat. 35).[5] It passed to F. E. BLISS (1847–1930), an American living in London and a passionate collector of nineteenth-century prints, particularly Legros,[6] and was later acquired by W. G. RUSSELL ALLEN (see Provenance, cat. 128), who gave it to the Museum of Fine Arts, Boston (inv. 27.1319).

J.W.B.

1. "Intérieur du Café Guerbois"; see Provenance, cat. 16, 17.
2. Reff 1982, no. 23.
3. Wilson 1977, no. 64, see addenda.
4. Harris 1970, no. 67, fig. 140. The proof reproduced from the New York Public Library has been extensively scraped to remove areas of printed ink.
5. Marx sale, Paris, April 27–May 2, 1914, lot 914.
6. Lugt 1921, no. 265; Lugt 1956, p. 41.

169. Café-Concert

1878
Oil on canvas
18⅝ × 15⅜″ (47.5 × 30.2 cm)
Signed (lower left): Manet
The Walters Art Gallery, Baltimore

Tabarant informs us that the setting of *Café-Concert* is the brasserie-concert Au Cabaret de Reichshoffen on the boulevard Rochechouart (see also cat. 172).[1] The interior of the Reichshoffen is also represented in *Corner in a Café-Concert* (cat. 172), *Girl Serving Beer* (cat. 173), and *At the Café* (RW I 278; cat. 172, fig. a).

With the exception of the top-hatted gentleman, every figure in the painting is either cropped by the edge of the canvas or overlapped by at least one adjacent figure; the composition consists almost exclusively of partially visible people, clothing, and objects. Indeed, the painting could serve as an illustration of the type of composition described in the following passage from Edmond Duranty's 1876 essay "La Nouvelle Peinture": "If one now considers the person, whether in a room or in the street, he is not always to be found situated on a straight line at an equal distance from two parallel objects; he is more confined on one side than the other by space. In short, he is never in the center of the canvas, in the center of the setting. He is not always seen as a whole: sometimes he appears cut off at mid-leg, half-length, or longitudinally."[2]

Although Duranty's essay addresses an exhibition at the Durand-Ruel gallery which included pictures by a group of avant-garde artists that did not include Manet, and the passage quoted here is generally believed to pertain to Degas's work, the essay describes "the new painting" in the broadest possible terms. Furthermore, Duranty chose not to cite the work of a particular artist to exemplify his observations, and by adopting such an approach he managed, probably intentionally, to accommodate the work of Manet. Despite Manet's refusal to exhibit with his friends, those artists whom we have long since labeled Impressionists, he was tacitly acknowledged as their leader, a fact that Duranty could not have ignored in 1876.[3] Although Manet continued to show work at the Salon, in 1880 he seems to have been willing to risk implicit identification with the Impressionists by holding a one-man show at the exhibition space on the premises of the weekly magazine *La Vie moderne*.

Exhibitions
Paris, La Vie Moderne 1880, no. 2 (Café-concert); New York, National Academy of Design 1886, no. 223; Paris, Durand-Ruel 1906, no. 18; London, Sulley 1906, no. 16; Berlin, Cassirer 1906, no. 15; Stuttgart 1906, no. 12; Munich, Heinemann 1907, no. 14; New York, Wildenstein 1948, no. 25; Philadelphia-Chicago 1966–67, no. 174; Washington 1982–83, no. 21

Catalogues
D 1902, 230; M-N 1926 II, p. 50; M-N cat. ms., 237; T 1931, 286; JW 1932, 303; T 1947, 300; PO 1967, 267; RO 1970, 267; RW 1975 I, 280

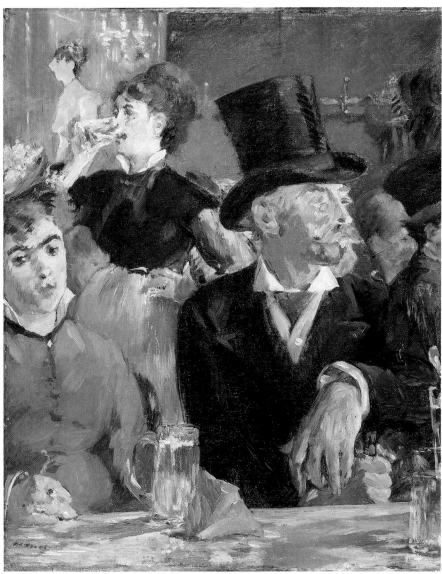

169

The gallery was run by Renoir's brother Edmond, and one of the artists scheduled to show shortly after Manet was Claude Monet. Item no. 2 in the checklist of works included in Manet's show was *Café-Concert*.

 The fragmented character of the composition and the cropping of figures may reflect Manet's long-standing admiration for Japanese prints, and the seemingly random disposition of people and objects may indicate the influence of photography, but the placement and postures of the figures seem intended to underscore the lack of social interaction between members of different classes. Public places such as brasseries undoubtedly provided a rare opportunity for individuals of different social status to mingle unselfconsciously, as is suggested by Renoir's *Le Moulin de la Galette*, 1876 (Musée d'Orsay-Galeries du Jeu de Paume, Paris). However, in *Café-Concert* the woman at the left, the waitress, the gentleman, and the working-class couple at the far right look in different directions. No one seems interested in La Belle Polonaise,[4] the singer on the stage, and everyone appears to have his or her

1. Tabarant 1931, pp. 334, 336; Tabarant 1947, p. 329.
2. Duranty 1876, quoted in Nochlin 1966, p. 6.
3. See above, Moffett, "Manet and Impressionism."
4. See Reff 1982, no. 21.
5. Moreau-Nélaton 1926, II, p. 52.
6. Meyer Schapiro, *Cézanne*, 3rd ed., New York, 1965, p. 10.

attention directed elsewhere in the room. Furthermore, not a single person displays even a hint of emotion. The only attempt at communication seems to be the eye contact established between the viewer and the woman in the left foreground, whom Moreau-Nélaton describes as an individual "of easy morals."[5]

The palette consists primarily of a limited range of blacks, grays, and browns, but throughout the composition there are touches of enlivening color, such as those in the tabletop and the hand of the woman at the extreme left. Although still controversial in 1878, such passages have long been celebrated as marvels of Impressionist technique. Indeed, the paint surface has a marked integrity of its own that is underscored by the well-defined brushwork, as can be seen, for example, in the face of the woman at the left, the glasses of beer, the blue object on the table, and the gentleman's face. It is clear that Manet delighted in both the physical presence and the manipulation of paint on the picture plane, and as a result the richly articulated paint surface has in itself a strong appeal.

In certain areas of the composition, the overlapping of figures and objects is apparently also intended to emphasize the two-dimensional aspect of the picture. Although the abstract and formal qualities of Manet's work are obviously less insistent than those of Cézanne's, it is significant that the following passage by Meyer Schapiro could also be used to describe *Café-Concert*: "Freely and subtly [Cézanne] introduced . . . many parallel lines, connectives, contacts, and breaks which help to unite in a common pattern elements that represent things lying on the different planes in depth. . . . these devices are the starting point of later abstract art, which proceeds from the constructive function of [his] stroke, more than from his color."[6]

7. Manet et al., "Copie faite pour Moreau-Nélaton. . . ," p. 79.
8. Boussaton sale, Paris, May 5, 1891, no. 61.
9. Rewald 1973, *Gazette des Beaux-Arts*, p. 107.
10. Letter from Charles Durand-Ruel, December 13, 1982 (archives, department of European paintings, The Metropolitan Museum of Art, New York).

Provenance
According to his account book, Manet sold this picture for 1,800 Frs in 1881[7] to the *commissaire-priseur* BOUSSATON. When his collection of nineteenth-century paintings was sold in Paris in 1891,[8] MONTAIGNAC bought this work for 1,100 Frs.[9] It later passed into the collection of the world-famous porcelain manufacturer CHARLES HAVILAND (1839–1921), whose son was portrayed by Renoir in 1884 (Nelson Gallery-Atkins Museum, Kansas City). By 1902, the picture was in the collection of FAURE (see Provenance, cat. 10), who sold it on March 13, 1907, to DURAND-RUEL (see Provenance, cat. 118), for 25,000 Frs. The dealer sold it for the same price on May 25, 1909, to HENRY WALTERS (1848–1931) of Baltimore.[10] The son of railroad magnate William T. Walters (1820–1894), Henry Walters had lived in France during the American Civil War, when his family was forced into exile because of his father's Confederate sympathies. He is reputed to have formed a close friendship with a member of the Durand-Ruel family at the lycée. Henry Walters inherited his father's art collection and spent much of his fortune expanding and refining it. To house the collection, he created the Walters Art Gallery, which first opened as a public museum in 1934 (inv. 37.893).

C.S.M.

170

170. In the Hall

1878–79
Pencil on squared paper
5⅛ × 6½" (13.1 × 16.6 cm)
Atelier stamp (lower right): E.M.
NY Musée du Louvre, Cabinet des Dessins, Paris

171. In the Hall

1878–79
India ink wash
8½ × 11" (21.5 × 27.9 cm)
Atelier stamp (lower center): E.M.
NY Musée du Louvre, Cabinet des Dessins, Paris

170
Catalogues
L 1969, 490; RW 1975 II, 523

171
Catalogues
L 1969, 492; RW 1975 II, 524

These two drawings hold a particular fascination because they bring us close to Manet's way of working. The pencil sketch was done from life, at a concert, on two pages of a small sketchbook, Manet being just behind the front rows of seats. The short, accurate notes later enabled him to execute the second, larger version in ink, with a more elaborate perspective but with the musicians remaining in the same position, beyond three rows of the audience.

He was later to use these notes in several works in various mediums. Thus, in a transfer lithograph known as *La belle Polonaise* (H 87), on the orchestra level, we recognize the violinist's bow at the left and two men's out-

171

lines taken from these sketches, the one far to the upper left and the small bearded head at the extreme right of the wash. The same figures reappear in the London version of *Corner in a Café-Concert* (cat. 172): the bearded profile and the bass viol can be seen over the barmaid's left shoulder, and the trombone at the left; the stage is also similarly placed.

We can thus appreciate how Manet in the studio recomposed, with the aid of models posed in the foreground, scenes that he "furnished" from drawings done from life or reworked in the studio. These are working materials, but the India ink wash is also a brilliant example of both the lively line and the conciseness that mark Manet's graphic style.

The London painting, then, is not a realistic representation of a scene at the Brasserie de Reichshoffen, as has been believed, but a composition, structured in the studio, that integrates observations of various scenes, those from the theater as well as the beer hall.

1. New York, Pierpont Morgan Library, Tabarant archives: Mme Manet's account book; Vollard 1937, p. 68.
2. Proust 1897, pp. 168, 180.
3. Pellerin sale, Paris, June 10, 1954, album nos. 4 (cat. 171), 5 (cat. 170).

Provenance 170–71
These drawings probably belong to the group acquired early in 1894 by the dealer VOLLARD (see Provenance, cat. 98) from SUZANNE MANET (see Provenance, cat. 12);[1] no. 171 was exhibited in 1895. Vollard still owned the latter in 1897, when it was reproduced in an article devoted to Manet.[2]

Some time later, these two drawings were acquired by AUGUSTE PELLERIN (see Provenance, cat. 100). The pencil sketch (RF 30.526) comes from album no. 5 and the wash (RF 30.523) from album no. 4, both acquired by the Musée du Louvre at the Pellerin sale in 1954.[3]

F.C.

172. Corner in a Café-Concert

1878 or 1879
Oil on canvas
38¼ × 30½" (98 × 79 cm)
Signed and dated (lower left): Manet / 7(9?)
P The Trustees of the National Gallery, London

According to Tabarant, in August 1878 Manet began a picture titled *Café-Concert de Reichshoffen*.[1] The establishment depicted, which is also seen in *Café-Concert* (cat. 169), was variously known as the Brasserie de Reichshoffen, Au Cabaret de Reichshoffen, A Reichshoffen, and simply Reichshoffen.[2] It is believed to have been situated on either the boulevard Rochechouart or the boulevard de Clichy, but is listed at neither address in the *Bottin* of 1879.[3] Before Manet finished *Café-Concert de Reichshoffen*, he cut it into two sections that were subsequently finished as independent works. The left side, approximately two thirds of the composition, became *At the Café* (RW I 278; fig. a). The remaining fragment, to which Manet added a strip of canvas about 7½ inches wide at the right, was completed as *Corner in a Café-Concert*.

The couple who posed as the top-hatted gentleman and the woman turned toward the viewer in *At the Café* are Manet's friends the engraver Henri Guérard and the actress Ellen Andrée,[4] but the model for the woman serving beer in *Corner in a Café-Concert* was apparently an actual waitress from the Reichshoffen. Duret and Moreau-Nélaton inform us that when Manet asked

Exhibitions
Paris, La Vie Moderne 1880, no. 3 (Coin de Café-Concert); Lyons 1883; Beaux-Arts 1884, no. 88; Paris, Drouot 1884, no. 10; London, Tate Gallery 1954, no. 14

Catalogues
D 1902, 228; M-N 1926 II, p. 52; M-N cat. ms., 238; T 1931, 284; JW 1932, 335; T 1947, 298; PO 1967, 266A; RO 1970, 266A; RW 1975 I, 311

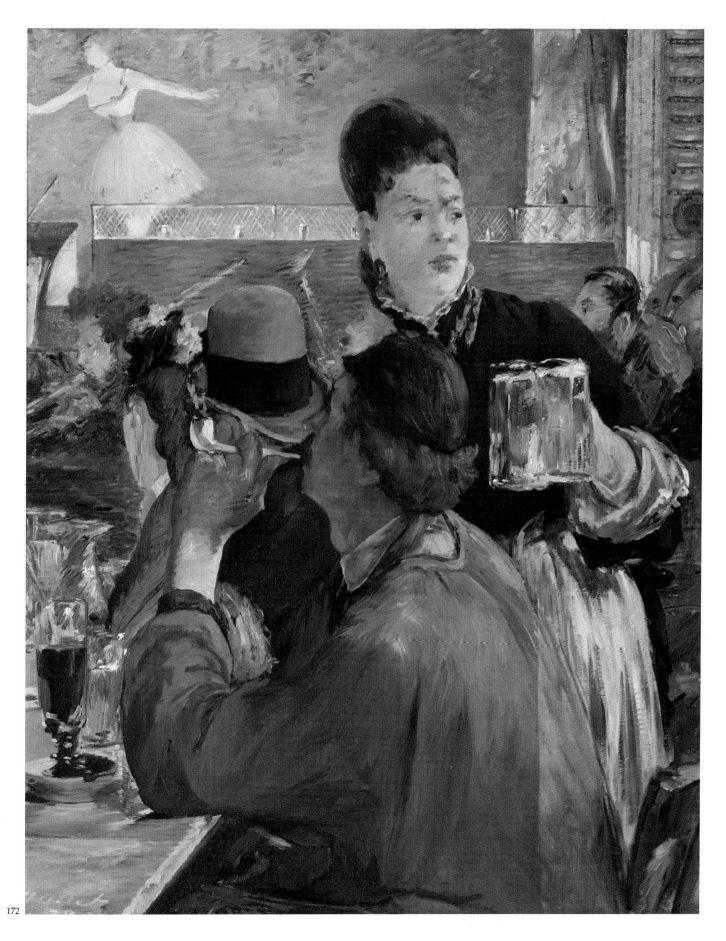

her to pose, she agreed to go to his studio (at that time, he was temporarily ensconced in the conservatory-like studio of the Swedish painter Otto Rosen, on the rue d'Amsterdam) only if accompanied by her *protecteur,* the pipe-smoking young man who appears in the foreground of the picture.[5] "Manet had noticed the position of the waitresses, who, while with one hand placing a beer on the table in front of a customer, knew how to hold several others in the other hand without spilling any beer. . . . Manet approached the one at the café whom he believed to be the most skillful."[6]

Tabarant asserts that an interval of several months elapsed between the completion of the two pictures.[7] *At the Café* is clearly signed and dated 1878, but Davies notes that the final digit of the date of *Corner in a Café-Concert* could be either an 8 or a 9.[8] If several months do in fact separate the reworking of the two segments, it is possible that *At the Café* was finished first, because it seems to have required less attention and reworking. The background, for example, appears to represent Manet's original conception, while that of *Corner in a Café-Concert* was entirely changed. Davies notes that X-rays of the London picture indicate "a patch on the left, the lower outline of which is horizontal and just above the top of the carafe on the table; it seems that this patch must be the remains of a continuation of the window occupying the background of *Au Café.*"[9] This information and the fact that Manet added a strip of canvas at the right indicate that *Corner in a Café-Concert* is the more extensively modified picture. The work could easily have overlapped into 1879; furthermore, the existence of a reprise of the composition (cat. 173) suggests that the project occupied his attention during an extended period of time.

Richardson proposes that it is this other version, for which we have retained the title *Girl Serving Beer* (cat. 173), rather than the picture in the National Gallery, that is the fragment cut from the *Café-Concert de Reichshoffen* and that constitutes the "missing half" of *At the Café.*[10] However, as Davies points out, "the shadows of some of the objects on the table at the left of [*Corner in a Café-Concert*] appear to continue the table seen at the right of *Au Café.*"[11] And as Reff observes, even though *At the Café* and *Girl Serving Beer* are the same in height, they are painted differently; the style of the London picture and *At the Café* is consistent, while that of the *Girl Serving Beer* is looser.[12] Moreover, since it is in fact possible to align the tabletop in *At the Café* with the one in *Corner in a Café-Concert,* the discrepancies "of scale and position of the various figures" that Richardson notes in comparing the two works appear to have been caused by Manet's having cut a horizontal section of canvas, about 8¼ inches in height, from the top of *At the Café.* Finally, there is no physical evidence in the *Girl Serving Beer* to suggest that it is a reworked fragment, but X-rays and pentimenti clearly indicate that the London version was subject to a variety of changes and revisions.

Reff suggests that the *Corner in a Café-Concert* was painted in 1877, not in 1878 or 1879 as is generally believed.[13] His principal reason is Callen's identification of the *Girl Serving Beer* with a picture known as *L'assommoir,* which Jean-Baptiste Faure purchased from Manet in 1877 for the astonishingly low price of 500 francs.[14] (Much earlier, Fénéon and Duret had suggested that the picture was executed in 1877, but neither offered any documentation.)[15] However, it is very unlikely that the London picture was painted in 1877, because the tattered poster in the window in the background of *At the Café* advertises the renowned Hanlon Lees clown-and-acrobat act, which opened at the Folies-Bergère May 24, 1878.[16] In short, *Corner in a Café-Concert* could not have been painted in 1877, and the picture known as *L'assommoir* must be another work.

Fig. a. *At the Café,* 1878. Sammlung Oskar Reinhart, Winterthur

1. Tabarant 1947, p. 328.
2. Tabarant 1931, p. 330; Bazire 1884, p. 130; Moreau-Nélaton 1926, II, p. 52.
3. Davies 1970, p. 100, no. 6; Reff 1982, no. 20.
4. Eudel 1885, pp. 173–74.
5. Duret 1902, pp. 107–8; Moreau-Nélaton 1926, II, p. 52.
6. Duret 1902, p. 107.
7. Tabarant 1947, p. 328.
8. Davies 1970, pp. 98–99.
9. Ibid., p. 99.
10. Richardson 1958, p. 129.
11. Davies 1970, p. 99.
12. Reff 1982, no. 20.
13. Ibid.
14. Callen 1974, p. 163.
15. Fénéon, in *Revue libre,* January 1884, p. 188; Duret 1902, pp. 249–50.
16. Tabarant 1947, p. 327.
17. Proust 1897, p. 311.
18. Manet et al., "Copie faite pour Moreau-Nélaton. . . ," p. 79.
19. Tabarant 1931, p. 333.
20. Rouart and Wildenstein 1975, I, p. 27, no. 21, "Tableaux et études" (300 Frs).
21. Eudel 1884, pp. 173–74; Bazire 1884, p. 71.
22. Manet sale, Paris, February 4–5, 1884, no. 10; Bodelsen 1968, p. 342.

Provenance

According to Antonin Proust, it was Méry Laurent (see cat. 215) who took FERNAND BARROIL to Manet's studio in 1879.[17] Barroil, about whom nothing is known except that he lived in Marseilles, paid 1,500 Frs for the painting "Reischoffen" (*sic*), according to the artist's account book.[18] Tabarant identifies "Reichshoffen" with the present *Corner in a Café-Concert*. Barroil evidently returned the picture to the artist almost immediately because his wife disliked it[19] (this anecdote, supplied by Tabarant, is similar to one he tells concerning the provenance of another picture, cat. 94). Three lines later, another entry in Manet's account book records Barroil's acquisition, in its place, of "Un coin de café" (*At the Café*, fig. a) for 2,500 Frs. The returned picture was probably the one referred to as "Café-concert" in Manet's posthumous inventory.[20] At the time of the Manet sale in 1884, it was said that this picture had originally been part of a large canvas that Manet had divided in two and that the other part was the picture then in Marseilles (RW I 278).[21] DURAND-RUEL (see Provenance, cat. 118) paid 2,500 Frs for the present painting at the Manet sale[22] and sold it to the collector CHARLES HAVILAND (see Provenance, cat. 169). On October 30, 1917, GEORGES BERNHEIM (see Provenance, cat. 20) sold it to M. KNOEDLER & CO. of New York. Founded in New York in 1846 by Goupil, the Knoedler gallery showed Durand-Ruel's Impressionist exhibitions, first organized in 1886. The National Gallery, London, acquired the present painting (inv. 3858) from Knoedler in November 1923, with funds provided by the Trustees of the Courtauld Fund.

C.S.M.

173. Girl Serving Beer

1879
Oil on canvas
30½ × 25⅝" (77.5 × 65 cm)
Inscribed (lower right, by Suzanne Manet): E. Manet
Musée d'Orsay (Galeries du Jeu de Paume), Paris

Exhibitions
Marseilles 1961, no. 22; Philadelphia-Chicago 1966–67, no. 195; Washington 1982–83, no. 20

Catalogues
D 1902, 229; M-N 1926 II, p. 52; M-N cat. ms., 239; T 1931, 285; JW 1932, 336; T 1947, 299; PO 1967, 266A; RO 1970, 266B; RW 1975 I, 312

The composition of this painting relates directly to that of *Corner in a Café-Concert* (cat. 172). It is often considered the second version, but the precise nature of the relationship between the two works has never been conclusively established. If it was painted in 1877, as Reff suggests,[1] it could be a study or a work preliminary to *Corner in a Café-Concert*; on the other hand, if it followed that picture, it must be considered a further reworking of the composition.

Reff proposes that Manet painted *Girl Serving Beer* after he cut the *Café-Concert de Reichshoffen* into two parts (see cat. 172) but before the fragments were independently reworked and finished as *At the Café* (cat. 172, fig. a) and *Corner in a Café Concert*. He argues that the Paris painting "was intended as a study for [*Corner in a Café-Concert*], to visualize it in its new, autonomous state." However, it seems just as plausible that *Girl Serving Beer* represents the final distillation of the compositional scheme, the composition indicating refinement rather than preparatory experimentation. Here Manet adopted a vantage point closer to the principal figures, eliminated the view of the cluttered tabletop, excised the musicians visible in the left and right middle ground, lowered the position of the stage and shifted it to the left, and considerably simplified the background, which is much closer to the viewer than in the London *Corner in a Café-Concert*.

The differences between the two versions are analogous to those of two photographs of the same scene, the first taken with a normal lens and the second taken with a telephoto zoom lens. In the *Girl Serving Beer*, the viewer is closer to the principal subject, which is itself larger in proportion to the framing edges of the picture. The depth of field has contracted, and Manet changed or eliminated many extraneous details. Moreover, in having the waitress return the viewer's gaze, Manet created a compositional focus that the

1. Reff 1982, no. 20.

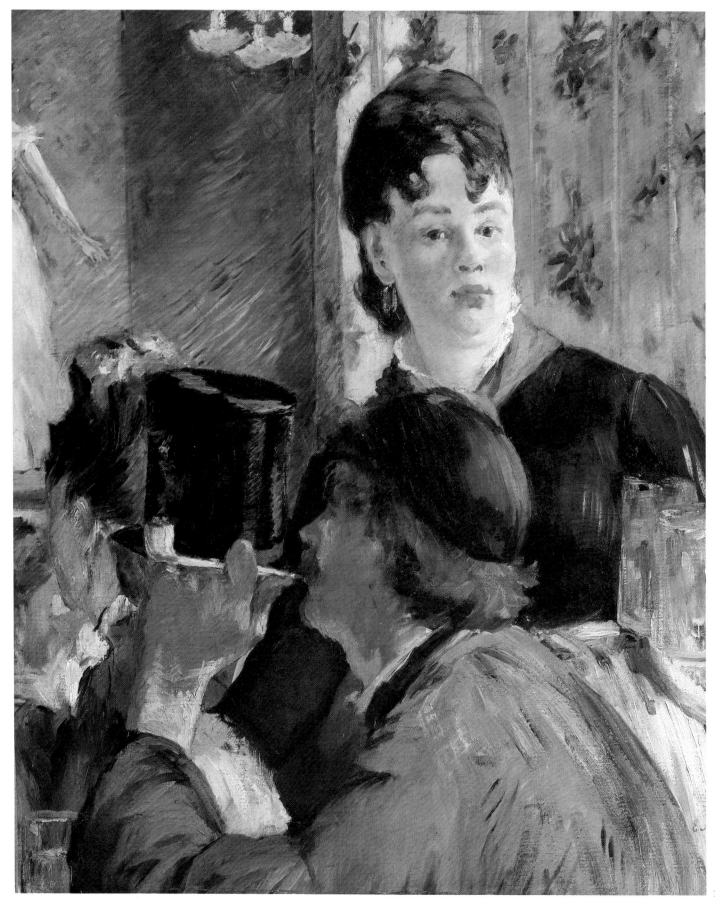

2. Manet sale, Paris, February 4–5, 1884, no. 10;
 Bodelsen 1968, p. 342.
3. Davies 1970, pp. 98–101.
4. Duret 1902, no. 229.
5. J. Manet 1979, pp. 213–14.
6. Rouart and Wildenstein 1975, I, no. 312.
7. Vollard 1937, pp. 124–29, 226–27, 349.
8. Cochin sale, Paris, March 26, 1919, no. 18, cited
 in Tabarant 1931, p. 334.
9. Gimpel 1966, pp. 170–71 : October 13, 1921.

Provenance
The provenance for this picture is puzzling. Many scholars have identified the work with one bought from Manet in 1879 by Fernand Barroil, but laboratory evidence and the dimensions given in the catalogue of the Manet sale[2] strongly indicate that he owned the other version (cat. 172).[3] The present picture was first recorded by Duret as being in the collection of AUGUSTE PELLERIN (see Provenance, cat. 109).[4] It was not included in the posthumous inventory or in the sale, and since the signature was added by the artist's widow, one is tempted to speculate that she discovered it in some odd corner. Manet surely would have signed the work if he had sold it himself, and noted the transaction in his account book. Unfortunately, Suzanne Manet's account book gives no further indications concerning the sale of this picture. Pellerin evidently did not yet own it in 1899, since Julie Manet does not mention it in her description of a visit to his house on January 27 of that year.[5] According to Rouart and Wildenstein, the picture passed from Pellerin to BERNHEIM-JEUNE (see Provenance, cat. 31) in 1907.[6] Whatever the case, the painting surely came into the possession of BARON DENYS COCHIN, whose eccentricities as a collector are delightfully described by Vollard.[7] At the Cochin sale in 1919, the work, valued at 100,000 Frs, was bought in for 73,000 Frs.[8] The lack of interest in this picture is surprising, since in the same year, Rosenberg valued a comparable painting by Manet (cat. 165) at 500,000 Frs. Cochin subsequently sold *Girl Serving Beer* to BERNHEIM-JEUNE, and the gallery sold it in turn to PRINCE KOJIRO MATSUKATA of Tokyo, who "burst upon Europe [in 1921] and cleaned the dealers out of modern pictures to set up a museum in Tokyo. He spent up to 800,000 francs with Georges Bernheim, and even more with Durand-Ruel," according to Gimpel.[9] Matsukata transported a large part of his collection back to Japan during the following years; but the pictures that remained in France were sequestered during World War II. Upon release of his art holdings in 1959, this work became the property of France and entered the Musée du Louvre (inv. RF 1959.4). In the same year, some four hundred of Matsukata's pictures were restituted to Japan and entered the collection of the National Museum of Western Art in Tokyo.

C.S.M.

London picture lacks. The comparatively scattered quality of the London version may have resulted in part from the artist's attempt to create a composition from a fragment limited by a predetermined figure scale and spatial arrangement. Perhaps only upon seeing the finished picture did Manet see how it could be improved. It appears, therefore, that the fragment finished as *Corner in a Café-Concert* served as the experimental variant of or "study" for the *Girl Serving Beer,* and not vice versa.

174. Reading (Reading *L'Illustré*)

1879
Oil on canvas
24¼ × 19⅞" (61.7 × 50.7 cm)
Signed (lower left): Manet
The Art Institute of Chicago

Exhibitions
Beaux-Arts 1884, no. 92; Paris, Bernheim-Jeune 1928, no. 25; New York, Wildenstein 1937, no. 29; Philadelphia-Chicago 1966–67, no. 161; Washington 1982–83, no. 22

Catalogues
D 1902, 255; M-N 1926 II, p. 53; M-N cat. ms., 242; T 1931, 293; JW 1932, 334; T 1947, 297; PO 1967, 261; RO 1970, 262; RW 1975 I, 313

Reading is the least typical of Manet's café paintings. In the others, he emphasizes a less sympathetic ambience and focuses on a clientele that generally reflects a lower social position than that of the figure seen here. For example, unlike the dejected young woman depicted in *The Plum* (cat. 165), who, according to Tabarant, is also seated at a table in the Café de la Nouvelle-Athènes,[1] the stylishly dressed figure in *Reading* seems completely content with her surroundings. She enjoys a glass of beer while perusing an illustrated periodical, borrowed from the café's reading rack, probably similar in kind to *La Vie moderne,* the recently inaugurated chronicle of artistic, social, and literary life in Paris.[2]

The spirited execution of *Reading* contributes significantly to the appeal of the painting. In certain areas, the open, rapidly stroked brushwork creates a decorative, quasi-abstract effect that is extremely effective as a foil for the comparatively unbroken rich fields of black created by the figure's hat and clothing. Indeed, the paint handling in the background is so nonillusionistic that the intended imagery remains more or less unrecognizable. Tabarant identifies it as a "mirror with a frame"; Hanson suggests that it "may be, instead, a window opening onto the garden beyond"; and Reff proposes that it "could as well be a painting or a wall hanging."[3] In addition, the background might easily be a stylization of some aspect of the Swedish painter

Otto Rosen's studio, which Manet occupied from early July 1878 through March 1879. Undoubtedly, the unidentified model posed either there or at the nearby studio that Manet occupied beginning in April. Since we know that aspects of at least some of Manet's café pictures (see cat. 169) are either approximations of real places or wholesale fabrications, it is possible that the background of *Reading* is either interpolated or fictitious.

The paint handling in the areas of the woman's tulle collar consists of a combination of quick but relatively dry strokes to indicate the folds and the diaphanous quality of the material. Considering Manet's predilection for well-worked, fluidly articulated surfaces, this passage is noteworthy. It underscores the fact that Manet was as accomplished a practitioner of the Impressionist idiom as of the more conservative technique he used for such works as *In the Conservatory* (cat. 180), which was exhibited at the Salon that year. As Hanson observes, *Reading* "amply demonstrates all the sureness of touch which Manet had at his command in the late 1870s. No attempt has been made to 'finish' the painting beyond the obvious rightness of the placement of the color areas and active lines."[4]

Tabarant tells us that the woman depicted here was known as "Trognette," a pejorative term for someone with a bloated face.[5] Whether it was in fact the model's nickname seems inconsequential, because the image itself presents a dignified, apparently affluent woman. Like many of the other women Manet painted in the late 1870s, this well-to-do individual appears to be a characteristic Parisian type representative of a certain aspect of "la vie moderne."

1. Tabarant 1947, pp. 314, 327.
2. Reff 1982, no. 22.
3. Tabarant 1947, p. 327; Hanson 1966, p. 173; Reff 1982, no. 22.
4. Hanson 1966, p. 173.
5. Tabarant 1947, p. 328; Reff 1982, no. 22.
6. Manet et al., "Copie faite pour Moreau-Nélaton. . . ," p. 81.
7. Callen 1974, p. 168.
8. Tabarant 1931, p. 341.
9. Hanson 1966, no. 161.

Provenance
Manet's account book records the sale of this picture, "Liseuse" (woman reading), to FAURE (see Provenance, cat. 10) in 1882 for 500 Frs[6]—a bargain price, according to Eugène Manet.[7] At Faure's death in 1914, the painting was inherited by his son MAURICE FAURE.[8] It subsequently appeared in the hands of the dealer HOWARD YOUNG in New York[9] and then entered the important collection of Impressionist paintings belonging to ANNIE SWAN COBURN, which was bequeathed to the Art Institute of Chicago in 1933 as the Mr. and Mrs. Lewis Larned Coburn Memorial Collection (inv. 33.435).
C.S.M.

175. George Moore at the Café

1878 or 1879
Oil on canvas
25¾ × 32" (65.4 × 81.3 cm)
The Metropolitan Museum of Art, New York

Before the Irish critic and novelist George Moore (1852–1933) became a writer, he wanted to be a painter. On his twenty-first birthday, in March 1873, he arrived in Paris, where he enrolled in classes at the Ecole des Beaux-Arts and studied with Cabanel. He later attended classes at the Académie Julian, but by 1876 he had decided to devote himself to writing. As Denys Sutton has pointed out, "He had the good fortune to meet Villiers de l'Isle-Adam, who took him to Mallarmé's famous *mardis* in the rue de Rome. What Moore called 'the great turning point in his stay in Paris occurred when the poet gave him a copy of [his] *L'Après-midi d'un faune* with illustrations by Manet. He was thrilled by the drawings, and Mallarmé, according to Moore, told the painter about his enthusiasm and suggested that the young Irishman would make a good model."[1]

George Moore himself described his first meeting with Manet: "It was a great event in my life when Manet spoke to me in the café of the Nouvelle

Exhibitions
Paris, Drouot 1884, no. 58; Salon d'Automne 1905, no. 31; Paris, Bernheim-Jeune 1928, no. 35; Orangerie 1932, no. 68; Philadelphia-Chicago 1966–67, no. 145

Catalogues
D 1902, not mentioned; M-N 1926 II, p. 54; M-N cat. ms., 248; T 1931, 290; JW 1932, 337; T 1947, 304; PO 1967, 251; RO 1970, 252; RW 1975 I, 296

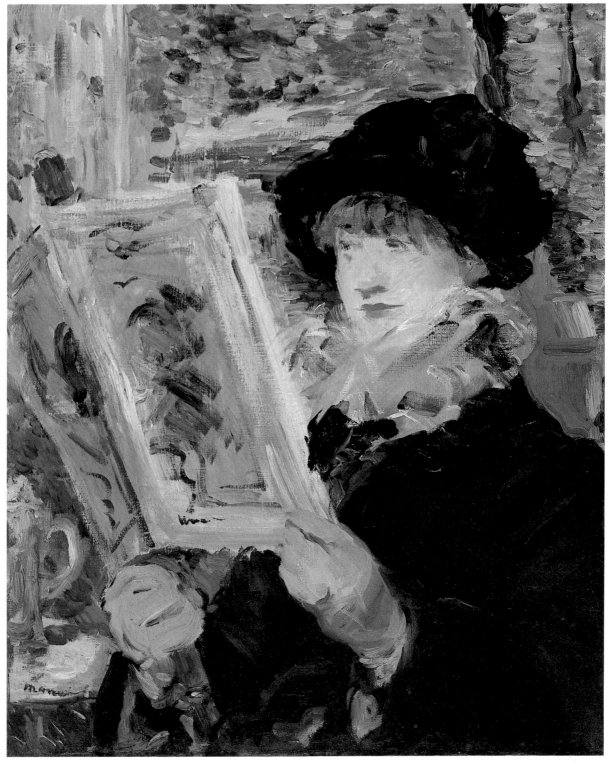

174

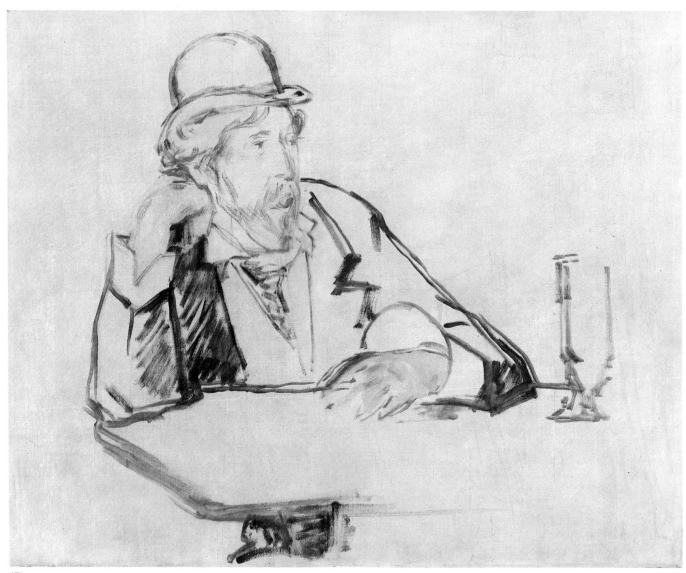

175

Athènes. I knew it was Manet, he had been pointed out to me. . . . I entered eagerly into conversation, and next day I went to his studio. It was quite a simple place. . . . There was very little in his studio except his pictures: a sofa, a rocking-chair, a table for his paints, and a marble table on iron supports, such as one sees in cafés. Being a fresh-complexioned, fair-haired young man, the type most suitable to Manet's palette, he at once asked me to sit. His first intention was to paint me in a café; he had met me in a café, and he thought he could realise his impression of me in the first surrounding he had seen me in."

In the passages that follow, Moore describes his astonishment when, a few days later, Manet scraped the paint from the picture he had started and began afresh: "He painted it again and again; every time it came out brighter and fresher, and the painting never seemed to lose anything in quality."[2] The process of scraping and repainting is consistent with what we know about other portraits in the late seventies, such as the unfinished portrait of Mme Manet in the Metropolitan Museum of Art, New York (RW I 117), which was abandoned after Manet attempted the face three separate times.

1. Denys Sutton, "The Vase and the Wash-Tub," *Apollo*, CIII (March 1976), p. 168; see also Pickvance 1963, p. 279.
2. Moore 1898, pp. 30–32.

3. Hanson 1977, p. 159; see also above, Hanson, "Manet's Pictorial Language."
4. Pickvance 1963, p. 279.
5. Manet sale, Paris, February 4–5, 1884, no. 58, "Au café, ébauche"; Bodelsen 1968, p. 344.
6. Chabrier sale, Paris, March 26, 1896, no. 14.
7. Chéramy sale, Paris, May 5–7, 1908, no. 218.
8. Hanson 1966, p. 158.

Provenance
At the Manet sale in 1884, this picture was purchased for 110 Frs by the composer ALEXIS-EMMANUEL CHABRIER (see Provenance, cat. 211).[5] When his collection was sold in 1896, *George Moore at the Café* was acquired for 750 Frs by PAUL CHERAMY (see Provenance, cat. 1).[6] At the sale of the latter's collection in 1908, AMBROISE VOLLARD (see Provenance, cat. 98) bought the picture for 625 Frs.[7] It subsequently passed to ALBERT S. HENRAUX of Paris, who owned it from about 1929 to 1946 or later.[8] M. KNOEDLER & CO. (see Provenance, cat. 172) acquired it from the Swiss dealer WALTER FEILCHENFELDT in February 1951 and sold it in 1954 to MRS. RALPH J. HINES (née Mary Elizabeth Borden, 1909–1961), who gave it to the Metropolitan Museum in 1955 (inv. 55.193).

C.S.M.

George Moore at the Café, too, seems to have been abandoned, but at the very earliest stage. It has the character of a large drawing, and it underscores the artist's considerable abilities as a draftsman with a brush. As Hanson has observed, "It is not only a beautiful brush drawing in itself, but it offers us a remarkable opportunity to see how Manet worked. The figure was briskly drawn in oil essence directly on the canvas without any preliminary pencil or charcoal drawing. Even in this initial drawing, however, Manet established not only the form but the color relationships. . . . On the hands, Manet has begun the second step, that of building up his color areas with denser paint."[3]

George Moore at the Café, *Portrait of George Moore* (cat. 176), and the unfinished portrait of Moore in the garden next to Manet's studio (RW I 297) were probably all painted in the late summer of 1878 or in the spring of 1879. Pickvance has pointed out that in *Avowals* (1919), Moore gives the address of Manet's studio as 73, rue d'Amsterdam. Although the street number was actually 77, it must have been the studio on the rue d'Amsterdam to which Manet moved in July 1878. Pickvance concludes that Manet and Moore must have met "after July 1878, when Manet took this studio—most probably in the spring of 1879, as Moore was absent from Paris in the previous autumn and winter."[4]

176. Portrait of George Moore

1879
Pastel on canvas
21¾ × 13⅞" (55.3 × 35.3 cm)
Signed (lower left, on chair back): Manet
NY The Metropolitan Museum of Art, New York

Exhibitions
Paris, La Vie Moderne 1880, no. 15 (Portrait de M. G.M.), Beaux-Arts 1884, no. 153; Paris, Drouot 1884, no. 96

Catalogues
D 1902, 67 (pastels); M-N 1926 II, p. 65; M-N cat. ms., 362; T 1931, 30 (pastels); JW 1932, 365; T 1947, 475; PO 1967, 278B; RO 1970, 278B; RW 1975 II, 11 (pastels)

The pastel medium seems to have provided Manet with a particularly effective means of portraying George Moore's somewhat eccentric appearance. Indeed, he clearly overcame the difficulties he encountered in trying to *paint* Moore's portrait (see cat. 175). Manet executed the pastel during a single sitting, something he seldom managed to do. Antonin Proust quotes Manet as having complained that it was often difficult for him to secure an adequate number of sittings for a portrait, but that George Moore presented a very different kind of problem: "And then on the other hand, there are some who come back unbidden, wanting me to revise, which I won't do. There's my portrait of the poet Moore. In one session, I thought that was that; but not he. He came bothering me, wanting a change here, an alteration there. I won't change a thing. Is it my fault that Moore has that look of a broken egg yolk, or if the sides of his face are not aligned? —which, by the way, is true for all of us; the plague of our times is the need for symmetry. There is no symmetry in nature. One eye never matches the other, it's always different. We all have more or less crooked noses, our mouths are always irregular."[1]

When *Portrait of George Moore* was exhibited at the Galerie de La Vie Moderne in 1880, the public apparently shared both Moore's feelings about

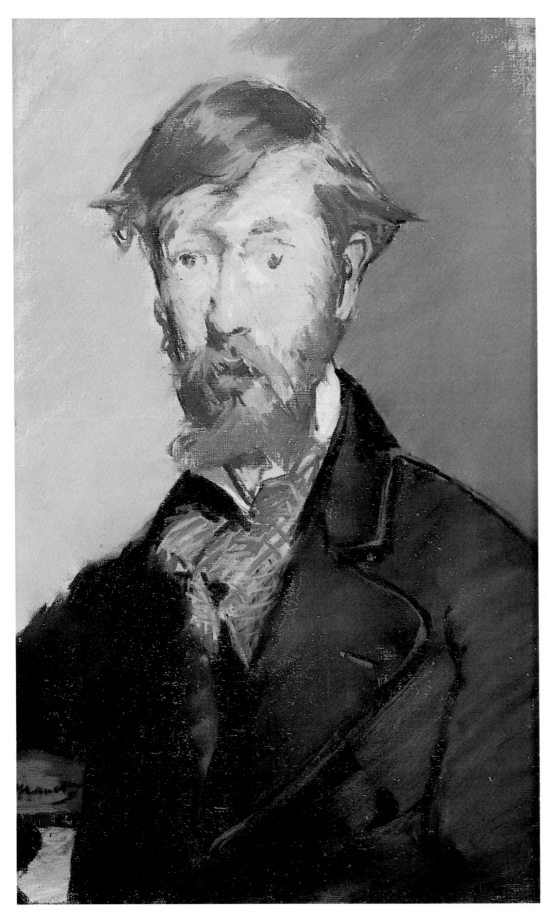

the picture and Manet's opinion of Moore. Jacques-Emile Blanche later wrote: "Before I made [Moore's] acquaintance, Manet's portrait of him (1880) had already roused the public's ridicule; both the artist and his model had achieved the distinction of caricaturist and caricature which neither at that time appreciated. Fools used to call the *Dandy des Batignolles* 'the drowned man taken out of the water.' In this painting [*sic*], Moore's pale blue eyes, that toned in with the colour of his face, and his chiseled pout, filled those with mirth who were unable to identify this amazing character."[2]

Moore himself, in a letter written to his brother in 1912, implied that he was embarrassed by Manet's pastel;[3] nevertheless, he chose it for the frontispiece of his volume of collected essays, *Modern Painting* (1893). Ronald Pickvance has noted that Moore "was singularly unlucky in his portraits: the Manet pastel was known as *Le noyé repêché* [the drowned man fished out of the water], he thought a portrait by Blanche made him 'look like a drunken cabby,' while Sickert's painting, exhibited at the New English Art Club in 1891, was variously called 'an intoxicated mummy,' 'a boiled ghost' and 'a leprous portrait.' "[4]

While *George Moore at the Café* (cat. 175) depicts an individual who looks like a jaded café habitué, the pastel seems to corroborate Duret's description of him as a "golden-haired fop, an aesthete before the days of Wilde,"[5] but others, including Manet, Degas, and Mallarmé, admired him. Degas, who also drew a portrait of Moore in 1879 (Ashmolean Museum, Oxford), gave the impression in a conversation with Daniel Halévy in 1890 that Moore occupied a respected position in the circle of well-known artists and writers who frequented the Café de la Nouvelle-Athènes. Halévy asked Degas if he knew Zola when *L'Oeuvre*, Zola's novel about a contemporary painter who bears similarities to both Manet and Cézanne, was published. Degas replied, "No—(his face lighting up)—it was before, with Manet, Moore, at the Nouvelle-Athènes. We used to talk about things interminably."[6]

1. Proust 1897, pp. 306–7.
2. Blanche 1937, pp. 136–37.
3. Cooper 1945, p. 120.
4. Pickvance 1963, p. 279.
5. Cooper 1945, p. 120.
6. Daniel Halévy, quoted in Pickvance 1963, p. 279.
7. Manet sale, Paris, February 4–5, 1884, no. 96; Bodelsen 1968, p. 342.
8. Duret 1902, no. 67.

Provenance
At the Manet sale in 1884, this pastel was knocked down for 1,800 Frs to Jacob,[7] who was acting as agent for an unknown collector. In 1902, Duret identified the owners as MR. AND MRS. H. O. HAVEMEYER (see Provenance, cat. 33) of New York.[8] Mrs. Havemeyer bequeathed it to the Metropolitan Museum in 1929 (inv. 29.100.55).

C.S.M.

177. Portrait of a Young Blond Woman with Blue Eyes

1878?
Pastel on board
24¼ × 19⅞" (61.5 × 50.5 cm)
Atelier stamp (lower right): E.M.
P Musée du Louvre, Cabinet des Dessins, Paris

Exhibitions
Paris, Drouot 1884, no. 117

Catalogues
D 1902, 54 (pastels); M-N cat. ms., 418; T 1931 (pastels); JW 1932, 354; T 1947, 470; PO 1967, 258B; RO 1970, 259B; RW 1975 II, 9 (pastels)

This portrait, with its undeniable charm and easy grace, is one of the few, among Manet's superb output in pastel, that recall the comments by Duret, who saw in the abundant production in this medium toward the end of the artist's life a growing fatigue with the labor of painting: "Pastel was for him a comparatively easy exercise, a diversion, and gained him the company of the engaging women who came to pose for him."[1] According to his friends Blanche and Duret, Manet hoped for public success, and was bitterly envious of that of the painter Chaplin.[2] But save for such close friends as Méry Laurent, or

177

enthusiastic testimonials from his models in letters like those of Madeleine Lemaire's daughter[3] and Valtesse de la Bigne (RW II 14), success eluded him: "In April 1880 he showed a series of works, predominantly pastels, at [the gallery of] *La Vie moderne*, and most of them were for sale. Exactly two were sold."[4]

 It has been thought, as Léon Leenhoff indicated on the photograph of a sketch for this work (RW II 8), that the sitter, the epitome of Parisian chic, was the actress Ellen Andrée,[5] who had posed for *Chez le père Lathuille* (RW I 291) and whose most famous likeness appears with that of Marcellin Desboutin in Degas's *L'absinthe* (Musée d'Orsay-Galeries du Jeu de Paume, Paris).

 On the photograph of this pastel, Léon Leenhoff made the notation "très effacé,"[6] which suggests that the doll-like appearance of the face may have resulted in part from some restoration.

1. Duret 1926, p. 175.
2. Blanche 1924, p. 49.
3. Paris, Bibliothèque d'Art et d'Archéologie, Manet archives.
4. Duret 1926, p. 176.
5. Tabarant 1947, p. 336.
6. Ibid., p. 337.
7. Manet sale, Paris, February 4–5, 1884, no. 117; Bodelsen 1968, p. 343.

Provenance
At the Manet sale in 1884, this pastel was purchased for 225 Frs by M. LASQUIN.[7] It subsequently remained in Paris, in the GROULT-MOTTARD family, and was bequeathed to the Musée du Louvre by MME PAUL MOTTARD in 1945 (inv. RF 29.470).

 F.C.

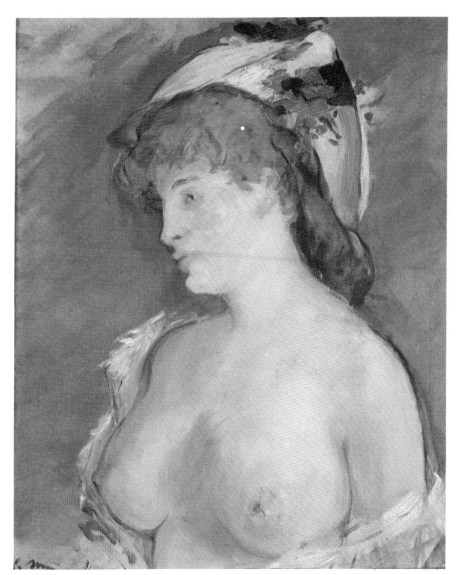

178

Fig. a. Tintoretto, *Lady Uncovering Her Breast.*
Museo del Prado, Madrid

178. The Blonde with Bare Breasts

1878?
Oil on canvas
24½ × 20¼″ (62 × 51.5 cm)
Signed (lower left): E.M
P Musée d'Orsay (Galeries du Jeu de Paume), Paris

More perhaps than any other, this work demonstrates Manet's virtuosity in an art of pure enjoyment, preserving—more successfully than Renoir, whom he here seems to challenge on his own ground—an elegance in the "carnal."

This painting bears some analogy to a Tintoretto of similar size that Manet may have seen at the Prado, *Lady Uncovering Her Breast* (fig. a), which shows a young woman, with blond hair caught up, facing the other way but

Exhibitions
Orangerie 1932, no. 60; Orangerie 1952, without no.

Catalogues
D 1902, 254; M-N 1926 II, p. 35; M-N cat. ms., 200; T 1931, 270; JW 1932, 257; T 1947, 286; PO 1967, 239; RO 1970, 240; RW 1975 I, 287

similarly unveiling her opulent bosom, outlined by her undergarment. Yet Manet seldom so closely approached the Impressionists, Renoir in particular, as here. The technique is flowing and rapid; X-ray examination reveals a voluptuous modeling of forms with the brush, especially the left breast, "sculptured" in the round.

According to Mme Manet's entry in her account book at the time of sale, the model was Amélie-Jeanne,[1] the same young woman who probably posed for the pastels of women dressing (RW II 22, 23). According to Tabarant, however, the model was Marguerite.[2] The date is also hypothetical; Tabarant and Wildenstein place the painting in 1878, and Moreau-Nélaton dates it 1875, together with *The Brunette with Bare Breasts* (cat. 129). Moreau-Nélaton's dating is based on association with *La parisienne* (RW I 236), which he believes to have been posed by the same model. But according to Mme Manet, Ellen Andrée posed for *La parisienne*.[3] In any case, the style places the work between 1875 and 1879. The hat also seems to be in the fashion of the late 1870s or early 1880s.

1. New York, Pierpont Morgan Library, Tabarant archives.
2. Tabarant 1947, p. 290.
3. New York, Pierpont Morgan Library, Tabarant archives: Mme Manet's account book.
4. Ibid.

Provenance
This work was sold by SUZANNE MANET (see Provenance, cat. 12) to VOLLARD (see Provenance, cat. 98) on March 26, 1894: "Amélie-Jeanne, buste nue [*sic*] P. 500 fr" (Amélie-Jeanne, bare bust for 500 Frs),[4] which seems a very low price for the period. It was later acquired by MOREAU-NELATON (see Provenance, cat. 62), bequeathed by him in 1927, and temporarily exhibited with his collection at the Musée des Arts Décoratifs, before entering the Musée du Louvre in 1934 and the Galeries du Jeu de Paume in 1947 (inv. RF 2637).

F.C.

179. Woman in the Tub

1878–79
Pastel on board
21¾ × 17¾" (55 × 45 cm)
Signed (lower right, on chair): Manet
P Musée du Louvre, Cabinet des Dessins, Paris

Manet created four superb pastels of nude women at their toilet. Tabarant believes they all represent the same model, named Marguerite, who also posed for *The Blonde with Bare Breasts* (cat. 178).[1] In this case, however, the subject appears to be other than a professional model; there are strong reasons to believe that the nude was posed by Méry Laurent. A poem written by Henri de Régnier on the occasion of an exhibition of works by Manet—it is difficult to pinpoint the event, but it must have been shortly before 1900, at Durand-Ruel or Bernheim-Jeune—is titled "Edouard Manet" and dedicated "to a lady who knew Manet":

Madame, je vous ai connue	Madam, it was later on
Un peu plus tard et celle qui n'est	That I met you, of a day
Déjà plus la baigneuse nue	When the bathing nude was gone,
Qu'avait peinte jadis Manet	Sometime painted by Manet;
Entre des murs tendus de perse	Walls of chintz and ceiling rose,
Sous la rosace du plafond	Water fills the sponge to scrub
Et qui, de l'éponge, se verse	Neck and shoulders, and it flows
Aux épaules l'eau du tub rond	Down into the rounded tub—

Exhibitions
Salon d'Automne 1905, no. 29; Paris, Bernheim-Jeune 1928, no. 39

Catalogues
D 1902, 66 (pastels); M-N 1926 II, p. 68; M-N cat. ms., 380; T 1931, 9 (pastels); JW 1932, 424; T 1947, 462; PO 1967, 243; RO 1970, 244; RW 1975 II, 24 (pastels)

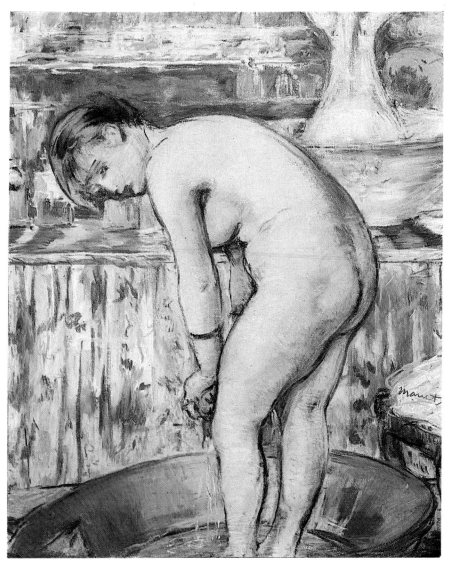

179

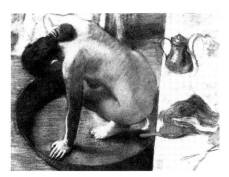

Fig. a. Edgar Degas, *The Tub*, ca. 1886, pastel.
Musée du Louvre, Cabinet des Dessins, Paris

Les deux portraits où, son modèle,
Vous offrîtes à son pinceau
Votre manière d'être belle
Etaient la gloire du panneau:

L'un vous montrait avec la toque
S'abaissant jusques aux sourcils. . . . [2]

Those two magic portraits where
You gave him the gift to know
Your own way of being fair
Were the glory of the show:

One presents you in a hat
Pulled down nearly to the brows. . . .

Besides the "baigneuse nue," one of the portraits mentioned in the poem is *Woman in Furs* (cat. 216), which indeed represents Méry Laurent.

Henri de Régnier and Méry Laurent were close friends in the 1890s, and she must have told him herself that she had posed for this intimate scene. She had established her reputation by appearing seminude on various occasions during the Second Empire, and even after she became an established *cocotte* would not have hesitated to pose undressed for her friend Manet, whom some affirm to have been her lover (see cat. 215).

433

Whoever the model was, this pastel is one of Manet's finest on the theme, together with *Woman with Garter* (RW II 22). It presents all the characteristic features of Manet's art: a very special blend of spontaneity and freshness—a gentle eye, one might say—with rigorous composition and a taste for clear curved lines across horizontals that subdivide the background of the picture: mirror, dressing table, flowered cretonne in subtly colored folds.

Degas was to make systematic use of the large-tub motif, but as a means of presenting his models as fine "human animals," seemingly caught unaware (fig. a); here, the woman posing looks at the artist unafraid, confident that her nude body, though imperfect, encounters a friendly and indulgent gaze.

This nude raises many questions of artistic priority between Manet and Degas. After Manet's death, Degas worked out his brilliant series of women dressing, or in the tub, generally viewed from above and in more complex positions. Even though Degas and Manet were not very close in the years from 1876 to 1880, Degas would have seen Manet's pastels exhibited in 1880, and they may have influenced him in adopting the theme. Nevertheless, Degas was the first to execute, in monotype heightened with pastel, scenes of women at their toilet—less innocent than Manet's, they depict scenes in houses of prostitution—from 1877 on. We do not know whether Manet ever saw them; according to Degas, he certainly had: "That Manet! always imitating. . . . When I did ballet dancers, so did he."[3] But beyond Degas's women at their toilet, in which the raised vantage point is more sophisticated, imposing, and revealing, Manet's *Woman in the Tub* prefigures the gentleness of Bonnard's boudoir scenes.

1. Tabarant 1931, p. 451; Tabarant 1947, p. 321.
2. Henri de Régnier, *Vertigia Flammae*, Paris, 1922, pp. 233–34.
3. D. Halévy 1960, p. 110.

Provenance
This pastel was not included in the Manet sale in 1884; it was sold, probably by the family, to the important collector of Impressionist paintings ED-MOND DECAP of Rouen. It was in the BERNHEIM-JEUNE collection (see Provenance, cat. 31) by 1905, when Josse Bernheim lent it to the retrospective exhibition at the Salon d'Automne. It remained in the family until its acquisition by the Musée du Louvre in 1973 (RF 35.739).

F.C.

180. In the Conservatory

1879
Oil on canvas
45¼ × 59″ (115 × 150 cm)
Signed and dated (lower left): Manet 1879
Nationalgalerie, Staatliche Museen Preussischer Kulturbesitz, Berlin

About ten years after completing *The Balcony* (cat. 115), Manet took up what appears to be a quite similar theme: elegant figures posed halfway between outdoors and indoors. They form a geometrical composition in which the slender spindles of the bench serve the same function as the green ironwork in *The Balcony*. If the hatched technique and clear color seem Impressionist, nothing is more strict and classical than the linear structure of the composition, the center being a square, three sides of which are defined by the woman's right shoulder, the parasol, and the man's left arm, with the two ringed

Exhibitions
Salon 1879, no. 2010 (Dans la serre); Beaux-Arts 1884, no. 90; New York, National Academy of Design 1886, no. 192; Berlin, Matthiesen 1928, no. 50; Orangerie 1932, no. 67; Philadelphia-Chicago 1966–67, no. 163

Catalogues
D 1902, 251; M-N 1926 II, p. 56; M-N cat. ms., 261; T 1931, 295; JW 1932, 296; T 1947, 312; PO 1967, 268; RO 1970, 268A; RW 1975 I, 289

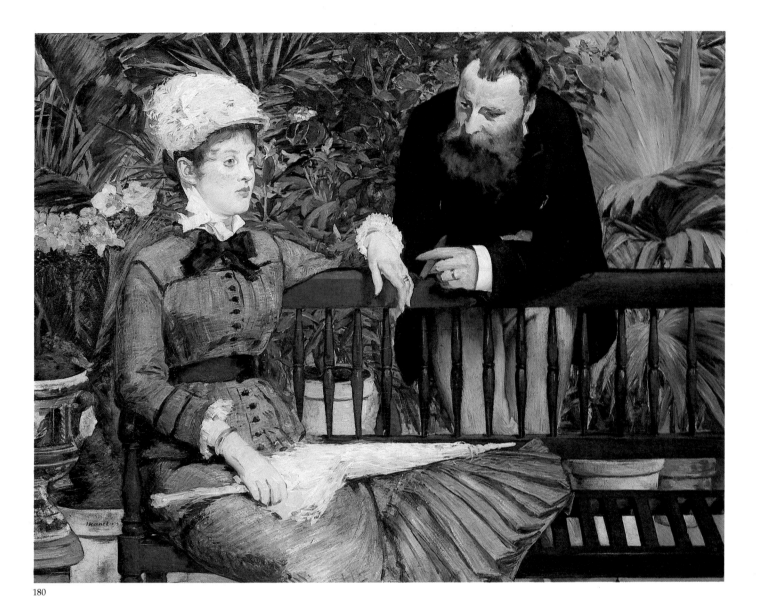

180

hands closely and familiarly allied at the center, qualifying the seeming abstraction of the faces. It is, in fact, a double portrait of M. and Mme Jules Guillemet, owners of a fashionable shop at 19, rue du Faubourg Saint-Honoré, and friends of the artist's.[1] It does not appear that Jules Guillemet was connected in any way with the painter Antoine Guillemet, who is seen in *The Balcony.*

Of American origin, Mme Guillemet was noted for her beauty and her Parisian elegance, here confirmed by the little hat of ostrich feathers and the smartly tailored dress, its pleats flatteringly emphasized in the foreground. Her fair, lightly made-up complexion is set off by the rose laurel at the left, enhancing the texture and coloring of the lips. Manet's charming watercolor sketches of Mme Guillemet, and the amusement with which he brushed in her various accessories—especially her boots—on little letters to her, show that he was very much aware of her studied and spirited femininity (see cat. 198). As for Jules Guillemet, he is portrayed sympathetically—a certain resemblance to Manet himself was noted by their contemporaries—as a

friend at a pause in the conversation, smoking, like the man in *The Luncheon in the Studio* (cat. 109) and like Mallarmé in his portrait (cat. 149).

The scene is a conservatory, an amenity that had won its patent of nobility under the Second Empire and that Zola eight years earlier had taken as a setting for the transgressions of the wife of Saccard, the financier and real-estate promoter in *La Curée*—a somewhat heavy-handed anthology piece considered scandalous at the time. Despite the decorous appearance of the painting, visitors to the Salon of 1879, where it was exhibited, no doubt readily made the connection. Thus Stop's caricature in *Le Journal amusant* (fig. a) revises the picture by placing the lady behind the bench, with the caption "An innocent young person cornered in the conservatory by an infamous seducer."[2]

DANS LA SERRE
Une jeune personne innocente est prise dans la serre d'un perfide séducteur (Salon de 1879)

Fig. a. Stop, caricature in *Le Journal amusant*, 1879

The locale was the studio Manet rented from July 1878 to April 1879 from the Swedish painter Otto Rosen, at 70, rue d'Amsterdam, a little way down the street from the studio he was to occupy from the summer of 1879 until his death. It is not known whether there was a real conservatory or whether Rosen had arranged part of the studio as a kind of winter garden.[3]

For Manet, clearly, the function of the decor is not so much literary or erotic as simply pictorial. Nature is present, though not *en plein air*; hence the faces retain more individuality, are less affected by outdoor light, and the verdant background becomes a modern tapestry, in which Manet has devoted more care than usual to detailing the foliage. It also enabled him to play on the contrast between the slightly stifling exuberance of the setting and the reserved delicacy of the young woman's head, a device that reflects the psychological tension of the scene. The figure of Mme Guillemet also provided an opportunity for a vivacious interplay of pink, yellow, and red touches.

In showing *Boating* (cat. 140) with *In the Conservatory* at the Salon, Manet was surely pointing to another contrast: a "plebeian" couple out of doors, and a "bourgeois" couple of city dwellers, a broad blue background for the one, green for the other. Except for the *Portrait of Faure in the Role of Hamlet* (RW I 257) in the 1877 Salon, Manet had been consistently rejected and had shown nothing since *Argenteuil* (cat. 139) in 1875, which had made him the Salon "Impressionist." This time, Renoir with *Mme Charpentier and Her Children* (Metropolitan Museum of Art, New York) and Manet with *Boating* and *In the Conservatory* brought their live color and *plein-air* painting to the official Salon walls. Manet, in fact, was still more castigated than Renoir, especially by the irrepressible Wolff, who on this occasion called him a "tzigane" of a painter.[4]

But now a new champion entered the lists, once more from the world of letters, J. K. Huysmans, who defended the painting in *Le Voltaire*: "Thus posed, in an interval of conversation, this figure is indeed beautiful; she flirts, she lives. The air moves, the figures are marvelously detached from the envelope of green surrounding them. Here is a modern work of great charm, a battle waged and won against the conventional rendition of sunlight, never observed from nature."[5] More formalist arguments, paradoxically, brought the apostle of realism, Castagnary, to a more favorable conclusion than formerly: "Nothing could be more simple than the composition, or more natural than the attitudes. Yet another point deserves higher praise, and that is the freshness of tone and the harmony of coloration generally. . . . The faces and hands are drawn with greater care than usual; can Manet be making concessions?"[6]

An unpublished letter from Manet to the undersecretary of state for fine arts, dated June 6, 1879, expresses his desire that one of his two paintings

1. Tabarant 1947, p. 340.
2. Stop, in *Le Journal amusant*, 1879.
3. Tabarant 1947, p. 326.
4. Wolff 1879, quoted in Tabarant 1947, p. 347.
5. Huysmans 1883, p. 35.
6. Castagnary 1879, quoted in Tabarant 1947, p. 348.
7. Paris, Archives Nationales: Dépôt Légal registry (AN-F²¹ 308).
8. Callen 1974, pp. 168–69.
9. Meier-Graefe 1912, p. 314.
10. Ibid.
11. Max Aubry, "Camps de concentration pour oeuvres d'art," *Arts*, January 4, 1946.

shown at the Salon be purchased by the government: "I had the honor of being received in audience by you, about the middle of last May, and though you held out no great hopes concerning the purchase of one of my canvases exhibited at the Salon, you were kind enough to promise to consider it and let me have your answer directly. Therefore, Monsieur le Sous-Secrétaire d'Etat, may I recall that you added that you were willing to buy a painting of mine for the Luxembourg from a private gallery, such as *Le bon bock* or some other having had the sanction of the Salon. I have the honor, then, to commend myself to your recollection, and trusting in your promise I beg to remain. . . ."[7] The state, needless to say, bought neither *Le bon bock* (RW I 186) nor either of the two 1879 Salon canvases.

Provenance
This painting was sold directly by Manet to FAURE[8] (see Provenance, cat. 10), evidently on January 1, 1883, for 4,000 Frs.[9] Faure assigned it to DURAND-RUEL (see Provenance, cat. 118) in 1896; purchased for 22,000 Frs,[10] it was donated to the museum in Berlin on the advice of Hugo von Tschudi (see Provenance, cat. 109), then curator, by the collectors Eduard Arnhold (see Provenance, cat. 29), Ernest and Robert von Mendelssohn, and H. Oppenheim (inv. 683). This was the first work by Manet to be purchased by a museum. It was not among the works belonging to German museums sold as "degenerate art" under the Nazi regime, and it was rediscovered by American soldiers in 1945, hidden in a salt mine.[11]

F.C.

181. Mme Manet in the Conservatory

1879
Oil on canvas
34 × 39⅜″ (81 × 100 cm)
Signed, and with a spurious (?) date (lower left): Manet / 1876
Nasjonalgalleriet, Oslo

Exhibitions
Berlin, Matthiesen 1928, no. 50; Orangerie 1932, no. 66

Catalogues
D 1902, 252; M-N 1926 II, p. 57; M-N cat. ms., 262; T 1931, 296; JW 1932, 297; T 1947, 213; PO 1967, 269; RO 1970, 269; RW 1975 I, 290

Suzanne Manet very rarely entered any of her husband's studios, but she was intimate with the Guillemets and was present at the sittings for *In the Conservatory* (cat. 180).[1] So Manet wished her to pose also, and portrayed her in a more familiar style, for her own pleasure, rather than for the Salon.

Since posing for *Reading* (cat. 97), Mme Manet had put on weight, and her kind, placid features, always somewhat ruddy, had coarsened. Manet portrays her with realism and affection. "There was something very special about Mme Manet: the gift of kindness, simplicity, candor of spirit; an unruffled serenity. In her slightest words, one felt the deep love she had for her charming *enfant terrible* of a husband," Nittis recounted. "One day, he was following some pretty girl, slender and coquettish. His wife suddenly came up to him, saying, with her merry laugh, 'This time, I caught you.' 'There,' he said, 'that's funny! I thought it was you.' Now Mme Manet, a bit on the heavy side, a placid Dutchwoman, was no frail Parisienne. She told the story herself, with her smiling good humor."[2]

Manet never left the background of a portrait to chance; his wife appears to be seated in the same place as the elegant Mme Guillemet, but the arrangement of plantings is quite different. He painted Mme Guillemet against a background of sharp, pointed foliage set with pink blossoms, well suited to

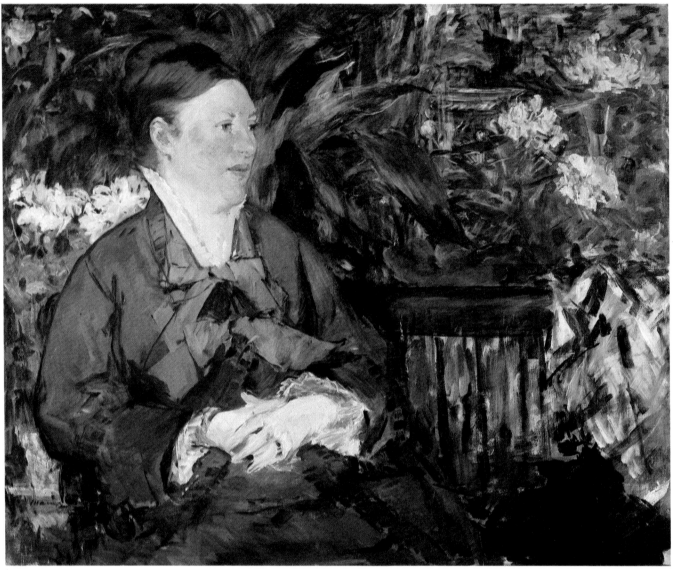

181

her piquant Parisian face; and his wife, dressed and coiffed with bourgeois simplicity, is painted against a background of broad leaves rendered with generous brushstrokes, like the dress and the hands. Manet provided for her a range of grays and blues, in the shawl and in the flowers, that harmonize with her white blouse and her gray eyes.

Provenance

"Mme Manet hung this portrait in the conjugal bedroom and, after her husband's death, in the bedroom she occupied as a widow," writes Tabarant rather strangely.[3] A pressing need for money forced SUZANNE MANET (see Provenance, cat. 12) to sell it to MAURICE JOYANT (1864–1930) on August 16, 1895, for 6,000 Frs.[4] Joyant, Toulouse-Lautrec's friend since childhood and his first biographer, had gone to work for the dealers Boussod and Valadon in 1871, taking the place of Theo van Gogh, who had recently died. Since Joyant himself had an independent income and his own collection, the painting may well have remained at his home, where his friends, Lautrec

and the painters of *La Revue blanche*, the Nabis, could have seen it. In July 1911, he sold the canvas to GEORGES BERNHEIM (see Provenance, cat. 20),[5] from whom the Friends of the Oslo museum purchased it in 1918 (inv. 1286).

Duret and Jamot included in their catalogues a second version of this portrait, which was sold by Léon Leenhoff in 1910 (four years after his mother's death) and circulated in Germany between the two world wars. That version is actually a copy by Edouard Vibert (see Provenance, cat. 164), made at the time of the sale of the original painting in 1895 and intended to replace it.[6]

F.C.

1. Tabarant 1947, p. 341.
2. Nittis 1895, p. 189, quoted in Moreau-Nélaton 1926, II, p. 50.
3. Tabarant 1947, p. 341.
4. New York, Pierpont Morgan Library, Tabarant archives: Mme Manet's account book.
5. Tabarant 1931, p. 345.
6. Tabarant 1947, p. 342.

182. On the Bench

1879
Pastel on canvas
24 × 19⅝" (61 × 50 cm)
NY Private Collection

Exhibitions
Beaux-Arts 1884, no. 143; Paris, Drouot 1884,
no. 111; London, Grafton 1905, no. 94; Orangerie
1932, no. 90; New York, Wildenstein 1948, no. 32

Catalogues
D 1902, 39 (pastels); M-N cat. ms., 407; T 1931, 12
(pastels); JW 1932, 361; T 1947, 467; PO 1967, 257A;
RO 1970, 258A; RW 1975 II, 19 (pastels)

Manet's fascination with women is more pronounced in his pastels than in any other medium. Of the eighty-nine pastels recorded by Rouart and Wildenstein, more than seventy are images of women. Many are bust- or half-length portraits with neutral backgrounds (e.g., cat. 216, 217), but several depict women in specific settings. The similarity of the profile of the figure in *On the Bench* to that of the young actress Jeanne Demarsy in *Le printemps* (RW I 372; see cat. 214) suggests that Manet used the same model for both pictures. Mlle Demarsy is shown seated on a bench in the conservatory-studio of the painter Otto Rosen, where Manet worked between July 1878 and April 1879 (see cat. 180).

182

Although *On the Bench* is unsigned and is loosely executed in most areas except the face, it is as finished as many of Manet's signed pastel portraits. However, it differs from most because of the somewhat wistful expression on the sitter's face. Like the women in *The Plum* (cat. 165), *The Blonde with Bare Breasts* (cat. 178), and *In the Conservatory* (cat. 180), Jeanne Demarsy appears withdrawn and contemplative. Such women in Manet's pictures appear to inhabit a world of their own, and the artist apparently wished to draw attention to them as a type often encountered in contemporary life.

1. Manet sale, Paris, February 4–5, 1884, no. 111; Bodelsen 1968, p. 342.
2. Rouart and Wildenstein 1975, II, no. 19 (pastels).
3. Ibid.
4. Rouart and Orienti 1967, no. 257A.

Provenance

At the Manet sale in 1884, this pastel was sold for 1,250 Frs to CHARLES DEUDON (see Provenance, cat. 165).[1] DURAND-RUEL (see Provenance, cat. 118) owned it in 1899.[2] During the 1930s, the work was in the collection of the playwright HENRY BERNSTEIN (see cat. 209), who lent it to the Manet exhibition at the Musée de l'Orangerie in 1932. In 1938, it passed through the New York galleries of DURAND-RUEL and CARROLL CARSTAIRS.[3] MR. AND MRS. MARSHALL FIELD III lent it to an exhibition at Carstairs in 1945. Mr. Field was heir to the fortune amassed by his grandfather, who founded the Chicago department store that bears his name. By 1967, the pastel was with ALEX REID & LEFEVRE (see Provenance, cat. 216) in London.[4]

C.S.M.

183. Portrait of Mme Emile Zola

1879
Pastel on canvas
20½ × 17¼" (52 × 44 cm)
Signed (lower left): Manet
P Musée du Louvre, Cabinet des Dessins, Paris

Gabrielle Alexandrine Meley (1839–1925) had shared Emile Zola's life since 1865, a year before Zola and Manet met. A dark shadow fell on the relation-

183

Exhibitions
Paris, La Vie Moderne 1880, no. 11 (Portrait de Mme
E. Z***); Beaux-Arts 1884, no. 130; Salon d'Au-
tomne 1905, no. 27

Catalogues
D 1902, 3 (pastels); M-N 1926 II, p. 64; M-N cat. ms.,
360; T 1931, 24 (pastels); JW 1932, 448; T 1947, 447;
PO 1967, 300; RO 1970, 304; RW 1975 II, 13 (pastels)

1. See Appendix I, letter 35.
2. Ibid., letter 37.
3. Walter 1961.

Provenance
In a letter to Zola, Manet agreed to make a por-
trait of his wife (see note 1). The letter seems to
indicate that Zola had wanted Manet to portray
him as well, but no trace of such a work has been
found. This portrait of MME ZOLA (see Prove-
nance, cat. 106) remained in the sitter's collection,
and in 1918 she gave it, retaining a life interest,
to the Musée du Louvre (inv. RF 4519), which
it entered at her death in 1925.

F.C.

ship between the writer and the painter when Zola published an article in the
Saint Petersburg *Messenger of Europe*, reprinted in part in *Le Figaro* of July 26,
1879, that Manet took as a betrayal.[1] Zola having reassured Manet with an
explanation, this portrait commission was perhaps an amicable pledge of rec-
onciliation on both sides (see Provenance). It should therefore be dated to the
summer or autumn of 1879, since just before April 1880 Manet wrote to Mme
Zola asking her for the pastel so that it might be shown "with others at La Vie
Moderne." He was already ill, for he added, "Forgive me for not making this
request in person, but I am forbidden to climb stairs."[2]

Mme Zola had been very beautiful, and Zola as a young man is
understood to have "kidnapped" her from Antoine Guillemet (see cat. 115).[3]
The Zola correspondence reveals a woman with neurasthenic and hypochon-
riacal tendencies, who was much affected by not having children. She was
compensated for her personal troubles by her importance to Zola in both his
public and his private life.

Manet, perhaps not without flattery, produced the image of a woman
estimable and charming in her way, but lacking in that zestful grace which at
the time he loved to capture in oils and pastels. The portrait is accordingly
rather conventional in character.

184. Young Woman in a Round Hat

1877
Oil on canvas
22 × 18½" (56 × 47 cm)
Signed (lower right): Manet
NY The Henry and Rose Pearlman Foundation

Exhibitions
Paris, Drouot 1884, no. 36; Munich, Moderne
Galerie 1910, no. 19; Paris, Bernheim-Jeune 1910,
no. 11; London, Grafton 1910–11, no. 4; New York,
Durand-Ruel 1913, no. 14; New York, Wildenstein
1948, no. 29; Philadelphia-[Chicago], no. 168

Catalogues
D 1902, 221; M-N cat. ms., 250; T 1931, 261; JW
1932, 340; T 1947, 281; RO 1970, 236; RW 1975 I, 305

Hanson has described *Young Woman in a Round Hat* as "one of Manet's finest
portraits."[1] Nevertheless, the obscuring effects of the veil and the shadow
cast by the brim of the hat suggest that it is not a portrait in the conventional
sense. Although Tabarant does not include the painting in the "'naturalist'
series" of contemporary Parisian women, which includes *Nana* (cat. 157),
The Plum (cat. 165), and *Skating* (RW I 260), *Young Woman in a Round Hat*
seems at least indirectly related. Indeed, Tabarant tells us it was painted
about the same time as *Nana* and *Skating*, September–October 1877.[2] Han-
son, however, believes it could have been painted any time between 1877
and 1879; and Rouart and Wildenstein assign it to 1879.[3]

The painting is similar in subject and compositional type to the un-
finished portrait of Mme Manet in the Metropolitan Museum of Art (RW I
117). Although in the latter work the artist's wife faces in the opposite direc-
tion and is seen slightly off profile, Manet seems to have intended a compa-
rable effect; like the figure in *Young Woman in a Round Hat*, she is hatted and
gloved, carries an umbrella, and appears ready to go out. Manet was obvi-
ously drawn to the image of a woman prepared for an outing in public. Like
Degas's investigations of the ceremonious activities enacted repeatedly in

1. Hanson 1966, p. 179.
2. Tabarant 1947, pp. 314–15.
3. Hanson 1966, p. 178; Rouart and Wildenstein
 1975, I, no. 305.
4. Rouart and Wildenstein 1975, I, p. 27,
 "Tableaux et études," no. 36, "Femme en bleu
 et chapeau rond."

441

184

millinery shops, Manet's pictures of women dressed for particular roles in urban society provide insight into "la vie moderne."

Evidently, the half-length profile portrait convention appealed to Manet during the late 1870s and early 1880s. He used it about 1878 for the portrait of his wife that he painted over with his self-portrait, as well as for *Spring*, 1881 (RW I 372), and *The Milliner* (cat. 213). Just as the device had been popular in the fifteenth century for portraits of elegant and important women at the center of contemporary society, so Manet adopted it in the nineteenth century for portraits of their counterparts in modern life.

5. Manet sale, Paris, February 4–5, 1884, no. 36; Bodelsen 1968, p. 342.
6. Meier-Graefe 1912, p. 316.
7. J. Zilczer, *"The Noble Buyer": John Quinn, Patron of the Avant-Garde* (exhibition catalogue), Hirshhorn Museum and Sculpture Garden, Washington, D.C., 1978.
8. B. L. Reid, *The Man from New York: John Quinn and His Friends*, New York, 1868, pp. 91–94; Letter from Charles Durand-Ruel, December 13, 1982 (archives, department of European paintings, The Metropolitan Museum of Art, New York).

Provenance

Valued at 100 Frs in the posthumous inventory,[4] this picture was acquired for 200 Frs at the Manet sale by one SAMSON.[5] Duret's catalogue of 1902 cites the owner as AUGUSTE PELLERIN (see Provenance, cat. 109). In 1910, Pellerin sold many of the works by Manet from his collection to the dealers BERNHEIM-JEUNE, PAUL CASSIRER, and DURAND-RUEL (see Provenance, cat. 31, 13, 118).[6] The latter sold this picture for $4,000 on April 3, 1911, to JOHN QUINN (1870–1924), the New York lawyer and collector of avant-garde art who led the effort to organize the Armory Show in 1913. Quinn's vast and extraordinary collection was to include Seurat's *Circus*, which he bequeathed to the Musée du Louvre, Matisse's *Blue Nude* (Baltimore Museum of Art), etc.[7] *Young Woman in a Round Hat* was Quinn's first major purchase. On November 9, 1911, he exchanged it with DURAND-RUEL as partial payment for a painting by Puvis de Chavannes.[8] On April 24, 1912, Durand-Ruel sold it to the Chicago lumber dealer and philan-thropist MARTIN A. RYERSON (1856–1932). MRS. RYERSON included it in her generous bequest of 1937 to the ART INSTITUTE OF CHICAGO. The work was deaccessioned in 1947 and sold to the E. & A. SILBERMAN galleries in New York, which still had it in 1955. It was subsequently acquired by MR. AND MRS. HENRY PEARLMAN of New York, whose collection also includes an outstanding group of works by Cézanne.

C.S.M.

185. Portrait of Clemenceau at the Tribune

1879–80
Oil on canvas
45¾ × 37" (116 × 94 cm)
Kimbell Art Museum, Fort Worth

Exhibitions
New York, Wildenstein 1948, no. 36

Catalogues
D 1902, 262; M-N 1926 II, pp. 65, 98; M-N cat. ms.,
267; T 1931, 298; JW 1932, 371; T 1947, 323; PO 1967,
276B; RO 1970, 276B; RW 1975 I, 329

There were numerous occasions on which Manet may have crossed the path of Georges Clemenceau (1841–1929): in 1875 through his younger brother Gustave, who was a member of the Paris municipal council when Clemenceau was its president and who succeeded him as president in 1876; or even earlier through the Paul Meurice family, who were close to the Manets and whose daughter Marthe was later married to a brother of Clemenceau's; or else through Zola. Two letters from Clemenceau to Manet confirming or postponing appointments for sittings have served to date the two portraits (cat. 185, 186) as done in the winter of 1879–80,[1] when the radical deputy was about to found the republican journal *La Justice* with Camille Pelletan.

Manet probably executed both portraits concurrently. This one would appear to have been the earlier. Indeed, Gustave Geffroy, later a close associate of Clemenceau's, believed it might have been painted in 1872.[2] The tribune in the portrait would be the one at the Luxembourg, where the municipal council held its sessions, the Hôtel de Ville having been burned down under the Commune.

Because the sittings were often interrupted, it is conceivable that this unfinished portrait remained for some years in abeyance. Not only was Clemenceau pressed for time; he was always displeased with portraits of himself—"I haven't a single portrait of me, they're all bad"[3]—and in fact his sessions with Manet were spent largely in conversation: "I had such good times talking with Manet! He was so witty!"[4]

It was perhaps because of these various obstacles that this portrait, like the next one, was never completed, as is noticeable especially in the coat and in the face, which are somewhat uncertain in line. The fact that the lower part of the picture is so precise and heavily painted may indicate that this portion was added later, and quite possibly not by Manet.

Curiously enough, when Tabarant visited Clemenceau in April 1929 and showed him a photograph of this painting, Clemenceau exclaimed, "But I didn't see that one! It's the best of all!"[5]

1. Paris, Bibliothèque d'Art et d'Archéologie, Manet archives: from Clemenceau to Manet, December 9, 1879; Private collection: from Clemenceau to Manet, January 8, 1880.
2. Gustave Geffroy, "Portraits de Clémenceau," *La Renaissance des arts français et des industries de luxe*, August 1918, pp. 181–86.
3. R. Godard, September 1929, quoted in G. Wormser, *Clemenceau vu de près*, Paris, 1979.
4. Tabarant 1947, p. 358.
5. Ibid.
6. Manet et al., "Copie faite pour Moreau-Nélaton . . . ," p. 146.
7. Tabarant 1947, pp. 358–59.
8. Rothenstein sale, Paris, February 23–24, 1922, not in catalogue.
9. Tabarant 1947, pp. 359–60.

Provenance
On July 11, 1883, after Manet's death, SUZANNE MANET (see Provenance, cat. 12) evidently presented CLEMENCEAU with his two portraits: "Don à Clemenceau. 2 portraits" (Gift to Clemenceau. Two portraits); this would be one of the two, unless there is some confusion with the pastel portrait of Mme Clemenceau (RW II 33), also noted on July 13: "Reçu de Clemenceau pour le pastel de sa femme 500 Frs" (Received from Clemenceau 500 Frs for the pastel of his wife).[6] Clemenceau sold it for the low price of 1,000 Frs to VOLLARD (see Provenance, cat. 98). According to the dealer, Mary Cassatt, having arranged for the purchase by Mrs. Havemeyer of the following painting (cat. 186), told him of the existence of a second version. Vollard places this transaction in 1896,[7] but the date has been questioned (see Provenance, cat. 186). The canvas was relined before Vollard sold it to the Hungarian collector MARCZELL VON NEMES (1866–1930). It was included in the sale of his collection at Manzi-Joyant's on June 18, 1913, estimated at 5,000 Frs—which is very low for the period; it remained unsold. In 1922, it appeared at the sale of the sequestered property of ROTHENSTEIN, again estimated at 5,000 Frs, and sold for 5,800 Frs to GEORGES BERNHEIM[8] (see Provenance, cat. 20). Since Clemenceau had become the "father of victory" in the meantime, it is surprising that the French government did not attempt to buy it. Soon afterward, the painting went to Oslo, to WALTER HALVORSEN.[9] Purchased later by the Berlin dealer JUSTIN K. THANNHAUSER (see Provenance, cat. 156), who emigrated to New York, it was on the market again in the 1960s. It was recently acquired by the museum in Fort Worth (inv. AP 81.1).

F.C.

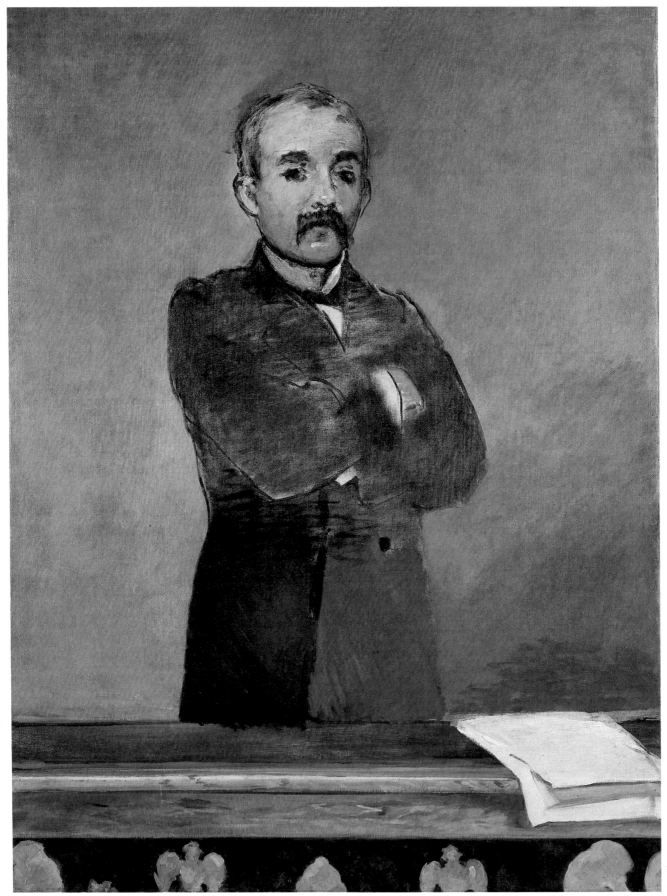

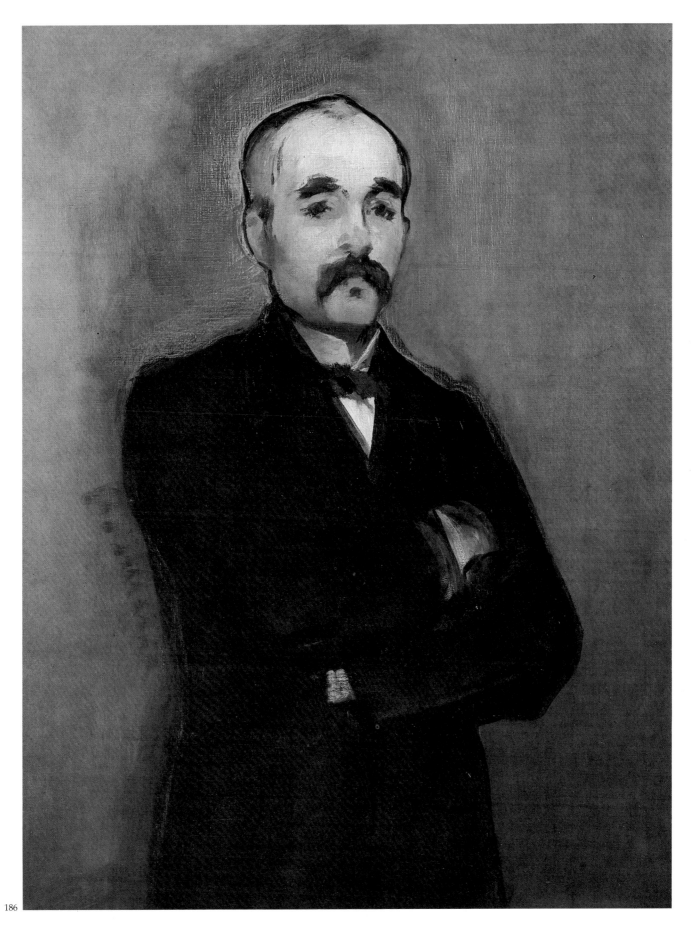

186. Portrait of Clemenceau

1879–80
Oil on canvas
37 × 29¼" (94 × 74 cm)
Musée d'Orsay (Galeries du Jeu de Paume), Paris

"My portrait by Manet? Very bad. I don't have it, and I don't mind. It's in the Louvre. I wonder why they put it there."[1] Such was the judgment of the sitter. We know that Clemenceau's artistic preferences, at a later period than that of this portrait, were for Rodin and especially Monet; it was probably under Monet's influence that Clemenceau in 1907 had Manet's *Olympia* transferred from the Musée du Luxembourg to the Louvre (see Provenance, cat. 64).

The strength of this portrait is the more apparent when it is compared with other likenesses of Clemenceau, such as Raffaelli's *Clemenceau Conducting an Electoral Meeting at the Cirque Fernando*, 1883 (Musée de Versailles), which is declamatory and anecdotal, or those by Eugène Carrière (such as the one in the Musée de Troyes), where the head is inclined and ghostlike.[2] Manet reduces detail and motion to a minimum, and accentuates the Asian cast of feature, which was to become more pronounced with time. X-ray examination reveals slight pentimenti about the head, and a different glance with lowered eyelids accentuating the Tartar type; the expression then appeared more realistic, weary, and uncertain. Considering the trouble Manet had in posing his model (who nevertheless complained of having sat "forty times"[3]), it is probable that he used a photograph, most likely the one taken by Benque in 1876, quite similar to the painting in the planes of the face and the position of the arms. He may also have used a little photograph of Clemenceau's head taken by Truchelet, which is today in the Manet family photograph album.[4]

In this portrait, Manet transposed onto canvas the allusive qualities of his brush- and pen-and-ink drawings of the same period. In a few Japanesque strokes and outlines, he concentrated in the head and torso all the energy, resolution, firmness, and also humor that are the physical expression of Clemenceau's commanding personality.

The painting was not exhibited before it entered the Musée du Louvre in 1927, yet many Fauve and Expressionist portraits from the early part of the present century now seem to us derived from it: for conciseness, reduction to essentials, and utter absence of comment—note the removal of the rostrum (see Provenance and fig. a)— this portrait, a quarter of a century too soon, is one of the first great portraits of the twentieth century. In the eyes of some critics, its pictorial power may have overwhelmed the truth of the representation. "For Manet to paint Clemenceau's portrait, he must have resolved to venture all and be all, and Clemenceau almost nothing," wrote André Malraux in 1957.[5] Now, twenty-six years after that time of highly formalist criticism, the portrait seems not only a triumph of pictorial modernity but a work of psychological truth, Manet's presence not by any means obliterating that of Clemenceau; it achieves an equilibrium essential to great portraiture.

Exhibitions
Orangerie 1952, without no.

Catalogues
D 1902, 261; M-N 1926 II, pp. 65, 98; M-N cat. ms., 268; T 1931, 297; JW 1932, 372; T 1947, 322; PO 1967, 276A; RO 1970, 276A; RW 1975 I, 330

Fig. a. Lochard, photograph of original state of painting, ca. 1883. Courtesy of The Pierpont Morgan Library, New York

1. R. Godard, September 1929, quoted in G. Wormser, *Clemenceau vu de près*, Paris, 1979.
2. Paris, Palais des Beaux-Arts de la Ville de Paris, Musée du Petit Palais, *Georges Clemenceau, 1841–1929* (exhibition catalogue), Paris, 1979.
3. Havemeyer 1961, p. 230.
4. Benque: see above, Hanson, "Manet's Pictorial Language," fig. 15. Manet et al., album of family photographs.
5. André Malraux, *Le Musée imaginaire*, Paris, 1957, p. 54.
6. Tabarant 1947, p. 359.
7. Havemeyer 1961, p. 231.

Provenance
SUZANNE MANET (see Provenance, cat. 12) gave this portrait to CLEMENCEAU on July 11, 1883, shortly after the painter's death (see cat. 185). When Mary Cassatt took her friend MRS. H. O. HAVEMEYER (see Provenance, cat. 33) to see Clemenceau, she purchased it from him for 10,000 Frs; it has always been assumed that the transaction took place in 1896,[6] but recent research by

Frances Weitzenhoffer in the Havemeyer archives, which she kindly shared with us, reveals that the purchase actually occurred in the fall of 1905. As seen in the photograph taken by Lochard (Pierpont Morgan Library, New York; fig. a), the painting was originally larger (114 × 94 cm), and the lower section, containing the outline of a rostrum, was unfinished. In her memoirs, Mrs. Havemeyer explains what happened: "Acting

upon Miss Cassatt's advice I took another stretcher and folded back that part of the canvas on which Manet had indicated the table and the still life. This was very easy to do as the picture was oblong."[7] Today these turned-back sections (20 cm at the bottom and 10 cm on each side) are gone, having been cut off at an unknown date. Mrs. Havemeyer generously presented the painting to the Musée du Louvre in 1927 (inv. RF 2641).

F.C.

187. Portrait of M. Antonin Proust

1880
Oil on canvas
51 × 37¾" (129.5 × 95.9 cm)
Inscribed, dated, and signed (lower left): à mon ami Antonin Proust / 1880 / Manet

NY The Toledo Museum of Art

Exhibitions
Salon 1880, no. 2450 (Portrait de M. Antonin Proust); Beaux-Arts 1884, no. 95; Exposition Universelle 1889, no. 492; Philadelphia 1933–34, without no.; New York, Wildenstein 1937, no. 31; New York, Wildenstein 1948, no. 37

Catalogues
D 1902, 263; M-N 1926 II, pp. 64–65; M-N cat. ms., 265; T 1931, 316; JW 1932, 376; T 1947, 340; PO 1967, 303; RO 1970, 307; RW 1975 I, 331

Manet and Antonin Proust (1832–1905) had known each other since childhood. In the 1850s, they were pupils in Couture's studio at the same time, but instead of pursuing a career as a painter Proust became a journalist, critic, and politician. He was appointed Gambetta's secretary when the Second Empire collapsed in September 1870, and during the Franco-Prussian War he acted as minister of the interior during the siege of Paris. Ten years later, he briefly held the position of minister of fine arts when Gambetta served as prime minister between November 1881 and January 1882. Despite his short tenure, he managed to have Manet awarded the Légion d'honneur. In 1884, Proust was one of the organizers of the memorial exhibition in honor of Manet at the Ecole des Beaux-Arts. He recounted his long friendship with Manet in a series of articles published in 1897 in *La Revue blanche*. The articles, which were later revised and reissued as a book in 1913, remain a key source of information about Manet's life and work.

The critic Bertall, writing in May 1880, insinuated that Manet painted the portrait of Proust in order to ingratiate himself with his powerful and influential friend. Anticipating Proust's appointment as minister of fine arts by more than a year, Bertall commented sarcastically: "It is Manet who has been charged with reproducing the characteristic contours of the hat and frock coat of the future minister of fine arts, the same individual who, one hears, will assume the direction of the Ecole des Beaux-Arts and chart the new course assigned to French art."[1] However, Manet's interest in his friend as a subject was by no means new. Tabarant states that Manet first portrayed Proust in the mid-1850s (RW I 12),[2] and Manet twice attempted to paint him in 1877 (RW I 262, 263). Undoubtedly, he appealed to Manet as a subject because he was a figure of style and character, a fashionable, dandified Parisian of the kind that had long interested Manet and dominated his work in the late 1870s and early 1880s. Indeed, Fantin-Latour's well-known 1867 portrait of Manet as a dapper, top-hatted, cane-carrying Parisian (fig. a) indicates that in terms of appearance and bearing alone Manet could easily have identified with his friend. Furthermore, the similarity in size in combination with the subject and the compositional type suggests that Fantin-Latour's portrait

Fig. a. Henri Fantin-Latour, *Portrait of Manet*, 1867. The Art Institute of Chicago

447

of Manet could easily have influenced Manet's conception of the portrait of Proust.

Proust himself informs us: "During the course of that year, 1879, Manet was obsessed by two *idées fixes*: to do a *plein-air* painting . . . and to paint my portrait on unprepared white canvas, in a single sitting. Simultaneously, he undertook *Le père Lathuille* [RW I 291], which is perhaps the most astonishing work he ever did, and my portrait."[3] According to Tabarant, in the last weeks of 1879, Manet began Proust's portrait by making several drawings.[4] Jacques-Emile Blanche later recalled: "There is nothing more difficult to draw than a top hat, Manet used to say. The one worn by Proust was begun anew twenty times in my presence!"[5] Tabarant states that although in late 1879 Manet may have experimented with "the first indications in oil paint," the portrait was not executed until January 1880,[6] and Proust tells us that after several false starts, Manet managed to paint most of the picture in a single sitting: "After using up seven or eight canvases, the portrait came all at once. Only the hands and parts of the background remained to be finished. The evening he completed the portrait, he turned it to the wall, unwilling to let anyone see it before it was framed. 'It needs the frame,' he kept saying as he paced happily around the studio. 'Without the frame, the painting fails totally. Look here, that's it this time, and how well the background works! I'll finish tomorrow. The gloved hand is only just suggested. With three strokes—*pique, pique, pique*—it will be there.'"[7]

The portrait of Proust was sent, together with *Chez le père Lathuille*, to the Salon of 1880. The Salon jury, which was chaired by Bouguereau, evidently considered awarding Manet a medal but ultimately refused him the honor. Laudatory remarks about the portrait were published in reviews of the Salon by Burty and Mantz and above all by Silvestre, for whom the portrait was "one of the most remarkable works at the Salon. What spirited execution in the physiognomy and in the attire! What brilliant execution in a clear, true key! I cannot understand the reluctance of the public before a picture whose immediate effect is to seduce the eye with a wonderful freshness of tone."[8]

Nevertheless, there were also several hostile reviews, and three weeks after the Salon opened, Manet reported to Proust that the portrait was poorly hung and had not been well received: "Ah! the portrait with hat, about which people are saying that everything is blue! All right, I'll wait them out. I will never live to see it, but after me, it will be recognized that I saw and thought correctly. Your portrait is a sincere work *par excellence*. I remember as if it were yesterday how quickly and succinctly I dealt with the glove of the ungloved hand. And when you said to me just at that moment, 'I beg of you, not another stroke,' I felt that we were so perfectly in agreement that I could not resist the wish to embrace you." Ironically, he also told Proust that he thought it would be a mistake for anyone to entertain the "fantasy" of including the portrait in a public collection.[9]

Portrait of M. Antonin Proust had in fact been attacked by such predictably unfriendly critics as Bertall and Wolff, who found it unfinished and crudely executed, a point of view espoused in connection with Manet's work by conservative and academically oriented critics since the early 1860s.[10] This long-standing but less widely held attitude was summed up by Philippe de Chennevières in an article published in the *Gazette des Beaux-Arts*. His comments are particularly noteworthy because they represent a quasi-official assessment; he had recently retired as director of the Ecole des Beaux-Arts,

1. Bertall 1880, quoted in Tabarant 1947, p. 379.
2. Tabarant 1947, p. 374.
3. Proust 1913, p. 100.
4. Tabarant 1947, p. 374.
5. Blanche 1919, p. 146.
6. Tabarant 1947, p. 374.
7. Proust 1913, p. 101.
8. Silvestre 1880.
9. Proust 1913, pp. 102–3.
10. Bertall 1880, Wolff 1880, quoted in Tabarant 1947, pp. 378–79.

and he signed his article "member of the Institute": "The portrait of M. Antonin Proust did Manet much good this year. All agree that this picture is an excellent preparation for a good piece of work, and that it lacked little for the artist to bring it to completion. . . . But in it one finds the misfortune and weakness of the Impressionist school, of which M. Manet is the standard-bearer."[11]

In the letter sent to Proust three weeks after the Salon opened, Manet commented laconically, "It is my lot to be reviled, and I take it philosophically,"[12] but he must have been particularly annoyed by the reviews by his erstwhile advocates Huysmans and Zola. Huysmans assailed the portrait of Proust, and, although he admired *Chez le père Lathuille*, he ended with the assertion that Manet had stagnated pitifully after initially establishing himself as the leader of the avant-garde, and that he had been superseded by those artists who formerly looked to him for leadership.[13] Zola adopted a similar position, but he took a more diplomatic approach. He referred to "a remarkable portrait of M. Antonin Proust and a *plein-air* scene, *Chez le père Lathuille* . . . painted with charm and delicate color," but in the lines that followed he identified Manet as a transitional figure who would be remembered for "the influence that he had on all the young painters who came after him."[14]

Two years later, in a review of the Salon of 1882, Proust himself complained that none of Manet's pictures hung in public collections that included works by less talented artists, many of whom had profited from Manet's example; moreover, he tacitly acknowledged the ubiquitousness of the point of view held by Huysmans and Zola, and he feared that it would be a long time before the situation changed: "This year, Manet is less controversial, but he is not yet accepted; and many years will pass before it is decided to rank him with his more fortunate followers."[15]

11. Chennevières 1880, cited in Tabarant 1947, pp. 381–82.
12. Proust 1913, p. 102.
13. Huysmans 1880.
14. Emile Zola, "Le Naturalisme au Salon," part 3, *Le Voltaire*, June 20, 1880.
15. Proust 1882.
16. Letter from Proust to Mme Manet, quoted in Tabarant 1947, p. 357.
17. [Denys Sutton], "Quality the Criterion," *Apollo*, LXXXVI (December 1967), pp. 414-17.
18. *Museum News, The Toledo Museum of Art*, no. 68 (June 1934), unpaginated.

Provenance
ANTONIN PROUST kept his portrait until his death in 1905. It then belonged to the Italian collector JOSEPH RAPHAEL, BARON VITTA (1860–1942), who with Proust's help began to acquire unfinished works by Manet in the late 1890s and hoped "to arrange in [his] villa at Evian a special gallery for sketches by Manet."[16] Vitta eventually acquired four works by the artist (RW I 73, 243, 367, 413) as well as this portrait, which hardly qualifies as a sketch. It next passed through the SCOTT & FOWLES gallery in New York and was acquired in 1925 by the glass manufacturer and art collector EDWARD DRUMMOND LIBBEY for the Toledo Museum of Art, which he had founded in 1910.[17] The portrait was first exhibited at the museum on January 5, 1926.[18]

C.S.M.

188

188. Asparagus

1880
Oil on canvas
6¼ × 8¼" (16 × 21 cm)
Initialed (upper right): M
Musée d'Orsay (Galeries du Jeu de Paume), Paris

Exhibitions
Munich, Heinemann 1907, no. 20?; Berlin, Matthiesen 1928, no. 85

Catalogues
D 1919 (supplement), 13; M-N cat. ms., 296; T 1931, 335; JW 1932, 388; T 1947, 360; PO 1967, 317; RO 1970, 321; RW 1975 I, 358

Fig. a. *Bunch of Asparagus,* 1880. Wallraf-Richartz-Museum, Cologne

1. Tabarant 1931, p. 381.
2. Bataille 1955, p. 104.

Provenance
Manet gave this picture to CHARLES EPHRUSSI (see Provenance, cat. 99). The "Spargel" (*Asparagus*) exhibited with the FAURE (see Provenance, cat. 10) collection in 1907 was probably this paint-

A pleasing story about this painting is known: Manet had sold Charles Ephrussi the *Bunch of Asparagus* (RW I 357; fig. a) for eight hundred francs. Ephrussi sent one thousand francs, and Manet, never wanting in delicacy or wit, painted this stalk and sent it along with a note: "Your bunch was one short."[1] The "parent" work was painted on a black background, rather in the manner of seventeenth-century Dutch still life, but here, on a light background, very delicately playing off the blues and grays of the asparagus against the colors of the marble, and adding a few vivid touches at the tip, Manet indulged in the pleasure of painting with complete freedom, displaying in the work of a moment his prodigious skill, his perfect taste, and his humor. "This is no ordinary still life," wrote Georges Bataille; "still certainly, but full of life."[2]

Increasingly in the 1880s, Manet would do these little still lifes which represent a single object, or very few objects—statements of a kind on the quintessence of painting. They were often sent to friends as occasional gifts, always with some cheerful allusion or expression of fondness and affection. Such are the delightful *Bunch of Violets* sent to Berthe Morisot (cat. 131), the *Three Apples* sent to Méry Laurent (RW I 359), or the sundry watercolor-illustrated letters like Isabelle Lemonnier's *Mirabelle* (cat. 193). These gifts "of fruit, flowers, leaves, and branches" are pictorial counterparts of the little topical rhymes sent out by Mallarmé at this period—on labels, fans, anniversary greetings, and so forth; thus painter and poet live on in these splendid yet unassuming little missives.

ing. It passed through the hands of BERNHEIM-JEUNE (see Provenance, cat. 31). The work was subsequently acquired by SAM SALZ (1894–1981), the Viennese collector and dealer whose galleries, in Paris and New York, specialized in Impression-ist pictures. He owned several Manets, among them the fine pastel *Portrait of Méry Laurent* (cat. 216). Salz perpetuated this little picture's tradition as an elegant gift by presenting it to the Musée du Louvre in 1959 (inv. RF 1959.18).

F.C.

189. Lemon

1880–81
Oil on canvas
5½ × 8¼" (14 × 21 cm)
Inscribed (lower right, by Suzanne Manet): E. Manet
Musée d'Orsay (Galeries du Jeu de Paume), Paris

Exhibitions
Orangerie 1952, without no.; Marseilles 1961, no. 29

The lemon played an important part in Manet's painting during the 1860s; in the still lifes, of course, especially of fish or oysters—following a convention well established since the seventeenth century in the Netherlands—and also

189

as a sort of emblem in his figure paintings (cat. 94, 96, 108, 109). Some recent interpretations belabor the symbolism of this fruit in certain portraits, such as that of Duret (see cat. 108). But these lemons should rather be seen both as a signature—introducing an accent of color that progressively becomes an element in the oeuvre—and as a celebration of two guiding traditions, Flemish painting and Spanish painting.

So, near the end of his life, here is Manet's lemon in its simplest expression, an occasion for gray and yellow harmony, an object of pure painting. "Any painter who can't conjure up a lemon on a Japanese plate is no fine colorist," Alfred Stevens used to say—possibly in salute to his friend.[1]

Catalogues
D 1902, 315; M-N cat. ms., 302; T 1931, 344; JW 1932, 409; T 1947, 370; PO 1967, 325; RO 1970, 329; RW 1975 I, 360

1. Stevens, quoted in Lemonnier 1906, p. 42.
2. Gérard sale, Paris, March 28–29, 1905, no. 81.
3. Tabarant 1931, p. 386.

Provenance
This picture of a lemon once belonged to Manet's longtime friend ANTONIN PROUST (see cat. 187). SUZANNE MANET (see Provenance, cat. 12) apparently gave it to him after the artist's death, as evidenced by the signature that she inscribed on the painting. It subsequently belonged to FELIX GERARD (see Provenance, cat. 81), and it appeared at this dealer's sale,[2] when it was acquired by LECLÉRCQ for 800 Frs.[3] The work later entered the CAMONDO collection (see Provenance, cat. 50), which was bequeathed to the Musée du Louvre in 1908 and exhibited from 1914 (inv. RF 1977).

F.C.

190. Isabelle Lemonnier with Muff

1879–82
Oil on canvas
32¼ × 28¾" (82 × 73 cm)
P The Dallas Museum of Fine Arts

Isabelle Lemonnier with Muff is one of Manet's six portraits of the subject, who, along with Méry Laurent (see cat. 215), was a preferred model in his later years. Most were painted at his new studio on the rue d'Amsterdam in the years between 1879 and 1882. Isabelle Lemonnier was the daughter of an important jeweler of the place Vendôme and the younger sister of Mme Georges Charpentier (wife of the publisher of the naturalist writers), who from the beginning of the Third Republic to the Dreyfus affair kept one of

Exhibitions
Paris, Drouot 1884, no. 16

Catalogues
D 1902, 177; M-N cat. ms., 276; T 1931, 312; JW 1932, 375; T 1947, 330; PO 1967, 283; RO 1970, 283; RW 1975 I, 302

the most brilliant salons in Paris. The Charpentiers will be remembered as the first *grands bourgeois* to give their support to Manet and the Impressionists—especially Renoir, to whom we owe the famous portrait *Mme Charpentier and Her Children* (Metropolitan Museum of Art, New York). Not content to help them with commissions and purchases, Georges Charpentier opened a gallery for their benefit, La Vie Moderne, at the entrance to the passage des Princes off the boulevard des Italiens. The first show, in the spring of 1880, was devoted to the work of Manet.

Renoir called himself in jest "painter in ordinary" to Mme Charpentier, but it was the "ravishing" younger sister, as we are told in the memoirs of her grandson Michel Robida, who interested Manet. "The sittings to which my grandmother submitted to please Manet, then quite ill, were most tiring. 'Manet couldn't draw,' she would tell us with her accustomed verve; 'he was forever starting my portraits over again. He destroyed I know not how many studies before my eyes. I'm sure he would have given them to me if I had asked. But I already had so many portraits.' . . ."[1] Prominent

190

among those known are *Isabelle in a White Fichu* (RW I 304) and a pastel, *Young Girl with a Rose* (RW II 15).

We know that Manet asked Isabelle for some photographs of herself for use in working on the portraits.[2] However, it would seem that this one, which has all the liveliness of a sketch, was painted not from a photograph but from life, during a winter visit. Its brilliant technique, a bit rapid, of utmost facility, is characteristic of Manet's late portraits; their influence can be seen in the *haut-monde* paintings of Jacques-Emile Blanche.

In the summer of 1880, Manet sent Isabelle a series of illustrated notes (cat. 191–97, 205) showing a special feeling for the girl, mingled with nostalgia before her lightheartedness, her fashionable tastes, her youth.

1. Robida 1958, p. 119.
2. Scharf 1968, p. 65.
3. Rouart and Wildenstein 1975, I, p. 27.
4. Manet sale, Paris, February 4–5, 1884, no. 16; Bodelsen 1968, p. 343.
5. Hazard sale, Paris, December 1, 1919, no. 199.
6. Santamarina sale, London, April 2, 1974, no. 18.

Provenance
This picture remained in Manet's studio and was listed in the posthumous inventory under the heading "études peintes" (painted studies).[3] It appeared at the Manet sale in 1884 (in place of *The Execution of Maximilian* [RW I 127], which Suzanne Manet had withdrawn at the last minute), when it was purchased by N. A. HAZARD (see Provenance, cat. 57).[4] At the Hazard sale in 1919,[5] it was acquired by GEORGES BERNHEIM (see Provenance, cat. 20), who sold it to the Argentine senator and collector ANTONIO SANTAMARINA (1880–1974). After remaining in Argentina for half a century, the picture was included in the Santamarina sale in 1974.[6] MR. AND MRS. ALGUR H. MEADOWS and the Meadows Foundation Inc. gave it to the Dallas museum in 1978 (inv. 1978.1). The painting has not been exhibited in Paris since 1919.

F.C.

191–205. Notes and Sheets of 1880, with watercolor drawings

Series of sheets or notes with watercolor illustrations, sent by Manet to Isabelle Lemonnier (cat. 191–97, 205), Mme Guillemet (cat. 198), and Méry Laurent (cat. 204). Four watercolors (cat. 200–203) were in the collection of Manet's friend Dr. Albert Robin.

191. Woman in a Blue Dress

1880
Watercolor
7⅞ × 4⅞" (20 × 12.5 cm)
P Musée du Louvre, Cabinet des Dessins, Paris

Manet was at Bellevue in the summer of 1880, when Isabelle Lemonnier (see cat. 190) was away on holiday in Normandy. He expressed his protective friendship for her in a series of charming watercolor-illustrated notes, in which he often depicted her, re-created from imagination. Here he envisions her in summer dress, "jeune fille en fleurs" out walking, elbows hooked behind her rolled-up umbrella, imparting a jaunty, determined posture. The letters provided for Manet a means through which to express his affection, reflected in the freshness and spontaneity of the drawings.

Catalogues
L 1969, 572; RW 1975 II, 567

Provenance
These seven illustrated letters and watercolors (cat. 191–97) are taken from the album of collected letters to ISABELLE LEMONNIER (see also Provenance, cat. 205). They were sold to ETIENNE MOREAU-NELATON (see Provenance, cat. 9) and were included in his bequest to the Musée du Louvre in 1927 (inv. RF 11.173).

F.C.

191 192

192. Isabelle Diving

Catalogues
T 1947, 64; L 1969, 577; RW 1975 II, 569

Provenance
See cat. 191 (inv. RF 11.175).

1880
Watercolor
$7\frac{7}{8} \times 4\frac{7}{8}''$ (20 × 12.3 cm)
NY Musée du Louvre, Cabinet des Dessins, Paris

Manet, with his characteristic humor, here sends Isabelle an imagined view
of her fetching silhouette as she prepares to dive, wearing the quaint bathing
costume of the period.

F.C.

193. Mirabelle

Catalogues
L 1969, 542; RW 1975 II, 574

1. Mallarmé 1945, pp. 81–181.

1880
Note, with watercolor
$7\frac{7}{8} \times 4\frac{7}{8}''$ (20 × 12.5 cm)
P Musée du Louvre, Cabinet des Dessins, Paris

Manet's illustrated letters remind one of the occasional compositions that
Mallarmé distributed to his friends, especially in the 1890s,[1] and also of the
delicate verse of Japanese haikai, so popular at the time. Unassuming yet

455

précieux—like Mallarmé's rhymed envelopes, fans with verse, and inscribed Easter eggs and cakes—the fruits and flowers sent in season by Manet, usually embellishing a letter, are in the same spirit, and seem to anticipate the poet by a few years. Here a quatrain in Isabelle's honor accompanies a plum from the garden: "à Isabelle / cette mirabelle / et la plus belle / c'est Isabelle."

<div align="right">F.C.</div>

Provenance
See cat. 191 (inv. RF 11.180).

194. Isabelle with Bonnet

1880
Note, with watercolor
7⅞ × 4⅞" (20 × 12.5 cm)

NY Musée du Louvre, Cabinet des Dessins, Paris

Here, on a note to Mlle Lemonnier, Manet puts a speaking likeness of the addressee. He mentions his portrait of a Bellevue summer neighbor, the singer Emilie Ambre, in the role of Carmen (RW I 334).

<div align="right">F.C.</div>

Catalogues
L 1969, 569; RW 1975 II, 578

Provenance
See cat. 191 (inv. RF 11.184).

195. Lanterns

1880
Note, with watercolor
7⅛ × 4⅜" (18 × 11 cm)

P Musée du Louvre, Cabinet des Dessins, Paris

It is hard to say whether this note was written for the occasion of Bastille Day, July 14: "I look forward, dear young lady, to your account of the festivities" might refer either to the national holiday or to a private party given at Luc-sur-Mer in Normandy by the Lemonniers or the Charpentiers. The report Manet read in the newspapers must have made him keenly aware of his enforced absence from the summer society to which he was accustomed: "I am at a loss to comprehend your silence." These charming lanterns very simply express his wish to have been present at the "festivities."

<div align="right">F.C.</div>

Catalogues
L 1969, 587; RW 1975 II, 568

Provenance
See cat. 191 (inv. RF 11.174).

196. Peach

1880
Note, with watercolor
7⅞ × 4⅞" (20 × 12.5 cm)

NY Musée du Louvre, Cabinet des Dessins, Paris

"It's no fault of mine if the peaches are ill-favored at Bellevue, but even the prettiest girl can give only what she has," Manet here writes to Isabelle. That same summer, besides the little still lifes of fruit painted at this time, he often adorned notes to his friends with sketches of fruit—an apple for Bracquemond (RW II 581), a plum for Mme Guillemet (RW II 586) and for Nadar (RW II 590), plums and cherries for Hecht (RW II 591), and for Marthe Hoschedé a cracked chestnut (RW II 594).

<div align="right">F.C.</div>

Catalogues
L 1969, 539; RW 1975 II, 565

Provenance
See cat. 191 (inv. RF 11.171).

Bellevue

à Isabelle
cette Mirabelle
et la plus belle
c'est Isabelle

E Manet

193

Bellevue

Chère mademoiselle
Si vous voulez nous voir comme
je l'espère bien. Venez plutôt
le Dimanche je fais en
ce moment le portrait de
la Comtesse
ma voisine Emilie Ambre
et je vous tous les jours après
déjeuner aux Montalais

194

195

Bellevue

J'attends chère
Demoiselle une relation
de la fête ; Jean vous ou
vous a-t-on vu vous promenez
le soir - avec qui ? votre
feu d'artifice l'illumination
de votre jardin ont été
dites dans les journaux,
mettez moi un peu au
courant d'ajournur

196

Bellevue

Chère mademoiselle,
ce n'est pas de ma faute si
les pêches sont laides à Bellevue,
mais la plus jolie fille ne
peut donner que ce qu'elle a –
Racontez moi les événements
de la plage de Luc et surtout
rien ne m'étonne et tout

457

197. "Philippine"

1880
Watercolor
7⅞ × 4⅞" (20 × 12.5 cm)
Title handwritten in pen and ink
P Musée du Louvre, Cabinet des Dessins, Paris

According to a familiar French custom, the first of two people to find a double fruit, generally in an almond, and to call out "Philippine!" at their first meeting next day must receive a present from the other. This charming watercolor, showing two halves of an almond, is a hint from Manet to Isabelle, no doubt for what he was continually claiming—a reply.

F.C.

Catalogues
L 1969, 547; RW 1975 II, 579

Provenance
See cat. 191 (inv. RF 11.185).

198. Note to Mme Guillemet

1880
Note, with watercolor
Each sheet: 7⅞ × 4⅞" (20 × 12.5 cm)
P Musée du Louvre, Cabinet des Dessins, Paris

On the first page of this letter, all four sides of which are illustrated, Manet portrays Mme Guillemet's legs, side by side in repose, under a pleated skirt similar to the one he had elegantly detailed in *In the Conservatory* (cat. 180) not long before. On the reverse, we see her legs again: crossed and in gaiters; and under the boldly lifted skirt, beneath a table as in *At the Café* (cat. 199). Finally, on the last page, they walk along in short steps. A profile of Mme Guillemet graces the close, below the signature.

F.C.

Catalogues
L 1969, 583; RW 1975 II, 580

Provenance
This letter passed from the collection of MME JULES GUILLEMET to that of ETIENNE MOREAU-NELATON (see Provenance, cat. 9), who bequeathed it to the Musée du Louvre in 1927 (inv. RF 11.186).

199. At the Café, Study of Legs

ca. 1880
Watercolor on squared paper
7¼ × 4⅝" (18.5 × 11.9 cm)
NY Musée du Louvre, Cabinet des Dessins, Paris

This watercolor, unlike the preceding ones, is a page from a notebook. The motif of a woman's legs crossed under a pedestal table on which a coffee cup is placed could indicate that it was a sketch from life done at the time Manet was painting his café and café-concert canvases (cat. 165, 172, 173), about 1878. But the strong resemblance of this motif to that of the illustrated note (cat. 198) suggests rather that Manet did the drawing in the summer of 1880, and that the table was in his garden at Bellevue.

F.C.

Catalogues
L 1969, 585; RW 1975 II, 518

1. Pellerin sale, Paris, June 10, 1954, album no. 5.

Provenance
This drawing belonged to AUGUSTE PELLERIN (see Provenance, cat. 100) and was acquired at his sale in 1954[1] by the Musée du Louvre (inv. RF 30.521).

197

198

199

200. Three Heads of Women

1880
Watercolor
$7\frac{1}{2} \times 4\frac{3}{8}''$ (19 × 11 cm)
Initialed (left center): E.M
P Musée des Beaux-Arts, Dijon

Manet had a fondness for hats, as witness, for example, the canvas known as *The Milliner* (cat. 213). These faces recall those in the illustrated notes to Isabelle Lemonnier (cat. 191–97), but evidently Manet here was more interested in the three summer hats: one adorned with a veil; another, a straw bonnet tied beneath the chin; and the third, a straw sun hat trimmed with a broad ribbon.

F.C.

Catalogues
RW 1975 II, 406

Provenance
DR. ALBERT ROBIN (see Provenance, cat. 156) bequeathed this and the following watercolors (cat. 200–203) to the museum in Dijon in 1930 (inv. 2959 A).

201. Two Hats

1880
Watercolor
$7\frac{1}{2} \times 4\frac{3}{4}''$ (19 × 12 cm)
Initialed (lower right): E M
P Musée des Beaux-Arts, Dijon

Two summer hats are here drawn in the style of fashion magazines of the period—isolated, and with much care for color and detail. Above, a kind of *charlotte* in green fabric, decorated with mauve flowers, probably artificial violets dotted with pansies. Below, in profile, a straw bonnet with a pale sky-blue brim edged in pink, decked with a garland of pink roses and secured by a wide pink ribbon tied under the invisible chin.

F.C.

Exhibitions
Marseilles 1961, no. 52

Catalogues
L 1969, 582; RW 1975 II, 675

Provenance
See cat. 200 (inv. 2959 C).

202. Three Plums

1880
Watercolor
$7\frac{1}{2} \times 4\frac{3}{4}''$ (19 × 12 cm)
Signed (lower center, in the shadow of the yellow plum): E. Manet
P Musée des Beaux-Arts, Dijon

Of the four watercolors in the collection of Dr. Albert Robin (cat. 200–203), this one by its placement on the sheet most resembles a heading for notepaper. There is no doubt that the fruit represented—strangely identified heretofore as apples—are plums, two mauve damsons above and a small yellow mirabelle below. It amused Manet to paint a bee, with enormous black eyes, buzzing over the plums.

F.C.

Catalogues
RW 1975 II, 613

Provenance
See cat. 200 (inv. 2959 B).

200

201

202

203. Almonds

1880
Watercolor
7½ × 4¾" (19 × 12 cm)
Signed (left center, in the shadow of the almond): Manet
P Musée des Beaux-Arts, Dijon

Although this watercolor was executed by Manet on a sheet of notepaper as though meant to serve as the first page of some future correspondence, similar to the illustrated notes he took pleasure in sending his friends in the summer of 1880 (cat. 191–98), the fact that he signed this one, like a work in its own right, suggests such was not the case. But whether inscribed or not, these casual sketches were certainly intended as little presents for Manet's friends. So it is very likely that the almonds were done for his friend Dr. Robin. The spontaneity of execution in no way diminishes the elegance of the composition, noticeable also in the signature worked into the drawing and in the Chinese delicacy of the opened almond below. Note the unexpected blue of the husk.

Exhibitions
Marseilles 1961, no. 51

Catalogues
RW 1975 II, 614

Provenance
See cat. 200 (inv. 2959 D).
 F.C.

204. Note to Méry Laurent

1880
Note, with watercolor
7½ × 4¾" (19 × 12.2 cm)
Bibliothèque Littéraire Jacques Doucet, Paris

In this illustrated message addressed to Méry Laurent (see cat. 215), Manet replies to a note expressing concern—Manet having been ill—over his absence from Paris. A watercolor morning glory adorns the sheet on which he states that his "prolonged stay at Bellevue does not mean that I'm worse; on the contrary, I'm getting better and better." In a previous letter, he had confided, "As for my doing penance, my dear Méry, so I am, as I've never done in my life. But as long as it turns out well. . . ."[1]

There are other watercolor notes to Méry Laurent. The location of one, dated September 8 (RW II 603), is not known. The present one, on the other hand, is not listed in the catalogues raisonnés of either Leiris or Rouart and Wildenstein.

Catalogues
Not mentioned

1. Paris, Bibliothèque Littéraire Jacques Doucet, MNR 1630.

Provenance
After the death of its recipient, MERY LAURENT (see cat. 215), this letter remained for many years with her heirs and was presented to HENRI MONDOR (see Provenance, cat. 150) on April 15, 1950. It was included in the Mondor estate, bequeathed to the Bibliothèque Littéraire Jacques Doucet in 1968 (inv. 132).
 F.C.

203

204

205. "Vive l'amnistie"

1880
Note, with watercolor
7⅛ × 4⅜" (18 × 11.2 cm)
Signed (at center): Ed. Manet
P Musée du Louvre, Cabinet des Dessins, Paris

This note is dated July 14, a date that a year earlier had been proclaimed a national holiday. It had just been announced that the law granting amnesty to the Communards would be enacted; Gambetta secured its adoption in the Chamber the following week, on July 20. The amnesty brought Henri Rochefort back to France, which gave Manet the idea of painting his portrait (cat. 206). On the same day, Manet drew a flag on a slip of paper, signed but not addressed, with the inscription "Vive la République" (RW II 596).

These two illustrated sheets express republican sentiments that Manet had held even before the Second Empire, to judge by a letter he wrote at the age of sixteen to his father from Rio de Janeiro: "Try to save us a good republic for our return, as I do fear that L. Napoleon is not very republican at all."[1]

The short message—"I won't write to you any more, you never answer"—like those above (cat. 191–97), is addressed to Isabelle Lemonnier (see cat. 190).

Catalogues
T 1947, p. 393; L 1969, 586; RW 1975 II, 577

1. Manet 1928, p. 67: to his father, March 22, 1849.

Provenance
This watercolor, like the other letters addressed to ISABELLE LEMONNIFR (cat. 191–97), was among those in her album purchased by ETIENNE MOREAU-NELATON (see Provenance, cat. 9) and included in his bequest to the Musée du Louvre in 1927 (inv. RF 11.183).

F.C.

205

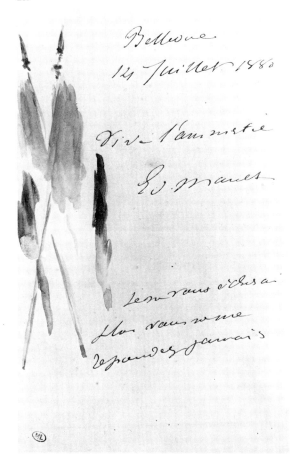

206. Portrait of M. Henri Rochefort

1881
Oil on canvas
32 × 26¼" (81.5 × 66.5)
Signed and dated (lower right): Manet / 1881
P Kunsthalle, Hamburg

Exhibitions
Salon 1881, no. 1516 (Portrait de M. Henri Roche-
fort); Beaux-Arts 1884, no. 108; New York, Na-
tional Academy of Design 1886, no. 21; New York,
Durand-Ruel 1895, no. 5; Paris, Durand-Ruel
1906, no. 22; London, Sulley 1906, no. 20; Berlin,
Cassirer 1906, no. 20; Stuttgart 1906, no. 16;
Munich, Heinemann 1907, no. 18; Berlin, Matt-
hiesen 1928, no. 70; Paris, Bernheim-Jeune 1928,
no. 48; Philadelphia-Chicago 1966–67, no. 172

Catalogues
D 1902, 283; M-N 1926 II, pp. 78–79, 84, 91; M-N
cat. ms., 312; T 1931, 352; JW 1932, 459; T 1947, 378;
PO 1967, 343; RO 1970, 347; RW 1975 I, 366

Henri de Rochefort (1830–1913), known as Henri Rochefort, had won fame under the Second Empire by his talents as a pamphleteer against the impe-rial regime and against Napoleon III in particular. He was responsible for the well-known epigram "There are twenty-five million French subjects, not counting subjects of complaint." After founding *La Lanterne* in 1868—a paper soon banned and then published in Brussels—he was active in the Commune, was deported in 1873, and escaped from the prison colony in New Caledonia in 1874 (see cat. 207). He returned to Paris· July 21, 1880, under the Amnesty Act, and set up the radical and socialist organ *L'Intransi-geant*. Some years later, after Manet's death, he came out in support of Gen-eral Boulanger, whom he followed in his flight to Belgium in 1889. Then, on returning to France, he placed his pen in the service of a virulent nationalism and anti-Semitism, notably at the time of the Dreyfus affair.

But at the time Manet portrayed him, Rochefort stood for radical and patriotic republicanism, and wore the romantic halo of his dramatic escape from prison. Manet might already have seen him at the salon of Nina de Cal-lias (see cat. 137), where he was a frequent guest, but in any case they be-came acquainted, or reacquainted, in the autumn of 1880 through Marcellin Desboutin (see cat. 146), a relative of Rochefort's.[1]

Manet and Rochefort were never very closely associated. Manet of-fered to do his portrait, and Rochefort none too graciously consented.[2] Ac-cording to Duret, when Manet later wished to make him a present of it, he declined, finding it "distasteful."[3] His tastes in art were quite traditional; at the time of the Zola sale in 1903, he wrote an article entitled "L'Amour du laid" [Love of the ugly], in which he directed his scorn primarily at Cézanne. He was apparently more pleased with the portrait Boldini had painted the previous year and with the eloquent busts of 1888 by Dalou and of 1897 by Rodin. These were in his collection, which otherwise consisted largely of eighteenth-century works, many of them not genuine.[4]

Yet there was nothing particularly revolutionary about this painting; the subject, not the artist, prompted the misgivings of the 1881 Salon jury, as is shown by a letter to Manet from Alphonse de Neuville, one of its influen-tial members: "I must admit I would not have done Rochefort's portrait; that prejudiced me against your entry."[5] However, both the canvases submitted by Manet, this one and the portrait of Pertuiset (cat. 208), were accepted, and Manet actually won a second-class medal, putting him at last *hors con-cours*. It was an important step: henceforth, he would be independent of the jury and could exhibit automatically.

The portrait by Manet shows the subject against a plain background in the traditional attitude of a man of action chafing under the enforced re-pose of a sitting, the arms folded, like Clemenceau's (see cat. 185, 186). Caricaturists were overjoyed with the face and upswept shock of hair

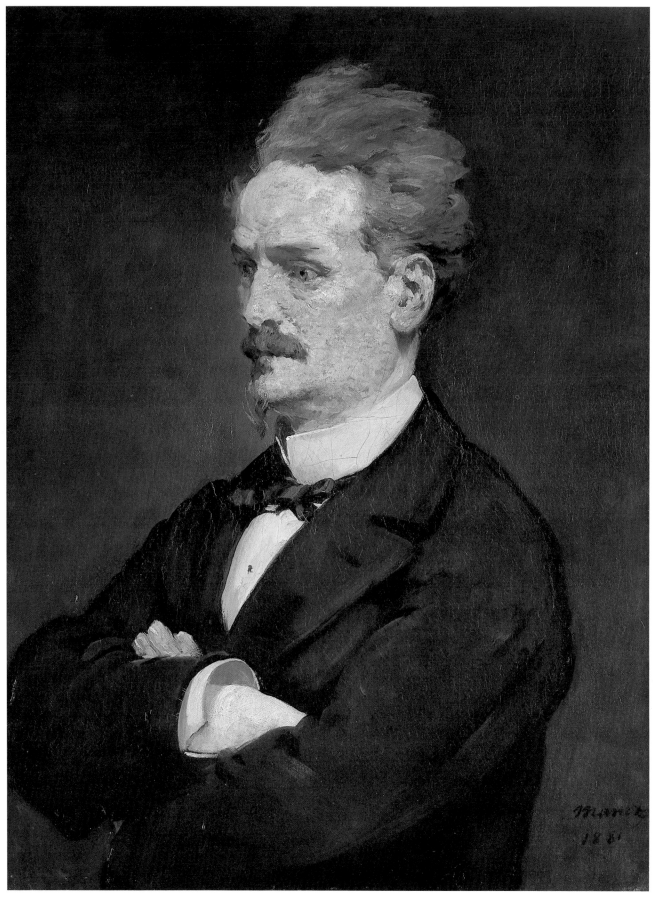

Fig. a. Stop, caricature in *Le Journal amusant,* 1881

1. Moreau-Nélaton 1926, II, p. 78.
2. Tabarant 1947, p. 405.
3. Duret 1918.
4. Henri Rochefort, "La Collection de M. Henri Rochefort," *Les Arts,* July 1905.
5. Paris, Bibliothèque d'Art et d'Archéologie, Manet archives: letter from A. de Neuville to Manet.
6. Alphonse Daudet, in *Le Nouveau Temps,* 1879, included in *Trente ans à Paris à travers ma vie et mes livres,* Paris, 1888, p. 193.
7. Huysmans 1883, pp. 181–82.
8. Callen 1974, p. 169.

(fig. a). "You recall that strange head," wrote Alphonse Daudet, who had known Rochefort from youth, "aflame like a bowl of punch . . . over that vast brow fraught with both migraine and enthusiasm, those deep-set black eyes shining through the gloom, nose straight and pinched, embittered mouth, the whole prolonged by a corkscrew of a goatee and irresistibly evoking a skeptical Don Quixote or a mellowed Mephistopheles."[6]

Manet's treatment of the slightly pock-marked face shows Impressionist touches, with some gray and blue *pointillage* that horrified J. K. Huysmans: "Like a young wine, a bit harsh but fresh and distinctive, this artist's painting was heady and engaging. Sophisticated to the palate, laden with fuchsine, without tannin, without bloom. His *Portrait of Rochefort,* fashioned after semiacademic precepts, does not hold up. Flesh of mottled cheese pecked at by the birds, hair a gray smoke. No accent, no life; M. Manet has in no way understood the sensitive energy of this unique physiognomy."[7]

Huysmans's objections are not altogether without foundation. Though painted with Manet's accustomed *brio,* this is one of his more conventional portraits, painted as though he had been overawed by the celebrity of his subject. All the same, the faint note of charlatanry did not altogether escape him—coiffure carefully arranged, from crown to tiny chin beard, signifying eloquence, *terribilità,* intransigeance. The swashbuckler peeps out from behind the hero, the Boulangist from behind the republican.

Provenance
Manet sold this painting to FAURE (see Provenance, cat. 10) in 1882, as one of five works for which he paid a total sum of 11,000 Frs. The group also included *Music in the Tuileries* (cat. 38) and *In the Conservatory* (cat. 180).[8] DURAND-RUEL (see Provenance, cat. 118) acquired the present work in 1907 and sold it the same year, through the dealer PAUL CASSIRER (see Provenance, cat. 13), to the museum in Hamburg (inv. 1564).

F.C.

207. The Escape of Rochefort

1880–81
Oil on canvas
57½ × 45¾" (146 × 116 cm)
Kunsthaus, Zurich

Exhibitions
Philadelphia-Chicago 1966–67, no. 170

Catalogues
D 1902, 290; M-N 1926 II, p. 78; M-N cat. ms., 314; T 1931, 350; JW 1932, 456; T 1947, 375; PO 1967, 342B; RO 1970, 346B; RW 1975 I, 369

The amnesty that brought Rochefort back to France (July 21, 1880) revived memories of his spectacular escape of 1874 from the French prison colony in New Caledonia. He had slipped out with four companions (Granthille, Jourde, Pascal Grousset, and Olivier Pain) in a whaleboat, by his account. An Australian ship was waiting for them and put them ashore in the United States, whence they returned to Europe, but not to France until the amnesty.[1] Manet called on Rochefort for full details with a view to doing a painting, and the artist Marcellin Desboutin (himself painted by Manet in 1875; see cat. 146) acted as intermediary: "The proposal was received *with enthusiasm.* The idea of an *Alabama* sea carried the day!! You shall have at your

command, when you choose, not only Robinson-Rochefort but also Olivier Pain-Friday. . . . All doors are opened to your name and to your talent by / Yours most sincerely / Desboutin."[2] On December 4, Mallarmé received the following note from Manet: "I saw Rochefort yesterday. The craft he used was a whaleboat. Its color was deep gray. Six [*sic*] men, two oars."[3] Five days later, Claude Monet wrote to Théodore Duret, "I saw Manet, in good enough health, very much taken up with a sensational painting for the Salon—Rochefort escaping in a rowboat on the open sea."[4]

This testimony enables us to date the work precisely (it was painted in late December 1880 or early January 1881), and it reveals Manet's intention: to do a "seascape" on a current theme, such as the *Battle of the Kearsarge and the Alabama* (cat. 83) had been in its day—in short, a "sensational" work for the Salon, where he wished as ever to be represented, but provocatively so.

Darragon has tracked down the circumstances of the escape and shown that Manet had rather innocently relied on Rochefort's story in representing the boat—the model for which, according to Léon Leenhoff, was carried into the garden in the rue d'Amsterdam[5]—on the high seas rather than in the sheltered harbor of an island. The ship that picked up the six men had in fact been in the waters of the commercial port, not out at sea. Their boat had served merely to bring them aboard from their place of escape. Manet placed Rochefort at the tiller, although it was Jourde. The escape had taken place at night,[6] a "phosphorescent night" as Rochefort described it in his novelized narrative *L'Evadé, roman canaque (Escaped: A Tale of the South Seas)*, published some months before the painting was produced.[7] In Manet's picture, the light is somewhat indeterminate, rather suggesting early dawn; the vigorous touches of white in the foreground doubtless represent the "phosphorescence" of the water.

Manet did two versions of the theme, this one and another (RW I 370; fig. a), but in the end he submitted neither to the Salon; instead, he sent the portrait of the escapee (cat. 206). It may well be that neither of the two versions really satisfied him. The first would seem to be this one, widely regarded as a study, unsigned but larger than the second.[8] In the first version, the fugitives' boat is nearer to the viewer, and the faces of Rochefort on the right and Olivier Pain on the left are quite recognizable. Pain, a journalist deported for his part in the Commune, was working with Rochefort on his paper *L'Intransigeant* at the time the painting was undertaken; Manet had done a small preparatory profile study of him (RW I 367). The sea, painted from memory at the studio on the rue de Saint-Pétersbourg, is more choppy in the first version than in the second. The composition carries the *Battle of the Kearsarge and the Alabama* to its logical conclusion; this time, the sea occupies virtually the whole area of the canvas, leaving a narrow, indefinite margin of sky at the top. The second version, where the boat is seen moments later, farther from shore, with the figures more indistinguishable, more isolated, more imperiled, brings to mind a cut to the next shot in a motion picture sequence. In both pictures, at the very top, we discern the outline of the Australian three-master that awaits Rochefort and his comrades.

In both versions, Manet sought to express the isolation of the fugitives and the precariousness of their fate: here by whipping up the surface of the waters, and in the second version by calming the waves but placing the boat, now a mere cockleshell bearing dimly seen occupants, at a distance, as in certain works of Delacroix admired by Manet in his youth (one of which he had copied; see cat. 1).

Fig. a. *The Escape of Rochefort*, 1880–81. Private collection, New York

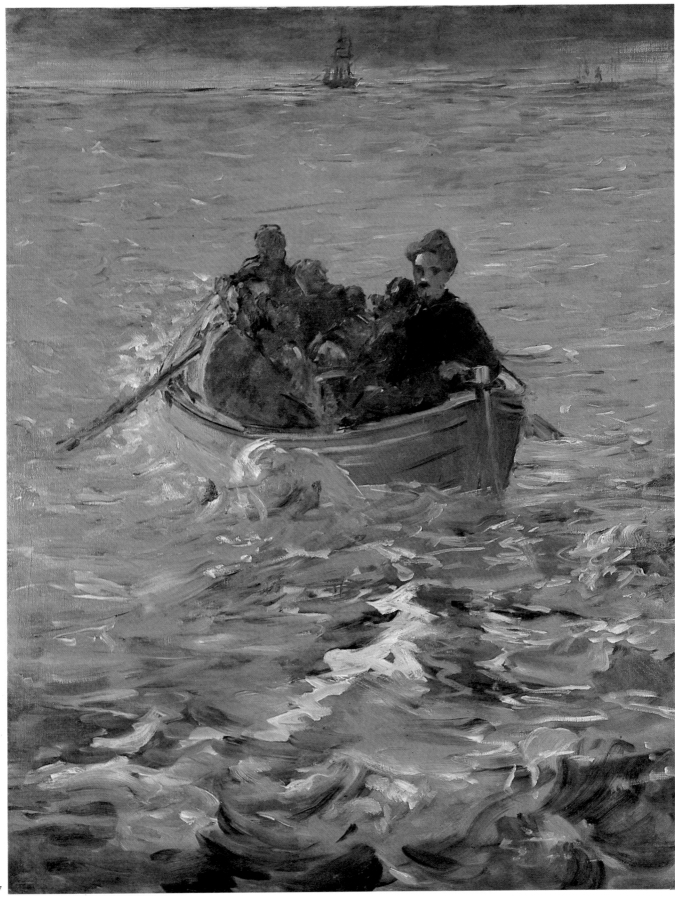

One reason for Manet's relative dissatisfaction with the composition, intended for the Salon but not submitted, may have been the difficulty of dramatizing an event of six years past, diminished to a picturesque memory by the presence of the protagonists themselves on the Paris scene. He may have felt uneasy depicting a romantic exploit that had ended in fine words making the rounds of the Paris cafés. This delay in timing robbed the painting of its pretext for polemic—save for a polemic that might prove embarrassing to Rochefort and Manet, regarding the true circumstances of the escape, which had been more prosaic and less flattering to the hero of the day.[9] Manet may have come to realize this in the course of the project, in speaking with Olivier Pain. He may have seen the risk of being thought an easy mark, of being ridiculed by those—and there were many, particularly in the press—who knew that Rochefort was not quite the romantic Hugo-esque hero, tiny in the immensity of the open sea, represented in the picture. Judiciously enough, Manet chose simply to submit a current portrait.

But it was the sea, finally, that had inspired him to paint. Proust reports that in sickness, one of Manet's favorite subjects of conversation was his voyages, to Cherbourg, to Italy, to Spain,[10] and especially to the seaside, his own symbolic escape from the confinement of ill health.

The affectation of carelessness—the zigzagging, arbitrary treatment of the "feathery" sea—would have both shocked the jury by its sketchiness, in this and the final version, and embarrassed his "modernist" and Impressionist friends by its chic manner in the style of Boldini, whose work was characterized by facile slickness. But today the work is impressive for just this extraordinary handling, which would have been called informal or gestural some years ago, but which in any case reflects a sort of painterly intoxication, the fascination of painting itself merging, and for the last time, with Manet's old love of the sea.

1. Tabarant 1931, no. 350; Tabarant 1947, p. 403; Darragon 1982.
2. Moreau-Nélaton 1926, II, p. 78.
3. Tabarant 1947, p. 403: from Manet to Mallarmé.
4. Tabarant 1947, p. 403: from Monet to Duret.
5. Manet et al., "Copie faite pour Moreau-Nélaton . . . ," p. 21.
6. Darragon 1982, p. 33.
7. Ibid.
8. Tabarant 1931, p. 393.
9. Darragon 1982, p. 34.
10. Proust 1897, p. 313.
11. Jamot and Wildenstein 1932, no. 456.
12. Tabarant 1947, p. 404.

Provenance
Both versions of *The Escape of Rochefort* were listed in the studio inventory. One of them (RW I 370) was apparently classified under "études peintes" (painted studies), and the present picture was evidently included among the more finished works, as no. 14 in the list of "tableaux et études" (paintings and studies). The latter did not appear at the 1884 retrospective or at the sale. According to Jamot and Wildenstein, it was acquired by the agent ALPHONSE PORTIER (see Provenance, cat. 122) from SUZANNE MANET (see Provenance, cat. 12),[11] but more probably she sold it to HERMANN PAECHTER (see Provenance, cat. 27),[12] her agent in the German art market. In fact, it soon appeared in the collection of MAX LIEBERMANN (1847–1935) of Berlin. The German painter owned the *Bunch of Asparagus* (see cat. 188, fig. a), which had formerly belonged to Charles Ephrussi, and many other works by Manet, almost all from the 1880s and very loosely painted (e.g., RW I 359, 379, 400). Liebermann—who has been called a German Impressionist—had lived in Paris for five years, from 1873 to 1878, and may have met Manet. This painting next belonged to Liebermann's daughter and son-in-law, HERR AND FRAU KURT RIEZLER, and then to WALTER FEILCHENFELDT of Zurich. In 1955, it was offered to that city's museum by the Association of Art Lovers of Zurich, with funds bequeathed by Dr. Ad. Jöhr (inv. 1955.9).

F.C.

208. Portrait of M. Pertuiset, the Lion Hunter

1880–81
Oil on canvas
59 × 67″ (150 × 170 cm)
Signed and dated (on tree trunk): Manet/1881
Museu de Arte, São Paulo

Exhibitions
Salon 1881, no. 1517 (Portrait de M. Pertuiset, le chasseur de lions); Beaux-Arts 1884, no. 104; London, Grafton 1905, no. 98; Salon d'Automne 1905, no. 23; Berlin, Matthiesen 1928, no. 68; Orangerie 1932, no. 76; New York, Wildenstein 1948, no. 32

Catalogues
D 1902, 282; M-N 1926 II, pp. 77–78; M-N cat. ms., 311; T 1931, 348; JW 1932, 454; T 1947, 373; PO 1967, 341; RO 1970, 345; RW 1975 I, 365

Manet had long been acquainted with Eugène Pertuiset, already a popular Paris figure under the Second Empire, who would appear at Tortoni's between expeditions to Algeria or Patagonia. He was a man of adventure, a mighty hunter, a sometime painter—some titles in the Pertuiset sale of 1888 were *The Lion Awakens, African Night, Cape Horn, Moonlight*[1]—a dealer in weapons, and a collector of paintings, particularly those by Manet (see Provenances, cat. 91, 220), and his stories were found entertaining by the artist. Very likely he tended to exaggerate. The lion hunter was a popular adventurer type in the 1860s. *L'Illustration* reproduced full-length representations of some of Pertuiset's famous predecessors, always with a Homeric epithet like that adopted by Manet: "Jules Gérard the lion slayer," for example, or "Bourbonnel, killer of lions and panthers."[2] As Darragon has noted, "Liberator, peacemaker, the lion slayer was, like the soldier, the physician, the missionary, one of the figures of European civilization. After military conquest, the elimination of predators becomes the very symbol of colonization."[3]

Antonin Proust relates that Pertuiset, accompanied by Manet and by Proust himself, went to present a lion skin to the emperor at the Tuileries: "They came and told us we could not be received, we'd have to come back. How Pertuiset raged! It was a treat to see him rolling up the hide."[4] A few years later, in 1872, Alphonse Daudet published his *Tartarin de Tarascon*, satirizing the boastful "lion killer" and demystifying the vogue of preceding years for heroic exoticism. A similar blend of admiration and irony seems to underlie this portrait of Pertuiset.

Manet posed his friend at the studio in hunting costume, "German style," more suitable, it would seem, to the pursuit of wild boar than of the king of beasts. For the landscape, he apparently used Pertuiset's garden at 14, passage de l'Elysée des Beaux-Arts, in Montmartre.[5] The tree, however, may equally well have been derived from watercolor sketches done at Bellevue the previous summer, such as the one Manet reproduced in a letter to Zacharie Astruc (RW II 601). The gun was a formidable weapon, recently developed, the Devisme carbine with "exploding" or "thunderbolt" bullet, a type dealt in by Rimbaud in Somaliland about the same period. As for the lion skin, probably it was none other than the famous trophy offered to the emperor fifteen years earlier and again exhibited at the Exposition Universelle of 1878, at the Palais Algérien du Trocadéro.[6]

Some historians relate the painting to the series of tragic works connected with death of the 1860s (see cat. 73, 74) and to the chronologically closer *Suicide* (RW I 258). Inasmuch as Manet's last illness was already manifest, they see here a preoccupation with mortality, which the well-meaning Pertuiset in his way personified.[7] But in the execution of this work, certainly Manet's sense of humor far outweighs any sense of impending death. The

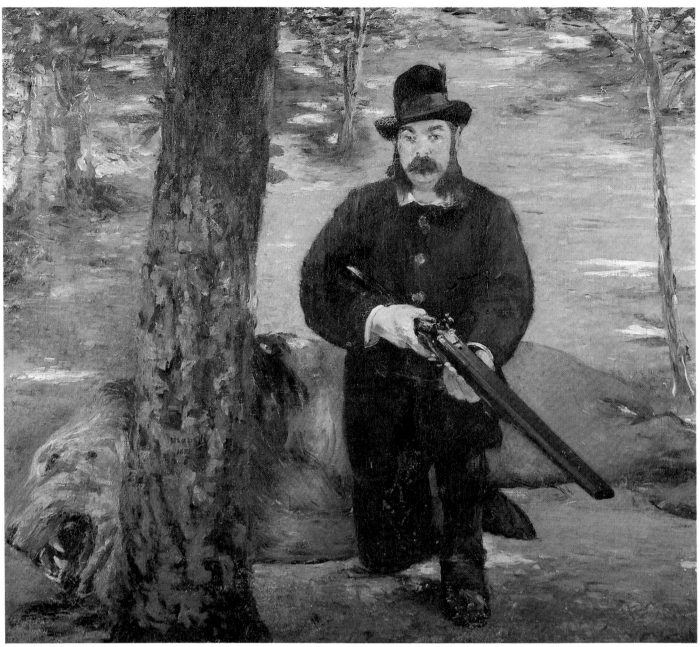

208

lion is a stuffed skin with glass eyes, a parodied version of the romantic, muscular wild beasts of Delacroix. Eighteen-eighty was also the year of the national subscription for Bartholdi's *Lion* at Belfort, which commemorated those who fell in the Franco-Prussian War of 1870–71.[8] If Manet was alluding to this nationalistic symbol, it was but to deflate and ridicule it. On the other hand, Pertuiset's brute strength is rendered impressive in the conventional, fixed "photographer's pose," the enormous hands in the foreground, the bull neck augmented by huge side-whiskers. The redness of the face accentuates the "butcher" and "big eater" aspect of the figure. A pen-and-ink drawing (RW II 487) probably made at the time of the painting shows Pertuiset's head only, hatless, in three-quarter view, facing left. There is the

M. Pertuiset demande pardon à Dieu et aux hommes d'avoir
tiré sur une vieille peau empaillée.

Fig. a. Stop, caricature in *Le Journal amusant,* 1881

Fig. b. *Pertuiset, the Lion Hunter,* 1881, pen and ink.
Private collection

1. Pertuiset sale, Paris, June 6, 1888, nos. 14, 20, 16.
2. *L'Illustration,* January 7 and February 11, 1865.
3. Eric Darragon, "Manet et la mort foudroyante," *L'Avant-guerre sur l'art,* no. 2 (1981), p. 23.
4. Proust 1897, p. 202.
5. Tabarant 1931, p. 390.
6. Darragon 1981 (see note 3 above), pp. 21–23.
7. Mauner 1975, p. 148; Darragon 1981 (see note 3 above), pp. 21–23.
8. Darragon 1981 (see note 3 above), p. 30.
9. Blanche 1919, pp. 140–41.
10. Manet to Moore, quoted by Jules Claretie, *La Vie à Paris,* Paris, 1881, p. 226.
11. Gervex, quoted in Fénéon 1970, I, p. 379.
12. Ephrussi, quoted in Tabarant 1931, p. 390.
13. Huysmans 1883, p. 182.
14. Renoir, quoted in Vollard 1938, p. 186.

same fixity of gaze, and the animal impression, with swollen neck and long side-whiskers, is still more caricature-like. In the painting, the effect of physical strength is enhanced by the parallel placement of torso and tree trunk, almost comically dividing the whole composition into two parts, hunter and hunted. Manet's signature in the middle, on the bark of the tree, parodies the carved initials of lovers, as the caricaturists did not fail to notice (fig. a).

The background was originally of a violent coloration, which appears to have faded with time. "I saw him painting *Pertuiset,* the lion slayer," Blanche tells us; "The violence and rawness of the colors were at first almost dissonant. . . . What are now grays were violets shot with pink; the flesh was tomato red, the landscape composed of carmine, winy lavenders and bluish greens, disagreeable enough. Time works *for* Manet and *against* the other modern painters."[9] It was just at this time that Manet, according to George Moore, said he had at last discovered the true color of the atmosphere: It was violet, the open air was violet.[10]

This purplish canvas was indeed a surprise. Curiously enough, both this work, which disconcerted even his friends, and the portrait of the controversial figure Rochefort (cat. 206), at last won for Manet his first real official recognition in 1881—none too brilliant, a second-class medal, but it gave him *hors concours* status. According to Gervex, this was due to Cabanel: "When the Salon jury (on which I served) came face to face with Pertuiset . . . there were storms of indignation. Then this same Cabanel, my teacher, who is no eagle, said, 'Gentlemen, there is not one among us fit to do a head like that *en plein air.'*"[11] The names of the artists on the jury who voted for Manet are known from a letter by Charles Ephrussi: "Here are the names of sixteen of the good men who voted for you. I don't have the seventeenth but believe it was Cabanel: Lavieille, Vollon, Duez, Cazin, Gervex, Carolus Duran, Bin, Roll, Feyen-Perrin, Vuillefroy, Guillemet, Eug. [Emile] Lévy, Lansyer, Lalanne, Henner, Neuville."[12] As a matter of fact, Cabanel had abstained, and Manet wrote in the missing name on the letter in pencil; it was Guillaumet.

Although he was thus at last admitted to the Salon with honors, the general reception was harsh. Suffice it to quote Huysmans: "As for his *Pertuiset,* on one knee, pointing his gun into the hall where he no doubt espies some wild beasts, while a yellowish dummy lion is stretched out behind him under the trees, I really don't know what to say. The pose of this side-whiskered hunter, as if to shoot a rabbit in the Bois de Cucufa, is childish, and in execution the canvas is no better than the sorry daubs it neighbors. To distinguish himself from them, M. Manet has been pleased to swathe the earth in violet—an innovation of no great interest and far too facile."[13]

A pen-and-ink drawing, more likely after the painting rather than a preparatory sketch (RW II 488; fig. b), places more emphasis on the tree and the human figure, the lion being all but nonexistent. Manet himself wrote below his signature, "Pertuiset, le chasseur de lions," corresponding to the Salon title.

It is difficult not to be perplexed about this astonishing canvas; it is ambitious—the largest in format since *Maximilian* (cat. 104), fourteen years earlier—provocative, on the verge of studied naiveté, and it aims at two apparently contradictory sentiments, shock and irony. All Paris knew Pertuiset and the rather comical anecdotes about his lion skin, and remembered *Tartarin*: "It was not understood that Manet meant to poke fun at the lion hunter, with his stuffed lion and his blunderbuss. . . . "[14]

If the portrait lacks that mortal *terribilità* which some have seen in it, the work is nevertheless energetic, droll, violent, derisive—in short, in some sense a true likeness of its hero.

15. Meier-Graefe 1912, pl. 180.
16. Jamot and Wildenstein 1932, no. 454.
17. Tabarant 1947, p. 411.

Provenance

This painting belonged to EUGENE PERTUISET, who owned as many as nine canvases by Manet. Probably painted on commission, the portrait was not included in the sale of part of his collection in 1888. It appeared near the end of the century with A. LEVY, and in 1898 with DURAND-RUEL (see Provenance, cat. 118), who still owned it in 1905, when he lent it to the Manet exhibition at the Salon d'Automne; its intense color must not have been discordant in the rooms where Fauvism prevailed. In 1911, it was in the OPPENHEIM collection. The portrait later appeared in Berlin with OTTO GERSTENBERG (see Provenance, cat. 25) in 1912,[15] and then in the collections of KATZENEL-LENBOGEN, and of SILBERBERG in Breslau.[16] PAUL CASSIRER and ETIENNE BIGNOU (see Provenance, cat. 13, 216) lent it to the 1932 exhibition.[17] It was donated to the museum in São Paulo by GASTON VIGIDAL and GEREMIA LUNARDELLI.

F.C.

209. Portrait of Henry Bernstein as a Child

1881
Oil on canvas
53¼ × 38¼" (135 × 97 cm)
P Private Collection

The future Paris dramatist Henry Bernstein (1876–1953) was five years old when Manet painted this delightful portrait. His father, Marcel Bernstein, a businessman and collector, had told Manet, now in ill health, of a house to let for the summer on the avenue de Villeneuve-l'Etang in Versailles, near his own.[1] In that summer of 1881, Manet (as Tabarant tells us, probably based on information from the sitter) had enjoyed his little neighbor's vivacity and assurance,[2] qualities apparent in the work, which was rapidly done and lightly painted. One feels Manet was particularly drawn to the contrast of the white sailor suit and fresh young face and the black tie and round hat. Perhaps this children's summer uniform reminded him of the uniform he had worn while serving on a training ship in 1848, and proudly described in a letter to his mother.[3]

The portrait, with all its charm of spontaneity, draws on a long past in Manet's work. There is the Watteauesque boy in white in *The Old Musician* (RW I 52), wearing a similar hat turned up in a halo effect. And Manet had often posed Léon Leenhoff (see cat. 14) and other children of about this age. This painting is like a negative, twenty years later, of the *Portrait of Young Lange* (RW I 61; fig. a), a Goya-like portrait of a little boy in black cloak with white collar, again wearing the round hat pushed back, life size on a sketchy background.

Renoir during these same years painted many portraits of children, with special attention to the soft, silky textures of hair and dress. There is no such concern here. Nothing of the sensuous or sentimental, on a theme usually treated with a great deal of both—especially at this time, and in particular by Bastien-Lepage in such works as *The London Bootblack*, 1882 (Musée des Arts Décoratifs, Paris) and *Pas mèche*, 1882 (National Gallery of Scotland, Edinburgh). But, rather, it is amusement, affection, and nostalgic reminiscence on many levels that inform this masterpiece, casually painted on a summer afternoon.

Exhibitions

Orangerie 1932, no. 77; New York, Wildenstein 1948, no. 43; Philadelphia-[Chicago] 1966–67, no. 155

Catalogues

D 1902, 288; M-N 1926 II, p. 91; M-N cat. ms., 326; T 1931, 360; JW 1932, 468; T 1947, 385; PO 1967, 351; RO 1970, 355; RW 1975 I, 371

Fig. a. *Portrait of Young Lange,* 1862. Staatliche Kunsthalle, Karlsruhe

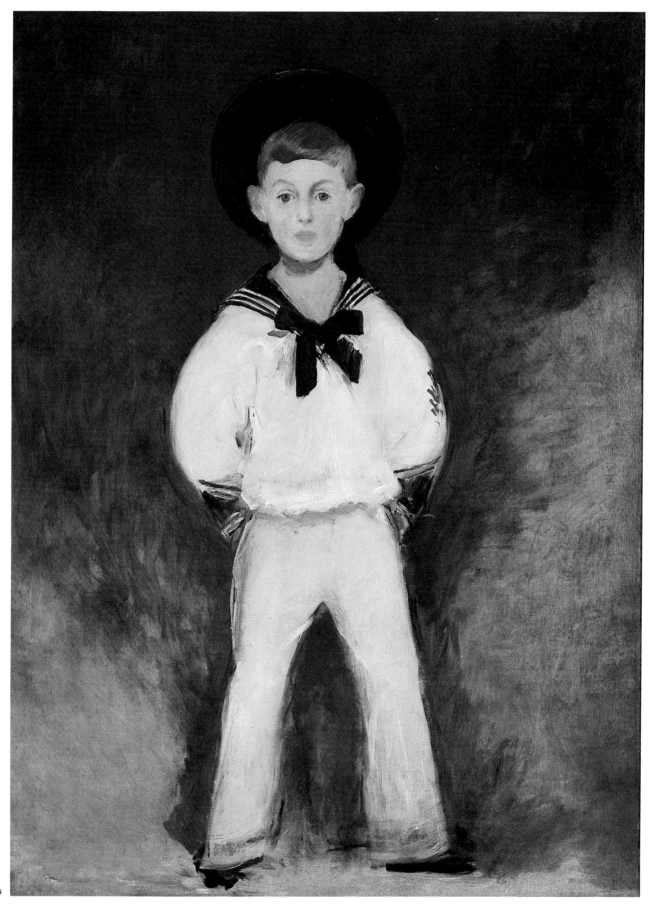

209

Provenance
Manet presented this portrait to MARCEL BERN-STEIN, banker and head of a large lumber company.[4] One of Manet's patrons, he purchased the *Monk in Prayer* (RW I 104) from the artist in 1882. His wife, née Weisweiller, was very interested in avant-garde art, and this painting was censured by her friends.[5] HENRY BERNSTEIN inherited it, and it later passed to his daughter, MME GRUBER, wife of the painter Francis Gruber (1912–1948), whose expressionist style and tortured subjects belong to one current of French art around the time of World War I.

F.C.

1. Tabarant 1947, p. 415.
2. Ibid., p. 419.
3. Courthion 1953, p. 42: from Manet to his mother, December 7, 1848.
4. Tabarant 1947, p. 419.
5. Henri Bernstein, pers. comm., to Mme C. Lefort, 1951.

210. My Garden *or* The Bench

1881
Oil on canvas
25⅝ × 31⅞" (65.1 × 81.2 cm)
Signed (lower right): Manet
Private Collection

In the late spring of 1881, Manet's doctor prescribed rest to combat the illness that had afflicted him since 1879. During the last week of June, he left Paris and went to Versailles, where he spent the summer in a rented house at 20, avenue de Villeneuve-l'Etang (see cat. 209). At first he was quite active and took long walks, but soon he was able to do little more than see friends, occasionally play croquet, and paint in the garden that is the subject of this picture. At the end of July, he confided to Stéphane Mallarmé: "Since arriving at Versailles, I have not been very happy about my health. Whether it is the change of air or the variations of temperature, it seems to me that I am less well than I was in Paris; perhaps I will get over it. . . . "[1]

In general, the summer was not a success. On September 23, Manet wrote to Eva Gonzalès Guérard: "Like you, alas, we have been having frightful weather. I believe it's been raining here for a good month and a half. And so, having left [Paris] in order to do some studies in the park laid out by Lenôtre, I've had to content myself with painting only my garden, which is the unloveliest of gardens. A few still lifes, and that's all I'll bring back; not to mention that I've found this downpour a bit of a trial, and we have not been able to take advantage of all the opportunities offered by our charming surroundings."[2]

Manet's comment about "the unloveliest of gardens" notwithstanding, *My Garden*, evidently painted during a rare period of good weather, is one of his most popular works and is regarded as a masterpiece of Impressionism. It differs from the garden subjects of most of Manet's contemporaries mainly in its feeling of intimacy; most Impressionist pictures are characterized by a less personal quality. In this work, the yellow hat on the bench and the vase of flowers on the table suggest a glimpse of someone's private world. Although the garden is relatively unexceptional in its appearance, it is particularly appealing because of its simplicity and unpretentiousness. Manet seems to have savored his view of "the unloveliest of gardens" with every brushstroke, every spot and dab of color. The execution of the subtle play of light and color on the path and the back of the bench is rarely equaled in Impressionist painting. Each blade of grass, each leaf and flower

Exhibitions
Beaux-Arts 1884, no. 106; Exposition Universelle 1889, no. 494; Berlin, Sezession 1903; London, Grafton 1905, no. 88; Salon d'Automne 1905, no. 24; Orangerie 1932, no. 79; Philadelphia 1933–34, without no.

Catalogues
D 1902, 299; M-N 1926 II, p. 85; M-N cat. ms., 316; T 1931, 357; JW 1932, 460; T 1947, 382; PO 1967, 349; RO 1970, 353; RW 1975 I, 375

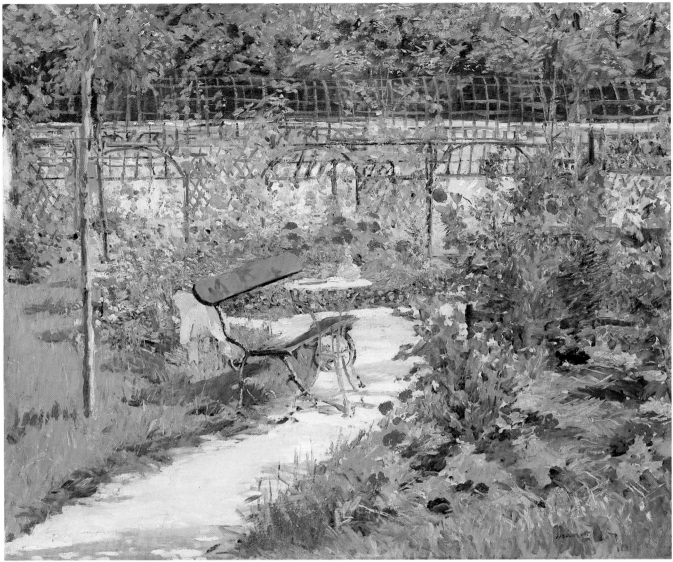

210

1. Tabarant 1947, p. 47.
2. Moreau-Nélaton 1926, II, p. 85; Wilson 1978, no. 107.
3. John Rewald, "The Impressionist Brush," *The Metropolitan Museum of Art Bulletin*, XXXII, no. 3 (1973–74), p. 20.
4. Manet et al., "Copie faite pour Moreau-Nélaton . . . ," p. 81.
5 Letter from Charles Durand-Ruel, December 13, 1982 (archives, department of European paintings, The Metropolitan Museum of Art, New York).
6. Rewald 1973, *Gazette des Beaux-Arts*, pp. 105–6.

is different; in no passage does the execution become mannered or repetitive. As Rewald has written, "The individual brush strokes seldom fuse, each bringing to the whole its precise, essential accent. The swirls and splotches, the energetic strokes of a pigment-loaded brush, the rashly drawn lines, the short commas, the scattered spots appear as inescapable necessities."[3]

Provenance
Manet recorded the sale of this picture in his account book in 1881: "Durand-Ruel Jardin 2000 fr."[4] According to the stock books of DURAND-RUEL (see Provenance, cat. 118), the transaction took place on November 18.[5] The dealer sold the work for 2,500 Frs on May 10, 1882, to LEON CLAPISSON (1837–1894), the Parisian stockbroker who began in the 1870s to build a collection of works by Renoir, Monet, Pissarro, Sisley, and Gauguin.[6] Clapisson sold the picture back to DURAND-RUEL on April 21, 1892, for 6,000 Frs, and it remained in the dealer's stock until 1945.

C.S.M.

211. A Bar at the Folies-Bergère

1881–82
Oil on canvas
37¾ × 51¼" (96 × 130 cm)
Signed and dated (lower left, on bottle label): Manet/1882
Courtauld Institute Galleries, Home House Trustees, London

Exhibitions
Salon 1882, no. 1753 (Un bar aux Folies-Bergère);
Beaux-Arts 1884, no. 112; Paris, Drouot 1884,
no. 7; New York, Durand-Ruel 1895, no. 3; Expo-
sition Universelle 1900, no. 448; London, Grafton
1905, no. 93; Munich, Moderne Galerie 1910,
no. 2; Paris, Bernheim-Jeune 1910, no. 20; Lon-
don, Grafton 1910–11, no. 7; Saint Petersburg
1912, no. 405; Orangerie 1932, no. 82; London,
Tate Gallery 1954, no. 16

Catalogues
D 1902, 293; M-N 1926 II, pp. 91, 92, 95; M-N cat.
ms., 329; T 1931, 369; JW 1932, 467; T 1947, 396; PO
1967, 357A; RO 1970, 361A; RW 1975 I, 388

The melancholy in the absent gaze of the serving girl in *A Bar at the Folies-Bergère* is answered by our own regret before what was the last masterpiece of an artist who died at the relatively early age of fifty-one. We are left to imagine the series of enthralling pictures that Manet might yet have forged, as here, from his own poetic universe, his taste for the work that is composed and pondered, and the "Impressionist" *peinture claire* of his last ten years.

In the foreground is one of Manet's most dazzling still lifes, as if re-capitulating the little paintings of fruits and flowers done toward the end of his life. On a marble counter top that Manet had brought into his studio[1] are bottles of champagne and of Bass Pale Ale with the red triangle on its label; a bottle of crème de menthe; a compote with mandarin oranges; and roses in a glass, beautifully set off against the blue-black velvet of the girl's redin-gote. Behind the serving girl, the gilt-framed mirror reflects the café-concert hall under the great chandeliers, a scene described by Maupassant: "A to-bacco haze lightly veils, like a very fine mist, the more distant regions . . . this thin fog keeps rising, piles up at the ceiling, and forms, under the wide dome, around the chandelier, above the first gallery laden with spectators, a cloudy sky of smoke."[2] The spectators seem to ignore a trapeze act in mid-performance; little feet shod in bright green are glimpsed at the upper left of the canvas. The woman in white, elbows on the rail of the balcony, is Méry Laurent (after a pastel, RW II 51; see cat. 215), and behind her, in beige, is Jeanne Demarsy (after the portrait, RW I 374; see cat. 214).

They embody the brilliant world of demimondaines that attracted all Paris to the Folies-Bergère, a café-concert much in vogue (fig. a), where the most diverse company rubbed shoulders, out for a good time and a taste of low life—a place of encounter as much as of spectacle.[3] This feature had merely become more marked between 1881, when the painting was con-ceived, and 1885–86, when the naturalist observers of the scene, Huysmans and Maupassant, described "the only place in Paris that stinks so sweetly of the *maquillage* of purchased favors and the extremes of jaded corruption"[4] and "the circular promenade where . . . a group of women awaited arrivals at one or another of the three bars behind which, heavily made-up and wilt-ing, three vendors of refreshments and of love held court."[5]

Such passages may have led T. J. Clark to interpret Manet's canvas as the image of dismal prostitution, and the girl's expression as one of aliena-tion.[6] But Manet surely had no intention of portraying the degradation of a fallen woman, the corruption of a working girl by the bourgeoisie; that is an ideological mirage willfully imposed on the work. The barmaid, certainly hired for her beauty and freshness, so as to attract the clientele, stands with hands resting upon the bar, looking out at the whirl of pleasure for sale. It must of course have been easy to slip out of the one role into the other, pro-vided one were pretty, but the model, at least at the time of the painting, is decidedly on the other side of the counter, an indifferent observer.

Fig. a. Jules Chéret, poster for the Folies-Bergère, 1875

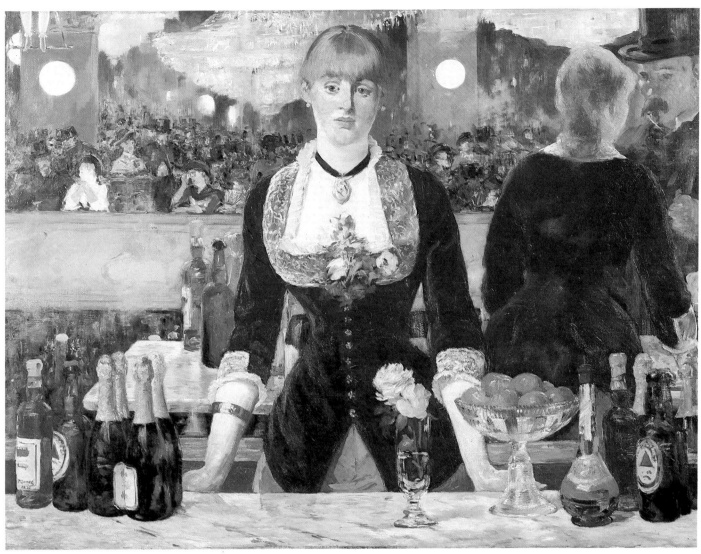

211

The "bartender, with bangs"[7] was not, as so often with Manet, a professional model. For this work, Manet posed a young woman who was actually employed at the Folies-Bergère; her name was Suzon.[8] He did a superb pastel of her (RW II 65), not in working clothes but dressed for a day out, with a sensuous profile, pouty and slightly porcine, and a dazzling pink complexion.

In the painting, her look is absent, weary, dispirited. Manet deliberately expressed an idea of solitude in this great motionless figure, isolated amid elegant animation and sparkling lights. Her country girl's face, as if new to Paris, is more drowsy than forward, more aloof than flirtatious. She suggests the opposite of promiscuity, and attains a kind of simple grandeur, in which Hofmann goes so far as to see analogies, in the frontality of the figure, with an antique deity.[9] Her reflected back, in a position that appears slightly more inclined than the erect, dignified figure confronting us would suggest, seems more "at your service," as Clark notes, as if a second barmaid were involved.[10] The mustachioed man talking to her, cane in hand, was posed by the painter Gaston Latouche, according to his own statement.[11]

The idea of a composition before a mirror may have been suggested to Manet by Caillebotte's painting *In a Café* (fig. b), shown at the Impressionist exhibition of 1880; a man standing, three-quarter length—an attitude itself probably derived from Manet's *The Luncheon in the Studio* (cat. 109)—leans against a table in front of a mirror reflecting a café scene.[12] And other painters before Manet had painted the bar at the Folies-Bergère; Boldini, for example, in *The Café-Concert*, 1878,[13] in which a similar barmaid, leaning forward, sets drinks before a couple, and in which the vulgarity of style is well suited to the characters' knowing expressions.

But there is a literary source certainly more significant to the artist's imagination: the passage in Zola's novel *Le Ventre de Paris* (of which Manet owned an autographed copy[14]) in which the hero admires the lovely *charcutière* of Les Halles, standing beside her pile of goods: "Fair Lisa stood behind the counter. . . . Florent beheld her, mute, amazed to find her so beautiful. . . . That day she had a superb freshness, the white of her apron and

sleeves continuing the white of the platters up to her plump neck, to her rosy cheeks, where the tints of tender hams and pale translucent fats lived again. . . . Florent took to looking at her stealthily, in the mirrors. . . . They reflected her from the back, the front, the side. . . . There, a host of Lisas showed the breadth of shoulder, the rounded bosom, so still and soft that she aroused no carnal thought, and might almost have been a side of bacon."[15]

This was the first use in Manet's oeuvre of the mirror effect, so convenient in portraiture, and previously adopted by Ingres and Degas in particular; but contrary to the traditional procedure, Manet does not exploit its possibilities for presenting several views of the same model. His mirror takes on an independence; for the first time, it extends over almost the whole canvas, covering its entire width and most of its height. On the one hand, it is treated as a plane, corresponding to the surface of the canvas; the gray touches with which it is punctuated reinforce the idea of a surface devoted to painting itself rather than to any illusionistic effect. On the other, the image mirrors a space in which we, the viewers, would really be stationed. It is as though the canvas itself were but a reflection of our world, and only the barmaid stands between the painting and ourselves, her physical presence affirmed between two absent places—the one in which her gaze situates us, and a reflection. The woman's presence gains, by this visual play, a singular emotional force. The mirror shows us the scene—bottles, lights, people—in a completely artificial reverse perspective, which is not attributable to artistic license alone. This tremulous, luminous image of reality is characteristic of Paris nightlife: "The city is reflected in a thousand eyes, a thousand lenses," Walter Benjamin wrote of Paris. "The beauty of Parisian women shines forth from mirrors such as these. . . . A riot of mirrors surrounds the men too, especially in the cafés . . . the mirrors are the immaterial element of the city, her emblem, within which have been enrolled the emblems of all schools of poetic art."[16]

The artificiality of the perspective was noted from the first. Although the mirror is strictly flat and parallel to the bar (witness the gilt frame intercepting the girl's wrists on either side), the reflected images are out of alignment, as though the glass were at an angle—the reflection of the table and the bottles at the left, and especially that of the girl's back, which her frontal pose should make scarcely visible. And her interlocutor at the right should stand between her and us, separating us from her wholly or in part. The preliminary sketch (cat. 212) is similarly out of alignment, but more plausibly so, the woman looking to her left and downward at a man standing farther away and on a lower level, who would be just outside the picture on the right. In the final painting, this "faulty" perspective, this unrealism, is clearly intentional; in any case, it was less important to Manet than the voluminous literature on the subject would suggest.

The false perspective, so rich in poetic implications, substituting the viewer of the picture for the bartender's interlocutor, was found astonishing from the outset. Consider the caricature by Stop (fig. c) at the time of the Salon, which restores the absent person; or Huysmans's description: "M. Manet's *A Bar at the Folies-Bergère* bewilders the throng of visitors, who exchange puzzled remarks concerning the mirage of this canvas, . . . which is not quite right optically. The subject is modern enough . . . but what is the meaning of this lighting? Gaslight, electric light? Not at all, it is a vague *plein-air*, a bath of wan daylight."[17]

Fig. b. Gustave Caillebotte, *In a Café*, 1880. Musée des Beaux-Arts, Rouen

UNE MARCHANDE DE CONSOLATION AUX FOLIES-BERGÈRES. — (Son dos se reflète dans une glace ; mais sans doute par suite d'une distraction du peintre, un monsieur avec lequel elle cause et dont on voit l'image dans la glace n'existe pas dans le tableau. — Nous croyons devoir réparer cette omission. Salon 1882).

Fig. c. Stop, caricature in *Le Journal amusant*, 1882

The *Bar* was in fact executed in the studio, "Manet making no pretense," Blanche tells us, "of seeking an illusion of evening. . . . The truth is that Manet is not a realist painter but a classical painter; once he puts a touch of color on a canvas, he always thinks more of pictures than of nature."[18] Clearly, the painting does not represent a real bar; the mirror gives a reflection of a borrowed marble-top table, and the bottles—with champagne warming on the counter—are not set up as they would normally be.

This reconstruction was described by the young painter Georges Jeanniot, who visited Manet's studio in January 1882. "He was then painting *A Bar at the Folies-Bergère*, and the model, a pretty girl, was posing behind a table laden with bottles and comestibles. He recognized me at once, offered me his hand, and said, 'It's a nuisance, excuse me, I have to remain seated, I have a bad foot. Sit down over there.' I took a chair behind him and watched him at work. Manet, though painting from life, was in no way copying nature; I noticed his masterly simplifications; the woman's head was being formed, but the image was not produced by the means that nature showed him. All was condensed; the tones were lighter, the colors brighter, the values closer, the shades more diverse. The result was a whole of blond, tender harmony. Someone came in, I recognized my boyhood friend Dr. Albert Robin. . . . More people came, and Manet stopped painting to go sit on the couch against the wall at the right. Then I saw how illness had changed him . . . he was cheerful all the same, and spoke of his early recovery."[19]

It is known that Manet, already quite unwell, worked slowly at this time. Visitors agree in their reports of "laborious sittings, but brief," during which Manet, "soon tiring, would stretch out on a low couch, under the light from the window, and contemplate what he had just painted."[20] This was his last masterpiece, a final representation of sensuous objects, a wistful repository of the Parisian world that had been part of his life, between a smoke-tarnished mirror and a *regard regardé* whose unfathomable sadness is as it were a farewell to painting.

1. Blanche 1919, p. 145.
2. Guy de Maupassant, *Bel Ami*, Paris (1885) 1973, p. 43.
3. François Caradec and Alain Weill, *Le Café-Concert*, Paris, 1980, p. 62.
4. J. K. Huysmans, "Les Folies-Bergère en 1879" (1880), reprinted in *Croquis parisiens*, Paris, 1886, p. 24.
5. Maupassant (1885) 1973, see note 2 above.
6. T. J. Clark, "The Bar at the Folies-Bergère," in *The Wolf and the Lamb: Popular Culture in France*, ed. J. Beauroy, M. Bertrand, and E. Gargan, Saratoga, Calif., 1977, pp. 233–52.
7. Eudel 1884.
8. Tabarant 1931, p. 412.
9. Hofmann 1973, p. 181.
10. Clark 1977, p. 236, see note 6 above.
11. Gaston Latouche, "Edouard Manet souvenirs intimes," *Le Journal des arts*, January 15, 1884.
12. J. K. T. Varnedoe and Thomas P. Lee, *Gustave Caillebotte* (exhibition catalogue), Museum of Fine Arts, Houston, 1976, p. 146.
13. Giovanni Boldini, *Opera completa di Boldini*, ed. C. I. Ragghianti, Milan, 1970, no. 58.
14. New York, Pierpont Morgan Library, Tabarant archives: list of volumes from Manet's library.
15. Zola 1960, I, p. 667.
16. Walter Benjamin, "Paysages urbains; Paris la ville dans le miroir" (1929); French trans. in *Sens unique: Enfance berlinoise*, Paris, 1978, p. 307.
17. Huysmans 1883, pp. 277–78.
18. Blanche 1919, p. 136.
19. Jeanniot 1907, pp. 853–54.
20. Blanche 1919, p. 141.
21. Manet sale, February 4–5, 1884, no. 7; Bodelsen 1968, p. 343.
22. Chabrier sale, Paris, March 26, 1896, no. 81; Rollo Myers, *Emmanuel Chabrier and His Circle*, London, 1969, pp. 5, 149, 152, 160.
23. Mr. and Mrs. Roussakov, pers. comm.
24. F. Rutter, "Manet's Bar aux Folies-Bergère," *Apollo* XIX (May 1934), pp. 246–47.

Provenance

At the Manet sale in 1884, this picture was sold to Chabrier for 5,850 Frs,[21] almost double the price brought by *The Balcony* (cat. 115) or *Nana* (cat. 157). The composer ALEXIS-EMMANUEL CHABRIER (1841–1894) was one of Manet's longtime friends and the only one present at the time of his death. An amateur painter and a man of great taste, Chabrier formed a remarkable collection of Impressionist paintings. In addition to works by Sisley and Cézanne, he owned three by Renoir, six by Monet, including *Street Decked out with Flags*, painted at the same time as Manet's views of the rue Mosnier (cat. 158–60), and seven more by Manet, including *Skating* (RW I 260). His wife was very fond of paintings, and it was apparently her recent inheritance that provided Chabrier with the means to purchase the present picture in 1884. Chabrier posed for two portraits by Manet (RW I 364; II 209, pastel), as well as for the *Masked Ball at the Opéra* (cat. 138). *A Bar at the Folies-Bergère* hung above the piano in his apartment until his death. At the Chabrier sale in 1896, the picture did not meet its reserve (23,000 Frs) and was bought in.[22] MME CHABRIER sold it to DURAND-RUEL (see Provenance, cat. 118) in May 1897, and it later entered the collection of AUGUSTE PELLERIN (see Provenance, cat. 109). Included among works by Manet from his collection that Pellerin sold as a group to the dealers BERNHEIM-JEUNE, PAUL CASSIRER, and DURAND-RUEL (see Provenance, cat. 31, 13, 118), the picture later entered the collection of EDUARD ARNHOLD (see Provenance, cat. 29) in Berlin. When it was exhibited in Saint Petersburg in 1912, it was apparently for sale, at a high price; the fact that it did not find a buyer because the rich collectors Shchukin and Morozov were away was deplored by the press.[23] In 1919, the picture appeared in Budapest, in the collection of BARON HATVANY. By the mid-1920s, it was with JUSTIN K. THANNHAUSER (see Provenance, cat. 156) in Munich and Lucerne; he sold it to ERICH GOERITZ of Berlin. Before 1926, it was acquired by Percy Moore Turner (see Provenance, cat. 120), acting as agent for the important silk manufacturer SAMUEL COURTAULD (1876–1957). Courtauld's collection was divided among several heirs, as well as the National Gallery, London, the Tate Gallery, and the Courtauld Institute (which he founded in 1931), to which he gave this painting. Shipped by plane to Paris for the Manet retrospective in 1932, this work was perhaps the first picture ever transported by air.[24]

F.C.

212. *Study for* A Bar at the Folies-Bergère

1881
Oil on canvas
18½ × 22″ (47 × 56 cm)
Stedelijk Museum, Amsterdam (lent by Ir. F. F. R. Koenigs, Bennekom, The Netherlands)

Exhibitions
Vienna, Miethke 1910, no. 3; Berlin, Matthiesen 1928, no. 73; Orangerie 1932, no. 81; Marseilles 1961, no. 37; Philadelphia-Chicago 1966–67, no. 177

Catalogues
D 1902, 294; M-N 1926 II, p. 91; M-N cat. ms., 330; T 1931, 370; JW 1932, 466; T 1947, 397; PO 1967, 357B; RO 1970, 361B; RW 1975 I, 387

This work is a preliminary study for the painting *A Bar at the Folies-Bergère* (cat. 211). The photograph by Lochard taken in 1883 bears the handwritten annotation, undoubtedly by Léon Leenhoff, "Painted from sketches made at the Folies-Bergère. Henry Dupray (the military painter) chats with the girl at the counter. Painted in the studio on the rue d'Amsterdam."[1] According to Tabarant, the canvas was altered, and in particular the lower section repainted.[2] Tabarant's argument is based on the Lochard photograph, where the lower part of the canvas does not appear, nor does it appear in the reproduction in Meier-Graefe's monograph. But close examination shows that no addition was made to the canvas; however, the manner in which the bar itself was painted, whether by Manet's hand or not, lacks the sureness of touch of the rest of the work.[3]

As is the case repeatedly in Manet's oeuvre—the series of seascapes

212

(RW I 144; cat. 119; RW I 146, 147), the *Maximilians* (see cat. 104, 105)—a great deal has been done between the preliminary study and the final canvas intended for the Salon. Between the liveliness of a little painting such as this and the definitive canvas, there is a transformation at work guided by the logic of the picture rather than of the scene; reality is transposed, bent, as it were, by a need for order and simplification, at the expense of actual appearance. The reflections of the two figures in the study become implausible in the painting, where they propound a more complex poetic truth. The principal figure in the study, seemingly not the final model, has not yet assumed a mythical stature. From a vignette of everyday life, Manet in the end created an icon of contemporary Paris; from an impressionistic memorandum, he fashioned a great *morceau de peinture*.

There seems to have been a preparatory watercolor as well, given by Manet to Antonin Proust[4] (RW II 527, not reproduced). Its present location is not known.

1. Manet et al.
2. Tabarant 1947, p. 424.
3. Hanson 1966, p. 187.
4. Tabarant 1947, p. 423.
5. Rouart and Wildenstein 1975, I, p. 27.

Provenance
This painting was listed in the posthumous inventory (no. 92, valued at 200 Frs).[5] In 1885, SUZANNE MANET (see Provenance, cat. 12) presented it to Manet's friend EDMOND BAZIRE (1846–1892), who had just written the first monograph on the artist (1884). The picture was acquired by CAMENTRON (see Provenance, cat. 50), then passed to DURAND-RUEL (see Provenance, cat. 118). In 1912, it entered the collection of DR. GOTTFRIED EISSLER (1862–1924) of Vienna, and it later appeared in the collection of FRANZ KOENIGS (see Provenance, cat. 13) of Haarlem, who lent it to the exhibitions at Matthiesen in Berlin in 1928 and at the Musée de l'Orangerie in Paris in 1932. It is at present on deposit in the Stedelijk Museum (inv. B 209).

F.C.

213. The Milliner

1881
Oil on canvas
33½ × 29″ (85.1 × 73.7 cm)
Signature, not authentic (lower left): E. Manet
The Fine Arts Museums of San Francisco

The title *The Milliner*, given to this work at the Manet sale of 1884, doubtless fails to correspond with the actual subject of the painting. What this shows, in fact, is a woman trying on hats, either in her own home or more likely in a hat shop; it would be difficult to imagine a milliner receiving her customers in such a state of undress.

Against a flowered background—wallpaper or a hanging, as in *Autumn* (cat. 215)—a woman in strict profile, bare-shouldered, wearing a shawl over what appears to be a corset and petticoat, has just taken a black hat from one of the hat stands before her. At the left, cut off by the frame, sits another hat, of straw, with a red ribbon.

Manet was fascinated by women's dress, and always painted their hats with a certain relish. *Music in the Tuileries* (cat. 38), in which he depicted the summer bonnets with wide, colorful ribbons of the Second Empire, inaugurated an amusing series of works in which hats are shown in different styles—from the flowered toque of Fanny Claus in *The Balcony* (cat. 115) to straw hats covered with veiling, as worn by women of the period to shield their complexion from the sun (cat. 135, 200); the neat yellow *bibi* of Mme Guillemet in *In the Conservatory* (cat. 180); and the extravagant creations

Exhibitions
Paris, Drouot 1884, no. 51; Berlin, Cassirer 1910; Paris, Bernheim-Jeune 1910, no. 18; New York, Wildenstein 1937, no. 28; New York, Wildenstein 1948, no. 26; Philadelphia-Chicago 1966–67, no. 165

Catalogues
D 1902, 273; M-N cat. ms., 254; T 1931, 356; JW 1932, 322; T 1947, 394; RO 1970, 360; RW 1975 I, 373

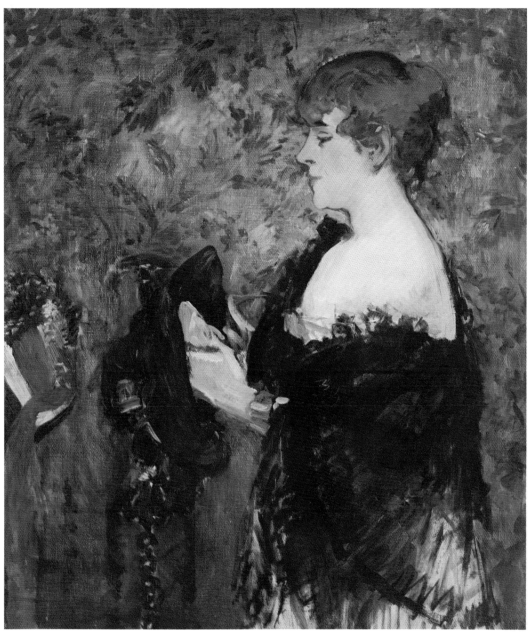

213

worn by Berthe Morisot (cat. 130), Méry Laurent (RW II 73), and Irma Brunner (cat. 217), the intense black offsetting the color of the skin. Manet is known to have gone at the same period to a milliner's on the rue de la Paix expressly to choose a hat for a portrait (see cat. 214, fig. b), after calling on a dressmaker, where, Proust tells us, "he spent the day in an ecstasy over stuffs unrolled before him by Mme Decot. Next day, it was the hats of a noted milliner, Mme Virot, that enthralled him. His purpose was to create a *toilette* for Jeanne [Demarsy]. . . ."[1] We know from Proust's account that the milliner in question had white hair, so she cannot have been the model for this painting, as some catalogues have suggested.[2]

Manet certainly also liked to escort his fair friends—Méry Laurent, for example—to the establishments of couturiers, furriers, and milliners; feminine finery, as may be seen in his letters (e.g., cat. 194, 198), enchanted and intrigued him.

This aspect of contemporary life was to become a favorite theme of Degas's from about 1882 on, but the differences between the two artists are if anything emphasized by a comparison of their approaches to similar motifs; Degas generally deployed the decorative and scenic resources of an array of hats, usually seen from above (fig. a), while Manet used the simplest and most direct forms, creating a modern image, true to life yet enigmatic, with the most banal image of frivolity as his point of departure.

The painting is unfinished. The flowered background, the hats, the vigorous lines of the shawl are Manet's very signature, and the selling price (see Provenance), nearly the same as for *Before the Mirror* (cat. 156), indicates an analogous state of completion. However, it is not impossible that another hand repainted certain details, especially the head, where the profile and coiffure evoke something indefinable associated with the 1890s and carried furthest by Toulouse-Lautrec: there is a touch of caricature in the simplification. But without close examination, it is difficult to say whether the hand was Manet's, responding to a somewhat later feminine mode and style, or that of an artist who undertook to "finish" the work, as is believed to have been done on occasion by Manet's nephew Edouard Vibert.[3] Julie Rouart-Manet in her journal records misgivings over the post-mortem embellishments undergone, with the family's permission, by sketches from Manet's studio in order to render commercial, at the turn of the century, works that had by then already become valuable property.[4]

Fig. a. Edgar Degas, *The Millinery Shop*, 1885, pastel. The Art Institute of Chicago

1. Proust 1897, p. 310.
2. Rouart and Orienti 1970, no. 360.
3. Tabarant 1947, pp. 520, 525; see Provenance, cat. 164.
4. J. Manet 1979, p. 230.
5. Rouart and Wildenstein 1975, I, p. 27.
6. Manet sale, Paris, February 4–5, 1884, no. 51; Bodelsen 1968, p. 343.

Provenance
Listed among the "études peintes" (painted studies) in the inventory after Manet's death,[5] this work was acquired at the Manet sale for 720 Frs by M. VAYSON.[6] It then appeared in the collection of AUGUSTE PELLERIN (see Provenance, cat. 109) and was probably sold soon after the traveling exhibition of works by Manet from the Pellerin collection (purchased by the dealers BERNHEIM-JEUNE, PAUL CASSIRER, and DURAND-RUEL; see Provenance, cat. 31, 13, 118) to the collector OSKAR SCHMITZ (see Provenance, cat. 119) of Dresden. The work appeared with WILDENSTEIN & CO. (see Provenance, cat. 119) in the United States and then entered the collection of MR. AND MRS. EDWIN C. VOGEL of New York, who were benefactors of the Metropolitan Museum. The picture was acquired in 1957 by the California Palace of the Legion of Honor with funds donated by Mr. and Mrs. H. K. S. Williams.

F.C.

214. Jeanne: Spring

1882
Etching and aquatint
Plate: 9¾ × 7¼" (24.9 × 18.4 cm); image: 6¼ × 4¼" (15.8 × 10.9 cm)
Signed (lower left, below the image): Manet
Bibliothèque Nationale, Paris (print and copperplate)

The portrait of the young actress Jeanne Demarsy, symbolizing Spring, was painted in 1881 (RW I 372), probably in response to a commission for four paintings from Antonin Proust (see cat. 215). Whether it is based here on an early Renaissance type of portrait or inspired by a contemporary "seasonal" cycle,[1] the idea of the four seasons symbolized by beautiful women is also an important Japanese theme, frequently encountered in Ukiyoe color prints, particularly in Utamaro's bust- or half-length portraits of courtesans set against a plain or delicately patterned ground. There the allusion—*mitate* in Japanese—is suggested by a play on words in the title or by the decorative symbolism. Here the image of Jeanne refers to the idea of spring directly, through her flowered dress, her deliciously lacy parasol, the flowers on her bonnet, and the blue sky glimpsed through shimmering foliage.

Exhibitions
Ingelheim 1977, no. 107; Paris, Berès 1978, no. 72

Catalogues
M-N 1906, 47; G 1944, 66; H 1970, 88; LM 1971, 66; W 1977, 107; W 1978, 72

2nd state (of 4). With aquatint. Proof on laid paper, perhaps made before the posthumous editions. Moreau-Nélaton collection.

Copperplate. With holes pierced at top and bottom of the plate. With the stamp of the maker, Eugène Leroux, on the verso. Suzanne Manet, Dumont, Strölin collections.

Fig. a. *Jeanne: Spring*, 1882, India ink. Fogg Art Museum, Cambridge, Mass. (verso of fig. b)

Manet exhibited the painting *Jeanne*, together with *A Bar at the Folies-Bergère* (cat. 211), at the Salon of 1882; both works met with immediate success, and Manet apparently received a number of requests to reproduce them. On April 29, he wrote to the critic Gustave Goetschy, author of a long article on Manet's work that had been published at the time of his 1880 exhibition at La Vie Moderne.[2] Goetschy's Salon review was to appear the next day in *Le Soir*,[3] and Manet informed him that "it is impossible to do a drawing of the *Bar* with a process that excludes half-tones—I will do the other picture, *Jeanne*, for you. If you agree, a word in reply, and best wishes."[4]

Only one reproduction of *Jeanne* made by "a process that excludes half-tones" is known. This is the "drawing by the artist after his painting" that appeared in the *Gazette des Beaux-Arts* on June 1[5] as a linecut reproduction of a drawing made with brush, pen, and India ink (RW II 439; fig. a). As Chiarenza has established, this drawing, on the back of a reversed photograph of the painting (fig. b), was probably intended to accompany Antonin

214

Fig. b. Photograph of the painting *Jeanne: Spring*, 1882. Fogg Art Museum, Cambridge, Mass. (recto of fig. a)

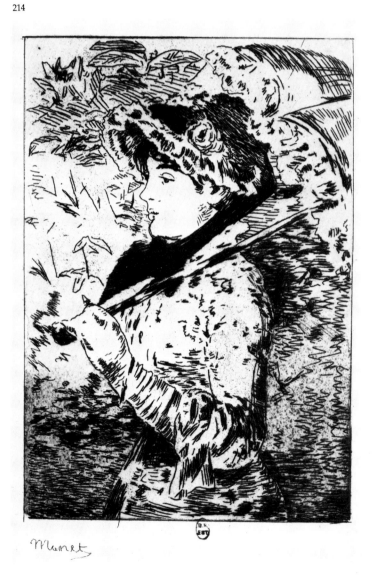

Proust's review of the Salon.[6] Proust is reported to have told Burty, at the exhibition, that the painting had already belonged to him "for a considerable time" (although he did not in fact pay Manet for it until early in 1883[7]).

This made the choice of *Jeanne* a natural one for the illustration of his article, particularly since the *Bar* would have presented formidable technical difficulties. During the 1870s and in 1880, Manet had taken to using transfer lithography (cat. 151, 168) for his "original" illustrations and India ink drawings intended for reproduction by such mechanical processes as linecut(see cat. 142, fig. a)[8] or wood engraving made by an artisan following Manet's drawing on the block (as in the case of his illustrations for Mallarmé's poem *L'Après-midi d'un faune* published in 1876; H 84).[9] Apart from *Queue at the Butcher Shop* of 1870–71 (cat. 123) and the failed portrait of Théodore de Banville of 1874 (H 81, 82), Manet had virtually ceased to use etching at this time, particularly reproductive etching. The little plates for the 1874 poem *Le Fleuve (The River)* by his friend Charles Cros (H 79)[10]—at the time when the salon of Nina de Callias (cat. 137) inspired both poets and artists—are nevertheless a demonstration of his ability to use his etching needle to recapture his sensations in the presence of nature.

As for the portrait *Jeanne*, Manet wanted to reproduce it in etching for Proust's article, and no doubt had the reversed photographic print of his painting made with this in mind (fig. b). On May 2, he wrote to Henri Guérard, who was helping him with the technical processes: "Thanks, my dear Guérard—evidently etching is no longer my affair—put a good burin stroke through the plate and best wishes."[11] Michel Melot has pointed out that the phrase "labourez [literally, plow] d'un bon coup de burin" is probably an instruction to Guérard not to strengthen or complete the design, as has previously been assumed, but, on the contrary, to destroy it by scoring the plate with the customary deep lines that prevent it from being printed.

Guérard did nothing of the sort, and the copperplate was printed after Manet's death—in 1890, in 1894, and finally in 1902 in the *Gazette des Beaux-Arts* (see Provenance).[12] Manet's discouragement with this plate is understandable; though charming, it is far from superlative, and it proved very difficult to print—fine impressions are a rarity. Manet was probably much more interested in Cros's color photograph of his painting. Made by a process invented by Cros about 1867 (and at the same moment by Ducos de Hauron),[13] the color reproduction of the three-color photographic print[14]—a "first" for the printer Tolmer—appears on the cover of a booklet by Ernest Hoschedé, *Impressions de mon voyage au Salon de 1882* (fig. c). The photographic color print, which reverses the image, was made from the original oil canvas. In an undated letter, probably written shortly before the opening of the Salon, Cros sent Manet "a thousand thanks for the kind loan of the exquisite painted person. The operation has succeeded beyond all expectations. I am delighted to have made the 'test run' of my final experiments with one of your works. You will see the proofs in a few days."[15] Jeanne Demarsy, "the exquisite painted person," whose image was multiplied thanks to a variety of contemporary methods of reproduction, was Manet's swan song to etching.

Fig. c. Cover of Ernest Hoschedé, *Impressions de mon voyage . . .*, with color reproduction of Charles Cros's trichromatic photograph after Manet's painting. Bibliothèque Nationale, Paris

1. John House, in Royal Academy of Arts, *Post Impressionism: Cross Currents in European Painting* (exhibition catalogue), London, 1979, no. 126.
2. Goetschy 1880.
3. Goetschy 1882.
4. Paris, BN Manuscrits, M. Guérin collection, n.a.f. 24839, f. 395: Manet to Goetschy, April 29, 1882, "Il est impossible de faire un dessein [*sic*] du Bar avec un procédé qui exclue les demies-teintes"
5. Antonin Proust, "Le Salon de 1882," *Gazette des Beaux-Arts*, 2nd ser., XXV (June 1882), p. 545.
6. C. Chiarenza, "Manet's Use of Photography in the Creation of a Drawing," *Master Drawings*, VII, no. 1 (Spring 1969), pp. 38–45, pl. 27.
7. Manet et al., "Manet's agenda 1883," p. 143.
8. See also the reproductions in *La Vie moderne*, April 10, 1880, p. 239; May 8, 1880, p. 303 (RW II 1975, not cited and no. 517).
9. Wilson 1977, nos. 101–4.
10. Ibid., nos. 82–87.
11. J. Adhémar 1965, pp. 234–35; Wilson 1978, nos. 72, 109. French text of letter: " . . . décidément l'eau-forte n'est plus mon affaire— labourez moi cette planche d'un bon coup de burin et amitiés."
12. Georges Denoisville, "Edme Saint-Marcel: Peintre, graveur et dessinateur," *Gazette des Beaux-Arts*, 3rd ser., XXVIII (September 1902), p. 249.
13. R. Lecuyer, *Histoire de la photographie*, Paris, 1945, pp. 235–37. See also A. Isler-de Jongh, "Manet, Charles Cros et la photogravure en couleurs," *Nouvelles de l'Estampe*, no. 68 (March–April 1983), pp. 6–13.
14. Charles Cros, *Oeuvres complètes*, Paris, 1964, pl. opp. p. 528.
15. Paris, Bibliothèque d'Art et d'Archéologie, quoted in Courthion 1953, I, p. 146.

Provenance
Print. The proof bears no indication of its earlier provenance, before its acquisition by MOREAU-NELATON (see Provenance, cat. 9).
Copperplate. The plate belonged to SUZANNE MANET and then LOUIS DUMONT and ALFRED STROLIN (see Provenance, cat. 11: copperplate) and was transferred to the Cabinet des Estampes in a group of twenty-two plates in 1923.

J.W.B.

215. Autumn

1881
Oil on canvas
28¾ × 20″ (73 × 51 cm)
Musée des Beaux-Arts, Nancy

Exhibitions
Beaux-Arts 1884, no. 113; Paris, Drouot 1884,
no. 21; Marseilles 1961, no. 33

Catalogues
D 1902, 295; M-N 1926 II, pp. 97–98; M-N cat. ms.,
333; T 1931, 372; JW 1932, 480; T 1947, 399; PO 1967,
372; RO 1970, 378; RW 1975 I, 393

Méry Laurent was the pseudonym of Anne-Rose Louviot (1849–1900), who made the artist's acquaintance in late April 1876, when Alphonse Hirsch brought her to the studio to see the exhibition organized by Manet—"to come and see his canvases rejected by the jury of 1876," as the invitation card read.[1]

It seems that during this visit, Méry Laurent expressed enthusiam for Manet's art, and Manet for his visitor, who was to become the closest of his women friends during his last years, to judge by the few informal first-name letters that have been preserved.[2] Whether he in fact had an affair with her, as George Moore insinuates,[3] is of little importance; she was in any case a faithful friend, exerting herself to interest collectors in his works, and diverting him with her society. All who knew her described her as full of gaiety, generosity, and the joy of life. Throughout Manet's illness, she sent him flowers and delicacies, and George Moore reports that she regularly put lilacs on his grave at the anniversary of his death.[4]

Méry Laurent was what is conventionally called a kept woman—supported by General Canrobert, and then by a rich American, Dr. Thomas W. Evans, dentist to the emperor. She liked to surround herself with artists and writers, had an affair with François Coppée, was Mallarmé's great love (though Huysmans states she was never his mistress), and, in the last years of her life, was romantically involved with the young musician Reynaldo Hahn, whom she made her executor. Through Hahn, Marcel Proust came to know her, and, having already been the subject of numerous poems and missives by Mallarmé, she again entered literature, as one of the models for Odette Swann—in her mode of life, the furnishing of her house, and certain particulars of dress.[5]

Her elegance enchanted Manet also, as did her laugh and her noted pink complexion, here immortalized. George Moore compared her to a "tea rose," and Mallarmé wrote this quatrain, which she had engraved over the door of her house:

Ouverte au rire qui l'arrose	Unto the laughing rain unclose—
Telle sans que rien d'amer y	No bitterness can therein be
Séjourne, une embaumante rose	Retained—for such a fragrant rose
Du jardin royal est Méry.[6]	In royal garden is Méry.

In the many pastel portraits he did of her, including the superb *Méry in a Black Hat* (RW I 73) and *Woman in Furs* (cat. 216), Manet loved to detail the slightly showy refinement of her dress.

Antonin Proust reports some remarks of Manet's, perhaps slightly fictionalized but no doubt fairly so and probably in part drawn from a letter: "She consented to let me do her portrait. I went to talk to her about that yesterday. She has had Worth make her a pelisse. Ah! what a pelisse, my friend, a tawny brown with old-gold lining. I was stunned. And as I was admiring

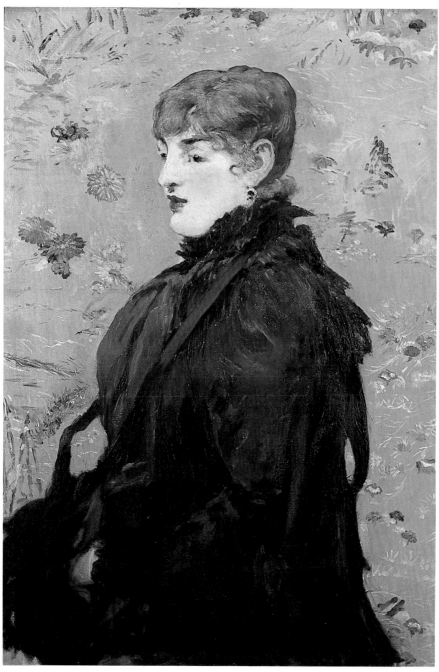

215

the pelisse, and asking her to pose, Elisa [her maid] entered to announce Prince Richard de Metternich. She did not receive him. I was grateful. Oh, these intruders! I left Méry Laurent, saying, 'When the pelisse is worn out, let me have it.' She has promised it to me. It will make a splendid backdrop for some things I have in mind."[7]

It would seem that Manet received a commission from Antonin Proust for a series of four portraits of women, an allegory of the four seasons.[8] Only *Spring* (RW I 372) and *Autumn* were executed. Hanson has suggested that *Amazon* (RW I 394) was a project for *Summer*.[9] The quite traditional idea of painting a series of decorative works seems to have been of

1. New York, Pierpont Morgan Library, Tabarant archives.
2. Paris, Bibliothèque Littéraire Jacques Doucet.
3. George Moore, *Memoirs of My Dead Life*, New York, 1907, p. 59.
4. Ibid., p. 73.
5. Painter 1966, I, pp. 279–81.
6. Mallarmé 1945, p. 145.
7. Proust 1897, p. 311.
8. Manet et al., "Copie faite pour Moreau-Nélaton . . . ," p. 20.
9. Hanson 1977, p. 86.
10. Montesquiou 1923, p. 175.
11. Manet et al., "Copie faite pour Moreau-Nélaton . . . ," p. 20.
12. Rewald 1947, p. 50.
13. Rouart and Wildenstein 1975, I, p. 27, no. 76, "Tableaux et études" (Laurent en marron).
14. Manet sale, Paris, February 4–5, 1884, no. 21; Bodelsen 1968, p. 343.
15. Manet et al., "Copie faite pour Moreau-Nélaton . . . ," p. 20.

Provenance

Valued at 400 Frs in the posthumous inventory,[13] this painting was purchased at the Manet sale for 1,550 Frs by Jacob,[14] probably acting as agent for MERY LAURENT. Méry Laurent's collection was somewhat uneven, but she owned a number of drawings and pastels by Manet, most of them probably gifts from him: a very fine study of apples (RW II 613) inscribed to her, for example, and most important, the small version of *The Execution*

little interest to Manet's young Impressionist friends at this time.

Méry Laurent, in the bloom of her thirty-two years, certainly did not mind posing for *Autumn*, a title justified by the pelisse alone. We recognize her rather full, fair features, eyebrows high on her forehead, lending her an air of perpetual wonder, and her country-fresh face, which Robert de Montesquiou said wore "the smile of a prize baby."[10]

Manet plays with the contrast between the great dark mass of the garment trimmed in fur—monkey fur?—with matching black muff, and the flowered blue wall covering (a Japanese robe borrowed from Antonin Proust[11]) to set off Méry's complexion.

Rewald has advanced the persuasive idea that Manet here transcribed in oils certain elements of composition and color that he had for some time been trying out in pastel.[12] It is not impossible also that the elegant Méry reminded Manet of Pisanello's *A Princess of the Este Family*, ca. 1440 (Musée du Louvre, Paris), whose clear profile, facing left, stands out from a sprinkling of flowers. Such profile portraits of women, more or less inspired by the Italian Renaissance, attracted considerable interest among painters in the 1880s and 1890s.

of *Maximilian* (RW I 125). Incidentally, she was one of the few purchasers at the Gauguin sale of 1891. Méry Laurent bequeathed *Autumn* to the Musée des Beaux-Arts in Nancy, her native city, which it entered in 1905 (inv. 1071). Thanks to her loyalty and generosity, the Musée des Beaux-Arts became the first provincial museum in France to acquire a Manet. The canvas, recently cleaned, has been somewhat retouched, possibly by Manet's own hand, especially in the area of the face. Mlle Guil-

laume, curator at the museum in Nancy, kindly informs us that an X-ray examination made in 1953 at the Rijksmuseum, Amsterdam, reveals an earlier state in which a flower appears in the background below the figure's chin, her gaze is directed higher, and her face is slightly heavier. According to Léon Leenhoff's notes, "The hand holding the muff was finished by the painter from Kievert's for the Exhibition."[15]

F.C.

216. Woman in Furs
Portrait of Méry Laurent

1882
Pastel on canvas
21¼ × 13⅜" (54 × 34 cm)
Signed (lower right): Manet
NY Private Collection

Exhibitions
Beaux-Arts 1884, no. 148; Munich, Moderne Galerie 1910, no. 24

Catalogues
D 1902, 26 (pastels); M-N cat. ms., 367; T 1931, 68 (pastels); JW 1932, 537; T 1947, 523; PO 1967, 378; RO 1970, 384; RW 1975 II, 72 (pastels)

Méry Laurent is aptly described by Richardson as "an indifferent actress but a courtesan of genius . . . [who] managed to have liaisons with many of the richest, most attractive and brilliant men of the time"[1] (see cat. 215). She lived on the rue de Rome not far from Manet's studio, where she posed for seven pastel portraits between February and June 1882.[2] These works were executed during a period when Manet strongly favored pastel as a medium; in 1881–82 he did at least thirty-nine, slightly fewer than half the number of pastels he produced during his entire career. As his health began to fail, the facility and speed offered by the medium must have increasingly appealed to him. This example was apparently done on a cold winter day as Méry Laurent sat in her hat and coat, keeping her hands warm inside her muff. According to Tabarant, "Manet would put paper or canvas on his easel, and

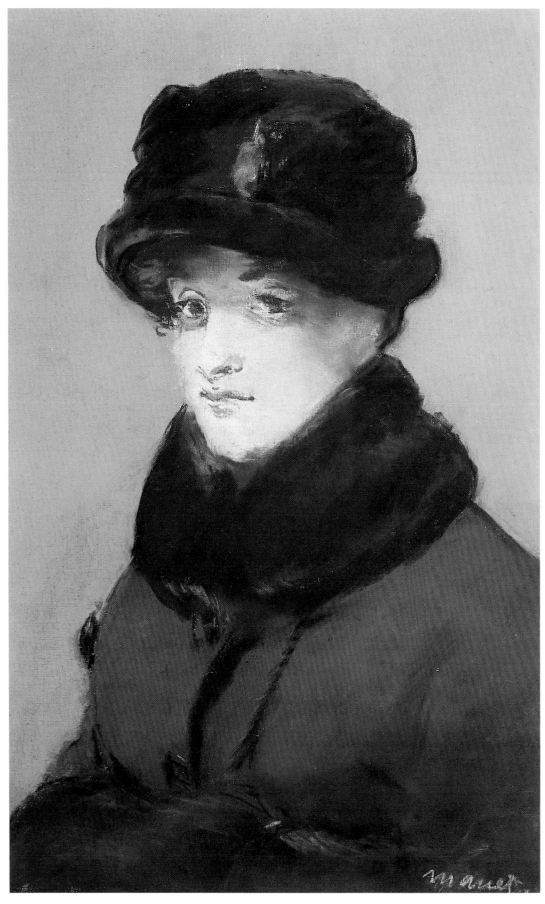

216

without having his visitor actually pose, and perhaps without her noticing, he would 'catch' her even while carrying on a conversation with her."[3]

1. Richardson 1958, p. 130.
2. Tabarant 1947, p. 443.
3. Ibid.
4. Paris, Beaux-Arts 1884, no. 148.
5. Tabarant 1931, no. 68 (pastels).
6. Stock books, Knoedler and Reid & Lefèvre.
7. D. Cooper, in *Alex Reid & Lefèvre, 1926–1976*, London, 1976, p. 9.

Provenance
This pastel was included in the Manet exhibition in 1884; since no lender's name is given in the catalogue, the work was apparently still in the artist's estate,[4] but it did not appear at the sale. It was shown in 1910 in the exhibition of works by Manet from the PELLERIN (see Provenance, cat. 109) collection acquired by BERNHEIM-JEUNE, PAUL CASSIRER, and DURAND-RUEL (see Provenance, cat. 31, 13, 118). It later belonged to ALFRED CASSIRER (Paul's brother), to the Parisian dealer ETIENNE BIGNOU,[5] and to the latter's London associates, ALEX REID & LEFÈVRE, who were to handle it several more times. (Rouart and Wildenstein include in the provenance for this work the Scottish collector David W. T. Cargill, perhaps confusing it with another pastel [RW II 52] that he purchased from Bignou.) In 1931, M. KNOEDLER & CO. (see Provenance, cat. 172), New York, acquired the present pastel from JUSTIN K. THANN-HAUSER (see Provenance, cat. 156) of Berlin, apparently on joint account with REID & LEFÈVRE,[6] who sold it in 1937 to SIR WILLIAM BURRELL (see Provenance, cat. 31), only to buy it back from him in 1943.[7] The stock books of REID & LEFÈVRE indicate that the pastel was purchased in the same year by an English collector "S.K.," who returned it to them in 1955. REID & LEFÈVRE then sold a half-share to the New York dealer SAM SALZ (see Provenance, cat. 188), who sold the work to MR. AND MRS. HENRY ITTLESON, JR., in December 1955. Mr. Ittleson (died 1973) was chairman of a financial services corporation and a benefactor of the Metropolitan Museum in New York, of which he was elected honorary trustee in 1968.

C.S.M.

217. La Viennoise
Portrait of Irma Brunner

1880?
Pastel on board
21¼ × 18" (54 × 46 cm)
Signed (lower left): Manet
P Musée du Louvre, Cabinet des Dessins, Paris

Exhibitions
Beaux-Arts 1884, no. 137; Paris, Drouot 1884, no. 100; Orangerie 1932, no. 99 bis

Catalogues
D 1919 (supplement), no. 17; M-N 1926 II, p. 98; M-N cat. ms., 383; T 1931, 76 (pastels); JW 1932, 531; T 1947, 531; PO 1967, 386; RO 1970, 392; RW 1975 II, 78 (pastels)

Between 1879 and 1882, Manet did a series of dazzling portraits of women, about which Rewald has noted that while "Manet had to fight frequently against a dangerous tendency of *faire jolie,* in his pastels he did not oppose this tendency."[1] Hence his great success with his models. Pastel allowed him a freshness, a gay palette, a powdery texture more flattering to the face and introducing a kind of makeup into the technique itself. The women who posed for him, whether of the *monde* or *demi-monde*—Mme Guillemet, Mme Michel Lévy, Valtesse de la Bigne, Irma Brunner, and Méry Laurent, then the most frequent subject—were delighted with their likenesses. Manet chose to portray these ladies in their finest raiment, often with a great dark hat or a toque to frame their pale skin. The most striking of the series is *Méry Laurent in a Black Hat* (RW II 73), too fragile to travel and therefore not included in the present exhibition.

Unlike Degas's pastel portraits, such as *Yves Gobillard-Morisot,* ca. 1869 (Metropolitan Museum of Art, New York), or *Mlle Malo,* ca. 1878 (Barber Institute of Fine Arts, Birmingham University, England), Manet's show no attempt at psychological analysis, no curiosity about the sitter's personality or the imprint of character on her features. In pastel, Manet painted his visitors like flowers, with attention to their elegance and refinement; they were above all Parisiennes. Irma Brunner, brought to Manet by Méry Laurent, here embodies all that was exquisite and dazzling in the high-style demi-monde of the 1880s. Her striking beauty and perfect profile were treated by

217

Manet as a decorative effigy of early Italian Renaissance art (see cat. 215). Here all is contrast and outline: the profile of the face and of the velvety black headdress; the bodice of pink set off against the background of gray. The touch of red on the lips seasons this elegant harmony.

Manet did another superb pastel of the lovely Viennese, *Irma Brunner with a Veil* (RW II 79), again in profile with a large black hat.

1. Rewald 1947, p. 45.
2. Manet sale, Paris, February 4–5, 1884, no. 100; Bodelsen 1968, p. 342.
3. Tabarant 1931, no. 76.

Provenance
This pastel was acquired for 310 Frs by DR. ALBERT ROBIN (see Provenance, cat. 156) at the Manet sale in 1884.[2] It must have been this work, since frames were often included in the measurements (61 × 51 cm) given in the sale catalogue.

According to Tabarant, the pastel was in the WENCKER collection;[3] it later belonged to COMTE ISAAC DE CAMONDO (see Provenance, cat. 50), who bequeathed it with his collection to the Musée du Louvre in 1911 (inv. RF 4101).

F.C.

218. The House at Rueil

1882
Oil on canvas
30¾ × 36¼" (78 × 92 cm)
Nationalgalerie, Staatliche Museen Preussischer Kulturbesitz, Berlin

Exhibitions
Beaux-Arts 1884, not in cat.; Berlin, Sezession
1903; Orangerie 1932, no. 84

Catalogues
D 1902, 300; M-N 1926 II, pp. 92–93; M-N cat. ms.,
317; T 1931, 376; JW 1932, 493; T 1947, 401; PO 1967,
391A; RO 1970, 397A; RW 1975 I, 407

Manet rented a house at Rueil, where he was to spend his last summer, in 1882. The owner of the house was named Labiche, and many have supposed him to be Eugène Labiche, the celebrated comedy playwright, who had in fact known the painter well enough to sign the visitors' register the day after Manet's death;[1] but a letter from the owner, André Labiche, about the lease shows that he can at most have been a relative of the author of *Le Voyage de M. Perrichon*.[2]

The house was charming, in the Restoration style, and Manet, now almost immobilized with locomotor ataxia, was able to sit in the garden, in the shade of a tree (an acacia, according to Léon Leenhoff[3]), to paint.

218

He did two like-sized versions of the garden façade, one vertical, now in the National Gallery of Victoria, Melbourne (RW I 406), and this one horizontal, marked a replica in the catalogue of the collection of the singer Faure, who owned the former. The only evidence that the present version is indeed a replica is that the Melbourne version is signed, while the Berlin version is not. But they are both finished works, and were preceded by six preparatory sketches (RW I 400–405), the two most important being in the museums at Bern (RW I 202) and Dijon (cat. 219).

The subject is typically Impressionist, and full of light; the arrangement of colors and blue shadows on the walk is very close to contemporary works by Monet and Pissarro, with a free, vibrant touch (see also cat. 210). However, the point of view and the cruciform composition so dear to Manet render this work very different from what his fellow artists might have chosen to do.

As in most of Manet's landscapes, there is no sky. To the very end, he was a city dweller, painting what he saw as in the course of a promenade or during a conversation in a landscaped environment, where the gardener is more in evidence than the Creator. In any case, Manet felt hemmed in by the enclosed gardens of the Ile-de-France, where illness confined him "en pénitence."[4]

1. New York, Pierpont Morgan Library, Tabarant archives.
2. Tabarant 1931, p. 450.
3. Manet et al., "Copie faite pour Moreau-Nélaton"
4. Paris, Bibliothèque Littéraire Jacques Doucet, Mondor endowment: from Manet to Méry Laurent.
5. Moreau-Nélaton 1926, II, fig. 352.

Provenance

This canvas was shown at the posthumous exhibition in 1884, although it was not listed in the catalogue (it appears in an installation photograph published by Moreau-Nélaton[5]). However, it was not included in the Manet sale. SUZANNE MANET (see Provenance, cat. 12) sold it to DURAND-RUEL (see Provenance, cat. 118), and it was later with PAUL CASSIRER (see Provenance, cat. 13) of Berlin, who exhibited it at the Berliner Sezession in 1903. The picture was purchased by the banker and collector KARL HAGEN, who gave it to the Nationalgalerie in 1906 (inv. A.I. 970.952).

F.C.

219. A Path in the Garden at Rueil

1882
Oil on canvas
24 × 19¾" (61 × 50 cm)
Musée des Beaux-Arts, Dijon

This landscape was done in the garden of the house at Rueil rented for the summer of 1882 (see cat. 218). Manet at that time painted several little landscapes, not properly speaking studies for the more important canvases, but depicting the shimmering color of the foliage through which the house is partially seen. Landscape here is but a pretext for organizing a color structure freely painted. As noted above (see cat. 218), Manet disliked the country, which he described as having "charm only for those not forced to stay there."[1] He was already very ill, but his vigor remained intact. This rapid sketch, governed by impression and by the pure pleasure of painting, suggests by its "Tachisme" and by the breaking up of forms a possible direction in Manet's oeuvre that was cut short by his death.

Exhibitions
Paris, Drouot 1884, no. 73; Marseilles 1961, no. 34; Philadelphia-Chicago 1966–67, no. 179

Catalogues
D 1902, 303; M-N cat. ms., 320; T 1931, 379; JW 1932, 496; T 1947, 404; PO 1967, 392B; RO 1970, 398B; RW 1975 I, 403

1. Paris, Bibliothèque d'Art et d'Archéologie: to Zacharie Astruc, June 5, 1880.
2. Rouart and Wildenstein 1975, I, p. 27.
3. Manet sale, Paris, February 4–5, 1884, no. 73; Bodelsen 1968, p. 342.

Provenance

This work is one of three sketches of the same subject (RW I 402–4), two of which were included in the posthumous inventory of 1883 (nos. 41, 50).[2] At the sale in 1884, DR. ALBERT ROBIN (see Provenance, cat. 156) bought the work for 340 Frs,[3] and he bequeathed it to the museum in Dijon in 1929 (inv. 2963).

F.C.

219

220. Apple on a Plate

1880–82
Oil on canvas
8¼ × 10¼" (21 × 26 cm)
Signed (lower left): Manet
Private Collection, Lausanne

Exhibitions
Paris, Bernheim-Jeune 1928, not in cat.; Orangerie
1932, no. 86

Catalogues
JW 1932, 489; T 1947, 417; PO 1967, 399; RO 1970,
405; RW 1975 I, 408

In his little still lifes, Manet usually arranged some fruits—three to five—on
a table, dividing the composition in two lengthwise. Here, as in *Lemon* (cat.
189), he placed a single fruit on a plate, playing the yellow of the apple—or is
it perhaps a quince?—against the background, and rendering the fruit at the
same time unassuming and precious. It represents nature in the only form

220

that Manet liked: cultivated, culled, displayed. It has become in its painted version purely an object of delight.

The circular forms of the fruit and of the plate—a theme so seriously explored at this time by Cézanne—are treated with a certain humor; the little plate is like a halo about the golden apple. Did Manet not say he would like to be the "Saint Francis of the still life"?[1]

1. Vollard 1936, p. 164.
2. Manet et al., "Copie faite pour Moreau-Nélaton . . . ," pp. 80–82.
3. Vogel sale, New York, October 17, 1979.

Provenance

The provenance of most of the small still lifes is very difficult to trace. Manet's account book[2] lists several, but not very specifically. In the catalogues, this still life is said to have belonged to EUGENE PERTUISET (see cat. 208), who did in fact buy many such small pictures. This one, however, was not in his sale in 1888. The work was in the collections of FREUND-DESCHAMPS, G. HOENTSCHEL (who lent it to the 1932 exhibition), and MALHERBE, and then, after the war, in the hands of SAM SALZ (see Provenance, cat. 188) of New York; it later belonged to MR. AND MRS. EDWIN C. VOGEL (see Provenance, cat. 213) and appeared in the sale of their collection in 1979.[3]

F.C.

221. Pinks and Clematis in a Crystal Vase

1882?
Oil on canvas
22 × 13¾" (56 × 35 cm)
Signed (lower right): Manet
Musée d'Orsay (Galeries du Jeu de Paume), Paris

In a glass vase with square base and gilt decoration, one that he often used in his paintings—*Roses, Tulips, and White Lilacs in a Crystal Vase* (RW I 381), *Roses and Lilacs* (RW I 417), *White Lilacs in a Crystal Vase* (RW I 418)—Manet

Exhibitions
Orangerie 1952, without no.; Marseilles 1961, no. 35

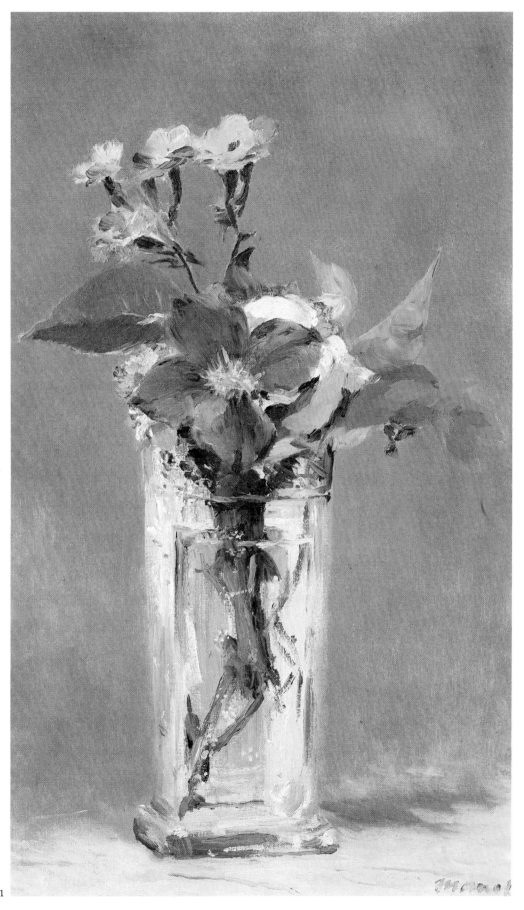

221

here presents a small bunch of quite ordinary garden flowers. He placed the bound stems in the vase as they were, with no care for arrangement or staging, setting the color of the China pinks against a blue-gray background in a subtle harmony accented by the violet clematis.

This charming painting was, according to Tabarant, one of the series executed by Manet in the last months of his life,[1] when, until he was finally bedridden, beginning April 6, 1883, he would paint the flowers brought and sent him by his friends, Méry Laurent among others, who knew he was failing. This touching account, unfortunately, cannot apply to this particular work; the flowers represented do not bloom before summer. The painting must therefore have been done in 1882, at Rueil, probably in July.

Catalogues
T 1931, 403; JW 1932, 506; T 1947, 444; PO 1967, 417A; RO 1970, 423A; RW 1975 I, 423

1. Tabarant 1947, p. 467.
2. Ibid.
3. Tabarant 1931, no. 403.

Provenance

This bouquet is supposed to have been purchased for 1,500 Frs by MLLE WEILL about 1883.[2] It subsequently remained for many years in the collection of EMILE STAUB in Switzerland (it was still there in 1931),[3] then appeared in Milan in the collection of CARLO FRUA DE ANGELI, and in Zurich with G. TANNER. Later, it was in Paris with the dealer A. DABER, who exhibited it in 1937. Purchased shortly before World War II by GEORGES RENAND, it was sold to VON RIBBENTROP in 1941 and taken to Berlin. Recovered at the end of the war, the work was assigned to the Musée du Louvre (inv. MNR 631) by the Office of Private Property (Ministry of Foreign Affairs) in 1951.

F.C.

Manet in Paris

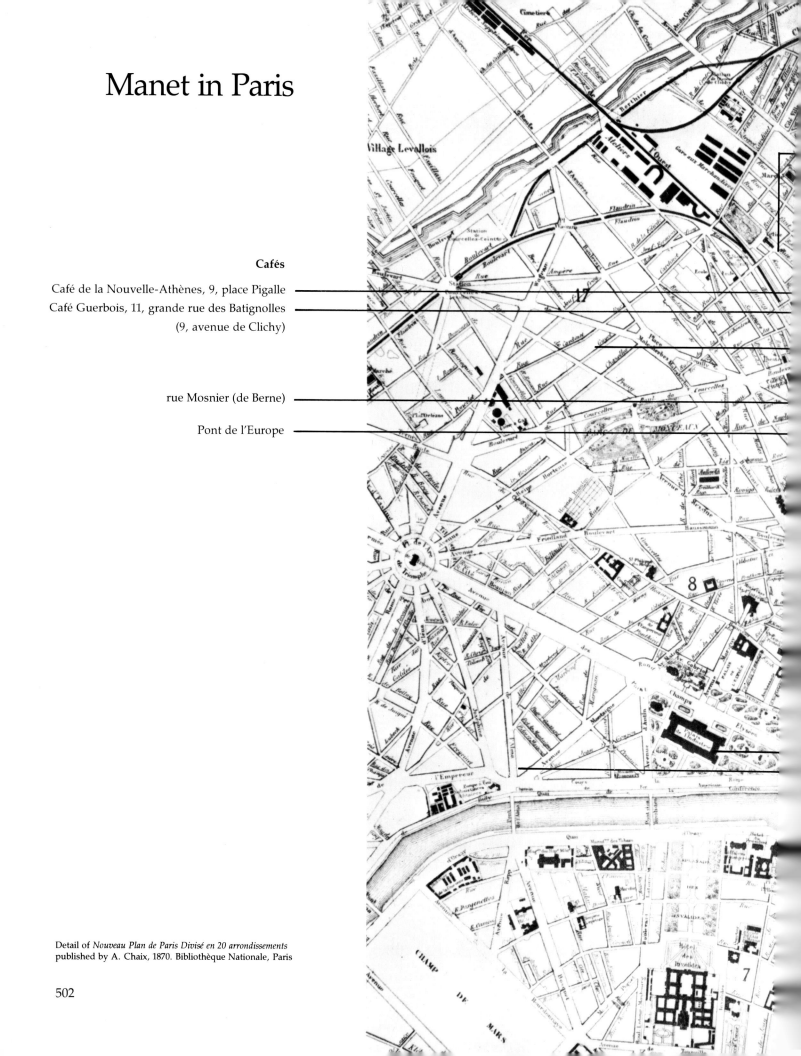

Cafés

Café de la Nouvelle-Athènes, 9, place Pigalle
Café Guerbois, 11, grande rue des Batignolles
(9, avenue de Clichy)

rue Mosnier (de Berne)

Pont de l'Europe

Detail of *Nouveau Plan de Paris Divisé en 20 arrondissements* published by A. Chaix, 1870. Bibliothèque Nationale, Paris

502

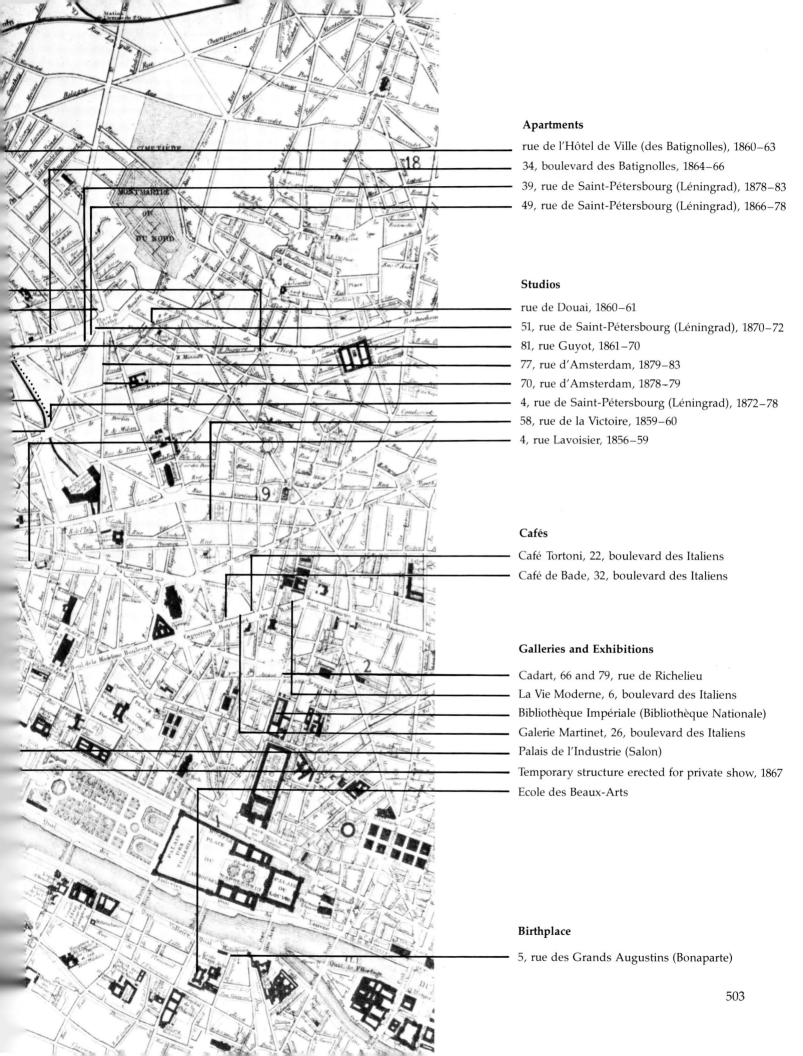

Apartments

rue de l'Hôtel de Ville (des Batignolles), 1860–63

34, boulevard des Batignolles, 1864–66

39, rue de Saint-Pétersbourg (Léningrad), 1878–83

49, rue de Saint-Pétersbourg (Léningrad), 1866–78

Studios

rue de Douai, 1860–61

51, rue de Saint-Pétersbourg (Léningrad), 1870–72

81, rue Guyot, 1861–70

77, rue d'Amsterdam, 1879–83

70, rue d'Amsterdam, 1878–79

4, rue de Saint-Pétersbourg (Léningrad), 1872–78

58, rue de la Victoire, 1859–60

4, rue Lavoisier, 1856–59

Cafés

Café Tortoni, 22, boulevard des Italiens

Café de Bade, 32, boulevard des Italiens

Galleries and Exhibitions

Cadart, 66 and 79, rue de Richelieu

La Vie Moderne, 6, boulevard des Italiens

Bibliothèque Impériale (Bibliothèque Nationale)

Galerie Martinet, 26, boulevard des Italiens

Palais de l'Industrie (Salon)

Temporary structure erected for private show, 1867

Ecole des Beaux-Arts

Birthplace

5, rue des Grands Augustins (Bonaparte)

Chronology

1832	January 23	Born in Paris, at 5, rue des Petits-Augustins, eldest son of Auguste Manet (1797–1862), a high official in the Ministry of Justice, and Eugénie-Désirée, née Fournier (1812–1885), daughter of a diplomat stationed in Stockholm (cat. 3, 4).

Birth certificate of Edouard Manet: Moreau-Nélaton 1926, I, p. 1. A plaque marks the building at the present 5, rue Bonaparte.

1833 November 21 Birth of his brother Eugène (1833–1892) (cat. 38, 62, 63, 135).

Moreau-Nélaton 1926, I, p. 4.

1835 March 16 Birth of his brother Gustave (1835–1884) (cat. 72).

Moreau-Nélaton 1926, I, p. 4.

1838–40 Studies at the Institut Poiloup in Vaugirard.

1844–48 October Studies at the Collège Rollin, where he meets Antonin Proust (1832–1905) (cat. 187). During these school years, he and Proust often visit the Louvre, escorted by Manet's maternal uncle, Captain Edouard Fournier. The captain encourages his nephew's budding talent for drawing.

Proust 1897, 1901, and 1913.

1848 late July Leaves the Collège Rollin and asks his father's permission to enter the Ecole Navale, but fails the entrance examination.

Moreau-Nélaton 1926, I, p. 7.

December 9 Embarks on the training ship *Havre et Guadeloupe* for Rio de Janeiro, where Pontillon (Berthe Morisot's future brother-in-law) is one of his fellow midshipmen. During the voyage, he does caricatures of crew, officers, and shipmates.

Manet 1928; Meier-Graefe 1912, pp. 11–12.

1849 February 4 Arrival in Rio de Janeiro.

June 13 On his return to Le Havre, he again fails the entrance examination of the Ecole Navale, and his family consents to his pursuit of an artistic career.

Tabarant 1931, p. 11.

Meets Suzanne Leenhoff (1830–1906), a young Dutchwoman who gives piano lessons to him and to his brother Eugène.

Manet et al., "Copie faite pour Moreau-Nélaton . . . ," p. 71.

1850 January 29 Enters his name as a pupil [of Couture's] in the register to copy paintings in the Louvre.

Reff 1964, p. 556.

September He and Proust join the studio of Thomas Couture (1815–1879) on the rue Laval. The rival studio is headed by François Picot (1786–1868), a member of the Institute. Couture, a painter much in favor since his success in 1847 with *Romans of the Decadence*, is opposed to strictly academic instruction and introduces some highly innovative principles.

Alazard 1949, pp. 213–18; Couture 1867; Boime 1971 and 1980.

Manet remains there for six years, until February 1856, despite numerous quarrels.

"I don't know why I'm here," he said. "Everything we see is ridiculous. The light is wrong; the shadows are wrong. When I arrive at the studio, it seems to me I'm entering a tomb. I realize you can't have a model disrobing in

the street. But there are fields, and, at least in summer, studies from the nude could be done in the country, since the nude is, it appears, the first and the last word in art." Proust 1897, p. 126.

1851	December 2	Coup d'état; Proust and Manet go out into the streets to witness the events. Proust 1897, p. 130.
	December [4]	Accompanies his studio companions to Montmartre cemetery, where the corpses—victims of Louis Napoleon—have been brought together. Proust 1897, p. 130.
1852	January 29	Birth of Léon-Edouard Köella, known as Leenhoff (1852–1927) (cat. 2, 12, 14–18, 102, 109, 110, 127–28), illegitimate son of Suzanne Leenhoff. Tabarant 1947, pp. 480–85.
	February 25	Begins copying François Boucher's *Diana at the Bath* at the Louvre. Reff 1964, p. 556.
	July 19	First trip to the Netherlands. His name appears on the register of the Rijksmuseum in Amsterdam. J. Verbeek, in *Bulletin van het Rijksmuseum, Gedenboek*, 1958, p. 64, cited in Ten Doesschate Chu 1974, p. 43 n. 1.
1853		Presumed trip to Cassel, Dresden, Prague, Vienna, and Munich. Bazire 1884, p. 10.
		Does studies from nature during a walking tour with the Couture studio in Normandy. Meets Alexander Dumas *fils* at Sainte-Adresse. Proust 1897, p. 130.
	September 17	During a visit to Italy with his brother Eugène, they meet Emile Ollivier in Venice and act as his guide. Emile Ollivier, *Journal* (Zeldin, Paris), 1961, p. 168 (September 17, 1853).
	October 7–15	Spends one week in Florence, where he again meets Ollivier. Copies old master paintings, including Titian's *Venus of Urbino* and Lippi's *Head of a Young Man*, in the Uffizi. Presumed departure for Rome. Letter from E. Ollivier to Eugène Manet, October 15, 1853: Manet et al., "Copie faite pour Moreau-Nélaton . . . ," p. 26.
1855 (?)		Makes the acquaintance of artists Eugène Devéria and Auguste Raffet. Pays a visit, with Proust, to Eugène Delacroix (at the studio he occupied until 1857, on the rue Notre-Dame de Lorette) and asks for his authorization to copy *The Barque of Dante* at the Musée du Luxembourg (cat. 1). Proust 1897, pp. 128–29.
1856	February	Leaves Couture's studio and shares a studio with the animal painter Albert de Balleroy (1828–1872), on the rue Lavoisier. Proust 1913, p. 31.
1857		Meets Henri Fantin-Latour at the Louvre, in front of the Venetian paintings. Duret 1902, p. 63.
	August 21	Begins copying Peter Paul Rubens's *Portrait of Helena Fourment and Her Children* at the Louvre. Reff 1964, p. 556.
	November–December	Journey to Italy with Eugène Brunet. Copies the frescoes of Andrea del Sarto in the cloister at S. Annunziata (RW 1975, II, nos. 1–8, 13–15, 24–25, 28, 30). Letter of November 19, 1857, to the president of the Florence Academy: "Gentlemen: Eugène Brunet and Edouard Manet of Paris have the honor to request the permission of the president of the Academy to work for thirty days in the cloister of the Annunziata." Wilson 1978, no. 1.

1858	November 26	Listed in the register of the Cabinet des Estampes at the Bibliothèque Impériale. J. Adhémar 1965, p. 230.
1859	April	Learns, in Charles Baudelaire's presence, of the rejection of *The Absinthe Drinker* (RW I 19) from the Salon, despite Delacroix's favorable opinion. "Ah, [Couture] had me turned down. What he must have said about it, in front of the other high priests of his ilk. But what consoles me is that Delacroix found it good. For, I have been told, Delacroix did find it good. He's a different customer from Couture, Delacroix. I don't like his technique. But he's a gentleman who knows what he wants and makes it clear. That's something." Proust 1897, p. 134; "We were sitting at his place with Baudelaire, when the rejection notice arrived." Ibid.
		Begins a large canvas, *The Finding of Moses.* Proust 1897, p. 168.
		By July, leaves the studio on the rue Lavoisier following the suicide of his assistant, who had posed for *The Boy with Cherries* (RW I 18). This incident inspires a piece by Baudelaire, "La Corde," dedicated to Manet, in *Le Spleen de Paris* (see cat. 9). Proust 1897, p. 168; Baudelaire 1975, pp. 328–31 (February 7, 1864).
		Moves to the rue de la Victoire. Proust 1897, p. 168 (no. 38); Reff 1964, p. 556 and n. 55 (no. 52: artist's card, July 1).
	July 1	Registers as an artist for copying privileges at the Louvre. Reff 1964, p. 556 n. 55.
		At the Louvre meets Edgar Degas, who is copying Velázquez's *Infanta Margarita* directly on a copperplate for etching. "How bold you are to engrave like that, without a preparatory study. I wouldn't dare do it that way!" Delteil 1919, IX, no. 12.
		Probably executes his copies after the same portrait (see RW II 69) and after *The Little Cavaliers* (RW I 21; cat. 37). Reff 1964, p. 556 and n. 58.
1860	April 14	Lithographic caricature of Emile Ollivier (H 1). Reproduced in *Diogène.*
	summer	Establishes his studio on the rue de Douai and rents an apartment on the rue de l'Hôtel de Ville in the Batignolles quarter with Suzanne and Léon. Moreau-Nélaton 1926, I, p. 30; Manet et al., "Copie faite pour Moreau-Nélaton . . .," p. 71.
1861	May	Exhibits at the Salon the *Portrait of M. and Mme Auguste Manet* (cat. 3) and *The Spanish Singer* (cat. 10), which receives an honorable mention.
		Makes two etchings of his father, dated 1860 and 1861 (H 6, 7), after the portrait of his parents.
		A group of young painters (Fantin-Latour, Alphonse Legros, Emile-Auguste Carolus-Duran, and Félix Bracquemond) and writers (Baudelaire, Champfleury, and Edmond Duranty) come to Manet's studio to express their admiration for *The Spanish Singer* (cat. 10). Desnoyers 1863, pp. 40–41; Alexis 1879, p. 1.
		Establishes his studio at 81, rue Guyot (until 1870). Moreau-Nélaton 1926, I, p. 33.
	August 15–31	Places on sale at the "Permanent Exhibition" of the Galerie Martinet, 26, boulevard des Italiens, *The Reader* (RW I 35), a portrait of the painter Joseph Gall, one of his neighbors on the rue Guyot. *Le Courrier artistique* I, no. 6 (September 1, 1861), p. 22.
	September 1–30	*The Boy with Cherries* (RW I 18) replaces *The Reader* at Martinet's. *Le Courrier artistique* I, no. 8 (October 1, 1861), p. 30.

September 18	Exhibits *The Surprised Nymph* (cat. 19) at the Imperial Academy in Saint Petersburg. Barskaya 1961, pp. 61–68.	
October 1–15	*The Spanish Singer* (cat. 10) exhibited at Martinet's. (It is not for sale.) *Le Courrier artistique* I, no. 9 (October 15, 1861), p. 34.	

1862 April

Prints by Manet on exhibit at Cadart's, 66, rue de Richelieu, seen by Baudelaire.
"MM. André Jeanron, Ribot, and Manet have also recently tried their hand at etching, for which M. Cadart has extended the hospitality of his shop window." Baudelaire 1975, p. 735: *La Revue anecdotique,* April 15, 1862.

May 31

Founding of the Société des Aquafortistes by Alfred Cadart and Félix Chevalier to promote the revival of etching; Manet is a founding member, together with Bracquemond, Fantin-Latour, Jongkind, Legros, and Ribot.
Bailly-Herzberg 1972, I, pp. 38–42.

Does *plein-air* studies in the Tuileries (cat. 38). Frequents the Café Tortoni.
Proust 1897, pp. 170–71.

August 12–
November 2

Troupe of Spanish dancers at the Hippodrome. Camprubi, Lola de Valence, and others pose for Manet at Alfred Stevens's studio (cat. 49–52).
Tabarant 1947, p. 52.

September 1

First publication by the Société des Aquafortistes of five etchings, including Manet's *The Gypsies* (cat. 48).
Bailly-Herzberg 1972, II, pp. 52–55, 72.

Announcement of publication of *8 Gravures à l'eau-forte par Edouard Manet* (cat. 7, 9, 11, 25, 35–37; see cat. 45).

September 25

Death of his father, Auguste Manet.

Meets Victorine Meurent, a professional model, and asks her to pose (cat. 31–35, 62–69, 133).
Goedorp 1967, p. 7.

1863 March 1

Exhibits fourteen paintings at the Galerie Martinet, eleven of which can be identified: *Portrait of Mme Brunet* (cat. 5), *Boy with Dog* (cat. 6), *Boy with a Sword* (cat. 14), *Young Woman Reclining, in Spanish Costume* (cat. 29), *The Street Singer* (cat. 32), *Music in the Tuileries* (cat. 38), *Lola de Valence* (cat. 50), *The Reader* (RW I 35), *The Gypsies* (RW I 41), *The Old Musician* (RW I 52), *The Spanish Ballet* (RW I 55; cat. 49, fig. a), and at least one etching, *The Gypsies* (cat. 48).
Mantz 1863, "Exposition du boulevard des Italiens," p. 383; Feyrnet 1863; Saint-Victor 1863; Zola 1867, *L'Artiste,* p. 55; Manet et al., "Expositions Martinet."

March 7

Publication of Zacharie Astruc's serenade *Lola de Valence,* illustrated by Manet (cat. 53).
Date of Dépôt Légal registration. Wilson 1978, no. 73.

late March

James McNeill Whistler introduces Algernon Charles Swinburne to Fantin-Latour and Manet.
Letter from Baudelaire to Fantin-Latour, March 22, 1864: Baudelaire 1973, II, p. 845 n. 4.

May 15

Opening of the Salon des Refusés (in the adjoining halls of the Palais de l'Industrie), where he exhibits the painting *Le déjeuner sur l'herbe* (cat. 62), flanked by *Young Man in the Costume of a Majo* (cat. 72) on the left and *Mlle V. . . in the Costume of an Espada* (cat. 33) on the right, and three etchings, *Philip IV, after Velázquez* (cat. 36), *Little Cavaliers, after Velázquez* (cat. 37), and *Lola de Valence* (cat. 52).

August 17

Attends Delacroix's funeral with Baudelaire.
Tabarant (1942) 1963, p. 375.

October 1

Publication of the etching *Lola de Valence* (cat. 52) by the Société des Aquafortistes.
Bailly-Herzberg 1972, I, pp. 93, 109.

	October 28	Marries Suzanne Leenhoff at Zaltbommel, in the Netherlands, where they remain one month. Tabarant 1947, p. 80; Manet et al., "Copie faite pour Moreau-Nélaton . . .," pp. 71, 72.
1864	January	Manet poses for the *Homage to Delacroix,* which Fantin-Latour submits to the Salon. Druick and Hoog 1982, no. 57.
	February 4	Opening at Martinet's, on the boulevard des Italiens, of the "Première exposition inédite" of the Société Nationale des Beaux-Arts, founded by Louis Martinet in 1862. Le Courrier artistique, February 7, 1864; (Ibid., April 1, 1862).
	late February	Asks for an extra eight to ten days to submit his paintings to the Salon jury. Unpublished letter to the comte de Nieuwerkerke, received on March 1, 1864: archives, Musée du Louvre, Paris.
	May	Exhibits at the Salon *Episode from a Bullfight* (see cat. 73) and *The Dead Christ and the Angels* (cat. 74).
	June 19	Naval battle of the American Civil War off Cherbourg between the *Kearsarge* and the *Alabama,* which Manet may have witnessed. At Cadart's, 79, rue de Richelieu, exhibits painting (cat. 83) based on the incident. La Presse, July 18, 1864, cited in Moreau-Nélaton 1926, I, p. 60; Hanson 1977, pp. 121–22.
	November	Moves into an apartment at 34, boulevard des Batignolles. Tabarant 1931, p. 128; Manet et al., "Copie faite pour Moreau-Nélaton . . .," p. 72.
	between December 1864 and August 1866	The Goncourt brothers visit his studio to take notes for developing the character of Coriolis in *Manette Salomon.* Proust 1901, p. 75.
1865	January	Destroys several of his works. "The discouraged Manet is tearing up his best studies." Letter from Mme Meurice to Baudelaire, January 5?, 1865: Baudelaire, Lettres à, p. 263.
	February 19	Opening of an exhibition of the Société Nationale des Beaux-Arts at Martinet's, where two Manet paintings are shown, including a still life sold to Chesneau (present location unknown). He plans to exhibit nine works, and then six; disappointed, he decides to resign from the Société. Letter from Manet to Martinet: Moreau-Nélaton 1926, I, p. 62; letters from Manet to Baudelaire [February] 14, 1865; from Lejosne to Baudelaire, February 21, 1865; from Manet to Baudelaire [March 25], 1865: Baudelaire, Lettres à, pp. 230, 215, 232.
		Acts as literary agent for Baudelaire, who is in Brussels. Letters from Baudelaire to Lemer, February 15 and July 4, 1865: Baudelaire 1973, II, pp. 463–64, 510.
	May	Sits for Fantin-Latour's *The Toast: Homage to Truth,* exhibited at the Salon. Druick and Hoog 1982, pp. 179–90.
		Exhibits at Cadart's (cat. 77, 80, 81). ". . . still life paintings," Bürger (Thoré) 1865.
		Exhibits *Jesus Mocked by the Soldiers* (cat. 87) and *Olympia* (cat. 64) at the Salon.
	spring	Dejected by critical response and by the fact that a seascape submitted to the Salon by Claude Monet has been attributed to him. Letter from Baudelaire to Champfleury, May 25, 1865: Baudelaire 1973, II, p. 502; Proust 1897, p. 175; Wildenstein 1974, p. 29.
		Rejection of his paintings at the Exhibition of the Royal Academy in London. Letter from Manet to Baudelaire (early May 1865): Baudelaire, Lettres à, p. 237.
		Frequents the Café de Bade at 32, boulevard des Italiens. Letter from Baudelaire to Lemer, August 9, 1865: Baudelaire 1973, II, p. 523.

	August	Leaves for a much anticipated visit to Spain, planned for him by Zacharie Astruc (cat. 94). Visits Burgos, Valladolid, Toledo, and Madrid, where he stays one week and meets Théodore Duret (cat. 108) at a hotel on the Puerta del Sol.

"Lettres d'Edouard Manet sur son voyage en Espagne," *Arts*, March 16, 1945; Flescher 1978, p. 145ff.; Duret 1902, pp. 35–36.

	September 13	Rejoins his family on vacation at the Château de Vassé, in the Sarthe.

Letter from Manet to Baudelaire, September 24, 1865: Baudelaire, *Lettres à*, p. 236.

	October	Falls ill during a cholera epidemic.

Letter from Manet to Baudelaire, October 25, 1865: Baudelaire, *Lettres à*, p. 237; letter from Baudelaire to Ancelle, October 26, 1865: Baudelaire 1973, II, p. 537.

1866	April	The Salon jury rejects *The Fifer* (cat. 93) and *The Tragic Actor* (cat. 89).

Meets Paul Cézanne.

Alfred Barr, "Cézanne d'après les lettres de Marion à Morstatt," *Gazette des Beaux-Arts*, 6th ser., XVII (1937), pp. 51–52.

	May 7	Emile Zola defends Manet in his review of the Salon, which leads to his resignation from the newspaper *L'Evénement*.

Emile Zola, "Mon Salon," *L'Evénement*, May 7, 1866: Zola 1959, pp. 64–69, 79; "Adieu d'un critique d'art," *L'Evénement*, May 20, 1866 (his last article).

Writes to Zola in the hope of meeting with him.

"Where could I meet you? If it suits you, I am at the Café de Bade every day from 5:30 to 7." Letter from Manet to Zola, Monday, May 7 [1866]: see Appendix I, letter 1.

The public confuses Monet's works with Manet's.

"[Manet] is much troubled, by the way, over his rival Monet. So much so, people are saying that, having *manetized* him, he would now like to *de-monetize* him." Letter from Duranty to Legros [early October 1866], quoted in Crouzet 1964, p. 232.

	May 13	Publication of a caricature after Monet's *Woman in a Green Dress (Camille)*, with the caption "Monet or Manet? Monet. But, it is to Manet that we owe this Monet. Bravo, Monet! Thank you, Manet."

André Gill, "La Découverte d'une nouvelle peinture," *La Lune*, May 13, 1866.

Introduced to Monet through Astruc.

Wildenstein 1974, I, p. 32 and n. 227.

	May–June	Exhibits in Bordeaux (cat. 97).

Burty 1866, p. 564.

	July 5	After a visit to Manet's studio, Théophile Thoré describes his recent paintings (including cat. 96) in *L'Indépendance belge*.

". . . a large portrait of a man in black, reminiscent of the portraits of Velázquez, and which the jury rejected. In addition to a 'marine landscape,' as Courbet would say, and exquisite flowers, there was also a study of a girl in a pink dress, which may well be rejected at the next Salon. Those soft pink tones on a gray background would challenge the finest colorists. A sketch, it is true, as is Watteau's *Isle of Cythera* at the Louvre." Bürger (Thoré) 1870, II, p. 318.

	September 15	Publication of *Plainte moresque*, a guitar piece by Jaime Bosch (see cat. 95).

Date of Dépôt Légal registration. Wilson 1978, no. 74.

About this time the Café Guerbois, at 11, grande rue des Batignolles (today 9, avenue de Clichy), becomes the favorite meeting place of Manet and his friends Astruc, Marcellin Desboutin, Emile Bellot, Duranty, Zola, Léon Cladel, Philippe Burty, and Hippolyte Babou, among others.

Duret 1902, pp. 63–64. See above, Moffett, "Manet and Impressionism."

	fall	The Manet family leaves the apartment on the boulevard des Batignolles and goes to live with Manet's mother at 49, rue de Saint-Pétersbourg.

Plans the illustration of Zola's *Contes à Ninon*.

Letter from Manet to Zola, October 15 [1866]: see Appendix I, letter 2.

1867	January 1	Zola publishes a biographical and critical study of Manet in *L'Artiste: Revue du XIX^e siècle*.

1867

January 1 Zola publishes a biographical and critical study of Manet in *L'Artiste: Revue du XIX^e siècle*.

January 2 Decides to organize a one-man show with "at least forty paintings . . . near the Champ de Mars."
See Appendix I, letter 4.

February Fantin-Latour works on Manet's portrait, which he exhibits at the next Salon.
Druick and Hoog 1982, no. 68.

Wednesday, May 22, or Friday, May 24 Opening of one-man exhibition of fifty paintings at the Pont de l'Alma, outside the Exposition Universelle grounds, in a pavilion specially constructed at great expense (his mother advances the sum of 18,305 Frs). Gustave Courbet also has his own pavilion.
"Manet opens in two days and is on awful tenterhooks. As for Courbet, he is opening one week from today, that is, next Monday." Letter from Monet to Bazille, May 20, 1867: Wildenstein 1974, I, p. 423.
"On Friday Manet opened his one-man exhibition." Letter from Zola to Valabrègue, May 29, 1867. See Appendix I, letter 5, n. 1; Manet et al., "Copie faite pour Moreau-Nélaton . . .," p. 12.

Advertises his exhibition in the catalogue of the Exposition Universelle.
Manet et al., "Copie faite pour Moreau-Nélaton . . .," p. 13: bill; Krell 1982, pp. 109–15.

Publication of a brochure with reissue of Zola's article of January 1, accompanied by a portrait of Manet by Bracquemond and the etching after *Olympia* (cat. 69).
Zola 1867 (Dentu). See Appendix I, letter 5.

June 19 Execution of Emperor Maximilian in Mexico. Manet undertakes a series of canvases (see cat. 104).

June 29 Randon devotes two pages of caricatures in *Le Journal amusant* to the Manet pavilion and to the principal paintings.
Randon 1867.

August Spends several days with Antonin Proust in Trouville. Returns to Paris late August–early September.
Proust 1897, p. 174.

September 2 Attends the funeral of Baudelaire (see cat. 98).
Mauner 1975, p. 120.

November Zola sends him his novel *Thérèse Raquin*.
See Appendix I, letter 7.

1868

February Zola sits for his portrait (cat. 106) at Manet's studio on the rue Guyot.
Letter from Zola to Duret, February 29, 1868: Musée du Louvre, Cabinet des Dessins, Paris, cited in Rewald, *Cézanne et Zola*, Paris, 1936, p. 61 (with a date error in the note).

May Exhibits *Portrait of Emile Zola* (cat. 106) and *Young Lady in 1866* (cat. 96) at the Salon.

June 28 Proposed publication of *Sonnets et eaux-fortes*.
Letter from Burty to Manet: Bibliothèque d'Art et d'Archéologie, Paris; Weisberg 1970, p. 299.

summer Family vacation at Boulogne-sur-Mer.
Proust 1897, p. 175.

Brief trip to London, where he hopes to exhibit the following year.
Letter to Fantin-Latour: Moreau-Nélaton 1926, I, p. 104; letter to Zola: see Appendix I, letter 10.

July 15–30 Exhibits *The Dead Man* (cat. 73) at Le Havre, receiving a silver medal.
See Appendix I, letter 10; Tabarant 1931, p. 121.

Fantin-Latour introduces Berthe Morisot and her sister to Manet at the Louvre.
Prins 1949, p. 26.

September 1	Zola dedicates *Madeleine Férat* to Manet. See Appendix I, letter 11.
September	Berthe Morisot poses for *The Balcony* (cat. 115).
October 17	Publication of the poster for *Les Chats* by Champfleury with Manet's lithograph *Cats' Rendezvous* (cat. 114). Date of Dépôt Légal registration. Wilson 1978, no. 78.
October 25	*La Chronique illustrée* reproduces the lithograph with an article announcing the publication of Champfleury's book (see cat. 111–14). At the Café de Londres (on the corner of the rue Duphot), makes the acquaintance of Léon Gambetta, who often attended the lectures organized by Lissagaray on the nearby rue de la Paix. Proust 1897, p. 175.
December 1	Exhibits two canvases, *The Spanish Singer* (cat. 10) and *Boy with a Sword* (cat. 14), at the Société Artistique des Bouches-du-Rhône in Marseilles, in the hope of selling them. See Appendix I, letter 13.
December	Publication of *Sonnets et eaux-fortes*, with Manet's *Exotic Flower* (H 57).

1869

January–February	Informed that *The Execution of Maximilian* (RW I 127; cat. 104) will be rejected at the Salon and that the publication of his lithograph (cat. 105) will be banned. Zola defends him in *La Tribune* of February 4. See Appendix I, letter 12; Appendix II.
February	Eva Gonzalès, brought to the studio by Alfred Stevens, becomes his pupil and poses for him. Letters from Manet to Eva Gonzalès: Wilson 1978, no. 107; Tabarant 1947, p. 158.
May	Exhibits *The Balcony* (cat. 115), *The Luncheon* (cat. 109), and five etchings (see cat. 37) at the Salon.
July–September	Vacations with his family at the Hôtel Folkestone in Boulogne-sur-Mer (see cat. 118, 119). Moreau-Nélaton 1926, I, p. 111.

1870

February 18	Exhibits the *Philosopher* (cat. 90) and the watercolor *The Dead Christ and the Angels* (cat. 75) at the Cercle de l'Union Artistique on the place Vendôme. Tabarant 1947, p. 173.
February 23	Provoked by an article in *Paris-Journal* by Edmond Duranty, Manet strikes him. A duel ensues, and Duranty is wounded. Bazire 1884, p. 32; Tabarant 1947, p. 173; Crouzet 1969, p. 291.
March	Joins a committee organized by the animal painter Jules de La Rochenoire and formed for the purpose of changing the method of selecting the Salon jury. Writes a manifesto and compiles a list of candidates with the names of avant-garde painters. Only Jean-François Millet is elected. "Could you have a brief notice inserted in *Le Rappel* and *La Cloche*, worded more or less as follows: 'The recommendation of the committee presenting the following list for the jury was completely open. The artists will all vote for the following names....'" Letter from Manet to Zola [March 2, 1870]: see Appendix I, letter 16; letter from Manet to La Rochenoire, March 19, 1870: Musée du Louvre, Cabinet des Dessins, Paris; Moreau-Nélaton 1926, I, pp. 119–20. Asked to pose by Frédéric Bazille, who is doing a painting representing his new studio on

the rue de la Condamine, Manet takes his friend's brush and paints in his portrait, but on a markedly disproportionate scale.

Musée d'Orsay (Galeries du Jeu de Paume). Moreau-Nélaton 1926, I, p. 117.

Repaints portions of the painting that Berthe Morisot is to submit to the Salon.

"For my part, I found the improvements to which Manet had subjected my head quite dreadful. Seeing it in this state, she told me she would rather have her picture at the bottom of the river than learn that it had been accepted." Letter from Mme Morisot, March 22, 1870: Morisot 1950, pp. 36–38.

May	Exhibits *The Music Lesson* (RW I 152) and the *Portrait of Eva Gonzalès* (RW I 154) at the Salon; Fantin-Latour submits *A Studio in the Batignolles Quarter*, a portrait of Manet surrounded by his friends (see above, Moffett, "Manet and Impressionism," fig. 1). Druick and Hoog 1982, no. 73.
summer	Stays with the painter Giuseppe de Nittis at Saint-Germain-en-Laye (see cat. 122). Proust 1897, p. 175.
September	Confronted by the threat of the Prussian army, sends his family to Oloron-Sainte-Marie, in the Pyrenees. Moreau-Nélaton 1926, I, p. 121; Manet 1935, passim.
September 16	Closes his studio and stores thirteen paintings at Duret's. "My dear Duret: I am sending you the paintings that you would be so kind as to shelter for me during the siege. Here is the list: *Olympia*, the *Déjeuner*, the *Joueur de guitare*, the *Balcon*, the *Enfant à l'épée*, *Lola de Valence*, *Clair de lune*, *Liseuse*, *Lapin*, *Nature morte*, *Danseuse espagnole*, *Fruits*, *Mlle B.* Let me shake your hand." And by the way of postscript: "In case I should be killed, I would like you to keep, *at your choice*, the *Clair de lune* or the *Liseuse*. You may, if you *prefer*, request the *Enfant aux bulles de savon*." Letter from Manet to Duret, Thursday, September 16, 1870, New York, Pierpont Morgan Library, Tabarant archives: Manet 1935, p. 6; Tabarant 1947, pp. 182–83.
September 30	Letters from Paris, under siege since September 19, are dispatched by balloon. Letters to his wife, his mother, and Eva Gonzalès: Manet 1935, p. 12ff.; Wilson 1978, no. 107.
November 7–19	Enlists, as does Degas, in the National Guard, with the rank of lieutenant. Letter to his wife, November 7, 1870: Manet 1935, p. 20; Tabarant 1947, p. 183; letter to Eva Gonzalès, November 19, 1870: Wilson 1978, no. 107.
December	"I am leaving the artillery to join the staff. The first duty was too harsh." Letter from Manet to his wife, December 7, 1870: Manet 1935, p. 22.
1871 February 12	Leaves Paris to join his family at Oloron-Sainte-Marie. Moreau-Nélaton 1926, I, p. 128.
February 21	Stays one week in Bordeaux with his family and probably meets Zola there. Tabarant 1947, p. 186; see Appendix I, letter 18.
March 1	Departs for Arcachon, where he remains one month (see cat. 127, 128). Tabarant 1947, p. 187; Wilson 1978, no. 107.
April 15	The *Journal officiel de la Commune* publishes a manifesto for the formation of a federation of artists, to which he is elected a delegate, in his absence, together with fifteen other painters and ten sculptors, on April 17. A. Dancel, "Les Musées, les arts et les artistes pendant la Commune," *Gazettes des Beaux-Arts*, 6th ser., LXXIX (January 1972), p. 50. Decides to return to Paris on April 1, but the Paris insurrection (beginning March 18) makes his return impossible. Passes through Royan (two days), Rochefort (two days), La Rochelle (one day), Nantes (two days), and Saint-Nazaire (two days); stays in Le Pouliguen one month. Tabarant 1947, p. 189; Manet et al., "Copie faite pour Moreau-Nélaton...," p. 68.
May 10	In Tours for one week.

	late May– early June	Returns to Paris, probably immediately after the "semaine sanglante" (May 21–28). Morisot 1950, pp. 58–59. See cat. 124, 125.
	July	Goes often to Versailles following the election of Gambetta to the National Assembly. Asks to do his portrait, but "Gambetta was unable to spare Manet the hours of sittings that he needed." Proust 1897, p. 177.
	August	In view of his state of nervous exhaustion, his doctor recommends a trip. Stays with his family in Boulogne. Manet 1935, p. 33; Tabarant 1947, p. 191.
1872	January	Durand-Ruel purchases twenty-four of Manet's paintings (see Provenance, cat. 118) and during the course of the year shows fourteen of them at different exhibitions of the Society of French Artists in London (cat. 6, 10, 74, 90, 93, 96, 118). Manet et al., "Copie faite pour Moreau-Nélaton…," pp. 130–31; Meier-Graefe 1912, pp. 310–16; Moreau-Nélaton 1926, I, pp. 132–33; Venturi 1939, II, 189–92; Cooper 1954, pp. 21–22.
	May	Shows the *Battle of the Kearsarge and the Alabama* (cat. 83) at the Salon.
		The Nouvelle-Athènes, on the place Pigalle, has by this time replaced the Café Guerbois as the meeting place of Manet and his fellow artists (Degas, Renoir, Monet, Pissarro, among others). Marcellin Desboutin (cat. 146), painter and engraver, joins the group upon his return from Italy. A. Lepage, *Les Cafés politiques et littéraires de Paris*, Paris, 1874, pp. 81–82.
		Travels again to the Netherlands. Proust 1897, p. 178.
	June 26 and 27	Visits, in the company of Ferdinand Leenhoff, the Frans Hals Museum, recently opened in Haarlem, and the Rijksmuseum in Amsterdam. J. Verbeek, in *Bulletin van het Rijksmuseum, Gedenboek*, 1958, p. 64: cited in Ten Doesschate Chu 1974, p. 45 n. 4.
	July 1	Moves into his studio on the second floor of 4, rue de Saint-Pétersbourg, near the Gare Saint-Lazare (see cat. 133, 134) and opposite the rue Mosnier, which is under construction (see cat. 158–60). Manet et al., "Copie faite pour Moreau-Nélaton…," p. 67; Moreau-Nélaton 1926, I, p. 136. See Appendix I, letter 21.
1873	May	Exhibits *Le bon bock* (RW I 186) and *Repose: Portrait of Berthe Morisot* (cat. 121) at the Salon.
	July	Leaves with his family for Etaples, near Berck-sur-Mer (see cat. 120, 135). Tabarant 1947, p. 215. See Appendix I, letter 24.
	September	Returns to Paris. Tabarant 1947, p. 221.
		Meets Stéphane Mallarmé (cat. 149). Letter from John Payne to Mallarmé, October 30, 1873: Mondor 1942, p. 344.
	October– December	Attends, at the Grand Trianon in Versailles, the court-martial of Marshal Bazaine, for his capitulation at Metz in 1870 (see cat. 126). Proust 1897, p. 179; Duret 1902, p. 174.
	November 18	Sells five paintings to Jean-Baptiste Faure, the famous baritone (see Provenance, cat. 10). Moreau-Nélaton 1926, II, pp. 10–11.
	December 25	The novelist Fervacques (Léon Duchemin) publishes a description of his visit to Manet's studio in *Le Figaro*. Moreau-Nélaton 1926, II, pp. 8–10.

1874	February 20	Publication of two lithographs, *Boy with Dog* (cat. 8) and *Civil War* (H 72; cat. 125, fig. a). Date of Dépôt Légal registration. Wilson 1978, nos. 75, 79.
	April 12	The Salon jury, having accepted *The Railroad* (cat. 133) and the watercolor *Polichinelle* (RW II 563) and rejected *The Swallows* (RW I 190) and *Masked Ball at the Opéra* (cat. 138), Mallarmé, in response, publishes his article "Le Jury de peinture pour 1874 et M. Manet" in *La Renaissance artistique et littéraire*.
	May 15	Opening of the first exhibition organized by the Société Anonyme des Artistes, Peintres, Sculpteurs, Graveurs at Nadar's, on the boulevard des Capucines. Manet takes no part in the "Impressionist" showing, despite an invitation to participate. Bazire 1884, pp. 84–85. See above, Moffett, "Manet and Impressionism."
		Manet asks his friends to supply verses to accompany his lithograph *Polichinelle* and selects the couplet sent by Théodore de Banville. Tabarant 1947, p. 235.
	June 16	Publication of the color lithograph *Polichinelle* (H 80). Date of Dépôt Légal registration. Wilson 1978, no. 83.
	July–August	Attempt at etched illustration for Banville's *Les Ballades* (H 81, 82). "TOUT ARRIVE [everything comes to pass] including the failure of the etching I would most want to succeed. I am very sorry and ashamed, but am forced to leave in the next few days." Letter to Banville, August 2 [1874]: Moreau-Nélaton 1926, II, pp. 15–16.
	August	Holiday at the family home in Gennevilliers, near Argenteuil, where Monet lives. Renoir visits them (see cat. 139–42). Wildenstein 1974, I, pp. 72–73.
	September	Returns to Paris.
	December	*Le Fleuve*, a poem by Charles Cros, published with eight etchings by Manet (H 79).
	December 22	Marriage of Eugène Manet and Berthe Morisot.
1875	January	Collaborates with Mallarmé, illustrating Mallarmé's French translation of *The Raven* by Edgar Allan Poe (cat. 151). Wilson 1978, nos. 89, 105.
	May	Exhibits *Argenteuil* at the Salon (cat. 139).
	May 20	Publication of *The Raven* (cat. 151).
		Plans a trip to London. Letter from Eugène Manet to his wife: Morisot 1950, p. 92.
	October	Trip to Venice with his wife and James Tissot (see cat. 147, 148). Tabarant 1947, p. 270.
1876	April	Mallarmé's poem *L'Après-midi d'un faune* published with wood engravings by Manet (H 84). Wilson 1978, no. 90.
		The Salon jury rejects *The Laundry* (RW I 237) and *The Artist* (cat. 146).
	April 15–May 1	Opens his studio to the public, from 10 A.M. to 5 P.M., to show the rejected paintings and other works. Méry Laurent (cat. 215, 216) is among the many visitors. Bazire 1884, pp. 90–98; Proust 1897, pp. 179–80; Tabarant 1947, pp. 282–88. See Appendix I, letter 6.

| | July | Spends two weeks with his wife at Ernest Hoschedé's in Montgeron (see Provenance, cat. 32), where he paints several canvases (RW I 246, 247). |
| | | Wildenstein 1974, I, p. 82. |

1877 | March 19 | Supports his Impressionist friends at their third exhibition and second sale.

"Perhaps you do not yet like this kind of painting, but you will." Letter from Manet to Wolff: Moreau-Nélaton 1926, II, p. 41; "At his studio on the rue Saint-Pétersbourg, when they came to visit him on Sunday, he was thinking only of singing the praises of all the loyal members of the Batignolles school. He put their canvases in a good light, concerned about finding buyers for them and forgetting his own works." Proust 1897, p. 178.

| | April | Submits two works to the Salon jury: *Faure in the Role of Hamlet* (RW I 257) is accepted; *Nana* (cat. 157) is rejected. |

| | May 1 | *Nana* displayed in the window at Giroux's, a fashionable shop on the boulevard des Capucines. |
| | | Tabarant 1947, p. 305. |

1878 | | Loath to submit to the jury of the Exposition Universelle, he plans his own show of one hundred works, under the slogan: "Il faut être mille ou seul" (To be a thousand strong or to stand alone).

Bazire 1884, pp. 102–3; Tabarant 1947, pp. 317–18.

| | April 29 | Three paintings are included in the second Faure sale; one brings a low price (RW I 213), and two are bought in (RW I 186; cat. 138). |
| | | Callen 1974, pp. 166–67. |

| | June 5 | Five paintings, submitted without a reserve price in the court-ordered sale held upon Hoschedé's bankruptcy, bring very low prices (RW I 137, 147; cat. 32, 72, 96). |
| | | Bodelsen 1968, p. 339. |

| | | The Manet family moves from 49 to 39, rue de Saint-Pétersbourg. |
| | | Tabarant 1947, p. 319. |

| | July | Forced to leave the studio at 4, rue de Saint-Pétersbourg, he sets up temporarily at 70, rue d'Amsterdam (studio rented "for three quarters" from Swedish painter Otto Rosen). |
| | | Tabarant 1947, p. 319; Manet et al., "Copie faite pour Moreau-Nélaton . . .," p. 67. |

1879 | February | Marriage of Henri Guérard and Eva Gonzalès. |

| | April 1 | Establishes his last studio at 77, rue d'Amsterdam. |
| | | Tabarant 1947, p. 326. |

| | April 10 | Submits to the prefect of the Seine a plan for decorating the Municipal Council Hall in the new Hôtel de Ville: |

"To paint a series of compositions representing, to use an expression now hackneyed but suited to my meaning, 'the belly of Paris,' with the several bodies politic moving in their elements, the public and commercial life of our day. I would have Paris Markets, Paris Railroads, Paris Port, Paris Under Ground, Paris Racetracks and Gardens. For the ceiling, a gallery around which would range, in suitable activity, all those living men who, in the civic sphere, have contributed or are contributing to the greatness and the riches of Paris." Bazire 1884, p. 142; Proust 1897, pp. 414–15.

| | May | Exhibits *Boating* (cat. 140) and *In the Conservatory* (cat. 180) at the Salon. |

| | | Interview with the undersecretary of state for fine arts regarding the purchase either of one of the paintings at the Salon or *Le bon bock*. |
| | | Letter from Manet, June 6, 1879: Archives Nationales, Paris (see cat. 180). |

| | spring | Meets George Moore (cat. 175, 176). |
| | | Pickvance 1963, p. 279. |

| | June | Article by Zola on contemporary art in Paris published in a Russian translation in *Viestnik* |

515

Europi (The Messenger of Europe), a magazine published in Saint Petersburg.

French translation: Zola 1959, pp. 225–30.

July 26	Report in *Le Figaro* of a break between Zola and Manet: Adolphe Racot cites a passage, translated from Zola's article in Russian, where Monet's name in the original is replaced by Manet's—an error that leads to an exchange of letters between the writer and the artist. Moreau-Nélaton 1926, II, pp. 58–59; Tabarant 1947, pp. 350–51; Wildenstein 1974, I, p. 97; Manet et al., "Copie faite pour Moreau-Nélaton . . . ," pp. 40–41; see Appendix I, letter 36.
September–October	Rest and treatment at Bellevue. Meets singer Emilie Ambre, whose portrait he paints (RW I 334). Tabarant 1947, pp. 364–65.
December	Exhibition at La Vie Moderne of painted tambourines, one of them by Manet (RW I 324). *La Vie moderne,* December 20, 1879; Tabarant 1947, p. 372.

1880

December–January	Exhibition of *The Execution of Maximilian* (RW I 127) in New York and Boston, organized by Emilie Ambre. Moreau-Nélaton 1926, II, p. 68.
	Marked deterioration in health. Moreau-Nélaton 1926, II, p. 68.
March	Exhibition at La Vie Moderne of decorated ostrich eggs, one of them by Manet depicting Polichinelle. *La Vie moderne,* March 27, 1880.
April 8–30	Exhibition, "Nouvelles Oeuvres d'Edouard Manet," organized by Georges Charpentier, is held at La Vie Moderne (see cat. 156, 165, 169, 172, 174, 176, 183). *La Vie moderne,* April 10, 17, 1880; Moreau-Nélaton 1926, II, pp. 66–67; Tabarant 1947, pp. 376–77.
May	Exhibits *Portrait of M. Antonin Proust* (cat. 187) and *Chez le père Lathuille* (RW I 291) at the Salon. Proust 1897, p. 308.
July–September or October	Dr. Siredey prescribes hydrotherapy and rest in the country; Manet rents a small house in Bellevue at 4, route des Gardes. Entertains himself by sending letters and watercolors to Eva Gonzalès, Isabelle Lemonnier, and Zacharie Astruc, among others (cat. 191–205). Proust 1913, p. 129; Moreau-Nélaton 1926, II, p. 68.
August 20	Announces to Proust that he is sending two "rather important" paintings to an exhibition in Besançon. Letter to A. Proust, published in *Le Journal des curieux,* March 10, 1907, p. 4, quoted in Rouart and Wildenstein 1975, I, p. 22.
October–November	In Marseilles exhibits a painting that he hopes will be purchased by the municipality. Two letters from E. Lockroy to Manet, November 5, 11, 1880: Manet et al., "Copie faite pour Moreau-Nélaton . . . ," pp. 1, 5.

1881

May	Exhibits at the Salon *Portrait of M. Henri Rochefort* (cat. 206), for which he is awarded a second-class medal, and *Portrait of M. Pertuiset, the Lion Hunter* (cat. 208). Bazire 1884, p. 108; Proust 1897, p. 313; Proust 1913, p. 110; Moreau-Nélaton 1926, II, p. 84.
late June	Leaves Paris for medical treatment and stays at 20, avenue de Villeneuve-l'Etang in Versailles, where he spends the summer (cat. 209, 210). Tabarant 1947, p. 415.
October	Returns to Paris. Bustling activity during the fall. Tabarant 1947, p. 421.

	October 22	Chief engineer E. Mayer gives Manet permission to do "a study of a locomotive ridden by its engineer and stoker," at Les Batignolles depot of the Compagnie des Chemins de Fer de l'Ouest.

Manet et al., "Copie faite pour Moreau-Nélaton . . . ," p. 33.

November 14 — Antonin Proust appointed minister of fine arts by Gambetta.

late December — Manet becomes a Chevalier de la Légion d'honneur.

Bazire 1884, p. 108; Proust 1897, p. 313; Duret 1902, pp. 152–53.

1882

December–
January — State of health grows worse.

May — Exhibits *A Bar at the Folies-Bergère* (cat. 211) and *Jeanne* (RW I 372; see cat. 214) at the Salon.

July–
October — Sojourn in Rueil (see cat. 218, 219).

Tabarant 1947, p. 450.

Draws up will, designating his wife, Suzanne, as his sole heir and Léon Leenhoff as residual legatee. Names Duret executor, with the responsibility of either offering the works in his studio for sale or destroying them.

Will published in Rouart and Wildenstein 1975, I, p. 25.

1883

February–
March — Exhibits *Corner in a Café-Concert* (cat. 172) at the Salon des Beaux-Arts in Lyons.

Tabarant 1947, pp. 328–29.

April — Asks Francis Defeuille to give him lessons in miniature painting.

Tabarant 1931, p. 443.

April 20 — Left leg is amputated.

Bazire 1884, p. 121.

April 30 — Death of Manet.

May 3 — Burial at Passy Cemetery.

"The pallbearers [were] Antonin Proust, Emile Zola, Philippe Burty, Alfred Stevens, Duret, Claude Monet." *Le Figaro*, May 4, 1883, quoted in Tabarant 1947, p. 477.

Letters from Manet to Zola

Edited by Colette Becker

Published here for the first time, by kind permission of Jean-Claude Le Blond-Zola, are some fifty letters and notes written by Manet to Zola in the period from 1866 to 1882. Between the first letter, of May 7, 1866, in which Manet asks to meet the man who has just defended him so warmly, and a final word of congratulation after reading *Pot-Bouille,* there were seventeen years of friendship and mutual esteem that are left to our imagination—seventeen years also of struggle for a common cause: the triumph, in painting as in literature, of a new art.

These are not "belles lettres," or choice morsels for inclusion in anthologies. Most consist of a few lines—the equivalent of a telephone call—written offhand, with no punctuation, in a conversational, sometimes chaotic style, the pen hard put to keep up with the thought. Manet makes an appointment with his friend, asks a question, reports an event of everyday life, thanks him for sending a book, congratulates him on some article. And yet, despite their brevity and allusive character, these words are precious to us; first because at the present time we have no more than five of Zola's letters to Manet, and then because they are part of that vast network of correspondence among a group of friends—Zola, Manet, Guillemet, Pissarro, Cézanne, Marion, Valabrègue, and others—to which we owe our perception of the years from 1860 to 1880, so fruitful in artistic creation.

Indeed, these letters give us something more than certain data about the life and works of Manet and Zola. They conjure up that much wider group of painters, novelists, critics, and politicians to which Manet and Zola belonged, their almost daily meetings at the Café de Bade or the Café Guerbois, the Thursdays at Manet's or Zola's, the Charpentiers' salon, the gallery La Vie Moderne. Zola visited the Salon exhibitions beginning in 1859. Until 1872, his friends were for the most part painters who had come from Aix to Paris or who were known to him through Cézanne—Pissarro, Guillemet, Monet, Béliard, Sisley, and others—with whom he would share holidays in the environs of Paris.

They formed a group bubbling with ideas and very close-knit, as described notably in *L'Oeuvre.* Each of them in his way—they were not a school, as witness the title of Fantin-Latour's *A Studio* (not "The Studio") *in the Batignolles Quarter*—defended the present and the future against the past. They made a united front against academicism and against sacred cows. They also helped each other in every way possible, and their letters provide some examples. On April 6, 1868, Zola asked Manet to lend him 600 francs; he in turn, a little later, helped out Cézanne and Monet. The novelists put their pens to work for the painters, making them the heroes of their stories and novels. The painters put the writers into their pictures, read and discussed their works and drew inspiration from them, attended their first nights. They vied with one another, each in his own medium, in treating the same subjects. All rejoiced in the success of one or other member of the group, for the victory of one was a victory for all, as Zola would often say.

These letters, then, recalling a few facets of their lives and giving us a glimpse of their struggle, are valuable testimony and a useful source for those interested in the period.

In editing the original letters for publication, I have omitted Manet's signature, supplied punctuation (Manet used hardly any), corrected some minor slips in spelling, and expanded all abbreviations (such as "t.a.v." often written for "tout à vous").

Two frequently cited sources are referred to in abbreviated form in the notes:

Corr. Emile Zola, *Correspondance,* ed. B. H. Bakker and Colette Becker, Montreal and Paris, 1978–: I. 1858–67; II. 1868–May 1877; III. June 1877–May 1880; IV. June 1880–1883 (in press).

O.C. Emile Zola, *Oeuvres complètes,* ed. Henri Mitterand, 15 vols., Paris, 1966–69.

1 Monday, May 7 [1866]

Dear Monsieur Zola,
I don't know where to find you, to shake your hand and tell
you how proud and happy I am to be championed by a man
of your talent. What a fine article! A thousand thanks.[1]

Your previous article ("Le moment artistique") was most
remarkable and made a great impression.[2] I should like to
ask your opinion on a point. Where could I meet you? If it
suits you, I am at the Café de Bade every day from 5:30 to 7.[3]

Until then, dear Sir, I beg you to accept the assurance of
my lively esteem and believe me your much obliged and ap-
preciative,

 Lundi 7 mai
Cher monsieur Zola,
Je ne sais où vous trouver pour vous serrer la main et vous dire combien je
suis heureux et fier d'être défendu par un homme de votre talent. Quel bel
article! Merci mille fois.[1]

Votre avant-dernier article ("Le moment artistique") était des plus re-
marquables et a fait un grand effet.[2] J'aurais un avis à vous demander. Où
pourrais-je vous rencontrer? Si cela vous allait, je suis tous les jours au Café
de Bade de 5½ à 7 h.[3]

A bientôt, cher monsieur. Veuillez, je vous prie, agréer l'assurance de ma
vive sympathie et me croire votre très obligé et reconnaissant.

1. In this letter—his first to Zola—Manet thanks the writer for the article
"M. Manet" that appeared on May 7 in *L'Evénement* (see cat. 93). Zola was
reviewing the Salon (*O.C.*, XII, pp. 785–818).
2. "Le Moment artistique," which had appeared on May 4, was the third in
a series of rousing articles. In it, Zola made the statement, "What I seek be-
fore all else in a painting is a man, not a painting."
3. The Café de Bade was probably located at 26, boulevard des Italiens, near
Tortoni's. It was there that Manet and his friends gathered before later
adopting the Café Guerbois, at 11, grande rue des Batignolles (now 9, ave-
nue de Clichy).

2 Monday, October 15 [1866]

My dear Zola, indeed, here is a friend where I never expected
one. I see new ones coming forward every day and I attribute
much of this to your courageous initiative.[1]

I have not written to you sooner because upon my return
from the country I found myself in the midst of moving, and
heavens, what a nuisance that is, but now I'm almost
through with it.[2] Will you come Thursday to the studio, at 1
or 2 o'clock, as you please? Friday, if Thursday is not conven-
ient. We must have a talk about the "Contes à Ninon."[3]

Yours ever,

 Lundi 15 octobre
Mon cher Zola, en effet, voilà un ami dont je ne me doutais pas, j'en vois
surgir de nouveaux tous les jours et j'en attribue une bonne partie à votre
courageuse initiative.[1]

Je ne vous ai pas écrit plus tôt parce qu'à mon retour de la campagne je
me suis trouvé au milieu d'un déménagement et quel ennui c'est, mon dieu,
mais me voilà à peu près débarrassé.[2] Voulez-vous venir jeudi à l'atelier à
1 h–2 heures, comme vous voudrez? Vendredi, si jeudi vous est incom-
mode. Nous avons à causer à propos des "Contes à Ninon."[3]

Tout à vous.

1. Zola had probably told Manet of someone's reaction to his writings about
the Salon.
2. This must have been the occasion when Manet moved from his apart-
ment at 34, boulevard des Batignolles to 49, rue de Saint-Pétersbourg.
3. From a letter of November 2, 1866, from Guillemet to Zola, we know that
Zola had planned a new octavo edition of his first book, *Contes à Ninon*, with
illustrations by Manet, and was seeking a publisher. He made the proposal
to Lacroix in May 1867, emphasizing the publicity that would result for the

bookseller: "My artist will make a great stir, a few weeks hence. It would be
a real advertisement for your house" (*Corr.*, I, pp. 494–97). The project came
to nothing.

3 Saturday [late 1866]

My dear Zola, I am so disappointed by the coincidence on
Thursday that prevents you from coming to the house. The
people who come are surprised not to see you, and I am
often told: show me M. Zola. So try to come next Thursday, it
would be a great pleasure for us.[1]

I am requested by Burty to ask whether you received his
book. He sent it to you at *Le Figaro*, not having your address,
and would like to know whether you will discuss it some-
where.[2] In short, he wishes you would—for one. You cer-
tainly have the reputation of being a powerful man: my
friend Zacharie Astruc wants me to ask whether you could
put in a good word for him at Hachette's to get a book of
poetry published?[3]

Cordially, yours ever,

 Samedi
Mon cher Zola, je suis horriblement ennuyé de cette coïncidence de jeudi
qui vous empêche de venir à la maison. Les personnes qui viennent sont
étonnées de ne pas vous y voir et l'on m'a souvent dit: montrez-moi donc
M. Zola. Tâchez donc de venir jeudi prochain, vous nous feriez grand
plaisir.[1]

Je suis chargé de vous demander de la part de Burty si vous avez reçu
son livre. Il vous l'a envoyé au *Figaro* ne sachant votre adresse et voudrait
bien savoir si vous en parlerez quelque part.[2] Enfin, il le désire—et d'une.
Vous avez décidément la réputation d'un homme puissant: mon ami
Zacharie Astruc me prie de vous demander si vous pouvez lui faciliter dans
la maison Hachette l'édition d'un livre de poésie?[3]

Je vous serre la main et suis tout à vous.

1. The curiosity was aroused by Zola's "Salon"—hence the 1866 dating of
this letter.
2. Zola, who had run the column "Livres d'aujourd'hui et de demain" in
L'Evénement until November 6, was a contributor to *Le Figaro*, in which he
published two series, "Marbres et plâtres" and "Dans Paris." Manet proba-
bly refers to the book Burty published in November 1866, *Chefs-d'oeuvre des
arts industriels*.
3. Zola had been in charge of publicity for Hachette from March 1, 1862, to
January 31, 1866. No trace has been found of the publication of a book of As-
truc's by that firm. In 1883, Charpentier published Astruc's *Romancero del Es-
corial: Poèmes d'Espagne*.

4 Wednesday, January 2 [1867]

My dear Zola, what a famous New Year's present you've
given me in your remarkable article, which is very gratify-
ing.[1] It comes in good time, for I've been found unworthy of
the privilege, enjoyed by so many others, of submitting by
list.[2] And so, since I look for no good from our judges, I shall
take care to send them no paintings of mine. They would
need only to play me the trick of accepting just one or two,
and the rest, as far as the public is concerned, I might as well
throw to the dogs.

I am making up my mind to hold a private show. I have at
least twoscore pictures to exhibit. I've already been offered a
site in a very good location near the Champ de Mars.[3] I'm
going to stake the lot, and seconded by men like yourself, am
hopeful of success. See you soon.

Cordially, yours ever,

All of us here are delighted with the article, and I am in-
structed to send you thanks.

Mercredi 2 janvier

Mon cher Zola, c'est de fameuses étrennes que vous m'avez donné là et votre remarquable article m'est très agréable.[1] Il arrive en temps opportun car on m'a jugé indigne de profiter comme tant d'autres des avantages de l'envoi sur liste.[2] Aussi, comme je n'augure rien de bon de nos juges, je me garderai bien de leur envoyer mes tableaux. Ils n'auraient qu'à me faire la farce de ne m'en prendre qu'un ou deux et voilà pour le public les autres bons à jeter aux chiens.

Je me décide à faire une exposition particulière. J'ai au moins une quarantaine de tableaux à montrer. On m'a déjà offert des terrains très bien situés près du Champ de Mars.[3] Je vais risquer le paquet et, secondé par des hommes comme vous, je compte bien réussir. A bientôt.

Je vous serre la main et suis tout à vous.

Tout le monde chez moi est enchanté de l'article et me charge de vous remercier.

1. Zola's article "Une Nouvelle Manière en peinture: Edouard Manet" had appeared in *La Revue du XIXe siècle* of January 1, 1867 (*O.C.*, XII, pp. 821–45).
2. The rules for selecting canvases to be exhibited at the Salon had been changed. Artists were to send in a list before December 15, 1866, indicating the sizes and subjects of their paintings, and the year of any previous exhibition. The jury was to choose from these lists. "Manet," wrote Duranty to Legros, "means to take the town by storm. He has displayed all his paintings in his studio, and is going to invite all Paris, Niewerkerke [*sic*] in the lead, to come and marvel. He is much troubled, by the way, over his rival Monet. So much so, people are saying that, having *manetized* him, he would now like to *de-monetize* him" (quoted by Crouzet 1964, p. 232).
3. The exhibition was held in a temporary building erected at the artist's expense (according to Zola, he laid out 15,000 francs) on a plot belonging to the marquis de Pomereaux, at the corner of the avenue Montaigne and the avenue de l'Alma.

5 [between January and May 1867]

My dear Zola, I confess I should be only too pleased to see your pamphlet about myself on sale at my show.[1] I should even like a great many to be sold, as might very well happen, and after all, nothing ventured nothing gained.

In fact I would suggest, if of course you approve, putting an etched portrait of me at the front.[2] Tell me what you think, and send me the format of the pamphlet so that I can have the etching printed.

Cordially, yours ever,

Would you like the two of us to go into this together?

I've reopened this letter. I recall that I recently made a woodblock of *Olympia*, which was intended for Lacroix's *Paris-Guide*.[3] If it didn't cost us too much, we could insert it. Furthermore, the woodblock being our property, we could place it elsewhere to advantage at any time. I am going to write to an engraver skilled enough to make a good job of it.[4]

Mon cher Zola, je vous avoue que cela ne peut que m'être agréable de voir votre brochure sur moi se vendre dans mon exposition.[1] Je voudrais même qu'il s'en vendît beaucoup, cela se peut très bien et enfin qui ne risque rien n'a rien.

Je vous proposerais même, si toutefois vous le trouvez bon, de faire pour le mettre en tête mon portrait à l'eau-forte.[2] Dites-moi votre avis et envoyez le format de la brochure que je puisse faire faire le tirage de la gravure.

Je vous serre la main et suis tout à vous.

Voulez-vous que nous fassions l'affaire à nous deux?

Je rouvre ma lettre. Je pense que j'ai fait dernièrement d'après *Olympia* un bois qui était destiné au *Paris-guide* de Lacroix.[3] Si cela pouvait ne pas nous coûter trop cher nous pourrions l'intercaler. Du reste le bois nous appartenant, on peut toujours à un moment donné le placer ailleurs avantageusement. Je vais écrire à un graveur assez habile pour en faire quelque chose de bien.[4]

1. The exhibition opened on May 24, 1867. In a letter dated May 29 to his friend Valabrègue, Zola says: "In the next few days I will send you a pam-

phlet I am publishing here—nothing more nor less than my article on Manet. It contains two etchings: a portrait of Manet and a reproduction of *Olympia*. You must know that on Friday Manet opened his private exhibition. In money terms, success so far is modest. The venture is not under way. I hope that my pamphlet will light the fuse" (*Corr.*, I, p. 500). The pamphlet, published by Dentu, was a slightly reworked version of the article in *La Revue du XIXe siècle*. It was in three parts: I. The man; II. The works; III. The public (*O.C.*, XII, pp. 821–45).
2. Bracquemond's portrait of Manet (see cat. 68, fig. a).
3. *Paris-Guide*, with text and illustrations by "the foremost writers and artists of France," was published by A. Lacroix, Verboeckhaven & Cie., Librairie Internationale, as a guide to Paris in 1867. It was in two volumes: I. Science and Art; II. Life.
4. For the wood engraving, see entry on *Olympia* (cat. 68).

6 Sunday evening [between January and May 1867?][1]

My dear friend, upon sober reflection, I believe it would be in bad taste and would unnecessarily dissipate our strength to reissue and sell such a perfect eulogy of myself at my own show.[2] I am still in too great need of your friendship and your valiant pen not to use them with the utmost discretion in the eyes of the public. We must consider that I may be violently attacked. Wouldn't it be better to marshal our forces and hold yours in reserve to do something then?

We will carry out the project for the first pamphlet at the end, after a success. If there is one, that will be an easy matter.

I am planning to come to see you anyway, and bring you up to date on my various projects.

Yours ever,

Dimanche soir[1]

Mon cher ami, toute réflexion faite, je crois qu'il serait de mauvais goût et user nos forces gratuitement que de rééditer et de vendre chez moi un éloge aussi parfait de moi-même.[2] J'ai encore trop besoin de votre amitié et de votre vaillante plume pour ne pas en user vis-à-vis du public avec le plus grand discernement. Il faut penser que je puis être violemment attaqué, ne vaut-il pas mieux faire quelque chose et ménager vos forces pour ce moment-là?

Nous réaliserons le projet de la première brochure pour la fin après une réussite. S'il y en a, ce sera affaire de dilettantisme.

Je compte aller vous voir du reste et vous mettre au courant de mes différents projets.

Tout à vous.

1. The dating of this letter is in doubt. It perhaps refers to Manet's scruples regarding the publication of Zola's article in the form of an illustrated pamphlet to be sold at his Alma exhibition in 1867 (see letter 5). However, it may possibly date from 1876 and refer to a planned reissue of this pamphlet for the show held by Manet at his studio. The Salon jury of 1876 had in fact rejected *The Laundry* (RW I 237) and *The Artist* (cat. 146). So Manet invited the public to come and see the paintings at his studio, April 15 to May 1, from 10 to 5 o'clock, 4, rue de Saint-Pétersbourg, ground floor (see cat. 136).
2. Manet refers either to the publication of Zola's article of January 1, 1867, in the form of an illustrated pamphlet (see letter 5, n. 1) or to the reissue of this pamphlet for the exhibition of 1876. In 1875–76, Zola undertook to edit all his articles for republication by Charpentier. In 1879, the publisher released a volume containing *Mes Haines: Causeries littéraires et artistiques; Mon Salon (1866); Ed. Manet: Etude biographique et critique*—this last being the title of the 1867 pamphlet.

7 [late 1867]

My dear friend,
I've just finished *Thérèse Raquin* and send you all my compliments.[1] It's a very fine novel and very interesting.

Yours ever,

Mon cher ami,

Je viens de terminer *Thérèse Raquin* et vous envoie tous mes compliments.[1] C'est un roman très bien fait et très intéressant.

Tout à vous.

1. *Thérèse Raquin* was published in late November 1867 by the Librairie Internationale.

8 [late April or May 1868]

Bravo, my dear Zola, that was a formidable preface, and you're making the case not only for a group of writers but for a whole group of artists as well.[1] Besides, if one is such a master of defense as you are, it must be a sheer pleasure to be attacked.

Regards

Bravo, mon cher Zola, voilà une rude préface et ce n'est pas seulement pour un groupe d'écrivains que vous y plaidez mais pour tout un groupe d'artistes.[1] Du reste, quand on peut se défendre comme vous savez le faire, ce ne peut être qu'un plaisir d'être attaqué.

Amitiés

1. Probably this was the preface to the second edition of *Thérèse Raquin*, dated April 15, 1868. Zola, who accounted himself a "naturalist" writer, compares himself to "painters who copy nudes, untouched by the slightest desire, and who stand amazed when a critic declares himself scandalized by the living flesh of their creation" (*O.C.*, I, pp. 519–23).

9 [April–May 1868?]

My dear Zola, I forgot to send you Champfleury's address. It's rue de Boulogne 20.[1] Do come Friday to the Café Guerbois, and don't be too late.

Yours ever,

Mon cher Zola, j'ai oublié de vous envoyer l'adresse de Champfleury. C'est rue de Boulogne 20.[1] Venez donc vendredi au Café Guerbois, pas trop tard surtout.

Tout à vous.

1. Champfleury was a very old friend of Manet (see cat. 114), who represented him among his friends in *Music in the Tuileries* (cat. 38) in 1862. Champfleury, after his marriage on July 17, 1867, in fact moved to 20, rue de Bruxelles (Geneviève and Jean Lacambre, eds., *Champfleury: Le Réalisme*, Paris, 1973, p. 41).

Perhaps Zola wanted Champfleury's address in order to send him a copy of the second edition of *Thérèse Raquin*, which Champfleury acknowledged with thanks on May 30, 1868 (Paris, Bibliothèque Nationale, Département des Manuscrits, n.a.f. 24517, f. 51).

10 Boulogne-sur-Mer [July–August 1868]

My dear Zola, I should be very glad to hear from you, with news of what you are doing. Tell me too what has become of our young friend Guillemet.[1] If he could learn something about my exhibition at Le Havre from Monet,[2] I should be much obliged.

I went to London some days ago and was delighted with the trip. I was very well received. There is something for me to do over there, I think, and next season I'm going to try it out.[3]

I saw some artists, who were very kind and strongly urged me to put in an appearance! They're not given to the petty jealousies we have here at home, they're "gentlemen" almost every one of them.

I meant to write to you from London but stayed there only two days, which were so full that I never found a moment to carry out my intention.

Adieu, my dear Zola, write to me as soon as you can.

Until the 17th, rue Napoléon 2 bis; from then on, 156, rue de Boston.

Yours ever,

I believe that at a suitable time we could distribute the pamphlet over there.[4]

Boulogne-sur-Mer

Mon cher Zola, je serais bien aise d'avoir de vos nouvelles, de savoir ce que vous faites. Dites-moi aussi ce que devient notre jeune ami Guillemet.[1] S'il pouvait savoir par Monet quelque chose de mon exposition au Havre,[2] cela me ferait plaisir.

Je suis allé il y a quelques jours a Londres et suis enchanté de mon excursion. J'y ai été très bien reçu. Il y a quelque chose à faire là-bas pour moi, je crois et je vais le tenter à la saison prochaine.[3]

J'ai vu quelques artistes fort aimables qui m'ont fort engagé à me produire! il n'y a pas chez eux cette espèce de jalousie ridicule qu'il y a chez nous, c'est presque tous des gentlemen.

Je voulais vous écrire de Londres mais je n'y suis resté que deux jours qui ont été si remplis que je n'ai pas trouvé un moment pour mettre ce projet à exécution.

Adieu, mon cher Zola, écrivez-moi le plus tôt possible.

Jusqu'au 17, rue Napoléon 2 bis; à partir de cette époque, 156 rue de Boston.

Tout à vous.

Je crois qu'à un moment donné on pourra écouler la brochure là-bas.[4]

1. According to his letters to Zola, Guillemet spent most of the summer at Bonnières except for ten days or so beginning August 6, during which time he stayed at Pontoise.
2. Monet had left Bonnières in July, his wife and son staying on at the innkeeper Dumont's, and had gone to Le Havre, where Manet was exhibiting *The Dead Man* (cat. 73; see also Chronology).
3. Manet expresses the same satisfaction in a letter to Fantin-Latour: "I was delighted with London, with the welcome I received there, with all the people I visited. Legros was kind and most obliging. The excellent Edwards was charming. . . . Whistler was not in London, so I couldn't see him" (quoted by Moreau-Nélaton 1926, I, p. 104).
4. The pamphlet published by Zola at the time of Manet's exhibition in 1867. See letter 5.

11 [December 1868]

My dear friend, I'm in the middle of *Madeleine Férat*[1] and don't want to wait till I've finished to send my congratulations. You paint the redheaded woman[2] so well it makes one jealous, and the expressions you find to render the love scenes would deflower a virgin just to read them.

Yours ever,

Mon cher ami, je suis en plein *Madeleine Férat*[1] et ne veux pas attendre que j'aie fini pour vous faire mon compliment. Vous peignez la femme rousse[2] à en rendre jaloux, et vous trouvez pour rendre les scènes d'amour des expressions à dépuceler une vierge rien qu'en les lisant.

Tout à vous.

1. *Madeleine Férat*, which appeared in installments in *L'Evénement illustré* from September 2 to October 20, 1868, was published by the Librairie Internationale in December. The novel bears a dedication to Manet, dated September 1 (see cat. 106). Zola sent out numerous copies of the work on December 7.
2. Madeleine Férat, the heroine, had "wonderful hair of a fiery red, with a tawny sheen," like Victorine Meurent, Manet's favorite model (see cat. 31).

12 [late January 1869]

My dear Zola, have a look at the enclosed letter and return it to me in an envelope along with your opinion.[1]

It seems to me that the authorities are bent on making me take action over my lithograph, which had been causing me considerable worry. I thought they could stop the publication but not the printing. Anyway, it speaks well for the work, since there's no caption of any kind underneath it. I was waiting for a publisher to have the stone inscribed—Death of Max., etc.[2]

I feel that a word about this ridiculously high-handed little act would not be out of place. What do you think?[3]

Yours ever,

Mon cher Zola, lisez un peu la lettre ci-incluse et renvoyez-moi la sous pli avec votre avis.[1]

Il me semble que l'administration veut me faire tirer parti de ma lithographie dont j'étais fort embarrassé. Je croyais qu'on pouvait empêcher la publication mais non l'impression. C'est du reste une bonne note pour l'oeuvre car il n'y a en dessous aucune légende. J'attendais un éditeur pour faire écrire sur la pierre—mort de Max. etc.[2]

Je crois que dire un mot de ce petit acte d'arbitraire ridicule ne serait pas mal. Qu'en pensez-vous?[3]

Tout à vous.

1. We have neither the letter mentioned by Manet nor Zola's reply.
2. The lithograph in question is the one Manet made after his painting *The Execution of the Emperor Maximilian*. See cat. 104 and 105 and Appendix II.
3. In his column "Coups d'épingle" ("Pinpricks") of February 4, 1869, for *La Tribune*, Zola denounced the order given to prohibit Manet from printing the lithograph (*O.C.*, XIII, p. 222; see also Appendix II, no. 3).

13 [early 1869]

My dear friend,
It would be very kind of you to write to *Bournat*, deputy to the legislature, president of the Société Artistique des Bouches-du-Rhône.[1]

I shall write Ollivier[2] for a recommendation to him.

I have sent the Spanish Singer and the Boy with a Sword.[3]

Yours ever,

Mon cher ami,
Vous seriez bien aimable d'écrire à *Bournat*, député au corps législatif, président de la société artistique des Bouches-du-Rhône.[1]

Je vais écrire à Ollivier[2] de me recommander à lui.

J'ai envoyé le Chanteur espagnol et L'enfant à l'épée.[3]

Tout à vous.

1. François-Joseph Calixte Bournat (1814–1886), Conseiller Général de la Bouches-du-Rhône, had been elected deputy over Thiers (1797–1877) on June 1, 1863. He served until 1870. He was president of the very active Société Artistique des Bouches-du-Rhône, which organized major exhibitions in Marseilles. Thus, on January 2, 1869, F. A. Marion wrote his friend Zola an account of an exhibition that opened on December 1, 1868. Manet had sent three pictures. "You know the rest. The impression made by the Guitar Player is incredible. The surprising thing, though, is that the canvas pleases most in those quarters with which we are least concerned. Even artistically speaking, I mean. But decidedly people of artistic education, whom I sometimes see genuinely admiring without affectation. I refer to Saporta and those about him" (Paris, Bibliothèque Nationale, Département des Manuscrits, n.a.f. 24522, f. 12).

Through another letter from Marion, dated "Wednesday evening," we know that Manet had sent his paintings to Marseilles with a view to their purchase by the Société Artistique des Bouches-du-Rhône. Hence this letter to Zola. Marion wrote, "You must by this time have heard from Manet about the unsatisfactory outcome of this business. Several days ago, he was advised that the canvases were being returned." Marion added, "The Société

Artistique, instead of the Manets, has bought a wretched canvas by Millet" (ibid., f. 18). That painting was *La bouillie*, which had been shown at the Société exhibition of 1868 and was purchased early in 1869 (Musée des Beaux-Arts, Marseilles).

In his letter, Marion mentions the coming Paris Salon, a course to be prepared for the baccalaureate, etc. He therefore wrote it before May 1869. Hence our dating of Manet's letter.
2. Emile Ollivier was born in Marseilles. Manet had in fact known him for a long time. He met him, on September 17, 1853, while in Venice with his brother Eugène. The Manet brothers had shown Ollivier around Venice, and Edouard met him again in Florence. (See E. Ollivier, *Journal, 1846–1869*, Paris, 1961, p. 168; see also Chronology.)
3. Cat. 10, 14.

14 Tuesday [1868–69?]

My dear Zola, I thank you and am returning the Lavertujon letter to you; it's very kind.[1]

I feel I really ought to thank him at some opportunity. So drop by the café this evening.

Yours ever,

Mardi

Mon cher Zola, je vous remercie et vous retourne la lettre Lavertujon qui est très aimable.[1]

Il me semble que je pourrais plutôt à l'occasion le remercier. Venez donc un instant ce soir au café.

Tout à vous.

1. We do not have the letter. In 1868, André Lavertujon (1827–1914) became a founder, with Duret, Pelletan, Hérold, and Glais-Bizoin, of *La Tribune*, a republican opposition paper to which Zola contributed. The first issue appeared June 14. Zola seems to have met Lavertujon through Duret at that time.

15 Saturday [1868–70?]

My dear Zola, I wanted to see you this morning but am detained. I believe you keep your newspapers. Please try to find the issue of Le Gaulois or La Cloche[1] reporting the attack of the English in the plains of Marathon,[2] and at 10 o'clock tomorrow, Sunday morning, I'll await you at the Café Guerbois, there's something I'd like to talk to you about.

Yours ever,

Samedi

Mon cher Zola, je voulais vous voir ce matin, je m'en trouve empêché—je crois que vous gardez vos journaux. Trouvez-moi donc le numéro du Gaulois ou de la Cloche[1] qui donne la relation de l'attaque des Anglais dans les plaines de Marathon,[2] et demain matin dimanche à 10 h. je vous attends au Café Guerbois, j'aurais à vous entretenir de quelque chose.

Tout à vous.

1. The first issue of *Le Gaulois* appeared July 5, 1868; *La Cloche* appeared from August 15, 1868, to December 21, 1872. Zola contributed to *Le Gaulois* from September 22, 1868, to September 30, 1869, and to *La Cloche* from February 2 to August 17, 1870, then from February 19, 1871, to December 20, 1872.
2. It is not known what event Manet had in mind.

16 Saturday [March 12, 1870]

My dear Zola, the committee of artists who voted the enclosed list have asked me to take the initiative in putting it

forward. Could you have a brief notice inserted in *Le Rappel* and *La Cloche*, worded more or less as follows:

"The recommendation of the committee presenting the following list for the jury was completely open. The artists will all vote for the following names"—then the list.[1]

I have a letter of invitation for this evening to a meeting of 150 artists to nominate me. The candidates are being asked to come and present their ideas on the organization, or disorganization, of artistic affairs.

I haven't a minute to myself. Running very late.

Yours ever,

At La Cloche it's Montrosier who deals with questions of art; he's very nice.[2]

Samedi

Mon cher Zola, le comité d'artistes qui a voté la liste que je joins à ma lettre me prie d'agir de mon côté pour la proposer. Pourriez-vous faire passer dans le *Rappel* et la *Cloche* une note courte et conçue à peu près dans ces termes:

"Le projet émanant du comité qui présente la liste suivante pour le jury, était absolument libéral. Tous les artistes voteront pour les noms suivants"—suivrait la liste.[1]

Je reçois une lettre de convocation pour ce soir, à une réunion de 150 artistes qui me porte. Les candidats sont invités à venir exprimer leurs idées d'organisation ou de désorganisation artistiques.

Je n'ai pas une minute à moi. Très en retard.

Tout à vous.

A la Cloche c'est Montrosier qui traite la question d'art; il est très gentil.[2]

1. This letter was probably written March 12, 1870. Zola worked on *Le Rappel* from May 15, 1869, to May 13, 1870, and on *La Cloche* from February 2 to August 17, 1870. In letter 17, written soon afterward, Manet mentions an appointment for Saturday the 19th. In 1870, the 19th fell on Saturday in February and March only. Finally, on March 19 Manet wrote a letter to La Rochenoire in which he refers to this letter to Zola.

What was going on? Manet refers to the new system under which all the members of Salon juries were to be elected by the accepted artists. Alongside the "official" list, a "dissident" list was drawn up, headed by the animal painter Jules de La Rochenoire; it was remarkable for not including any member of the Institute. Manet's name was there, with among others Corot, Daubigny, Courbet, Daumier, and Bonvin. With the exception of Corot, Daubigny, and Millet, who appeared on both of the rival lists, none of the candidates on the dissident list was elected. The list did not appear in either *La Cloche* or *Le Rappel*.

2. Montrosier devoted six articles to the Salon in *La Cloche* from May 12 to June 13, 1870.

17 [between March 12 and 19, 1870]

My dear friend, it's all right. I was going to write you not to proceed. The committee advises me that the list is incomplete. What you say is very true, and in any case there is no objection to my applying to these gentlemen, with whom I am on excellent terms.[1]

Yours,

I look forward to your visit Saturday the 19th in the afternoon.

Mon cher ami, cela se trouve très bien. J'allais vous écrire de ne pas agir. Le comité me fait savoir que la liste est incomplète. Ce que vous me dites est très juste et du reste rien ne s'oppose à ce que je m'adresse à ces messieurs avec lesquels je suis très bien.[1]

A vous.

Je compte sur votre visite samedi 19 dans l'après-midi.

1. See letter 16.

18 Paris, February 9, 1871

My dear friend, I am very glad to get your news, and good news at that. You haven't wasted your time.[1] It has indeed been pretty bad for us in Paris lately.[2] I learned only yesterday of the death of poor Bazille, I was devastated.[3] Alas, we've seen a lot of people die here, in one way and another. Your house was occupied at one point by a refugee family, the ground floor at least. All the furniture had been put in the rooms above. I don't think you have any damage to complain of.[4] I'm leaving in a few days to join my wife and my mother, who are at Oloron in the Basses-Pyrénées.[5] I can't wait to see them. I'll be going by way of Bordeaux.[6] Perhaps I'll pay you a visit. Then I'll speak of things that one cannot write. My regards to your wife and your mother.

Yours ever,

Paris, 9 février 1871

Mon cher ami, je suis bien aise d'avoir de vos nouvelles et de bonnes. Vous n'avez pas perdu votre temps.[1] Nous avons bien souffert ces derniers temps à Paris.[2] J'apprends d'hier seulement la mort du pauvre Bazille, j'en suis navré.[3] Hélas! nous avons vu mourir bien du monde ici de toutes les façons. Votre maison a été habitée un moment par une famille de réfugiés, le rez-de-chaussée au moins. On avait mis tous les meubles dans les pièces du haut. Je crois que vous n'avez pas de dégâts à déplorer.[4] Je pars ces jours-ci pour retrouver ma femme et ma mère qui sont à Oloron dans les Basses-Pyrénées.[5] J'ai hâte de les revoir. Je passerai par Bordeaux.[6] J'irai peut-être vous voir. Je vous raconterai ce qu'on ne peut écrire. Mes amitiés à votre femme et à votre mère.

Tout à vous.

1. After the defeat at Sedan and the capitulation of Napoleon III, the Republic was proclaimed on September 4. The German troops advanced as far as Paris, which they surrounded on September 19. A delegation of the National Defense government withdrew to Tours, then to Bordeaux beginning December 6. Zola, who as a widow's son and myopic was exempt from military service, left Paris with his mother and his wife. He stayed first at L'Estaque, then at Marseilles. There he started a political newspaper, *La Marseillaise*. He left for Bordeaux on December 11. On the 22nd, he was named private secretary to Glais-Bizoin, a member of the government. Beginning February 12, he reported in *La Cloche* on the sessions of the Assembly, which was meeting at Bordeaux.
2. On the great hardships suffered by the Parisians during the siege, see among other accounts the letter of February 18 from the painter Solari to Zola (*Corr.*, II, p. 278, n. 2) or the "Carnets" of Victor Hugo (*Oeuvres complètes*, Paris, 1967–70, XVI), and Manet's letters to his family (see cat. 123).
3. Frédéric Bazille, who had enlisted in the Zouaves, was killed at Beaune-la-Rolande on November 28, 1870. Bazille, together with Manet and Zola, is portrayed in Fantin-Latour's painting *A Studio in the Batignolles Quarter* (Musée d'Orsay-Galeries du Jeu de Paume, Paris).
4. Since June 1869, Zola had been living in a small house in the garden behind 14, rue de la Condamine, in the Batignolles quarter. Paul Alexis was to reassure Zola in his turn: "Manet's canvas [cat. 106], your silver, sundry articles you left lying about on the tables, have been taken up to the first floor at my instance. I have several times looked in on my way by" (*Corr.*, II, p. 276, n. 5).
5. The armistice having been signed at Versailles on January 28, Manet, who had served in the National Guard as a staff officer, made his way to Oloron (see Chronology).
6. In the latter part of February, the Manets spent a week at Bordeaux (see Chronology). Manet must have seen Zola then.

19 Wednesday [after June 1871]

My dear friend,
I find I can't go to de Goncourt's this week. We might, if you like, put it off until Saturday week.[1]

Regards,

Mon cher ami, Mercredi

Je ne pourrai pas aller cette semaine chez de Goncourt. Nous pourrions, si vous voulez, remettre cela à samedi en huit.[1]

 Amitiés.

1. This letter was written after Zola's return to Paris in 1871; he had first called on the two Goncourt brothers on December 14, 1868. Jules de Goncourt died June 20, 1870.

20 [after June 1872?]

TOUT ARRIVE
[ALL IN DUE TIME / EVERYTHING COMES TO PASS]
My dear Zola, at last I have an answer from Duquesnel.[1] I'm forwarding it to you. This morning I received a letter from Guillemet telling me that his painting has just been purchased by the Beaux-Arts administration.[2]

 Yours,

TOUT ARRIVE
Mon cher Zola, je reçois enfin une réponse de Duquesnel.[1] Je vous la transmets. Il m'arrive ce matin une lettre de Guillemet qui m'annonce que son tableau vient d'être acheté par l'administration des Beaux-Arts.[2]

 A vous.

1. After being associated with the management, Henri-Félix Duquesnel himself became manager of the Théâtre de l'Odéon from July 1872 until 1880. We do not have the letter to which Manet refers. Perhaps he had spoken for Zola, who wished to produce a play (if this letter indeed dates from 1872, the play may have been *Thérèse Raquin*), or on behalf of Flaubert, who wished to produce a play by his friend Bouilhet, recently deceased. (See Gustave Flaubert, *Correspondance*, 9 vols., Paris, 1926–33, VI, 1871–72 passim, and on *Le Sexe faible*, Zola, *Corr.*, II, letter no. 186, n. 6.)
2. *Low Tide at Villerville*, 1872, purchased by the state on June 14, 1872 (date of order) and deposited in the Musée de Grenoble.

Fig. 1. Letter 20

21 Thursday [July 4?, 1872]

My dear Zola, here I am all settled in, or nearly so, at 4, rue de Saint-Pétersbourg.[1] Do come and see me.

 Yours ever,

 Jeudi
Mon cher Zola, me voilà complètement installé ou à peu près 4 rue de Saint Pétersbourg.[1] Venez m'y faire une petite visite.

 Tout à vous.

1. Manet moved into his studio at 4, rue de Saint-Pétersbourg on Monday, July 1, 1872.

22 Wednesday, December 4 [1872]

Gentlemen: Messrs. Pissarro, Sisley, Monet, and Manet request the pleasure of your company at dinner on Wednesday the 11th instant.[1]

 7 o'clock Café Anglais[2]
 R.S.V.P.

 Mercredi 4 décembre
Mrs, Mrs Pissarro, Sisley, Monet et Manet vous prient de leur faire le plaisir d'accepter à dîner le mercredi 11 courant.[1]

 7 h. Café Anglais[2]
 R.S.V.P.

1. Between 1866 and 1883, December 4 fell on a Wednesday in 1867, 1872, and 1878 only. Zola was at Médan in December 1878, hence our choice of date. Zola still had close relations with the artists. In late July 1872, for example, he went to join Béliard and his friends at Pontoise.
2. At 13, boulevard des Italiens.

23 Friday [late April 1873]

TOUT ARRIVE
My dear Zola, my wife was to call on Madame Zola yesterday and convey our thanks for *Le Ventre*,[1] but unfortunately she was indisposed. I therefore hasten to acknowledge receipt of this latest book, which looks wonderful and exhales the freshest market-garden odors.

 I met Aubryet a couple of weeks ago; he asked me for your address and wanted me to thank you on his behalf for an article you had just written about his play.[2]

 Regards to all,

TOUT ARRIVE Vendredi
Mon cher Zola, ma femme devait aller voir Madame Zola hier et se charger de nos remerciements pour le *Ventre*[1] mais elle s'est trouvée souffrante. Aussi je m'empresse de vous accuser réception de ce dernier livre qui a fort bonne mine et exhale des parfums de primeurs.

 J'ai rencontré il y a une quinzaine Aubryet qui m'a demandé votre adresse et m'avait chargé de vous remercier pour lui d'un article que vous veniez de faire sur sa pièce.[2]

 Mon amitié à tous.

1. *Le Ventre de Paris (The Belly of Paris)* had been published in book form by Charpentier on April 19, 1873. Zola's descriptions impressed Manet deeply (see cat. 211).
2. In his "Causerie dramatique" of April 10, Zola, then drama critic for *L'Avenir national*, had discussed *Le Docteur Molière*, a one-act play in verse by Xavier Aubryet, which had had its premiere at the Odéon on April 7 (*O.C.*, X, pp. 1096–97).

My dear friend, I'm off tomorrow for Etaples at 6:30 in the morning.[1] I should have liked to come and take my leave this evening but am not yet packed. My compliments on the preface.[2] It is from the hand of a master. The arrival of your book made me aware that you were still in Paris; for on my return from a short absence last week,[3] the concierge at my studio told me that a gentleman of my acquaintance and his *lady* had called on me and left a message that they were leaving town for the waters. From her portrait of the visitors, I thought I recognized you. Otherwise, I should have called before.

Yours ever, with my regards to Madame Zola,

<div align="right">Dimanche</div>

Mon cher ami, je pars demain pour Etaples à 6 h ½ du matin.[1] J'aurais voulu aller vous serrer la main ce soir, mais je n'ai pas encore fait ma malle. Mes compliments sur la préface.[2] Elle est écrite de main de maître. L'arrivée de votre livre m'a appris que vous étiez encore à Paris, car à mon retour d'une petite absence que j'ai fait la semaine dernière,[3] la concierge de mon atelier m'a dit qu'un Monsieur de mes amis et sa *dame* étaient passés chez moi et qu'ils l'avaient chargée de me dire qu'ils partaient pour les eaux. Au portrait qu'elle m'avait fait des visiteurs, j'avais cru vous reconnaître. Vous auriez eu ma visite autrement.

Tout à vous et mes amitiés à Madame Zola.

1. Etaples is in the Pas-de-Calais, in the district of Montreuil-sur-Mer, near Berck (see cat. 135).
2. Zola's preface to the printed version of his play *Thérèse Raquin*, published by Charpentier and dated July 25, 1873. The play had been performed for the first time at the Théâtre de la Renaissance on the 11th.
3. Manet had spent a few days at Argenteuil in June.

25 [a few days before March 11, 1874]

My dear friend,
I'd very much like a stall, for love or money, to see the "Flaubert"[1] opening on Saturday. Would you be able to get me one?

 Regards

Mon cher ami,
J'aimerais bien avoir un fauteuil, même payant, pour la première de samedi "Flaubert."[1] Etes-vous à même de m'en faire avoir un?

 Amitiés

1. Flaubert's comedy *Le Candidat*, first performed at the Théâtre du Vaudeville on March 11, 1874, in the presence of the princesse Mathilde. From January to April 1874, Zola wrote several articles in defense of the play, which Flaubert withdrew after four performances, in *Le Sémaphore de Marseille* (*Corr.*, II, p. 352, n. 2).

26 Saturday 7 [1872–78]
<div align="right">4 RUE SAINT-PETERSBOURG</div>

My dear friend, I can't come to see you, being very busy at the moment. But please write whether you intend to be away, and when? I'd like to have you both to dinner with some other couples, and we must plan early if we are to get everybody together.

 Regards to your wife and yourself,

We're taking advantage of being masters of our house.[1]

Mon cher ami, je ne puis aller vous voir, étant très occupé pour le moment. Mais écrivez-moi donc si vous avez l'intention de vous absenter, et quand? Je voudrais vous avoir à dîner tous deux avec quelques ménages amis et il faut s'y prendre à l'avance pour avoir tout son monde.

 Amitié à votre femme et à vous.

Nous voulons profiter de ce que nous sommes maîtres de maison.[1]

1. Manet had a studio at 4, rue de Saint-Pétersbourg from 1872 to 1878 (see Chronology). In the postscript to this letter, he probably refers to some period when his mother was away; the Manets lived with her at no. 49 in the same street.

27 Paris, Wednesday [late July or August 1876]

My dear Zola, I learn at one and the same time that you had an accident that might well have been fatal, and that you all came out of it unharmed—happily.[1] You will be receiving a letter from Flor, who has been to ask me for an introduction to you. Too late, you had just left. He heads a very handsome publication.[2] Give him any information he may require. My regards to you and your wife, and remember me to your good friends the Charpentiers. I am beginning Mlle Isabelle's portrait on Friday.[3]

 Yours,

I have just read the last installment of L'Assommoir in La République des lettres—brilliant![4]

<div align="right">Paris, Mercredi</div>

Mon cher Zola, j'apprends en même temps qu'il vous est arrivé un accident qui aurait dû être fatal et que vous vous en êtes tiré tous le mieux possible—heureusement.[1] Vous allez recevoir une lettre de Flor qui est venu me demander de vous le présenter. Trop tard, vous veniez de partir. Il est à la tête d'une très belle publication.[2] Donnez-lui tous les renseignements qu'il vous demande. Mes amitiés pour vous et votre femme et rappelez-moi au souvenir de vos aimables compagnons Charpentier. Je commence vendredi le portrait de Mlle Isabelle.[3]

 A vous.

Je viens de lire le dernier numéro de l'Assommoir dans la République des lettres—épatant![4]

1. The accident happened to the Zolas and the Charpentiers on July 18 near Piriac, in Brittany, where the two families stayed from mid-July to September 6, 1876. Zola tells the story in a letter to Roux dated August 11 (*Corr.*, II, p. 478).
2. Charles Flor, known as Flor O'Squarr, who covered the Salon of 1880, favorably to Manet, for *Le National*. It is not known to what publication Manet here refers.
3. Isabelle Lemonnier (see cat. 190).
4. *L'Assommoir* appeared in installments in *Le Bien public* from April 30 to June 7, 1876, then in *La République des lettres* from July 9 to January 7, 1877.

28 Thursday [after 1876?]

My dear Zola,
This will introduce a friend of mine, M. de Marthold,[1] a great admirer of your talent—himself a writer, he seeks employment for his pen. Could you find a place for him somewhere, either as a correspondent out of town or in some other paid capacity on a newspaper? He would be personally much obliged to you.

 Regards,

Mon cher Zola,

Je vous adresse un des mes amis Mr. de Marthold[1] grand admirateur de votre talent—écrivain lui-même, il voudrait utiliser sa bonne plume. Pourriez-vous le caser quelque part soit pour faire une correspondance pour la province soit pour toute autre besogne rétribuée dans un journal? Il vous serait personnellement reconnaissant.

 Amitiés.

Jeudi

1. Possibly Jules de Marthold, who praised Manet's painting *Nana* (cat. 157). Jules de Marthold wrote a large number of works—comedies, dramas, popular history, etc.

29 Tuesday 31 [April 1877]
4 RUE SAINT-PETERSBOURG

My dear friend,

I know you've almost if not quite finished moving.[1] Would you like me to pick up your portrait[2] and have it cleaned? You would do well yourself to send the frame to Nivard's for repair.[3] Awaiting word from you,

 Regards,

Mardi 31
4 RUE SAINT-PETERSBOURG

Mon cher ami,

Je sais que vous avez opéré votre déménagement ou à peu près.[1] Voulez-vous que je passe prendre votre portrait[2] pour le faire nettoyer? Vous ferez bien de votre côté d'envoyer le cadre à restaurer chez Nivard.[3] En attendant un mot de vous,

 Amitiés.

1. Manet occupied the studio at 4, rue de Saint-Pétersbourg from 1872 to 1878 (see letter 26, n. 1). During that time, Zola moved on April 1, 1874, from 14, rue de la Condamine to 21, rue Saint-Georges, and on April 20, 1877, to 23, rue de Boulogne, where he remained until September 1889. This letter of "Tuesday 31" must therefore be dated in April 1877.
2. See cat. 106.
3. Nivard, maker and restorer of picture frames.

30 Tuesday, December 4 [1877][1]

My dear Zola, we shall remain at home on Thursday evening. I'd like to have a few friends in. So try to come next Thursday, we'd be so glad to see you. Nothing formal.

 Yours ever,

49, rue de Saint-Pétersbourg.

mardi 4 Décembre[1]

Mon cher Zola, nous allons rester chez nous le jeudi soir. J'aimerais avoir quelques amis. Tâchez donc de venir jeudi prochain, vous nous feriez grand plaisir. C'est sans cérémonies.

 Tout à vous.

49, rue de Saint-Pétersbourg.

1. December 4 fell on a Tuesday in 1866 and in 1877, and Manet lived at 49, rue de Saint-Pétersbourg from 1867 (see Chronology)—hence the dating of this letter as 1877.

31 August 21 [1878]

My dear Zola,

This letter will reach you through a friend of mine, M. Vielard [?], an architect and your neighbor in the country, who has done a lot of building around there, and whom I warmly recommend if you plan to build, as is rumored.[1]

 Regards to you and to Madame Zola,

21 Août

Mon cher Zola,

Cette lettre vous sera remise par un architecte de mes amis, M. Vielard [?], qui est votre voisin de campagne, a beaucoup bâti par là et que je vous recommande de toutes façons si vous avez l'intention de bâtir comme le bruit en court.[1]

 Amitiés à vous et à Madame Zola.

1. On May 28, 1878, Zola had bought a small house—a "rabbit hutch"—at Médan, for the sum of 9,000 francs. He had considerable additions made to it, beginning in the summer of 1878 and continuing for years. He purchased the adjacent land. Thenceforth, he spent a large portion of the year at Médan.

32 Monday [December 9, 1878][1]

My dear Zola,

For his publication,[2] Bergerat has asked me to do two drawings of a story of yours entitled Jean-Louis.[3] To do peasants, in Paris and in the winter, seems to me impossible. You wouldn't have something else with a Paris locale? That would be more suited to my resources and the season.

 Regards,

Lundi[1]

Mon cher Zola,

Bergerat m'a demandé de lui faire pour sa publication[2] deux dessins sur une nouvelle de vous intitulée Jean-Louis.[3] Faire des paysans, à Paris et l'hiver me semble impossible. Vous n'auriez pas plutôt un rien qui se passe à Paris? Ce serait plus dans mes moyens et de saison.

 Amitiés.

1. Zola replied to this letter on December 10, 1878 (*Corr.*, III, p. 245).
2. This was *La Vie moderne*, an illustrated weekly, whose first issue appeared April 10, 1879. The editor in chief was E. Bergerat, the publisher G. Charpentier. Bergerat had asked Zola for "something, . . . a page or two from your studies on the common people."
3. Manet here refers to part five of "Comment on meurt," the death of the peasant Jean-Louis Lacour. This selection never appeared in *La Vie moderne*.

33 January 15 [1879]

My dear friend, we'll go to Charpentier's together if you like.[1] There's no need to arrive before *11 o'clock*. Take a cab and come pick me up at half past 10, quarter to 11. Yours ever,

15 Janvier

Mon cher ami, nous irons ensemble si vous voulez chez Charpentier.[1] Il n'est pas nécessaire d'y arriver avant *11 h*. Prenez une voiture et venez me prendre à 10 h ½, 11 h. moins ¼. Tout à vous.

1. The publisher Charpentier, who wanted to reissue Zola's *Salons* and his pamphlet on Manet, asked Zola for this material on January 8, 1879 (*Trente Années d'amitié: Lettres de l'éditeur Charpentier à Emile Zola, 1872–1902*, Paris, 1980, pp. 46–47). Zola, who was staying at Médan, was to be in Paris by the 15th to attend the first night of *L'Assommoir* (see letter 34).

34 Thursday morning [after January 18, 1879]

My dear Zola,
Should the happy thought occur to you to come and see us this evening, please put it off to next Thursday. We have to go out. Congratulations on the success of L'Assommoir.[1]
Yours,

Jeudi matin

Mon cher Zola,
Si vous avez par hasard la bonne idée de venir nous voir ce soir, remettez cela à Jeudi prochain. Nous sommes obligés de nous absenter. Compliments sur le succès de l'Assommoir[1] et à vous.

1. The first night of L'Assommoir, adapted for the stage from Zola's novel by W. Busnach and Zola, took place on Friday, January 18, 1879. The play was a triumphant success. It ran continuously at the Ambigu until January 18, 1880—254 performances in 1879 alone—and was revived several times thereafter, notably beginning September 22, 1881. It played in Paris, in the provinces, and abroad.

35 Tuesday 8 [April? June? 1879?]

My dear Zola, I am delighted to be able to do something that may give you pleasure and am entirely at your command. Would you like the first sitting to be for *Monday next*, half past twelve at the latest? We can then make appointments for Madame and for you.[1]
Yours,

Mardi 8

Mon cher Zola, je suis enchanté de pouvoir faire quelque chose qui vous fasse plaisir et suis tout entier à votre disposition. Voulez-vous que la première séance soit pour *Lundi prochain*, midi ½ au plus tard? Nous prendrons alors les jours de Madame et les vôtres.[1]
Tout à vous.

1. This may refer to Manet's pastel portrait of Alexandrine Zola, executed in 1879 (cat. 183). If so, the letter would date from Tuesday, April 8 or June 8. The wording suggests that both the Zolas wished to be portrayed. No portrait of Zola by Manet is known other than the one of 1868 (cat. 106).

36 Monday [July 28, 1879]

My dear friend, your letter gives me the greatest pleasure,[1] and you won't, I hope, take it amiss if I ask to have it appear in *Le Figaro*.[2]
I must admit that I felt sadly disillusioned when I read the article, and that I was very distressed by it.
Regards,

Lundi

Mon cher ami, votre lettre me fait le plus grand plaisir[1] et vous ne trouverez, j'espère, pas mauvais que j'en demande l'insertion au *Figaro*.[2]
Je vous avoue que j'avais éprouvé une forte désillusion à la lecture de cet article et que j'en avais été très peiné.
Amitiés.

1. "I am stupefied to read the story in *Le Figaro*, stating that I have broken with you," Zola had written on July 27, "and this is to send you a firm clasp of the hand. The passage quoted was not correctly translated; besides, the meaning of the piece has been distorted. I spoke of you in Russia, as I have spoken in France these thirteen years, with profound regard for your talent and your self" (*Corr.*, III, pp. 355–56). As correspondent for the Russian

journal *The Messenger of Europe* (see Chronology), Zola had devoted part of his column for July 1879 to the fourth Impressionist exhibition, held in Paris at 28, avenue de l'Opéra from April 10 to May 11. He declared, in particular: "The Impressionists are . . . , in my view, pioneers. For a moment, they entertained high hopes of Monet; but he seems to have been exhausted by an overhasty output; he is satisfied with near misses." A French translation of the article was published in *La Revue politique et littéraire* on July 26; "Monet" was turned into "Manet," and this mistake was repeated by Alphonse Racot in *Le Figaro* of Monday the 28th, which appeared on Sunday the 27th. Hence Zola's letter and Manet's reply. Zola has often been taxed with refusing Monet, on July 23, 1889, his support for a collection taken up to purchase a painting by Manet for the Louvre (see Provenance, cat. 64). However, that refusal was based on a point of principle, not on any lack of admiration for the artist. In "L'Argent dans la littérature," an article published in *The Messenger of Europe* of March 1880 and reprinted shortly after by *Le Voltaire*, Zola had written: "Any talent of some importance must sooner or later be seen and recognized. The question lies there and nowhere else. Genius needs no midwife; it gives birth alone. Let me take an example from painting. Each year, at the Salon, that emporium of art wares, we see the works of pupils, students' exercises of the utmost insignificance, admitted by patronage and sufferance; no matter, the only great wrong in that is the waste of space. . . . The workman himself must impose his work upon the public. And if he lacks that power, he is nobody. He remains unknown by his own fault, and quite justly so" (*O.C.*, X, pp. 1281–82).
2. Adolphe Racot ran a correction in *Le Figaro* of July 30, publishing the closing lines of Zola's letter.

37 Letter to Mme Zola

Monday [before April 8, 1880]

Dear Madam,
Would you be kind enough to lend me your pastel, and allow me to show it with others at La Vie Moderne.[1] Forgive me for not making this request in person, but I am forbidden to climb stairs.[2]
My regards to Zola, and to you, Madam, my sincere compliments,

Lundi

Chère Madame,
Seriez-vous assez aimable pour me prêter votre pastel et m'autoriser à l'exposer avec d'autres à la Vie moderne.[1] Excusez-moi si je ne vais pas moi-même faire ma demande mais on me défend de monter les escaliers.[2]
Mes amitiés à Zola et à vous, Madame, mes meilleurs compliments.

1. The pastel portrait of Mme Zola (cat. 183). *La Vie moderne* was holding exhibitions on its premises. According to Robida (1958), Charpentier had founded the periodical on the initiative of his wife, "the better to introduce and sponsor artist friends." An exhibition of the "New Works of Edouard Manet" was held there April 8–30, 1880.
2. The artist was suffering the early effects of his malady. See subsequent letters.

38 Wednesday [before April 1880]

My dear Zola, please come and dine with Duranty and me *Friday*. We meet in my studio at 5 o'clock.[1]
Yours ever,

Mercredi

Mon cher Zola, venez donc dîner avec Duranty et moi *Vendredi*. Rendez-vous à mon atelier à 5 h.[1]
Tout à vous.

1. Manet, Duranty, and Champfleury appear in *Homage to Delacroix*, exhibited by Fantin-Latour at the Salon of 1864. It is not known exactly when the first two became associated. Duranty, who died April 9, 1880, must have joined the delegation of young painters who in 1861 came to congratulate Manet on his *Spanish Singer* (cat. 10).

39
<div align="right">Bellevue[1]
October 15 [1880]</div>

Thank you, my dear Zola, for sending your book.

But what an ordeal all this time! Your country vacation this year cannot count as a rest. Well, your shoulders are broad and your pen is swift.[2]

The Bellevue air has done me a world of good, and I shall take advantage of it for another two weeks. But, alas! naturalist painting is more in disfavor than ever.

My wife and I send you and Madame Zola our kindest regards.

<div align="right">Bellevue[1]
15 Octobre</div>

Merci, mon cher Zola, de l'envoi de votre livre.

Mais quel attrapage depuis quelque temps! Votre villégiature de cette année ne peut pas compter pour un repos. Enfin, vous avez bon dos et bonne plume.[2]

L'air de Bellevue m'a fait beaucoup de bien et je vais encore en profiter pendant quinze jours. Mais, hélas! la peinture naturaliste est plus en défaveur que jamais.

Ma femme et moi envoyons à vous et à Madame Zola nos meilleures amitiés.

1. We know that Manet stayed at Bellevue, near Meudon, where he was undergoing hydrotherapeutic treatment, in 1879 and 1880. It is not known what book he received from Zola, who published nothing in September or October of those years. The state of health to which Manet alludes and the date given place the letter in 1880.
2. For Zola, the year 1880 was marked by a big campaign in the newspapers, first *Le Voltaire,* for which he wrote until August 31, when he had a dramatic falling-out with Laffitte, its manager, and then *Le Figaro,* in which he published a weekly column beginning September 20. During the summer, he had collaborated on Busnach's stage adaptation of *Nana.*

40
<div align="right">Bellevue
20 October [1880]</div>

My dear Zola,
My mother and my wife join me in expressing our sympathy in your recent sad loss, and ask me to offer you our condolences.[1]

Regards,

<div align="right">Bellevue
20 Octobre</div>

Mon cher Zola,
Ma mère et ma femme se joignent à moi pour vous dire la part que nous prenons à la perte douloureuse que vous venez de faire et me chargent de vous l'exprimer.[1]

Amitiés.

1. Zola's mother had just died at Médan, on October 17.

41
<div align="right">November 21 [1880]</div>

My dear Zola, Burty has just brought me his book and would very much like you to have an excerpt put into the Supplement to Le Figaro. You could easily do it, I believe, and it would make our new novelist extremely happy.[1]

What an awakening this morning for Maître Floquet! He'll certainly have paid dear for his lecture at the Ambigu.[2]

Regards to Madame Zola and yourself,

77 rue d'Amsterdam.

<div align="right">21 Novembre</div>

Mon cher Zola, Burty vient de m'apporter son livre et désirerait beaucoup que vous lui en fassiez mettre un extrait dans le Supplément du Figaro. Cela vous serait facile, je crois, et comblerait de joie le nouveau romancier.[1]

Quel reveil ce matin pour maître Floquet! Décidément il aura payé cher sa conférence à l'Ambigu.[2]

Amitiés à Madame Zola et à vous.

77 rue d'Amsterdam.

1. Charpentier had just published, in November, Burty's *Une Grave Imprudence.* Zola had then been contributing to *Le Figaro* regularly since September 20. He replied to Manet on November 28, "I have no influence at *Le Figaro,* and I don't want any," but he suggested recommending Burty to Gille (*Corr.,* IV, November 28, 1880). No excerpt from Burty's novel seems to have appeared in the Supplement.
2. On November 28, 1879, the deputy Charles Floquet had given a lecture at the Théâtre de l'Ambigu on *"L'Assommoir* and the Paris Worker." He had violently attacked Zola, whom he called a "false republican" (*Corr.,* II, pp. 408–9). Zola was deeply offended. He took the opportunity afforded him in *Le Figaro* to settle accounts. In "Futur Ministre," an article that appeared November 21 and was dated Monday the 22nd, he drew a scathing portrait of his accuser, describing him as a "journalist without talent, a trial lawyer without eloquence or authority, . . . a deputy without grammar or consequence, this embodiment of smug mediocrity" (*O.C.,* XIV, pp. 471–75).

42
<div align="right">Wednesday [after January 29, 1881]</div>

My dear friend,
An artist couple, friends of mine, beg me to ask you for two good seats to see *Nana.* It would be very kind of you if you could give them that pleasure.[1]

Yours,

<div align="right">Mercredi</div>

Mon cher ami,
Un ménage d'artistes de mes amis me prie de vous demander deux bonnes places pour aller voir *Nana.* Vous seriez très aimable si vous pouviez leur procurer ce plaisir.[1]

A vous.

1. The premiere of *Nana,* a play in five acts and seven scenes, adapted by William Busnach from the novel with Zola's collaboration, was held at the Ambigu on January 29, 1881. The play ran until May 29, and was revived October 21 (*Corr.,* IV, January 1881). The "artist couple" were perhaps the engraver Henri Guérard and his wife Eva Gonzalès, a painter and a protegée of Manet's.

43
<div align="right">Monday morning [August–September, 1881]</div>

My dear Zola,
I eagerly awaited this morning's article,[1] and hope I am one of the first to congratulate you. You have been throughout this campaign the forthright, frank, and honorable man whom I have long held dear.

<div align="right">Lundi matin</div>

Mon cher Zola,
J'attendais avec impatience l'article de ce matin[1] et j'espère être un des premiers à vous féliciter. Vous avez été dans toute cette campagne l'homme crâne, franc, et honnête que j'aime depuis longtemps.

1. No doubt one of the thirty-nine articles that Zola published in *Le Figaro* on Mondays between September 20, 1880, and September 22 (a Thursday), 1881, and that he collected soon after under the title *Une Campagne.* The articles were "not the exposition of a political doctrine but an outburst of anger and

Fig. 2. Letter 43

impatience from a man who loves the Republic with jealous affection and who cannot bear to see her on the auction block of careerism. . . . Indeed, Zola professes not so much a political as a moral creed" (H. Mitterand, *O.C.*, XIV, p. 430). Manet, the liberal and republican, equally disappointed in Gambetta's policies, must have followed his friend's campaign with close attention. This letter, written on the morning of publication, seems to refer to one of the last articles—which were also the most critical of Gambetta—in the series.

44 Saturday [April–May 1882]

My dear friend, I've just finished Pot-bouille.[1] Astonishing. I don't know but that it's the finest of them all.
 Regards,

Samedi

Mon cher ami, je viens de finir Pot-bouille.[1] C'est étonnant. Je ne sais pas si ce n'est pas le plus fort de tous.
 Amitiés.

1. *Pot-Bouille* (the tenth novel in the Rougon-Macquart series of twenty) was published by Charpentier on April 12, 1882.

45 [not dated]

Impossible to do anything worthwhile on the fan you sent me.[1] It's at once too beautiful and very ugly. I should have liked a fan of unpainted wood—a one-franc one, with a white paper leaf. I'd have painted the handle and the leaf. I searched the neighborhood all morning, nothing. Would your dealer have anything like that? Send for one if possible. I need two hours to do it.

Impossible de rien faire de bien sur l'éventail que vous m'envoyez.[1] Il est en même temps trop beau et très laid. J'aurais voulu un éventail en bois blanc—de 1 fr et feuille de papier blanche. J'aurais peint manche et feuille. J'ai cherché tout ce matin dans le quartier, rien. Y en a-t-il comme je vous l'indique chez votre fournisseur? envoyez chercher un si c'est possible. Il me faut 2 heures pour le faire.

1. The opening of this letter seems to be missing. Nothing is known about the fan in question.

46 Thursday [date unknown]

My dear friend, would you be good enough to let me know whether you accept for *Tuesday.* I'd like to invite a young couple and there is only just time enough.
 Yours,

Jeudi

Mon cher ami, seriez-vous assez aimable pour me dire si vous acceptez pour *Mardi.* Je voudrais inviter un jeune ménage et il ne me reste que le temps.
 A vous.

47 Thursday [date unknown]

My dear friend,
I meant to come and see you but I can't get farther than the studio. I gave myself a torn ligament when we were moving,[1] and I can't walk much.
 Come to see me. I'll be at home until 5 o'clock.
 Regards,

Jeudi

Mon cher ami,
Je voulais aller vous voir mais je ne puis dépasser l'atelier. Je me suis donné en déménageant[1] ce qu'on appelle un coup de fouet et ne puis beaucoup marcher.
 Venez me voir. Je suis jusqu'à 5 h. chez moi.
 Amitiés.

1. June–July 1878, or March–April 1879? (See Chronology.)

48 Saturday [date unknown]

My dear Zola, don't come Sunday. I haven't finished and must shut myself in, but if you have a moment on Monday, at the end of the day, it would be a pleasure to see you.
 Regards,

If Mme Zola cares to come with you, we'll have the benefit of her opinion.

Samedi

Mon cher Zola, ne venez pas dimanche. Je n'ai pas fini et suis obligé de m'enfermer, mais si vous avez un moment Lundi, à la fin de la journée, vous me ferez plaisir.
 Amitiés.

Si Mme Zola veut bien vous accompagner, son opinion ne sera pas de trop.

49 [not dated]

My dear friend, my compliments on yesterday's theater article.[1] I thought it was very good. I hasten to tell you this, for *between the two of us* I know that the first was not well received. If it's done in the same spirit, all the worse for [G.G.?]

 Regards,

Mon cher ami, mes compliments pour l'article du théâtre d'hier.[1] Je le trouve très bien fait. Je m'empresse de vous le dire car je sais *entre nous* que le premier n'avait pas plu. S'il est fait dans le même esprit, tant pis pour [G.G.?]

 Amitiés.

1. Zola wrote a great many columns on the theater, for various papers: *L'Avenir national* (twenty-one "Causeries dramatiques" from February 25 to June 10, 1873), *Le Bien public* ("Revue dramatique," later "Revue dramatique et littéraire," weekly from April 10, 1876, to June 24, 1878), *Le Voltaire* ("Revue dramatique et littéraire" from July 9, 1878, to August 31, 1880), etc.

50 Tuesday [1872–82]

My dear Zola, we're not going to the Charpentiers' Friday evening as I told you.[1] My wife has another call to make during the day, so we shall not go [until] the evening of Friday week. I looked for you yesterday at the Théâtre Français— but no Zola. What's the mystery? On the other hand, I did meet Léonide Leblanc,[2] who was all cordiality and told me she had inquired for your address and mine in order to call on us—(I found her most agreeable) and I said we should be delighted. I am counting on Madame Zola's kindness to pardon me for committing you thus far.

 Yours ever,

 Mardi

Mon cher Zola, nous n'irons pas vendredi soir comme je vous l'avais dit chez les Charpentier.[1] Ma femme ira faire d'abord une visite dans la journée et nous n'irons alors [que] le soir de vendredi en huit. Je vous ai cherché hier au théâtre français—mais point de Zola, quel est donc ce mystère? En revanche, j'ai rencontré Léonide Leblanc[2] qui m'a fait force amabilités et qui m'a dit qu'elle s'était enquis de votre adresse et de la mienne pour venir nous faire une visite—(je l'ai trouvé bien bonne) et je lui ai dit que cela nous ferait grand plaisir. Je compte sur l'amitié de Madame Zola pour me pardonner de vous avoir ainsi compromis.

 Tout à vous.

1. The Charpentiers received on Fridays. Their salon was much frequented by writers, artists, and politicians. On July 22, 1872, Zola signed an agreement with Charpentier, who thenceforth published all his works and became, as he himself put it, "the naturalist's publisher."

2. A celebrated actress who appeared in many theaters (Variétés, Vaudeville, Odéon), and who was a leading member of the demimonde.

51 Letter from Eugène Manet to Zola

 May 7 [18]83[1]

My dear Zola,
I called at the rue de Boulogne[2] with my wife to convey thanks from my sister-in-law and our entire family for your kind support in the funeral ceremonies on Thursday.[3]

 Please express our appreciation to Madame Zola for the touching tribute she rendered with you to the memory of our poor friend.

 Faithfully yours,

J. Ferry, at Proust's request, has offered the Ecole des Beaux-Arts for an exhibition of Edouard's works.[4] This exhibition cannot take place until the month of October, as the rooms will only be available June 15. I beg you to serve on the arrangements committee together with Proust, my brother Gustave, L. Leenhoff, Duret, the abbé Hurel, and at the same time ask if you would write a short biographical note to appear at the front of the catalogue.[5]

 7 Mai 83[1]

Mon cher Zola,
J'étais allé avec ma femme vous porter rue de Boulogne[2] les remerciements de ma belle-soeur et de toute notre famille pour le concours dévoué que vous nous avez donné dans la cérémonie funèbre de jeudi.[3]

 Exprimez à Madame Zola notre reconnaissance pour l'hommage touchant qu'elle a rendu avec vous à la mémoire de notre pauvre ami.

 Votre tout dévoué.

J. Ferry sur la demande de Proust a donné l'école des Beaux-Arts pour faire une exposition des oeuvres d'Edouard.[4] Cette exposition ne peut avoir lieu qu'au mois d'octobre, les salles n'étant libres que le 15 juin. Je vous prie de faire partie du comité d'organisation avec Proust, mon frère Gustave, L. Leenhoff, Duret, l'abbé Hurel, et vous demande en même temps de vous charger d'une petite notice biographique qui sera placée en tête du catalogue.[5]

1. This letter was written by Manet's younger brother Eugène.
2. The Zola residence, 23, rue de Boulogne.
3. Edouard Manet's funeral on May 3.
4. Jules Ferry was then minister of public instruction and fine arts. The exhibition to be organized was held January 5–28, 1884, prior to the sale at auction that took place in accordance with the artist's will. The director of the Ecole des Beaux-Arts, Kaempfen, having refused to provide facilities, Manet's old friend Antonin Proust, a former minister of fine arts, interceded with Jules Ferry.
5. Zola wrote the biographical note (*O.C.*, XII, pp. 1037–43).

Documents Relating to the "Maximilian Affair"

Edited by Juliet Wilson Bareau

All the known documents relating to the "Maximilian affair" are presented here. Between the summer of 1867 and the winter of 1868–69, Manet devoted much time and energy—not to mention emotion and personal commitment—to the painting of three very large canvases (see cat. 104) and the preparation of an impressive lithograph (cat. 105) representing the execution of the emperor and his two Mexican generals.

In January 1869, Manet received an unofficial letter from "the authorities"; the letter is not known but must have come from a Ministry of the Interior department responsible for censorship matters, specifically the censorship of prints and printed books registered with the Dépôt Légal. The letter intimated that Manet's painting would be refused at the upcoming Salon and that the printing or publication of his lithograph would be forbidden.

It was the ban on the printing of his lithograph that most disturbed the artist, as well as his journalist and art-critic friends. Thanks to Colette Becker, who presents Manet's letters to Zola in Appendix I, two new documents can now be added to the group already published: a report in the January 31 issue of *La Tribune* (undoubtedly inserted as a result of Manet's letter to Zola) was followed four days later by a long commentary by Zola. These documents establish much more clearly than any hitherto published the political, anti-establishment implications of the affair and the response of the government. This clarification sheds light on Manet's involvement with his three paintings and also on his analogous aims, later on, in transforming the execution of Maximilian into the drawing and lithograph of a summary execution during the repression of the Commune (see cat. 124, 125)—a subject that he apparently also envisaged as a large painting.

1 January 1869

Undated letter from Manet to Zola.

My dear Zola, have a look at the enclosed letter and return it to me in an envelope along with your opinion.

It seems to me that the authorities are bent on making me take action over my lithograph, which had been causing me considerable worry. I thought they could stop the publication but not the printing. Anyway, it speaks well for the work, since there's no caption of any kind underneath it. I was waiting for a publisher to have the stone inscribed—Death of Max., etc.

I feel that a word about this ridiculously high-handed little act would not be out of place. What do you think?

Yours ever,

Mon cher Zola, lisez un peu la lettre ci-incluse et renvoyez-moi la sous pli avec votre avis.

Il me semble que l'administration veut me faire tirer parti de ma lithographie dont j'étais fort embarrassé. Je croyais qu'on pouvait empêcher la publication mais non l'impression. C'est du reste une bonne note pour l'oeuvre car il n'y a en dessous aucune légende. J'attendais un éditeur pour faire écrire sur la pierre—mort de Max. etc.

Je crois que dire un mot de ce petit acte d'arbitraire ridicule ne serait pas mal. Qu'en pensez-vous?

Tout à vous.

See Appendix I, letter 12.

2 January 31, 1869 (Sunday)

Unsigned report under the heading "Faits divers" ("News in Brief"), in *La Tribune* (a newspaper to which Zola was a regular contributor), Sunday, January 31, 1869, no. 34.

M. Manet has just been refused permission to print a lithograph representing the execution of Maximilian. M. Manet having treated this subject from a purely artistic point of view, it is to be supposed that before long the government will be led to pursue people who simply dare to maintain that Maximilian was shot.

On vient de refuser à M. Manet l'autorisation de faire imprimer une lithographie représentant l'exécution de Maximilien. M. Manet ayant traité ce sujet à un point de vue exclusivement artistique, il est à penser qu'avant longtemps le gouvernement en arrivera à poursuivre les gens qui oseront seulement prétendre que Maximilien a été fusillé.

Text kindly communicated by Colette Becker.

3 February 4, 1869 (Thursday)

Remarks by Zola under the heading "Coups d'épingle" ("Pinpricks"), in *La Tribune*, Thursday, February 4, 1869, no. 35.

I read, in the most recent issue of *La Tribune,* that M. Manet has just been refused permission to print a lithograph representing the execution of Maximilian.

This is the sort of measure that can save a government. Is its authority in such a bad way then that those who serve it feel bound to spare it the slightest annoyance?

The censors no doubt thought, "If we allow Maximilian to be shot in public, his shade will go wandering, with ominous cries, in the corridors of the Tuileries. There's a ghost that it is our duty to put behind bars."

I know exactly what kind of lithograph these gentlemen would be delighted to authorize, and if M. Manet wants to have a real success in their eyes, I advise him to depict Maximilian alive and well, with his happy, smiling wife at his side. Moreover, the artist would have to make it clear that Mexico has never suffered a bloodbath and that it is living and will long continue to live under the blessed rule of Napoleon III's protégé. Historic truth, thus interpreted, will bring tears of joy to the censor's eyes.

The fact is, I could not at first understand the censor's severity toward M. Manet's work. I remembered having seen, in all the newspaper vendors' windows, a penny print that came, I believe, from the Epinal workshops, which represented with terrifying naïveté the last moments of Maximilian. Why should an accomplished artist be refused what an industrial artisan was permitted? I believe today that I have found the key to the enigma, and it is truly a gem.

On examining a proof of the condemned lithograph, I noticed that the soldiers shooting Maximilian were wearing a uniform almost identical to that of our own troops. Fanciful artists give the Mexicans costumes from comic opera. M. Manet, who truly loves truth, has drawn their real costumes, which closely resemble those of the Vincennes infantrymen.

You can understand the horror and anger of the gentlemen censors. What now! An artist dared to put before their eyes such a cruel irony: France shooting Maximilian!

In M. Manet's place, I would regret not having intended to add a biting epigram, an intention with which the censor no doubt credited him.

J'ai lu, dans le dernier numéro de *La Tribune,* qu'on venait de refuser à M. Manet l'autorisation de faire tirer une lithographie représentant l'exécution de Maximilien.

C'est là une de ces mesures qui sauvent un gouvernement. Le pouvoir est donc bien malade que ses serviteurs croient devoir lui éviter les plus légères contrariétés?

Les censeurs ont sans doute pensé: "Si nous laissons fusiller Maximilien en public, son ombre ira rôder, avec des plaintes sinistres, dans les corridors des Tuileries. Voilà un fantôme que notre devoir est de mettre au violon."

Je sais bien quelle lithographie ces messieurs seraient enchantés d'autoriser, et je conseille à M. Manet, s'il veut avoir auprès d'eux un véritable succès, de représenter Maximilien, plein de vie, ayant à son côté sa femme, heureuse et souriante: il faudrait en outre que l'artiste fît comprendre que jamais le Mexique n'a été ensanglanté, et qu'il vit et vivra longtemps sous le règne béni du protégé de Napoléon III. La vérité historique, ainsi entendue, ferait verser à la censure des larmes de joie.

Au fond, je ne m'expliquais pas d'abord les rigueurs de la censure pour l'oeuvre de M. Manet. Je me souvenais d'avoir vu, à toutes les vitrines des papetiers, une image d'un sou, sortie, je crois, des ateliers d'Epinal, qui représentait les derniers moments de Maximilien, avec une naïveté terrible. Pourquoi interdire à un artiste de talent ce que l'on avait permis à un industriel? Je crois avoir trouvé aujourd'hui le mot de l'énigme, et ce mot est une véritable perle.

En examinant une épreuve de la lithographie incriminée, j'ai remarqué que les soldats fusillant Maximilien portaient un uniforme presque identique à celui de nos troupes. Les artistes fantaisistes donnent aux Mexicains des costumes d'opéra-comique; M. Manet, qui aime d'amour la vérité, a dessiné les costumes vrais, qui rappellent beaucoup ceux des chasseurs de Vincennes.

Vous comprenez l'effroi et le courroux de messieurs les censeurs. Eh quoi! un artiste osait leur mettre sous les yeux une ironie si cruelle, la France fusillant Maximilien!

A la place de M. Manet, je regretterais de n'avoir pas eu l'intention de l'épigramme sanglante, que la censure a dû lui prêter.

Zola 1966–69, XIII, p. 222 (passage kindly brought to my attention by Colette Becker).

4 Early February? 1869

Undated letter from Manet to Théodore Duret.

My dear Duret, I am sending you the little note you asked me for. E.M.

We understand that M. Manet has been refused permission to print a lithograph that he has just made representing [the mas(sacre)—*struck out*] the execution of Maximilian; we are astonished at this act by the authorities of banning a purely artistic work.

Mon cher Duret, je vous envoie la petite note que vous m'avez demander [*sic*]. E.M.

Nous apprenons qu'on a refusé à Mr Manet l'autorisation de faire imprimer une lithographie qu'il vient de faire représentant [le mas(sacre)— *struck out*] l'exécution de Maximilien, nous nous étonnons de cet acte de l'autorité, frappant d'interdit une oeuvre absolument artistique.

Paris, Musée du Louvre, Cabinet des Dessins. Autographs.

5 February 7, 1869 (Sunday)

Report in *La Chronique des arts et de la curiosité.*

M. Edouard Manet has painted the tragic episode that brought to an end our intervention in Mexico, the "Death of Maximilian." It appears that this lamentable event has still not become accepted history, since M. Edouard Manet has been unofficially informed that his picture, which is in fact excellent, would have every likelihood of being rejected at the next Salon, if he insisted on presenting it. This is strange, but what is even more peculiar is that after M. Edouard Manet executed on a lithographic stone a sketch of this picture and the Dépôt [Légal] was made by the printer Lemercier, an order was immediately given that this composition should not be put on sale, even though it has no title.

M. Edouard Manet a peint le tragique épisode qui a clos notre intervention au Mexique, la "Mort de Maximilien." Il paraît que ce fait lamentable n'est point encore acquis à l'histoire, car on aurait fait officieusement savoir à M. Edouard Manet que son tableau, excellent d'ailleurs, avait toutes les chances de ne point être admis au prochain Salon, s'il insistait pour l'y présenter. Ceci est singulier, mais ce qui l'est plus encore, c'est que M. Edouard Manet ayant exécuté sur une pierre lithographique un croquis de ce tableau, lorsque le dépôt fut fait par l'imprimeur Lemercier, ordre fut immédiatement donné de ne point laisser mettre en vente cette composition, quoiqu'elle ne porte point de titre.

Published by Griffiths 1977, p. 777.

6 February 17, 1869 (Wednesday)

Manet sends a process server with a legal injunction to Lemercier, who had refused to return the stone (see document 7).

7 February 18, 1869 (Thursday)

Letter from Manet to Burty.

My dear Burty, My Maximilian affair is becoming more complicated. The printer is now refusing to return the stone to me and is asking me for permission to efface it. I have of course refused, and also refuse, naturally, to take any steps, as he advises me, to have the ban lifted, and yesterday I sent him an injunction through a process server. There the matter rests. But it seems to me of some interest to know how it will turn out. One cannot destroy a block, stone, etc., without a court order, it seems to me, and there must at least be a publication to constitute an offense.

I am sending you these fresh details in case you should feel it appropriate to mention them.

It is the kind of question that is important to settle in the interest of all artists, in case the same situation occurs.

Mon cher Burty, Mon affaire Maximilien se complique. L'imprimeur refuse maintenant de me rendre la pierre et me demande l'autorisation de l'effacer. Je refuse bien entendu aussi bien sûr de faire aucune démarche comme il me le conseille pour faire lever l'interdiction et je lui ai envoyé hier sommation par huissier. L'affaire en est là. Mais il me semble assez intéressant de savoir comment cela peut tourner. On ne peut détruire un cliché, pierre, etc. sans un jugement, il me semble, et il faut tout au moins la publication qui constitue le délit.

Je vous envoie ces nouveaux détails au cas où il vous semblerai[t] opportun d'en parler.

C'est de ces questions importantes à vider dans l'intérêt de tous les artistes, le même cas échéant.

Paris, Musée du Louvre, Cabinet des Dessins. Autographs.
Facsimile in *La Vie moderne,* May 12, 1883; published by Guérin 1944, no. 73.

8 February 20 or 27, 1869 (Saturday)

Letter from Manet to Lemercier asking that the stone be ready for collection on "Monday" (February 22 or 29).

Saturday

Sir, Would you please have my stone ready by *Monday.* I shall send someone to collect it.

You are surprised at the way I have behaved toward you; you have no doubt forgotten that you refused to deliver my stone to me. I do not believe it was the fear of not being paid that led you to behave in this way, as you seem to imply in your last letter. Anyway, whatever the reason, you are charging me 35 Frs 50 for a stone worth 29 Frs. Would you please look into this.

I have had three trial proofs. I had asked for four but understand that one was given to a M[onsieur] R. I trust that you will not charge me for it.

Samedi

Monsieur Je vous prie de tenir ma pierre prête pour *Lundi.* Je l'enverrai chercher.

Vous vous étonnez de la manière dont j'ai agi vis à vis de vous; vous oubliez sans doute que vous aviez refusé de me livrer la pierre. Je ne pense pas que se soit la crainte de ne pas être payé qui vous ai fait agir ainsi, comme vous semblez vouloir le faire comprendre dans votre dernière lettre. Enfin, que ce soit pour un motif ou un autre, vous me demandez 35 frs 50 pour une pierre qui est du prix de 29 frs. Je vous prierais d'y voir.

J'ai eu trois épreuves d'essai. J'en avais demandé 4 mais appris qu'on en avait donné une à un Mr R. J'espère que vous ne me la compterez pas.

Paris, Musée du Louvre, Cabinet des Dessins. Autographs.
Published by Moreau-Nélaton 1906, intr.; Guérin 1944, p. 18.

9 February 21, 1869 (Sunday)

La Chronique des arts publishes, with minor variations, Manet's letter to Burty of February 18, with an editorial comment by Galichon relating to the "legal rights of the prefect of police."

AN IMPORTANT QUESTION OF LAW
We have received the following letter:

Sir, "the Maximilian affair," which you have been good enough to bring to the attention of the readers of *La Chronique,* is becoming more complicated.

The printer Lemercier is now refusing to return the lithographic stone to me and is asking me for permission to efface it.

I have of course refused, and also refuse to take any steps, as he advises me, to have the ban lifted. And yesterday I sent him an injunction through a process server.

There the matter rests. But it seems to me of some interest to know how it will turn out. One cannot destroy a block, stone, etc., without a court order, it seems to me, and there must at least be a publication to constitute an offense.

I am sending you these details in case you should feel it appropriate to mention this matter again. It is the kind of question that is of the greatest importance to settle in the interest of all artists.

Ed. MANET.

The question raised in relation to the seizure of a drawing on lithographic stone is of quite exceptional gravity, and we must be very grateful to M. Manet for the firmness he is showing in this affair. It is important for everyone to know what are the legal rights of the prefect of police over the ideas of an author or an artist.

Emile Galichon

UNE IMPORTANTE QUESTION DE DROIT
Nous recevons la lettre suivante:

Monsieur, "l'affaire Maximilien" dont vous avez bien voulu entretenir les lecteurs de la "Chronique" se complique.

L'imprimeur Lemercier refuse maintenant de me rendre la pierre lithographiée et me demande l'autorisation de l'effacer.

Je refuse, bien entendu, aussi bien que de faire aucune démarche, ainsi qu'il me le conseille, pour faire lever l'interdiction. Et je lui ai envoyé hier sommation par huissier.

L'affaire en est là. Mais il me semble assez intéressant de savoir comment cela peut tourner. On ne peut détruire un cliché, pierre, etc., sans un jugement, me semble-t-il, et il faut tout au moins la publication qui constitue le délit.

Je vous envoie ces détails au cas où il vous semblerait opportun de parler de nouveau de cette affaire. C'est une de ces questions les plus importantes à vider dans l'intérêt de tous les artistes.

Ed. MANET.

La question soulevée à propos de la saisie d'un dessin sur pierre lithographique est d'une gravité tout exceptionnelle et nous devons savoir le plus grand gré à M. Manet de la fermeté qu'il met dans cette affaire. Il importe à tous de connaître quels sont les droits de la préfecture de police sur la pensée d'un auteur ou d'un artiste.

Emile Galichon

Published by Griffiths 1977, p. 777.

10 February 22 or 29, 1869 (Monday)

The stone is collected from Lemercier.

11 February 28, 1869 (Sunday)

La Chronique des arts informs its readers that Lemercier has advised Manet that the stone is at his disposal.

We learn with pleasure that M. Manet's complaints have met with success. The printer Lemercier has advised him that his lithographic stone, representing "The Execution of the Emperor Maximilian" or, if one prefers to remain vague, a "Shooting in Mexico," is at his disposal.

Nous apprenons avec plaisir que les réclamations de M. Manet ont été suivies de succès. L'imprimeur Lemercier lui a donné avis que sa pierre lithographique, représentant "L'Exécution de l'empereur Maximilien" ou, si l'on préfère rester dans le vague, une "Fusillade au Mexique", était tenue à sa disposition.

Published by Griffiths 1977, p. 777.

Editions of the Prints

The list includes all the editions made during the artist's lifetime and the posthumous printing of the lithographs in 1884. (For a complete list of the posthumous editions, see Harris 1970, pp. 18–19, and Wilson 1977, pp. 137–38.) Prints not included in the exhibition are identified by Harris catalogue number. A date followed by [DL] is that of the Dépôt Légal registration.

1862
8 Gravures à l'eau-forte par Edouard Manet. Album of nine etchings on eight sheets, Cadart, Paris, announced September (H 16, 19; cat. 7, 9, 11, 25, 35–37).

Sept. 1
The Gypsies. Etching in *Eaux-fortes modernes,* Société des Aquafortistes, 1st year, 1st issue, Cadart, Paris, pl. 4 (cat. 48).

1862–63?
Boy with a Sword, turned left III. Presumed small edition, Cadart, Paris (cat. 18).

1863 Mar. 7 [DL]
Lola de Valence. Lithographic cover for sheet music, printed by Lemercier for Astruc, Paris (cat. 53).

Oct. 1
Lola de Valence. Etching in *Eaux-fortes modernes,* Société des Aquafortistes, 2nd year, 2nd issue, Cadart, Paris, pl. 67 (cat. 52).

Eaux-fortes par Edouard Manet. Presumed small edition of fourteen etchings in an illustrated cover, printed for the artist (H 8, 16, 19, 34; cat. 7, 9, 11, 18, 25, 35–37, 47 cover, 48, 52).

1866 Sept. 15 [DL]
Moorish Lament. Lithographic cover for sheet music, printed by Lemercier for Bosch, Paris (cat. 95).

1867 May
Olympia. Etching for Emile Zola, *Ed. Manet,* Dentu, Paris (cat. 69).

July
The Spanish Singer or *Guitarrero.* Separate etching inserted in *L'Artiste,* July 1867 (cat. 11).

1868 Oct. 17 [DL]
Cats' Rendezvous. Poster for Champfleury, *Les Chats,* J. Rothschild, Paris (cat. 114).

1869
Baudelaire with a Hat and *Baudelaire.* Two etchings for Charles Asselineau, *Charles Baudelaire, sa vie et son oeuvre,* Lemerre, Paris (cat. 55, 58).

1870
Cat and Flowers. Lithograph for Champfleury, *Les Chats,* 2nd, deluxe edition, J. Rothschild, Paris (cat. 117).

1872
The Gypsies. Etching in *Cent Eaux-fortes par cent artistes,* Cadart, Paris (cat. 48).

1874
Edouard Manet. Eaux-fortes. Album of nine etchings, Cadart, Paris (H 14, 55; cat. 7, 11, 25, 37, 47 cover and 1st plate, 48, 52).

Feb. 15
La Parisienne—Nina de Callias (H 78). Wood engraving by Prunaire from a drawing by Manet in *La Revue du monde nouveau* 1 (February 15, 1874).

Feb. 20 [DL]
Boy with Dog and *Civil War* (H 72). Two lithographs printed by Lemercier for the artist(?) (cat. 8, cat. 125, fig. a).

Feb.?
At the Café (Interior of the Café Guerbois?). Transfer lithograph published in an unidentified periodical (cat. 168).

June 16 [DL]
Polichinelle (H 80). Chromolithograph printed by Lemercier for the artist(?).

Dec.
Le Fleuve (H 79). Eight etchings for Charles Cros, *Le Fleuve,* Librairie de l'Eau-forte, Paris.

1875 May 20
The Raven. Poster, cover and slipcase, ex libris, and four transfer lithograph illustrations for Edgar Allan Poe, *Le Corbeau. The Raven,* translated by Stéphane Mallarmé, Lesclide, Paris (cat. 151).

1876 Apr.
L'Après-midi d'un faune (H 84). Four woodcut illustrations for *L'Après-midi d'un faune. Eglogue par Stéphane Mallarmé,* Derenne, Paris.

1877 Apr. 21 [DL]
Au Paradis (H 86). Transfer lithograph printed by Lefman for *Revue de la semaine,* 1st ser., 2nd year [no. 13] (April 29, 1877?). See Wilson 1978, no. 86.

1884 Mar. 26 [DL]
The Execution of Maximilian; The Races; Portrait of Berthe Morisot (H 74); *Portrait of Berthe Morisot* (H 75); *The Barricade*(?). Five lithographs (of which four were registered with the Dépôt Légal) printed by Lemercier for Suzanne Manet (cat. 101, 105, 125, and see cat. 130, fig. a). For a full description of the edition, see cat. 105.

List of Exhibitions

The list includes exhibitions cited in the catalogue. Numbers corresponding to individual works appear in parentheses following the exhibition titles. See also exhibitions cited in the Chronology.

The posthumous exhibitions listed are those devoted exclusively to Manet or with major representations of his work. For a more comprehensive listing, see Rouart and Wildenstein 1975, II, pp. 241–48.

Authors of recent exhibition catalogues are cited in brackets following the title.

1861	May 1	Paris	Palais des Champs-Elysées	Salon (3, 10)
	September 18	Saint Petersburg	Imperial Academy of Art	Annual exhibition (19)
1862	April	Paris	Cadart, 66, rue de Richelieu	(prints in Cadart's window)
1863	March 1	Paris	Galerie Martinet, 26, boulevard des Italiens	(14 works by Manet: 5, 6, 14, 29, 32, 38, 48, 50)
	May 15	Paris	Salon annexe, Palais des Champs-Elysées	Salon des Refusés (33, 36, 37, 52, 62, 72)
	August	Brussels		Exposition des Beaux-Arts (14)
1864	February 4	Paris	Galerie Martinet, 26, boulevard des Italiens	Première exposition inédite de la Société Nationale des Beaux-Arts
	May 1	Paris	Palais des Champs-Elysées	Salon (73, 74)
	July	Paris	Cadart, 79, rue de Richelieu	(painting in Cadart's window: 83)
1865	February 19	Paris	Galerie Martinet, 26, boulevard des Italiens	Société Nationale des Beaux-Arts (two paintings from among 27, 73, 77, 80, 81, 84, 86)
	spring	Paris	Cadart, 79, rue de Richelieu	(several paintings: 77, 80, 81)
	May	Paris	Palais des Champs-Elysées	Salon (64, 87)
1866	May–June	Bordeaux		Société des Amis des Arts de Bordeaux (97?)
1867	May 22	Paris	Avenue de l'Alma	Tableaux de M. Edouard Manet (3, 5, 6, 10, 12, 14, 19, 29, 32, 33, 37, 38, 48, 50, 62, 64, 72–74, 77, 80–84, 86, 87, 89, 90, 92–94, 96)
1868	May 1	Paris	Palais des Champs-Elysées	Salon (96, 106)
	July 15–31	Le Havre		Exposition Maritime Internationale du Havre (73)
	December 1	Marseilles		Société des Artistes des Bouches-du-Rhône (10, 14)
1869	May	Paris	Palais des Champs-Elysées	Salon (37, 58, 109, 115)
	July 29	Brussels		Salon des Beaux-Arts (109, 115, 118)
1870	February 18	Paris	18, place Vendôme	Cercle de l'Union Artistique (75, 90)
	May	Paris	Palais des Champs-Elysées	Salon
1872	spring	London	Durand-Ruel	Society of French Artists, 3rd Exhibition (6, 77, 90, 93, 118)
	May 1	Paris	Palais des Champs-Elysées	Salon (83)
	August 15–October 15	Brussels		Salon des Beaux-Arts (6)
	summer	London	Durand-Ruel	Society of French Artists, 4th Exhibition (10, 74)
	winter	London	Durand-Ruel	Society of French Artists, 5th Exhibition (96)

1873	May 5	Paris	Palais des Champs-Elysées	Salon (121)
	summer	London	Durand-Ruel	Society of French Artists, 6th Exhibition (115?)
1874	spring	London	Durand-Ruel	Society of French Artists, 8th Exhibition (72?)
	May	Paris	Palais des Champs-Elysées	Salon (133)
1875	May 1	Paris	Palais des Champs-Elysées	Salon (139)
1876	April 15–May 1	Paris	Manet's studio, 4, rue de Saint-Pétersbourg	(paintings rejected by the Salon, and other works: 99?, 140, 146)
1877	May 1	Paris	Boutique Giroux, boulevard des Capucines	(painting in Giroux's window: 157)
1878	October	Paris	Galerie Toul	(painting for sale: 141)
1879	May 12	Paris	Palais des Champs-Elysées	Salon (140, 180)
1879–80	December 1879–January 1880	New York	Clarendon Hotel, 757 Broadway	*The Execution of Maximilian* (see 104)
		Boston	Studio Building Gallery, Ipswich Street	Idem
1880	April 8–30	Paris	La Vie Moderne, 7, boulevard des Italiens	Nouvelles Oeuvres d'Edouard Manet (97, 156, 165, 169, 172, 176, 183)
	May 1	Paris	Palais des Champs-Elysées	Salon (187)
	October–November	Marseilles		(a painting)
1881	May 2	Paris	Palais des Champs-Elysées	Salon (206, 208)
1882	May 1	Paris	Palais des Champs-Elysées	Salon (211)
1883	February–March	Lyons	Palais des Beaux-Arts	Salon des Beaux-Arts (172)
	April 25	Paris	Ecole Nationale des Beaux-Arts	Portraits du Siècle (3, 106)
	September	Boston		American Exhibition of Foreign Products, Arts and Manufactures (74)
	December 3	New York	National Academy of Design	Pedestal Fund Art Loan Exhibition (14, 96)
1884	January 6–28	Paris	Ecole Nationale des Beaux-Arts	Exposition des Oeuvres d'Edouard Manet (3, 6–8, 10, 11, 17–19, 24, 25, 29, 32, 33, 35–38, 48, 50, 52, 62, 64, 67, 72, 73, 76, 78–81, 83, 85, 90–93, 96?, 97, 99, 101, 102, 106–9, 114, 115, 118, 119, 121, 122, 124, 125, 129, 132, 133, 135, 137–40, 146, 148, 149, 153, 163, 165, 172, 174, 176, 180, 182, 183, 187, 206, 208, 210, 211, 215–18)
	February 2–3	Paris	Hôtel Drouot	Succession Edouard Manet (presale exhibition: 5, 7, 19, 20, 23, 26, 37, 47, 52, 64, 71, 76, 85, 101, 105, 114, 115, 120, 124, 125, 137, 139, 153, 156, 157, 163, 172, 175–77, 182, 184, 190, 211, 213, 215, 217, 219)
1886	May 25–July 18	New York	National Academy of Design	Works in Oil and Pastel by the Impressionists of Paris (14, 50, 83, 90, 93, 115, 169, 180, 206)
1889	May–November	Paris	Exposition Universelle	Centennale de l'Art Français 1789–1889 (10, 50, 64, 73, 93, 118, 139, 140, 187, 210)
1893	May 1–October 9	Chicago	World's Columbian Exhibition	Loan Collection: Foreign Works from Private Collections in the United States (73)
1895	March	New York	Durand-Ruel	Paintings by Edouard Manet (38, 74, 87, 89, 92, 94, 99, 109, 121, 133, 138, 148, 157, 206, 211)
1900	May–November	Paris	Exposition Universelle	Centennale de l'Art Français 1800–1889 (62, 63, 67, 77, 81, 86, 91, 109, 141, 146, 211)
1903	spring	Berlin	Berlin Kunstlerhaus	Siebente Kunstausstellung der Berliner Sezession (210, 218)

1905	January–February	London	Grafton Galleries	Pictures by Boudin, Cézanne, Degas, Manet, Monet, Morisot, Pissarro, Renoir, Sisley. Exhibited by Messrs. Durand-Ruel (38, 91, 94, 182, 208, 210, 211)
	October 18–November 25	Paris	Grand Palais	Salon d'Automne (2, 3, 6, 38, 104, 106, 130, 137, 158, 175, 179, 183, 208, 210)
1906	March 1–17	Paris	Durand-Ruel	Exposition de 24 Tableaux et Aquarelles par Manet, formant la Collection Faure (10, 147, 169, 206)
	June 12–July 7	London	Sulley Gallery	Paintings by Manet from the Collection of Monsieur Faure of Paris (147, 169, 206)
	September 22–October 22	Berlin	Paul Cassirer	Ausstellung der Sammlung Faure (145, 169, 206)
	November 9–December	Stuttgart		Manet-Monet Ausstellung: Sammlung des Französischen Opernsängers Faure (145, 169, 206)
1907	January	Munich	Galerie Heinemann	Manet–Monet Ausstellung (145, 169, 188, 206)
1910	April	Berlin	Paul Cassirer	Edouard Manet (Aus der Sammlung Pellerin) (141, 146, 157, 164, 213)
	May 1	Munich	Moderne Galerie	Idem (109, 141, 146, 157, 184, 211, 216)
	May 10	Vienna	Miethke	Manet–Monet (156, 212)
	June 1–17	Paris	Bernheim-Jeune	Manet: Trente-cinq Tableaux de la Collection Pellerin (109, 141, 146, 157, 164, 184, 211, 213)
1910–11	November 8, 1910–January 15, 1911	London	Grafton Galleries	Manet and the Post-Impressionists (184, 211)
1912		Saint Petersburg	Institut Français	L'Exposition Centennale (French Painting 1812–1912) (70, 157, 211)
1913	November 29–December 13	New York	Durand-Ruel	Loan Exhibition of Paintings by Edouard Manet (10, 72, 81, 82, 90, 122, 132, 140, 148, 184)
1928	February 6–March 18	Berlin	Galerie Matthiesen	Ausstellung Edouard Manet 1832–1883: Gemälde, Pastelle, Aquarelle, Zeichnungen (6, 12, 20, 28, 67, 75, 88, 91, 94, 106, 108, 115, 180, 181, 188, 206, 208, 212)
	April 14–May 4	Paris	Bernheim-Jeune	Exposition d'Oeuvres de Manet au Profit des "Amis du Luxembourg" (3, 67, 75, 106, 115, 129, 137, 149, 174, 175, 178, 179, 188, 206, 220)
1930	April 7–19	Paris	Edmond Sagot	Dessins et Estampes de Manet (11, 52)
1932	June–July	Paris	Orangerie des Tuileries	Manet: 1832–1883 (3, 5, 12, 20, 22, 24, 31, 39, 40, 43, 50, 62, 64, 66, 71–74, 77, 80, 93, 97, 102, 104, 106–9, 113, 115, 118, 122, 129, 130, 135, 137, 139, 143, 148, 149, 162, 165, 175, 178, 180–82, 209–12, 217, 218, 220)
1933–34	November 29, 1933–January 1, 1934	Philadelphia	Pennsylvania Museum of Art	Manet and Renoir (14, 31, 64, 83, 92, 140, 148, 187, 210)
1934	May–October	Venice	XIXª Esposizione Biennale Internazionale d'Arte	Rétrospective Edouard Manet (12, 97, 106, 137, 165)
1937	March 19–April 17	New York	Wildenstein	Edouard Manet: A Retrospective Loan Exhibition for the Benefit of the French Hospital and the Lisa Day Nursery (10, 26, 31, 81, 83, 99, 102, 119, 147, 164, 174, 187, 213)
1940	May–October	New York	World's Fair	Masterpieces of Art (10, 74, 81, 102, 133)
1946–47	December 26, 1946–January 11, 1947	New York	Paul Rosenberg	Loan Exhibition: Masterpieces by Manet for the Benefit of American Aid to France, Inc. (6, 83, 91, 132)
1948	February 26–April 3	New York	Wildenstein	A Loan Exhibition of Manet for the Benefit of the New York Infirmary (5, 10, 34, 72, 84, 88, 119, 163, 165, 169, 182, 184, 185, 187, 208, 209, 213)

1952	January	Paris	Orangerie des Tuileries	Hommage à Manet (50, 62, 64, 77–80, 93, 97, 106–8, 115, 118, 137, 143, 178, 186, 189, 221)
1954	April 24–June 7	London	Tate Gallery	Manet and His Circle: Paintings from the Louvre (38, 50, 97, 107, 137, 149, 172, 211)
1961	May 16–July 31	Marseilles	Musée Cantini	Manet (2, 3, 51, 71, 75, 97, 107, 108, 129–31, 135, 149, 161, 166, 173, 189, 201, 203, 212, 215, 219, 221)
1966–67	November 3–December 11	Philadelphia	Philadelphia Museum of Art	Edouard Manet 1832–1883 [A. Hanson] (7–9, 11–13, 18, 23–26, 29, 30, 33, 35–37, 42, 44–48, 50, 52–56, 60, 68, 69, 73, 76, 81–85, 87, 95, 99, 101, 103–5, 108, 114, 116, 117, 121, 123, 125, 128, 137, 140, 145, 147, 148, 151, 160, 163, 164, 168, 169, 173–75, 180, 184, 189, 206–9, 212, 213, 219)
	January 13–February 19	Chicago	The Art Institute of Chicago	Idem (with exception of 121, 164, 184, 209; and addition of 67, 86, 90)
1969	January 19–March 2	Ann Arbor	Museum of Art, University of Michigan	Manet and Spain: Prints and Drawings [J. Isaacson] (7, 8, 11, 18, 25, 30, 34–37, 45, 47, 48, 52, 53, 68, 69, 76, 95, 105, 123, 125)
1973	January 19–April 1	Hamburg	Hamburger Kunsthalle	Nana: Mythos und Wirklichkeit [W. Hofmann] (157)
1974–75	October 15, 1974–January 15, 1975	Paris	Bibliothèque Nationale	L'Estampe Impressionniste [M. Melot] (9, 11, 41, 44, 54–58, 68, 69, 101, 123)
1977	April 6–May 8	Santa Barbara	University of California	The Cult of Images [B. Farwell et al.] (44, 53, 55, 58, 95, 101)
	April 30–June 19	Ingelheim am Rhein	Villa Schneider	Edouard Manet: Das Graphische Werk [J. Wilson] (7–9, 11, 15, 17, 18, 25, 35–37, 40, 41, 44–48, 52–60, 66, 68, 69, 76, 95, 100, 101, 103, 105, 114, 117, 123, 125, 149, 151, 168, 214)
1978	March 30–October 1	London	British Museum	From Manet to Toulouse-Lautrec: French Lithographs 1860–1900 [F. Carey and A. Griffiths] (44, 101, 105, 125, 151)
	June 6–July 13	Paris	Galerie Huguette Berès, 25, quai Voltaire	Manet [J. Wilson] (7–9, 11, 15, 16, 18, 23, 25, 28, 35–37, 45, 47, 48, 52–55, 58–60, 63, 68, 69, 76, 95, 101, 103, 105, 114, 117, 123, 125, 134, 151, 168, 214)
1981	February 21–March 22	Providence	Bell Gallery, List Art Center, Brown University	Edouard Manet and the "Execution of Maximilian" [K. S. Champa et al.] (37, 44, 101, 104, 105, 123–25)
1982–83	December 5–March 6	Washington, D.C.	National Gallery of Art	Manet and Modern Paris [T. Reff] (42, 44, 52, 73, 89, 98–101, 105, 124, 125, 133–35, 138, 160, 163, 164, 168, 169, 173, 174)

Bibliography of Works Cited

Works listed below are cited in abbreviated form.

About, Edmond
Le Salon de 1864, Paris, 1864.

Ackerman, Gerald M.
"Gérôme and Manet," *Gazette des Beaux-Arts*, 6th ser., LXX (September 1967), pp. 163–76.

Adhémar, Hélène
"La Donation Kahn-Sriber," *Revue du Louvre et des musées de France* 26, no. 2 (1976), pp. 99–104.

Adhémar, Jean
"Le Portrait de Baudelaire gravé par Manet," *Revue des arts* II (December 1952), pp. 240–42.

Adhémar, Jean
"Le Cabinet de travail de Zola," *Gazette des Beaux-Arts*, 6th ser., LVI (November 1960), pp. 285–98.

Adhémar, Jean
"Notes et documents: Manet et l'estampe," *Nouvelles de l'estampe*, 1965, pp. 230–35.

Alexis, P.
"Manet," in *La Revue moderne et naturaliste*, Paris, 1880, pp. 289–95.

Alston, David
"What's in a Name? 'Olympia' and a Minor Parnassian," *Gazette des Beaux-Arts*, 6th ser., XCI (April 1978), pp. 148–54.

Anderson, Wayne
"Manet and the Judgement of Paris," *Art News* 72 (February 1973), pp. 63–69.

Angoulvent, Monique
Berthe Morisot, Paris, 1933.

Astruc, Zacharie
"Le Salon des Refusés," *Le Salon*, May 20, 1863, p. 5.

Babou, H.
"Les Dissidents de l'exposition: Mr. Edouard Manet," *Revue libérale* II (1867), pp. 284–89.

Baignières, Arthur
"Le Salon de 1879," *Gazette des Beaux-Arts*, 2nd ser., XIX (June 1, 1879), pp. 549–72.

Bailly-Herzberg, Janine
L'Eau-forte de peintre au dix-neuvième siècle: La Société des aquafortistes 1862–1867, 2 vols., Paris, 1972.

Banville, Théodore de
in *Le National*, May 15, 1873.

Baraskaya, Anna
"Edouard Manet's Painting 'Nymph and Satyr' on Exhibition in Russia in 1861" (in Russian). In *Omagiu lui George Oprescu, cu prilejul împlinirii a 80 de ani*, Bucharest, 1961.

Barbey d'Aurevilly, Jules
"Un Ignorant au Salon," *Le Gaulois*, July 3, 1872.

Bataille, Georges
Manet, Lausanne, 1955.

Baticle, Jeannine, and Marinas, Cristina
La Galerie espagnole de Louis-Philippe au Louvre, 1838–1848, Paris, 1981.

Baudelaire, Charles
The Painter of Modern Life and Other Essays, trans. and ed. Jonathan Mayne, London, 1965.

Baudelaire, Charles
Baudelaire: Oeuvres posthumes, ed. Eugène Crépet, Paris, 1887.

Baudelaire, Charles
Correspondance, ed. Claude Pichois and Jean Ziegler, 2 vols., Paris, 1973.

Baudelaire, Charles
Oeuvres complètes, ed. Claude Pichois, new ed., Paris: vol. I, 1975; vol. II, 1976.

Baudelaire, *Lettres à*
Pichois, Claude, comp. *Lettres à Charles Baudelaire*, Neuchâtel, 1973.

Bazin, Germain
"Manet et la tradition," *L'Amour de l'art* 13 (May 1932), pp. 153–64.

Bazire, Edmond
Manet, Paris, 1884.

Beraldi, Henri
Les Graveurs du XIXe siècle: Guide de l'amateur d'estampes modernes, 12 vols., Paris, 1885–92: vol. III, *Bracquemond*; vol. IX, s. v. "Manet."

Bernardille (V. Fornel)
"L'Atelier de Mr. Manet," *Le Français*, April 21, 1876.

Bertall
"L'Exposition de Monsieur Manet," *Paris-Journal*, April 30, 1876.

Bertall
"Le Salon de 1880," *Paris-Journal*, May 10, 1880.

Biez, Jacques de
E. Manet: Conférence faite à la Salle des Capucines, le mardi 22 février 1884, Paris, 1884.

Blanc, Charles, et al.
Histoire des peintres de toutes les écoles, 14 vols., Paris, 1861–78: *Ecole hollandaise*, 2 vols., 1861; *Ecole flamande*, 1868; *Ecole vénitienne*, 1868; *Ecole espagnole*, 1869. First issued in 631 undated parts, 1849–76.

Blanche, Jacques-Emile
Essais et portraits, Paris, 1912.

Blanche, Jacques-Emile
Propos de peintre de David à Degas, Paris, 1919.

Blanche, Jacques-Emile
Manet, Paris, 1924. Trans. F. C. de Sumichrast, London, 1925.

Blanche, Jacques-Emile
Portraits of a Lifetime, trans. and ed. Walter Clement, London, 1937.

Blot, Eugène
Histoire d'une collection de tableaux modernes, Paris, 1934.

Bodelsen, Merete
"Early Impressionist Sales 1874–1894 in the Light of Some Unpublished 'Procès verbaux,'" *Burlington Magazine* CX (June 1968), pp. 331–48.

Bodkin, Thomas
"Manet, Dumas, Goya and Titian," *Burlington Magazine* L (March 1927), pp. 166–67.

Boime, Albert
"New Light on Manet's 'Execution of Maximilian,'" *Art Quarterly* XXXVI (Autumn 1973), pp. 172–208.

Boime, Albert
Thomas Couture and the Eclectic Vision, New Haven, 1980.

Bouillon, Jean-Paul
Félix Bracquemond, 1833–1914: Gravures, dessins, céramiques. Marie Bracquemond, 1841–1916: Tableaux (exhibition catalogue), Mortagne, 1972.

Bouillon, Jean-Paul
"Bracquemond, Rops et Manet et le procédé à la plume," *Nouvelles de l'estampe*, March–April 1974, pp. 3–11.

Bouillon, Jean-Paul
"Manet vu par Bracquemond," *La Revue de l'art*, no. 27 (1975), pp. 37–45.

Bowness, Alan
"A Note on Manet's Compositional Difficulties," *Burlington Magazine* CIII (June 1961), pp. 276–77.

Bürger, W. (Théophile Thoré)
"Le Salon de 1863 à Paris," *L'Indépendance belge*, June 11, 1863.

Bürger, W. (Théophile Thoré)
in *Le Constitutionnel*, May 16, 1865.

Bürger, W. (Théophile Thoré)
Salons de W. Bürger 1861 à 1868, 2 vols., Paris, 1870.

Burty, Philippe
"Exposition de la Société des Amis des Arts de Bordeaux," *Gazette des Beaux-Arts* XX (June 1866), pp. 558–66.

Burty, Philippe
"Les Ateliers," *La Renaissance littéraire et artistique* I (1872), pp. 220–21.

Callen, Anthea
"Faure and Manet," *Gazette des Beaux-Arts*, 6th ser., LXXXIII (March 1974), pp. 157–78.

Callias, Hector de
"Salon de 1861: Les Lettres K. L. M. N. O. P.," *L'Artiste*, July 1, 1861, pp. 1–11.

Callias, Hector de
"Le Salon de 1864," *L'Artiste*, June 1, 1864.

Castagnary, Jules
"Le Salon des Refusés," *L'Artiste*, August 15, 1863, pp. 73–76.

Castagnary, Jules
"Le Salon de 1868," *Le Siècle*, June 26, 1868.

Castagnary, Jules
"Le Salon de 1869," *Le Siècle*, June 11, 1869.

Castagnary, Jules
"Le Salon de 1874," *Le Siècle*, May 19, 1874.

Castagnary, Jules
"Le Salon de 1875," *Le Siècle*, May 29, 1875.

Castagnary, Jules
"Le Salon de 1879," *Le Siècle*, June 28, 1879.

Castagnary, Jules
Salons (1857–1870), 2 vols., Paris, 1892.

Cézanne, Paul
Conversations avec Cézanne, ed. P. M. Doran, Paris, 1978.

Champa, Kermit
Studies in Early Impressionism, New Haven, 1973.

Chaumelin, M.
"Le Salon de 1868," *La Presse*, June 23, 1868.

Chennevières, Philippe de
Souvenirs d'un directeur des Beaux-Arts, Paris, 1883–89. Reprint, Paris, 1979.

Chesneau, Ernest
"L'Art contemporain," *L'Artiste*, April 1, 1863, pp. 145–49.

Chesneau, Ernest
L'Art et les artistes modernes en France et en Angleterre, Paris, 1864.

Chesneau, Ernest
"Le Salon de 1865, III, Les Excentriques," *Le Constitutionnel*, May 16, 1865.

Claretie, Jules
"Deux Heures au Salon," *L'Artiste*, May 15, 1865, pp. 224–29.

Claretie, Jules
"Echos de Paris," *Le Figaro*, June 25, 1865.
Claretie, Jules
"Le Salon de 1872," *Le Soir*, May 25, 1872.
Claretie, Jules
L'Art français en 1872, Paris, 1872.
Claretie, Jules
L'Art et les artistes français contemporains, Paris, 1876.
Clark, Timothy J.
"Preliminaries to a Possible Treatment of 'Olympia' in 1865," *Screen*, Spring 1980, pp. 18–41.
Cogniat, R., and Hoog, Michel
Manet, Paris, 1982.
Collins, Bradford R.
"Manet's 'Rue Mosnier Decked with Flags' and the Flâneur Concept," *Burlington Magazine* CXVII (November 1975), pp. 709–14.
Collins, Bradford R.
"Manet's 'Luncheon in the Studio': An Homage to Baudelaire," *Art Journal* XXXVIII (Winter 1978–79), pp. 107–13.
Compte, P.
Catalogue raisonné des peintures du Musée des Beaux-Arts de la ville de Pau, Pau, 1978.
Connolly, John
"Ingres and the Erotic Intellect," *Art News Annual* XXXVIII (1972), pp. 25–27.
Cooper, Douglas
"George Moore and Modern Art," *Horizon: A Review of Literature and Art* XI (February 1945), pp. 113–30.
Cooper, Douglas
The Courtauld Collection: A Catalogue and Introduction. With a Memoir of Samuel Courtauld by Anthony Blunt, London, 1954.
"Copie faite pour Moreau-Nélaton..."
see Manet et al.
Courthion, Pierre, ed.
Courbet raconté par lui-même et par ses amis, Geneva, 1948.
Courthion, Pierre, and Cailler, Pierre, eds.
Manet raconté par lui-même et par ses amis, 2 vols., Geneva, 1953.
Courthion, Pierre
Edouard Manet, Paris, 1961. Ed. Milton S. Fox, New York, 1962.
Crépet, Eugène
Charles Baudelaire: Etude biographique..., ed. Jacques Crépet, Paris, 1906.
Crouzet, Marcel
Un Méconnu du réalisme: Duranty (1833–1880), Paris, 1964.
Curtiss, Mina
"Manet Caricatures: Olympia," *Massachusetts Review* VII (1966), pp. 725–52.
Darragon, Eric
"Manet, 'L'Evasion,'" *La Revue de l'art*, no. 56 (1982), pp. 25–40.
Davidson, Bernice Frances
"'Le Repos,' a Portrait of Berthe Morisot by Manet," *Rhode Island School of Design Bulletin* 46 (December 1959), pp. 5–10.
Davies, Martin
London, National Gallery. *French School: Early 19th Century, Impressionists, Post-Impressionists, etc.*, new ed., London, 1970.
Delteil, Loÿs
Le Peintre-graveur illustré, Paris, 1906–30: vol. IX, *Degas*, 1919; vols. XX–XXIX, *Daumier*, 1925–26.
Denker, S.
Providence, Rhode Island School of Design, Museum of Art. *Selection V: French Watercolors and Drawings from the Museum's Collection, ca. 1800–1910* (exhibition catalogue), Providence, R.I., 1975.
Deriège, F.
"Le Salon de 1865," *Le Siècle*, June 2, 1865.

Desnoyers, Fernand
Salon des Refusés: La Peinture en 1863, Paris, 1863.
Dorival, Bernard
Japon et Occident: Deux Siècles d'échanges artistiques, Paris, (1976) 1977.
Druick, Douglas, and Hoog, Michel
Paris, Grand Palais. *Fantin-Latour* (exhibition catalogue), Paris, 1982. Eng. ed., National Gallery of Canada, Ottawa, 1983.
Duranty, Edmond
La Nouvelle Peinture: A Propos du groupe d'artistes qui expose dans les galeries Durand-Ruel (1876), ed. Marcel Guérin, Paris, 1946.
Duret, Théodore
Les Peintres français en 1867, Paris, 1867.
Duret, Théodore
Histoire d'Edouard Manet et de son oeuvre par Théodore Duret, avec un catalogue des peintures et des pastels, Paris, 1902. Reissued 1906, 1919 with a supplement, and 1926.
Duret, Théodore
Manet and the French Impressionists, trans. J. E. Crawford Flitch, London, 1910.
Duret, Théodore
"Les Portraits peints par Manet et refusés par leurs modèles," *Renaissance de l'art français et des industries de luxe* I (July 1918), pp. 149–53.
Duret, Théodore
Renoir, Paris, 1924.
Duvergier de Hauranne, E.
"Le Salon de 1873," *La Revue des deux mondes*, June 1, 1873.
Elder, M. (Marc Tendron)
A Giverny, chez Claude Monet, Paris, 1924.
Etienne, L.
Le Jury et les exposants—Salon des Refusés, Paris, 1863.
Eudel, Paul
"La Vente Manet (1re journée)," *Le Figaro*, February 5, 1884. Reprinted in *L'Hôtel Drouot et la curiosité en 1883–1884*, Paris, 1885.
Faison, Samuel Lane
"Manet's 'Portrait of Zola,'" *Magazine of Art* XLII (May 1949), pp. 162–68.
Farwell, Beatrice
"Manet's 'Espada' and Marcantonio," *Metropolitan Museum Journal* 2 (1969), pp. 197–207.
Farwell, Beatrice
Manet and the Nude: A Study of Iconography in the Second Empire (Ph.D. diss., University of California, Los Angeles, 1973), New York, 1981.
Farwell, Beatrice
"Manet's 'Nymphe Surprise,'" *Burlington Magazine* CXVII (April 1975), pp. 224–27+.
Farwell, Beatrice, et al.
The Cult of Images: Baudelaire and the 19th Century Media Explosion (exhibition catalogue), University of California, Santa Barbara, 1977.
Fels, Florent
"Monsieur Duret," *Jardin des arts*, no. 107 (October 1963), pp. 24–31.
Fénéon, Félix
Oeuvres plus que complètes, ed. Joan U. Halperin, Geneva, 1970.
Fervacques
"Visite à l'atelier de Manet," *Le Figaro*, December 25, 1873.
Feyrnet, X.
in *L'Illustration*, April 25, 1863.
Flaubert, Gustave
Oeuvres complètes, Paris, 1952.
Flescher, Sharon
Zacharie Astruc: Critic, Artist and Japonist (Ph.D. diss., Columbia University, 1977), New York, 1978.
Flescher, Sharon
"Manet's 'Portrait of Zacharie Astruc': A Study of a Friendship and New Light on a Problematic Painting," *Arts Magazine* 52 (June 1978), pp. 98–105.

Florisoone, Michel
"Manet inspiré par Venise," *L'Amour de l'art* XVIII (January 1937), pp. 26–27.
Florisoone, Michel
Manet, Monaco, 1947.
Fournel, François-Victor
Les Artistes français contemporains: Peintres, sculpteurs, Tours, 1884.
Francion
"Le Salon de 1873," *L'Illustration*, June 14, 1873.
Fried, Michael
"Manet's Sources: Aspects of His Art, 1859–1865," *Artforum* 7 (March 1969), pp. 28–82.
Gautier, Théophile
Voyage en Espagne, Paris, 1842. Reprint, Paris, 1981.
Gautier, Théophile
Abécédaire du Salon de 1861, Paris, 1861.
Gautier, Théophile
"Le Salon de 1861," *Le Moniteur universel*, July 3, 1861.
Gautier, Théophile
"Le Salon de 1864," *Le Moniteur universel*, June 25, 1864.
Gautier, Théophile
"Le Salon de 1865," *Le Moniteur universel*, June 24, 1865.
Gautier, Théophile
"Le Salon de 1869," *L'Illustration*, May 15, 1869.
Gautier fils, Théophile
"Salon de 1865," *Le Monde illustré*, May 6, 1865.
Gay, Peter
Art and Act: On Causes in History: Manet, Gropius, Mondrian, New York, 1976.
Geffroy, Gustave
"Olympia," *La Vie artistique* I (1892), pp. 14–82.
Georgel, Pierre
"Les Transformations de la peinture vers 1848, 1855, 1863," *La Revue de l'art*, no. 27 (1975), pp. 62–77.
Gimpel, René
Journal d'un collectionneur marchand de tableaux, Paris, 1963. *Diary of an Art Dealer*, trans. J. Rosenberg, New York, 1966.
Glaser, Curt
Edouard Manet: Faksimiles nach Zeichnungen und Aquarellen, Munich, 1922.
Goedorp, J. L.
"L'Olympia n'était pas montmartroise," *Journal de l'amateur d'art*, February 23, 1967.
Goetschy, G.
"Edouard Manet," *La Vie moderne*, April 17, 1880, pp. 247–50.
Goetschy, G.
"Avant le Salon," *Le Soir*, April 30, 1882.
Goncourt, Edmond de, and Goncourt, Jules de
Journal: Mémoires de la vie littéraire, 4 vols., Paris, 1956.
Gonse, Louis
"Manet," *Gazette des Beaux-Arts*, 2nd ser., XXIX (February 1, 1884), pp. 133–52.
Griffiths, Antony
"Execution of Maximilian," *Burlington Magazine* CXIX (November 1977), p. 777.
Guérin, Marcel
L'Oeuvre gravé de Manet, Paris, 1944.
Gurewich, Vladimir
"Observations on the Iconography of the Wound in Christ's Side, with Special Reference to Its Position," *Journal of the Warburg and Courtauld Institutes* XX (July 1957), pp. 358–62.
Hadler, Mona
"Manet's 'Woman with a Parrot' of 1866," *Metropolitan Museum Journal* 7 (1973), pp. 115–22.
Halévy, Daniel
Degas parle, Paris, 1960.
Halévy, Ludovic
Carnets. Intro. and notes by Daniel Halévy, 2 vols., Paris, 1935.

Hamilton, George Heard
Manet and His Critics, New Haven, 1954. Reprint, New York, 1969.

Hanson, Anne Coffin
"A Group of Marine Paintings by Manet," *Art Bulletin* XLIV (December 1962), pp. 332–36.

Hanson, Anne Coffin
Philadelphia, Philadelphia Museum of Art. *Edouard Manet 1832–1883* (exhibition catalogue), Philadelphia, 1966.

Hanson, Anne Coffin
"Edouard Manet, 'Les Gitanos,' and the Cut Canvas," *Burlington Magazine* CXII (March 1970), pp. 158–66.

Hanson, Anne Coffin
"Popular Imagery and the Work of Edouard Manet." In *French 19th Century Painting and Literature: With Special Reference to the Relevance of Literary Subject-Matter to French Painting*, ed. Ulrich Finke, Manchester, 1972.

Hanson, Anne Coffin
Manet and the Modern Tradition, New York, 1977.

Hanson, Anne Coffin
"A Tale of Two Manets," *Art in America* 67 (December 1979), pp. 58–68.

Harris, Jean C.
"A Little-Known Essay on Manet by Stéphane Mallarmé," *Art Bulletin* XLVI (December 1964), pp. 559–63.

Harris, Jean C.
"Manet's Race Track Paintings," *Art Bulletin* XLVIII (March 1966), pp. 78–82.

Harris, Jean C.
Edouard Manet: Graphic Works, a Definitive Catalogue Raisonné, New York, 1970.

Harris, Tomás
Goya: Engravings and Lithographs, 2 vols., Oxford, 1964.

Haskell, Francis
"Il 'Concerto campestre' del Giorgione," *Arte illustrata*, December 1973, pp. 369–76.

Havemeyer, Louisine W.
Sixteen to Sixty: Memoirs of a Collector, New York, 1961.

Hédiard, Germain
Fantin-Latour: Catalogue de l'oeuvre lithographique du maître, Paris, 1906. Reprinted in Y. Bourel et al., *Fantin-Latour: Toute la lithographie*, Geneva, 1980.

Hoetink, Hendrik
Rotterdam, Museum Boymans-van Beuningen. *Franse tekeningen uit 19ᵉ eeuw*, Rotterdam, 1968.

Hofmann, Werner
The Earthly Paradise in the Nineteenth Century, trans. Brian Battershaw, New York, 1961.

Hofmann, Werner
Nana: Mythos und Wirklichkeit, Cologne, 1973.

Hopp, Gisela
Edouard Manet: Farbe und Bildgestalt, Berlin, 1968.

Howard, Seymour
"Early Manet and Artful Error: Foundations of Anti-Illusionism in Modern Painting," *Art Journal* XXXVII (Fall 1977), pp. 14–21.

Howe, Winifred E.
History of the Metropolitan Museum of Art, New York: vol. I, 1913; vol. II, 1946.

Huth, Hans
"Impressionism Comes to America," *Gazette des Beaux-Arts*, 6th ser., XXIX (April 1946), pp. 225–52.

Huysmans, J. K.
in *L'Artiste* (Brussels), May 13, 1877.

Huysmans, J. K.
"Le Salon de 1880," *La Réforme économique*, July 1, 1880, p. 783.

Huysmans, J. K.
L'Art moderne, Paris, 1883.

Hyslop, Lois Boe, and Hyslop, Francis
"Baudelaire and Manet: A Re-appraisal." In *Baudelaire as a Love Poet and Other Essays Commemorating the Centenary of the Death of the Poet*, ed. Lois Boe Hyslop, University Park, Pa., 1969.

Isaacson, Joel
Manet and Spain: Prints and Drawings (exhibition catalogue), University of Michigan, Museum of Art, Ann Arbor, 1969.

Isaacson, Joel
Monet: Le Déjeuner sur l'herbe, New York, 1972.

Ives, Colta
New York, The Metropolitan Museum of Art. *The Great Wave: The Influence of Japanese Woodcuts on French Prints* (exhibition catalogue), New York, 1974.

Jamot, Paul
"Etudes sur Manet," *Gazette des Beaux-Arts*, 5th ser., XV (January and June 1927), pp. 27–50, 381–90.

Jamot, Paul
"Manet and 'Olympia,'" *Burlington Magazine* L (January 1927), pp. 27–35.

Jamot, Paul
"Manet 'Le Fifre' et Victorine Meurend," *Revue de l'art ancien et moderne* LI (January–May 1927), pp. 31–41.

Jamot, Paul, and Wildenstein, Georges
Manet, 2 vols., Paris, 1932.

Jeanniot, Georges
"En Souvenir de Manet," *La Grande Revue* XLVI (August 10, 1907), pp. 844–60.

Jedlicka, Gotthard
Edouard Manet, Zurich, 1941.

Johnson, Lee
"A New Source for Manet's 'Execution of Maximilian,'" *Burlington Magazine* CXIX (August 1977), pp. 560–64.

Jones, Pamela M.
"Structure and Meaning in the 'Execution Series.'" In *Edouard Manet and the "Execution of Maximilian"* (exhibition catalogue), Brown University, Providence, R.I., 1981.

Junius
"Monsieur Edouard Manet," *Le Gaulois*, April 25, 1876.

Kovács, Steven
"Manet and His Son in 'Déjeuner dans l'atelier,'" *Connoisseur* CLXXXI (November 1972), pp. 196–202.

Krauss, Rosalind E.
"Manet's 'Nymph Surprised,'" *Burlington Magazine* CIX (November 1967), pp. 622–27.

Krell, Alan
"Manet, Zola and the 'Motifs d'une exposition particulière,' 1867," *Gazette des Beaux-Arts*, 6th ser., XCIX (March 1982), pp. 109–15.

Lagrange, L.
"Salon de 1861," *Gazette des Beaux-Arts* XI (July 1, 1861), pp. 49–73.

Lambert, Elie
"Manet et l'Espagne," *Gazette des Beaux-Arts*, 6th ser., IX (June 1933), pp. 369–82.

Laran, Jean, and Le Bas, Georges
Manet: 48 planches hors-texte, accompagnées de 48 notices..., Paris, 1911.

Leenhoff, Léon
see Manet, Edouard, et al.

Leiris, Alain de
"Manet's 'Christ Scourged' and the Problem of His Religious Paintings," *Art Bulletin* XLI (June 1959), pp. 198–201.

Leiris, Alain de
The Drawings of Edouard Manet, Berkeley, 1969.

Leiris, Alain de
"Edouard Manet's 'Mlle V. in the Costume of an Espada': Form-Ideas in Manet's Stylistic Repertory: Their Sources in Early Drawing Copies," *Arts Magazine* LIII (January 1979), pp. 112–17.

Leiris, Alain de
"Manet and El Greco: The 'Opéra Ball,'" *Arts Magazine* LV (September 1980), pp. 95–99.

Leiris, Alain de
Le Ruban au cou d'Olympia, Paris, 1981.

Lemonnier, Camille
Alfred Stevens et son oeuvre, Paris, 1906.

Lemoisne, Paul André
Degas et son oeuvre, 4 vols., Paris, 1946–49.

Leymarie, Jean, and Melot, Michel
Les Gravures des impressionnistes: Manet, Pissarro, Renoir, Cézanne, Sisley, Paris, 1971.

López-Rey, José
Velázquez: A Catalogue Raisonné of His Oeuvre, London, 1963.

Lowry, Bates
Muse or Ego: Salon and Independent Artists of the 1880's (exhibition catalogue), Pomona College, Claremont, Calif., 1963.

Lucas, George A.
The Diary of George A. Lucas: An American Art Agent in Paris, 1857–1909, 2 vols., Princeton, 1979.

Lugt, Frits
Les Marques de collection de dessins et d'estampes, Amsterdam, 1921; supplement, The Hague, 1956.

Mallarmé, Stéphane
"The Impressionists and Edouard Manet," *Art Review Monthly*, September 30, 1876, pp. 117–22.
"Stéphane Mallarmé: Les Impressionnistes et Edouard Manet," trans. Philippe Verdier, *Gazette des Beaux-Arts*, 6th ser., LXXXVI (November 1975), pp. 147–56.

Mallarmé, Stéphane
Oeuvres complètes, ed. Henri Mondor and Georges Jean-Aubry, Paris, 1945. Reprint, Paris, 1979.

Mallarmé, Stéphane
Correspondance, 5 vols., Paris, 1965–73.

Manet, Edouard
Lettres de jeunesse: 1848–1849. Voyage à Rio, Paris, 1928.

Manet, Edouard
"Une Correspondance inédite d'Edouard Manet: Les Lettres du siège de Paris (1870–1871)," ed. Adolphe Tabarant, Paris, 1935. Reprint from *Mercure de France*, 1935, pp. 262–89.

Manet, Edouard
"Letters from Manet to Zola," ed. C. Becker, see above, Appendix I.

Manet, [Edouard] et al.
Notes and documents: "Copie faite pour Moreau-Nélaton de documents sur Manet appartenant à Léon Leenhoff" (Yb³ 2401, and see SNR Manet). "Expositions Martinet" (yb 2012 [18]). "Carnet de notes (de L. Leenhoff?) sur des oeuvres de Manet" (SNR Manet). Paris, Bibliothèque Nationale, Département des Estampes, Moreau-Nélaton endowment. Albums of photographs by Godet and Lochard and family photograph album.

Manet, Julie
Journal (1893–1899): Sa Jeunesse parmi les peintres impressionnistes et les hommes de lettres, Paris, 1979.

Mantz, Paul
"Exposition du boulevard des Italiens," *Gazette des Beaux-Arts* XIV (April 15, 1863), pp. 381–84.

Mantz, Paul
"Le Salon de 1863," *Gazette des Beaux-Arts* XV (July 1, 1863), pp. 32–64.

Mantz, Paul
"Le Salon de 1869," *Gazette des Beaux-Arts*, 2nd ser., II (July 1869), pp. 5–23.

Mantz, Paul
"Le Salon," *Le Temps*, May 24, 1873.

Mantz, Paul
"Les Oeuvres de Manet," *Le Temps*, January 16, 1884.

542

Mathey, François
Olympia [de] *Manet*, Paris, 1948.
Mathey, Jacques
in *Bulletin de la Société d'Etudes pour la Connaissance d'Edouard Manet*, no. 1 (June 1967).
Matisse, Henri
in *L'Intransigeant*, January 25, 1932.
Mauner, George
Manet, Peintre-Philosophe: A Study of the Painter's Themes, University Park, Pa., 1975.
Maxon, John
The Art Institute of Chicago, New York, 1970.
Meier-Graefe, Julius
Edouard Manet, Munich, 1912.
Melot, Michel
Paris, Bibliothèque Nationale. *L'Estampe impressionniste* (exhibition catalogue), Paris, 1974.
Mondor, Henri
La Vie de Mallarmé, 2 vols., Paris, 1941–42.
Mongan, Alice
French: Thirteenth Century to 1919. Vol. III of *Great Drawings of All Time*, ed. Ira Moskowitz, New York, 1962.
Montesquiou, Robert de
Les Pas effacés: Mémoires, 3 vols., Paris, 1923.
Moore, George
Modern Painting, new enl. ed., London, 1898.
Moreau-Nélaton, Etienne
Manet graveur et lithographe, Paris, 1906.
Moreau-Nélaton, Etienne
Manet raconté par lui-même, 2 vols., Paris, 1926.
Moreau-Nélaton, Etienne
Catalogue manuscrit (SNR Manet). Paris, Bibliothèque Nationale, Département des Estampes.
Morisot, Berthe
Correspondance de Berthe Morisot avec sa famille et ses amis, ed. Denis Rouart, Paris, 1950.
Natanson, Thadée
Peints à leur tour, Paris, 1948.
Needham, Gerald
"Manet's 'Olympia' and Pornographic Photography," *Art News Annual* XXXVIII (1972), pp. 81–89.
Nittis, Joseph de
Notes et souvenirs, Paris, 1895.
Nochlin, Linda, ed.
Impressionism and Post-Impressionism, 1874–1904: Sources and Documents, Englewood Cliffs, N.J., 1966.
Nochlin, Linda
Realism, New York, 1972.
Orienti, Sandra
The Complete Paintings of Manet. Intro. by Phoebe Pool, New York, 1967.
Orienti, Sandra
Tout L'Oeuvre peint d'Edouard Manet. Intro. by Denis Rouart, Paris, 1970.
Otrange-Mastai, Maria Louise d'
"'Au Jardin': Two Manet Versions in America," *Apollo* LXIV (December 1956), pp. 168–73.
Painter, George Duncan
Marcel Proust, 2 vols., Paris, 1966.
Paris-Guide
Paris-Guide par les principaux écrivains et artistes de la France, ed. Lacroix, 2 vols., Paris, 1867.
Pauli, G.
"Raphaël und Manet," *Monatshefte für Kunstwissenschaft* I (January–February 1908), pp. 53–55.
Péladan, Josephin
"Le Procédé de Manet d'après l'exposition de l'Ecole des Beaux-Arts," *L'Artiste*, February 1884, pp. 101–17.
Perruchot, Henri
La Vie de Manet, Paris, 1959.
Peters, Susan Dodge
"Examination of Another Source for Manet's 'The Balcony,'" *Gazette des Beaux-Arts*, 6th ser., XCVI (December 1980), pp. 225–26.

Pickvance, Ronald
"A Newly Discovered Drawing by Degas of George Moore," *Burlington Magazine* CV (June 1963), pp. 276–80.
Pickvance, Ronald
"A Model of Modernism," *Times Literary Supplement*, June 24, 1977, pp. 761–62.
Pool and Orienti
see Orienti, Sandra
Poulain, Gaston
Bazille et ses amis, Paris, 1932.
Prins, Pierre
Pierre Prins et l'époque impressionniste: Sa Vie, son oeuvre, 1838–1913, par son fils, Paris, 1949.
Proust, Antonin
"Le Salon de 1882," *Gazette des Beaux-Arts*, 2nd ser., XXV (June 1882), pp. 531–54.
Proust, Antonin
"L'Art d'Edouard Manet par Antonin Proust," *Le Studio*, January 15, 1901, pp. 71–77.
Proust, Antonin
"Edouard Manet: Souvenirs," *La Revue blanche*, February–May 1897, pp. 125–35, 168–80, 201–7, 306–15, 413–24. Expanded and reissued as *Edouard Manet Souvenirs*, Paris, 1913.
Randon, G.
"L'Exposition d'Edouard Manet," *Le Journal amusant*, June 29, 1867, pp. 6–8.
Reff, Theodore
"The Symbolism of Manet's Frontispiece Etchings," *Burlington Magazine* CIV (May 1962), pp. 182–87.
Reff, Theodore
"Copyists in the Louvre, 1850–1870," *Art Bulletin* XLVI (December 1964), pp. 552–59.
Reff, Theodore
"Manet's Sources: A Critical Evaluation," *Artforum* 8 (September 1969), pp. 40–48.
Reff, Theodore
"Manet and Blanc's 'Histoire des peintres,'" *Burlington Magazine* CXII (July 1970), pp. 456–58.
Reff, Theodore
"Manet's 'Portrait of Zola,'" *Burlington Magazine* CXVII (January 1975), pp. 34–44.
Reff, Theodore
Manet: Olympia, New York, 1976.
Reff, Theodore
"Courbet and Manet." In *Malerei und Theorie: Das Courbet-Colloquium, 1979*, Frankfurt, 1980.
Reff, Theodore
Manet and Modern Paris (exhibition catalogue), National Gallery of Art, Washington, D.C., 1982.
Rewald, John
Edouard Manet Pastels, Oxford, 1947.
Rewald, John
The History of Impressionism, 4th rev. ed., New York, 1973.
Rewald, John
"Theo van Gogh, Goupil and the Impressionists," *Gazette des Beaux-Arts*, 6th ser., LXXXI (January and February 1973), pp. 1–64, 65–108.
Rey, Robert
Manet, Paris, 1938. Trans. E. B. Shaw, New York, 1938.
Richardson, John
Edouard Manet: Paintings and Drawings, London, 1958. 2nd ed., 1982.
Rishel, Joseph
Philadelphia, Philadelphia Museum of Art. *The Second Empire 1852–1870: Art in France Under Napoleon III* (exhibition catalogue), Philadelphia, 1978.
Robida, Michel
Le Salon Charpentier et les impressionnistes, Paris, 1958.

Rosenberg, Pierre
Chardin, 1699–1779 (exhibition catalogue), Grand Palais, Paris, 1979; Eng. ed., Cleveland Museum of Art, 1979.
Rosenthal, L.
Manet aquafortiste et lithographe, Paris, 1925.
Rouart and Orienti
see Orienti, Sandra
Rouart, Denis, and Wildenstein, Daniel
Edouard Manet: Catalogue raisonné, 2 vols., Lausanne, 1975.
Ruggiero, Marianne
"Manet and the Image of War and Revolution: 1851–1871." In *Edouard Manet and the "Execution of Maximilian"* (exhibition catalogue), Brown University, Providence, R.I., 1981.
Saarinen, Aline
The Proud Possessors, New York, 1958.
Saint-Victor, Paul de
"Beaux-Arts," *La Presse*, April.27, 1863.
Saint-Victor, Paul de
"Le Salon de 1865," *La Presse*, May 28, 1865.
Sandblad, Nils Gösta
Manet: Three Studies in Artistic Conception, trans. Walter Nash, Lund, 1954.
Scharf, Aaron
Art and Photography, London, 1968; pbk. ed., 1974.
Schneider, Pierre
Dialogues du Louvre, Paris, 1967.
Schneider, Pierre
The World of Manet, 1832–1883, New York, 1968.
Manet et son temps, Paris, 1972.
Seitz, William Chapin
Claude Monet, New York, 1960.
Silvestre, Armand
"L'Ecole de peinture contemporaine," *La Renaissance artistique et littéraire*, September 28, 1872.
Silvestre, Armand
"Les Deux Tableaux de Monsieur Manet," *L'Opinion nationale*, April 23, 1876.
Silvestre, Armand
"Le Monde des arts, le Salon de 1880, les portraits," *La Vie moderne*, May 22 and June 5, 1880, pp. 327, 352.
Silvestre, Armand
Au Pays des souvenirs, Paris, 1887.
Sloane, Joseph Curtis
"Manet and History," *Art Quarterly* 14 (Summer 1951), pp. 92–106.
Solkin, David
"Philbert Rouvière: E. Manet's 'L'Acteur tragique,'" *Burlington Magazine* CXVII (November 1975), pp. 702–9.
Spuller, E.
"Edouard Manet et sa peinture," *Le Nain jaune*, June 8, 1867.
Sterling, Charles, and Salinger, Margaretta
XIX–XX Centuries. Vol. III of *French Paintings: A Catalogue of the Collection of the Metropolitan Museum of Art*, Cambridge, Mass., 1955–67.
Stuckey, Charles F.
"What's Wrong with This Picture?" *Art in America* 69 (September 1981), pp. 96–107.
Tabarant, Adolphe
"Le Peintre Caillebotte et sa collection," *Bulletin de la vie artistique*, August 1921, pp. 405–13.
Tabarant, Adolphe
"Les Manets de la collection Havemeyer," *La Renaissance de l'art* XIII (February 1930), pp. 57–74.
Tabarant, Adolphe
Manet: Histoire catalographique, Paris, 1931.
Tabarant, Adolphe
La Vie artistique au temps de Baudelaire, Paris, 1942. Reprint, Paris, 1963.
Tabarant, Adolphe
Manet et ses oeuvres, Paris, 1947.

Tabarant 1935
see Manet, Edouard

Ten Doesschate Chu, Petra
French Realism and the Dutch Masters: The Influence of Dutch Seventeenth-Century Painting on the Development of French Painting Between 1830–1870, Utrecht, 1975.

Tomkins, Calvin
Merchants and Masterpieces: The Story of the Metropolitan Museum of Art, New York, 1970.

Toussaint, Hélène
Rome, Villa Medici. *Courbet* (exhibition catalogue), Milan, 1969.

Tschudi, Hugo von
Edouard Manet, Berlin, 1902.

Tucker, Paul
Monet at Argenteuil, New Haven, 1982.

Valéry, Paul
"Triomphe de Manet." In *Exposition Manet, 1832–1883* (exhibition catalogue), Musée de l'Orangerie, Paris, 1932.

Valléry-Radot, Jean
"Le Dessin préparatoire de Greuze pour 'L'Oiseleur accordant sa guitare,'" *Gazette des Beaux-Arts,* 6th ser., LIV (October 1959), pp. 215–18.

Van Emde Boas, C.
"Le Geste d'Olympia." In *Livre jubilaire offert au Dr. Jean Dalsace,* Paris, 1966.

Van Gogh, Vincent
Verzamelde Brieven van Vincent van Gogh, ed. I. V. W. van Gogh, 4 vols., Amsterdam, 1954.

Venturi, Lionello
Les Archives de l'impressionnisme, 2 vols., Paris, 1939.

Venturi, Lionello
"Manet, un créateur d'images," *Arts,* June 5–11, 1953.

Villot, Fréderic
Paris, Musée du Louvre. *Notice des tableaux dans les galeries du Musée du Louvre,* Paris, 1864.

Vollard, Ambroise
Auguste Renoir (1841–1919), Paris, 1920.

Vollard, Ambroise
Degas (1834–1917), Paris, 1924.

Vollard, Ambroise
Recollections of a Picture Dealer, trans. Violet M. Mcdonald, London, 1936. *Souvenirs d'un marchand de tableaux,* Paris, 1937.

Vollard, Ambroise
En Ecoutant Parler Cézanne, Degas et Renoir, Paris, 1938.

Walker, John
The National Gallery of Art, Washington, London, 1964.

Walker, John
The National Gallery of Art, Washington, New York, 1975.

Walter, Rodolphe
"Emile Zola et Paul Cézanne à Bennecourt en 1866," *Bulletin de la Société 'Les Amis du Mantois,'* no. 12 (March 1, 1961).

Walter, Rodolphe
"Les Maisons de Claude Monet à Argenteuil," *Gazette des Beaux-Arts,* 6th ser., LXVIII (December 1966), pp. 333–42.

Wechsler, Jill
"An Aperitif to Manet's 'Déjeuner sur l'herbe,'" *Gazette des Beaux-Arts,* 6th ser., XCI (January 1978), pp. 32–34.

Weisberg, Gabriel Paul
"Philippe Burty: A Notable Critic of the Nineteenth Century," *Apollo,* n.s. XCI (April 1970), pp. 296–300.

Weisberg, Gabriel Paul
Cleveland, Cleveland Museum of Art. *Japonisme: Japanese Influence on French Art 1854–1910* (exhibition catalogue), Cleveland, 1975.

Weisberg, Gabriel Paul
The Realist Tradition: French Painting and Drawing, 1830–1900 (exhibition catalogue), Cleveland Museum of Art, 1980.

Weitzenhoffer, Frances
"First Manet Paintings to Enter an American Museum," *Gazette des Beaux-Arts,* 6th ser., XCVII (March 1981), pp. 125–29.

Weitzenhoffer, Frances
"The Creation of the Havemeyer Collection, 1875–1900." Ph.D. diss., City University of New York, 1982.

Welsh-Ovcharov, Bogomila
Vincent van Gogh and the Birth of Cloisonism (exhibition catalogue), Art Gallery of Ontario, Toronto, 1981.

Whitehill, Walter Muir
Museum of Fine Arts, Boston, 2 vols., Cambridge, Mass., 1970.

Wildenstein, Daniel
Claude Monet: Biographie et catalogue raisonné, 3 vols. to date, Lausanne, 1974–.

Wilson, Juliet
Edouard Manet: Das Graphische Werk: Meisterwerke aus der Bibliothèque Nationale und weiterer Sammlungen (exhibition catalogue), Ingelheim am Rhein, 1977.

Wilson, Juliet
Manet: Dessins, aquarelles, eaux-fortes, lithographies, correspondance (exhibition catalogue), Galerie Huguette Berès, Paris, 1978.

Wolff, Albert
"Le Salon," *Le Figaro,* May 20, 1869.

Wolff, Albert
"Le Calendrier parisien," *Le Figaro,* May 11 and 28, 1879.

Wolff, Albert
"Monsieur Manet," *Le Figaro-Salon,* May 1, 1882.

Wright, Willard Huntington
Modern Painting, New York, 1915.

Yriarte, Charles
Goya, Paris, 1867.

Zervos, Christian
"Manet, est-il un grand créateur?" *Cahiers d'art* VII, nos. 6–7 (1932), pp. 295–96.

Zola, Emile
"Mon Salon: M. Manet," *L'Evénement,* May 7, 1866.

Zola, Emile
"Une Nouvelle Manière en peinture: Edouard Manet," *L'Artiste: Revue du XIXᵉ siècle,* January 1, 1867. Reprinted as *Ed. Manet: Etude biographique et critique, accompagnée d'un portrait d'Ed. Manet par Bracquemond et d'une eau-forte d'Ed. Manet, d'après Olympia,* Paris (Dentu), 1867.

Zola, Emile
Salons, ed. Fredrick William John Hemmings and Robert J. Niess, Geneva, 1959.

Zola, Emile
Oeuvres complètes, Paris, 1960–67.

Zola, Emile
Oeuvres complètes, ed. Henri Mitterand, 15 vols., Paris, 1966–69.

Zola, Emile
Correspondance, ed. B. H. Bakker and Colette Becker, 4 vols. to date, Montreal, 1978–.

Index of Sales

Numbers in parentheses refer to catalogue numbers. See also Index of Names Cited in the Provenances.

André
 Paris, Drouot, May 18–19, 1914 (49).
Anonymous (de L*** et al.)
 Paris, Drouot, March 23, 1878 (83).
Anonymous
 Paris, Drouot, March 30, 1935 (65).
Anonymous
 Paris, April 24, 1944 (163).
Barrion
 Paris, Drouot (2nd sale), May 25–June 1, 1904 (39, 40, 43, 56, 59, 66, 113, 162).
Baugnée
 Brussels, Hollender, March 22, 1875 (82).
Beurdeley
 Paris, G. Petit (9th sale), November 30–December 2, 1920 (70).
B[iron]
 Paris, Drouot, April 13, 1910 (see 101).
Blot
 Paris, Drouot, May 10, 1906 (63).
Bodinier
 Paris, Drouot, February 17, 1903 (1).
Boussaton
 Paris, G. Petit, May 5, 1891 (169).
Burty
 Paris, Drouot, March 4–5, 1891 (42, 47, 52, 58, 95).
Chabrier
 Paris, Drouot, March 26, 1896 (175, 211).
Champfleury
 Paris, Drouot, April 28–29, 1890 (78).
Chéramy
 Paris, G. Petit, May 5–7, 1908 (1, 2, 175).
Chocquet
 Paris, G. Petit, July 1–4, 1899 (78, 158).
[Churchill]
 Paris, Drouot, March 30, 1938 (120).
Cochin
 Paris, G. Petit, March 26, 1919 (173).
David-Weill
 Paris, Drouot, May 25–26, 1971 (see 114).
Davis
 New York, Chickering Hall, March 19–20, 1889 (14, 96).
Degas
 Paris, G. Petit (1st sale), March 26–27, 1918 (23, 26, 126, 143, 144).

Degas
 Paris, Drouot (2nd sale), November 6–7, 1918 (15, see 17, 18, see 44, 47, 52, 58, 95).
Delteil
 Paris, Drouot, June 13–15, 1928 (11, 25).
Desfossés
 Paris, private residence, April 26, 1899 (37).
Dollfus
 Paris, Drouot, March 4, 1912 (124).
Doria
 Paris, G. Petit, May 5, 1899 (166).
Dorville
 Nice, June 24, 1942 (30).
Doucet
 Paris, Drouot, December 28, 1917 (65).
Duret
 Paris, G. Petit, March 19, 1894 (92, 121, 130).
[Edwards]
 Paris, Drouot, February 24, 1881 (14).
Fantin-Latour
 Paris, Drouot, March 14, 1905 (53).
Faure
 Paris, Drouot, April 29, 1878 (138).
Flanagan
 New York, Plaza Hotel, January 14, 1920 (156).
Garnier
 Paris, G. Petit, December 3–4, 1894 (157).
Gérard
 Paris, Drouot, March 28–29, 1905 (81, 189).
Goldschmidt
 London, Sotheby's, October 15, 1958 (164).
Goodfriend
 New York, American Art Association, January 4–5, 1923 (26).
Goupy
 Paris, Drouot, March 30, 1898 (84, 122).
Guérin
 Paris, Drouot (1st sale), December 9, 1921 (56).
Guérin
 Paris, Drouot (2nd sale), May 10–11, 1922 (see 56).
Guérin
 March 19, 1952 (56).
Hazard
 Paris, G. Petit (1st sale), December 1, 1919 (190).
Hazard
 Paris, Drouot (3rd sale), December 12–13, 1919 (57, 117).

Hoschedé
 Paris, Drouot, June 5–6, 1878 (32, 72, 96).
Koenigs
 ? 1939 (13).
Laperlier
 Paris, Drouot, April 11–13, 1867 (see 102).
Manet
 Paris, Drouot, February 4–5, 1884 (5, see 12, 19, 23, 26, 37, 64, 71, 85, 87, see 101, 115, 120, 124, see 126, 137, 139, 153, 156, 157, 163, 172, see 173, 175–77, 182, 184, 190, 211, 213, 215, 217, 219).
Marx
 Paris, Drouot, April 27–May 2, 1914 (35, see 101, 168).
Milliken
 New York, American Art Association, February 14, 1902 (86).
N[adar]
 Paris, Drouot, November 11–12, 1895 (29).
Nemes
 Paris, Manzi-Joyant, June 18, 1913 (185).
Parguez
 Paris, Drouot, April 22–24, 1861 (see 44).
Pellerin
 Paris, Drouot, May 7, 1926 (24, 71).
Pellerin
 Paris, Charpentier, June 10, 1954 (111, 112, 136, 154, 155, 161, 166, 167, 170, 171, 199).
P[ertuiset]
 Paris, Drouot, June 6, 1888 (91, see 208).
Picard
 Paris, October 26, 1964 (see 47).
Pissarro
 Paris, G. Petit, December 3, 1928 (13).
Rothenstein
 Paris, Drouot, February 23–24, 1922 (185).
Rouart
 Paris, Manzi-Joyant, December 9, 1912 (65, 129, 135).
Salamanca
 Paris, private residence, June 3–6, 1868 (see 115).
[Santamarina]
 London, Sotheby's, April 2, 1974 (190).
Saulnier
 Paris, Drouot, June 5, 1886 (77).
T[homas]
 Paris, Drouot, June 18, 1952 (11, 52).
Vogel
 New York, October 17, 1979 (220).

Index of Names Cited in the Provenances

Numbers refer to catalogue numbers
 boldface: principal mention in the provenance
 italics: mention in the entry
 italicized boldface: principal mention in the entry and in the provenance
Parentheses indicate person who played role in history of work
 but did not own it.
Question mark indicates uncertainty about ownership.

Photograph Credits

Reproductions are by permission of the owners of the original works, who supplied color transparencies and black-and-white photographs except in the following cases:

Acquavella Galleries, New York 216; The Art Museum, Princeton University 184; Bulloz, Paris 108; Cooper Colour-Library, London 129; Fernand Hazan, Paris 124; Geri T. Mancini 29; Gilbert Mangin, Nancy 215; The Metropolitan Museum of Art, New York 5, 84, 122, 164; Philadelphia Museum of Art 83, 147; Photorama S.A., Le Havre 120; Pinakothek, Munich 109; Eric Pollitzer, New York 132; Réunion des Musées Nationaux, Paris 3, 4, 6, 50, 51, 62, 64, 65, 71, 75, 77–80, 91, 93, 97, 100, 106, 107, 111, 112, 115, 118, 119, 130, 131, 135–37, 143, 149, 150, 154, 155, 161, 166, 167, 171, 173, 177–79, 183, 186, 188, 189, 191–99, 205, 217, 221; Studio Lourmel, Paris 142; Henri Tabah, Rueil-Malmaison 70.